P9-CKL-554

SISTER WENDY'S
1OOO
MASTERPIECES

SISTER WENDY'S
1000
MASTERPIECES

SISTER WENDY BECKETT
CONTRIBUTING CONSULTANT PATRICIA WRIGHT

DK PUBLISHING, INC.
New York
www.dk.com

A DK PUBLISHING BOOK
www.dk.com

Senior editor Louise Candlish
Senior art editor Heather M^cCarry
US editor Barbara Minton
Senior managing editor Anna Kruger
Deputy art director Tina Vaughan
Production controller David Proffit, Louise Daly
Picture researchers Jo Walton, Sam Ruston, Louise Thomas
DTP designer Robert Campbell

PRODUCED FOR DORLING KINDERSLEY BY STUDIO CACTUS

I would like to dedicate this book to Tricia Wright, without whose support, research, insights, and inspiration, it would never have been begun; let alone finished. Thank you dear Tricia, invaluable friend.

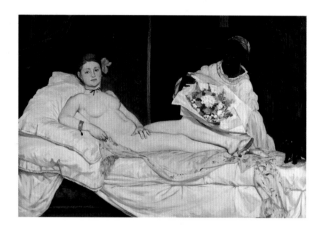

First American Edition, 1999
2 4 6 8 10 9 7 5 3 1

Published in the United States by DK Publishing, Inc.
95 Madison Avenue, New York, New York 10016

Copyright © 1999 Dorling Kindersley Limited, London
Text copyright © 1999 Sister Wendy Beckett

DK Publishing books are available at special discounts for bulk purchases for sales promotions or premiums. Special editions, including personalized covers, excerpts of existing guides, and corporate imprints can be created in large quantities for specific needs. For more information, contact Special Markets Dept./DK Publishing, Inc./95 Madison Ave./New York, NY 10016/Fax: 800-600-9098.

All rights reserved under International and Pan–American Copyright Conventions. No part of this publication may be reproduced, stored in a retrieval system, or transmitted in any form or by any means, electronic, mechanical, photocopying, recording, or otherwise, without the prior written permission of the copyright owner. Published in Great Britain by Dorling Kindersley Limited.

Library of Congress Cataloging-in-Publication Data

Beckett, Wendy.
 Sister Wendy's 1000 Masterpieces/by Sister Wendy Beckett. — 1st
American ed.
 p. cm.
 ISBN 0-7894-4603-0 (alk. paper)
 1. Painting, Modern?tbc. I. Title II. Title: Sister Wendy's one
thousand masterpieces.
ND160.B425 1999
759—dc21 99-20355
 CIP

FOREWORD

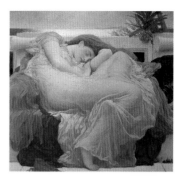

SOME PEOPLE FIND THE VERY IDEA OF MASTERPIECES IRRITATING: an elitist attempt to impose high culture. The medieval apprentice would have found this baffling. Whatever his craft, he graduated into the happy position of being a master when he had served his time and produced his "masterpiece." At this homely level, an artist's masterpiece is a solid piece of work – well constructed and admirable – making no claims to world importance. Such a work can bring endless pleasure, and the least of the paintings in this book is just such a masterpiece. However, this is a masterpiece at its most modest. If every painting in this book is a masterpiece, then some are more masterly than others. Great art offers more than pleasure; it offers the pain of spiritual growth, drawing us into areas of ourselves that we may not wish to encounter. It will not leave us in our mental or moral laziness. It is not just that we are privileged to see the world through the insight of a genius – great though that experience is – but that the painter's insights awaken and challenge us, and we end up changed. We pass from the less demanding to the more, and then back again, constantly widening our love, knowledge, and understanding. Part of the fascination of this book is the divergence of quality: always good, sometimes great, sometimes overwhelming – absolute masterpieces like the Sistine Chapel, which are among the world's greatest achievements. I defy anyone to find a work here unworthy of its place, although you might well wonder why this particular work was chosen rather than that! Where is your favorite Giotto, or Picasso's *Guernica?* (The answer to the last is that it is not here because I think it is a wonderful propaganda poster rather than painting.) A thousand sounded so many until we got down to it and then began the anguish of choice. This is a book where the pictures alone matter; the purpose of the text is to keep you in the presence of the painting. Look long enough, and each one will work its magic on you.

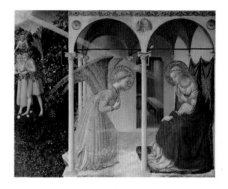

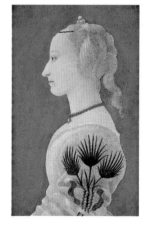

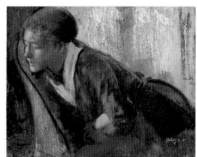

CONTENTS

ALBERS, JOSEF 1888–1976 b. Germany
STUDY FOR HOMAGE TO THE SQUARE

THE EXTRAORDINARY SUBTLETY with which colors interact – how one shade can change another and relate to a third – so fascinated Josef Albers that he decided to restrict his paintings to geometrical patterns. By using the square, that most common of forms, he hoped to withdraw the viewer from any involvement in the interest of the actual object. But in blending and relating colors within the square, he hoped that the eye would be infinitely tantalized and delighted by a sense of what color truly was. (He claimed, for example, that he had eighty kinds of yellow alone.) Here, he is playing with a deep pink, with the square that encloses it in an infinitesimally lighter pink, and, outside that, a pale orange – all held within another square of a still-lighter orange. This is the kind of subtle modulation of color that a casual glance all too easily misses. Albers sacrificed so much of the interest and beauty that we expect from a work of art, solely in order to concentrate on this color play. In doing it, he makes us aware of the lovely silence that, with intelligent perception, can flow from one color to another.

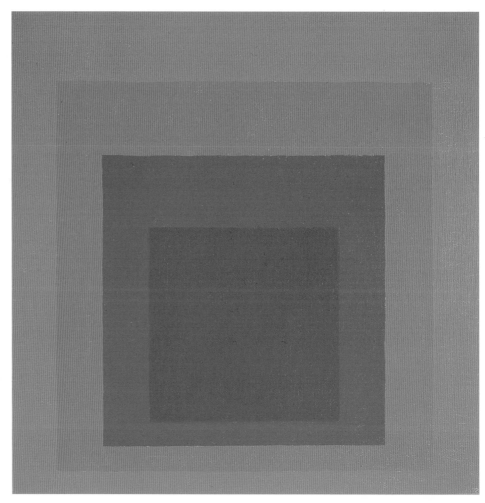

STUDY FOR HOMAGE TO THE SQUARE, *1972, oil on masonite, 24 x 24 in (62 x 62 cm), San Francisco Museum of Modern Art*

ALBERTINELLI, MARIOTTO 1474–1515 b. Italy
THE VISITATION

IN THE GOSPELS, we read how Mary was told that her elderly cousin Elizabeth had become pregnant with John the Baptist and that she set out to help Elizabeth. When the women met, the children in their womb – Jesus and John – seemed to communicate. Elizabeth said that she could feel her unborn child leaping for joy. The image of the two pregnant women meeting and communicating is a beautiful one, and Albertinelli depicts it in all its dignity. Both women are majestic figures, meeting before a great arch that symbolizes the entrance through the womb into history that their unborn sons will soon be making. Elizabeth bends humbly before the mother of her Lord while Mary has the extraordinary experience of meeting, for the first time, one who understands her singular destiny. The clasped hands, the inclining bodies, the meeting of the eyes - all express with understated power this communion of spirit. Albertinelli seems to understand the rarity of meeting another who can enter into one's own experience. It seems to be a meeting between two heroes. Mary's beautiful face is awestruck as she looks with a tender smile at the elderly woman who embraces her. There is a beautiful richness of color here: the flowing golden-orange and dark green of Elizabeth's clothes and the rough wool of her white scarf make a wonderful union with the subdued splendor of Mary's blue and red. The intensity, of both emotion and color, leaves no space for the landscape that is just visible at either edge. These two rejoicing women are a country all to themselves.

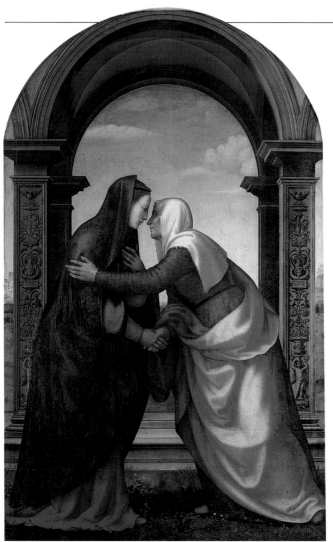

THE VISITATION, *1503,*
oil on wood, 91 x 57½ in (232 x 146 cm),
Galleria degli Uffizi, Florence

ALLORI, CRISTOFANO 1577–1621 b. Italy

JUDITH WITH THE HEAD OF HOLOFERNES

WHEN HOLOFERNES INVADED PALESTINE, it was the beautiful widow Judith who went into his camp, lured him with drink, and then, when he was insensible, beheaded him, carrying the trophy back in triumph to her people. This powerful woman fascinated many Renaissance artists. She subverted the feminine role, taking for herself the emotions of aggression and triumph – something, apparently, that men of the time feared in womankind. Allori's Judith possesses an exceptional loveliness: her face is both sensual and pure. She poses for us, aware of her status as heroine, one who controls the situation with effortless ease. But the very innocence and grace of her appearance make the dichotomy between what she is and what she has done seem more alarming.

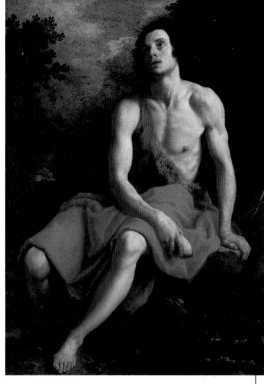

ST JOHN THE BAPTIST IN THE DESERT

c.1620s, oil on canvas, 70 x 63 in (177 x 159 cm),
Galleria degli Uffizi, Florence

Allori's St John the Baptist is a beautiful young male in the full flush of his strength, whose animal skins remind us of the lion-skin of Hercules. This is a benign desert, in which a sunlit stream sparkles beside him, and it may well depict the moment when the idea of baptism struck him – he would dip his container in the waters and pour them over the heads of penitents as a sign of God's forgiveness. In this moment of epiphany – of revelation – John is rapt, oblivious to all but the vocation for which he has long prepared and now understands.

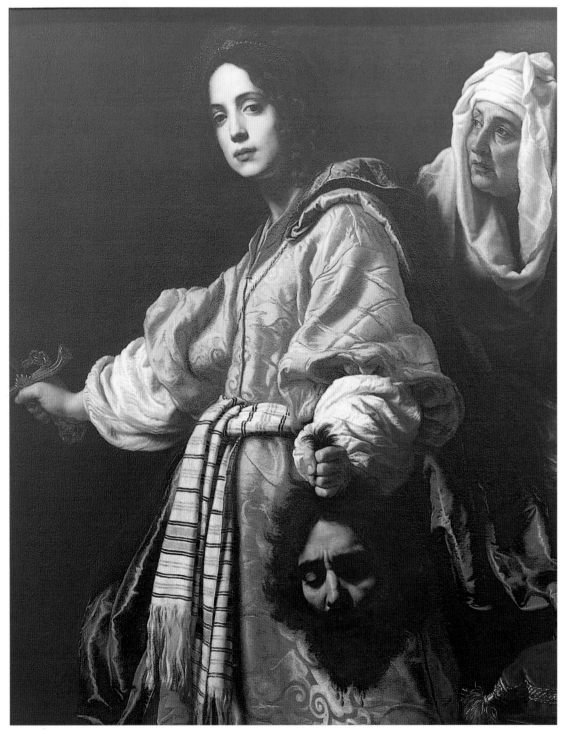

THE SEVERED HEAD *is that of a mature tyrant – a savage head, outlined by the golden damask of her garment, and forming an intriguing contrast with the slender elegance of her own head, which rises almost directly above it. The face of the maid is an elderly contrast to both. Her look of awe and unease emphasizes for us the true magnitude of the act that this casual and beautiful young woman has brought herself to perform.*

ONE NOTICES THAT *the body under the robes is slender – this is a very young woman, however daring her deeds. She is dressed in robes of the utmost richness and splendor. Allori, great Mannerist that he was, has delighted in the richness of the textiles, but perhaps the image that remains with us longest is the plain white headgear that frames the ancient and dismayed face of Judith's follower.*

JUDITH WITH THE HEAD OF HOLOFERNES, *1619–20, oil on canvas, 54 x 46 in (139 x 116 cm), Galleria degli Uffizi, Florence*

ALMA-TADEMA, SIR LAWRENCE
1836–1912 b. Netherlands, active England

UNCONSCIOUS RIVALS

THE VICTORIAN UPPER-CLASS SCHOOLBOY basically studied nothing but Latin and Greek, and it was in that context and for that clientele that Alma-Tadema created his extraordinary evocations of that lost classical world. He took historical accuracy very seriously, but, as we can see from this painting, he infused it with a romantic passion. This lost world, with its marbles, gladiators, and imperial follies, haunted the imagination of Queen Victoria's British Empire, and whether Alma-Tadema was accurate or not, he was felt to be so, and felt it so himself. Here, he shows two Roman beauties in a setting of extreme opulence, and the suggestion is that this is one of those Roman pleasure villas that were built around Naples. The girls are each rapt in some erotic reverie, waiting, it would seem, and in this luxurious setting the implication is that they are waiting for a lover.

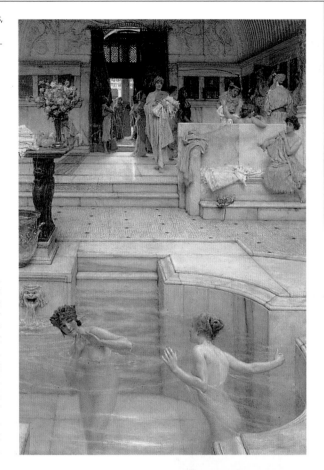

A FAVORITE CUSTOM
1909, oil on panel, 26 x 18 in
(66 x 45 cm), Tate Gallery, London

Here, in the cool ambience of the Roman bath, Alma-Tadema is able to delight those who cherish the classical way of life, while, with perfect propriety, introducing the theme of the nude. The communal bath fascinated his contemporaries and afforded the artist every occasion to show his technical skills. This is a calm, cool, alluring picture, with hints of implicit narrative that add to its attraction.

UNCONSCIOUS RIVALS, *1893, oil on panel, 18 x 25 in (45 x 63 cm), Bristol Museum and Art Gallery, UK*

ON THE LEFT *is a marble cupid; on the right are the feet of a statue of a gladiator. Gladiators were the toy-boys of Imperial Rome and, whether or not this is the subtext here, there is certainly a feeling that more is going on beneath the surface than we are aware.*

ALTDORFER, ALBRECHT c.1480–1538 b. Germany
ALEXANDER'S VICTORY

ALTDORFER WAS AN ARTIST OF DAUNTING AMBITION. *Alexander's Victory* does not merely record the outcome of the Battle of Issus, nor does it simply show the massed movement of combat; in this painting, Altdorfer attempts nothing less than to encompass the whole known world, which that battle was to affect. He starts in the sky, with an announcement of the importance of what we are to view; the ringed and tassled rope that hangs from the heavenly plaque leads us directly down to the central event. A tiny Alexander, lance at the ready, charges towards Darius III, who can be seen further ahead, fleeing in his chariot. For the rest, huge surging multitudes struggle ignorantly and vainly – flags wave, lances advance, and men fall. Yet all seems to us bloodless and silent because, along with the artist, we are entirely removed, looking down on these horrors without concern. The encampments of the armies seem no more real or unreal than the castles and fortresses they surround.

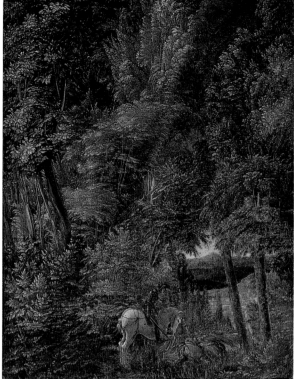

ST GEORGE
1510, oil on wood, 11 x 9 in (28 x 23 cm),
Alte Pinakothek, Munich

The Roman mind and the Teutonic mind were moved by different impulses: one towards the order of the high road; the other towards the dark mystery of the forest. Altdorfer is essentially painting the weird encompassing wilderness of the German forests, but he gives his picture a focus and a theme by entitling it *St George*. This St George is not in his usual scenario (saving the princess before an admiring crowd); instead, he is tackling the dragon alone and for his own sake. Essentially, like all of us, the knight is on his own, and Altdorfer sets him in the echoing silence of the forest to make this poignantly clear.

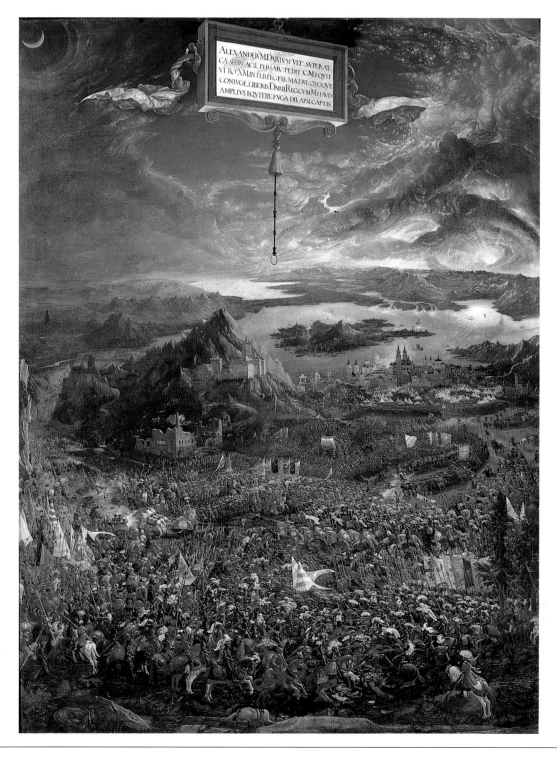

ALL THIS INFINITE *expenditure of energy is set in the real landscape of the Mediterranean world, with the Red Sea in the middle. On the right is Egypt and on the left the Gulf of Persia. Far away, we see the long, narrow needle of the Tower of Babylon. All these great expanses of territory will be affected by what takes place in miniature in the center of this huge canvas.*

THE VERY SUN *in the sky is setting in horrified splendor behind the mountains, as if to emphasize that this is a world affected by nature but ruled by men and their individual choices. Only a few solitary soldiers on horseback at the very edge of the picture are recognizable as individuals, and yet Altdorfer involves us, should we choose to make the imaginative effort with him, in one of the great sagas of all time.*

ALEXANDER'S VICTORY
(or BATTLE OF ISSUS), *1529, oil and tempera on wood, 62 x 48 in (158 x 121 cm), Alte Pinakothek, Munich*

ALTICHIERO DA ZEVIO c.1330–95 b. Italy
THE BEHEADING
OF ST GEORGE

ALTICHIERO IS AN INTRIGUING 14TH-CENTURY ARTIST about whom we know very little except that he seems to have looked long and hard at the work of Giotto. He has clearly understood the fundamental revolution in the way of regarding the human body that was Giotto's supreme contribution to painting. Altichiero shows us solid figures with three-dimensional reality. He understood even more Giotto's interest in human drama – the relationships between people – as is evident in this painting, where we see St George with head bowed to receive the executioner's stroke. All those around are intimately involved in the tragedy. On the left, a father leads away his child, who, like all youngsters, is fascinated by the prospect of the bloodshed but will be horrified by its actuality.

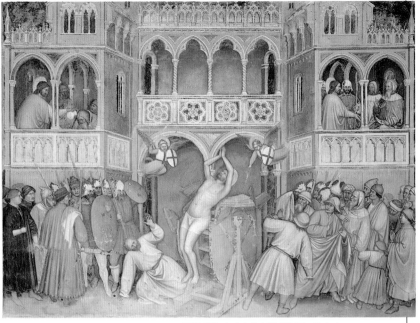

THE MARTYRDOM
OF ST GEORGE (DETAIL)
c.1382, fresco, dimensions not known,
Oratorio di San Giorgio, Padua, Italy

This is another image from the long and painful progress of St George from hero on horseback to beheaded martyr. This shows the pagans' attempt to execute him on the torture wheel. The martyr, in the center of the picture, is strapped to the wheel, which is visibly exploding to the astonishment and horror of those who have assembled to see the death. St George is poised to spring upwards, like a diver in reverse, to that world above – the world to which he aspires. On one side, Christ blesses and pardons; on the other, He encounters His judges. Both images of Christ reflect events in the life of St George.

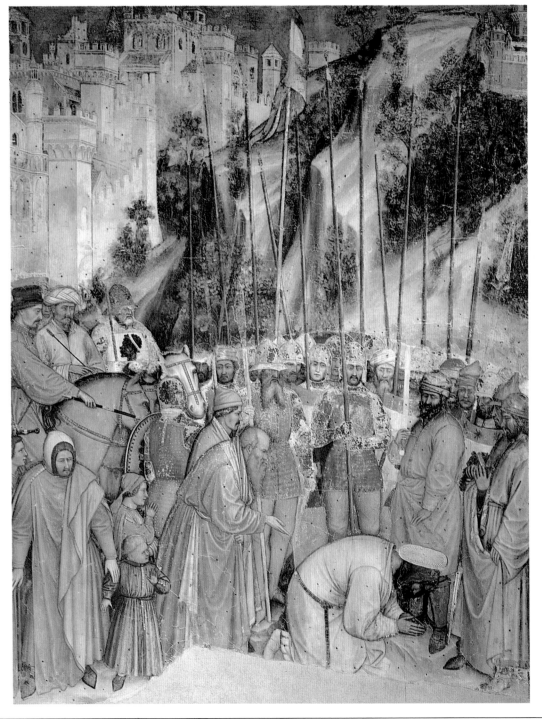

THE PAGAN PRIEST *still harangues, with anxious futility, the resolute back of the kneeling saint, while the various grandees and soldiers look on with sadness. Legend has it that St George himself was a soldier, and these may well be his companions in arms. Even the executioner is seen by Altichiero as a living personality, carefully measuring with his eye where he will place the sword.*

AS WELL AS STUDYING GIOTTO, *Altichiero had also looked at Simone Martini, hence the glory of Sienese color here – the pinks, the blues, and the pale yellows. The circle of people involved in this terrible act is put into perspective by the upper half of the picture: on one side, the great tall towers of authority; on the other, the mighty cliffs of nature. Land and city will endure long after the sorrows of this martyrdom have passed away.*

THE BEHEADING
OF ST GEORGE (DETAIL)
c.1382, fresco, dimensions not known,
Oratorio di San Giorgio, Padua, Italy

Andrea del Sarto 1486–1530 b. Italy
MADONNA of the HARPIES

ANDREA DEL SARTO paintings are instantly recognizable for their indefinable smudginess. It is an engrossing quality, highlighting the splendor of his color and suggestive of meaning and mystery. The *Madonna of the Harpies* takes its name from the two extraordinary little creatures with splayed legs and gaping mouths that so strangely adorn the pedestal on which the Virgin is standing. The harpies' malevolence, however curbed, seems to affect the little angels who balance the Virgin as if she were about to teeter unsteadily on her plinth. Despite the large and agile Child wriggling in His mother's grasp, Mary appears unperturbed. As the eye travels up the scarlet and blues and pale greens and yellows of her garment, the face we come to is one sunk in that reverie that is also peculiar to the artist. Two saints flank the Virgin: St Francis, sad and thoughtful, gazing not at us, but past us; and, on the other side, St John with his gospel. It is a grand composition, bright and glorious, and yet perhaps the most significant element in it is the darkness behind the Virgin – the great hollow that suggests far more than is visible.

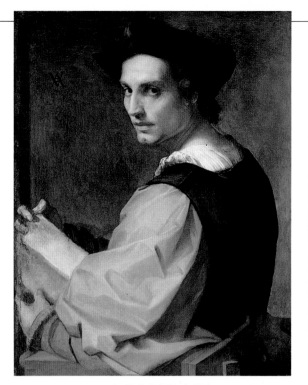

PORTRAIT OF A YOUNG MAN
c.1517, oil on linen, 28 x 22 in (72 x 57 cm), National Gallery, London

Andrea del Sarto was in his early forties when he died, never quite having achieved the promise that his work suggests. This faint element of melancholy, of genius unfulfilled, seems to have infused much of his work. This young man – holding either a book or a stone to be sculpted – turns towards us with that melancholy that the artist seems to know from within. It is a fine, noble face but not a happy one.

THIS ST JOHN *is unusual in his colorful splendor. He seems to wrestle with the book that he props up on one muscular leg, and we see the tension of the veins of his hands, perhaps in contrast to the quiet grace with which his counterpart, St Francis, holds the simple crucifix.*

AS WE CAN SEE *from the Virgin's pedestal, the harpies are insistently female. They are creatures from Greek mythology, winged and voracious, destructive enemies of life. Andrea del Sarto has turned them into stone, leeched them of color, and made them serve as footstool to a divine goodness.*

MADONNA OF THE HARPIES, *1517, oil on wood, 81 x 70 in (207 x 178 cm), Galleria degli Uffizi, Florence*

ANGELICO, FRA (GIOVANNI DA FIESOLE) c.1387–1455 b. Italy

THE ANNUNCIATION

FRA ANGELICO IS THE ONLY ARTIST, so far, to be canonized, and the profound spirituality of *The Annunciation* seems visibly to be the creation of a deeply believing spirit. The angel, luminous in pinks and golds with a ravishingly pale-blue underskirt, bows with beautiful humility before the meek and receptive Virgin. Her pinks are softer than his, her blue more defined. Gabriel's golden hair froths with angelic freedom; hers sits tightly to her neat little head. On her knee is the prayer book with which she was occupied before the summons reached her. Fra Angelico shows the wonderful enclosure of the Virgin's purity and, in the top-left corner, the sacred dove of the Holy Spirit. The great streak of light symbolizes the moment of the Immaculate Conception – the incarnation of Christ. With a sophisticated subtlety that is often overlooked in Fra Angelico's work, the angel has a single foot and the tips of both wings protruding out of the Virgin's sanctuary into that wild world from which she has secluded herself. Nature and the supernatural are not, after all, as separate as they may appear.

APART FROM THE ANGEL, *Virgin, and bird, there is no living plant or creature within Mary's enclosure; outside, the world riots with life and fertility, with flower and tree, with an undisciplined vegetative force. Pathetic and lost, Adam and Eve move out into the unknown.*

TWO ARCHANGELS *appear in this picture. In the distance, the Archangel Michael can be seen tenderly ushering our first parents, Adam and Eve, out of Eden and into the world; in the center of the picture, Gabriel joyously ushers the Son of God into the womb of His mother.*

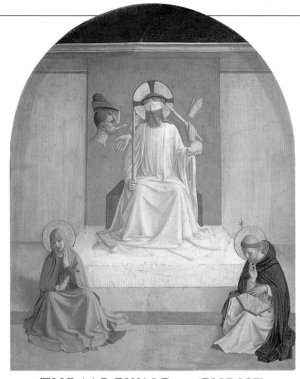

THE MOCKING OF CHRIST
1410–41, fresco, 77 x 77 in (195 x 195 cm), Museo di San Marco dell' Angelico, Florence

This is an image for contemplation, painted on the wall of a monk's cell. We see Mary and St Dominic rapt in prayer, and behind them the image forming in their minds of the mocking of Christ on the way to His crucifixion. The objects of torment have been abstracted, reduced to their essence.

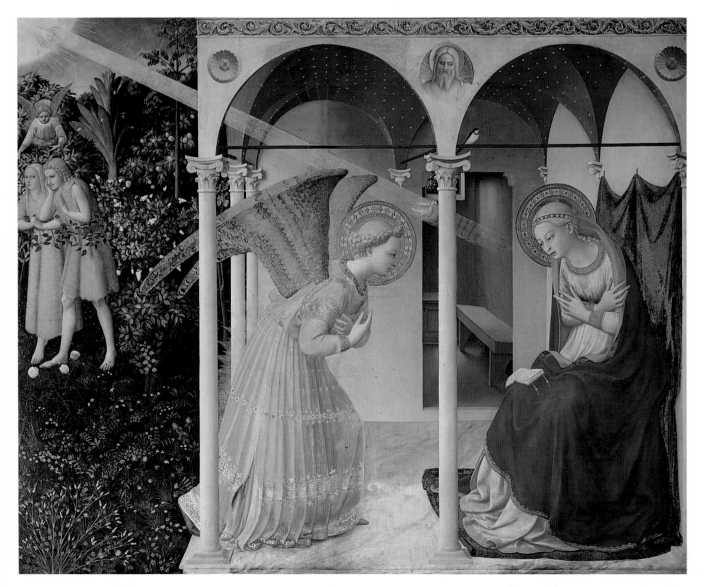

> **"HE WHO WISHES TO PAINT CHRIST'S STORY MUST LIVE WITH CHRIST"**
> Fra Angelico

THE ANNUNCIATION
1435–45, tempera on board, 76 x 76 in (194 x 194 cm), Museo del Prado, Madrid

ANTONELLO DA MESSINA c.1430–79 b. Italy
VIRGIN ANNUNCIATE

ANTONELLO DA MESSINA IS FAMED for having been the conduit through which oil painting made its first great impact on Italian art. He had studied in the Netherlands, and was probably the first to unify the luminosity of oil with the wonderful understanding of the human body that the Italians had pioneered. What makes his *Virgin Annunciate* such a remarkable image is the fact that Antonello has completely done away with the angel – it is us Mary faces, and we, however unworthy, are forced into the angelic position and are met not with dismay but with an almost daunting self-possession. This is the face of a completely adult woman. She turns from her prayer book, not merely to welcome the angel with that uplifted hand, but perhaps even to quell him, to restrain the heavenly enthusiasm with which she is being greeted. A woman of such serene resolution may well have made up her mind as to what answer is required of her before the angelic act got under way. It is that concentration of strong clear outline and of an interior dynamic force that makes this picture so unforgettable.

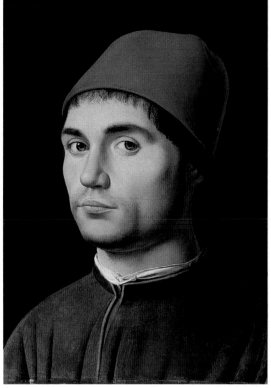

PORTRAIT OF A MAN
c.1475, oil on wood, 14 x 10 in (36 x 25 cm)
National Gallery, London

Whoever this young man was, his face is fairly unremarkable with its pudgy cheeks and watchful brown eyes. A rather suspicious fellow perhaps, this young unknown, and yet he has no call to be suspicious of the artist. Authority is stamped on every line of the portrait. Antonello has responded with a sensitive awareness of light and shade, and an even deeper awareness of the hidden reserves of character. This is unmistakably a specific and unique individual.

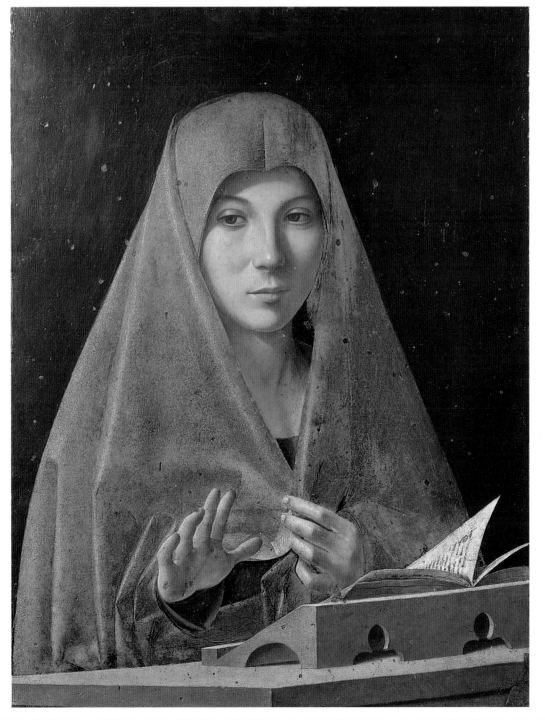

"ONCE THIS NEW SECRET THAT ANTONELLO HAD BROUGHT FROM FLANDERS INTO THE CITY OF MILAN HAD BEEN UNDERSTOOD, ANTONELLO WAS ADMIRED AND CHERISHED BY THOSE MAGNIFICENT NOBLEMEN FOR AS LONG AS HE LIVED"
Giorgio Vasari

ANTONELLO PAINTS *with a tenderness and an interior glow that was new in Italian art. Light lingers around his figures, enhancing their sculptural solidity with an almost romantic softness. Mary is presented to our gaze almost full on, face to face, clear and simple against a black background, suggesting that her past is insignificant compared with her future.*

VIRGIN ANNUNCIATE, *c.1465, oil on wood, 18 x 13 in (45 x 34 cm), Galleria Nazionale, Palermo, Italy*

ASSERETO, GIOACHINO 1600–49 b. Italy
CHRIST HEALING THE BLIND MAN

CHRIST HEALING THE BLIND MAN,
c.1640, oil on canvas, 38 x 54 in (97 x 138 cm),
Museum of Art, Carnegie Institute, Pittsburgh

THIS IS THE BEST KNOWN of Assereto's paintings. It is a work of uncommon power and vitality. Christ plunges forward with rough peasant force, poking one strong finger into the blind man's eye; as He does so, the effect is mirrored on the faces of the bystanders. We know from their expressions that a blind eye has opened, that with a vigorous jab of divinity, Jesus has worked a miraculous healing. The setting's rough reality comes across with extraordinary simplicity and force. As an image of what it means to be cured by an influx of transcendent power, this could hardly be bettered. The expression on Christ's face tells us that this is no easy miracle, and although His methods are crude, He is as intent and focused as a surgeon. The cost to Him is almost tangible.

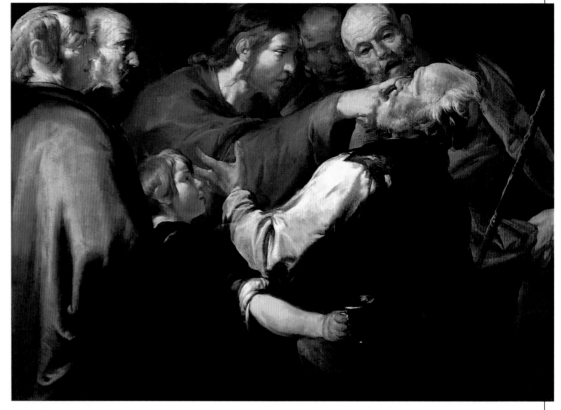

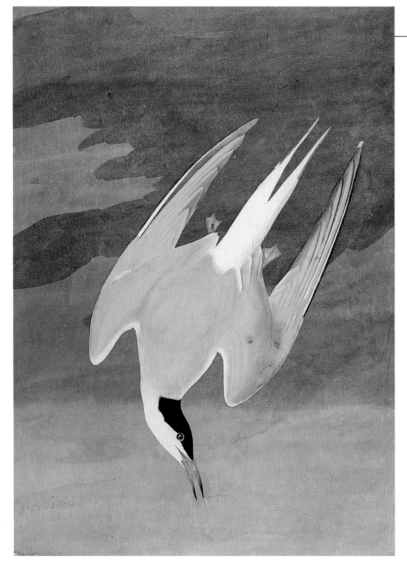

AUDUBON, JOHN JAMES 1785–1851 b. Haiti, active US
ARCTIC TERN

EARLY 19TH-CENTURY AMERICA was fortunate to have a great naturalist like John James Audubon whose eye for the reality of a bird was matched by his capacity to depict it. Audubon was a pupil of the great French artist, Jacques-Louis David, but he fled to the United States to avoid conscription in Napoleon's army. He made a living in the New World as an artist, hunter, and taxidermist. Unfortunately, the very nature of bird art usually means that the subject must first be dead in order to be painted – as is almost certainly the case here. Audubon's skill is to set the bird in a context that makes us conscious of what this creature was like when living. The arctic tern, swooping like a dive-bomber into the dark seas to spear its fish, is a remarkable image. It is one of 1,065 studies of birds that Audubon painted from life, and which were published in 1827–38 in four volumes entitled *The Birds of America*.

ARCTIC TERN, 1827–38,
watercolor, graphite, and collage,
21 x 14 in (53 x 36 cm), New
York Historical Society

AUERBACH, FRANK 1931– b. Germany, active England

E.O.W. ON HER BLUE EIDERDOWN II

FRANK AUERBACH IS ONE OF THOSE RARE ARTISTS who are only drawn to paint what they have known intimately and loved for a long time. His models are exceptionally few, mainly two women, both of whom are dear to him. Nevertheless, it is clear that they are a pretext, as it were, for a superb and sensitive indulgence in the act of painting itself. Of the almost countless images of E.O.W., this one of the model on her blue eiderdown is among the most seductive. Auerbach's relationship with paint is clearly an abiding passion: he slathers it on, almost spendthrift in the thick swirls and globs of color, and yet out of this indulgence, in his sheer delight in painterly texture, there emerges an image of a long, fragile body, curled up on the rich, soft blue of her bed-covering. Ironically, Auerbach's images seem to belong to the subject more than they belong to the artist; they retain a privacy behind the fluid and intensely-worked surface of paint, with which Auerbach is so obviously obsessed.

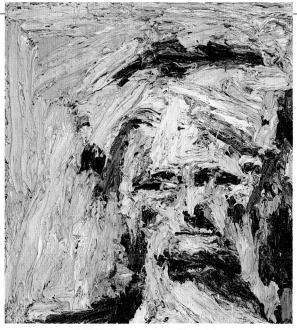

HEAD OF E.O.W. VI
1961, oil on board, 24 x 22 in (60 x 56 cm),
National Gallery of Modern Art, Edinburgh

E.O.W. ON HER
BLUE EIDERDOWN II
1965, oil on board, 24 x 32 in
(60 x 81 cm), Private Collection

AUERBACH'S IMAGES EMERGE *and disappear; they will not stay still for us to visually digest them. E.O.W. on her Blue Eiderdown has a compelling presence that makes it impossible to glance at it with merely casual interest.*

So thickly has the paint been applied here that it seems almost chiselled from stone. The intensity of the head is striking, but there is also great subtlety in the texture of the paint, the peaks and hollows of which catch the light to give added vitality.

Avercamp, Hendrick 1585–1634 b. Netherlands
FROZEN RIVER

Avercamp had a physical disability that he overcame in his art. He was known locally as *"de stomme van Kampen"* (the mute of Kampen). Visually speaking, Avercamp seems to have had one great emotional experience: the sight of a frozen river. The transformation of a normal world into an icy hardness must have brought profound astonishment, yet he paints it with such infectious delight that it is hard to imagine how little of this pleasure he could physically have shared. Almost from the beginning, he seems to have known what he wanted to paint, and that was scenes of winter with small contented figures skating on the ice. The air is always chill but the atmosphere is strangely relaxed. Here, he brings us close to the frozen river, where ships have lost their freedom and all trading activities have come to a relative standstill. Over half the picture shows the bleak winter sky, but it is punctuated by the brave folly of masks and flags that have lost their function. What is so striking about the small groups of people is their animation and their separateness. The groups are all small – twos and threes. Even through the extremity of cold the townsfolk remain separate, each engrossed in an activity that is private to himself. However, there is no sense of exclusion in this delightful painting.

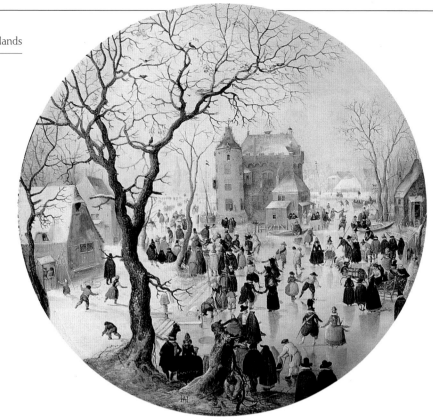

A WINTER SCENE WITH SKATERS NEAR A CASTLE
c.1610, oil on wood, 16 in (41 cm) diameter, National Gallery, London

Here, Avercamp has created an imaginary castle, that image of inviolable security, and has punctuated his tondo with a tree, again a symbol of shelter. The images are too small for us to distinguish exactly and perhaps that is his point – not to focus on the skaters, but to show them as animated little figurines, as generic humanity able to enjoy the treat of a frozen world, to play and divert themselves on the treacherous ice.

A
16

FROZEN RIVER
*c.1620, oil on wood, 6 x 14 in (16 x 36 cm),
Boymans-van Beuningen Museum, Rotterdam*

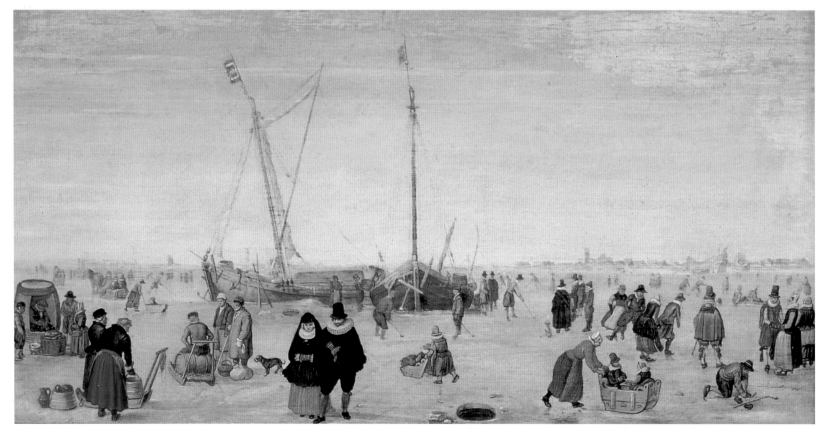

SOME PEOPLE PLAY *either golf or ice hockey, some are setting up market stalls on the ice, some are taking the air, mothers playing with children: all manner of activity disappears into the icy haze.*

THE HOLE THAT HAS BEEN CUT *in the ice can frighten us when our eye falls into it and this is the only hint of the inherent danger of the scene. All ignore it; work and play go on with happy intent.*

THE WINTRY AIR HAS BLEACHED *away the strength of the color – we see blacks, grays, whites, a few muted reds – and outlined faintly against the skyline we can see the towers of the city.*

BACON, FRANCIS 1909–92 b. Ireland, active England

HEAD SURROUNDED BY SIDES OF BEEF

FRANCIS BACON HAS BEEN CALLED the greatest poet of the second half of the 20th century, and even those who deeply dislike his work find it memorable and horribly impressive. He is an artist obsessed by the horror of existence and the terrible vulnerability of being. He professed to see no hope, and yet his very life is a denial of such despair, because creativity can never really come without some belief in the meaning of what is created. Certain images recur again and again in Bacon's paintings, and the best known is that of the screaming pope, after Velázquez's great portrait of Pope Innocent X. Bacon refused to study Velázquez's portrait, preferring instead to paint from his memory of that painting's authoritarian majesty. Here, he shows the pope, father of the Catholic Church, both enthroned and imprisoned by his position. Bacon's relationship with his own father was a very stormy one, and perhaps he has used some of that fear and hatred to conjure up this ghostly vision of a screaming pope, his face frozen in a rictus of anguish.

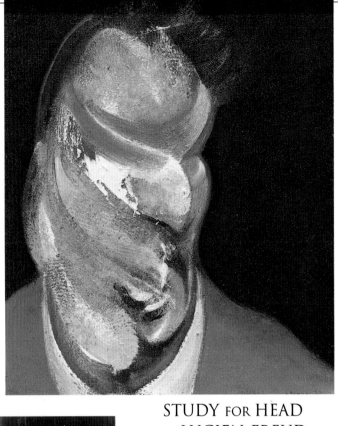

STUDY FOR HEAD OF LUCIEN FREUD
1967, oil on canvas, 14 x 12 (36 x 31 cm), Private Collection

Bacon's portraits are unique. He insisted on painting portraits only of friends, and Lucien Freud was one of his closest. He insisted, too, that he did not want to paint his subjects from life, but from photographs, and the absence of the actual person set him free to mould and deform with a wild virtuosity. Here, he seems to have painted the portrait, and then, perhaps with his finger or thumb, smeared out the features of the face; yet, despite this arrogance with paint and feature, enough significant traces remain to recognize the face of the sitter.

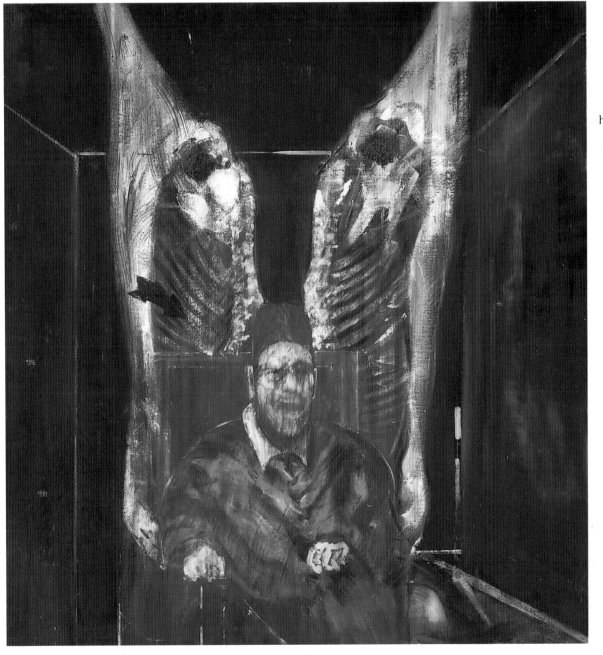

THE POPE IS *pushed down to the bottom half of the canvas and squashed low into his chair. Around him, Bacon has built the suggestion of a cage or cell. He has marked him out with an arrow, as if this clenched and tortured image was an exhibit in the artist's chamber of horrors.*

BACON HAS *also drawn from another famous image, Rembrandt's great Carcass of Beef, and has hung the animal's flayed and bloody flesh on either side of this human animal. Rembrandt painted his carcass with reverence; Bacon sees these carcasses as raw meat – the pope as he will be – and dangles them, almost insouciantly, behind the papal chair.*

HEAD SURROUNDED BY SIDES OF BEEF, *1954, oil on canvas, 51 x 48 in (129 x 122 cm), The Art Institute of Chicago*

BALDOVINETTI, ALESSO c.1425–99 b. Italy
THE VIRGIN AND CHILD

WHEN LOOKING AT ITALIAN PAINTERS, one can sometimes feel that they had practically no other theme except the Virgin and Child. And yet, the unmistakable personality of the artist is never more visible than in such a well-worn subject. Baldovinetti's Virgin is one of the most appealing. Her smile, with its shyness and sweetness, is intended solely for the Child; she seems unaware of the viewers who are watching her, and she has that look of inward content peculiar to a young mother with her first child. The little Jesus, too, is a sturdy and believable baby. His swaddling bonds have come amiss but His mother is contemplating Him with too much pleasure to become aware of His needs. One feels that soon His actions will become more dominant and the appeal might even become vociferous. For all the pleasure that the picture gives us, it nevertheless also conveys a deep sense of loneliness – of what it means to be a mother, to be responsible, and have nothing at your back but the emptiness of the world.

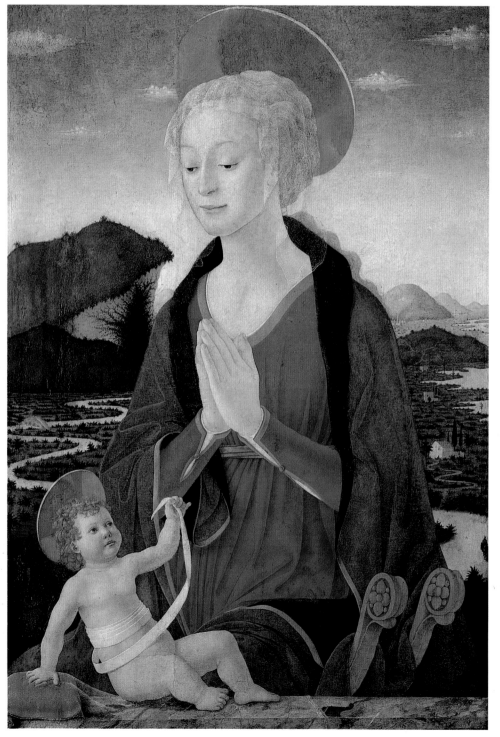

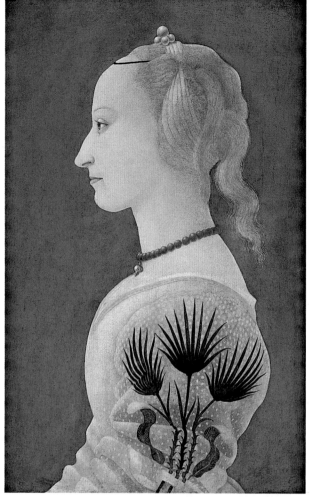

PORTRAIT OF A LADY IN YELLOW
c.1465, tempera and oil on wood, 25 x 16 in (63 x 41 cm),
National Gallery, London

The *Lady in Yellow* is rather paradoxical in that she seems almost a paper silhouette with no substance, yet still emerges as a distinctive personality – austere and resolute. Her identity is unknown, yet the motif on her sleeve is clearly meant to distinguish her family and would, one presumes, have been recognized by her contemporaries. She, however, gives nothing away and the artist colludes with her in this, setting her in an anonymous background that has as its sole function to highlight the fairness of her skin and hair, and the distinguished yellow of her gown.

THIS YOUNG WOMAN *in her scarlet dress and blue cloak is seated in a precarious position, the landscape seems to drop away behind her and there are precipitous cliffs and winding rivers. The habitations that we see appear small, unwelcoming, and remote from the gentle intimacy of the Virgin and Child.*

ALTHOUGH THE MOTHER *is safe enough in her solid and elaborate chair, and her precious baby rests on a marble ledge with His own private little scarlet cushion, Baldovinetti seems to be conscious of the fragility of life. The sky, with its pale light and its small and flickering clouds, enhances this mood of vulnerability.*

THE VIRGIN AND CHILD
c.1460, tempera and oil on wood,
42 x 30 in (106 x 75 cm),
Musée du Louvre, Paris

BALDUNG, HANS (GRIEN) c.1485–1545 b. Germany
PYRAMUS AND THISBE

THE STORY OF PYRAMUS AND THISBE is one of the great tragedies. Their love was long thwarted by unkind parents, and they finally took courage to elope. On their way to meet each other Pyramus encountered a blood-smeared lion, and his mistaken belief that it had devoured Thisbe brought him to kill himself in despair. This was followed by Thisbe's own suicide at the discovery of her dead lover. Baldung's version of the story is uniquely sinister. The man is shown as a helpless victim, at the feet of a tearless woman. She may wring her hands, but Thisbe seems strangely detached and in control. Baldung had a neurotic fear of women, and in depicting them he would often invoke the form of a witch, a creature with an evil and uncanny power over men. The tall figure of Thisbe – red-headed, as witches were often portrayed – expresses silently Baldung's great unease at female beauty. Above, water flows fruitlessly into a tomb-like structure, and a small Cupid mourns. Behind them rises the dark, threatening forest and the night clouds. The relationship is taut with unspoken suspicions and fears.

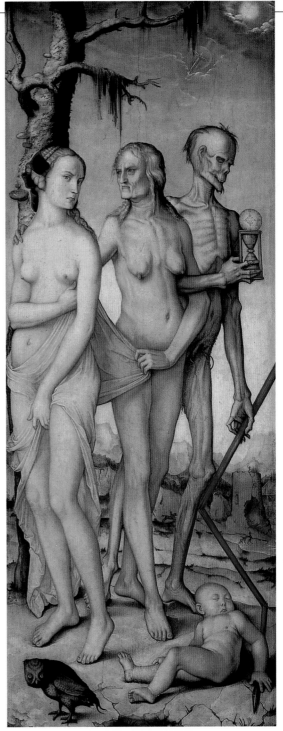

THE THREE AGES OF MAN AND DEATH
c.1510, oil on wood, 59 x 24 in
(151 x 61 cm), Museo del Prado, Madrid

It pleased Baldung to explore the passage of life and death using the form of woman. His point seems to be not so much that the child grows to a young woman and then to an old woman and then death comes with the hourglass and all is over, but that women in themselves are deceitful and will not accept the mortality of the body. All in the picture is weighted towards cynicism and despair; the buildings in the background are ruined and the tree is lifeless, dripping with a sinister moss. The owl, a symbol of wisdom, but also of the witch, rolls its eyes at us as if to implore our patience with the folly of such creatures.

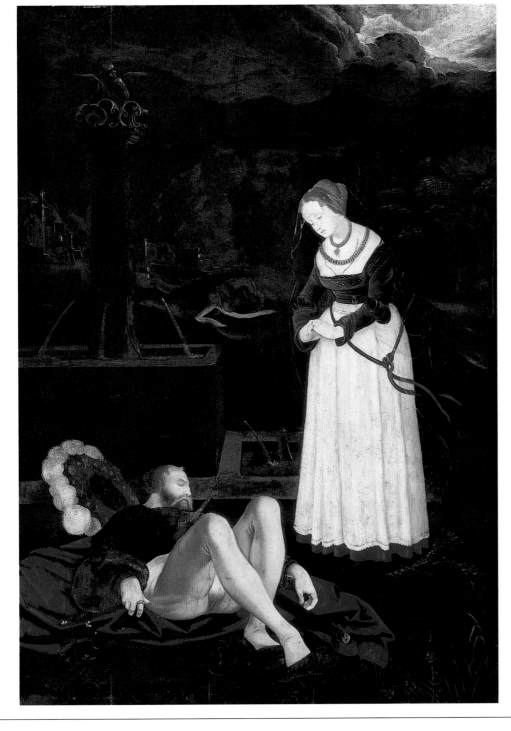

PYRAMUS AND THISBE
c.1530, oil on wood, 37 x 26 in
(93 x 67 cm), Staatliche Museum, Berlin

BALLA, GIACOMO 1871–1958 b. Italy

PATRIOTIC DEMONSTRATION

BALLA WAS ONE OF SEVERAL ITALIAN ARTISTS who, at the beginning of the 20th century, established a short-lived movement called Futurism. These Futurists, as their name suggests, believed that art should turn its back on the past and move boldly into a future in which the machine was triumphant. The beauty of the machines, the importance of movement, the necessity to express the emotions of the day – these were the motivating factors when Balla painted his most important pictures. *Patriotic Demonstration* can, at first, look like nothing more than swirls of color. It is, in fact, carefully planned, using the red, white, and green of the Italian flag, and this is Balla's attempt to express the excitement felt in 1914 and 1915 as Italy prepared to go to war. The Futurists, who believed that war was a great and necessary purification, pressed for Italy's involvement with all the fervor at their command.

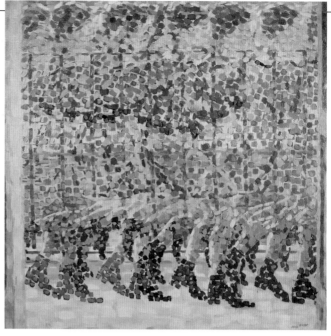

GIRL RUNNING ON A BALCONY
1912, oil on canvas, 49 x 49 in (125 x 125 cm), Galleria d'Arte Moderna, Milan

With the invention of multiple-exposure photography, motion could be "frozen" in stages and studied. Here, Balla has collated a sequence of photographs of a girl running on a balcony, and using the divisionist technique of dots that barely cohere into a shape, succeeds in giving the impression of speed and energy.

PATRIOTIC DEMONSTRATION
1915, tempera on canvas, 39 x 54 in (100 x 137 cm), Museo Thyssen-Bornemisza, Madrid

THE NATION'S FERVOR, EXCITEMENT, *and hunger for involvement is given visual shape in this abstract arrangement of wildly waving flags. These flags are not flapping in the wind; they are being swirled by enthusiasts as they cheer visually for the adventure of combat. Balla, who urges such visual energy, did not himself enlist, but stayed in Rome.*

BALTHUS (BALTHASAR KLOSSOWSKI DE ROLA) 1908–97 b. France

NUDE AT REST

OVER THE YEARS, FROM HIS YOUTH INTO HIS OLD AGE, Balthus has painted the same subject again and again: a girl on the verge of adolescence, still wholly unaware of the full implications of womanhood. He has brought to this subject an ever-greater sensitivity and delight, and, although he has been much criticized and misunderstood for his attraction to this theme, it is nevertheless a pure delight. It is not the awakening to sexuality that intrigues him, but the period immediately prior to that awakening, when the child is on the verge of growing up, unconsciously sensing life's complexities – the joys and anxieties of adulthood – but, as yet, not acknowledging them. For Balthus, she still maintains her innocence. As such, these figures have a poignancy and visual sweetness, to which this great artist is peculiarly sensitive.

JAPANESE GIRL WITH RED TABLE
1967–76, oil on canvas, 57 x 75½ in (145 x 192 cm),
Private Collection, New York

Balthus worked on this painting over a period of nine years, thickening the paint, refining his image, exploiting to the full this long, white, graceful body, whose head, although looking in the mirror, is turned full to us with its enigmatic mouth and mysterious eyes. The setting has all the classical austerity that we associate with Japanese art. The red table, which has equal billing with the girl, sits there solid and strong, supporting that glory of Japan – great ceramics. Their cold beauty provides a touching contrast with the radiant promise of the young woman in her loose and flowing kimono.

THE NUDE, *with her small, budlike breasts and her casual, dreaming slouch in the chair, appears to be unaware of the artist's eye. She is not a pretty girl, and Balthus has never needed the attractions of a superficial charm. She is the quintessential maiden, preparing herself, even if unconciously, for life fulfilment. Balthus shows one leg tucked up in the safety of childhood, as it were, and one leg stretched out, ready for the challenges of adolescence.*

ONE HAND CLUTCHES *for reassurance, the other dangles free to accept what will come. But the girl's head is still turned away from the light that so brilliantly and beautifully washes over her body, white and gold in the embrace of the chair. She dreams and ponders, and the artist makes no attempt to enter into the mystery of her thoughts; it is precisely that mystery that enchants him.*

NUDE AT REST
1977, oil on canvas,
79 x 59 in (200 x 150 cm),
Private Collection, Paris

BAROCCI, FEDERICO c.1535–1612 b. Italy
THE CIRCUMCISION

BAROCCI WAS ESSENTIALLY A RELIGIOUS ARTIST, but not of the heavy-handed type. He was less interested in martyrs expiring in convulsed agonies than he was in communicating spiritual joy. He had a particular gift for humanizing the Holy Family, painting them with a delicate charm and iridescence of color that give his pictures their unique attraction. *The Circumcision* commemorates the event in the life of every young Jewish boy in which he is ritually circumcized. Here, we see the priest holding a delightful Christ, who tilts His small, round face at us almost quizzically as He awaits the knife – that symbol to the Church of a later and total shedding of blood. The circumcizer, splendid in yellow, performs the operation, while Mary, who has no part in the scene, looks on with painful understanding; a more emotional St Joseph holds his hand to his heart. Barocci *is* emotional, but the timbre of the work is at a level that makes the emotion acceptable and not mawkish. The sheer brilliance of the color in itself raises the emotional temperature.

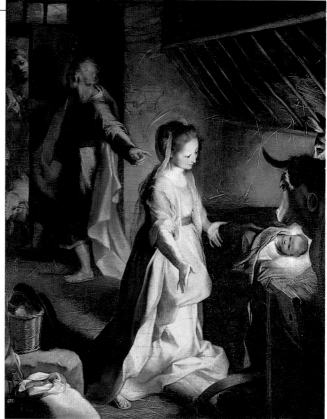

THE BIRTH
c.1597, oil on canvas, 53 x 41 in (134 x 105 cm),
Museo del Prado, Madrid

Barocci was especially good at painting babies and young women, so naturally he comes into his own triumphantly with a nativity scene. Here, a delightful little Christ, the most charming of babies, cosies down in His manger bed under coverings of subtle lavender, watched over by His young mother. She is a luminous column of the most heavenly rose-pink and saffron, her garments folding and cascading in full brightness, which comes, it appears, not from any external source, but from the Child Himself, who has lit his pillow with the luminosity of His being. Behind, St Joseph gesticulates excitedly to the shepherds, but he is merely a backdrop to the intimacy of the scene.

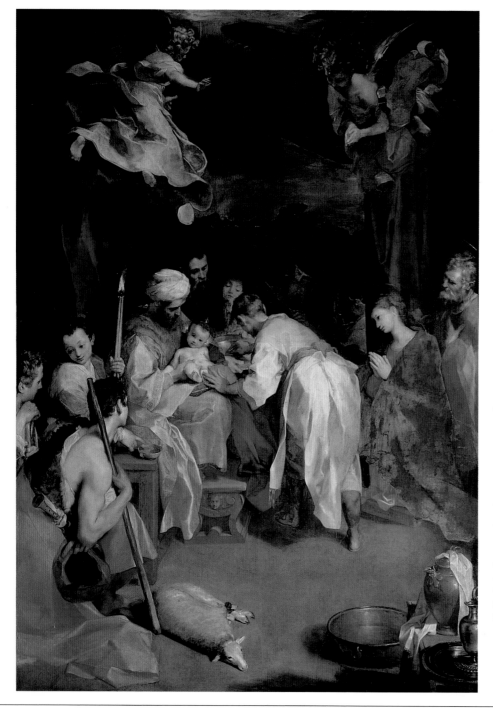

A SHEPHERD WATCHES *with his sheep – again a symbol of sacrifice – as the surgeon presses the cloth against the baby's penis. The concentration of the young adult is contrasted with the indifference of the Child, who draws our attention to the spot of blood and the floating foreskin in the bowl. It is a crowded scene that yet retains a sensation of space and stillness – a sense of lightness and brightness that is appropriate to the meaning of the operation, if not to its unavoidable painfulness.*

THE LINE THAT RUNS *from Joseph, through Mary and the circumcizer to Christ and then to the priest, curls up to the angels and down again in an intense circle. From the bottom right another circle emerges, starting from the magnificent still life, leading up through the baby and the operator, and then down again to the sacrificial sheep. At the intersection of the two circles is, inevitably, the small and appealing Christ.*

THE CIRCUMCISION
1590, oil on canvas, 140 x 99 in
(356 x 251 cm), Musée du Louvre, Paris

BARTOLOMMEO, FRA (BACCIO DELLA PORTA) 1472–1517 b. Italy

THE VISION OF ST BERNARD

FRA BARTOLOMMEO WAS A TRAINED ARTIST who, in 1500, entered into monastic life. *The Vision of St Bernard* was one of the first works that he painted as a professed monk. It was commissioned by a man called Bernardo del Bianco, and to honor his patron, the image centers around St Bernard, the great preacher and writer of the Middle Ages. Coming towards him is Mary, who was said to have appeared in a vision to thank him for having written about her so beautifully. The picture is divided into two: on one side, a great phalanx of angels bear forth the Virgin and Child in triumph; on the other side, St Bernard, St Benedict, and St John are solidly grouped together.

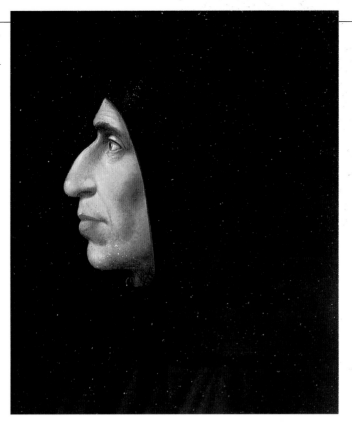

SAVONAROLA
*16th century, oil on panel,
21 x 14½ in (53 x 37 cm), Museo di
San Marco dell' Angelico, Florence*

The young Fra Bartolommeo was so inspired by Savonarola's preachings against worldly vanity that he publicly burned many of his early paintings and became a monk himself. He depicts his hero with a strong, implacable profile, with bright eyes and a resolute jaw line. Savonarola is not only black-hooded but appears to be the sole brightness in a world of darkness.

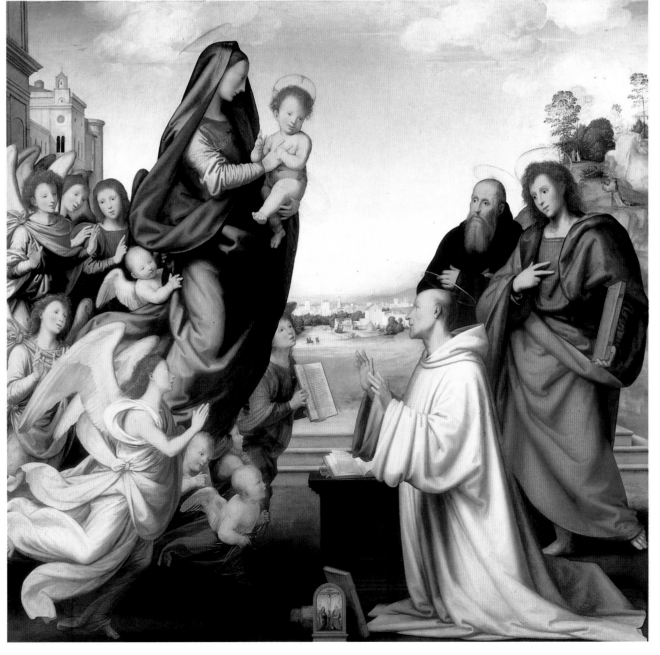

THE MASSIVE *cluster of heavenly beings has been compared to a juggernaut bearing down on the kneeling saint, albeit with the utmost love. Fra Bartolommeo understands the space between the two worlds, and so between the Virgin and the saint stretches the whole city of Florence with its horsemen, buildings, teeming life.*

BEHIND ST BERNARD, *dressed austerely in his white Cistercian robes, stand St Benedict and the scarlet-swathed St John. On the mountain behind them is the figure of St Francis, who kneels in prayer. He was the visionary who saw the crucified Christ and whose life was changed by that experience, just as St Bernard's life was transformed by his vision of the Virgin.*

THE VISION OF
ST BERNARD
*c.1504, oil on wood,
85 x 91 in (215 x 231 cm),
Galleria degli Uffizi, Florence*

BASELITZ, GEORG 1938– b. Germany
FORESTERS

BASELITZ WAS A CHILD OF WORLD WAR II, and, like many young artists of his day, he became deeply concerned with the need for authenticity. He felt abstraction was too easy, for him almost meaningless, and yet realism was far too regularly written off in terms of its theme: paint a forest and it was discussed as a forest, not as a work of art. He began to tackle this problem of how to get people to see the work in terms of color and form, irrespective of theme, by fragmenting the image. In *Foresters*, he has played with the shapes of the two men working in the woods. One has been truncated, though he is still right-side-up, the other has been turned on his head. The image as such makes no sense, but Baselitz wants us to appreciate the elements of the painting – the colors, the forms – to respond to the substance of what he has painted, rather than to our ideas about foresters and woodlands and all that he felt was extraneous sentimentality. It is a picture about painting, about what it means to be involved in the act of painting; it tells us that what is created is less important than how it was created. This was a drastic solution, and one that the artist experimented with for a whole year, exploding his image but never discarding it. The year after *Foresters*, Baselitz fixed upon the idea that would become his motif: he would not fragment, but invert.

THE MOTIF: GIRAFFE
1989, oil on canvas, 51 x 38 in
(130 x 97 cm), Private Collection

This extraordinary image is basically an upside-down head. However, we are not meant to read the image literally, rather we are asked to respond, emotionally and thoughtfully, to the strangeness of the composition and the expression of the artist. The elongated and decorated neck explicitly recalls the animal after which the painting is named, but the long yellow hair and lashes suggest that it is a woman – albeit a bearded one. Again, we are not expected to draw conclusions from these observations, but rather to appreciate the clarity of the blue, the brilliance of the yellow, the vigor of the paint handling, and the intensity of the emotions with which the artist has entered into this curious encounter with reality.

"THE INFLUENCE OF THE STARS IS UNDENIABLE, THE PURITY OF THE NIGHT SKY IS AWESOME, ONLY THE SOURCE IS POISONED"
Pandemonium Manifestos
Georg Baselitz

AS BASELITZ WORKED upon this painting, he also worked upon his own understanding of what art means – its definition for him. This was a ground-breaking work for the artist and, through the layers of paint built up as the composition developed, we can see Baselitz's struggle to make his own mark upon the concept of art.

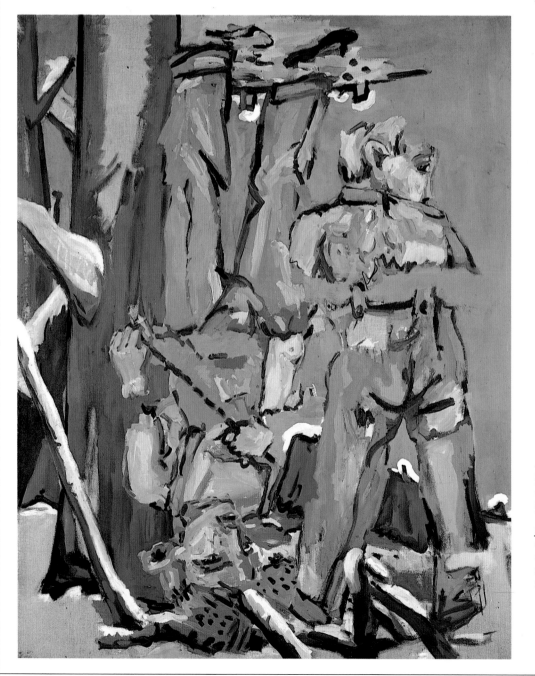

FORESTERS, *1967/8, charcoal and synthetic resin on canvas, 98 x 79 in (250 x 200 cm), Private Collection*

BASSANO, JACOPO c.1517–92 b. Italy
THE GOOD SAMARITAN

STRANGELY ENOUGH, THE GOOD SAMARITAN is not often the subject of a painting, although it is a well-known story and one to which we can all respond. A Jewish man going from Jerusalem to Samaria was set upon by thieves, who stripped him and left him for dead. Bassano shows the naked victim being lifted by a passer-by who took pity on him. This passer-by was a Samaritan, who in Jewish terms was a heretic, an outcast. We are told that he bound up the wounds, poured oil into them, and then lifted the unlucky victim onto his steed. He took him to an inn, where he gave the innkeeper money to care for the Jew until he returned. The point of the story is that two religious Jews had already seen the wounded man and taken no notice; Bassano shows them in the distance.

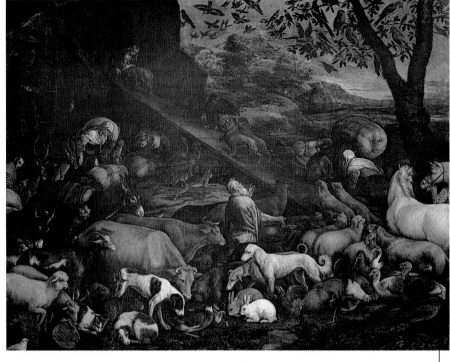

THE ANIMALS ENTERING NOAH'S ARK
1574, oil on canvas, 81 x 104 in (207 x 265 cm), Museo del Prado, Madrid

For Bassano, the real interest in this story is clearly the animals. One could almost feel that it gave him an excuse to indulge his delight in the animal world. Animals, especially dogs and cows, tend to edge into all his pictures, and he makes real to us some of the vast and wonderful diversity of animal form and behavior. There is spiritual significance too. For those who know the end of the story, the dove, which will eventually signal that the rains have gone and the world is habitable again, has already made its appearance, humbly and inconspicuously at the bottom left.

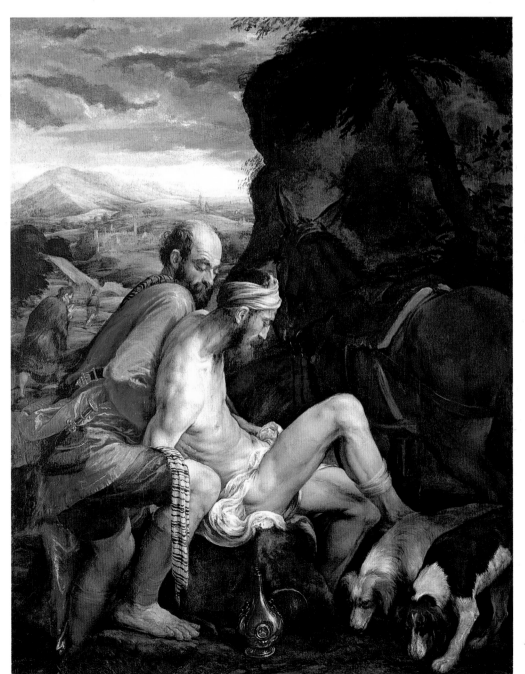

THE MASSIVE DARKNESS *of the hill to the right-hand side, and the vista with its faint green mountain and its glowing skies on the left, are suggestive of the moral dilemmas that are always before us: the choice between good and evil, the self and the other. Bassano makes the spiritual meaning of the story clear, but does so subtly, without in any sense seeming to preach.*

THE CITY IN THE DISTANCE – *the Holy City – is actually the city of Bassano, from which the artist takes his name, and so he resolutely sets this parable in his own world. Bassano was a man of vigorous realism, his roots were in the country and he tended to set his narratives in the context of the real agricultural world. Perhaps what attracted him to the Good Samaritan was precisely the natural setting in which the drama of the Gospel story takes place.*

THE GOOD SAMARITAN
c.1550–70, oil on canvas, 40 x 31 in (102 x 79 cm), National Gallery, London

BATONI, POMPEO 1708–87 b. Italy

THOMAS WILLIAM COKE

IN THE EIGHTEENTH CENTURY, men of wealth with aspirations to culture and refinement would embark upon a Grand Tour to the Continent; and for many, part of such a tour would include sitting for the famous Italian portraitist Pompeo Batoni. Since most of Batoni's sitters were very young men, much of this "culture" was theoretical and in prospect, rather than actual, but Batoni is far too tactful a painter to make that clear. Here is Thomas William Coke, arrayed in his costly best; he poses with aristocratic nonchalance in a setting that the *cognoscenti* would recognize as Roman, against a background landscape of wild grandeur. Standing in the light and with a slight smile upon his lips, Coke is the embodiment of what it meant to be young, healthy, rich, and set free to wander among the glories of past civilizations.

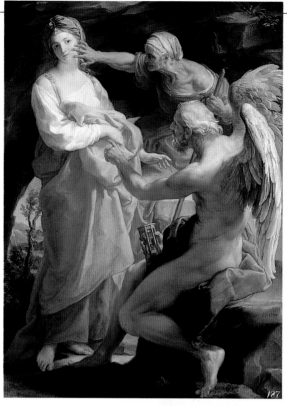

TIME ORDERS OLD AGE TO DESTROY BEAUTY
1746, oil on canvas, 53 x 38 in (135 x 96 cm), National Gallery, London

The winged figure of Time, holding his hourglass, directs an envious Old Age, with her stick and her withered flesh. He is urging her towards the destruction of Beauty, the only upright figure in the picture. Time and Old Age bend and curve threateningly towards her, and she is captured by the rocky arch that is a metaphor for life itself. Once we have passed through the arch and into a temporal existence, we are helpless against the promptings of Time.

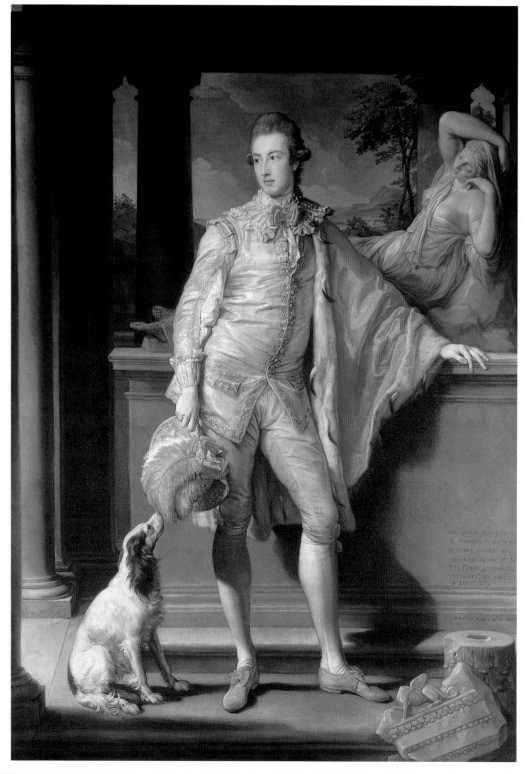

PERHAPS WITH A TOUCH *of irony, Batoni shows this handsome young man turning his back on the statue of the naked Venus, quite unmoved by her charms. The rose bow, the extravagant frills at his neck, and the extraordinary feather in his hat outline the sense of privilege. We may notice, however, that his dog seems bewildered by the feather, which it sniffs with patent distrust – perhaps a subtle indication that such splendid attire was not natural to Thomas William.*

PART OF BATONI'S *extraordinary skill was his deftness in handling color. The sandy hues of stonework all around him, and the cool silver of his clothes are all in contrast with the fair, clear skin of the young Englishman. The extravagant salmon-pink that punctuates this picture is repeated in Coke's butterfly-buckled shoes, which draw our attention to another experience of the Grand Tour – that the cultures studied were in decay (note the broken column at his feet).*

THOMAS WILLIAM COKE
1774, oil on canvas, 97 x 67 in (246 x 170 cm), Holkham Hall, Norfolk, UK

BAZILLE, FRÉDÉRIC 1841–70 b. France
THE PINK DRESS

FRÉDÉRIC BAZILLE AND CLAUDE MONET often painted together, but there were several differences between them. Bazille came from a wealthy, cultured family; in fact, he was a great patron of the arts, and gave financial support to Monet. Unlike Monet, he died young, while still in his twenties. He was, however, a genius, capable of painting a work such as *The Pink Dress* when only 23. He would surely have gone on to greater heights had it not been for his early death; he was killed in action in the Franco-Prussian War. About a year after showing us the back of his cousin's head in this great work, Bazille turns to show us his own alert, creative face in his *Self-Portrait*.

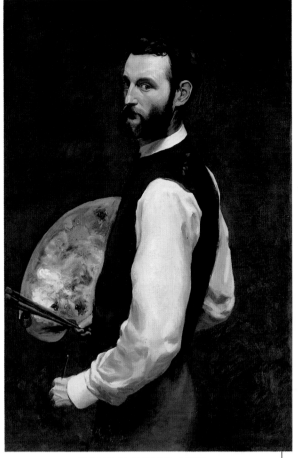

SELF-PORTRAIT
1865–66, oil on canvas, 43 x 28 in
(109 x 72 cm), The Art Institute of Chicago

Bazille shows us a long, thin, angular form, but he fixes us with an alert and challenging eye. He is content to restrict the color in this self-portrait to a modest palette, and by this, he suggests, perhaps, that it is within this constricted range of hues that we will find the scope of his life. Yet, in the handling of the whites and the blacks, and the pink flush of color on that long, sallow face, we catch a hint of the possibilities that he does not exploit here.

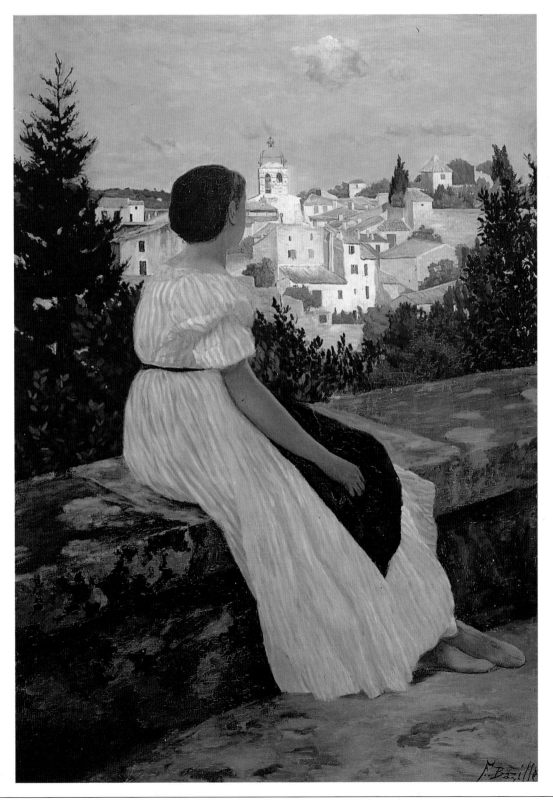

BAZILLE PAINTS *his cousin sitting on the terrace of the family estate near Montpellier. Without the impassioned intensity that was later to characterize Impressionism, Bazille makes us very aware of true realities: the girl, solid in her pink, white, and black clothing, appears remote from life's complexities and the sunlit world of the small city that lies behind her.*

BOTH THE GIRL *in shadow and the sunlit townscape have equal validity in Bazille's composition. Both become very present to us, set as they are in the cool of the summer's evening, with all the eternal verities of Church and family intact.*

THE PINK DRESS
c.1864, oil on canvas, 58 x 43 in
(147 x 110 cm), Musée d'Orsay, Paris

BAZIOTES, WILLIAM 1912-63 b. US
WHITE BIRD

BAZIOTES WAS AN ABSTRACT EXPRESSIONIST and a near contemporary of the movement's most famous practitioner, Jackson Pollock. The first impression one gets when looking at *White Bird* is of the work's extreme beauty – the glorious delicacy of the color, so nuanced and yet so rich. Baziotes was greatly interested in the subconscious, and believed in a primordial art – an art that allowed "a glimpse into the unfathomed abyss of what has not yet become". This is not an easy concept with which to come to terms. The Abstract Expressionists did tend to use grand and cloudy language to explain their intentions, and, ultimately, one can only savor it and see, as it were. How does this interest in the "unfathomed abyss" stand up to what Baziotes has actually created? It seems to me, pretty well. Whatever he thought he was doing, what he has actually produced is a strange and magical shape – some creature, with vague, wing-like extremities, placed on a primordial rock, if one wants to speak the language of Baziotes.

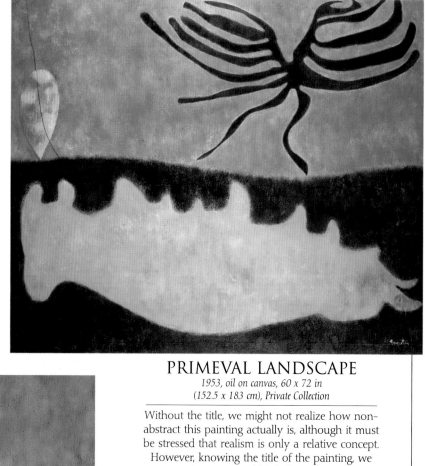

PRIMEVAL LANDSCAPE
1953, oil on canvas, 60 x 72 in
(152.5 x 183 cm), Private Collection

Without the title, we might not realize how non-abstract this painting actually is, although it must be stressed that realism is only a relative concept. However, knowing the title of the painting, we can see the prototypal bird, the archaeopteryx, skimming at full stretch over the earth, while a luminous mastodon lumbers superbly over the grass. The one puzzle is the radiant shape at the far left. Perhaps this was what the tree might have become had it seized its opportunities? Or is this an extinct tree, as lost to us as the beautiful creatures of air and earth that are represented in this many-colored landscape.

FILAMENTS SWAY *delicately in the air and spread with wavering clarity along the mottled blue of the base. According to his widow, these filaments stood, in Baziotes's mind, for extrasensory perception – the faculty of intuitive understanding, which he felt animals still possessed but humans had lost.*

THE WHITE SHAPE *calls to mind the form of a bird – a rather tempting realism indicated by the title. However, perhaps we limit the picture by attaching precise meanings to these strange and magical shapes. As forms, they please us, and perhaps it is just that sheer ability to give us pleasure – to suggest a world more magical than any we can actually see for ourselves – that is the achievement of Baziotes.*

WHITE BIRD, *1957, oil on canvas, 48 x 36 in (122 x 92 cm), Albright Knox Art Gallery, Buffalo*

BECCAFUMI, DOMENICO c.1469–1551 b. Italy
AN UNIDENTIFIED SCENE

BECCAFUMI IS THE SIENESE MANNERIST SUPREME. He startles us both by his vivid colors, with their strange and haunting intensity, and by the originality of his interpretations. He has a grandeur of imagination that makes his work memorable, quite apart from his dazzling and seemingly arbitrary color combinations. The interplay of fantastic color with furious activity can make his pictures alarming at first sight. That strange sweetness that characterizes the Sienese can be seen here, but there is also an almost ice-green acidity that is peculiar to Beccafumi. In this *Unidentified Scene* his little figures are picked out in strange and alluring hues: pinks and blues and half-greens. Despite the smallness of the figures, we can see quite clearly that activities are in progress. The setting would appear to be Rome, with the *Castel Sant'Angelo* there in the background, but the story behind the painting has always eluded art historians. The mystery is perhaps part of the charm of this remarkable painting; we are obliged to speculate on the passions and emotions at work within these little clusters of human beings, so engaged with each other and their private world.

AN UNIDENTIFIED SCENE
*c.1540–50, oil on wood, 29 x 54 in
(74 x 138 cm), National Gallery, London*

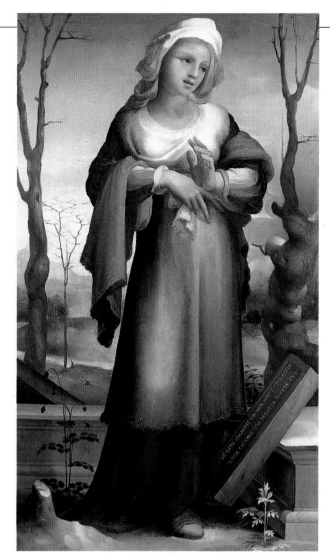

MARCIA
*c.1520, oil on wood, 36 x 21 in
(92 x 53 cm), National Gallery, London*

Beccafumi painted a series of heroines, of whom Marcia is perhaps the most intriguing. Plutarch tells us that she was Cato's wife but, nevertheless, agreed to be given to a friend of his. When the friend died, she remarried Cato. None of this strange marital history seems obvious in the painting. Marcia looks out with an innocent serenity, perfectly posed between two leafless trees. However, she is hemmed in by a narrow parapet and a stone block – a subtle allusion, perhaps, to her life history. Contrasting with the stone is evidence of fresh, springtime growth.

THE SHAPE AND SCALE OF An Unidentified Scene *suggests that it was possibly part of a piece of furniture. If this is so, it provides an instance of the great splendor with which Italians of the Renaissance could afford to surround themselves.*

BECCAFUMI, WHO DIED IN THE *middle of the 16th century, is possibly the last of the great Sienese School, which delighted in color and movement. Whatever the actual story, we are struck by the painting's energy and by a sense that something significant is taking place.*

THE CHARM AND SKILL *of this artist is so appealing precisely because he leads us to delight in speculation, to mental activity. We ponder the meaning of these figures, with their particular, elusive behavior, while the eye roams with pleasure over the colors and forms of the setting.*

BECKMANN, MAX 1884–1950 b. Germany
JOURNEY ON THE FISH

BECKMANN PAINTED ABOUT 80 SELF-PORTRAITS – just a few less than Rembrandt –
and yet this was not for reasons of vanity any more that it was for Rembrandt.
Both artists sought earnestly to find out who they were – to explain themselves
to themselves in the means at their command. Beckmann went even further: he
seemed to want to know not just who he was but *that* he was – to be assured
of his own existence. Even a painting such as *Journey on the Fish*, which at first
strikes us as an almost Surrealist narrative, turns out to be, at another level, a
self-portrait. Strapped to the two fish, the great blue male and the slender gray
female, are the lovers. He sprawls, head hidden; she crouches on his back. He
holds up the mask with which she confronts society, and she holds up his mask:
the Beckmann face, monolithic and frightening. His real face is hidden, while her
real face, shown to us in the intimacy of the picture, is far more beautiful than her
mask. The fish have leapt from the sea and are now arching back into its darkness.
The lovers have turned their back on the human security of the boat and
entrust themselves to the depths that are familiar to their strange steeds.

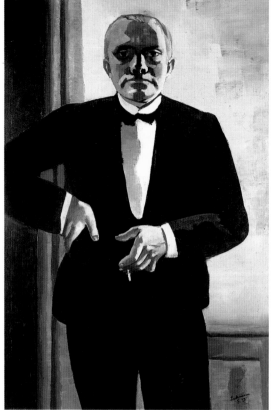

SELF-PORTRAIT
IN TUXEDO
1927, oil on canvas, 56 x 38 in (141 x 96 cm),
Busch-Reisinger Museum, Cambridge, MA

Self-Portrait in Tuxedo was painted at the height
of Beckmann's fame, and a special room was
allotted to house the work at the National
Gallery in Berlin. The portrait shows him fully
aware of his status as a great artist. He
confronts us in the armor of the successful
man, his trademark cigarette in one hand,
while the other rests nonchalantly at his hip.
Yet that face, glaring out with such hauteur, is
surely a mask. Shadows thicken around the
eyes, and the whole impact seems assumed for
the occasion. Despite the arrogance of his
stance, he is shut in by verticals and
horizontals – this apparently simple image
is strangely contradictory.

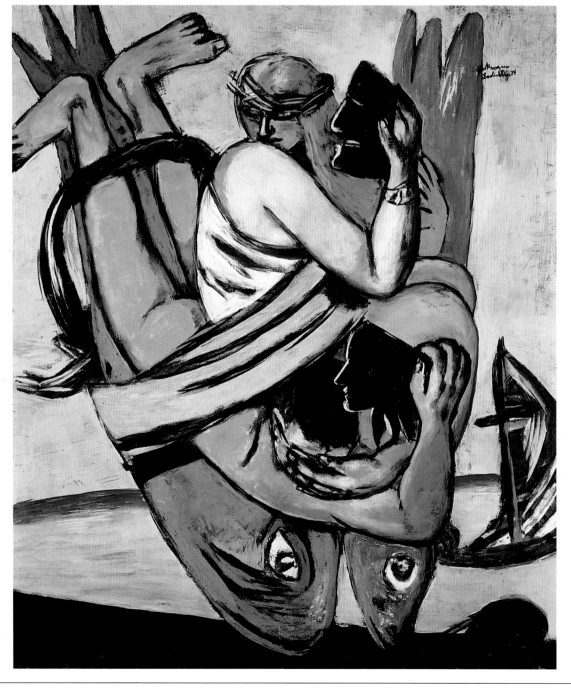

THIS IS A HAUNTING *image of love –
an image of risks and magic that conveys
the essential need for one-to-one trust.
The lovers have exchanged masks, but
they have not yet plunged into the sea
and become one. There is an extraordinary
succulence in Beckmann's art, an almost
tangible sense of the flesh of the body
in both its vulnerability and its solidity.*

JOURNEY ON THE FISH
*1934, oil on canvas, 53 x 46 in
(135 x 116 cm), Staatsgalerie, Stuttgart*

BELLINI, GIOVANNI c.1430–1516 b. Italy

ST FRANCIS IN THE WILDERNESS

GIOVANNI BELLINI CAME FROM A FAMILY OF ARTISTS. His father Jacopo and his brother Gentile were both famous Venetians, and yet their glory is obscured by the achievement of Giovanni. There is a tenderness and depth to his work – a response to the physical world with poetry and quiet grace – that makes him one of the very greatest of artists. *St Francis in the Wilderness* shows all these qualities. The saint is alone and in prayer, living in the rocks of Mount Alvernia. He stands before his little hermitage, arms outstretched as the early morning sunlight caresses him. It has been suggested that this illustrates the moment when St Francis composed his canticle to the sun – that hymn that calls upon all nature, brother sun, and sister wind, to praise their creator.

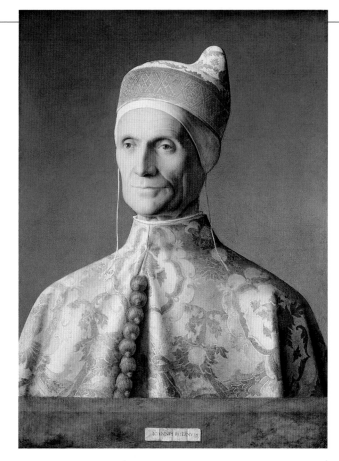

THE DOGE LEONARDO LOREDAN
1501–04, oil on wood, 24 x 18 in (62 x 45 cm), National Gallery, London

Bellini has not merely caught forever the lineaments of that thin, brooding face; he has seen beyond this specific instance of an aristocrat in power to the universal reality of what it means to have authority. The extraordinary garb was the s]pecific uniform of the Doge, and the calm, inward majesty shows the attitude of one who holds power that can't be challenged. No modern elected leader, whose power is dependent on the votes of the people, could ever afford such true reserve.

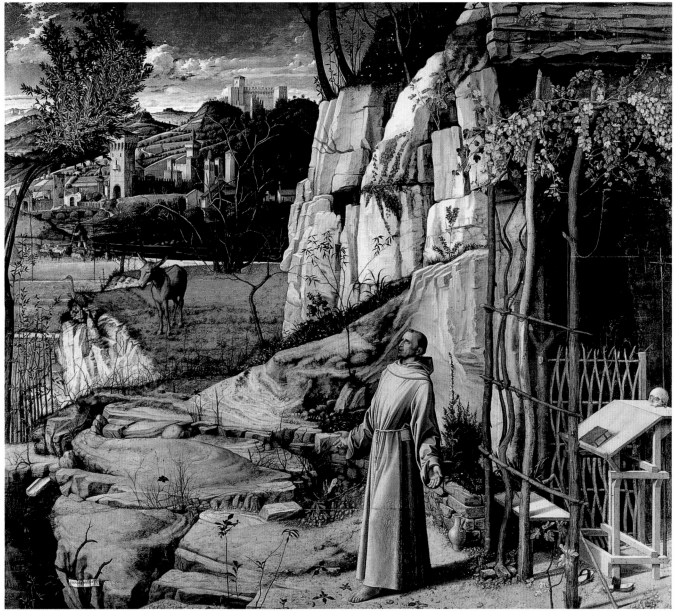

BELLINI'S EYE *sees the created world in all its singularity and beauty: the rocks around the saint, the ass in the field beyond, the farmer ploughing with his oxen, the little hill town beyond, and the castle on the hill. This quiet, sunlit world is suffused with praise, and there is a gentle awareness of the wonder, not only of the spiritual, but also of the material being.*

THE SKULL ON *the far right resting on the saint's reading desk is as glorious and true as the bird that sits winged and eager on the bow of the tree. If St Francis sang a hymn celebrating his relationship with the natural world, then Bellini has painted its visual equivalent.*

ST FRANCIS IN THE WILDERNESS, *c.1480, tempera and oil on wood, 49 x 56 in (124 x 142 cm), Frick Collection, New York*

BELLOTTO, BERNARDO

1720–80 b. Italy, active Italy and Poland

COURTYARD OF THE CASTLE AT KÖNIGSTEIN FROM THE SOUTH

BELLOTTO COULD ALMOST BE SAID to have a genetic claim to be a landscape artist because he was the nephew and student of Canaletto. He certainly learned from his uncle to appreciate the grandeur of great buildings, but perhaps it was only when he had moved away from Canaletto's direct influence that he came into his own as an artist. Bellotto was summoned by the King of Poland and Elector of Saxony to paint views of the castle at Königstein, and although Königstein is not one of the architectural marvels of the world, it becomes marvellous in Bellotto's sensitive understanding of the glories of light and shade. This is Königstein from the south – the back of the castle, as we can see – with the extraordinary foreground of courtyard and laundry. The maids have done the castle laundry and are laying it out on the grass to dry and hanging it up to air.

THE CASTLE AT KÖNIGSTEIN FROM THE WEST
c.1750–58, oil on canvas, 53 x 94 in (134 x 238 cm), Manchester City Art Gallery, UK

This is the kitchen garden view of Königstein. Here, the light is far less caressing. Yet Bellotto is enraptured by that foreground, with its splotches and cracks, and the lovers silhouetted against it seem merely to highlight its capacity to receive shadows. Bellotto gazes with enchantment at the garden, the people, the trees, the sky, the buildings fading away into shadow, and the wall on the left, still radiantly lit as the sun sinks. This is the moment in the evening when the diversity of light gives Bellotto the greatest freedom to explore – with his eye and his brush and his sheer virtuosity – the scene that he shares with us here.

COURTYARD OF THE CASTLE AT KÖNIGSTEIN FROM THE SOUTH, *1756–58, oil on canvas, 52 x 94 in (133 x 239 cm), Manchester City Art Gallery, UK*

THE DOMESTIC DETAIL OF THE *laundry, seemingly so unimportant, lifts the whole picture up into the realm of poetry. Bellotto has humanized the great, squat bulk of the castle by the tenderness with which he depicts light gleaming on white linen. The light touches the linen with silver delicacy, and plays rich and golden on the background of stone, gleaming here then thickening over tree and steeple.*

BELLOTTO GIVES US AN EXHILARATING *sense of space – of a world peopled with activity that retains the order and dignity of the buildings that form its setting. Behind, on the left, the fields ripple away to the distant mountains, but the viewer is enclosed in the warm evening of a summer's day, with the sky still blue while the shadows lengthen.*

BENOIST, MARIE-GUILLEMINE 1768–1826 b. France
PORTRAIT OF A NEGRESS

SOMETIMES AN ARTIST REACHES A PEAK and paints a masterpiece greater than anything he or she has achieved before or will achieve later. *Portrait of a Negress* is that masterpiece in the career of Marie-Guillemine Benoist. She was a highly successful society painter in Napoleonic France, winning a gold medal from the Salon and receiving the most prestigious of commissions. Yet, ironically, it was this nameless black woman who drew from Benoist her greatest work – a work of unique power and significance. The woman herself has an extraordinary dignity and beauty, with that long oval of her face and the graceful column of the neck, which is so reminiscent of Egyptian sculpture. Benoist was clearly fascinated by the chromatic effect, and she offset this glory of black and white against a background of almost pea-green and yellow. However, it is more than a delight in color that has taken hold of the artist; it is a delight in the woman herself, the inner sureness, the sad self-awareness, the infinite otherness of this fellow woman who, in all probability, had lived through the horrors of slavery. Even now, her bare breast recalls the lack of privacy that was part of the humiliation of a slave's life.

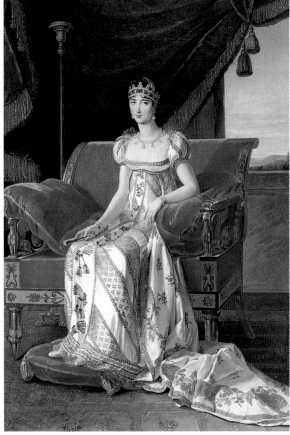

PAULINE BONAPARTE
1808, oil on canvas, 79 x 56 in (200 x 142 cm), Château Versailles

Here is Benoist in much more typical mode, painting a much more typical sitter. This is Napoleon's sister, the notorious Pauline Borghese, splendidly attired in a robe of the utmost magnificence to which Benoist, scrupulously, pays due honor. Yet, for all its glory, the painting does little more than give us a surface excitement and an insight into the extraordinary sense of values of the Napoleonic aristocracy. Perhaps, as a female artist, Benoist does not highlight the notorious element that distinguished Princess Pauline amidst a rather loose-living court.

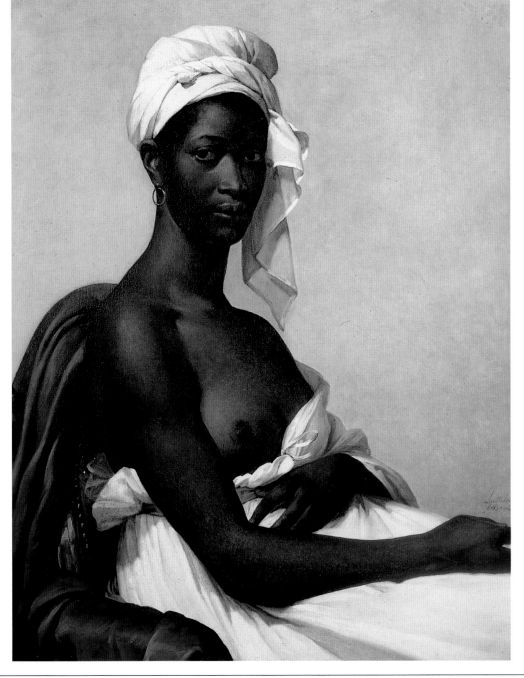

BENOIST CONTRASTS *the marvellous, almost matt blackness of the skin, which gleams darkly with its undercolor of pink against the white of the cascading turban. This silhouettes the beautiful bones of the woman's head.*

BENOIST IS NOT ONLY *painting a beautiful woman, she is also painting the whole sadness of regarding such a noble creature as a commodity to be bought and sold. As she lovingly details the earring, the studs in the chair, even the faint gleam of one fingernail, she is also celebrating the glory of womanhood itself.*

PORTRAIT OF A NEGRESS
1800, oil on canvas, 32 x 26 in (81 x 65 cm), Musée du Louvre, Paris

BERCKHEYDE, GERRIT 1638–1698 b. Netherlands
THE MARKET PLACE

GERRIT BERCKHEYDE WAS AN ARCHITECTURAL PAINTER in a clear, classical sense, a master at turning his excellent draftsmanship to the landscape of the painted canvas. The buildings of his native Holland stand strongly outlined against the wide northern sky, not romanticized but seen in their massive clarity. Here, he is giving us a true sense of the appearance of a market place and a great church at Haarlem, every cobble of which seems to have been noted and portrayed for us. He fills the square with human activity, but for all the interest of these figures, and his genuine pleasure in depicting them, Berckheyde's true passion is clearly devoted to the buildings. He has looked long and hard at that great church, with its spires and pinnacles and the Calvanistic sharpness with which it announces itself in stern contrast to the transience of the activity beneath it. It is not stern in any narrow sense, because the pinnacled tower has a pleasing exuberance of fancy, but stern in the sense that this building announces its purpose implacably. It is resolutely the great church. Its architectural form is like a huge ship set towards heaven, and by its very presence it draws the flotilla of houses and people in its wake.

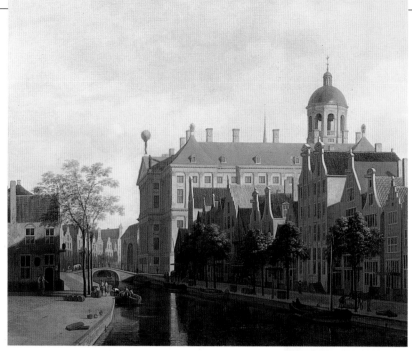

THE CANAL AND CITY HALL IN AMSTERDAM
c.1690, oil on canvas, 21 x 25 in (53 x 63 cm), Hermitage, St Petersburg

Here, Berckheyde paints not only the city hall but also the canal that passes by it. Water, of its nature fluid, offers complete contrast to the solidity of the buildings that are his primary pleasure. He is not a romantic, yet the mystery of the water, and those small, well-cultivated trees, soften his vision, adding just that touch of lightness and charm to what could be a heavy scene of Dutch municipal pride.

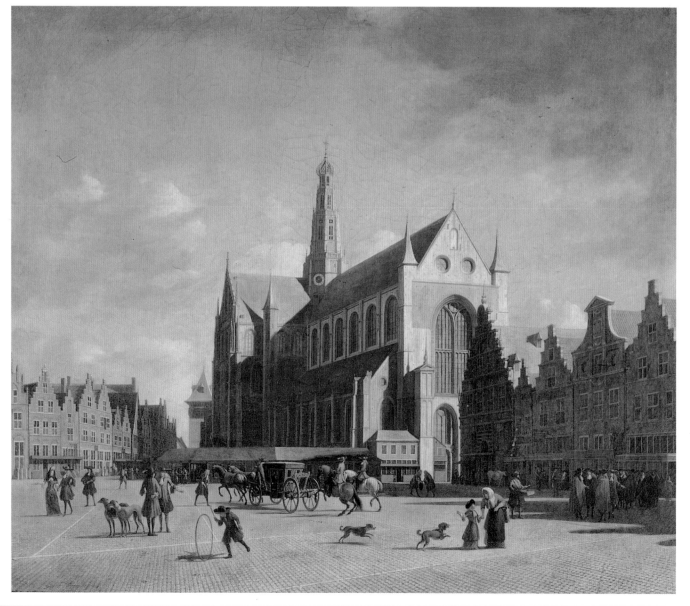

IN A WAY, *the secular and the religious life are here intimately juxtaposed. The houses and the shops that fall away to the left, and the darkened and more impressive buildings that loom towards us on the right, are the possessions of the world. It is from them that the worldly activity spills out onto the great sunlit square.*

IN THE WIDE *open space of the square we can see lovers walking together, men out with their dogs, children playing, a coach and horses, and, at the far right, amid the shadows, a group of men so earnestly immersed in discussion that they do not notice the beggar or pedlar who looks towards them wistfully.*

THE MARKET PLACE AND THE GROTE KERK AT HAARLEM
1693, oil on canvas, 21½ x 25 in (54 x 64 cm) Galleria degli Uffizi, Florence

BERMEJO BARTOLOMÉ active 1474–98 Spain

ST DOMINGO DE SILOS

BARTOLOMÉ DE CÁRDENAS was known as Bermejo, meaning "red", but what this refers to, we do not know – red hair, perhaps, or red passions (he certainly painted with passion). His *St Domingo de Silos Enthroned as Abbot* is a work of extraordinary intensity, and, although this is a 15th-century artist well aware of Renaissance expertise, he still has that complex intensity that characterizes the Gothic. This whole canvas is filled with an intricate splendor. St Domingo's very garment, his cape, is vividly embroidered with a succession of saints, from St Peter clearly depicted on the left to the portrait of St Catherine over on the right. The stupendous Gothic throne in which he sits in monolithic majesty has carvings so vital that they almost seem alive. The cardinal virtues flank him, fortitude and justice on his left, temperance and prudence on his right.

ST DOMINGO DE SILOS
ENTHRONED AS ABBOT
*1474–77, oil on wood, 95 x 51 in
(242 x 130 cm), Museo del Prado, Madrid*

ONE HAS TO LOOK HARD *through all this decorative elaboration to see the great, squat, impassive face of St Domingo de Silos looking out at us, in control, aware of the intricate splendor of his context and his mastery over it. Amid so many dark, subdued, and complex colors and shapes, the squat solemnity of that ruddy face becomes all the more impressive.*

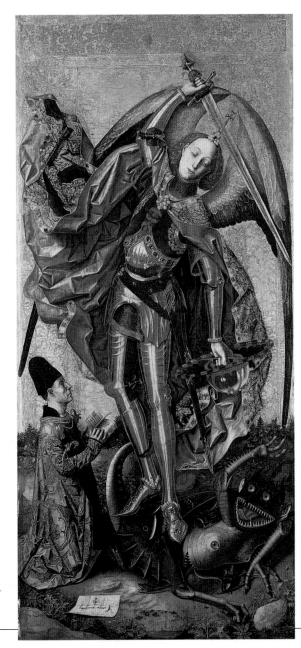

ST MICHAEL TRIUMPHANT OVER THE DEVIL
*c.1468, oil on wood, 71 x 32 in (180 x 81 cm),
National Gallery, London*

St Michael may be triumphing over the devil, but we feel it is at the bequest of the painting's donor, one Antonio Juan, who kneels beneath him in contrition. The great floating violence of Michael's cloak might suggest to us why the artist was nicknamed "red". The ludicrous caricature of a devil (very much sub-Bosch) hardly merits the armored vigor of such a powerful, angelic presence. Perhaps it is specifically intended to reassure the donor, who holds in his hands two of the penitential psalms and whose stance indicates fear.

BERRUGUETE, PEDRO active 1438–1504 b. Spain
DEATH OF ST PETER THE MARTYR

SPANISH ART OFTEN SEEMS TO HAVE A DARK PASSION that distinguishes it. Here, we are shown a martyrdom at its most stark, with the hour of death almost thrust in our faces. Peter the Martyr was an inquisitor, who, after having sentenced several to the fire for their heresy, was journeying on to another city when enraged friends of the so-called heretics attacked him and killed him. The other friar, who holds one hand up in terror as he retreats into the background, was able to make his escape despite the menacing approach of a support group. What is extraordinary about this picture is that Peter the Martyr surrenders himself to death as though in his heart he welcomes it. With his finger he scratches in the soil the name of Jesus as the dagger is embedded in his tonsured head.

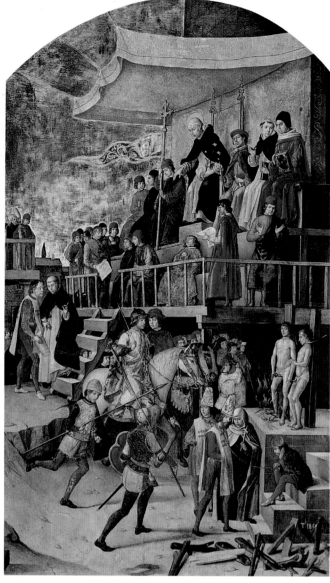

ST DOMINIC PRESIDING
OVER AN AUTO DA FÉ
late 15th century, oil on wood, 61 x 36 in (154 x 92 cm),
Museo del Prado, Madrid

The Dominicans were the great inquisitors, and here we see them seeking to convert those of a different faith and following them to the scaffold with earnest exhortations. For those who did not recant, escape from death by burning was impossible. Condemned heretics were made to wear fool's caps. To lead human beings to their death dressed in the garb of mockery seems to us the final refinement of cruelty. Although Berruguete certainly believed in such heresy trials, he is still a truthful enough artist to show the condemned suffering their terrible punishment with dignity and faith.

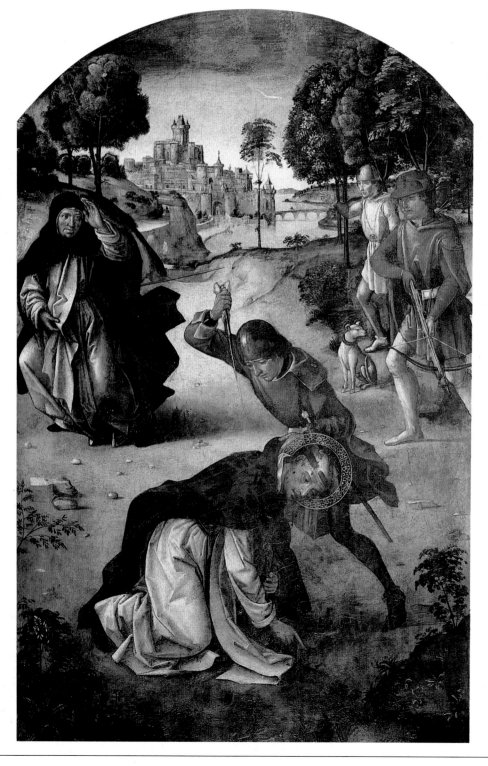

THE EXECUTIONER IS *dedicating himself to the final goal with exquisite attention, and the men behind are advancing with the grave serenity of those who feel their cause is just. The friar is clearly terrified. Only the dog is disinterested, and impartial. Berruguete has set this scene on the edge of the forest, as was historically true, with the great city behind. A sense of the loneliness of death is made inescapable by the rock-strewn and barren ground of the setting.*

DEATH OF ST PETER
THE MARTYR, *late 15th century,*
oil on wood, 50 x 32 in (128 x 82 cm),
Museo del Prado, Madrid

BICCI DI LORENZO 1373–1452 b. Italy

VIRGIN AND CHILD WITH DONOR

NOT ALL ARTISTS ARE INNOVATORS, and the late–medieval painter Bicci di Lorenzo is a splendid example of one who kept within a limited scope and did so superbly. The innovators of his particular world were Masaccio and Lorenzo Monaco, and Bicci had the intelligence to look well at their art in order to understand just what they were doing. This is still a medieval picture, as we can see from the smallness of the donor – it took time for Renaissance ideas of physical reality to permeate the minds of medieval painters. Here, the donor is portrayed as small and humble because he is in a position of supplication rather than merely being the subject of a portrait. The donor has chosen to be insignificant in order to complement the spiritual power of the figure to whom he prays. It is this marvellously solid image of the Virgin, holding her Child of believable weight, that shows Bicci di Lorenzo's awareness of the developments in his art world.

VIRGIN AND CHILD WITH DONOR
c.1424, tempera and gold leaf on wood, 48 x 28 in (124 x 72 cm), Collegiate Church, Empoli, Italy

THE VIRGIN AND CHILD *sit on the throne, and here, Bicci has enjoyed playing with shapes – curling them, covering them, and yet still keeping a real sense of masonry. He has done the same with the steps – squaring, circling, and decorating. The panel has been filled and he has made every part of the picture appealing to the eye.*

NOT ONLY IS *Mary dressed in glorious, gold-trimmed scarlet and blue, but her robes fall in sculptural folds, with the hem rippling in delightful patterns. The gold background to the scene tells us this is not the real world but the world of heaven, and yet Bicci di Lorenzo has made this world of heaven seem almost tangible.*

ST PAUL
15th century, tempera on panel, 17 x 4 in (44 x 11 cm), Galleria dell' Accademia, Florence

This painting captures our attention mainly because of the glory of its color – the splendid intensity of the olive green robe, with its red lining. This is a particularly youthful St Paul; he is traditionally depicted as a small, bald, and bandy–legged man, as he was described in apocryphal writings. Paul was at first a persecutor of Christians, but he was converted by a vision of Christ. He was martyred at Rome during the persecution of Nero.

BIERSTADT, ALBERT

1830–1902
b. Germany, active US

YOSEMITE VALLEY

HAVING TRAINED IN EUROPE, like many American artists of the 19th century, Bierstadt embarked upon a series of expeditions to the far west of America in his late twenties. It was as if he felt a need to know the full scope of his adopted country before he could settle down and paint. What he discovered on these adventures in the West revealed to him the extraordinary majesty of an untouched America. The West was still a wilderness, where native Americans lived without polluting or disrupting the natural majesty of the land. For those in the cities of the East, who, until then had had no concept of what the non-industrialized heartland of their country looked like, Bierstadt's work was astonishing and uplifting. Here, the painter glories in the absolute purity and stillness of the lake, the vast blue and golden sky, and the awesome scale of the mountains, which dominate but do not overwhelm the two small human figures.

YOSEMITE VALLEY
c.1863, oil on canvas,
14 x 20 in (36 x 51 cm),
Berry-Hill Galleries, New York

BIERSTADT'S PAINTINGS *of the American wilderness also have an implicit spiritual significance. This is a paradisiacal world, a world of great simplicity and purity, into which human beings are privileged to enter, and must do so aware of the responsibilities of their inheritance.*

A STORM IN THE ROCKY MOUNTAINS
1866, oil on canvas, 83 x 142 in (211 x 361 cm), Brooklyn Museum, New York

For Bierstadt, this painting had a special poignancy, because he named one of the Rockies Mount Rosalie after the woman he was to marry a few years later (though first she had to divorce the explorer who was Bierstadt's travelling companion when he painted this scene). Bierstadt gives us a sense of what it is to be within this great landscape, looking down onto the plane, surrounded by the stillness of the mountains as the storm gathers. It is not an idyllic world, however, and trees that have been battered by past storms are strewn around. This is a world that asks for heroism.

BINGHAM, GEORGE 1811–79 b. US

FUR TRADERS DESCENDING THE MISSOURI

AT ONE LEVEL, THIS PAINTING DESCRIBES the economic realities of frontier life in 19th-century America. Two fur traders – or rather the fur trader and his mixed race son – are making their way down the broad Missouri River to unload their furs at the port. However, this picture suggests so much more: Bingham has caught a glimpse of an idyllic way of life – hard-working, and yet somehow removed from the constraints of time. The boy in his bright blue shirt lounges dreamily on the bales, while the father, equally resplendent in his pink-and-white stripes and his woollen bobble-hat, paddles the canoe with a measured stroke. In the silence and calm of the atmosphere, even the little trail of smoke from his pipe seems to hang in the air. It is not just the two men on their boat but the whole untouched world of the Midwest that Bingham makes us conscious of. Behind them are the rough clumps of a mid-river island, with great expanses stretching to the right and left; above, there is the clouded glory of a wide, open sky.

SHOOTING FOR THE BEEF
1850, oil on canvas, 33 x 49 in (85 x 125 cm), Brooklyn Museum of Art, New York

Shooting for the Beef again recalls the realities of frontier life. Activities arose partly from the human desire for entertainment and partly from the need to survive. These men are engaging in a contest, but the skill they practise might one day mean life or death. What Bingham does so poignantly is set this little cluster of men, with their dogs and cattle, in the wide expanse of an untamed mid-America. The people are dwarfed by the misty distances in which they comport themselves, and yet they raise themselves with dignity to the challenge of the wilderness.

PERHAPS THE *most evocative figure is the mysterious animal chained to the canoe, which, in its outline, seems to resemble a cat. The three creatures – two human and one animal – look out at us with a level, unthreatening regard that seems to emphasize the silence and peace of this river setting.*

FUR TRADERS DESCENDING THE MISSOURI
c.1845, oil on canvas, 29 x 37 in (74 x 93 cm), Metropolitan Museum of Art, New York

BLAKE, WILLIAM 1757–1827 b. England
THE ANCIENT OF DAYS

THE 18TH CENTURY, WITH ITS ELEGANCE AND ATHEISM, has been called the Age of Rationalism, yet, paradoxically, it was also the time of the greatest of the mystical artists, William Blake. Blake was an extraordinary character who fits into no categories and whose talent as a poet outshone even his artistic prowess. He lived on the cusp of sanity but did so with such intensity that that cusp has fascinated us ever since. Michelangelo had overwhelmed him with a sense of the potential glory of the human body, and Blake's figures always have that giant muscularity that can, at times, remind us of the Sistine Chapel. Yet, what is balanced and orthodox in Michelangelo has a wild heterodoxy in Blake. *The Ancient of Days*, of course, is God the Father as the Bible describes him at the time of Creation, measuring out the world. But for Blake, God the Father was an evil figure, an oppressive law-maker.

GHOST OF A FLEA
1819–20, tempera on wood, 9 x 7 in (22 x 17 cm),
Tate Gallery, London

Blake had visions, not metaphorically but quite literally, creatures that appeared to him in his dreams and in the light of day, both consoling him and alarming him. He told friends, in all solemnity, that he had seen the ghost of a flea, and this weird and sinister image is that apparition. The ghost appears to be hemmed in by the curtains, perhaps echoing Blake's subconscious image of the flea trapped within his bedclothes or sheets. Although this rather Frankensteinian figure in no way attracts, it inhabits a world of golden stars and glimmering light and Blake in no way suggests that this is an ignoble calling.

BLAKE FEARED AND *despised the compass as he did all the malevolent instruments of the likes of Newton and the vicious gang who he felt had conspired to rob life of its poetry. This God is not establishing order, he is circumscribing the imagination. Eventually, Blake shows, God himself is circumscribed, shut up in the room of the sun.*

ONLY THE FLYING *locks of hair and beard suggest that God, too, need not stay within his self-imposed prison, but could fly out from that sinister red that shuts him in and move into the mystery of the dark – that world of the spirit, of the unimprisoned imagination, which Blake regarded as the truest happiness.*

THE ANCIENT OF DAYS
1824, etching with watercolor, pen, and ink on paper, 9 x 7 in (23 x 17 cm),
Whitworth Art Gallery, Manchester, UK

BLOEMAERT, ABRAHAM 1564–1651 b. Netherlands

ADORATION OF THE MAGI

NOT ALL PAINTERS OF RELIGIOUS SUBJECTS are themselves religious, but all commentators agree that Bloemaert, though he lived in a Protestant society, was himself the most devout of Catholics. *Adoration of the Magi* is painted with a certainty of faith. The New Testament story tells how a star in the East (and here we can see it shooting like a comet up and out of the picture) brought three magi, or wise men, to adore the new-born Christ. Christian myth seized upon these exotic figures and elaborated their stories. The magi became the three kings – an old king representing Europe, a darker, middle-aged king representing Asia, and a young black Nubian king representing Africa. They had brought gifts with them, which, again, were seen as symbolic. Here, the old king offers a gold cup, almost materialistically full of golden coins, and we notice that Christ's mother and St Joseph, lurking protectively behind, are interested not in the gifts but in the Child's reaction.

PARABLE OF THE WHEAT AND THE TARES
1624, oil on canvas, 39 x 52 in (100 x 133 cm), Walters Art Gallery, Baltimore

Not many artists illustrated the parables, which are primarily verbal, but here we have the parable of the man who sowed good seed. During the night, however, an enemy sowed tares (corn-weeds) among his seeds, and only when the harvest came up was the devious trick discovered.

OLD KING MELCHIOR
kneels in the foreground, with a glorious cape that suggests Bloemaert was remembering the vestments of his local cathedral. Behind him, the young king, Casper, holds incense. If Melchior's gold symbolizes kingship, Casper's incense represents divinity, and the closed box of myrrh, held by the middle-aged king, Balthasar, is a symbol of death.

FOR ALL ITS GLORY
and sensitivity to texture and pattern, this picture makes no intellectual sense if we do not know the narrative. The story represents the need of the whole world for redemption. The empty hand of the old king proffering his rich present is stretched out almost in supplication to the Child, and it is as if Jesus is the giver.

ADORATION OF THE MAGI, *1624, oil on canvas, 67 x 76 in (169 x 194 cm), Centraal Museum, Utrecht, Netherlands*

BOCCIONI, UMBERTO 1882–1916 b. Italy
THE CHARGE OF THE LANCERS

THE FUTURISTS, WITH THEIR PASSIONATE BELIEF in the machine, in movement, and in struggle, felt themselves blessed to be living at a time when war seemed almost inevitable. *The Charge of the Lancers* hurls in an implacable diagonal across the canvas. It is clear that Boccioni wants to show great speed and inexorable force, and that the object of the attack, which is spelled out for us in the headlines of an Italian newspaper that Boccioni has collaged onto his canvas, is the "tedeschi", the Germans. By collaging his painting in this way, Bocciono is convincing himself – and he hopes us, too – that it is not an imaginary enemy being attacked, but the real foe of the actual world, a world in which, as a Futurist, he felt he must take his stance. There is a nastiness about Boccioni's vision that, nevertheless, does not detract from the power of the painting; it requires a great painter to show so clearly the unthinking cruelty of war.

STREET NOISES INVADE THE HOUSE
1911, oil on canvas, 39 x 42 in (100 x 107 cm), Niedersachsische Landesmuseum, Hanover

The title might sound unappealing, but for Boccioni the opposite is true. He wants the noise, excitement, and bustle of the outside world to enter and take control of the sedate conformities of the home. The whole street is bending in, funnelling its noise and activity, and the woman, our surrogate, leans forward, visibly accepting and absorbing it. It is all too palpably a vision of the future.

THE CHARGE OF THE LANCERS
1915, tempera and newspaper on canvas, 13 x 20 in (34 x 51 cm), Riccardo Jucker Collection, Milan

IRONICALLY, THE CHARGE OF THE LANCERS *recalls* The Charge of the Light Brigade, *that icon of the folly of past battles. Boccioni seeks to depict the wisdom of battle and the modernity of means, unaware that mounted combat was soon to be obsolete on the battlefield. A year after he painted this hymn to war, he was killed by a fall from a horse, not in battle, but in the context of war.*

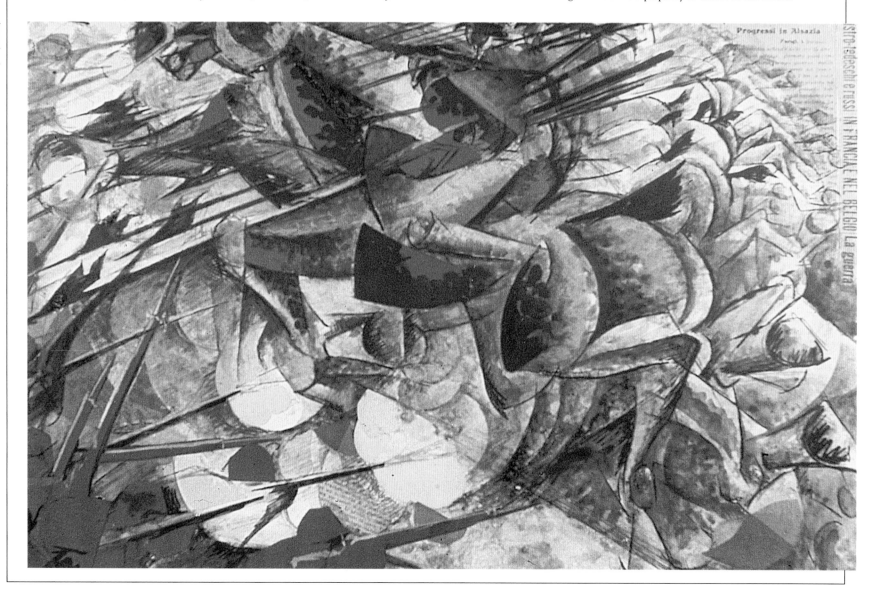

BÖCKLIN, ARNOLD 1827–1901 b. Switzerland
THE ISLE OF THE DEAD

AN INTENSELY THEATRICAL ARTIST, Böcklin knew when he was on to a good thing. He painted five versions of *The Isle of the Dead*, all of which were greatly appreciated by Adolf Hitler. This is death as a megalomaniac would wish it to be: immensely dignified, with the whole of nature as a stage set onto which the dead are gracefully brought. It goes against the grain ever to agree with Adolf Hitler, but this is indeed an impressive painting. Böcklin is actually saying very little, and even the title, *The Isle of the Dead*, could merely refer to a place where the dead are buried or could possess a significantly more mystical meaning. The sinister little recesses in the rock suggest a burial place, and the white figure standing so dramatically in the boat, with the portable altar in front, is the high-Germanic equivalent of a vicar, who has come to conduct the funeral rights. However, those tall, dark trees, those towering rocks, the lurid sky, and the quiet, still water all give death a significance that befits it.

THE ISLE OF THE DEAD
1883, oil on panel, 31 x 59 in (80 x 150 cm), Staatliche Museum, Berlin

SELF-PORTRAIT WITH DEATH AS A FIDDLER
c.1871–74, oil on canvas, 30 x 24 in (75 x 61 cm), Staatliche Museum, Berlin

The Dance of Death is a popular theme in medieval German art, and Böcklin, as a German-speaking Swiss, was well aware both of the theme and its significance. Here, he shows himself in full sway as artist, and yet, behind him, Death plays the fiddle and no-one can tell when the tune – and, by implication, the artist's life – will end. Fortunately for Böcklin, Death fiddled for a further twenty years after the completion of this self-portrait.

BÖCKLIN IS VERY MUCH *on the side of the sublime, albeit a rather melodramatic sublime. The composers Rachmaninov and Elgar were both inspired by this work, although Böcklin himself was thinking not of music but of silence. His world was a profoundly symbolic one, and here it is symbolic of the reality of death – the absolute of silence.*

BÖCKLIN WROTE TO THE WIDOW *for whom he painted this canvas: "You will be able to dream yourself into the world of dark shadows (until you believe that you can feel the soft and gentle breeze that ripples the sea), so that you shy away from interrupting the stillness with sound…it will become so quiet you will be frightened by a knock at the door."*

BONHEUR, ROSA 1822–99 b. France
THE HORSE FAIR

THERE WAS A TIME WHEN Rosa Bonheur was one of the most famous of contemporary artists, and it was *The Horse Fair* that made her so. She prepared to paint this subject with enormous diligence. For 18 months she went twice a week to the horse market in Paris (dressed as a man so as not to attract attention) and made sketches of equine exuberance. As someone who seemed wary of her own kind – whether male or female – she was attracted always to the world of the animal, and it was primarily as an animal painter that she was famous. It is obvious to all who gaze with admiration at this painting that Bonheur understood the horse and respected its grandeur and vitality – the beauty and innocence that still make the horse so appealing to us. A horse market was a wild riot of animality and commerce, where men displayed the horses they had brought for sale, exhibiting their power, lineage, and potential for training. Bonheur sets us in the midst of this dusty, wild world, and yet she distances us. Between us and the horses is a swathe of dusty ground, which is as marvellously observed as is the riot of activity beyond.

PLOUGHING IN THE NIVERNAIS
1849, oil on canvas, 53 x 102½ in (134 x 260 cm), Musée d'Orsay, Paris

It was this painting, *Ploughing in the Nivernais*, that first brought Bonheur to critical attention. Here, we see that it was not the animal excitement that interested her but the entire animal in the fullness of its physicality. These placid oxen are the antithesis of wild and whirling horses. They are creatures that move steadily and purposely over the land, and here, we sense that sluggish movement over the field below the green swell of the distant hill and the pale arch of sky. Bonheur makes us conscious of the thick hide, the sharp horns, the heaviness of the beasts, and the sheer strength with which they draw the plough through the chocolate-brown earth.

THE HORSE FAIR, *1855, oil on canvas, 47 x 100 in (120 x 255 cm), National Gallery, London*

BONHEUR PLAYS WITH *light and shade using a masterly touch, and we can almost move with those white horses, just off-center, as they make their way out of the brilliance and into the shadows, following the horses ahead of them. As an evocation of a setting, it has rarely been bettered.*

THIS PAINTING *was famous across Europe at the time of its completion and was even exhibited in America. It is the second of two versions, in fact, and here Bonheur has overcome the criticisms that the original received at the Salon in 1853 – that in her excitement to depict the horses, she had not paid sufficient attention to the trees and the sky.*

WE SEE A WHOLE COMPLEX *world, with the dome of the church of La Salpêtrière in Paris more clearly defined than in the first version, painted two years before. The scene is superbly visualized, with each horse and its owner individualized for us, so that, despite the turmoil, we can respond imaginatively to every element of the painting.*

BONINGTON, RICHARD PARKES
1802–28
b. England

THE UNDERCLIFF

BONINGTON, LIKE HIS CONTEMPORARY, the great English poet John Keats, was a genius who died young of tuberculosis. He was only 25 when, desperately ill, he painted *The Undercliff*, completing it just one month before his death. This luminous work, which seems to float with such radiant ease before us, was produced by a young man dying under the oppressions of a painful illness, and it is difficult not to think that, for all its beauty, it somehow still expresses a sense of personal mortality. Perhaps it is in the way the great dark waves bear inexorably on the sands, frothing and foaming and eating away at the solidity of the cliffs. *The Undercliff* is a reference to this sabotage of sea on land, and for all the hectic activity of the sailors, as they wait for the ship to come in, it is the sea and the sky and the doomed cliff that are the center of our attention. The solitary figure with bowed head in the foreground may well be that of the artist himself, physically crushed by the dissolution of his body. But we can see from the great watery splendors of sky, cliff, and sea, the still brilliant flame of his spirit.

THE UNDERCLIFF
1828, watercolor on paper, 5 x 9 in (13 x 22 cm), Castle Museum and Art Gallery, Nottingham, UK

BONINGTON HAS SIGNED *his name with his initials R.P.B. The way in which they appear etched into the sand below the lonely figure brings to mind a chiselled epitaph inscribed upon a tombstone. Bonington's then imminent death makes this gesture all the more poignant.*

VENETIAN CAMPANILI
c.1826, watercolor on paper, 6 x 5 in (16 x 13 cm), Maidstone Museum and Art Gallery, UK

Perhaps because of his physical frailty, Bonington spent most his life on the Continent. This view of Venice (which few artists of the time would have thought worthy of their attention) has all the freshness and inspiration that makes his early death such a loss. Dark, but somehow light-filled, it gives us the essence of the city.

BONNARD, PIERRE 1867–1947 b. France
NUDE IN BATHTUB

FACED WITH THE GLORY OF A LATE BONNARD – drawn in and overwhelmed by the sheer wonder of the colors – we have to make an effort to withdraw enough to understand the motif. This is the most familiar of Bonnard's motifs: his wife Marthe in the bathtub. Theirs was a strange relationship. He lived with this neurotic and difficult woman for many years before they married, and although to his friends she was bad news, as it were, the relationship between them seemed to have been, artistically, intensely productive. Her need to immerse herself frequently in the bathtub drew from Bonnard a series of magnificent pictures, of which this is the last. Marthe never aged in Bonnard's imagination; she was always that slender, long-legged girl he found so enticing many years before. She has become subsumed into a strange, luminous world. Even the small dachshund on the bath mat is as magical and glittering as the strange lady herself.

NUDE IN BATHTUB, c.1941–46,
oil on canvas, 48 x 59 in (122 x 151 cm),
Museum of Art, Carnegie Institute, Pittsburgh

THE ALMOND TREE IN BLOSSOM
*1945–47, oil on canvas, 22 x 15 in (55 x 38 cm),
Musée National d'Art Moderne, Paris*

This was Bonnard's last painting. It offers a world of stupendous color, evoking a sense of the warm sweetness of a French garden in spring rather than meticulously documenting it. On his deathbed, Bonnard asked his nephew to bring him this painting because he felt that the green on the lower left needed to be overlaid with yellow. His last act was to make that golden stroke, giving his picture the intellectually satisfying pattern that his mind, so orderly in its lyricism, always sought.

BONNARD makes no attempt to convince us that this is visually realistic. This, he appears to suggest, was what it felt like to be in an enclosed world of bright tiles and clear water, with every part of it reflecting the splendor of light and warmth. If Marthe is almost drowned in that reflective light, so too is the viewer.

THIS IS A MAGICAL world of safety and brightness, where one can only live, as Marthe does, in a moment treasured and prolonged. This is not the world as it is, nor as it should be; it is the world of vision, lost and cherished. The bathroom in Bonnard's house was, in fact, white, and all this chromatic splendor comes from his mind.

BORDONE, PARIS 1500–71 b. Italy
THE BAPTISM OF CHRIST

BEFORE HE LEFT HIS HOME to embark on the preaching of the Word of God, Jesus went to John the Baptist to be baptized. This was not baptism in the sacramental sense, but a solemn gesture acknowledging the need for purity. In the Gospel this seems to be the first adult encounter of these two great charismatic figures: John, who has prepared the way, and Jesus, who has now to enter fully into the revelation of the fatherhood of God. Bordone pares the scene to the bone. It is not set in an expanse, but narrowed down to the river bank, the flowing water, and a single tree. There is an almost claustrophobic sense of nearness, as if we are shut up with John in the sense of drama and emotion. There are no spectators except an angel waiting; all the attention is on the two adult males meeting for this symbolic action. Jesus stands ankle deep in the water, His hands clasped in prayer and His face bent to receive the baptism. But the extraordinary image here is that of John himself, who, far from stepping into the stream, seems held back by what appears to be fear and reverence; this is echoed by the extraordinary physical tension, in which he twists his body, muscles rippling under the strain of steadying himself with one hand while raising the other to pour the water.

PORTRAIT OF A YOUNG WOMAN
c.1550, oil on canvas, 42 x 34 in (107 x 86 cm), National Gallery, London

We know nothing about this rather challenging young woman except that she was 19 years old, which in the mid-16th century was an age of greater maturity than it is considered today. Bordone has looked at her with a truly Venetian eye, delighted in that extraordinary arrangement of bright chestnut curls and jewellery that sits like a personal crown on her well-shaped head. He is an artist who likes to clash his colors, to see what sparks will result from his daring, and the hair makes a most wonderful discord with the muted crimson of her gown.

THERE SEEM TO BE *no witnesses to this encounter – even the angel looks away, as if it would be almost an act of voyeurism to watch more closely, and his companions in the sky behind him are too distant to be a part of the drama. Bordone summons us, as it were, to be witnesses to the baptism, and we may share the angel's sense that the scene is essentially a private one.*

THE BAPTISM OF CHRIST
c.1540, oil on canvas, 51 x 52 in (130 x 132 cm), National Gallery of Art, Washington, DC

BOSCH, HIERONYMUS 1450–1516 b. Netherlands

GARDEN OF EARTHLY DELIGHTS: HELL

BOSCH IS THE GREAT MASTER OF THE MACABRE. The hell scene from *The Garden of Earthly Delights* shows the sinister and unforgettable imagery of which this artist is capable. He sets it in an atmosphere of darkness and fire; the background is a catastrophic scene of flaming buildings and mayhem, almost a prophetic foretaste of an aerial bombardment. But away from that world of indeterminate destruction, we come to the opposite, a foreground full of precisely determined scenes of anguish and humiliation. Although events – sadistic, humorous, even scatological in nature – spill from every corner of the work, Bosch's ordered composition denies a sense of crowding. We can distinguish every particular agony of the damned, as they are laid out before us. But Bosch is not just delighting in invention; the painting is also created as a warning. For all its horrific wit, it is essentially a serious portrayal of hell.

WHAT THESE IMAGES MEAN is left to our own fearful imaginings – Bosch doesn't explain or clarify the symbolism he employs. The enigmatic creatures and events of his work have been puzzled over by art historians since they were first painted, but no systematic explanation of his oeuvre is definitive.

THE GARDEN OF EARTHLY
DELIGHTS: HELL
*c.1510–15, oil on panel,
86 x 38 in (219 x 96 cm),
Museo del Prado, Madrid*

THE HAWKER (or THE PRODIGAL SON)

c.1510, oil on panel, 28 in (71 cm) diameter, Boymans-van Beuningen Museum, Rotterdam

Because Bosch always has a moral in view, *The Hawker* is often thought to represent the prodigal son. It is one of the very few works in which he keeps his righteous fancy in check, and only the sinister owl in the tree reminds us that this is the great poet of the monster. The hawker himself, poor, bent, gentle, is a wholly attractive figure. Although there is a lot of background activity, this gaunt traveller completely dominates the scene.

BOSSCHAERT, AMBROSIUS 1573–1621 b. Belgium
VASE with FLOWERS

AMBROSIUS BOSSCHAERT THE ELDER, like many Dutch and Flemish painters, was a specialist, and his particular area of expertise was flower painting. In this work, painted two years before he died, he has not only made the subtlety, shape, and patterns of the flowers vividly present to us, but has also set them in a wonderful window niche. Right behind the small, immediate beauty of the flowers is a misty and unfathomable world that stretches into the distance. Flowers, he suggests, we can cope with – they are small, bright, and beautiful – but the world beyond is uncontained; it is *beyond* in all senses. Bosschaert accepts this and creates this extraordinary challenge, as it were, to the untamability of nature. He has gathered shells for the niche and has set the blossoms in a vase that glitters with sculptural forms, and yet, despite the scene – the architecture, the landscape, the ledge with its distractions, and the sheer vitality of the flowers themselves – he has invested enormous emotional reserves in contemplating and depicting these short-lived creatures, almost as if he is intent on circumventing time.

FLOWERS IN A GLASS VASE
1614, oil on copper, 10 x 8 in
(26 x 21 cm), National Gallery, London

This bouquet consists mainly of common flowers and has been set not in a vase but in a wine glass. As in the glorious *Vase with Flowers*, Bosschaert suggests to us here that the heady nature of the flower is as intense and intoxicating to the eye as wine is to the palette. The fly, oblivious in the foreground, is suggestive, too. Only the sordid and vulgar would turn their back on something as magnificent as this bouquet of flowers.

THERE IS A PATHOS HERE *that is hidden but intentional. Bosschaert shows the flowers in triumphant bloom, thrusting towards the uppermost flower. Yet all these flowers will die – several leaves are already in tatters, and a glorious carnation lies stalkless on the sill. It is the shells below the flowers and the bejewelled vase that will survive and outlast the multicolored splendor of the flowers.*

NOTHING IS QUITE *what it seems here. The complex splendor of the shells is redolent of death. The shells are the empty tombs of sea creatures, and once held as much life as the flies, dragonflies, and caterpillars that we see on the periphery of the painting. Furthermore, one good push and the vase with all its decorations will be out the window. Bosschaert continually reminds us that everything material knows some form of death.*

VASE WITH FLOWERS
c.1618, oil on panel, 25 x 18 in
(64 x 46 cm), Mauritshuis, The Hague

BOTH, JAN c.1618–1652 b. Netherlands
A ROCKY ITALIAN LANDSCAPE

BOTH LEFT HIS NATIVE HOLLAND when he was twenty to spend six years in Rome, but it was on the experience of those formative years that he lived, pictorially, for the rest of his life. Coming from a land of majestic flatness, he found the romantic scenery of Italy overwhelming in its diversity, associations, and beauty. He was able to live quite happily amid the buildings and fields of Utrecht, and paint the visions of his imagination and memory – those richly textured landscapes of his Italian youth. On this occasion, Both acknowledges explicitly that this is a portrayal of an Italian landscape. There are rocks in the foreground, and on the right a small waterfall. As the eye wanders further into the pictorial space, the landscape rises to a distant cliff, framed by an exuberance of foliage – a celebration of the untamed countryside. Yet Both has not entirely romanticized Italy into fabledom. He clearly has no time for mythological adventures: no Pan or Narcissus peeks out of the undergrowth. We believe in his world all the more for those sturdy peasants who may not, in the Dutch sense, actually work, but who are still going about their daily lives.

MULETEERS AND A HERDSMAN
WITH AN OX AND GOATS BY A POOL
c.1645, oil on wood, 22 x 27 in (57 x 69.5 cm), National Gallery, London

Just sometimes we are aware that Both was not unconscious of the glories of his own country. This work could well be a memory of Italy, but the golden light is somehow reminiscent of that employed by the great 17th-century Dutch landscape painters. The pure and mellow translucence of the sky reflected in the pool suggests that, at some level, Both was very aware of the flatness that allows the sky to so utterly possess a landscape.

THE GOATS *shelter by the rock, and the men while away an indolent hour gossiping in the sunshine. The great glory of the picture – achieved through its sense of sunlight and distance – is that it seems to encapsulate happiness, perhaps that which Both knew in his twenties.*

MULES PASS *along with their drivers, and there is a happy sense that this beautiful landscape is not unpeopled. The presence of the muleteers implies that this shadowed enclave is along the course of a busy trading route.*

A ROCKY ITALIAN LANDSCAPE
mid-1640s, oil on canvas, 41 x 49 in (103 x 125 cm,), National Gallery, London

BOTTICELLI, SANDRO c.1445–1510 b. Italy

THE BIRTH OF VENUS

THIS IS PERHAPS BOTTICELLI'S BEST-KNOWN AND BEST-LOVED PAINTING. Venus has extraordinary presence as she floats, naked and beautiful, in a gilded scallop-shell, away from the world of the gods to the world of humanity. Zephyr, the west wind, his strong cheeks puffed with energetic breath, wafts her towards us. Carried by him and clasping him is the nymph Chloris, who brings the flowers that herald Spring, which are already floating softly and gently around the self-contained figure of Venus at the center. A nymph awaits to welcome her with a glorious embroidered cloak, because beauty as startling as that of Venus cannot be seen naked. Botticelli seems to have been one of those naturally pure-minded men, with a remarkable ability to show a beautiful woman unclothed and yet somehow without the slightest suggestion of the over-sensual. It is hard to believe that a Botticelli figure sweats and labors, or even understands the concept of dirt. The legend of the birth of Venus proclaimed that the goddess was born from the genitals of her murdered father as they foamed in the sea, yet all this unpleasantness has been transcended and, typically, Botticelli shows only beauty and purity in Venus.

VIRGIN AND CHILD
WITH EIGHT ANGELS
c.1481–83, oil on poplar wood, 53 in (135 cm) diameter, Staatliche Museum, Berlin

If we turn from *The Birth of Venus* to this Virgin and angels we are struck immediately by the resemblance – Venus and the Virgin are the same woman. This seems to have been integral to Botticelli's philosophy, that beauty in itself was holy, and that the holy in itself was beautiful. His Virgin looks out on the world from that same perfect face, and with that same air of gentle melancholy, in all his paintings.

THE BIRTH OF VENUS
c.1484, tempera on canvas, 68 x 110 in (172.5 x 278.5 cm), Galleria degli Uffizi, Florence

UNAWARE OF ANYBODY *but herself, Venus will float, one feels, across the land, much as she has floated across the ripples of the sea. Not for her, labor or difficulty, yet this is not a painting out-of-touch with reality; as the shell bears Venus towards the shore, we can see the sea-bed darkening under the transparent wavelets, and the flowers that greet her and the trees under whose shade she will pass are all of recognizable species.*

BOUCHER, FRANÇOIS 1703–70 b. France
DIANA BATHING

BOUCHER IS RENOWNED most of all for the prettiness of his naked women. This may sound frivolous, but Boucher's greatness was to take the charm of adolescent curves and invest them with a mythical significance. He saw these delightful young women as symbols of something fresh and sweet, something that should not be disregarded because it had not the weightier values. Here, he imagines the goddess Diana, leaving her ritual bath after returning from the hunt. The small crescent moon in her fair hair, anchored by its unobtrusive pearls, is the symbol of Diana, the virgin goddess of hunting. Boucher shows her purity and her strength. Despite those enchanting curves and delicate limbs, she is in a confident pose, relaxed after the success of the day's kill, but certainly not languishing passively for the viewer's gaze. Boucher excels in the pale skin tones, reflecting the soft rays of the evening sun. A great swathe of royal blue snakes down the bank, with a bed of ivory and pink cushioning Diana's resting place. He is clearly entranced by the female form, and particularly its youthful perfection, which he elevates to a divine status.

THE BREAKFAST
1739, oil on canvas 32 x 26 in (82 x 66 cm), Musée du Louvre, Paris

This domestic scene, with its elegant interior of somewhat overstated richness, is focused on the two charming children. Our eye is directed by the attention of the adults and the pointing with spoons towards the small child on the right, almost overburdened with toys, and the delightful baby, who sits with resolutely closed mouth on the left.

DIANA'S *hounds emphasize the controlled violence of the hunt, and the soft grass against which Diana is silhouetted contrasts with the spiky reeds and the darkness of the trees in the distance.*

A WHOLE *string of dead birds and game has fallen victim to the huntress, who is framed on either side by her bow and her quiver of arrows – both picked out in scarlet so that we should not mistake the nature of the goddess.*

DIANA BATHING
1742, oil on canvas, 22 x 29 in (56 x 73 cm), Musée du Louvre, Paris

BOUDIN, EUGÈNE 1824–98 b. France
APPROACHING STORM

BOUDIN WAS FASCINATED BY THE PHENOMENON of the middle class at play. These are not the peasants or the laborers, these are the wealthy shopkeepers, lawyers, doctors, and their families, who have come to enjoy themselves at the beach resort of Trouville on the Normandy coast. Boudin was criticized for vulgarizing his landscape with these arrays of expensive crinoline, but he insisted that the wealthy had an equal right to their day in the sun, pictorially. He was clearly very taken by the contrast of that great pool of sunlit sand, shadowed to one side, and the immensity of a burgeoning sky on the other – and between them, the long line of overdressed people. The artist is best known, perhaps, for his influence on Monet, who revered him and was encouraged by him, but a work like this shows that he has an importance in his own right.

THE BEACH AT TOURGÉVILLE-LES-SABLONS
1893, oil on canvas, 20 x 29 in (51 x 74 cm), National Gallery, London

As he grew older (this was painted five years before he died), Boudin became less interested in the visitors to the beach than in the setting itself. There are people here, walking on the sands with their sunshades and their pet dogs, but they are swallowed up in the austere beauty of the landscape. Two thirds of the picture is cloud-filled sky and the rest is the pallor of the sands, with a dash of green to suggest the countryside and a dash of the palest blue to suggest the sea. It is a picture of great silence.

APPROACHING STORM, *1864, oil on wood, 15 x 23 in (37 x 58 cm), The Art Institute of Chicago*

THE GAIETY OF THE SCENE, *with its wonderful touches of red and its shimmer of activity, is, however, a threatened gaiety. These people are confronted by nature, but without understanding. Only the man gesturing to the skies has realized that it is time now to go home. Boudin is painting the beauty, both of the setting and of the human beings within it and, consequently, the significance of the contrast.*

BOUGUEREAU, ADOLPHE-WILLIAM
1825–1905
b. France

YOUNG GIRL DEFENDING HERSELF AGAINST EROS

BOUGUEREAU EPITOMIZES THE ART against which the Impressionists were allied. He was a Salon painter, a man universally admired in his time, whose work exhibited the highest technical skill. Yet, to the Impressionists, it seemed so spiritually dead that the artist's reputation sank without a ripple. Recently, however, the Salon artists have come back into favor. We can see how superbly this work is painted, but Bouguereau's interest is also in the psychological – in the conflict a young woman may feel between her maiden state, inviolate and self-possessed, and the attraction and pain of the world of love. She keeps Eros at a distance, but smilingly.

CHARITY
1865, oil on canvas, 48 x 60 in (122 x 152 cm), Birmingham Museum and Art Gallery, UK

Charity, an earlier picture than *Young Girl Defending Herself Against Eros*, is equally well painted, but here the sentimentality is more obvious. The beggar woman and her children are all beautiful and poignant, making it impossible for us to believe in a drab reality. Despite this, however, it remains a splendid picture, with the artist responding to every nuance of the scene he has conjured up for his models, and with an intellectual subtlety that is not necessarily apparent. The wall of the church is brilliantly white on the left; to the right, though, it advertises a lecture on charity, and this is darkened and stained. Bouguereau is suggesting that actual giving, as opposed to worldly explanations of charity, is more effective.

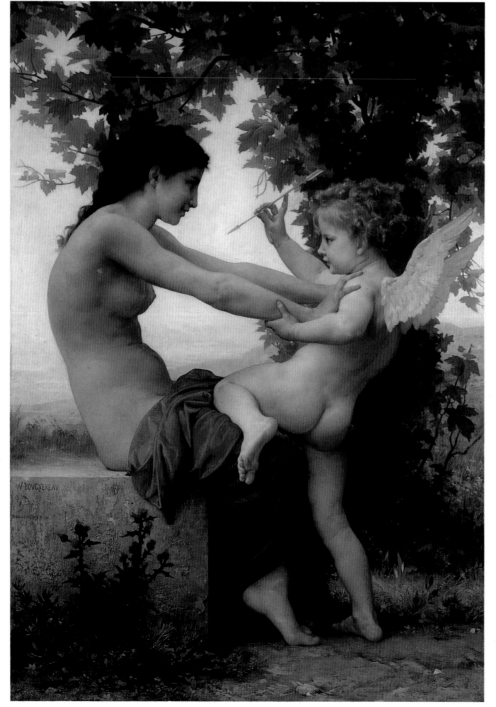

WE CAN ADMIRE *the truthfulness with which Bouguereau has looked at the two bodies of the young woman and the child – how the artist has responded to the textures of leaf and stone and silk. He has fully understood the play of light on Eros's curls and how that same light transfigures the leaves of the tree.*

THE ARTIST DOES NOT *romanticize what Eros has to offer. When the young girl rises from her feet, there are thistles, and the world that she now has behind her is distant and lonely. It is a picture of great charm, teetering dangerously on the edge of "chocolate-box" style, and only redeemed by the artist's superb skills.*

YOUNG GIRL DEFENDING HERSELF AGAINST EROS, *c.1880, oil on canvas, 31 x 22 in (80 x 55 cm), J. Paul Getty Museum, Malibu*

BOUTS, DIERIC c.1415–75 b. Netherlands
THE LAST SUPPER

DIERIC BOUTS HAS DESIGNED *THE LAST SUPPER* with such skillful zeal that the sheer patterning seems to outweigh the significance of what is happening. By the convergence of the central beam of the ceiling and the chandelier, the eye is led down the central line of the panelled door, and we are focused on Christ. The perfect symmetry of the room, with its austere and lofty Gothic architecture, heightens the impression that we are witnessing a moment of stillness. This is Jesus at the point when He institutes the Holy Communion – an event of enormous solemnity, which might well have frozen the apostles into attitudes of awe and wonder. Indeed, the disciples seem almost formulaic in their silence and stillness. It is a deeply theological picture, in which the apostles' relative impassivity is meant to indicate that they are meditating on the miracle rather than denoting indifference. Judas, that angry black-and-red cut-out in the foreground, seems consumed with the only emotion that we can see. He is bitter, and will reject the gift of the Host that Jesus so trustfully will offer to His friends. Bouts seems not to have been temperamentally drawn to drama, and so this moment of tranquillity – this institution of the sacraments – accords admirably with the austere gravity of his temperament.

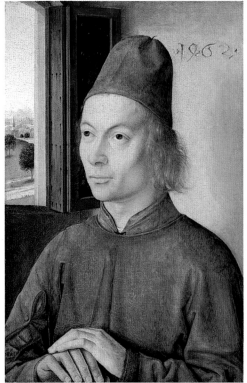

PORTRAIT OF A MAN
1462, oil on wood, 13 x 8 in (32 x 20 cm),
National Gallery, London

There is no suggestion whatever that this is a self-portrait, but if one were to imagine what Bouts might have looked like this might well meet our imaginings. It is an impassive face, and yet closely observed. One tends not to think of Bouts as in any sense avant-garde, and yet this is the earliest example of a portrait in which there is a window in a room looking out onto a view. The view both enlivens the picture and suggests other dimensions to the character. Although the man stares fixedly ahead, the very steadiness of his forward look only serves to draw our attention to the view.

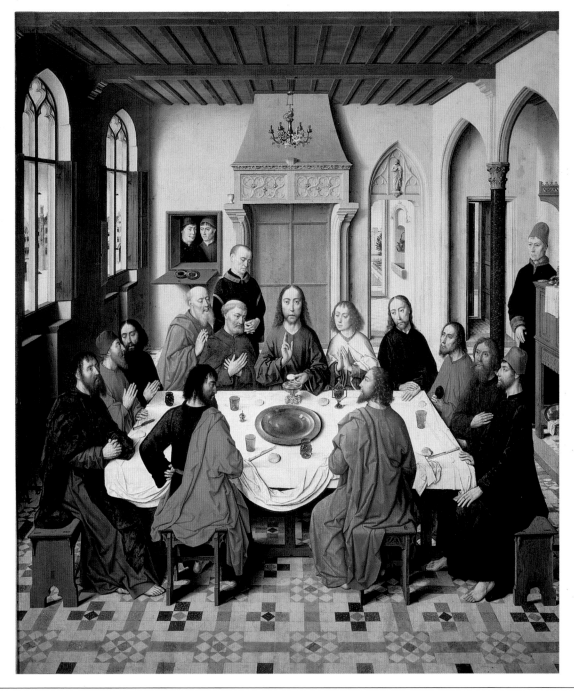

THE SILENT BYSTANDERS
(the man standing behind Peter, the solemn steward on the right, and the two who look without apparent curiosity through the hatchway) may represent the donors. By asking the artist to paint their likenesses, the members of the confraternity would have achieved (in intention at least) their wish to be a part of the holiness of the Last Supper.

THE TWELVE *disciples are neatly arrayed, three solemn upright faces on the left facing three on the right. Jesus is flanked by four apostles so that Judas can be isolated to the left at the bottom of the table, with one other figure, whose function is to balance Judas and emphasize the figure of Christ.*

THE LAST SUPPER
1464–67, tempera on wood, 71 x 59 in
(180 x 150 cm), Sankt Peter, Louvain, Belgium

BOYD, ARTHUR 1920– b. Australia

CAVE, NARCISSUS, AND ORANGE TREE

BOYD LIVED NEAR THE SHOALHAVEN RIVER in New South Wales and has said it was the stillness of the river and the echoes of the valley that inspired *Cave, Narcissus, and Orange Tree*. It is a mysterious picture, in which all the elements of realism seem to be contradicted by the elements of fantasy. We might accept the background, the desert-like sands with the stretch of brilliant blue beyond, but what are we to make of that cave, with its dragon's back resting on nothing and yet miraculously bordered by a small tree and an orange bush? The picture impresses us, weighty with significance. The ragged bird is, perhaps, the only pointer we are given: the bird is tattered by life and yet it still flies.

B
56

NUDE TURNING INTO A DRAGONFLY
1961, oil and tempera on cardboard, 63 x 72 in (160 x 183 cm), Museo Thyssen-Bornemisza, Madrid

Here is the thick, green, prehistoric jungle of the imagination, mysteriously filled with reflected light from the foaming river and yet impervious to the sky. It is a secret world, where the glistening body of a woman, of which only the head and the hands are still readable, is being magically transformed into a dragonfly. It is as if all the heaviness of the human body has been squeezed to a point and then floated out into these four long translucent shapes, which are completely at home in the wild beauty of the landscape as the mortal human can never be.

ACCORDING TO THE *myth, Narcissus saw himself in the water, fell in love with himself, and pined away. If the name Narcissus were not in the title, we would think this vigorous blue creature was crouching down to drink. It seems not so much on the verge of being transformed into a Narcissus flower as mutating into some kind of monkey. We see a "tail" hanging down and the head is becoming decidedly simian.*

THE CAVE IS ALWAYS *a symbol of secrecy and refuge. The rich, round gold of the oranges are a symbol of vitality, and Narcissus will always stand for self-absorption. But Boyd does not weave these strands together into a coherent narrative; he rather sets them before us, united by the artist's eye, but not in any way that points us to a single, conclusive reading of the picture.*

CAVE, NARCISSUS, AND ORANGE TREE
c.1976, oil on board, 60 x 48 in (152 x 122 cm), Private Collection

BRAQUE, GEORGES 1882–1963 b. France
HOUSES AT L'ESTAQUE

BRAQUE IS AN ARTIST WITH WHOM it is not all that easy to come to terms; there is a distancing in his work, a sense of holding the viewer away from true involvement. Braque's name is indissolubly linked with Picasso's, and although others were to join them, these two artists epitomized the Cubist movement. Certainly, they were the originators of this strange and fractured view of reality, which changed forever the way in which all artists came to look at the world. *Houses at L'Estaque* was painted when Braque was just beginning to realize the potential of Cubism, which refused to conform to the well-established views of the past. Cézanne had shaken the tree, and Braque – along with Picasso – caught the fruit as it fell. This painting shows the most significant aspect of Cubism more clearly than later and more complex works. Braque has not only simplified – with this extraordinary view of houses as giant building blocks and trees and mountains as generic shapes – but he has refused that one-point perspective upon which landscape painting had depended.

CAFÉ-BAR
1919, oil on canvas, 64 x 33 in (163 x 83 cm),
Kunstmuseum, Basel, Switzerland

When World War I began, Picasso, as a Spaniard, went on painting, while Braque, as a loyal Frenchman, went off to fight. They never cooperated again and, in fact, rarely ever met. Cubism was to develop differently in the hands of these temperamentally very different artists. Braque was wounded in the head during the war and is thought never to have recovered his full strength. However, *Café-Bar* is a demonstration of great creative vigor. All is enlivened by Braque's delight in texture – both visual texture and tactile – and the mood seems one of unambiguous pleasure.

BRAQUE TRANSGRESSES *the laws of perspective with dexterity and wit, using shadows and angles in a semi-serious tone that gives the work a visual excitement. He sees not just the frontage of the houses but also, to coin a phrase, their "backage and sideage". Cubism was later to pass through solidity into an almost indecipherable play with shape, but here, at the beginning, it makes no great demands on our capacity to solve puzzles.*

HOUSES AT L'ESTAQUE, *1908, oil on canvas, 28 x 23 in (72 x 58 cm), Kunstmuseum, Bern, Switzerland*

BRIL, PAUL 1554–1626 b. Belgium, active Italy

HEBE WITH THE EAGLE OF JUPITER

BRIL SEEMS TO HAVE BEEN A DEEPLY ROMANTIC ARTIST whose native land was too pedestrian in its beauty to appeal to him. However, in Italy he found the mountain ranges and the drama that satisfied something deep within him. Here, it is not landscape alone but landscape in the context of Greek myth that engrosses him. Hebe was the daughter of Zeus and Hera, and she was cup-bearer to the Olympian gods. Her name is the Greek word meaning "young maturity" or "bloom of youth" and later ages saw her as the patron of young womanhood. Certainly, this small pink creature, alone in the towering mountains, is an image of the maiden still unwed. Zeus's symbol was that great predatory bird the eagle, but, as his cup-bearer, Hebe is safe in his presence, and, here, with the innocent security of a loved child, she raises the cup for the great bird to quench his thirst.

HEBE WITH THE EAGLE OF JUPITER, *1610, oil on canvas, 36½ x 50½ in (93 x 128 cm), Museo del Prado, Madrid*

THE DRAMATIC INTERCHANGE *between father and daughter is set amid the extravagance of a wild mountain scene: a waterfall explodes down the rocky cliff, a double rainbow (that image of hope) arches over the water, and on the very peak is a remote fortress.*

THE STAG HUNT
1595, oil on copper, 8 x 11 in (21 x 28 cm), Palazzo Pitti, Florence

This tiny work sparkles with life and activity. Yet, despite this, it is the large oak lit by the western sun that dominates the scene. All the excitement is somehow contained by the great stretch of the river valley and the gathering storm clouds. We feel that, though the hunt will pass, the tree and its surroundings will remain forever.

BROEDERLAM, MELCHIOR

active 1381-1409 Belgium and France

THE ANNUNCIATION
AND THE VISITATION

BROEDERLAM WAS COURT PAINTER to the Duke of Burgundy, and this is the left-hand panel to a great gilded altarpiece produced for a monastery church. Broederlam had no qualms about combining in one picture two distinct events in the Christian story. On the left, we see the angel announcing to Mary that she is to be mother of God, and, on the right, we see her journeying into the hill country to meet her cousin Elizabeth, who is about to give birth to John the Baptist. The two pregnant women meet and so, too, do the two children within their wombs. Broederlam makes his painting a picture of two distinct worlds. The angel comes to Mary within the safe world – the architecturally beautiful world of human invention. The story begins here, within the limits of human genius, but it will progress beyond the safety and elegance of the civilized world into the bare landscape of nature, where mountains soar, and Mary's body will know the changes of pregnancy and the uncontrollable forces of that same nature. Civilization and wilderness, a message from heaven and a message from another woman, a long journey and an understanding of what that journey might involve – all these elements are subtly and intelligently combined to make this a true masterpiece.

THE PRESENTATION
AND THE FLIGHT INTO EGYPT
1394–99, tempera on wood, 66 x 51 in (167 x 130 cm), Musée des Beaux Arts, Dijon, France

This is the right-hand panel that accompanies *The Annunciation and the Visitation*, and again Broederlam has to cope with two elements of the story. The left side of the painting shows Mary presenting the newborn Christ in the Temple for Him to be circumcized – the first shedding of His blood. The right side of the painting depicts the flight into Egypt, when the news came that Herod was seeking to kill the Child – the first experience of His rejection. Again, Broederlam juxtaposes an interior and an exterior, and once again the two elements make a whole that is greater than the parts.

IN THE UPPER–LEFT CORNER, *God the Father is accompanied by two brilliant swirls of angels – the scarlet of the cherubim and radiant blue of the seraphim. God overshadows Mary with the Holy Spirit. Soon she will move into the hill country to see her cousin, St Elizabeth, and Broederlam also shows this meeting.*

THE ANNUNCIATION AND THE VISITATION, *1394–99, tempera on wood, 64 x 51 in (162 x 130 cm), Musée des Beaux-Arts, Dijon, France*

BRONZINO, AGNOLO 1503–72 b. Italy
A LADY WITH A DOG

BRONZINO PAINTED THE ARISTOCRACY. Through him we know how the grandees of the Medici Court looked – their glamour and their elegance. In this early masterpiece, Bronzino reveals his distinctive ability to combine presence and reticence in equal measure. This Lady, so supremely confident, has come down to us nameless, which would have given her a great surprise. She knows who she is, and she looks with benign aloofness and self-possession at the artist who has the privilege of painting her. It is a picture of somebody completely at ease with herself – able to carry the trappings of wealth without being burdened by them. The books behind her chair only emphasize what Bronzino has already made clear to us: that this is a very intelligent woman. The artist glories in the sheer style of her dress, with those great ballooning scarlet sleeves narrowing down to the rich black velvet of the armband, and in the elegance of that swan-like neck so perfectly set-off by the white fabric, with just the slightest imperfection in the buttoning to make her human. Perhaps this gracious, almost sculptural, woman is also humanized by the presence of that small and fluffy dog.

AN ALLEGORY WITH VENUS AND CUPID
c.1545, oil on panel, 57 x 46 in (146 x 116 cm), National Gallery, London

This deeply unpleasant picture is nevertheless thought to be Bronzino's masterpiece. It is an allegory of love, and in the forefront are three beautiful figures: Cupid and Venus in incestuous embrace, and a rejoicing putti. But behind, all is very different. Envy tears her hair in anguish, Deceit looks on with her mask, an angry Father Time tries to end it all by drawing a curtain, and a strange figure – part pretty girl, part animal – holds in one hand a honeycomb and in the other a bitter sting. Bronzino is depicting the deepest fears and desires of the human heart, but in a manner so cold, so polished, so impersonal, that we are left bewildered.

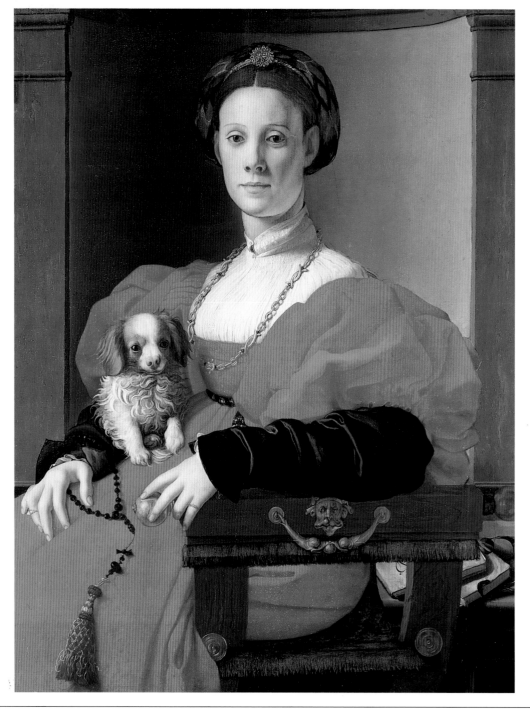

ONE OF THE MOST *brilliant touches in this portrait – which might daunt us by its perfection – is the one single imperfection: the fabric of the sitter's embroidered and pleated collar slightly creases and the buttons gape. The effect, of course, is to draw attention to the slender column of her neck supporting the perfect oval of her face. It also serves to remind us that she, too, is subject to the vagaries of the material world.*

THE DOG IS AS CONSCIOUS *of his dignity as she is, equally at ease with it, fully aware that he is a beautiful, well-cared-for pedigree. He does not need to be restrained – his mistress's hands lie completely relaxed. One exquisite hand is resting on her lap, the other rests with equal self-assurance on the golden knob of her elaborate chair. In counterpoint, her dog gently lifts one small but exquisite paw.*

A LADY WITH A DOG
c.1529–30, oil on panel, 35 x 28 in (89 x 70 cm), Städeliches Kunstinstitut, Frankfurt

BROUWER, ADRIAEN c.1605–38 b. Netherlands
THE BITTER DRAUGHT

BOTH RUBENS AND REMBRANDT collected the works of Brouwer and so perhaps we should be hesitant in assigning them to a rather undignified category. It is true that Brouwer's artistic interest was drawn by scenes of vulgarity, but he entered into them with democratic enthusiasm and awareness of human truth. Here, an initially unprepossessing peasant – with a large, bulbous nose, straggly hair, an unshaven chin, and few teeth – is objecting vociferously to the bitterness of his drink, as he spits out in disgust whatever he has almost swallowed. It is not a romantic scene, yet this peasant is as convincing as any human being in the story of painting.

THE BITTER DRAUGHT
c.1635–38, oil on wood, 18½ x 14 in
(47 x 35 cm), Städelsches
Kunstinstitut, Frankfurt

PEASANTS SMOKING AND DRINKING
c.1635, oil on wood, 14 x 10 in
(35 x 26 cm), Alte Pinakothek, Munich

Seventeenth-century Antwerp had low-class dives where peasants congregated to indulge in the dangerous pleasure of tobacco. Here, they seem weighed down by the effects of smoke and alcohol. Shut into this wooden tavern (which, apparently, they do not even enjoy) they sit vacantly, stupidly, and sullenly, inhaling and looking away from the sunlight.

BROWN, FORD MADOX 1821–93 b. France, active England
THE LAST OF ENGLAND

IN ITS VICTORIAN CONTEXT, this a poignant image. It was inspired by the emigration to Australia of fellow Pre-Raphaelite Thomas Woolner and his wife (a journey undertaken by many as a means of escape from grinding poverty). They are painted with that meticulous precision that is the hallmark of the Pre-Raphaelites, whose overriding belief was that of truth to nature. The eyes of the husband and wife carry the full charge of loneliness and rejection that Brown is anxious to convey. Reinforcing the reality of this drama are the material details: the rough texture of the husband's jacket, the way his hat is fastened to his button, the weave of the wife's shawl, the splash of the waves, and the cabbages hanging on the netting. All these small particulars convey to us the immediacy of an observed moment.

THE LAST
OF ENGLAND
1852–55, oil on panel,
33 x 30 in (83 x 75 cm),
Birmingham City Museum
and Art Gallery, UK

AN ENGLISH AUTUMN AFTERNOON, HAMPSTEAD
1852–53, oil on canvas, 71 x 135 cm,
Birmingham City Museum and Art Gallery, UK

This painting was criticized for its pointlessness, yet the very point of Pre-Raphaelite art was to glorify any small section of the world. This was the view from the artist's back window, and because of the intensity with which he has gazed at it, the painting has a surreal quality – colors seem too bright, shapes oversharp – and yet it is utterly convincing.

BRUEGEL, JAN 1568–1625 b. Belgium

FOREST'S EDGE (FLIGHT INTO EGYPT)

THE FLIGHT INTO EGYPT HAS BEEN AN ABIDING SOURCE of interest to religious artists. Strangely, it has always been treated as a lonely journey – there have been angels accompanying the Holy Family, but otherwise it is just the three family members and their donkey. Jan Bruegel was an intensely human painter. He sees these three as one family among many. Theirs might be a special destiny, but so was that of the other families. He sets his drama in the real world of humanity and yet, also in the world of poetry. All of the journeying – the human travail – is on the left of the picture; above and to the right stretches the whole mysterious world of nature. Joseph and Mary are leaving all that they know to venture down into the mystery of the unknown.

THE EARTHLY PARADISE
1610, oil on canvas, 20 x 16 in (59 x 41 cm), Museo del Prado, Madrid

Jan Bruegel was particularly drawn to the theme of the earthly paradise. Here, all blooms luxuriantly and animals live together in harmony. All this will be lost: the happy communion of bird and beast will degenerate into savagery; the easy sweetness of fertile nature will become hard labor. But Bruegel does not make heavy weather of this; he is not a dramatist. He simply displays for us the full golden glory of a world where man and woman can walk naked with nothing to fear.

FOREST'S EDGE (FLIGHT INTO EGYPT), *1610, oil on copper, 10 x 14 in (25 x 36 cm), Hermitage, St Petersburg*

THE HOLY FAMILY *follow a well-trodden path; but Bruegel directs our attention up and away from it, suggesting that, although they are in flight, they are moving into freedom, out of a green and shadowed world and into one that is blue and silver, pathless, and beautiful.*

BRUEGEL, PIETER c.1525–69 b. Netherlands
HUNTERS IN THE SNOW

PIETER BRUEGEL WAS NICKNAMED "PEASANT BRUEGEL", because his paintings so often depicted the peasants in his native landscape. He himself was a man of the highest sophistication, with an understanding of what one might call the bones of the earth, which makes him one of the greatest landscape painters of all time. *Hunters in the Snow* is perhaps the coldest painting ever created; the tired men are sinking deep into the brittle surface of a frozen world, their dogs following, thin and dejected. Bruegel was intensely aware of the constraints of peasant life, how it bound them up in a constant and fatiguing attempt to glean a living. The birds fly free, but even the small figures skating on the ice seem constrained, enclosed in their occupations, unaware of life's possibilities. It is a specifically northern landscape, not that of his flat Netherlands, but that of an ideal world in which we see into a great space from a great height. Bruegel marches us down the hill with those vertical trees, and we plunge down into the valley and out, with one great peak taking us up to the heavens. A strange undertone of sadness seems to come from his consciousness that he (and we with him) takes that plunge, but not the peasants.

HUNTERS IN THE SNOW
1565, oil on panel,
46 x 64 in (117 x 162 cm),
Kunsthistorisches Museum, Vienna

THE HUNTERS TRUDGING *wearily through the snow pass by with their heads down. A family behind, roasting a pig outside an inn, are so taken up by the struggle to exist that they, too, seem utterly unaware of the astounding beauty of the world that spreads out before them.*

THE MISANTHROPE
1568, oil on canvas, 34 in (86 cm) diameter, Museo Nazionale, Naples

A disgruntled monkish figure with a large, unhappy nose and bitter mouth turns his back on a sun-bathed landscape. The inscription reads "Because the World is unfaithful, therefore I go in mourning". The World, however, poor but alive, sneaks up behind him and steals his heart (indistinguishable from his purse). Ahead lie only thorns.

BURNE-JONES, SIR EDWARD COLEY

1833–98
b. England

KING COPHETUA AND THE BEGGAR MAID

BURNE-JONES WAS A PRE-RAPHAELITE in a double sense. Not only did he desire to paint with the simplicity that preceded Raphael, but he also chose as themes riddles from the innocent world that he imagined were typical of the Middle Ages. *King Cophetua and the Beggar Maid* is based on a 17th-century ballad about a king who chooses for his wife a beggar woman. The people here live in a dream world – part of that construction peculiar to the Pre-Raphaelites, and above all to Burne-Jones – of romance and clinical beauty that has been forever lost to the present. The king – male, but wholly without lust – sits at a distance, admiring this woman, who gazes out from the picture, her large eyes set within the pale oval of her face. With her general air of debility, she is instantly recognizable as a Burne-Jones maiden – they are not exactly anorexic in body, but one feels that they are so in spirit.

THE KING *has removed his crown as an abeyance to his beggar-maid bride, and sits humbly at her feet. Awestruck by her wan beauty, this mighty warrior has no thoughts of war. In many ways, this extraordinary image might equally be read as* Mars conquered by Venus.

KING COPHETUA AND THE BEGGAR MAID, *1884, oil on canvas, 104 x 53 in (265 x 134 cm), Tate Gallery, London*

WHAT GIVES THIS PAINTING *its power is the artist's obsessive interest in detail. In particular, the crown has a Gothic intensity and precision of extraordinary vigor. More generally, from the physical rendering of the bride and the King to the steely elaborations of the armour and the discarded lance and shield, all is celebrated with an intensity of perception that makes the image memorable.*

THE GOLDEN STAIRS
1880, oil on canvas, 109 x 46 in (276 x 117 cm), Tate Gallery, London

There is no narrative here, and no pretence of a narrative. All Burne-Jones is showing us is an extraordinary stairway, down which processes a line of almost identical virgins. Each – slender, gracious, and fair-skinned – is clad in white and holds a musical instrument. The pressure of the angels' proximity could be almost unbearable, were it not for that little oblong at the top, open to the sky with white doves poised on the wing.

CAILLEBOTTE, GUSTAVE 1848–94 b. France

RUE DE PARIS, WET WEATHER

CAILLEBOTTE IS AN ARTIST whom the social historians would have had to invent had he not already existed. This, his most famous work, represents what a sociologist would perhaps consider the correct subject matter for artists: the real, contemporary world in all its drabness and lack of romance. The Impressionists made token references to this, and in their paintings we see the occasional factory chimney or cityscape. But it was Caillebotte who, despite being more a well-to-do patron and hanger-on of the Impressionist scene, encapsulated the world of 19th-century Paris in this celebration of a wet street on a dull day. Without great visual excitement, it remains a picture of originality and beauty.

RUE DE PARIS, WET WEATHER
1877, oil on canvas, 83 x 109 in
(212 x 276 cm), The Art Institute of Chicago

SELF-PORTRAIT
1892, oil on canvas, 16 x 13 in
(41 x 33 cm), Musée d'Orsay, Paris

Most of Caillebotte's work is stubbornly unromantic and clearly focused on the absolutely ordinary. It comes as a salutary surprise, therefore, to find that he himself had the appearance of the typical romantic artist. Here are the brooding eyes, the anguished lips, the sunken cheeks – the full gamut of the artist as creative genius – and, although one senses a subliminal touch of irony in his landscapes, there is none here. He looks at himself with utter seriousness.

SUCH IS *Caillebotte's own fascination with what he sees that this painting has held viewers spellbound since its creation. It manages to convey a slice of life that – despite (or maybe because of) the lack of incident – makes us feel we have a measure of the pulse of late 19th-century Parisian life.*

CAILLEBOTTE *convinces us that this is what it was like on that particular afternoon in 1877, at a certain time of day, on a certain street in Paris, when the light was cool and bright, the streets were quiet, and the rain fell in a fine drizzle.*

CALVAERT, DENYS (DIONISIO FIAMMINGO) c.1540–1619 b. Belgium, active Italy

ST MICHAEL ARCHANGEL

CALVAERT WAS ONE OF MANY PAINTERS from the Low Countries who went to Italy. For him, however, it was not the landscape that held him enthralled but the revelation of great religious art – art that Italy held in abundance. In 1572, he opened an academy in Bologna, a rare instance of an artist seriously setting about training young artists to share his vision. *St Michael Archangel* is a visionary picture. Michael is the warrior archangel, often seen holding the scales of justice at the last judgment, and it is he who was thought to have defeated Lucifer – the brightest of the angels – who refused to obey God and who changed from radiant angel to devil. Calvaert not only structures his picture on the contrast between the opposites of good and evil, light and darkness, beauty and deformity, but also simplifies the composition, concentrating on that great diagonal: the spear with which St Michael thrusts the devil down into the abyss of hell. The moral is unmistakably plain. Michael does not actually stab Lucifer, nor does he need to; instead, he drives him down fiercely and progressively. Calvaert thus implies that evil shrinks from good without the need for actual violence.

CALVAERT IMAGINES *the transformation of Lucifer. He is still bright, but as he falls, he is visibly transmuted into a hideous creature of serpentine deformity. The wings of this fallen angel are becoming leathery and batlike as he plummets into the depths. His skull, with its great jut of a nose and horns that are beginning to deform the forehead, is in piteous contrast to the free-flowing curls of St Michael. The Good Spirit is all light, clarity, and youthful vigor. Behind him is the glory of God, and his angelic wings spread eagle-like against the sky.*

C
66

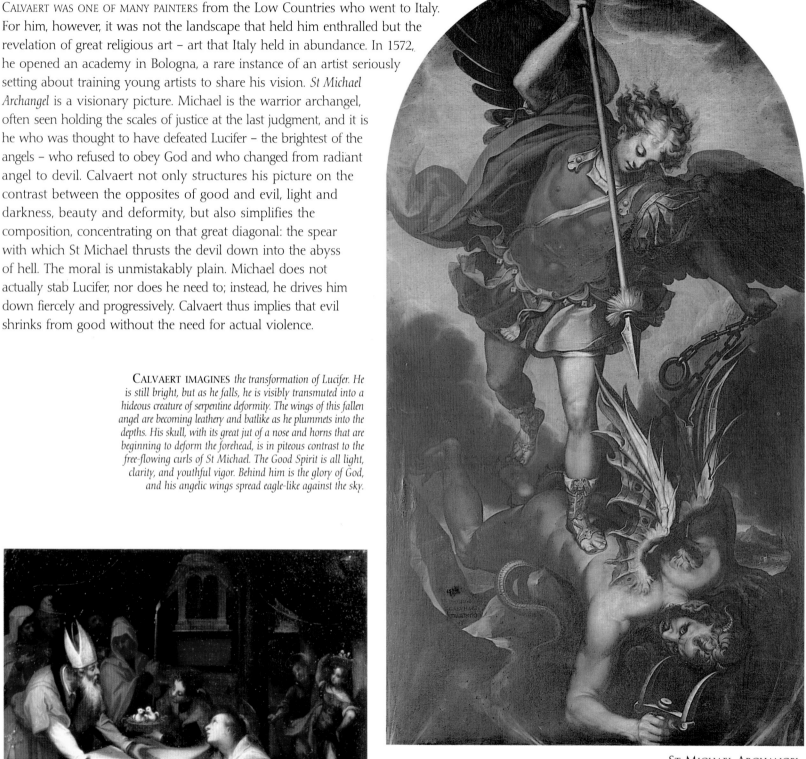

ST MICHAEL ARCHANGEL
late 16th century, oil on canvas, 157½ x 71 in (400 x 180 cm), San Petronio, Bologna

THE PRESENTATION
IN THE TEMPLE
late 16th century, oil on canvas, 20 x 20 in (50 x 50 cm), San Domenico, Bologna

Here is Calvaert, in a tender and emotional mood, telling the story of Jesus's circumcision. The offering for the poor was two young pigeons – two squawking little chicks, unaware of their biblical importance. The High Priest reaches out his hands with tenderness, although the Scriptures tell us he was at first completely unaware of the identity of the young mother and her baby. Calvaert, however, is profoundly aware. Mary looks up with gentle entreaty as she brings Jesus to the altar, where His blood will be shed in the act of circumcision.

CAMPIN, ROBERT c.1378–1444 b. Belgium
SAINT BARBARA

ALTHOUGH FROM THE VIEW THROUGH THE WINDOW we can see that it is a fine spring day, the cosiness of this little room makes us believe that it is chill outside and the fire blazing away behind St Barbara's back seems a most welcome source of warmth. It may also be a symbolic reminder of the lightning that came down from heaven to vindicate the saint's death and destroy her executioner. Warm and comfortable, she sits in her seclusion, reading her book of hours, which Campin makes almost legible to us in its actuality. The tower outside the window is St Barbara's emblem, and recalls the tower in which her father imprisoned her so that she would not come in contact with Christianity, and in which she carefully built three windows in honor of the Trinity. Campin achieves, almost effortlessly, two aims: to give us a sense of the comfort of an upper-class living room, and to express in almost everything we see a religious symbolism. However, this symbolism, although it may reinforce the image of dedication, is not obtrusive.

SAINT BARBARA
1438, oil on wood, 40 x 18½ in
(101 x 47 cm), Museo del Prado, Madrid

THE WONDERFUL *silver ewer in its bowl and the carved elegance of the furnishings indicate bourgeois comfort, but there are also symbols of purity: the simple cloth hanging above the ewer, the vase of clear water, the single candle before the sculpture of the Trinity on the fireplace, and the flag lily itself.*

A WOMAN
c.1430, oil on wood, 16 x 11 in
(41 x 28 cm), National Gallery, London

This portrait is one of a pair, and the other – presumably of the subject's husband – is of a much older man with a stern face, which gives an added poignance to the sweetness of the young countenance portrayed here. Her face is resolute and inward-looking, framed with the flowing white shades of her headdress.

CANALETTO (GIOVANNI ANTONIO CANAL) 1697–1768 b. Italy

THE STONEMASON'S YARD

THE SPECIFIC GENIUS OF CANALETTO was his ability to record the great festivals and vistas of his native Venice, so it might seem impertinent to suggest that his greatest masterpiece is *The Stonemason's Yard*. This is certainly Venice, but it is a behind-the-scenes Venice, a non-touristic Venice. It speaks a great deal for Canaletto's genuine love of his city that such a potentially uninteresting view should become, in his hands, a great masterpiece. What is so wonderful is his sense of the reality of the textures of wood and stone, of sand and rubble, of the washing hanging from windows and the broom leaning against the wall. In the foreground an impartial light plays over the rough wooden huts that have large slabs of stone piled up on them; it also plays upon the soaring steeple of the church across the canal. The human actors, intent upon their own concerns, bring additional interest to the scene: the woman on the left gesticulates towards the child with great Italianate arm movements, while a girl at the right looks out from the balcony.

THE STONEMASON'S YARD (VENICE: CAMPO SANTA VIDAL AND SANTA MARIA DELLA CARITÀ), *1726–30, oil on canvas, 49 x 64 in (124 x 163 cm), National Gallery, London*

A VIEW OF THE DUCAL PALACE IN VENICE
before 1755, oil on canvas, 20 x 33 in (51 x 83 cm), Galleria degli Uffizi, Florence

This may well be the most famous view in the world. The great roseate, intricate splendors of the Ducal Palace, and, behind it, the series of domes that make St Mark's one of the greatest cathedrals in the world. Canaletto seems to paint this view from within the Grand Canal itself. For all its splendor of architecture, it is a deliciously watery picture, with gondoliers plying their trade with busy insistence on all sides, and the great tangled mass of shipping drawn up at the docks. This is the quintessential Venice, in its sparkle, in its light, in its activity, in its sheer grandeur, and Canaletto catches every least nuance of it.

CANALETTO'S *true interest is in the actual structure of Venice. Even its unromantic elements are portrayed with beauty. The fabric of Venice, the stone from which it is built, surrounds us: solid and refined in the house on the left, painted with fading reds and ochres on the right.*

WITHOUT *the canal that cuts through the lower third of the picture, one might think this was any city in Italy. Yet there are sufficient landmarks and just enough expanse of sky to tell those who know the area precisely where this yard is placed.*

CAPPELLE, JAN VAN DE c.1624–79 b. Netherlands

A SMALL DUTCH VESSEL BEFORE A LIGHT BREEZE

IN TRUE NETHERLANDISH TRADITION, Jan van de Cappelle was a specialist. He specialized in scenes of shipping. But his centre of interest is only superficially the ships and their activities; what truly enthrals him is the image of sky and sea, their vastness, their fluidity, the image of a world that could change with bewildering rapidity from complete tranquillity to life-threatening storm. *A Small Dutch Vessel Before a Light Breeze* shows us the sea in its mood of benignity – the waters ripple around the little boat from which the fishermen tend their nets, the larger ships on the horizon move slowly and peacefully over the tranquil waters. And the waters themselves seem to be there merely to reflect the immensity of the sky, the glorious subtleties of those soft grays looming and lightening as the wind blows them. This is a picture of profound silence, of loneliness, of the ability to use technical skill and respond to the world of the sea and sky. It moves us not so much for what it shows, but for what it suggests, for its promise, for the sheer affirmation of what it is.

A DUTCH YACHT FIRING A SALUTE AS A BARGE PULLS AWAY
1650, oil on wood, 34 x 45 in (86 x 115 cm), National Gallery, London

What is actually happening in this picture is not an issue. It is a wonderful picture of security, of the human ability to find a haven at sea almost in defiance of the threat of the uncontrollable elements. The scene is crammed with vessels – of various ambitions, destinations, and purpose – at anchor in waters that seem almost motionless. Although the great and lowering sky behind suggests that this condition may not last, these ships are safe for now.

THE SMALL SHIP *is not far from land (at the far left we can see a jetty). It is a ship setting out, its small sail spread to catch the light and fleeting wind, and one has a tantalizing sense of the world beyond that dim and distant horizon over which a large ship is already moving.*

THE FISHERMEN *in the foreground seem almost deprived wingless birds, creatures who can indeed go to sea but who can never know its mysteries, or set sail into the deep, into that silvery grayness, and pass beyond what is known.*

A SMALL DUTCH VESSEL BEFORE A LIGHT BREEZE
c.1645–55, oil on canvas, 17 x 22 in (44 x 56 cm), National Gallery, London

CARAVAGGIO, MICHELANGELO MERISI DA 1571–1610 b. Italy

THE INCREDULITY OF SAINT THOMAS

CARAVAGGIO IS THE GREAT ARTISTIC CRIMINAL, one of the few artists who led a wild, bad, interesting life. His character in itself should not have affected how he painted, but when we look at a work like *The Incredulity of Saint Thomas* we cannot but feel in touch with that untamed and questing spirit. The artist himself was constantly searching, and here he clearly identifies himself with the great searcher St Thomas, the apostle who doubted the Resurrection of Christ. After His death, Christ appeared to his disciples at a time when Thomas was missing from the group. Thomas, man of doubts, refused to believe – after all, who does come back once they are dead? He demanded, by way of proof, that he actually put his finger into Christ's wounds. What makes Caravaggio's version of the event so extraordinary is the physicality of the image. One squirms to see that questing finger actually poking deep into the human flesh of Jesus. All Caravaggio's attention is focused on this compact group of figures, and on the intensity of their experience into which we are also drawn. He provides us with no setting to the picture, just the mysterious black background of the unknown.

BACCHUS
c.1597, oil on canvas, 37 x 33 in (95 x 85 cm), Galleria degli Uffizi, Florence

THIS IS A PICTURE *based on hands: Christ holding back His robe so that Thomas can see the wound; Thomas with furrowed brow, tense with half-belief, poking; and Jesus firmly guiding that hand, although it causes pain. The light falls on the protruding elbow of the foolhardy doubter, and on the gentle, relaxed arm of the risen Christ.*

THE HEADS *of the four protagonists form a compact diamond. Christ's face is in shadow as He watches the man emerge from disbelief into faith; the faces of the two other apostles are rapt with excitement. One feels that, even for them, there is still a lingering doubt, which made them anxious to explore – through Thomas – the mystery of this risen body.*

Here is Caravaggio in completely different mode – soft, sensual, sophisticated. Bacchus, although a youth, has an over-plump body, and the weary eyes of someone who has seen it all, done it all. Even the glorious still life of fruit is overripe, and Bacchus wears autumnal leaves in his hair. It is a picture of a young man who is called a god, but who is worn out by a life of sensual excess. For all its decadent beauty, it is a sad picture.

C
70

> " ...BY AVOIDING ALL PRETTINESS AND FALSITY IN COLOR, HE [CARAVAGGIO] STRENGTHENED HIS HUES, GIVING THEM BLOOD AND FLESH AGAIN "
> Giovanni Bellori

CARAVAGGIO'S *refusal to idealize the world made him controversial in his lifetime. Here, he has imagined an episode from the Bible taking place in the real world. The disciples are unkempt and shabbily dressed (Thomas, we notice, also has decidedly dirty fingernails). Perhaps it is because of this that Caravaggio's religious works are so potent and moving.*

THE INCREDULITY OF SAINT THOMAS
1601–02, oil on canvas, 42 x 57 in (107 x 146 cm), Galleria degli Uffizi, Florence

CARPACCIO, VITTORE c.1460–c.1525 b. Italy

YOUNG KNIGHT IN A LANDSCAPE

CARPACCIO HAS THE SINGULAR GIFT of bringing before us the magic of a vanished world. His young knight seems to encapsulate the very virtues of chivalry, with his pensive, oval face and the wonderful gleam of his polished armor. But it is not just the young knight that gives this picture its fascination; it is also the world in which he stands – a world in which trees grow from the battlements of an already decaying castle. Carpaccio does not paint the young knight in solitary splendor but sets him in a teeming and fascinating landscape, every element of which excites our curiosity. This painter is also one of the great storytellers of art. Even when, as here, there is no apparent narrative, it is still implied. Perhaps most enigmatic of all the activities in this great picture is the combat between two birds – one black, one white – above the knight's head.

THE DREAM OF URSULA
1495, oil on canvas, 9 x 9 in (23 x 23 cm), Accademia, Venice

Here is Carpaccio in full narrative mode. Legend has it that St Ursula was a little princess who led 11,000 virgins, believe it or not, on a pilgrimage to Rome. On their return journey, travelling through Cologne, they were all martyred by a king of the Huns. In this painting, Ursula sleeps while an angel comes to her, bearing the palm of martyrdom. Although Carpaccio is fully serious, it is impossible not to smile at the charm of this incident. Ursula's slippers and dog wait for her to awake, and at the foot of the bed she has neatly laid her crown. Every element is imagined with a delight in the particular, which makes the story, for all its improbability, seem totally convincing.

EVERYTHING HERE *seems to have some enigmatic meaning, some deliberate reference either to history or politics, from which Carpaccio forms a significant setting for his young hero. His genius is to make us feel convinced that these elements do have meaning, that no choice, here, is made randomly. We look on, we admire, and we speculate; yet most of this world remains closed to us.*

THE MORE ONE LOOKS, *the more strange and beautiful animals appear lurking in the rich undergrowth: a white ermine scurries beneath the irises; two dogs flank the knight from behind; a rabbit, a stag, and a variety of bird life fringe the lake – notably the falcon with its prey. The armored squire in his extraordinary black and yellow outfit appears to have a peacock riding on his head, although closer inspection reveals that the bird is actually perched on the battlement.*

YOUNG KNIGHT IN A LANDSCAPE, *1510, oil on canvas, 86 x 60 in (219 x 152 cm), Museo Thyssen-Bornemisza, Madrid*

CARRÀ, CARLO 1881–1966 b. Italy
SUMMER

CARRÀ, ALONG WITH DE CHIRICO, was one of the founders of Metaphysical painting, as well as being one of the originators of Futurism. These were the movements of Carrà's youth: as a Futurist, he wanted to show action and the importance of the machine; as a Metaphysical painter, he desired to show the value of thought and the transcendence of meaning over appearance. He matured into a quite different kind of painter, however, as we can see in *Summer*. Here, he has gone back to the roots of the old masters, and the two young women have a solidity that one could trace right back as far as Giotto. Despite this re-emergence of tradition in Carrà's technique, this is still a work of the modern, fragmented, post-Cubist world. However solid the girls' bodies, however massive the bathing hut to one side, however convincing the small, black, rather ape-like, hound, it is not all that easy to understand the geography of their setting.

MERIGGIO D'OTTOBRE
1927, oil on canvas, 31 x 35 in
(80 x 90 cm), Collection Vercesi, Rome

This is a romantic view of the Italian countryside. It is mid-October, and yet we have to look carefully before we notice the leaves turning scarlet and the stubble of the harvested field. What delights Carrà is the light that gleams upon the buildings and plays so subtly on the white wall and on the pools and stones of the road. This is a world of stillness, held in the silence of an afternoon. Carrà delights in the sheer color of the scene – the brilliant blue of a door, the darkened orange of a window. It is a world of the suggested, of the half-expressed, and only the autumnal vine on the wall makes it clear to us that there is movement, in time if not in space.

C
72

THE IMMEDIATE WORLD *of the two young women has a certain haze to it, which is not inappropriate to the title. This is the haze of summer, in which light glimmers on the water and dazzles the eye. Carrà is as interested in what he suggests as in what he articulates. The boat at sea has not yet raised its sail, and, as the girls dry themselves, they peer out at the world: all is still to come; all is yet to happen.*

IRONICALLY, THERE IS *a Futurist element in this painting (if we use the word in a very broad sense): we are being given an exhilarating impression of the freedom and sunlight of youth, as it advances into the fullness of summer. The lack of the obvious picturesque is daring; the most dominant note in the painting is the white-toweled behind of the girl who leans forward – a glorious globe, and yet completely modest.*

SUMMER, *1930, oil on canvas, 65 x 48 in (165 x 121 cm), Civica Galleria d'Arte Moderna, Milan*

CARRACCI, ANNIBALE 1560–1609 b. Italy

THE HOLY WOMEN AT CHRIST'S SEPULCHRE

THE THREE CARRACCIS, TWO BROTHERS AND A COUSIN, affected the entire course of painting. They seemed able to combine the classic beauty of Raphael with the more earthy and dramatic world of Caravaggio. This image of the holy women coming to anoint the dead body of Christ on the morning of Easter Sunday and being told by an angel that Christ has risen from His tomb has an extraordinary weight to it. The figures loom out of the darkness with massive force, each woman individualized by the difference of her reaction to the bright and unearthly figure that imparts a message they cannot understand. The woman on the left shrinks back in fear and bewilderment at the apparition; the central woman – the astonishing beauty of her profile outlined for us in shadow – moves forward with the most touching earnestness, intent only on finding the dead Christ. The woman nearest the angel seems to question him. She argues with him and implores him, refusing to accept the unacceptable – that Christ has gone.

FISHING
c.1587–88, oil on canvas, 54 x 100 in (136 x 253 cm), Musée du Louvre, Paris

The Carraccis had a remarkable sense of landscape and of activities taking place in their real world. This scene is amusing and well observed: we are shown the catching of fish from a boat, the vigorous hauling in of fish, the gutting of fish, even the selling of fish to elegant customers. These are more or less foreground activities, however; what truly draws the attention is the background, elusive and magical in the twilight, which – as the owl in the tree reminds us – is deepening as nightfall approaches.

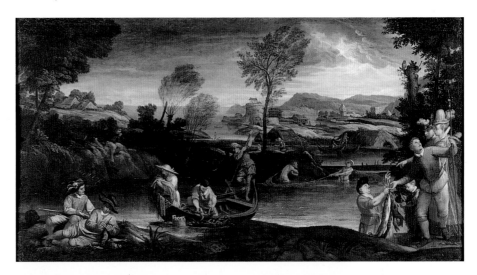

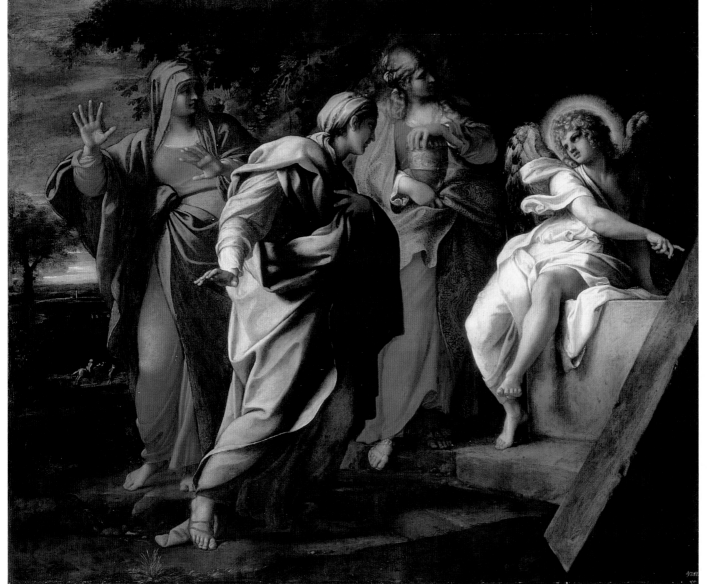

THE HOLY WOMEN *live in the world of shadows; the angel, on the other hand, is all brightness, not because light falls on him but because light radiates from him. His finger points away, into the mystery of the resurrection.*

BEHIND THE *women, the sun is rising and the world is beginning its activities. Here in the lonely garden at the stone sepulchre, silently and passionately, three mourning figures are trying to come to terms with the angel's message.*

THE HOLY WOMEN AT CHRIST'S SEPULCHRE
late 1590s, oil on canvas, 48 x 57 in (121 x 145 cm), Hermitage, St Petersburg

CARRIERA, ROSALBA 1675–1757 b. Italy

SELF-PORTRAIT WITH A PORTRAIT OF HER SISTER

MANY AN ARTIST HAS TRIED HIS OR HER HAND at the self-portrait, but few have risen to the heights of unflattering truth as did Rosalba Carriera. All credit to her for the clarity with which she has depicted that flat, heavy sponge of a face. She has tried her best with little kiss curls and roses, with a crop of lace and silken clothes, but, as a beauty, she remains a non-starter. The portrait of her sister that she holds renders a marginally more attractive face, but she too is clearly cursed with the Carriera genes. So, no beauty as a woman, but what a beautifully able artist. Pastel is a notoriously difficult medium with which to work, yet Carriera seems to triumph without effort. In fact, her skill in the medium was held in such high regard in 18th-century France that she is said to have introduced Maurice Quentin de la Tour to the use of pastel. The end of her life was sad, however, and, having become blind, she withdrew into a melancholy despair for her last ten years.

A YOUNG LADY WITH A PARROT
c.1730, pastel on paper, 24 x 20 in (60 x 50 cm), The Art Institute of Chicago

As a female artist in the 18th century, Carriera frequently had to exercise caution, yet this is a pastel of extraordinary daring. Her young lady is an independent and courageous spirit – she holds her head high and flings those superb pearls recklessly in all directions. She smiles confidently out at us as a woman to be reckoned with. The bird (a male surrogate, perhaps) is so small and so helpless – while the woman is so large and so completely swelling with power – that one feels Carriera relishes the contrast.

C

74

AS HER LUMINOUS COLOR *might suggest, Carriera was a Venetian by birth. Light flickers on her ivory sleeve, with its pink lining and rich blue borders. It is a delicate, glowing light, and it caresses the solidity of flesh as sweetly as it does the powdered stiffness of her elaborate coiffure.*

CARRIERA WAS ONE OF *the most famous artists of her day, and her sister worked with her, albeit in a subordinate role (as this picture suggests). It is an affectionate portrait of her sister, and one would like to see how her sister would have portrayed Rosalba. Both women, for all their dignity, have a half-smile that suggests a healthy sense of proportion.*

SELF-PORTRAIT WITH A PORTRAIT OF HER SISTER, *1709, pastel on paper, 28 x 22 in (71 x 57 cm), Galleria degli Uffizi, Florence*

CASSATT, MARY 1844–1926 b. US, active France

GIRL ARRANGING HER HAIR

As a wealthy American spinster, Mary Cassatt was the most unlikely of the Impressionists. Yet, because of the implacability of her eye and the certainty of her sense of form, even Degas was forced to recognize, however unwillingly, that she was an equal. *Girl Arranging Her Hair* is an extraordinary painting for the 19th century. It completely disregards any attempt at the picturesque or romantic, and eschews a sense of narrative. For once, we are not asked to ponder on the mental workings of this young woman – on her love life or its absence – but to look at the truthfulness of the painting. The firmness of that flushed face, with its mouth too full of teeth, and the practical plait of her hair are entrancing in their very freedom from romanticism. The simplicity of the wash table behind her, with its curving basin and water jug, and the chair – rather uneasy in its perspective – that frames the girl with a vertical to match the table's, all cause us to see this girl in her voluminous night smock as innocent and spring-like.

MOTHER ABOUT TO WASH HER SLEEPY CHILD
1880, oil on canvas, 39 x 26 in
(100 x 65 cm), Los Angeles County Museum

Although she herself never wanted marriage and children, apparently many of Cassatt's paintings deal with these most womanly of relationships. She has a special gift for understanding the intimacy between mother and child, and the happy, relaxed sprawl of the baby on its mother's knee is unusual in art. The baby's leg dangles between the mother's, while the maternal hand rests casually in the water, as if about to pick up the cloth and wipe the child's sleepy face. This is painted by an artist who has looked long and often at babies and mothers, and who can show uncomplicated affection with immense skill.

CASSATT'S PAINTINGS have a warm solidity that will not let us encounter them without a genuine confrontation. The surprising thing about this work is that its composition is so appealing in itself that we become unaware that the girl herself may not be. It has been said that Cassatt once claimed she could paint an attractive picture of an unattractive person, which is, after all, almost a definition of art.

GIRL ARRANGING HER HAIR
1886, oil on canvas, 30 x 24 in
(75 x 62 cm), National Gallery
of Art, Washington, DC

CASTAGNO, ANDREA DEL c.1423–57 b. Italy
THE VISION OF ST JEROME

THIS ASTONISHING PICTURE encapsulates the entire life of St Jerome. He stands in the center with the lion that he rescued and which followed him obediently ever after. There is the cardinal's hat that he spurned, feeling himself unworthy of such a dignity. On either side are two saints, Paula and Gesticius, the mother and daughter who followed him from Rome to Jerusalem, where he withdrew to write his Bible and to live a life of great penitence. Above, in strange and marvellous foreshortening, is the Holy Trinity: God the Father holding the cross on which Christ hangs, while the Spirit flies down to inspire St Jerome in his translation of the Scriptures. The body of Christ is upheld by the red wings of the cherubim – the angels of love. Jerome's face is not upturned in love and peace as are the faces of the women; the very muscles of his neck twist in pain as he looks up to the vision, which he sees as condemnatory and his friends see as blessing. He holds a stone with which to beat himself, and blood trickles down onto his garments.

THE VISION OF ST JEROME c.1454–55, fresco,
117 x 70 in (297 x 178 cm), SS. Annunziata, Florence

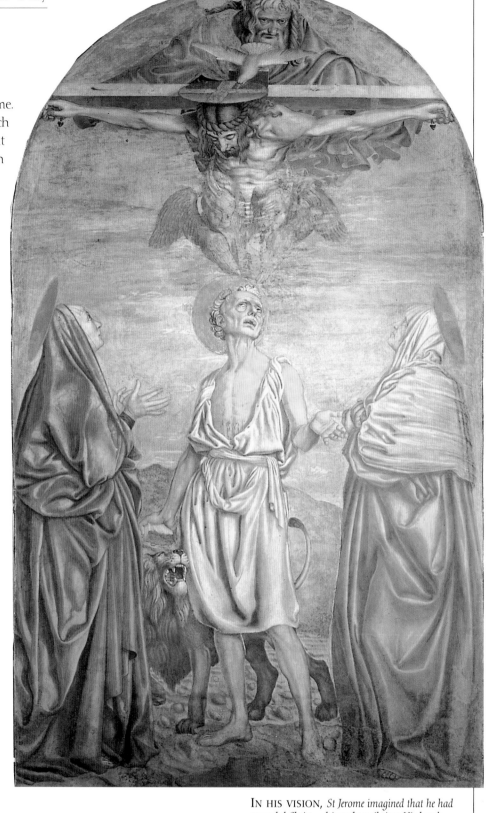

THE YOUTHFUL DAVID
c.1450, oil on leather, 46 x 30 in (116 x 77 cm),
National Gallery of Art, Washington, DC

Castagno has painted David on a leather shield to be carried in procession before a tournament. It is the equivalent of the banner of a boxing club – all male, all power, and all ruthless strength. David's triumph is depicted as a foregone conclusion: although he is just about to whirl that sling, he has, as we can see, already overcome his opponent. It is an image to inspire and comfort any warrior going into battle.

IN HIS VISION, *St Jerome imagined that he had wounded Christ – driven the nails into His hands – with his passion for secular literature, for writers like Virgil and Horace. In his scrupulous desire to serve God purely, Jerome came to believe these great writers were an obstacle to his prayer. These were the visions of a man unbalanced by fasting and penance; whether Castagno understood this or not, he shows the women as balanced and happy, while St Jerome is a stark column of anguish.*

CAVALLINI, PIETRO active 1273–c.1330 b. Italy
LAST JUDGMENT

LAST JUDGMENT (FRAGMENT), c.1290, fresco, dimensions not known, Santa Cecilia in Trastavere, Rome

VERY LITTLE IS LEFT OF THE WORK OF PIETRO CAVALLINI, who painted in Rome, through the end of the 13th and the beginning of the 14th century. Time has destroyed so much painting, but certainly what is left of Cavallini's work, which is mainly a great fresco in a Roman church, is very impressive. What the artist is trying to make clear to the worshippers in this church is the human reality of the twelve Apostles on their thrones of judgment. They are a celestial jury who have been carefully chosen by the Lord himself. Each Apostle is seen as a distinct individual. These are men of different temperaments and qualities, just like the worshippers themselves. The bodies are full, strong, and convincing. They may rest in the heavens, but they are creatures of the earth. The young Apostle in the center may well be St John. He was the only Apostle who did not suffer a martyr's death, and so, while the others carry swords, he carries a cross, which gives added significance to that hand raised in blessing. The swords that the other Apostles carry are not swords of judgment but what St Paul referred to as the "Sword of the Spirit".

CAVALLINO, BERNARDO 1616–56 b. Italy
CHRIST DRIVING THE TRADERS FROM THE TEMPLE

IN THE GOSPELS WE ARE TOLD THAT CHRIST gathered cords into a whip and drove out of His Father's temple the money-changers and the traders. This act of passionate protest fascinates Cavallino. Christ stands at the center of the picture, emphasized by the great pillar behind Him. On either side, the traders and the money-changers fold away like playing cards, overcome by the divine indignation. Cavallino imagines the reality of the scene: the shock and confusion of the traders, the money spilling out over the floor, the animals being huddled away into cages and baskets, and the beggars watching in amazement. The artist's desire for authenticity, to involve the viewer emotionally in the scene, conveys something of the passion with which Christ acted.

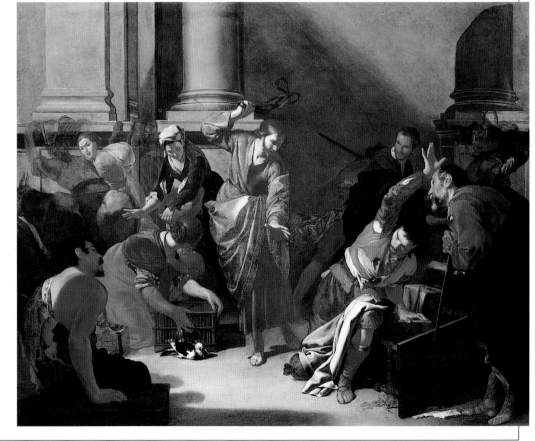

CHRIST DRIVING THE TRADERS FROM THE TEMPLE
c.1645–50, oil on canvas, 40 x 50 in
(101 x 128 cm), National Gallery, London

C

78

THE TREES BEND IN *to enclose these vulnerable bodies with a frail protection, while the river guards them from behind. Yet, across the divide are those two strange and unreadable figures who seem to represent another world – a world on which the bathers, literally, turn their backs.*

AT FIRST, THE BATHERS *are immensely off-putting – large, awkward, and unconvincing – but they have a strange majesty. There is a courage and a neediness about the bathers that makes them the most emotional, and perhaps the most powerful, of all that this great artist painted.*

"I AM THE PRIMITIVE OF A NEW ART. I SHALL HAVE MY SUCCESSORS; I CAN SENSE IT"

Paul Cézanne

CÉZANNE, PAUL 1839–1906 b. France
THE LARGE BATHERS

FOR CÉZANNE, THE IMAGE OF NAKED bathers in a wood had an ambiguous fascination. It recalled his boyhood, the one time in which he seems to have been unreservedly happy; and yet he was also drawn by the idea that the perfect woodland idyll would not be composed of young men, but of young women – woodland nymphs. Cézanne seems to have feared women; they were a mystery to him. He never painted from a naked model, but sought out photographs from which he assembled his compositions. His passion for truthfulness, to show the world as it really was, reached its culmination in the challenge that the bathers set him: to give an idea of blissful permanency while recognizing with equal force that nothing in nature is permanent, that change is encoded in the very genes of creatures who live under the dominion of time. For years I could make no sense of the bathers; they seemed so unappealing compared to the radiance of Cézanne's landscapes and still lifes. But gradually they have come to seem, to me, the greatest of his works, the strongest and, strangely, the most beautiful. If one abstracts from the actual lumpiness of the bodies, then that gleaming flesh dappled by shade – with all the burden it bears of Cézanne's hopes and fears – has an unforgettable poignancy.

STILL LIFE WITH APPLES AND ORANGES
c.1895–1900, oil on canvas, 29 x 37 in (74 x 93 cm), Musée d'Orsay, Paris

What Cézanne loved about a still life was that he could control it. Whereas a hillside changed constantly under the shadows of the clouds, his still life stayed there for him to master it. In a strange way he sees the still life as a minor landscape: the great cascades of the cloth, the towering forms of the jug and the bowl, all have a grandeur that makes us aware that we are looking at more than what appears. He blithely ignores perspective, tilting his planes in a way that paul, of course, be impossible in real life, so that we can take in the full scale of what is displayed on the table – a device that Picasso and the Cubists were later to take up, and turn almost inside-out.

THE LARGE BATHERS
1899–1906, oil on canvas, 82 x 98 in (208 x 249 cm), Philadelphia Museum of Art

CHAGALL, MARC 1887–1985 b. Russia

THE ROOSTER

CHAGALL IS ONE OF THOSE ARTISTS who seem to draw all their inspiration from childhood. Indeed, his early life reads like a fable – he was a Jew in a Russian village, and desperately poor. But the poverty was only material, for his childhood was rich with Jewish stories and Jewish culture. All the farmyard images of that rural life come back in his mature work and transfigure it with a supernatural energy. The rooster that is ridden and so tenderly embraced by one woman has parallels in this painting: we see other lovers in the rowing boat, and lovers peeking behind the girl's foot, as if Chagall is eager that we should not misunderstand the significance of the painting. This is an image of marriage, of the great male and all his sexual splendor supporting and accepting and becoming one with a barefoot woman. Chagall's emotional life revolved wholly around his wife, and his images of their relationship are among the most tender in painting.

THE FIDDLER
1911, oil on canvas, 37 x 27 (95 x 69 cm),
Kunstsammlung Nordrhein-Westfalen, Düsseldorf

Chagall painted *The Fiddler* a year after he had left his Russian village for the sophistications of Paris. The fiddler who lived in Chagall's village was an important character in the artist's life, stimulating his childhood imagination and his wish to create. That may be the young Chagall behind him, drawing our attention to the fiddler's skills and needs. In a mixture of memory and poetic invention, this is both the dusk as it was and the dusk as he imagines it, just as the shutters on the little house show vivid green on one side and plain reality on the other.

CHAGALL SETS THIS *mysterious closeness in a magical world. The lovers are embowered by the rich vegetation of a tree and their alter egos in the boat do not row, but merely lean forward together, falling towards each other by the impetus of their affection. The couple peeking out behind the girl's foot can hardly be distinguished. Are they lovers? Or are they gossips?*

AS USUAL WITH CHAGALL, *it is the color that enthralls us; it is rich, glowing, and somehow suggestive of an inner radiance. Even the tail of the cock, that great flourish of feathers, seems to have a life of its own. We could read an eye there and a mask. Love seems to have made the whole bird vibrant and vital.*

THE ROOSTER
1929, oil on canvas,
32 x 26 in (81 x 66 cm),
Thyssen Bornemisza
Museum, Madrid

CHAMPAIGNE, PHILIPPE DE
1602–74 b. Belgium, active France

EX VOTO

EX VOTO IS AN UNUSUAL PICTURE for the court portrait painter of Louis XIII and Marie de' Médici. Artists who paint in royal and aristocratic circles seem to develop a style that flatters and dares not go too deep. But de Champaigne had suffered a series of personal catastrophes that eventually left him with only one living child, a young nun, who then was struck with paralysis. This painting, deeply autobiographical, depicts the period in which her Mother Superior prayed with her for healing – a nine-day session that ended with a miraculous cure. For de Champaigne this incident had a profound personal meaning: it confirmed his faith in God and forced from him a work of such simple truth that its austere beauty is unique in his artistic repertoire. He paints without the intrusion of his own ego, and the power of this extraordinary picture comes from the sacrifice of that expression.

TRIPLE PORTRAIT OF CARDINAL RICHELIEU
1642, oil on canvas, 23 x 28 in (58 x 72 cm), National Gallery, London

Here is de Champaigne in more typical mode, twenty years before he painted *Ex Voto*. He has painted three views of the notorious Cardinal Richelieu. In a sense it is a utilitarian portrait – undertaken as a visual guide for a sculptor to choose the best view (stuck to the stretcher is an old piece of canvas on which is written "of two profiles, [the right] is the better") – yet the painting grips us with its dazzling vitality and the overpowering sense of personality.

EX VOTO
1662, oil on canvas, 65 x 90 in (165 x 229 cm), Musée du Louvre, Paris

IN THE BARE MONASTIC CELL *the two unite not in pleading but in trustful expectation. Light floods in from a hidden skylight – such a painting needs no supernatural trappings. The light most beautifully illuminates the grey wall and the white and black of the nun's habit.*

CHARDIN, JEAN 1699–1779 b. France
THE YOUNG SCHOOLMISTRESS

CHARDIN HAS A GRAVITY AND SIMPLICITY that is wholly his own. No other artist has ever seen such simple things – devoid of drama, lacking the glamour of beauty or special significance – as so important, on a human level, that they demand lengthy contemplation. There are only two protagonists here – a young girl and a child – both completely absorbed in their own activity. Neither has any special charm, except that of utter integrity. The girl's face is an indescribable amalgam of superiority, irritation, and affection. The child's expression is equally indescribable, a mixture of incomprehension, eagerness to learn, and the faintly dawning hope that the mystery of legibility will become plainer. They are enwrapped in one of the most fundamental of human relationships: teaching and learning. Chardin is among the most economical of artists – not a line or a mark here is wasted. The plain support for their work and the almost anonymous background dimly serve to focus us on this extraordinary interplay of age and youth, even if there are but a few years between them.

THE SILVER GOBLET
c.1765, oil on canvas, 13 x 16 in (33 x 41 cm), Musée du Louvre, Paris

It is not – as is often the case with still-life painters – the splendor or costliness of the silver goblet that interests Chardin, but its reflectiveness, the fact that the simple apples lying beside it are repeated and magnified in its gleaming metal. He might even be putting the question: which is more beautiful, the precious goblet, the humble bowl with light glancing on its rim, the fruit, or even the two chestnuts hunkering together at the edge of the table?

C
82

CHARDIN IS PERHAPS *best known for his still lifes in which humble utensils take on extraordinary grandeur as the artist regards them with creative reverence. But this ennobling vision of the rare yet commonplace can be found equally in his figure paintings, such as this superb example.*

THE CHUBBY, *fumbling hands of the infant, the tense, poised hands of the elder sister, the chins – jutting out abruptly in the elder, plump and subdued in the younger: every part of this picture works together to give us this image of the sublimity of normal human intercourse.*

BOTH CHILDREN *are taut with effort: one with the effort of teaching, the other of comprehending. The conditions are not ideal; the two do not even work from a table, but from what looks like a cupboard, and the teacher's pointing rod looks suspiciously like a knitting needle.*

THE YOUNG SCHOOLMISTRESS *c.1735–36, oil on canvas, 24 x 26 in (62 x 67 cm), National Gallery, London*

CHASSÉRIAU, THÉODORE 1819–56 b. France
THE TWO SISTERS

CHASSÉRIAU DIED IN HIS MID-THIRTIES, which is hard to believe when one examines the astonishing maturity of his work. Here, he has painted his two sisters, Adèle and Alène, in a portrait that is as striking for its psychic charge as it is for its decorative splendor. It is as though he has caught the graphic austerity of Ingres and blended it with the coloristic brilliance of Delacroix. The sisters regard us unwaveringly with their large black eyes, made more striking by the silken constraints of their black hair. Their lips are set and it is perhaps their stillness and monumentality that makes that black gaze seem so accusatory. Their clothes are not overly grand – simple ruched dresses – and each wears just a touch of jewelry. But the intensity of the color comes, of course, from the scarlet shawls with the extraordinary riot of embroidery at their base. The absolute simplicity of the background is broken by the presence of the shut door. And that is what these sisters suggest - a psychic likeness, and a relationship that presents to the outsider a door that is closed to them.

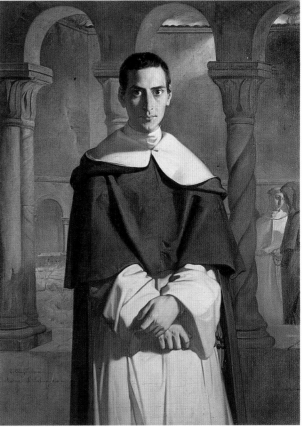

PÈRE LACORDAIRE
1840, oil on canvas, 57 x 42 in (146 x 107 cm), Musée du Louvre, Paris

This young priest, seemingly humble and unassuming, was Père Lacordaire, a name to conjure with in the 19th century. He was a late convert for the ministry, a man of extraordinary foresight and brilliance, and his revolutionary ideas about Catholicism brought him into conflict with papal authority. His hands are folded submissively, but he looks with an air of challenging intelligence into the viewer's eyes. The fire of this young man's temperament is not made explicit by color or drama. Standing in the calm of the cloister, sunlit in the subdued black and white of his Dominican habit, all Lacordaire's passion is concentrated in his eyes.

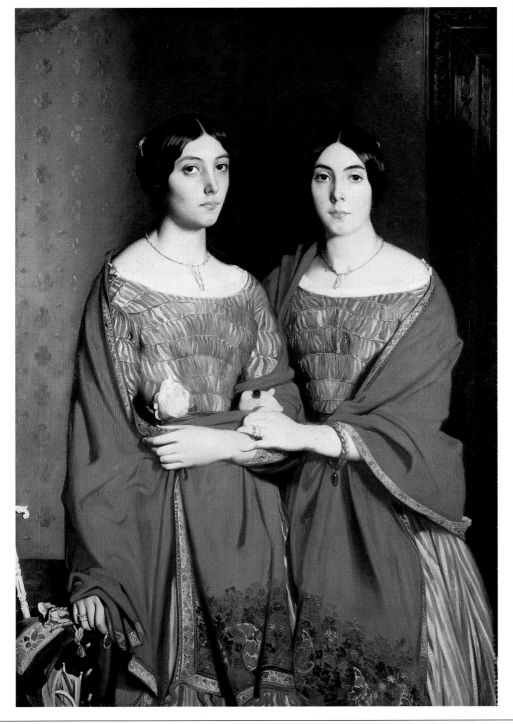

TEN YEARS SEPARATE *Alène from Adèle, and the ripened rose at the older sister's waist is meant to indicate that. Yet they are so similar in their stern beauty and in the watchfulness with which they regard their painting brother that the age gap seems immaterial.*

THE ONLY OTHER *appreciable difference between these two women is that the younger sister holds with both hands the arm of the elder, while Alène has her hand free to hold the straps of her bag and her walking umbrella.*

THE TWO SISTERS
1843, oil on canvas, 71 x 53 in (180 x 135 cm), Musée du Louvre, Paris

CHIRICO, GIORGIO DE 1888–1978 b. Greece, active Italy

MELANCHOLY AND MYSTERY OF A STREET

ABOUT TEN YEARS BEFORE THE SURREALISTS set out to make an art based upon the unconscious, de Chirico was embarking upon what he called Metaphysical painting. He wanted to produce a highly troubling dream-reality, combining images that, for him personally, carried a charge of mystery. The same haunting shapes tend to appear again and again in poetic combinations. In *Melancholy and Mystery of a Street*, we can see the long, white arcade on one side, with its contemporary feel, and the classical arcade on the other, suggesting a world long past. The shadow of a public sculpture – one of the images that most obsessed de Chirico – looms out, and what looks like an empty railway car indicates another obsession: the mystery of the train. His father was a railway engineer, and much of de Chirico's early experience seems to have been linked to journeying on a train through unknown countryside. The little girl is half-real and half-phantom – she is little more than a shadow to balance that of the statue.

THE UNCERTAINTY OF THE POET

1913, oil on canvas, 42 x 37 in (106 x 94 cm), Tate Gallery, London

One of the ways in which de Chirico expressed his vision of life as enigmatic was to mix together images from the past and the present. Here, he has a marble statue, and yet, as the fat creases and the buttocks dimple, it is very far from the suave perfection of the classical ideal. Spread exuberantly before it, with all that classic smoothness that is missing in the marble, sprawls a great bunch of bananas. Behind, we see the steam of that mysterious train, always voyaging into the unknown, and to the right march those classical arcades, through which we can see only darkness beyond.

DE CHIRICO CALLS HIS *painting* Melancholy and Mystery of a Street, *and any attempt to make sense of the images is doomed to failure. He is creating a mood that combines loss and incompletion. This is a place in which warm-blooded youth and aged stone are merely shadows – a place in which arcades echo mysteriously and blankly. It is a narrow world, but doors stand open, seemingly offering a voyage without ending.*

THE WORLD MAKES *no sense, de Chirico announces; the parts do not add up to a comprehensible whole. Nevertheless, the parts intrigue us and tickle our minds with the suggestion that we are just missing the meaning, that comprehension would be possible if only we possessed the key to understanding. This sense is marvelously evoked by de Chirico.*

MELANCHOLY AND MYSTERY OF A STREET
1914, oil on canvas, 35 x 28 in (88 x 72 cm), Private Collection

CHRISTUS, PETRUS d.1475/6 b. Netherlands
A YOUNG LADY

SO MUCH OF A MEDIEVAL ARTIST'S WORK WAS OF NECESSITY religious that it can give us a jolt to find a painter such as Petrus Christus capable of producing a portrait so startling in its modernity. This strange, sulky young woman could have come from any era. Christus intrigues us with the mystery of her presence. Was she corralled into sitting for this artist? Why that strange sideways look, half-seductive, half-indignant? We feel that the artist is presenting us with a human enigma, one that he himself did not propose to investigate; this is what he saw, this is what he shows us. He leaves her with the whole history of her being, and her potential, intact. Almost certainly Petrus Christus was commissioned to paint her, but we cannot but feel he would have wanted to, whether he was paid or not. The final irony is that this young woman, with such unique distinction and personal presence, comes down to us anonymously.

CHRIST AS THE MAN OF SORROWS
c.1450, oil on wood, 4 x 3½ in (11 x 9 cm)
Birmingham Museum and Art Gallery, UK

This tiny picture is only four inches high, yet it is transfixing in its emotional intensity. Christ displays His wounds, and "display" is the operative word here, because, behind Him, two angels – one holding the lilies of mercy, the other the sword of judgment – draw back curtains and, as it were, usher their Lord onto the stage. The extraordinary halo that springs like silver filigree behind the crown of thorns makes the image still more arresting. This compound of the highly theatrical and the totally genuine makes a powerful impact on the viewer.

CHRISTUS CONCENTRATES *on the sitter's head, almost to the exclusion of her body, and this heightened interest in her face is exaggerated by the fashions of the time – the shaven forehead and the tall dome of the hat. Once we are past the exquisite necklace and the fur draped on the shoulders, her actual frame diminishes rapidly to an almost token presence.*

WHO COULD NOTICE *the shape of her body, when confronted with that strange gleaming oval of a face, the pink prominence of the ear, the almost invisible eyebrows, and the whole atmosphere of mystery, reluctance, and wanton beauty? One feels that whatever our fascination, the artist's was even greater.*

A YOUNG LADY, *c.1470,*
oil on wood, 11 x 9 in (29 x 23 cm),
Staatliche Museum, Berlin

CHURCH, FREDERICK EDWIN 1826–1900 b. US
COTOPAXI

CHURCH IS SLIGHTLY UNUSUAL FOR A 19th-century American landscape painter in that his imagination was first stimulated by the glory, not of his own country, but by the countries of South America. These were exotic lands to a citizen of the United States; they were strange and almost barbarous in their historical associations with Incas and Aztecs and their geographical associations with volcanoes. South America had a whole exotic ambience that contrasted so strikingly with the certainties that would later be encapsulated in Grant Wood's famous painting *American Gothic*. *Cotopaxi*, which depicts an active volcano in the Andes, made an enormous impact when it was first shown to the public. This was partly a happy accident in that its date, 1862, came early in the Civil War when America was reeling under the impact of its savagery. For those who saw this magnificent picture, it was impossible not to see its volatility as a parable for American society, the industrious order of which had exploded into an eruption of red-hot violence and pain.

SOUTH AMERICAN LANDSCAPE
c.1856, oil on canvas, 12 x 18 in (30 x 46 cm), Berry-Hill Galleries, New York

South American Landscape has none of the symbolical undertones of *Cotopaxi*. Here, Church is giving full vent to his sense of awe at what he experienced in the strange vastness of the southern continent. There is the great snow-capped mountain and, almost challenging it, a small church on the opposing hill. But perhaps his main interest is in the richness of the vegetation that fills the foreground. He has looked with a botanist's eye at these exotic flowers and trees, and exalts in their colors and shapes.

COTOPAXI
1862, oil on canvas,
48 x 85 in (122 x 216 cm),
Detroit Institute of Arts

THE WORLD THAT CHURCH *depicts is the blood-red world of American society. Although, literally, he shows the Andes, those barren rocks, those great lonely lakes, and those heavy skies are all symbolic. There is a terror in the devastation that corresponds to the emotional reaction of North and South, and all is under the threat of those scarlet heavens.*

THERE IS A SECURITY *in the picture in that Church paints it as one removed to a position of safety above the scene. He suggests a way of insulating the heart from the violence, perhaps, by abstracting it and contemplating the possibility of moving beyond the dark and lurid skies on the right and into the tiny patch of clear blue on the upper left.*

Cima da Conegliano, Giovanni Battista c.1459–c.1518 b. Italy

DAVID AND JONATHAN

RENAISSANCE VENICE WAS SO RICH in artists that Cima, who lived in the little neighboring town of Conegliano, received few important commissions. He is nevertheless one of the most impressive and interesting of Venetian artists, with a wonderful sense of space, color, and human relationships. In this particular picture, we know for certain that the slight young man on the left is David, who has succeeded in slaying the giant Goliath and has triumphantly cut off his head – he carries his trophy home like a shopping bag. Goliath's massive sword rests on the shoulder of David, who has about him a general air of having completed a good day's work. But who is his dark-skinned companion looking at him in such admiration? Since in later life David's greatest friend was Jonathan, son of King Saul, the conclusion is that Cima is interested in showing us when these two men first met. They are isolated in a great plain, both immature, both gifted, both perhaps conscious of the loneliness that is endemic in adolescence. David has triumphed, and yet his face expresses anxiety. His identity, as it were, depends upon his triumph. Jonathan's hands are relatively free and he looks longingly at the younger man, who has already made his mark.

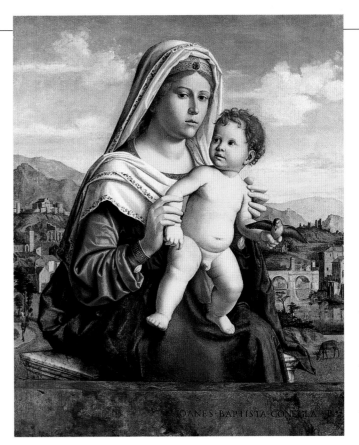

VIRGIN AND CHILD
c.1505, oil on wood, 21 x 17 in (53 x 44 cm), National Gallery, London

Cima's Virgin sits on a stone slab before a parapet with the whole glorious world of Italy spread out behind her. Mountains are blue in the distance, buildings white in the sunlight nearer at hand. What gives all Cima's paintings their power is their truthfulness to the human experience. This is not a glamorized young woman, but a solid young mother, beautifully dressed and holding a mischievous and attractive child. The spirituality is in the human truthfulness, not despite it.

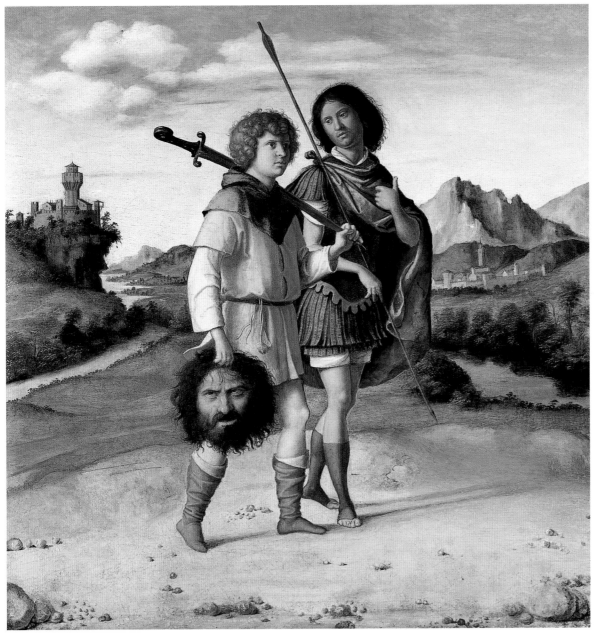

AHEAD OF *the two young men stretches an apparently featureless plain. We see around them the vast world of adult life into which they are venturing. Each provides comfort for the other as they venture together, and, very subtly, Cima makes us aware of both the support and the dangers of young male friendship.*

DAVID AND JONATHAN
c.1505–10, oil on wood, 16 x 15 in (41 x 39 cm), National Gallery, London

CIMABUE (CENNI DI PEPPI) c.1240–1302 b. Italy

MADONNA AND CHILD ENTHRONED WITH EIGHT ANGELS

THIS GREAT PICTURE was commissioned as an altarpiece for the Church of Santa Trinita in Florence. What strikes us first is the extraordinary grandeur of the throne on which Mary is seated. It seems more a conceptual throne than a real one – an abstract image of glory there in the church to remind the priest, who will say Mass before it, of the greatness of God. The niches at the foot of the throne are inhabited by the prophets who, in the Old Testament, foretold the coming of Christ. They do not enter into the world of Mary and the saints, but they support it. Their faces look out almost piteously at the world from which they are removed. All above are superlatively blessed, beautiful, and happy.

MADONNA AND CHILD ENTHRONED WITH EIGHT ANGELS AND FOUR PROPHETS (or MAESTÀ), *c.1280, tempera on wood, 152 x 88 in (385 x 223 cm), Galleria degli Uffizi, Florence*

MADONNA AND CHILD ENTHRONED WITH TWO ANGELS AND SS. FRANCIS AND DOMINIC
c.1300, Tempera on wood, 52 x 32 in (133 x 82 cm), Pitti Palazzo, Florence

It has been suggested that between painting the great *Maestà* and this much smaller altarpiece, Cimabue had met Giotto; certainly this delightful painting is considerably more earthy than the earlier work. The throne is more believable and less ornate – notice, however, the splendor of the scarlet cushion and the gold background. Also, Mary wears a more believable, although equally glorious, garment. Yet the withdrawn faces, with only the Virgin looking out at us, again suggests the otherness of the heavenly.

MARY SITS AT A SLIGHT *angle to indicate her ease in the world of heaven, and smiles gently as she points out to us her son, who raises one hand in blessing. The angels bear aloft the throne so that it floats above the altar, not part of our material world but removed from it in the golden haze of the heaven to which we aspire.*

CLAUDE LORRAIN c.1604–82 b. France, active Italy
HAGAR AND THE ANGEL

IN HIS VERY EARLY TEENS, Claude left the Duchy of Lorraine, where he was born, and journeyed to Rome. He was so seduced and inspired by the layers of history and mythology and by the natural beauty of the Roman countryside that he made it his home and dedicated his life to recreating these intangibilities in paint. The actual story of Hagar has her cast out into the wilderness with her child Ishmael, and it is only when she is dying of thirst that an angel comes to comfort her with a divine message of salvation and protection. Unlike his compatriot and highly literate friend Poussin, Claude was not an educated man – he has no qualms about setting the drama in an enchanting grove by a lake, where vast expanses of gleaming water make the prospect of dying of thirst extremely remote. Claude loved the Roman *campania* so completely that he used its imagery to create a setting for any incident from the Bible or for any tale from the ancient world.

LANDSCAPE WITH ASCANIUS SHOOTING THE STAG OF SYLVIA
1682, oil on canvas, 19 x 23 in (47 x 59 cm), Ashmolean Museum, Oxford, UK

This was the last work of Claude's life, and in its gravity and dignity it is a suitable swan song. It refers to the story of Ascanius, one of the Trojans who had been welcomed into Italy. Ascanius shot the sacred stag of the priestess Sylvia, and by this act of blasphemy unleashed the horror of civil war. Claude seizes upon the moment of decision; the bow is still poised and Ascanius can yet refrain from action and alter the course of history. All nature seems to wait in trembling anticipation, but there is a deep, pervasive, and fatalistic sense of sadness.

WHAT SEEMS TO CLAUDE *to be so appropriate to this tender landscape, with the soft gleam of the evening light, is the conversation between the angel and the despairing woman – that the angel has come to comfort Hagar, and that she will leave the scene consoled and strengthened. The curve of the angel's body is almost perfectly echoed by the curve of the dark tree behind, which bends down as if in blessing.*

THE VERY LANDSCAPE *is acting in concert with the angel, consoling and strengthening by its visual beauty. Significantly, the angel's pointing hand directs our eye to the arched bridge in the distance. This bridge, and also the boat on the lake, hints that there is always a way to get away from, or go beyond, the circumstances of the present.*

LANDSCAPE WITH
HAGAR AND THE ANGEL
*1646, oil on canvas, 21 x 17 in
(53 x 44 cm), National Gallery, London*

CLOUET, FRANÇOIS c.1510–72 b. France

DIANE DE POITIERS

ALTHOUGH THE SUBJECT HAS BEEN IDENTIFIED as Diane de Poitiers, a mistress of Henry II, this mysterious portrait has also been known as *A Lady in her Bath* and its enigmatic heroine associated with Mary, Queen of Scots. The implication would seem to be that this shameless beauty, with her prominent nipples and overflowing bowl of ripe fruit, is a woman of dubious morals. Yet, one cannot but feel that the artist admires the natural freedom of his subject. Her children and her grinning wet-nurse are at her side, and, in the background, the maid prepares hot water. Surely this domestic scene is no more than a simple and endearing vignette.

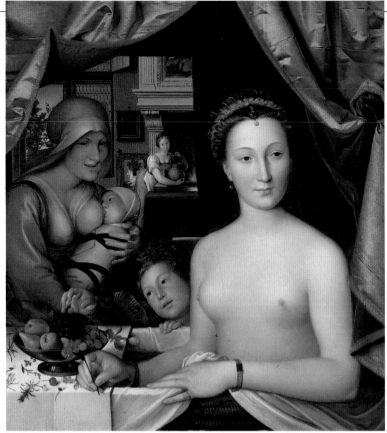

DIANE DE POITIERS
c.1571, oil on wood, 36 x 32 in (92 x 81 cm), National Gallery of Art, Washington, DC

FRANCIS I ON HORSEBACK
c.1540, oil on wood, 11 x 7 in (27 x 22 cm), Galleria degli Uffizi, Florence

Jean Clouet's *Francis I* is one of the great iconic images of royalty. Jean's son, François, also tried his hand at Francis I. Here, the King is elevated to horseback – a device to stress power – but his impact is rather outdone by the extravagance of decoration that adorns him and distinguishes this beautiful work.

CLOUET, JEAN c.1485–1540 b. France

FRANCIS I

CLOUET WAS TO FRANCIS I OF FRANCE what Holbein was to Henry VIII of England. Both monarchs were exceptionally fortunate to have great artists to catch, not only the essence of their regal style, but also their personality. Clouet shows us Francis I as so towering in his greatness, so magnificent in his opulence, and such a figure of immense authority that the picture frame cannot contain him. Strip away the glory of the garb and this face would still command our attention, with its long, powerful nose, so impressively kinked, its firm mouth and judgmental eyes, and the powdery sprinkle of beard that emphasizes the line of the face and the great bull-neck beneath it.

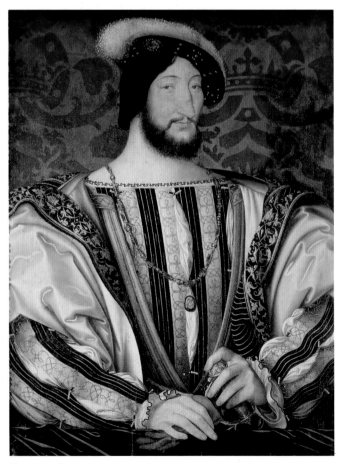

FRANCIS I
c.1535, oil and tempera on wood, 38 x 29 in (96 x 74 cm), Musée du Louvre, Paris

PORTRAIT OF CLAUDE OF LORRAINE, DUKE OF GUISE
early 16th century, oil on wood, 11 x 10 in (29 x 26cm), Palazzo Pitti, Florence

Claude of Lorraine, Duke of Guise, is one of the princely figures of 16th-century France. Yet Jean Clouet, keen psychologist, shows a man at odds with himself – he has a noble face but anxious eyes, a great breadth of shoulder but hands that are somehow imprisoned in the gleaming masses of his drapery. In such a time and place, only a king could stride free and fearless; even the noblest of the land must be circumspect.

COLE, THOMAS 1801–48 b. England, active US

SCENE FROM THE LAST OF THE MOHICANS

IN 1825, YOUNG THOMAS COLE wandered into the American wilderness on an extended sketching trip. Early the next year, James Fenimore Cooper published *The Last of the Mohicans*, a great American epic tale of heroism which found a perfect setting in the splendid and lonely mountains. Cole uses this scene from the novel as a pretext for glorifying Lake George and the surrounding countryside. He paints it from above, as if perched on an adjacent mountain looking down on this autumnal wilderness, with its scarlet leaves and the wild rush of the mountain streams. It is a setting as romantic as the novel that Cooper wove around it. Cooper used the potential of the landscape to form his epic novel; Cole uses both book and nature to form his epic landscape.

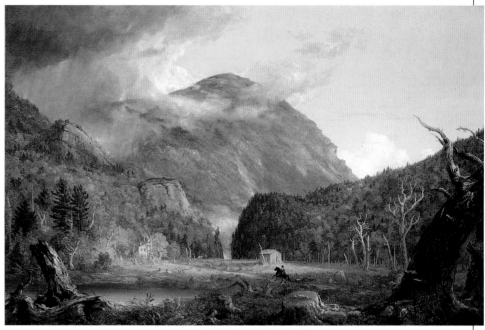

THE NOTCH OF THE WHITE MOUNTAINS
1839, oil on canvas, 40 x 58 in (102 x 148 cm);
National Gallery of Art, Washington, DC

Here is the stuff of romance: a small white house set bravely in a great wilderness of undiscovered America; a lone horseman; and, overhead, dark rainclouds beginning to lower. It is not the narrative content that interests Cole, however, but the reality of life in the wilderness – the vulnerability of having so little protection against the savagery of nature and the courage that survival requires. Great swathes of forest stretch on either side; here, man is small and nature formidable.

SCENE FROM THE LAST OF THE MOHICANS
1826, oil on panel, 26 x 43 in (66 x 109 cm), Terra Museum of American Art, Chicago

WE DO NOT NEED AN INTIMATE *understanding of the story told by Cooper to see that, in Cole's eyes, this is an amphitheatre in which great deeds have been done, great tragedies have been suffered, and great nobility has been quickened. Cole sees these great spaces as symbols of the human spirit's potential.*

CONSTABLE, JOHN 1776–1837 b. England
WEYMOUTH BAY

CONSTABLE WAS ATTRACTED TO PAINT the landscapes he so obviously loved, a familiar world, saturated with memories and emotions. Weymouth Bay, though not the home of his childhood (the Suffolk landscape so unforgettably set before us in paintings such as *The Hay Wain* and *The Cornfield*), was still very dear to Constable – he had spent time there with his beloved wife Maria, whose early death had dealt him a devastating blow. This superbly empty landscape could only have been painted by an artist of supreme confidence, determined in his ambition and ability. He needs no incident to enliven the scene. There is a small figure picked out in white, standing to the right, but its presence goes almost unnoticed; all Constable's attention is focused on the long, slow swell of the hill, the bare sands stretching round and out to the headland, and the slow swish of the tide as it creeps gently in. But perhaps the greatest feature of this painting is the sky, that huge, pale stretch of blue over which dark clouds are gathering, giving the scene, however somber, a strangely lucid quality.

WEYMOUTH BAY (BOWLEAZE COVE)
1816, oil on board, 3 x 4 in (8 x 10 cm), Victoria & Albert Museum, London

Many people today love Constable's sketches above all his work. Here, he has caught a fleeting moment in which the sky is overwhelmed by the sudden storm, while one spotlight of brilliance penetrates, lighting up the central area of sand. Whether clouds and brilliance rolled away, to present the scene we have in the finished picture below, only Constable could say.

WEYMOUTH BAY (BOWLEAZE COVE), 1816, oil on canvas, 8 x 12 in (21 x 30 cm), National Gallery, London

IN THE FOREGROUND ARE ROCKS *that Constable may well have sat down upon to contemplate this scene. It is hard to believe that this was painted in his studio, rather than there and then, on the beach, as the sun shone and the clear light distinguished each rock shape and made the pebbles sparkle.*

COOPER, SAMUEL 1609–72 b. England
HENRIETTA, DUCHESS OF ORLÉANS

SINCE, OF ALL ART FORMS, the miniature is the most personal, there must always be a temptation to idealize. Cooper, however, gives us the impression of truthfulness. We feel he has looked with clarity, and that what he has seen in the face of the Duchess of Orléans is an enchanting young woman in her late teens. Even the absurd hairstyle of the day cannot detract from the sweetness of her oval face. As the youngest daughter of Charles I – and princess though she was – she had lived an adventurous childhood as a poverty-stricken outsider on the fringes of the French Court. Cooper shows her as mature beyond her years. The picture was painted the year after she had returned in triumph with her brother Charles II when she was 16. Yet, triumph seems an inappropriate word for this grave young beauty; she looks out resolutely, head high, lips firm, austere for all her sweetness, giving the impression of a lady not to be approached with too casual an air.

HENRIETTA, DUCHESS OF ORLÉANS
1661, watercolor on vellum, 3 in (7.2 cm) diameter, Victoria & Albert Museum, London

ONCE RE-ESTABLISHED *as a moneyed princess, Henrietta was to be sought in marriage by the brother of the French king, but sadly she died when only 26. Somehow, this early death is not seen as extraordinary. For all her vigor and charm, there is an underlying melancholy to which Cooper has responded. Within the tiny dimensions of the miniature, he has achieved a true sense of the person.*

OLIVER CROMWELL
c.1650, watercolor on vellum, 3 in (8 cm) diameter, Collection of The Duke of Buccleuch and Queensberry

Cromwell insisted that an artist must paint him true to life, warts and all. Cooper has met this challenge head on. He shows the furrowed forehead, thinning hair, and bulbous nose; yet, there is a look of real authority. Perhaps it is fortunate that the picture remains unfinished, with that plain square of brown behind the head, because, in its severity, it seems a very fitting background for this great Puritan.

COPLEY, JOHN SINGLETON 1738–1815 b. US

THE THREE YOUNGEST DAUGHTERS OF GEORGE III

NOT ALL AMERICANS STAYED TO FIGHT in the War of Independence. Copley left the country for Britain, not from a lack of patriotic feeling, but because he felt he needed the scope of a wider and more settled society. His success in 18th-century London can be gauged by the prestigious commissions that most flatteringly came his way. This is one of his most enchanting works. What makes the picture so significant is not that these three are princesses, but that they are three charming and distinctive young women, each of whom Copley has understood as an individual. The relationship between the three little sisters is delightful, too, especially the nine-year-old Princess Mary, who shakes a tambourine to amuse baby Amelia.

WATSON AND THE SHARK
1778, oil on canvas, 182 x 130 cm, National Gallery of Art, Washington, DC

In his youth, General Watson had suffered a horrific attack by sharks when swimming in Havana harbor. Three times he was mutilated, while the heroic crew fought to rescue him. Copley thrills at the drama, the heroism, and the incipient tragedy, and – born storyteller that he is – leaves us uncertain as to the outcome. The shark, in itself, is the least convincing element of this lurid story, but we are wholly convinced by the emotion and fear of the human beings involved. It is said that this picture made Copley famous, and it is not hard to believe that he would have been suddenly lifted into fame by this painting's dramatic tension.

THE PORCELAIN *fairness of the three girls, the fresh elegance of their clothes, and the exuberance of the spaniels are set splendidly against the backdrop of Windsor Castle; while the pillars above, with their grapes and parrots, hint most subtly at the elaborate lifestyle to which these children are destined.*

FAR FROM BEING POSED, *the three children and their pets play before us in the charming disorder that seems appropriate to their age, and yet which would have been so astonishing to the sensibility of the average courtier. Copley is, perhaps, making a claim that even the bluest blood needs to be allowed to warm itself in the sun.*

THE THREE YOUNGEST
DAUGHTERS OF GEORGE III, *1785,
oil on canvas, 105 x 73 in (266 x 186 cm),
Collection of Her Majesty The Queen*

CORINTH, LOVIS 1858–1925 b. Germany
SAMSON BLINDED

LOVIS CORINTH HAD BECOME A POPULAR and successful portrait painter when, in his early fifties, he suffered a stroke. Following his recovery, his art changed fundamentally, becoming rough, passionate, and intensely physical. *Samson Blinded*, which he painted the very year that he regained his faculties, is a terrifying image of what he must have felt during his debilitation – imprisoned, shamed, and shut away from normal life. Samson staggers forward, bleeding, overpowering us with his pain and physical torment. We are most conscious of his eyes and hands – the tools of the artist. The hands stick out, useless and pathetic, and the eyes are covered with a bleeding bandage. Corinth clearly felt that he had been stripped bare of all his abilities, and that the struggle back into creativity was as terrible as that of the blinded Samson.

SELF-PORTRAIT WITH STRAW HAT
1923, oil on cardboard, 28 x 33 in (70 x 85 cm), Kunstmuseum, Bern

Corinth marked his birthday every year by painting a self-portrait. *Self-Portrait with Straw Hat* was painted two years before he died, but he has clearly struggled back from his earlier trauma into some sort of equilibrium. His gaze is no longer frantic, and although we do not see his hands, we see clearly the searching and introspective eyes. He sets the picture in his own world, close to Lake Walchensee in the south of Germany, where he lived after his illness. But, significantly, the lake is at his back, and the searching gaze of the artist looks wistfully into the future.

CORINTH'S SAMSON *is not only chained, he is shut in between two great verticals – a door at the right and a column-like structure to the left (a reminder of the columns in the Philistines' temple that Samson destroyed when he recovered his strength). These verticals hem him in, leaving no space to maneuver, and the top of the frame presses down upon his sparse hair. The very paint of the body twists and turns and splatters.*

THERE IS A SUBLIMINAL *suggestion that this is a blind man painting, dabbing violently into a palette, careless of whether greens or blues or pinks appear on the brush. The savagery of execution carries a psychic force that makes this almost unrecognizable as the work of a society portrait painter.*

SAMSON BLINDED, *1912, oil on canvas, 51 x 41 in (130 x 105 cm), Staatliche Museum, Berlin*

COROT, JEAN-BAPTISTE CAMILLE 1796–1875 b. France

THE COLOSSEUM SEEN FROM THE FARNESE GARDENS

ON HIS TRAVELS IN FRANCE AND ITALY, the young Corot looked at landscape with a truthfulness that only Cézanne has surpassed. The impulse to romanticize, to idealize, seemed absent in him, and yet, in this absolute commitment to the truth, how deeply romantic are his paintings. It is as if Corot abnegates himself in the presence of the landscape, subduing all his creativity to pure receptiveness, so that the sheer weight of what is there before him can take visual form on the canvas. The lack of excitement in this scene is what seems to attract him. The purity of his vision – its selfless delight in the material world – is unique in art and makes all his early paintings masterpieces. They all breathe an air of profound tranquillity, of belief in the unadorned beauty of the world and what man has made of it; that is profoundly reassuring. One can sometimes feel, looking at a Corot, that here for the first time, the world has been seen.

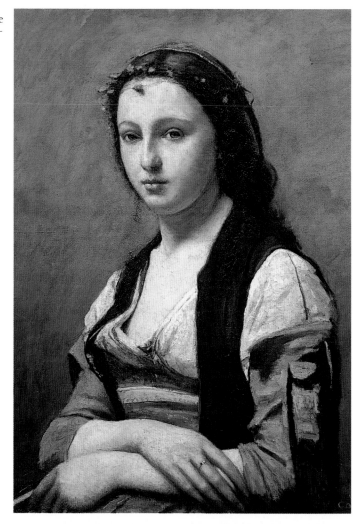

WOMAN WITH A PEARL
*1842, oil on canvas, 28 x 22 in
(70 x 55 cm), Musée du Louvre, Paris*

The title of this exquisite painting is misleading – the "pearl" is actually a small leaf that casts its shadow on the model's forehead. Nevertheless, this young woman has a pearly radiance that makes the title truly appropriate. Corot delights pure-heartedly in the beauty of this dignified and enigmatic woman, who presents herself to him with the same tranquillity and trust with which he presents her to us.

THE COLOSSEUM SEEN FROM THE FARNESE GARDENS, *1826, oil on paper, 12 x 19 in (30 x 49cm), Musée du Louvre, Paris*

NOTHING SEEMS *alien to Corot. He is as fascinated by the poplars set in their designated rows in the monastery gardens in the background as he is by the wild vegetation that dominates the foreground or the sultry sky with the wisps of unruly cloud.*

CORREGGIO (ANTONIO ALLEGRI) c.1490–1534 b. Italy
VENUS with MERCURY and CUPID

CORREGGIO CAN PRESENT US with images that combine extraordinary sensuality with great tenderness. A painter of delicious softness, he is, nevertheless, well aware of skeletal structure. Here, Venus and her son Cupid are accompanied not by Venus's frequently depicted partner, Mars, but by Mercury, the god of messengers. There is a subtle undercurrent here, in that Cupid, who steals hearts, is perhaps being encouraged in a career of amatory crime by that elusive thief Mercury, who bends very lovingly towards his villainous protégé.

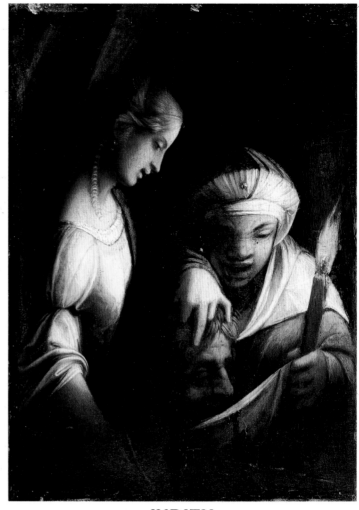

JUDITH
1512–14, oil on panel, 10½ x 8 in
(27 x 20 cm), Musée des Beaux-Arts, Strasbourg, France

Judith – a Jewish heroine, who, to save her people, beheaded the tyrant Holofernes – is usually shown with a maidservant who acts as protector and supporter. But in this little picture, Correggio has split the character of Judith so that she remains pure, noble, and virtuous, leaving all the demonic elements of the deed to the maidservant. The maid's face contorts with a hideous grimace of pleasure as she gloats upon the murder. Judith, meanwhile, stands at the side, remote and silent, looking with incredulous horror at what, in fact, she alone has done. It is a schizophrenic picture, a strange tribute to the desire to see all in black and white.

VENUS ABSTRACTS HERSELF *somewhat from the drama, leaning back glamorously and allowing the two males to get on with it. She is all breast and thigh, although, unusually, her divine character is indicated by ethereal wings. Venus has but one function: she is goddess of love. Cupid also has one function, shooting arrows to make people fall in love.*

THE WINGED–MESSENGER GOD, *Mercury, is also the god of merchants, and, as such, the patron god of arithmetic and calculation (the primary concerns of a merchant). Hence, one could say, he is the god of elementary education. Mercury opens a whole world of possibilities: of virtue and vice, of the mercantile and of the romantic. If he is indeed teaching Cupid, this god has a lot to share with him.*

MERCURY WITH VENUS AND CUPID (THE SCHOOL OF LOVE)
c.1525, oil on canvas, 61 x 36 in
(156 x 91 cm), National Gallery, London

COSSA, FRANCESCO DEL c.1435–c.1477 b. Italy
SAINT LUCY

COSSA WAS ONE OF THE GREAT ARTISTS FROM FERRARA, who all seemed to share an almost spiny definition that makes their work both powerful and emphatic. St Lucy is the patron saint of those with any disease of the eye. Legend has it that her eyes were plucked out, and Cossa depicts her with the long sweeping palm of her martyrdom in one hand and in the other an extraordinary visual invention – a stem from which two buds spring, each bud an eye. There is almost a surrealistic shock to the image. One glances involuntarily up to her pale face and sighs with relief to see eyes (eyes lowered indeed, but casting a sidelong glance towards the weird growth that she carries with such insouciance). Nothing is quite as it seems with St Lucy. She is on one knee, the other knee rears up, drawing attention to the hand behind it with its sinister blossom.

THE CRUCIFIXION
c.1470, oil and tempera on panel, 25 in (64 cm) diameter,
National Gallery of Art, Washington, DC

This is a small crucifixion, but all the more remarkable for that. It is as though Cossa has compressed the intensity of emotion into this gold circle, squeezing the episode for the essence of what was experienced at that very moment. The crucifix fills the space, with Jesus as the pale, silent center. Both Mary and John are astonishing figures of grief. Cossa has not been afraid to show Mary's face in the ugliness of grief and John's almost as a caricature. The three are isolated, not on the Hill of Calvary, but on a section of stone arch. At the bottom, daringly, we see through the arch. The skull that rests immediately above it explains what we are seeing; these are the bones of the dead, heaped contemptuously under the crucifix.

THE GOLD BACKGROUND *tells us that this is not real life, this is a vision, and yet the plump fairness of that round Italian face suggests not so much heaven as a well-stocked larder. The neat cap on St Lucy's fair hair and the linen foaming around her neck frame that almost self-satisfied young face. The decorous sweep of her dark-green gown contrasts with the lighter touch of the scarlet, and the lovely floating ribbon around her waist plays an elegant counterpoint to the impractical dangling threads from her wrists.*

SAINT LUCY, *c.1470, oil and tempera on panel, 31 x 22 in (79 x 56 cm), National Gallery of Art, Washington, DC*

COSTA, LORENZO c.1460–1535 b. Italy
A CONCERT

IT WAS RARE IN THE RENAISSANCE for an artist to paint a scene without symbolic reference, but for its own sake alone. Unusually, Costa seems to have done just that: *A Concert* is painted for the pure pleasure of showing three people singing in harmony, lost in the music that they create. In the middle stretches the great and elaborate lute, to which the skillful hands of the musician are busily attending. Yet the lute player seems to be lost within himself, attentive only to the harmony he makes with his companions. The two on either side beat time on the honey-colored marble that shuts them off into the world of music. They are completely unselfconscious as, with mouths wide open and attention fixed, they concentrate not on the written score that lies before them but on their memory of the melody. The woman, richly dressed and bejewelled, rests a companionable hand on the musician's shoulder – an act of casual comradeship that removes any suggestion of sexual involvement. Music was often taken as a symbol of courtship, but here, in the purest sense, we have a trio whose aim is greater than themselves.

PORTRAIT OF BATTISTA FIERA
c.1507–08, oil on wood, 20 x 15 in (51 x 39 cm),
National Gallery, London

After Mantegna died, Costa became court painter to the Gonzaga court in Mantua. Here he has painted the court physician, who, like many medical intellectuals, was also a poet. It is known that Costa himself suffered from syphilis, and it could be that this compelling portrait was a gesture of gratitude towards the doctor who had treated him. It is a strange and haunting face, set against total blackness; his black cap is practically invisible, which makes the long, pale, austere face loom out at us all the more impressively.

ON THE PARAPET *is another musical instrument: some kind of bow with its elaborate playing apparatus. The singers are fenced off – secluded in the mysterious world of their art. Each looks in a different direction and each seems to come from a different stratum of society.*

THE RICH WOMAN, *the well-dressed lute player, the rather more simply dressed man on the right – each is so engrossed in their respective activities that we can see the effort in the very movement of their heads. The girl's hair comes loose with her intensity and the men's fringes seem almost damp with perspiration from their effort.*

THE SINGER ON THE *right claps the shoulder-strap that crisscrosses his body and anchors his feathered hat; but one feels the action is involuntary. Both singers beat time but, in their wide, staring eyes, we discern that the rest of their intention is occupied solely by the wonder of music.*

A CONCERT, *c.1485–95, oil on wood, 37 x 30 in (95 x 76 cm), National Gallery, London*

COSWAY, RICHARD 1742–1821 b. England

GROUP OF CONNOISSEURS

THE 18TH CENTURY WAS THE AGE of the connoisseur, a time when every gentleman made the grand tour, the better to appreciate – at least in theory – the glories of the fine arts. He then, if he could, brought back a plaster cast of some sculpture from antiquity, or a contemporary version, to exhibit proudly in the family mansion. When Townley asked his young friend Richard Cosway to paint *Group of Connoisseurs*, it was originally intended as a jest, and that element of a caricature is still very visible. Townley (second from the left) is the most distinguished figure present and is the only one not looking with vacuous and erotic excitement at the nude figure of Venus. Cosway bathes them in a golden glow, and the gentlemen – three decrepit, two relatively adolescent, and one (Townley, of course), a mature man of middle years – all respond with an almost palpable excitement.

LADY ELIZABETH FOSTER
after 1785, watercolor on ivory, 3 x 2 in (8 x 6 cm), National Gallery of Victoria, Melbourne

One could not guess from the ethereal charm of this young lady in her late twenties, that she was one of the most notorious women of the 18th century. She fled her brutal husband and lived with the Duke and Duchess of Devonshire – wife, it is said, to both of them. Here, she conveys all the pathos of her ambiguous position. Cosway saw her considerable charm and responded with admiration and sympathy.

THESE WORKS *have been hidden away – we see that a curtain has been pulled back to allow this private group to enter. The elderly man in the chair cannot even keep his feet on the ground, such is his excitement, and the skinny-legged man standing next to the sculptures reaches out a salacious hand.*

TOWNLEY *distances himself (he still has his gloves on), and his presence in the group of connoisseurs is merely to show them up for what they are. Here, the term "connoisseurs" is used with irony, for no true connoisseurs are such vulgarians – Cosway succeeds in his devious intention with delightful touches of humor.*

GROUP OF CONNOISSEURS
1771–75, oil on canvas, 33½ x 43 in (85 x 111 cm), Townley Hall Art Gallery, Burnley, UK

COTÁN, JUAN SÁNCHEZ 1560–1627 b. Spain

STILL LIFE with CARDOON and CARROTS

BECAUSE HIS WORK IS SO IMBUED WITH A SENSE of reverence, it is not difficult to believe that Cotán became a monk halfway through his professional life as an artist. His still-life paintings have a sacramental quality, partly because the artist sets them within a stone niche (which may well be a 17th-century form of larder), the black mysterious background of which suggests to us a sacred hollow. This dramatically offsets the humble vegetables that occupy, with such modest dignity, the sunlit space. One can feel that only a mystic would see that a handful of pale carrots and a thick bunch of the cardoon plant would offer the viewer a satisfaction equal to any artistic scene. Granted, as a monk, Cotán had assumed a life of austerity – vegetarian at that – but his choice of theme seems to go far beyond his personal history. It is the shapes that allure him – the integrity of each vegetable, created by his God with the same individual care as for humanity itself.

STILL LIFE WITH CARDOON AND CARROTS
After 1603, oil on canvas, 25 x 33 in (63 x 85 cm),
Museo Provincial, Granada, Spain

STILL LIFE with QUINCE, CABBAGE, MELON, and CUCUMBER
c.1602, oil on canvas, 26 x 32 in (65 x 81 cm), San Diego Museum of Art

This is probably Cotán's most famous still life. The fruit and the vegetables hang before us, visibly weighty and full-bodied. The curve of the objects ends emphatically with the cucumber, edging out from the shelf, reminding us that the objects are not only at different heights within the frame but also are at different depths within the niche.

READING A *moral into this picture is a vulgarity. Cotán sees the little pile of carrots – each lovingly individualized – and their fleshy companion as intrinsically objects of great worth and beauty. In the bare majesty of his style, he persuades us to rise above the superficial and share his vision.*

A CARDOON *is a fleshy and faintly pink Spanish vegetable. Whatever Cotán made of its flavor, he was certainly profoundly attracted by its shape. The cardoon turns up again and again in his work, curving grandly and firmly against the stone wall.*

COTMAN, JOHN SELL 1782–1842 b. England
CHIRK AQUEDUCT

COTMAN HAD AN AUSTERE AND RATHER MELANCHOLY VIEW of the British countryside. *Chirk Aqueduct* is one of his great images; he has painted it from beneath so that the great stern arches of the aqueduct rise with easy power above us up into the sky. This simple sunned and shadowed world of architecture is contrasted with the chaos of the natural world. It is almost as if the two are in a benign conflict; the water upturns the strength of the aqueduct, reflecting it upside-down, and the cluster of dense woods seems to flaunt a wild freedom, as opposed to the regimented discipline of the aqueduct itself. Yet the picture is more subtle still, because this very countryside is not itself unregimented. Pathetic little trails of fence line their way up the hillside and an agricultural implement has been left abandoned on the left (or is this perhaps simply a cluster of sticks – there is a certain ambiguity of subject matter in the apparent clarity of this image; is that a box, or a dog, or two dark stones cosily ensconced by the water's edge?) This scene that seems so alien to the encroachments of humanity has, however, been entered by the artist himself, who has shared with us the enigma of what he saw.

THE MARL PIT
c.1810, watercolor on paper, 12 x 10 in
(30 x 26 cm), Norwich Castle Museum, Norwich, UK

Cotman seems always to have been attracted by the noble and the mysterious. *The Marl Pit* is seen as a great scoop out of the Earth's surface into which animals innocently roam and on the edge of which mysterious shapes cluster. Although he shows us with a most impressive clarity what he is experiencing at that moment, he never nails down the forms in such a way that we feel complete conviction in them. Only color differentiates those massed trees on the right and those similarly massed clouds on the left, and the goat – the horns of which make us feel confident enough in our label – is in itself rather a vague shape.

C
102

ALL HIS LIFE, *Cotman suffered from depression – at some periods, acutely so. Perhaps the power of Chirk Aqueduct comes in part from a defiance of personal misery. Objectively, as this watercolor shows us, we live in a world of great natural beauty – of blue sky and green tree – superbly complemented by man-made beauty.*

ALTHOUGH COTMAN *was at his greatest as a watercolorist, he made his name in 19th-century Britain as an etcher of architectural antiquities, publishing several books. Even here, we can see his delight in the aqueduct's construction, and see how the massive formality of architectural structure gave shape to his world.*

CHIRK AQUEDUCT, *1806–07, watercolor on paper, 13 x 9 in (32 x 23 cm), Victoria & Albert Museum, London*

COURBET, GUSTAVE 1819–77 b. France

BONJOUR MONSIEUR COURBET

COURBET, AS WE CAN DEDUCE FROM the self-portrait here, was tall, strong, and handsome; and, as we can see all too well, he clearly held a very high opinion of himself. In fact, *Bonjour Monsieur Courbet*, or *The Meeting*, which shows the artist's patron Alfred Bruyas and his valet greeting him on the road, was sardonically entitled by critics, "Fortune Bowing Before Genius". For Courbet, even to acknowledge a patron was an imposition to his greatness, and it galled his pride to depend upon the money and influence that Monsieur Bruyas provided. Although, in one sense, this is a threefold portrait, in another it is a glorious depiction of the sunlit French countryside, from the clear, sharp color of the wayside flowers in the foreground to the far expanses of the landscape beyond. Courbet's belief in the power of the individual human spirit blazes out from the picture, as does his utter confidence in the compelling presence of an undramatic countryside to grasp our attention.

THE WAVE
1870 oil on canvas, 44 x 57 in (112 x 144 cm), Staatliche Museum, Berlin

Courbet's subdued passion, intense emotion, and belief in himself becomes startlingly apparent in a picture such as *The Wave*. The mutual battle, as it were, between the tossing emotion of the sea and the wild fury of the sky appeal profoundly to Courbet's great, untutored spirit, and he clearly admires the dignity with which water and air maintain their individuality.

THE ARTIST *shows himself as of a different species to his patron. He is a footloose traveller, free to roam with the tools of his trade, relying on his gifts as opposed to wealth. In contrast, the gentleman is stifled, buttoned to the neck, and constantly attended by the obsequious valet.*

IT WAS AN *independent act even to think of making art out of such a theme – the artist and patron encountering one another. But Courbet was equally determined to force his world to accept that the French countryside and its activities had as much potential for great art as religious narratives or the major events of history.*

BONJOUR MONSIEUR COURBET (or THE MEETING), 1854, *oil on canvas, 51 x 59 in (129 x 149 cm), Musée Fabre, Montpellier, France*

COUSIN, JEAN THE ELDER c.1490-1561 b. France
EVA PRIMA PANDORA

Eva Prima Pandora was the first great French nude, and the honor of calling her into being belongs to Jean Cousin the Elder. She is a glorious figure, sprawling with majestic dignity across the whole surface of the picture. This is a nude as both woman and goddess – she is to be adored, not ogled. The title, *Eva Prima Pandora* ("Eve, the first Pandora"), is significant. It links two great female characters: Eve, the biblical mother of all humanity, and Pandora, the mythical figure who opened the casket containing all human afflictions. Her right arm rests confidingly on the skull, because with birth came death, and Eve, as the first woman to live, was the first woman to die. The other hand suggestively caresses a casket that, as yet, remains sealed. A snake rises over her arm, forming a living bracelet and reflecting her role as Eve, the temptress. However, this confident woman is far removed from the weak, seduceable Eve, or the foolish, curious Pandora.

EVA PRIMA PANDORA
*late 1540s, oil on wood, 39 x 59 in
(98 x 150 cm), Musée du Louvre, Paris*

COX, DAVID 1783–1859 b. England
THE CHALLENGE

Through Turner, Victorian artists learned to value the sublime – the wild, unleashed power of nature. For David Cox, however, the forces of nature had meaning primarily as an inescapable part of a laborer's life; he was himself a blacksmith's son and his origins were deep in the countryside. Three years before he died, Cox painted *The Challenge: A Bull in a Storm on a Moor*. Here we see the wild surgings of nature, and the desperate attempts of an animal to stand up to the adversity of its current conditions. This blind courage, doomed and yet noble, may well have a personal significance for Cox, for he seems to empathize entirely with this animal's plight.

THE CHALLENGE: A BULL
IN A STORM ON A MOOR
*c.1856, watercolor and gouache
on paper, 18 x 26 in (46 x 67 cm),
Victoria & Albert Museum, London*

RHYL SANDS
*c.1854, oil on canvas, 18 x 25 in
(46 x 64 cm), Manchester City Art Gallery, UK*

Cox had a stroke in 1853 and, although he recovered, he died within six years of that traumatic shock. He painted this picture in the aftermath of the stroke, and many art historians attribute its originality – the vivacity and freedom that pre-empts Impressionism – to his illness. The fresh air breathes almost visibly over the landscape, and it is impossible not to believe that Cox dashed out this watercolor there and then.

COZENS, JOHN ROBERT 1752–97 b. England

SEPULCHRAL REMAINS IN THE CAMPAGNA

THE ROMAN CAMPAGNA – the great and desolate plains that once surrounded the city of Rome, littered with romantic ruins and inhabited only by cattle and their guardians – had an immense fascination for 18th-century artists. Not only was this great expanse beautiful in itself but it was also redolent of so many memories, of so many classical hopes and defeats and achievements. When Cozens went to Italy in the 1780s, he painted what he saw and also what he felt. This, in its quiet beauty, is a grieving picture. He has entitled it after the tombs, or rather the battered evidence of tombs, and he paints them with the most sensitive awareness of what this land is and of what it once had been. Using very little color, Cozens draws us into a contemplation of death and memory, of the vastness in which we live, of the meaninglessness of fame, and of the eternity of earth and air, those two fundamentals on which this great picture is based.

TWO GREAT TEMPLES AT PAESTUM
c.1783, watercolor on paper, 256 x 336 cm, Lees Collection, Oldham, UK

On his trip to Greece, Cozens suffered extensively from malaria, and there is, in this view of temples under a stormy sky, a sense of the wavering haze of delirium. One temple is spotlit by the sun, the other already subsiding into darkness. This is the culture on which our own is based, and the glimmering light signals its importance; yet, it is a culture that could not sustain itself, and so the onrush of the storm clouds also has a symbolic significance.

SEPULCHRAL REMAINS IN THE CAMPAGNA
c.1783, watercolor on paper, 10 x 15 in (26 x 37 cm), Ashmolean Museum, Oxford, UK

AGAINST THE SKYLINE STRETCHES THE *great aqueduct of the Emperor Claudius, and a little down from that, silhouetted on a slope, is a long line of cattle. For the rest, the plain lies under the majesty of a great and lowering sky, with the evening light casting in shadow the pyramidal and box-like shapes that once honored noble Roman citizens.*

CRANACH, LUCAS THE ELDER

1472–1553
b. Germany

CUPID COMPLAINING TO VENUS

CRANACH WAS AN ARTIST WITH three strings to his bow: in his role as court painter to the Elector of Saxony, he produced aristocratic portraits; as an intimate friend of Martin Luther, he painted religious works; and out of his own deep desires, he produced paintings of provocative and enigmatic nudes. Cranach's popularity today, though well-deserved, is to some extent a fluke in that his ideal of female beauty corresponds with modern tastes – slender women with small, apple breasts and gently swelling bellies (often wearing extraordinary hats and sometimes boots) have a contemporary charm. The hat and necklace are typical of Cranach: both are splendid but quite unnecessary, enhancing the kinky beauty of this elegant nude. Cranach is careful to provide his picture with a moral, however: Cupid has stolen honey and the bees have stung him – pleasure that is sought immoderately can cause us pain.

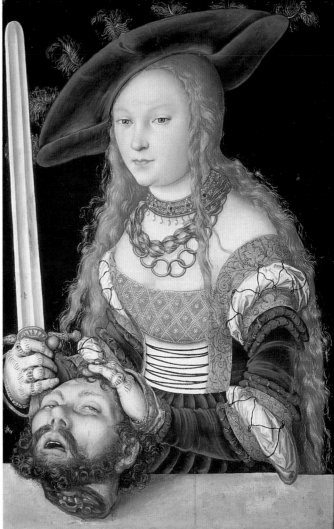

JUDITH WITH THE HEAD OF HOLOFERNES
c.1530, oil on wood, 34 x 22 in (87 x 56 cm),
Kunsthistorisches Museum, Vienna

Judith with the Head of Holofernes would seem to be Cranach in biblical mode. There is the slaughtered tyrant, most unpleasantly showing us the severed vessels of his neck, and there is the modest Jewish heroine who has saved her people by decapitating him. Yet, once again, Cranach cannot resist the extravagance of the hat, with its lush velvet brim and silly feathers. Again, he wreathes his heroine's neck with an array of elaborate necklaces and cannot resist embellishing all there is of her garment with flourishes and decoration. The sword, we notice, is held in a gloved hand (with her rings clearly visible beneath), as if to insulate this fair Judith from the cold steel of the weapon.

SHOULD THE MORAL *(which for Cranach completely sanitizes the picture) be missed, he has written it out at the top right for viewers to ponder. Venus and Cupid are in conversation, but one cannot but feel that this is a pretext. The focus of the picture is Venus in her own world, where the sensual lemon tree bears its fruit and rocks and stones are reflected in still waters. This is the paradise world in which one's worst fear is a bee sting, and if we were to enter this world and happen upon Venus, she would be sure to protect our modesty with a feathered hat.*

CUPID COMPLAINING
TO VENUS, *c.1530s,*
oil on wood, 32 x 22 in (81 x 55 cm),
National Gallery, London

CREDI, LORENZO DI c.1458–1537 b. Italy
THE ANNUNCIATION

EVERY RENAISSANCE ARTIST SEEMS to have tried his hand at an Annunciation. This is one of the most beautiful not only in its grace but in its sincerity. The yearning of the angel and the dignified surprise of Mary are set so superbly in that shadowed loggia, its elegant decoration picked out in white, and with a cultivated landscape beyond it. Mary and Gabriel are – in the purest and most sublime sense – actors playing out for us the drama of redemption that will reverse the initial tragedy of Adam and Eve's expulsion from the Garden of Eden and lead us, through the stage set, out into another paradise. The perfect symmetry of the setting, the delicacy of the color, the way Mary's veil ends in that faint blush of pink or the way Gabriel's auburn curls are set against the background of the sunlit meadow – all of this involves us emotionally, as it clearly does the artist himself. Gabriel is coming out of a wall of shadow, the background of which is human history, to encounter Mary, who stands there in the sunlight with her hand uplifted in a gesture that combines surprise, blessing, and affirmation.

VENUS
c.1490, oil on wood, 59 x 27 in (151 x 69 cm),
Galleria degli Uffizi, Florence

Credi was later to fall under the pernicious influence of Savonarola and refuse ever again to paint work that was not strictly religious; but at this time Credi had a flourishing instinct for the significance of the Greek myths. Since most of our Renaissance paintings are altarpieces, it is rare to find a work like this Venus. This goddess of love is, nonetheless, a work of devotion. She is a strong, muscular being whose look is a challenge to the male and has none of the prudish fear of the body that was later to inhibit artists such as Credi.

CREDI HAS SET HIS ACTORS, *as it were, on a stage, and the stage set bears images of the great events of creation. On the bottom left of the picture, we see God creating Eve out of Adam's side; in the middle, the serpent tempts Eve, who is passing the forbidden fruit to Adam; finally, Credi shows us the heartbroken departure of Adam and Eve from paradise.*

THE ANNUNCIATION
c.1480–85, oil on wood, 35 x 28 in
(88 x 71 cm), Galleria degli Uffizi, Florence

CRESPI, GIUSEPPE MARIA 1665–1747 b. Italy
THE FLEA

EIGHTEENTH-CENTURY SOCIETY enjoyed a moral narrative. At the beginning of the century Crespi embarked on a series that would show the rise and fall of a beautiful woman; at a similar time in England, William Hogarth would produce his modern satirical series, *The Rake's Progress*. Crespi's *The Flea* is a most astonishing glimpse into the life of another. It is a picture so intimate that we feel intrusive as we look at it. The girl is poor, although we notice that she already has an ornament in her hair and a small lapdog curled up on her bed. As she sets about her morning toilet, she discovers on her body a flea, and Crespi shows the concentrated attention with which her fingers roam over that plump white form to find it. Her determination to catch and kill the flea has its moral overtones, yet one cannot help but feel that what really interests Crespi is peeping in on that white body in its white shirt, at the young woman amid the crumpled bed-linen and the discarded clothes, gleaming in the sunlight and aware only of her own bodily concerns.

SELF-PORTRAIT
c.1700, oil on canvas, 24 x 20 in
(61 x 50 cm), Hermitage, St Petersburg

Crespi was clearly not a man for the bright lights. What grasps our attention in this extraordinary picture is the dark intensity with which he sees himself. One can even find an uncanny prevision of Picasso, in that we see the profile and look at the whole face. He highlights a noble forehead with a white turban, which was often worn by artists as they worked. Then we see the clever hand responding immediately to the keen, quick glance of the artist, as he tries to show to himself how he looks.

SHE IS SPOTLIT FOR US, *surrounded by the detritus of the life of a poor but pretty girl. Her clothes are hung simply on the brick wall, yet she has a vase of roses by her bed and a jar of cosmetics. Crespi tells us that, for now, she is still a virtuous girl, and the wall behind her bed is strewn with assorted religious images.*

THE FLEA IS SO SMALL, *yet it remains such a succinct image of the life of poverty. In her search for the flea, Crespi shows the young woman at a point in her life when it can go either way – into the allurements of what for her will mean moral downfall, or into the hardships of virtue.*

THE FLEA
c.1707–09, oil on copper,
18 x 13 in (46 x 34 cm),
Galleria degli Uffizi, Florence

CRIVELLI, CARLO c.1430–c.1494 b. Italy
MADONNA of the SWALLOW

CRIVELLI HAS A TERRIFIC HARDNESS AND SHARPNESS OF VISION. He paints almost as if he has carved his image in stone. His bejewelled Mary wears an extraordinarily rich gold-brocaded robe, and the Child, supine on her lap, clasps an apple. Fruits, richly rounded and outlined with particular clarity, adorn the whole picture and, indeed, are almost a signature element in a Crivelli painting. Their presence has a double-edged significance, symbolizing both the fruitfulness of Christ's birth and His vulnerability (although the fruit is never shown in a state of decay). The two saints are equally remarkable: an ancient, bad-tempered St Jerome, with attendant lion, is balanced by the young soldier, St Sebastian, depicted as a fashionable gallant. The one natural element in the picture is the swallow itself, perhaps a symbol of the resurrection or the spirit. It also serves to remind us that there is a world beyond the gilded artificiality of the throne-room.

ST MICHAEL
c.1476, tempera on wood, 35 x 10 in (90 x 26 cm),
National Gallery, London

This extraordinary picture is an unforgettable instance of the unique, almost perverse, imagination of Crivelli. Here is St Michael, shown at his moment of triumph, casting Satan into hell. He looks down upon his foe with serene dispassion, in one hand gently holding scales to weigh the souls of the dead. The delicacy of this touch contrasts perfectly with the terrible deformation of Satan's grasping claws.

MADONNA OF THE SWALLOW
c.1490–92, tempera and oil on wood, 59 x 42 in
(150.5 x 107.5 cm), National Gallery, London

CROME, JOHN 1768–1821 b. England
NORWICH RIVER: AFTERNOON

AT ONE TIME, NORWICH WAS THE SECOND GREATEST city in England and it was probably no surprise to its proud inhabitants that the greatest regional school of painting should have flourished there. The father of the Norwich society of artists, and the greatest artist among them, was John Crome. *Norwich River: Afternoon* is a perfect example of the gentle clarity of this artist's work at its best. It is a deeply poetic image: the evening wears on and the very trees seem to drowse peacefully in the setting sun. It is a world that is for the most part lost to the noisy Britain of today. Here, all is silence, peace, and – we deduce – contentment. It is a superbly organized picture, both in its lines and in its color. All that organization, that thoughtful planning, is directed to the end of recreating on canvas the warm calm of a particular sun-blessed afternoon.

NORWICH RIVER:
AFTERNOON
1819, oil on canvas,
28 x 39 in (71 x 100 cm),
Norwich Castle Museum, UK

THE BOAT MOVES TRANQUILLY *through the reflections of the houses on the river. They are not romantic houses – we see washing on the line and the untidiness of an ill-kept fence – and yet Crome has seen them with such intellectual certainty as to render them beautiful and poetic.*

MOUSEHOLD HEATH, NORWICH
c.1818–20, oil on canvas, 43 x 71 in (110 x 180 cm), Tate Gallery, London

As in all low-lying lands, the great glory is the sky, but it is the light reflected from the sky that has fascinated Crome. He has caught the strange shadowed gold of light at that particular hour of the day as it spreads over that mysterious and age-old landscape. It was an extraordinary picture for the time because this great expanse is almost completely without event or visual excitement. There is not so much as an emphatic vertical to break the long, low format of his picture, yet he holds us enthralled.

Cuyp, Aelbert 1620–91 b. Netherlands

A Herdsman with Five Cows by a River

A SIMPLE HERDSMAN WITH FIVE COWS at the edge of the river and a
few boats drifting by is the quiet theme for this landscape painting.
Fundamentally, all of Cuyp's pictures play with similar elements –
cows, a river, a herdsman – yet these humble elements are transformed
into great art by being bathed in a mellow golden light, the hallmark
of his work. Cuyp paints the rural countryside against a heavenly sky,
and he explores how sky and land interact with one another,
combining to form an image of gentle serenity. Without meaning
to denigrate these glorious paintings, the focus of interest in Cuyp's
work is the light, which is similar to his Dutch contemporary Vermeer.
Three-quarters of the painting is taken up by sky. There is a shoulder
of earth on the right and a rim of buildings on the far left. For the
rest, air flows sweetly over the calm water and the sober animals.
The ruminating cows, both monumental and calm, seem perfectly
suited to this still and benign art. The human characters are secondary,
merely there to assure us that this is the real Dordrecht countryside.

A HERDSMAN WITH
FIVE COWS BY A RIVER
*c.1650–55, oil on wood,
18 x 29 in (45 x 74 cm),
National Gallery, London*

THE REASSURING, TIMELESS *quality of this artist's
work has always held great appeal for the British –
both artists and art collectors – and many of Cuyp's
most luminous works inspired British landscape
artists such as John Constable and David Cox.*

A DISTANT VIEW OF DORDRECHT
WITH A MILKMAID AND FOUR COWS
c.1650, oil on canvas, 62 x 78 in (158 x 197 cm), National Gallery, London

Here, the city of Dordrecht is visible on the horizon and, typically, the
forefront is occupied by a herd of resting cows, a milkmaid, and other
figures silhouetted against the skyline. This, however, is a darker picture than
Cuyp's other works. The evening is drawing in and shadows fall silently
on the earth and its inhabitants. The darkening sky is devoid of a sunset
but still occupies at least half of the composition. Its light lends an ethereal
beauty to the city architecture and gleams on the flanks of the central cow.

DADDI, BERNARDO c.1290–c.1349 b. Italy

THE MARRIAGE OF THE VIRGIN

BERNARDO DADDI WAS THE LEADING ARTIST of the generation that followed Giotto (the artist considered to be the founder of Florentine painting). Hence, in Daddi's work we see a solidity and dramatic narrative reminiscent of his mentor, as well as a brightness in his use of color.

The Marriage of the Virgin is a small jewel of a painting with the most subtle interplay of rather delicate hues. The story derives from the imaginative curiosity of the early Christians, who, since they did not know how Mary and Joseph met, concocted a fable by which her suitors were told to bring a rod to the temple. The man whose rod flowered would be her husband. Here, an astonished elderly Joseph moves forward to pledge his troth to a shy and beautiful young Mary.

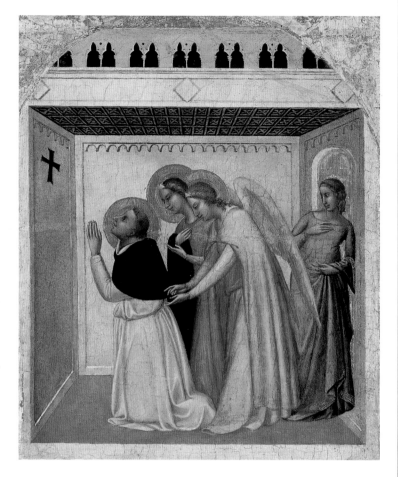

THE TEMPTATION OF THOMAS AQUINAS
1338, tempera on wood, 15 x 13 in (38 x 34 cm), Staatliche Museum, Berlin

This is a story rarely told. Furious that Thomas Aquinas was about to become a Dominican priest, his brothers pushed a prostitute into his cell whom the saint stubbornly rejected, whereupon two angels appeared and tied the girdle of chastity around his waist. The prostitute is visibly astonished – both at this male resistance and the appearance of the angels. Daddi is a great storyteller and this is one of the most memorable and enchanting of his painted narratives.

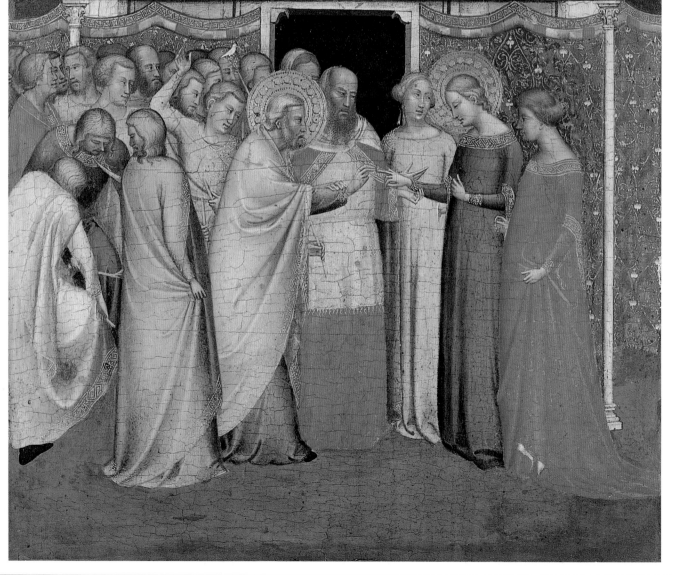

IN THE BACKGROUND, *we witness the crowd of disappointed suitors, breaking their rods on their knees in frustration. However, our attention is concentrated on the betrothal itself. Mary, a serene and dignified figure in blue, receives her elderly husband as he inclines his head reverently towards her.*

THE EMOTIONS *surrounding the event are made real to us. The small figures, both bright and jewelled, act out the drama in a real space, even though they are hemmed in by a flowery backdrop of wedding decorations. Daddi wisely leaves the foreground space free of decorative detail so that our eyes can move over the elaborate and skilful arrangement of colors.*

THE MARRIAGE OF THE VIRGIN *c.1330–40, tempera on wood, 10 x 12 in (26 x 31 cm), National Gallery, London*

Dalí, Salvador 1904–89 b. Spain

SEATED GIRL SEEN FROM THE REAR

DALÍ IS ONE OF THE MOST SCANDALOUS ARTISTS of the 20th century. His personal antics, his provocative statements, his eerie and brilliant images, all set him apart as the supreme Surrealist. He referred to his paintings as hand-painted dream photographs, and there is indeed an unearthly combination of the unreality of a dream with the precision of the photograph. What I find personally distressing is that his early work shows he was supremely gifted, but his temperament – his inveterate desire to show off and to shock – meant that these gifts never came to full fruition. Painted when Dalí was barely 21, this portrait of his sister shows what might have been. He has not yet felt compelled to play tricks with the image, but it is, nevertheless, an enigmatic picture.

PREMONITION
OF CIVIL WAR
1936, oil on canvas, 43 x 33 in (110 x 83 cm),
Philadelphia Museum of Art

Dalí was ever an opportunist. When the Spanish Civil War broke out, he added to his *Soft Construction with Boiled Beans* a parallel title: *Premonition of Civil War.* Since he is an artist of fragmentation and disillusion, the extra title fits well enough. The more we look at this giant in self-inflicted agony, the more we see bodily parts: wrists, bellies, and sexual organs, squeezed and disintegrated, turning into bone, flopping, and losing vigor. The whole nightmare scene is set in a lucid and precisely rendered landscape, so truthful and so haunting that we return with added horror to the monstrous figure of human cruelty that dominates it.

WE ARE BOTH ALLURED *by this self-possessed young woman and kept at a distance; only that marvellous back, with its loose, striped chemise and a thick bundle of dark curls, allows us any intimacy. She could be seen as imprisoned in the cage of her chair, and yet the geometry of that chair is hard to read, as is her exact position looking out over a Spanish city.*

THE ARCHITECTURE *has a baffling quality, with blank walls and strangely spaced windows. Also, the landscape on the left seems to bear little relation to the landscape on the right. Yet Dalí convinces us that the girl is a real person with a real body, and it could well be that the landscape – half sunlit and half shadowed, half urban, and half rural – is an image of her dreaming mind.*

SEATED GIRL SEEN FROM THE REAR, *1925, oil on canvas, 20 x 31 in (51 x 78 cm), Museo Nacional Centro de Arte Reina Sofia, Madrid*

Daubigny, Charles-François
1817–78
b. France

Evening on the Oise

THE MID-19TH CENTURY IN FRANCE saw the birth of a school of romantic landscape artists who based themselves around the village of Barbizon in the forest of Fontainebleau. Their ideal was to show nature in its strength and simplicity, without human involvement but with a deep appreciation of the moral strength that the untouched forest, field, and river could offer those suffering from the encroachments of industry and the noise of the city. Here, Daubigny shows us nature at its most silent and serene. He seems almost to scorn the support of color and romantic interest. His sky is the clear, pale yellow of early evening, and his trees and riverside are almost blanched of any vividness or dramatic vigor of their natural greenery. In this landscape we have to search to see movement, which can be found in the form of a weary laborer leading home his donkey, one or two somnolent cows, and, on the far side of the river, cattle drinking; but these are secondary to Daubigny's real interest, which is devoted to the silence of a secluded, twilight world.

EVENING ON THE OISE, *1867,*
oil on canvas, 39½ x 79 in (100 x 200 cm),
The Taft Museum, Cincinnati, Ohio

SUNSET ON THE OISE
1865, oil on canvas 15 x 26 in (39 x 67 cm), Musée du Louvre, Paris

Evening on the Oise is a studio picture. Daubigny had seen the view, experienced the tranquil atmosphere of the place, sketched it, brought the image home, and then, in his studio, painted a distillation of all he had seen and felt. *Sunset on the Oise,* however, is a sketch, painted with all the blurred excitement of immediate vision. For us, that wild sky, those rough blots that signify trees, and the loose but emphatic handling of the paint can seem more convincing than the considered and deliberate work produced in the studio. Daubigny saw this scene one evening, just as it is, and he shares that sight with us.

AN EVENING MIST *is rising, blurring the distant outlines, while the shadows of night dim the foreground, with its multitude of wild flowers and herbs. The sheer non-excitement of such a scene is what makes it beautiful to the artist.*

HERE, THERE IS NO PICTURESQUE *view, not even the natural drama of cliff or rushing water; just quiet, stillness, and solitude. Scenes like this, painted with an almost photographic truthfulness, had, even for Daubigny, a quality of nostalgia.*

THIS SILENT, RUSTIC WORLD *was slipping away into the past with the onslaught of the Industrial Revolution, which was rapidly blurring the boundaries between urban and rural life, even in 1867. Only in art does such a rural landscape remain forever visible and approachable.*

DAUMIER, HONORÉ 1808–79 b. France
THE LAUNDRESS

FOR MOST OF HIS LIFE DAUMIER earned his living as a left-wing cartoonist for satirical journals. His brilliance as a caricaturist made it difficult for him to be accepted by the art Establishment, especially since he refused to polish up his works to the high degree of finish that was expected. *The Laundress*, little appreciated at the time, shows Daumier's profound understanding and ability to portray the heroic lives of the poor with the utmost pathos. The rough majesty of the woman helping her child climb the stairs has a grandeur that recalls an artist of the stature of Michelangelo. The figure of the woman is outlined by the city that towers above her. It is out of bounds to a humble woman and offers nothing to someone so low in status. Yet the woman dominates the scene, warm and compassionate, tired after her day's work and yet alert to the needs of her child.

THE PRINT COLLECTOR
c.1860, oil on panel, 17 x 13 in (42 x 33 cm), The Burrell Collection, Glasgow Museums, UK

To those who knew Daumier's work as an illustrator, *The Print Collector* would have been a more typical example than *The Laundress*. However, this image is not a caricature but a deeply compassionate portrayal of the loneliness of a man whose sole interest in life is prints. Daumier shows us a long, thin, self-contained bachelor, arms stuck in his pockets, legs pressed tightly together, shoulders hunched, hat pulled down over his forehead.

He is a man who has no access to colorful and pleasurable things – no love in his life and nothing to brighten his solitude except these affordable prints. Daumier draws our attention to the image of a young girl laughing out loud at this man, while the gaze of the print collector is both hungry and desperate.

THE LACK OF FINE *detail adds to the immediacy and impact created by this great maternal figure. Although living in darkness, she effortlessly dominates the bright, soulless city buildings behind her. Daumier is not trying to make a heavy-handed social comment or indulge in histrionics – he seems hardly to touch on our emotions – and yet the effect of the composition is both humbling and uplifting.*

THE LAUNDRESS
c.1860, oil on panel, 19 x 13 in (49 x 34 cm), Musée du Louvre, Paris

DAVID, GERARD c.1460–1523 b. Netherlands

A REST DURING THE FLIGHT TO EGYPT

MARY'S YOUNG FACE BENT BROODINGLY towards her baby suggests not the majesty of the mother of God but the sheer sweetness of maidenhood. This little Madonna has brought with her as luggage a precious basket, which David paints with complete conviction and pleasure. Nowhere can we see habitation for the night, and although there are flowers in the immediate foreground, they are flanked by rocks. The inhospitable walls of a castle beyond serve to emphasize the sense of exile. She is dressed, most unsuitably for this frantic dash for safety, with diaphanous headgear and a long, voluminous mantle of the deepest blue; it is certain to get dirty and torn by the rocks. But it is the poetry here that appeals to David – the young family, alone in the woods, serenely and courageously accepting the exigencies of fortune.

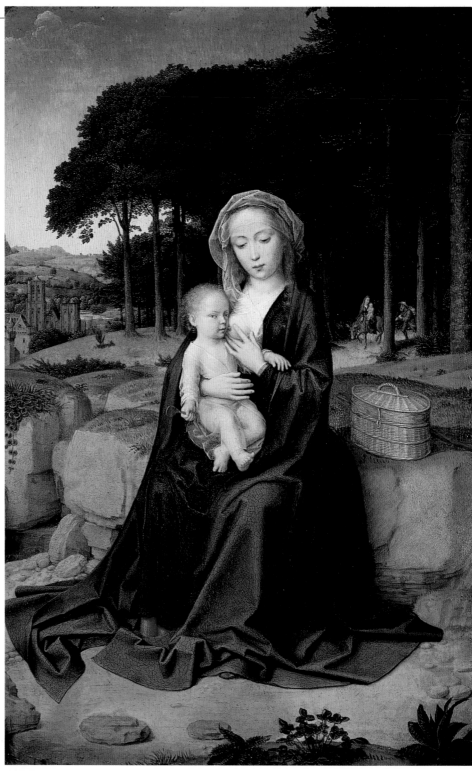

AT THE BACK OF THE PICTURE, emerging from the dark wood, we can see the Holy Family on their flight into Egypt: Mary and the Child on the donkey, and Joseph following with surprising vigor for so elderly a man. Having set the scene, David then focuses on the Virgin and Child, now at rest in the foreground.

DAVID SHOWS US both mother and Child in a moment of reflection. The Infant does not press His mouth to the nipple, but rests His cheek against her breast – one little hand laid confidently on His mother's, while, with a baby's seriousness, he ponders this change in their fortunes.

A REST DURING THE FLIGHT TO EGYPT
c.1510, oil on wood, 24 x 15 in (60 x 39 cm), Museo del Prado, Madrid

GOD THE FATHER BLESSING
1506, oil on wood, 40 x 50½ in (101 x 128 cm), Musée du Louvre, Paris

David has little sense of drama but a great sensitivity to charm. *God the Father Blessing* suggests another aspect of his genius. This is an extraordinary picture, framed as it is in dark thunder clouds, in which the heavy maturity of an abstracted God holds His sceptre and lifts His hand in blessing. But there is no flicker of animation, no benign response in that solid and impervious face. On either side press two small angels; their scarlet feathers tell us they are cherubim. They, too, seem ill-at-ease with this darkly brooding figure. Both angels bend forward, hands anxiously clasped in a pleading gesture. Whatever David's intention, the feel of this work is far from reassuring.

DAVID, JACQUES-LOUIS 1748–1825 b. France
DEATH OF MARAT

DAVID WAS A HIGHLY IMPRESSIVE ARTIST, but a sadly troubled and unbalanced human being. He seems to have lost his emotional equilibrium completely in the French Revolution, chanting loudly for the death of the King and urging on the worst excesses of the Reign of Terror. Foremost among the Jacobins was Marat, a former doctor whose appearance was repulsive due to a severe skin disorder – a condition that forced him to bathe frequently in calming lotions. Charlotte Corday, the sister of one of his victims, stabbed him as he sat in his bath, and David, who had visited him the day before, painted this astonishing image of his dead friend, transformed into a heroic martyr. Nearly every detail here seems to be either exaggerated or literally untrue, and yet the propaganda effect was immense.

MADAME RÉCAMIER
c.1800, oil on canvas, 68½ x 96 in (174 x 244 cm),
Musée du Louvre, Paris

Madame Récamier was a Napoleonic hostess who fascinated the Parisian upper class. The daughter of a banker, she married a banker herself (an elderly man who, rumor had it, had promised to live with her without sex). Rumors proliferated around this elegant and enigmatic young woman. David has clearly been affected by her, and he delights in the contrast between the bare feet, the revealing simplicity of the white dress, and the careful elaboration into simplicity of her hairstyle. All that the Empire came to symbolize – in style, rich austerity, the gracious line, supreme self-possession – is made actual for David in Madame Récamier.

WHATEVER one may think of the morals of this subject, this painting remains one of the strongest and most powerful images ever painted. It is a loud accusation against human ingratitude, a vindication of nobility, and, just as in the images of the medieval martyrs, it is a challenge to rise to heroism.

ONE OF THE marvelous touches here that makes this picture unforgettable is the background. The bathroom wall has been transformed into a deep black-and-gold speckled setting, with the martyr's torso embedded into the black, as his hand still points us forward into the gold.

DEATH OF MARAT, *1793,*
oil on canvas, 65 x 50 in (165 x 128 cm),
Musées Royaux des Beaux-Arts, Brussels

DAVIS, STUART 1894–1964 b. US
ODOL

STUART DAVIS WAS ESSENTIALLY AN ABSTRACT ARTIST, but not at all in the sense of the Abstract Expressionists. He scorned their work, describing it (I am sorry to tell you) as a belch from the unconscious. Davis had no time for the unconscious and had no truck with any grandiloquent plans for a mystical or spiritual art. His aim was not to express the higher things of life but rather to do as the poet Walt Whitman had done before him – to make art out of the world in which he lived. In this sense, Davis was a Pop artist years before the movement began. *Odol* demonstrates his methods perfectly. In this painting, he takes a humble toilet accessory, a mouth freshener, and uses it to make an abstract, flat, decorative pattern. Davis's play on shapes depends upon our recognition of the real world, a familiarity with its objects, and an understanding of their functionality. In his attention to the ostensibly insignificant, Davis does not try to elevate objects to a higher status, but merely to represent something of contemporary American life.

COMPOSITION CONCRETE
1957, oil on canvas, 203 x 96 in (515 x 244 cm),
Museum of Art, Carnegie Institute, Pittsburgh

Thirty years later, Davis has a more complex vision. Here, he is thinking not so much of clarity as of complexity, of jazz rhythms. *Composition Concrete* was commissioned for the lobby of the Heinz company building in Pittsburgh, and the date, 1957, which has been incorporated into the painting, is a witty reference to the company's 57 varieties. Davis deliberately uses red, white, and, blue for patriotic reasons, and here he plays with colors and shapes as jazz musicians play with sounds, and he delights in the flatness of geometry, with which he makes his colors cohere into a consistent pattern.

FOR DAVIS, *abstract art was not an ego trip or a vague device for creating "beauty", it was a way of responding to the clean lines of the modern world. He felt that unless artists recognized the aesthetic potential before them, they were living in a pseudo-world and refusing to allow the genuine environment its rightful place in art history.*

JUST AS WARHOL *would be later attracted to the Coca Cola bottle, so Davis is drawn, here, to the Odol bottle. He likes the shape of it and the lettering upon its surface, and so he has made a multicolored framework in which to highlight this modern device, with its cunning, squirtable opening and the simple clarity of its message.*

ODOL, *1924, oil on canvas,*
24 x 18 in (61 x 46 cm),
Cincinnati Art Museum

DEGAS, EDGAR 1834–1917 b. France
THE TUB

MANY GREAT WORKS of art depend upon the artist's emotional involvement in the subject matter. This is not true of Degas. It is his lack of involvement, his ability to stand back from the subject, his skill at seeing animate or inanimate objects and human or non-human forms as simple shapes, that gives his art an edge. His compositions are conceived as if peering through a keyhole, especially when he paints one of his favorite themes – women washing. It is well documented that Degas regarded women's bodies as not fully human, but it is this lack of humanity in his representation of the female form that sets him free. He focuses instead on the curve of the body and on the way light falls on the form. He delights in shapes – the tub in which she squats – before cutting obliquely across the canvas to the line of the table top.

MELANCHOLY
c.1874, oil on canvas, 7 x 10 in (19 x 25 cm), Phillips Collection, Washington, DC

Melancholy is an unusual picture for Degas. Atypically, he focuses on emotion rather than form outlined by colour. This woman is not merely an animal shape, it is her sadness, her suffering that has attracted the artist. Typical of Degas, he conveys this inertia as clearly in her body posture as in her facial expression; no artist ever understood body language more intuitively than Degas.

THE TUB
1886, pastel on paper,
24 x 33 in (60 x 83 cm),
Musée d'Orsay, Paris

THE TUB IS A strangely intimate picture, almost embarrassing in its closeness, but at the same time awe-inspiring in the way the artist's eye perceives the subject. Degas controls his world view with such elegance that he can take the reality and incoherence of life and build it without omission or illusion into a powerful image.

DE KOONING, WILLEM 1904-97 b. Netherlands, active US

ROSY-FINGERED DAWN AT LOUSE POINT

ROSY-FINGERED DAWN AT LOUSE POINT is de Kooning's reaction to a real, although rather unromantically named, place. He was living in Long Island, close to Louse Point, when he painted this work, and in the early morning he could see light flooding tenderly over the vast, flat fields. It reminded him (well-educated Dutch schoolboy as he had been) of Homer's description of dawn with its "rosy fingers". His painting makes no attempt to describe, literally, those fields and the early-morning brightness, but it gives us a sense of a sweet and gentle light before the midday sun becomes harsh. We can, if we like, read in the upper-left the faint green-and-white surgings of the sea on the headland, and perhaps the lines so strictly demarcating the soft pink and the radiant whites suggest to us a field and fences, with possibly a house or a small dam of water; these, however, are the merest suggestions of physical reality. His brush, one could imagine, moved almost automatically as he gazed, seeking to recreate for us the bliss of being young, with the whole day to paint, and a whole world to delight in.

THE VISIT
1966–67, oil on canvas, 60 x 48 in (153 x 122 cm), Tate Gallery, London

De Kooning has been accused of fearing and even hating women; certainly this is a violent picture, and so horrifying that one hesitates to call it a masterpiece. It is masterly, however, in the savagery of its execution and the power with which the artist destroys our expectations. Because there is so much pink flesh and because de Kooning had already painted large pink women, *The Visit* has been attached to his *Women* series. But this is too easy a classification, for the image is more like a slaughtered ox – something hacked at and partially devoured. It carries such power and conviction that one cannot look at it unmoved.

IF WE TIE DOWN DE KOONING'S *imagery too specifically, we spoil that glorious awareness of freedom. Prosaic talk about this rectangle or that being a field or a stretch of woodland turns what is actually a glorious evocation of place into what would then seem to be a rather unsuccessful attempt at topographical description.*

ONE WOULD NOT NATURALLY *link de Kooning to that other great Dutch painter Vermeer, but both have as their primary concern the glory of light. De Kooning is painting that extraordinarily tender and gentle first light, which floods freely over his American home, unveiling its beauty and mystery.*

ROSY-FINGERED DAWN AT LOUSE POINT
1963, oil on canvas, 80 x 70 in (204 x 179 cm), Stedelijk Museum, Amsterdam

DELACROIX, EUGÈNE 1798–1863 b. France
THE BARQUE OF DANTE

DANTE'S GREAT EPIC, *THE DIVINE COMEDY*, has always inspired artists, but few have measured up to its epic theme. Delacroix, one of the most ambitious of painters, was only 24 when he produced this immense canvas showing Dante with Virgil crossing the lake that leads to the city of hell. Virgil stands composed, occupying center stage, and he extends a compassionate hand to Dante, who understandably reacts in horror to the fearful scenes around him of anguish, death, suffering, remorse, and fear. In the background, the fire of hell darkens the skies. It is a melodramatic picture, and one could accuse Delacroix of turning the emotional screw tighter and tighter as he surrounds the floating barque with this terrifying catalogue of human misery.

THE BARQUE OF DANTE
*1822, oil on canvas, 74 x 95 in
(189 x 242 cm), Musée du Louvre, Paris*

ORPHAN GIRL
AT THE CEMETERY
*1824, oil on canvas, 26 x 21 in
(66 x 54 cm), Musée du Louvre, Paris*

Here, Delacroix shows his ability to empathize with human suffering while revealing little of the girl's story. The cypress trees and gravestones indicate that the setting is a cemetery. One hand lies in her lap, while her tearful eyes turn to someone beyond the frame to plead for alms. Delacroix infers with the wind that ruffles her curls and the gathering dark clouds that there is little hope for this orphan.

THE BRILLIANCE *and emotional conviction with which Delacroix has painted this vision of hell is remarkable. Every drop of water shines with lurid brightness on the white and putrid bodies of the drowned men that sprawl across the foreground. The hand of the poet is raised in horror and disbelief, mirroring the response of the viewer.*

THIS IS HUMANITY *at its most repulsive, kicking and screaming as it descends in agony into the chill of death. Yet the picture is anchored by the dignity of Virgil, the central figure. He is aware of the sorrow of man and yet is able to see suffering as part of a grand design. For a young artist, this large-scale painting is an incredible achievement.*

DELAUNAY, ROBERT 1885–1941 b. France

SIMULTANEOUS OPEN WINDOWS

DELAUNAY WAS ONE OF THE EARLIEST TO UNDERSTAND the revolution of Cubism, and he considered himself a Cubist, albeit one with a difference. As well as an interest in the shattering of form that Cubism had shown to be so exciting, he had an equal fascination in the shattering of color: he sought to apply the principles by which a prism breaks up light into its constituent parts to his own work. He became known as an Orphic Cubist (the term Orphic referring to Orpheus, the minstrel singer and poet of Greek mythology, who was torn to pieces by the wild women of Thrace). To give his paintings stability, Delaunay cunningly supported this fragmentation of color with some strong central motif. In our age, where high buildings are the norm, it is hard to appreciate the extraordinary significance for the Parisian of the Eiffel Tower. Delaunay found it an inexhaustible motif, and used the tower as a means to investigate the glory of color.

RED EIFFEL TOWER
1911, oil on canvas, 50 x 36 in (126 x 91 cm),
Solomon R. Guggenheim Museum, New York

Here is the Eiffel Tower again; this time not refracted through imaginary prisms but painted pillar-box red and then dislocated – splayed vividly across the canvas. In the upper corners of the painting, there seem to be curtains, and Delaunay mischievously shows them as of different colors. He makes only a playful reference to the world in which the tower stands: those great half-circles of yellow on the right might represent roads. Delaunay maintains just sufficient closeness to reality to keep this great fantasy from toppling over into the bizarre.

AT FIRST SIGHT, Simultaneous Open Windows seems to be merely glorious, incoherent patches of color, but it was actually painted from the top of the Arc de Triomphe, looking out towards the Eiffel Tower – we can see it quite clearly once we know it is there. Nevertheless, it is the interplay – the almost wanton mixture of hues, all held together round that familiar shape – that is the true motif of this strange and wonderful work.

DELAUNAY HAS FELT FREE to play creatively with the colors that he could imagine reflecting on open windows; the prism that has liberated these oblongs and shafts came from his imagination. He opens to us a sense of the beauty, excitement, and mystery of the world – a world in which color is free to move in its own patterns and obey only the laws that seem natural to it.

SIMULTANEOUS
OPEN WINDOWS
1912, oil on canvas, 18 x 15 in
(46 x 37 cm), Tate Gallery, London

DELVAUX, PAUL 1897–1994 b. Belgium

A SIREN IN FULL MOONLIGHT

IT IS DIFFICULT FOR US TO UNDERSTAND why Delvaux was considered so deeply shocking in his native Belgium. His nudes, after all, are never creatures of reality; they live in their strange dream world – remote, mysterious, and subtly threatening. Perhaps it is this menacing presence in his paintings that was considered to be so alarming by compatriots. Nothing could be further from the image of the trim Belgian housewife than Delvaux's siren, half-woman, half-fish, beached on her plinth and regarding, not us, but the fishy majesty of her tail. It is an enchanted world: the trees, so regimented and precise, line the avenue, and behind are the well-lit porticoes of classical temples. All is beyond reproach, until we look closely at the temples and notice the peculiarity of the sculpture. What strange, romantic scenes are being depicted, and why is the lamplight held up as if to illuminate us? On the other side, the trees are in darkness, and we cannot see beyond the mesh of the shutters.

THE RED CITY
1941, oil on canvas, 43 x 51 in (110 x 130 cm), Private Collection

There is a sublime silliness in Delvaux's work that never fails to attract. Here, amid a series of bizarre pairings in an unlikely setting, we puzzle as to whether the "red city" is the grave, red soil. Delvaux clearly imagined he was exploring his unconscious. It is the absurdity and innocence of this belief that gives his pictures their undeniable charm.

A SIREN IN FULL MOONLIGHT
1940, oil on wood, 44 x 71 in (112 x 180 cm), Yale Center for British Art, New Haven, CT

THIS IS A MAGICAL WORK *that seems to me to be completely without sexual provocation. This is not "woman as temptress" but "woman as alien". Delvaux depicts her enclosed in the secret world of her unknowable mysteries. This woman of fish is living on the land of man; she is distanced by Delvaux, seemingly with a mixture of fascination and fear.*

DEMUTH, CHARLES 1883–1935 b. US

I SAW THE FIGURE FIVE IN GOLD

I SAW THE FIGURE FIVE IN GOLD was painted in honor of Charles Demuth's old friend of nearly 25 years, the poet William Carlos Williams. It is perhaps Demuth's greatest work. The composition was inspired by a phrase from Williams's poem *The Great Figure*: "Among the rain and lights I saw the figure five, in gold, on a red firetruck, moving, tense, unheeded, to gong, clangs, siren howls, and wheels rumbling, through the dark city." Demuth's work is an interpretation of Williams's evocative imagery. Demuth chooses a vibrant red and yellow palette to raise the temperature and to create an emotionally charged atmosphere. What makes this work so magnificent is the orchestration of color and shape into movement.

MY EGYPT
1927, oil on board, 35 x 30 in (88 x 75 cm),
Whitney Museum of American Art, New York

My Egypt is one of Demuth's most personal and contemplative paintings. He chooses a utilitarian piece of farm machinery, the grain elevator, as his subject, but treats this American construction with monolithic grandeur, drawing a comparison with the pyramids of Egypt. The monumental simplicity of the elevator is clearly as satisfying to the artist as the geometry of an Egyptian temple. It has even been suggested that Demuth is thinking ahead to his death. His health was declining, and perhaps he saw this work as his memorial, just as the pyramids were to the Pharaohs.

WE SEE THE *fire truck as if moving at speed along the street. The great "5" emblazoned in gold fills the space, and then the "5"s become smaller and smaller as the truck hurtles into the distance with the sirens going. Williams's poem described this event in the rain, and so here we have the full drama of the slanting diagonals of rain whipping across the vehicle, reminding us of the treacherously wet streets, and filling us with exhilaration.*

THIS IS NOT JUST *a description in paint but truly a homage to the great American poet William Carlos Williams. There are several references to him in the painting. At the top of the frame is the name Bill, Demuth's nickname for his friend, and then to the right, picked out in lights, stands the nightclub Carlo. Finally, in discreet but precise lettering at the bottom of the frame are the initials "WCW", while in the center right, Demuth declares that this is "art co" – a joint artistic venture with the poet.*

I SAW THE FIGURE FIVE
IN GOLD, *1928, oil on board,
35 x 30 in (90 x 75 cm), Metropolitan
Museum of Art, New York*

DERAIN, ANDRÉ 1880–1954 b. France
SOUTHERN FRANCE

DERAIN CONSTANTLY EXPERIMENTED with different artistic styles, gaining freedom and confidence in his brushstrokes as he grew older. This lyrical and romantic picture of southern France is not typical of his work, yet it has that inner poetry that makes Derain, when at his best, such a splendid artist. Here, he divides the canvas into three distinct areas: the foreground is filled with blossoming trees, shimmering in the evening sun; behind the trees stands the dark mass of a hill, planted with rigid poplars and with a little stone town perched high on the ridge; then, above, the broad sweep of the bright sky echoes the luminous colors in the blossoming trees. This bracket of light seems to embrace the dark earth with its richness and comfort. Derain constantly stimulates our interest in this painting of contrasts. He draws long evening shadows over the fields and forests, and then cuts through the brightness with a road that leads up into the dark hinterland.

SOUTHERN FRANCE, 1927,
oil on canvas, 30 x 37 in (76 x 93 cm),
Phillips Collection, Washington, DC

PORTRAIT OF MATISSE
1905, oil on canvas, 18 x 14 in
(46 x 35 cm), Tate Gallery, London

Although Derain's work was always experimental, he was originally a disciple of Matisse. Derain was inspired by his early works, when Matisse and his followers were known as the Fauves – the wild beasts of color. Matisse taught Derain to use paint emotionally and to express deep truths. Here, Derain paints his teacher, boldly departing from an exact likeness to convey Matisse's strong and earnest character.

IN HIS FAUVIST *period, which is still the best-known, Derain juxtaposed brilliant swathes of color, using them to express an emotional rather than a literal truth. There is a touch of that here, not in the brilliance but in a use of color that is more poetry than prose.*

A CHURCH SPIRE *dominates the small town on the hill. It is echoed by a chimney, and then by the sharp verticals of a fortress-like group of trees. This is an enclosed, almost hostile, world, which contrasts with the radiant, puffball foliage in front.*

DEVIS, ARTHUR 1711–87 b. England

JOHN BACON AND HIS FAMILY

ALTHOUGH THE FIGURES APPEAR STIFF AND DOLL-LIKE, Arthur Devis has given us a most convincing idea of what it was like to be a well-born intellectual in the middle of the 18th century. John Bacon had gathered his family around him in his most elegant drawing room. Behind him, with classical restraint, are medallions of Milton, Pope, Francis Bacon, and Isaac Newton to show the cultivation of the family, while to the right, near the window, are scientific instruments to indicate that Bacon is a noted intellectual himself (in fact, he was a member of the Royal Society). But the father kindly encourages his young son, John William, with his flute playing. Two younger children, Charles and Catherine, are allowed to amuse themselves with a game of cards, while the youngest, Dorothy, clings to the skinny protection of her mother.

EDWARD PARKER
AND HIS WIFE, BARBARA
1757 oil on canvas, 50 x 40 in (127 x 102 cm), Spink-Leger Pictures, London

Fifteen years later, Devis had come to understand something of the solidity of the human anatomy. The bodies are far more convincing and the faces and gestures more individualized. Nevertheless, lifestyle remains his true interest; Parker shows by his air of nonchalance that he is a sportsman – we notice his spurs, and on the far right a horse emerges from the stables.

JOHN BACON
AND HIS FAMILY,
*c.1742–43, oil on canvas,
30 x 51 in (76 x 129 cm),
Yale Center for British Art,
New Haven, CT*

DE WINT, PETER 1784–1849 b. England

ON THE DART

THIS PAINTING SEEMS TO EXPRESS TO PERFECTION THE WARM and misty beauty of Devonshire. Even for De Wint, there might be an element of nostalgia here. This quiet world of the country was under threat by the Industrial Revolution. For us, of course, the poignancy can be almost unbearable. Here are pure, clear waters, here are trees and fields flourishing in the crystal air. De Wint does not choose a day of bright sun, but a cloudy day, in which light plays over the expanse of the landscape, and there is an almost intoxicating air of space and freedom. The pace of the cows and of the fishermen seems so perfectly compatible with the slow rhythms of nature, and there is a low bridge in the middle right to remind us that there is a way into this tranquillity as well as a way out.

HARVEST TIME
19th century, watercolor on paper, 12 x 20 in (30 x 50 cm) Lees Collection, Oldham, UK

Although De Wint calls his work *Harvest Time*, we feel that he is as interested in the sky as he is in the earth. Small, busy creatures gather the corn and pile it high, but above them is an infinite pale gold sky. Not even the cloud disturbs the peace, as the workers move in the rhythms of the past. De Wint sets his harvest in a world without signposts, looking up, so that the hay wain is silhouetted against that glimmering sky, and the basic labor of the fields becomes ennobled by its setting.

ON THE DART
*c.1848–49, watercolor on paper,
22 x 37 in (56 x 95 cm),
Fitzwilliam Museum, Cambridge, UK*

DIEBENKORN, RICHARD 1922–94 b. US
OCEAN PARK No. 136

DIEBENKORN'S BEST-KNOWN WORKS form a series of paintings, each entitled *Ocean Park*. Because so many of the paintings contain large expanses that are blue, one may be tempted to think that he is painting the ocean, but the name, in fact, comes from a Californian suburb. However, there is a certain truth here, in that the suburb is within sight of the great Pacific depths, and the precise squaring of the canvas, with its boxed edges and its geometric alignments, is a happy amalgam of the suburb – with the certainties of its enclosures, plots, and bisecting roads – and the pure freedom of the ocean, where color ebbs and flows by its own laws. Diebenkorn was always torn between realism and abstraction, and one senses that in these glorious (and, indeed, abstract) paintings, he is expressing something of the light, color, and freedom that is said to be typically Californian.

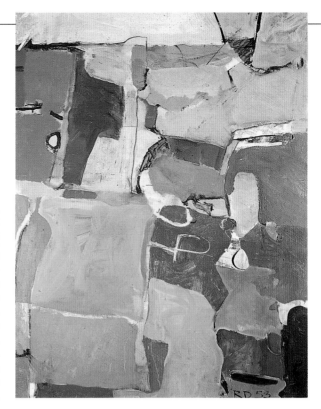

URBANA
*1953, oil on canvas, 66x 49 in
(168 x 125 cm), Private Collection*

Urbana suggests that the artist is looking down upon an urban area, yet nothing is made explicit. The eye is kept in motion as it moves across the planes laid out before us, much as the artist would be if he were sailing in a great balloon over an urban sprawl, catching its emotional color and occasional configurations, but unwilling to commit himself to the drab particularity of the specific.

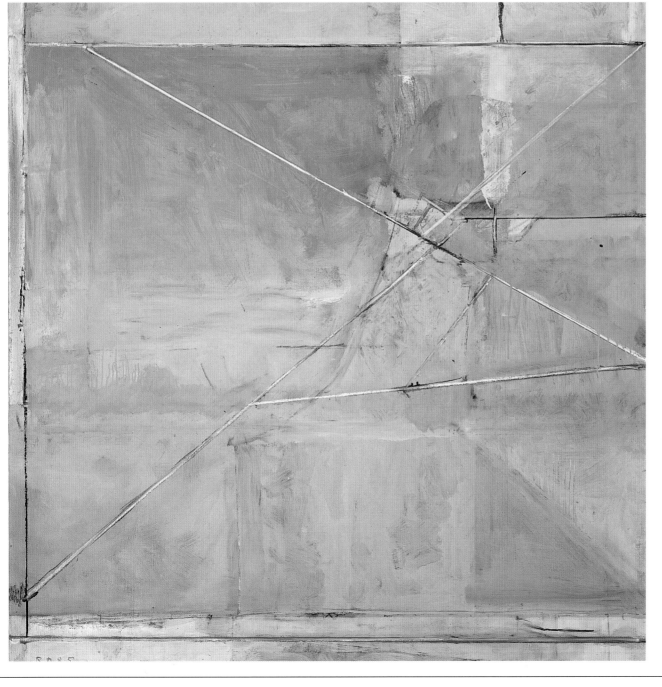

AS ONE LOOKS at the painting, one is struck by the diagonals, with their apparent inconsequence, and, behind them, one can sense subtle bands of layered and various blues mixed with faint pinks. It is as if the artist is playing with the whole concept of blueness. This, in turn, suggests water, in which we see various intensities of color and degrees of clarity as we look into, and through, it.

THE MORE one contemplates Ocean Park No.136, the more pure and subtle it appears to be. The red line at the bottom deepens and broadens as it moves to the right and, above it, a band of the palest orange is only free to reveal itself a third of the way across the picture. Such relationships of color and form mount up, and the picture begins to integrate itself into a complex and magnificent whole.

OCEAN PARK No. 136
*1985, oil on canvas, 60 x 60 in
(152 x 152 cm), Private Collection*

DIX, OTTO 1891–1969 b. Germany
SYLVIA von HARDEN

OTTO DIX WAS ONE OF SEVERAL young German artists who was devastated by the horrors of World War I. They opened his eyes to the cruelty and injustice of life, and, although he survived physically, his postwar work is deeply marked with bitterness. Sylvia von Harden represented everything that Dix feared and disliked about the Germany of his day. She was a prolific and aristocratic journalist, and one would not like to be the object of scrutiny of that monocle – pitiless, searching, and fundamentally as vulgar as the uncouthly baroque chair at her back. Dix sees her as a predator, perverse in her sexual ambiguity; she sports a male hairstyle yet her desire for female glamour is evinced by the stocking rolled down on her pin legs. The dress, too, is almost unisex, and although she wears a ring, her hands have a masculine sinuosity. This is a deeply unpleasant figure, and yet it wields an uncanny power. It is that twofold aspect of his contemporary world that Dix is struggling, successfully, to convey to us.

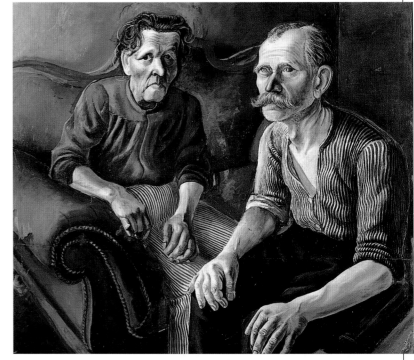

THE ARTIST'S PARENTS
1921, oil on canvas, 40 x 45 in (101 x 115 cm), Kunstmuseum, Basel

Here, Dix paints his parents. Worn out by the toils and narrowness of their lives, they are imprisoned in the corner of their room, in the confines of that torn sofa. They do not communicate. The father stares with icy severity at a world that has deprived him of the fruits for which those gnarled hands have labored. The mother's face brings us no more comfort. She looks at us more directly but she, too, is withered, turned in on herself by disappointment. Despite the sadness of their situation, Dix does not seem to regard his parents with sympathy, but almost with fear - they are menacing, inescapable reminders of duty and of failure. A harsh light falls upon them and Dix can apparently see no excuse for tenderness, still less for hope.

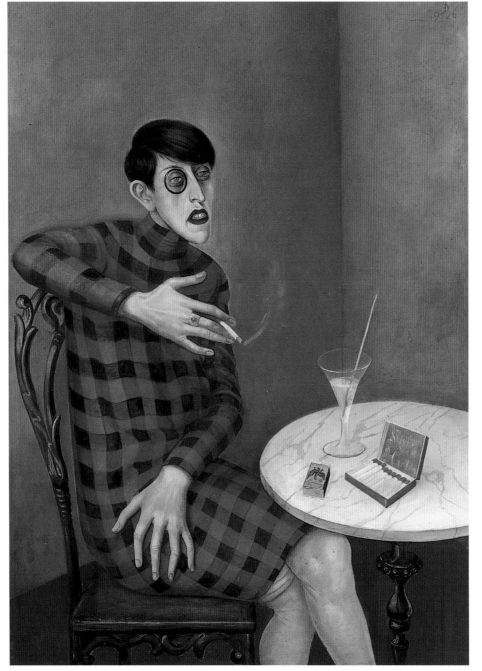

DIX HAS DARINGLY *set von Harden's red dress against a red background. Her red-tipped cigarettes rhyme with her large red mouth, open to show teeth that remind us perhaps of Little Red Riding Hood's grandmother. Her lean face, like a predatory weasel, is yet lipsticked and bemonocled and, although Dix regards her with cynical dislike, one cannot help but feel that, despite his will, he is affected by the secret voluptuousness of this figure.*

SYLVIA VON HARDEN *is intended to represent the height of that decadent glamour which, it is often said, gave Berlin an international caché. She smokes red-tipped cigarettes, and she has fashionable spritzer in her glass. The great Hapsburg eagle, the time-honored symbol of a powerful empire, decorates her matchbox – reduced to the fashion accessory of a rich woman who will order her own brand of cigarettes and have her own name printed on the box.*

SYLVIA VON HARDEN
1926, oil on panel,
47 x 35 in (120 x 88 cm),
Musée National d'Art Moderne, Paris

DOMENICHINO (DOMENICO ZAMPIERI) 1581–1641 b. Italy

THE LAST COMMUNION OF ST JEROME

THE WORK OF THE GREAT Baroque painters was instilled with the Counter-Reformation ideal that religious art should be profound, touching the heart rather than just delighting the senses. The glory of Domenichino's painting is that he achieves both with immense power. Emotionally, we are moved to witness the frail and aged body of the dying saint, carried to the church to receive his last communion. The lion, who was St Jerome's constant companion in the wild, grieves with Jerome's friends, and the whole picture is suffused with an air of tender reverence, of awe and wonder.

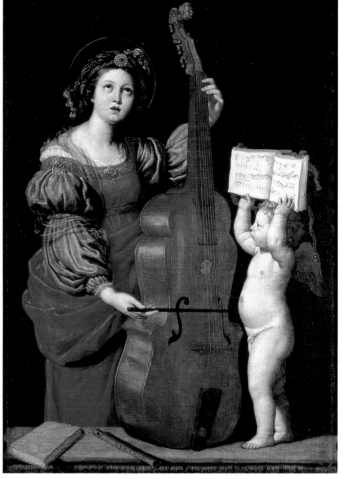

ST CECILIA WITH AN ANGEL HOLDING MUSIC
1620, oil on canvas, 63 x 47 in (160 x 120 cm), Musée du Louvre, Paris

Domenichino was a great lover of music and here he paints St Cecilia, the patron saint of music. Cecilia appears as a somber figure, sumptuously dressed in warm tones that echo the instrument she is playing. She is unaware of the angel who patiently acts as a music stand, and her expression suggests that she is drawing inspiration from a higher source – heaven itself. On one level, this is a very sensitive painting of a woman, cello, and child, but it is also a moving representation of what it means to make music of the spirit and receive inspiration from the Divine.

A RURAL LANDSCAPE set against the evening sky is seen through a great arch and offers a glimpse of the life that the dying Jerome is about to leave behind. The solid architecture can be interpreted as a symbol of the gravity of Jerome's biblical studies, while the wild vegetation is an emblem of his life of prayer and spiritual liberty.

THE HOVERING ANGELS, radiant in their innocence and beauty, await St Jerome, while the dimmer, earthbound figures still suffer with the saint. We see their beauty, too, in the shadowy richness of their garments and in their reverent faces. One tall candle soars heavenwards, clearly expressing that this is essentially a painting of spiritual aspiration.

THE LAST COMMUNION OF ST JEROME, *1614, oil on canvas, 165 x 101 in (419 x 256 cm), Vatican Museums, Rome*

DOMENICO VENEZIANO c.1400–61 b. Italy

ST JOHN IN THE DESERT

THE SCRIPTURES DESCRIBE ST JOHN THE BAPTIST as a man of great austerity, living in the desert, dressed in goatskins, and eating locusts and wild honey. In this revolutionary and strangely mystical picture, Domenico Veneziano imagines the young St John embarking on his unique and profound destiny. He has come into the desert and now strips off his worldly clothes – all that speak of ordinary, domestic life and the comforts of his home – and is about to clothe himself in animal skins and live without human comfort. The image irresistibly recalls that of a young athlete stripping down for combat or competition, laying aside all that would impede the struggle for victory. Something of this significance must have been in Domenico Veneziano's mind, too. The combat here is with the forces of evil and the victory is a purely spiritual one; yet, it will be a battle unto death, and St John will need total dedication to reach his goal and become the herald of Christ.

THE MARTYRDOM OF ST LUCY
c.1445–48, tempera on wood, 11 x 12 in (27 x 30 cm), Staatliche Museum, Berlin

Just enough is left of Domenico's work for us to appreciate how great is our loss. *The Martyrdom of St Lucy* is set in the most lucid of geometries, and at the picture's center is the drama of executioner and victim. While Lucy is austere in the massive simplicity of her faith, the tyrant who orders her death is small and remote on his puny balcony.

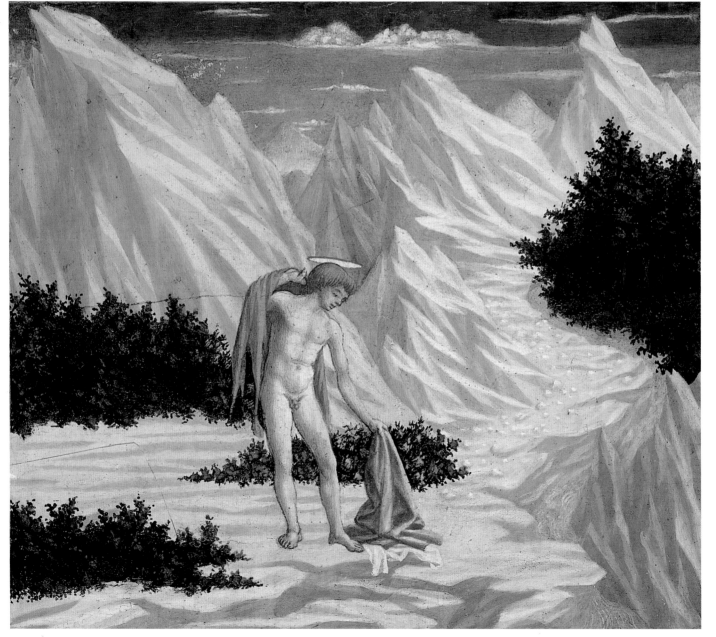

THE GREAT *sand dunes, which look like barren mountain peaks, summon St John upwards. That the way will be hard, Domenico makes very clear to us: the path, as the saint advances further into self-denial, is strewn with stones.*

ALTHOUGH *St John's privation is self-imposed, there is no sense here of a foolish desire for penance. The saint bathes in a golden irradiation, making clear that this new life is one of supreme fulfilment. In this context, the little stream of water that flows down on the right might even be thought of as the very water of life.*

ST JOHN IN THE DESERT *c.1445, tempera on wood, 11 x 13 in (29 x 33 cm), National Gallery of Art, Washington, DC*

DOSSI, DOSSO (GIOVANNI LUTERI) c. 1479–1542 b. Italy
MELISSA

DOSSO DOSSI, WITH HIS EUPHONIOUS NAME, seems to have been especially attracted to myths in which women alter the shapes of men. He painted a wonderful Circe, who had turned her lovers into animals, and here he deals with Melissa, who undid such evil works. Melissa is a heroine from Ariosto's great epic poem, *Orlando Furioso*, and here, as a white witch, she is working her spells to free heroes from the non-human forms into which they have been bewitched by the sorceress Alcina. Melissa's upward gaze directs our attention to two small, doll-like figures, reminiscent of shrunken pygmy victims, which are hanging from trees. As she holds her sheet of magic diagrams and sets alight her magic wand, we know that soon these trees are to be returned to human forms. The dog beside her looks intently at what we gather must have been his former suit of armor, and a rather sleepy pigeon perched upon it may also turn back into something recognizably human, if only we could stay longer in this enchanted moment.

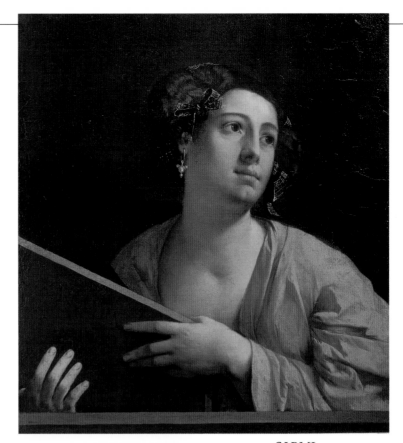

SIBYL
c.1516–20, oil on canvas, 33 x 27 in
(84 x 69 cm), Hermitage, St Petersburg

The sibyl was the pagan equivalent of the prophet – she was the wise woman who could see into the future. Dossi's sibyl is a glorious creature, with large, luminous eyes capable of prophetic vision. Yet she is so superbly of our world despite her profoundly spiritual calling. She adorns herself with all the charm of a society lady, with fanciful pearl earrings and an extraordinary arrangement of black and gold bows. It is this dichotomy, that foot in both worlds, that attracts Dossi.

ENCHANTMENT IS THE KEY *word here; not merely the enchantment of Melissa's spell, but the enchantment of an evening in the glorious countryside. Magic is, in its essence, an act of faith, but Dossi creates a surprisingly convincing image. He cannot prove that Melissa is a sorceress and that her spells will work, but, by the sheer beauty of the image, he makes us unwilling to doubt her identity or powers.*

MELISSA IS RADIANT *in her beauty, and Dossi elaborates every detail of her extraordinary costume, with its rich brocades, tassels, and patterns. Her costume – scarlet, blue, and gold in essence – sets off the noble head and the gold turban that crowns it.*

MELISSA
1520s, oil on canvas, 69 x 68½ in)
176 x 174 cm, Galleria Borghese, Rome

DOU, GERRIT 1613–75 b. Netherlands
A POULTERER'S SHOP

DOU WAS A PUPIL OF REMBRANDT and during the 17th century his work was more popular than his master's. Now, ironically, he is little known and only occupies a footnote in the history of art. What so enthralled Dou's 17th-century admirers was the perfection of his work. He was the first of what are known as the *fijnschilders*, "fine painters", who concentrated on small, detailed pictures and perfected their work until the brushstrokes were invisible (a very different approach to Rembrandt's). The technique rather than the subject matter was almost the most important aspect of the work. Most of Dou's pictures are very small, making it all the more astonishing that he could paint in such detail. One of the hallmarks of his work is the use of a grand niche, which he employs as a device to frame his subjects, however simple. Here, an elaborate stone niche with a carved relief of cherubim serves as a rather grand entrance to the poulterer's shop.

AN OLD MAN LIGHTING HIS PIPE IN A STUDY
17th century, oil on canvas, 19½ x 25 in (49.3 x 61.7 cm), Jonny van Haeften Gallery, London

Dou normally chose relatively ordinary themes. *An Old Man Lighting his Pipe in a Study* is a case in point. Here, he takes a commonplace event and lavishes the kind of artistic attention that would normally be reserved for a more elevated theme. Dou paints with such precision that you feel that you might be able to read the text written in the pages of the book propped up on the floor, if only you had a magnifying glass. Today, our admiration for this disciplined artistic skill has diminished, and the subject itself offers little to excite us. This is what one might call a masterpiece of craft – skill taken to its furthest limit, yet lacking in imagination.

THE CONTRAST BETWEEN *the humble wares for sale – the dead hare, the dead birds, and the live birds in their cages – set against the surprising grandeur of the surrounding arch is perhaps more incongruous to us than to Dou's contemporaries. The decorative lintel and carved relief on which the dead birds lie is actually a copy of a well-known sculpture by Francois Duquesnoy and appears in other paintings by Dou of the period.*

KINGS AND QUEENS *queued up to buy works of art such as this, not for their realism at capturing an ordinary event, but for the artist's skill at depicting a setting with such precision and his ability to draw us into a human relationship. In the poulterer's shop, both women are delightfully real, a contrast of youth and age. Amusingly, the older woman is brightly dressed, while the young woman wears a modish but relatively plain outfit.*

A POULTERER'S SHOP
c.1670, oil on wood, 23 x 18 in (58 x 46 cm), National Gallery, London

DUBUFFET, JEAN 1901-85 b. France
LARGE SOOTY NUDE

THIS EXTRAORDINARY, LIFE-SIZED nude is precisely the kind of painting that makes some people gnash their teeth and say "a child could do it". With respect to the artist, there is an element of truth in this critical remark. Dubuffet was attracted to what he called Art Brut (literally "raw art"). In the over-civilized world of 20th-century France, Dubuffet looked to the crude vitality in "poor people's art" – for example, the work of pavement artists – to find what he considered lacking in the elaborate "confections" of successful studio artists. On close examination, it is clear that this painting is not the art of an amateur but the art of a sophisticated and intelligent man who has turned to the immediacy of simpler, less contrived art forms for inspiration. Like the graffiti artist who scribbles energetically to make a shape, Dubuffet paints freely to bring the subject to life. His use of color is wholly beautiful, and here, he expertly plays with the human form, not to denigrate it, but to delight in its contours and its unique capacity to express emotion.

DUBUFFET SEEMS *to have scrawled his* Large Sooty Nude *on a chaotic background, marked with graffiti. If taken in isolation, the background is purely abstract, but it is dominated by the vitality of the woman. This woman is a different creature from the well-groomed models who posed in established studios; she is a grubby nude, displaying not just her hands but the mechanisms of her body with unashamed delight.*

LARGE SOOTY NUDE
1944, oil on canvas, 64 x 38 in (162 x 97 cm), Collection of Linda and Harry Macklowe, New York

SPINNING ROUND
1961, oil on canvas, 38 x 51 in (97 x 130 cm), Tate Gallery, London

Dubuffet's work always seems to arise from his personal experiences. For seven years he had immersed himself in the countryside, delighting in its earthiness, before realizing that in order to paint the earth the painter tended to *become* the earth and to cease to be a man or an artist. At this low point, he determined to return to the excitement of Paris, a city bustling with people and activity. This painting is an expression of how he felt on his return to the Parisian world. *Spinning Round* records the hectic over-stimulation that the artist experienced when he was plunged back again into the breakneck pace of city life.

" IT WOULD APPEAR THAT MY OBSESSION FOR REPRESENTING THINGS ONLY IN A RUDIMENTARY AND UNCERTAIN MANNER FORCES THE IMAGINATION OF THE VIEWER TO FUNCTION MORE VIGOROUSLY THAN IT WOULD IF THE OBJECTS WERE MORE PRECISELY REPRESENTED "
Jean Dubuffet

DUCCIO DI BUONINSEGNA c.1260–c.1319 b. Italy
NATIVITY

ALL THE USUAL ELEMENTS OF THE NATIVITY scene are here: the angels, the shepherds, the sheep, midwives bathing the baby, and Joseph. However, Duccio shows them forming a great framework under the rocks, in the midst of which is set the rough hut that is the stable. The true center around which all these actors circle is clearly the Madonna, outlined for us in scarlet and dominating her surroundings. Even the infant Christ, shown twice in the picture, seems secondary to this iconic figure, floating before us in the rich hues of red and blue – dominant in color and dominant in form. Duccio is making quite certain we understand that this is Mary's moment, this is Mary's story. Duccio sees her as infinitely fatigued. She has responded to God, she has brought forth the Savior, now she rests, too tired to do more than recline with folded hands. It is an understanding of the nativity that grows in significance the more we look at it. Mary's world, that of the enclosed stable, has blackness as its background. She herself is the only source of brightness. For everybody else – angels, humans, and animals alike – the background is the gold of bliss and heavenly joy. It is as if Duccio sees Mary having gone a step further than anybody else into a world of mystery, which, for the moment, is too much for her to grapple with.

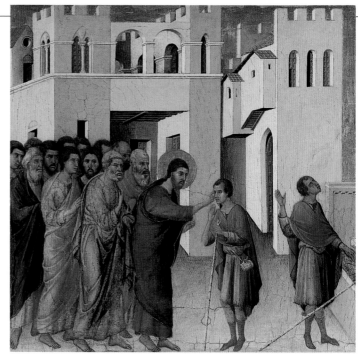

JESUS OPENS THE EYES OF A BLIND MAN
1311, tempera on wood, 17 x 18 in (43 x 45 cm), National Gallery, London

There are surprisingly few paintings of the miracles of Jesus. Here, Duccio shows us Jesus opening the eyes of a man born blind. Jesus is central and behind Him is a great colored wall of apostles, giving grace and power to the picture. They are not differentiated into specific individuals, but are a solid mass – His support. They are the Church, waiting in readiness to take over when Jesus is no longer with them.

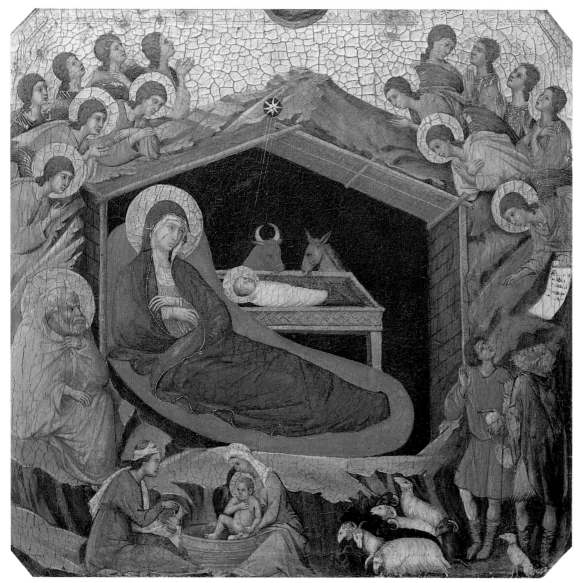

BETWEEN THE TWO figures of Christ is the majestic cocoon of Mary, showing only her face and her peaceful hands. The angels peer down at her, the shepherds look up at her, the sheep and the intelligent dog take an interest in her, and Joseph broods protectively over her. The gold of the sky is not literal but symbolic, and, for once, the star here indicates the place where Jesus lies, rather than the position of His triumphant Mother.

THIS PICTURE WAS originally part of the huge and complex painting called the Maestà, which Duccio painted for Siena Cathedral in Mary's honor. Apart from a large painting of the Virgin in Heaven, it was made up of small panels that detailed the events of her life and that of her Son. Christ here appears twice – as a small swaddled bundle in the manger and as a small naked child being bathed by the midwives.

NATIVITY
c.1308–11, tempera on wood, 17 x 17 in (44 x 44 cm), National Gallery of Art, Washington, DC

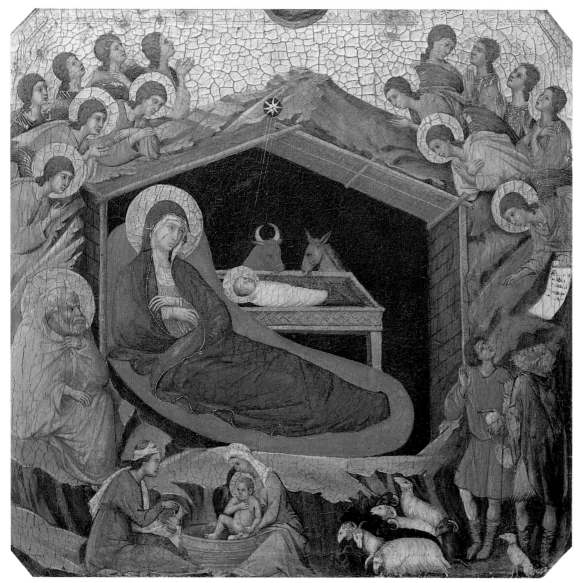

DUCHAMP, MARCEL 1887–1968 b. France, active France and US

THE BRIDE STRIPPED BARE BY HER BACHELORS, EVEN

DUCHAMP SEEMS TO BE THAT STRANGE ANOMALY – an artist who does not believe in art. We can take this back still further: he did not believe in reason or even in life, and yet from these disbeliefs he created works that still fascinate us today. In fact, as the great exponent of conceptual art – the art of the idea – Duchamp has had more influence over our century than even Picasso or Matisse. *The Bride Stripped Bare by her Bachelors, Even* is almost an anti-painting. There are two glass panels: the top is the domain of the bride and the bottom the domain of nine manly-molded forms of bachelors. Between the bride and the bachelors are the eternal, immovable bars that divide them.

NUDE DESCENDING A STAIRCASE, No. 2
1912, oil on canvas, 38 x 24 in (96 x 60 cm), Philadelphia Museum of Art

When contemporary art first came to America in force at the famous Armory Show of 1913, this was the work that so shocked innocent viewers, who had always regarded art as something comprehensible. Without the title, one could not tell what Duchamp was representing; with it, one can grasp that there is a figure moving down a flight of stairs. Typically, Duchamp is tantalizing the viewer by calling the figure a nude and then presenting what looks like copper machinery, clanking down the steps clumsily and heavily. The brilliance of the picture was that it forced the viewer to rethink attitudes towards an image, perhaps even to rethink attitudes towards the body and movement.

DUCHAMP IS CLEARLY PLAYING with the idea of "otherness" in respect of male and female genders. He is playing with the physical mechanisms – the machine mechanisms of the body – on the occasion when these two "others" meet most intimately on the night of marriage. With a lofty disregard for romance, he presents this union as something material, clinical, and almost as mindless and contemptible as the grinding of machinery.

THE BRIDE STRIPPED BARE BY HER BACHELORS, EVEN
1915–23, oil and lead wire on glass, 109 x 69 in (277 x 175 cm), Philadelphia Museum of Art

DUFY, RAOUL 1877–1953 b. France

INTERIOR WITH OPEN WINDOWS

DUFY WAS A SUPERB ILLUSTRATOR who turned his skills to a variety of media, from printing and designing fabrics to producing ceramics, illustrating books, and painting glowing accounts of the contemporary social world. He is acknowledged as a painter of note, but rarely regarded as a truly great artist. His work appears light-hearted and contains an effortless grace that is so difficult to achieve. It lives up to the medieval adage, "true art will conceal art" – the accomplished artist will never make the mechanical process of painting look difficult or labored. In *Interior with Open Windows* we are struck by the intense sweetness of the color palette – the brightness of a pure canary yellow set against the deep blue of sea, sky, and vase, and the crimson glow of the carpet. The whole scene vibrates with the pure joy of the artist's vision. We not only view the interior of this vivid room, but also see the mirrored image of what lies behind us – Dufy completely encloses us in the gay freshness of his technicolor vision. It is a small room, but the windows are flung wide open to the world.

NICE, THE BAY OF ANGELS
c.1926, oil on canvas, 24 x 29 in (62 x 74 cm), Galerie Daniel Malingue, Paris

Here, the viewer stands on a balcony looking into a glorious blue world. The sky is blue, the streets are blue, even the small white yacht is wrapped in the splendor of the water. It is only as the buildings rise up from the water that they take on their own color. Dufy does not wish us to take his picture literally; this is an enchanted world in an enchanted medium. It is the artist's vision that has created this world, not reality.

THE CITY, *palm trees, and mountains curve around the bay on the right, and then, as the buildings diminish in the distance, we reach the full intensity of the blue bay. Typically of Dufy, there are chairs on either side of the frame to relax us, and yet the invitation is not to slump in an armchair, but to move out through the open windows and breathe in the glory of the world that the sun reveals to us.*

IT IS DIFFICULT *to interpret every element in this composition. The chair and curiously angled structure reflected in the mirror are baffling; so, too, are the marks leading out from the open French window on the right. The suggestion seems to be that these marks are a visual abbreviation for steps leading out and down.*

INTERIOR WITH OPEN WINDOWS
1928, oil on canvas, 26 x 32 in (66 x 82 cm), Galerie Daniel Malingue, Paris

DUGHET, GASPARD 1615–75 b. Italy

A LANDSCAPE WITH MARY MAGDALENE

GASPARD DUGHET HAD THE VERY GOOD FORTUNE to be brother-in-law to Nicolas Poussin. The great French painter was 20 years his senior and trained his young protégé to be a landscape artist. Although Dughet's work never achieved the sublimity of his teacher's, he clearly grasped the significance of landscape and understood how it draws upon human longings and memories to transcend its actuality. Here, he is apparently illustrating the legend about Mary Magdalene in which she is said to have fled into the desert to live alone in prayer, clothed only in her hair. This green and lush world, however, is hardly the desert – Dughet does not seem to feel the need to adhere closely to the facts of the story – and here the saint is barely a stone's throw from a rustic peasant watering his cattle. The pale figure of Mary anchors the painting, but the real focus of interest is the view itself.

LANDSCAPE WITH HERDSMAN
c.1635, oil on canvas, 21 x 18 in
(54 x 46 cm), National Gallery, London

In the 17th century, it was difficult to accept that a landscape could be painted solely for the delight of its natural qualities. Nearly always, a story or some action had to be provided. Here, Dughet has painted a herdsman with his cows, and it has even been suggested that this is a mythological story. Whether it is or not is of no significance – the essence of the picture is the evening light as it comes through the trees, falling in dappled patterns over the cows, glimmering on the water, and revealing the distant hills and towers. He is painting a moment of quiet, and this in itself is sufficient justification.

A LANDSCAPE WITH MARY MAGDALENE WORSHIPPING THE CROSS, 1660, oil on canvas, 30 x 51 in (76 x 130 cm), Museo del Prado, Madrid

DUGHET HAS MANAGED to convey something of the stillness and evening chill that makes such a scene a place of prayer. There is even an unstated suggestion that if the Magdalene prays to the Cross, then does not the hard-working peasant pray in his own way as he leads his flock to the water?

WE FOLLOW THE SLOW passage of the river, with its twists and turns and its waterfall, back to the far bridge, where a city is spread out on the other side of the divide. Beyond that, the whole world stretches into the misty distance. We, however, remain with Magdalene in the cool, green quiet of the shade.

DUJARDIN, KAREL c.1622–78 b. Netherlands
PORTRAIT OF A YOUNG MAN

IF THIS IS A SELF-PORTRAIT OF DUJARDIN, as some scholars suggest, then we are looking at a young man in his early thirties, the son of a painter, and one who would spend much of his life traveling. There is, in fact, a restless look about this young face: the challenging eyes and the full mouth, which, beneath its whiskered moustache, looks slightly dissatisfied. Whatever his temperamental need to move away from his home town of Amsterdam, one thing is clear about this youth, and that is his delight in his appearance. His curls are artfully tousled in what may well be the height of fashion, and he is wearing a costly suit, with gold buttons and tassels, and all the lace that a gentleman needs for self-respect. The contrast of the sartorial elegance with the rather brutal vigor of the face makes it a memorable portrait. If this is Dujardin, the relative blandness of his usual work is all the more surprising. Perhaps as a rather vain young man only his own image could inspire a work of this quality.

WOMAN AND A BOY AT A FORD
*1657, oil on canvas, 15 x 17 in
(38 x 44 cm), National Gallery, London*

This is an image that both pleases and perhaps disappoints. There is an austere quality to the rather chalky nature of the paint. The woman may be lifting her skirts in order not to get them wet as she walks to the ford, but the little boy is lifting his garment for a far more practical purpose, and we may perhaps be grateful that the evening shadows to some extent obscure this childish activity.

THE YOUNG MAN'S *eyes meet ours with a challenging stare, or so it would seem at first. Then we notice that his gaze slides past us, over to the right, almost as if drawn away from the immediate into the distant. Yet the pathos of this rather hungry expression on so unformed a face is undercut by the care with which he has tousled those brown curls, affecting a casual look.*

DUJARDIN *has provided no setting – a fact that is all the more intriguing when we reflect that he was an artist who specialized in painting landscapes. Behind this youth, with his flowing locks and elaborate sleeves, is only a blank wall, forcing us to concentrate on his appearance, and his personality.*

PORTRAIT OF A
YOUNG MAN
*c.1665, oil on canvas,
24 x 21 in (62 x 53 cm),
National Gallery, London*

DÜRER, ALBRECHT 1471–1528 b. Germany
SELF-PORTRAIT

DÜRER IS THE FIRST OF THE GREAT GERMAN PAINTERS, and he is still the greatest.
He has the added distinction of being one of the first artists to be so fascinated
by his own appearance that he was drawn several times to the self-portrait.
We know, therefore, that as well as being a very great artist Dürer was an
exceedingly good-looking artist. We also know that Dürer shared this opinion.
The obsession with which he painted all portraits is almost terrifying, every
hair, every mark on the skin, every thread on the clothes noted and captured.
Yet this intense fascination with appearance is at its most profound when
he is looking at himself. This is Dürer just back from Italy, where he had
the heady experience of being treated as a person of importance – an artist.
The view of snow-capped mountains through the window is meant to
indicate that he has just returned from prestigious travels, and he presents
his person as being equally high and noble – the frame can barely contain
him. In his native Germany, artists were still classed as workmen, and
Dürer is here making a serious claim for the status of the painter.

WING OF A ROLLER
1512, watercolor on vellum with gold, 8 x 8 in (20 x 20 cm),
Graphische Sammlung Albertina, Vienna

Dürer had a mesmerizing power to see what was
before him. Here, he has taken merely the wing of
a roller, fascinated by the color of the feathers –
how they modulate from blues through greens to
palest aquamarines and out again to a blue-black.
Dürer's power to see, to respond, and to recreate,
is almost overwhelmingly tactile. It is not just our
eyes that respond, but our bodies. We feel those
feathers, and how they change from soft fluff near
the bone to a smooth rigidity as the wing develops.
Dürer has communicated his own sense of
the miraculous inspired by the dead bird.

DÜRER IS DRESSED *in very expensive and*
highly fashionable clothing, and he sports
a small beard (unusual and striking in his
native Nuremberg). The classiness of his attire
is the perfect foil for the hauteur of a still more
classy face. Perhaps what strikes us most of
all, apart from the sheer force of personality
blazing out of that quiet face, is the beautiful,
arrogant mouth and eyes. To all this, he has
added the inscription: "I have thus painted
myself. I was 26 years old. Albrecht Dürer".

THE CLASPED HANDS, *gloved and still,*
imply that Dürer has not actually "worked" on
his painting – it has somehow, miraculously,
come into being. And yet, Dürer is well aware
that this is all a majestic confidence trick. The
shirt alone, with its multitude of infinitesimal
pleats, and the moustache, with its multitude
of the finest and softest hairs, inevitably
reveal the extraordinary pain with which this
genius has scrutinized what was before him.

SELF-PORTRAIT, *1498, oil on*
wood, 20 x 16 in (52 x 41 cm),
Museo del Prado, Madrid

DURROW, BOOK OF late 7th century
LION

ALTHOUGH SCHOLARS FEEL FAIRLY CONFIDENT in dating the Book of Durrow to the late 7th century, they hesitate when it comes to nailing down the place where it was made. All we know is that somewhere in the British Isles a group of monks set about producing one of the most splendid manuscripts of Early Christian art. These pages, made in honor of the Word of God, are extraordinary in the richness of their decoration. Each Gospel began with a full-page illustration of the symbol of that Gospel writer. St Mark has as his symbol a lion, and here, stretching confidently across the page, is the attempt of a Celt – who had certainly heard of, but never seen, a lion – to produce an image of this ferocious creature. The art of the Celtic culture was instinctively abstract; it came late to the figurative style, and with difficulty. However, when it comes to suggesting power, savagery, and majesty, this lion is overwhelming in its brutal force. The body is formed of intricate patterning, but we are struck mostly by the strange, superimposed curlicues, which possibly hint at ribs beneath the skin, or perhaps play with the idea of the lion as a fabled and imaginary beast.

BOOK OF DURROW (LION)
late 7th century, illuminated manuscript,
9½ x 6 in (24 x 16 cm), Trinity College, Dublin

DYCE, WILLIAM 1806–64 b. Scotland
PEGWELL BAY

WITH THEIR INSISTENCE on absolute truth to nature, the Pre-Raphaelites tended to paint very slowly. It is all the more surprising then to find that William Dyce included a specific date of reference in the full title of this painting: 5 October 1858. His recollection of that time and place might be connected to the distant streak in the upper sky, for a comet was visible on that very day. Nevertheless, although searching that expanse of pale, lemonish air for the comet is intriguing, the full glory of this picture is in the extraordinary realism with which this moment is set before us. Dyce's family are gathering shells on the beach, and behind them, with almost photographic realism, rises the cliff, while fishermen and holiday makers still linger before sunset. The notes of color are so few – an orange shawl, a pink scarf, dark decorations on a hat – that the subtle modulations of the gray-white stone and gold and silver sea, punctuated by dark streaks of rock, take on a gentle power all of their own.

PEGWELL BAY, KENT:
RECOLLECTION
OF OCTOBER 5, 1858
1859–60, oil on canvas, 25 x 35 in
(64 x 89 cm), Tate Gallery, London

DYCK, SIR ANTHONY VAN 1599-1641 b. Belgium

CHARLES I, KING OF ENGLAND, HUNTING

SOMETIMES A SITTER AND AN ARTIST SEEM MADE FOR EACH OTHER. Van Dyck was a brilliant portrait painter of the aristocracy, but he came fully into his own when painting Charles I. Van Dyck made visible what Charles believed of himself: that his crown had been bestowed by divine authority. We see the very image of majesty, standing with assured confidence upon the soil of his great kingdom, which stretches out before him. The great oak bends as if in homage, as does his steed. Charles was, in fact, an exceptionally small man, but that is tactfully glossed over by van Dyck, who shows the king setting his small but aristocratic feet upon the land that he believed was unquestionably his. Although his subjects were already gathering in hostile groups, this portrait presents him as he would have wished – exquisite and benign.

A LADY AS ERMINIA, ATTENDED BY CUPID
c.1638, oil on canvas, 43 x 51 in (109 x 130 cm), Blenheim Palace, Oxfordshire, UK

Van Dyck's rare mythological paintings show him to have had considerable narrative skills. This may well be essentially a portrait, but it is also an episode from Tasso's famous epic of the crusades, *Gerusalemme Liberata*. Here, we see Erminia, delicately exposing a slender arm as she prepares to put on armor and search for her lover, lost in battle during the siege of Jerusalem. Behind her, a chubby and convincing Cupid points the way that love demands she must take. The story is merely touched upon, but no educated reader of the day would have required further explanation. It is a splendidly organized work, and for all its incipient flirtatiousness, there is a sense of resolute courage.

TO THE RIGHT *of the painting is the great charger, powerful yet demure, and appreciative of the groom's attention. Van Dyck manages to imply that this mighty horse is ridden with consummate ease by the hero who stands before us. The artist has portrayed Charles as the gentleman king, at ease with power and towering above his subjects with a natural nonchalance.*

IN HINDSIGHT *we can see the tragedy: that a man so remote from common humanity, so superb in his conceit, must be heading for a fall. It is easy to attribute such insight to van Dyck himself, and yet this would be an anachronism. Van Dyck paints Charles in his glorious hauteur and ostentation only with reverential appreciation.*

CHARLES I, KING OF ENGLAND, HUNTING
c.1635, oil on canvas, 105 x 81½ in (266 x 207 cm), Musée du Louvre, Paris

EAKINS, THOMAS 1844-1916 b. US
THE BIGLIN BROTHERS RACING

THIS IS PROBABLY ONE OF THE GREAT ICONS of American painting. In itself, the scene seems almost like a snapshot of reality. We notice that the racing skiff is not contained by the canvas and that another skiff is bearing fast up at

the bottom of the picture. Yet what Eakins has done is to convey, in a single painting, something of the courage, spirit of competition, and athletic force of late 19th-century America and show it in a setting of extraordinary beauty. The waters that for centuries were either disregarded or used as a primitive means of transport between isolated areas, have been cultivated into an area where men can extend their athletic abilities for the sheer pleasure of it – the sheer pleasure of action and competition.

THE GROSS CLINIC
*1875, oil on canvas, 96 x 78 in
(244 x 198 cm), Jefferson Medical College,
Thomas Jefferson University, Philadelphia*

Eakins was a great portrait painter with an innate sense of drama, and here we see these qualities at fullest stretch. The famous Professor Gross is lecturing as he and his assistants perform a delicate operation on the human leg. The patient's body is curled up on the operating table, while the anaesthetist holds a cloth to his face. One would think that this naked and suffering body would be the center of the picture, but in fact our attention is focused on the gleaming forehead of the professor.

THE BIGLIN BROTHERS
RACING, *1873/74, oil on canvas,
24 x 36 in (61 x 91 cm), National
Gallery of Art, Washington, DC*

ON THE DAY *that this contest took place, a great storm
caused the race to be delayed until the early evening.
Eakins, however, has used poetic licence to set the scene in
the light of mid-afternoon, with a brilliant blue sky above.*

WE CAN FEEL *the tension of the race because
Eakins has almost pushed us up against it. We
are there, with the Biglin boat sliding off the canvas
and a competing sliver of a boat creeping up behind.*

ELSHEIMER, ADAM 1578–1610 b. Germany, active Italy

THE FLIGHT INTO EGYPT

ELSHEIMER WAS SO GIFTED THAT HIS DEATH, in his early thirties, cut short what would surely have been an increasingly powerful career as a painter. Rubens, who venerated him, is said to have exclaimed that he would like to kill Elsheimer for dying so young. We are, however, left with some magical and enchanting paintings, usually small in scale (although not in impact), nearly always on copper, and quite distinct from any other work of the time. *The Flight into Egypt* is one of the most marvellous night scenes in art. Providing illumination on the far left is a fire, around which shepherds huddle in the enclosure of a grove of trees. On the far right is the natural, nocturnal light of the moon, which rises serenely in the heavens and is reflected with almost equal brilliance in the still waters of the lake. Above the twinkling diamond points of starlight is the white shower of the Milky Way, while below, the Holy Family make their escape into Egypt, their bodies lit by the supernatural brilliance of their own holiness.

NYMPH FLEEING SATYRS
c.1605, oil on copper, 5½ x 8 in (14 x 20 cm), Staatliche Museum, Berlin

Within its tiny compass, this picture conveys an immensity of mysterious meaning. All the light falls on two elements in the forefront: the nymph's clothes, and the nymph herself as she climbs naked out of the water. Looming out of the dark recesses of the scene come the satyrs. Will she escape? Elsheimer leaves the question open-ended. For one moment we enter into this crisis, and there we stay.

FLIGHT INTO EGYPT, *1609, oil on copper, 12 x 16 in (31 x 41 cm), Alte Pinakothek, Munich*

THIS MOVEMENT FROM LIGHT *to darkness, back to light, and into darkness again, evokes a profound sense of the loneliness of the journey we all make. Joseph carries a small lamp, and yet we feel that the light comes from the significance of the child they carry with them – it is an interior, unquenchable light.*

ENSOR, JAMES 1860-1949 b. Belgium
THE INTRIGUE

ENSOR WAS A MAN PROFOUNDLY SUSPICIOUS OF LIFE. He trusted no one and thought that all appearance was deceptive – and probably malicious at that – hence, his almost sinister delight in the mask and his revelry in the gross distortion of human forms and features. *The Intrigue* shows the warm, unhealthy closeness with which Ensor felt others were aligned against him. The center of the painting is occupied by a moronic and almost puppet-like man in a top hat, flanked by two hectoring women: the large lady in red to the right (who is perhaps the most realistic figure in the picture), laying down the law with open mouth and wagging finger, and his sanctimonious eye-rolling companion, wearing some sort of floral hat, who lays a stiff, proprietorial hand upon him. The whole impression is of a world of secret nastiness, inescapable, and encompassing even the little one, who lies like a twisted doll on the shoulder of the berating female. What makes this work worth looking at is the glory of the paint. It may be a sick vision of the world, but it is painted with manic gusto and terrific vibrancy in a radiance of color and light – almost an oxymoron.

STILL LIFE WITH RAY
1892, oil on canvas, 31½ x 39 in (80 x 100 cm), Musées Royaux des Beaux-Arts, Brussels

The ray is a wonderful example of Ensor at his most frightening. The radiance of the color serves to isolate for us a world that is half beauty and half ugliness. Even by itself, the great weighty mass of the ray – its face a rictus of accusation and pain – is disturbing. Put in its context, of what seems like a bloodied shell and agonized fish, we are left conscious of the grotesque reality of death and the irremediable fact of its presence.

THE INTRIGUE
1890, oil on canvas, 35 x 59 in (90 x 150 cm), Koninklink Museum voor Schone Kunsten, Antwerp

ALL AROUND LURK *half-real, half-monstrous creatures. On the far left there is a figure that almost seems to be a judge, in what looks like a wig, swallowing down or regurgitating a mass of white cloth. This is in turn linked to the bizarre figure beside him, who seems almost an emanation of the behatted woman.*

SOME OF ENSOR'S CREATURES *bear upon their faces expressions from the wild reaches of the artist's imagination: the clothed skeleton with lower jaw afloat, to the right; the toothy and pop-eyed creature behind; and, to the far bottom right, a head, less noticeable than the others perhaps, but memorable for its gaze of quiet malice.*

ERNST, MAX 1891–1976 b. Germany
FOREST AND DOVE

MAX ERNST WAS A COMMITTED SURREALIST, greatly given to invoking chance, seeking out the accidental, discovering a way in which an image could be given rather than created. This was the way, the Surrealists felt, to tap the unconscious, to use the "Freudian slip" as a gateway into a world that the rational mind feared to enter. A method of painting that Ernst frequently found helpful in his pursuit of this kind of artistic exploration was called frottage, in which textures and arbitrary shapes could be transferred on to paper by laying the paper directly on the uneven surface beneath and then rubbing with pencil or charcoal. He later applied the frottage technique to his oil paintings, which he called *grattages*. This involved laying a canvas covered with paint over rough wood or stone or another kind of uneven surface and then scraping the surface of the canvas with a spatula, accepting the accidental images that arose from the irregularity of the surface beneath as a basis for a picture. This is what he has done in *Forest and Dove*, and clearly these strange haphazard shapes have led him into the depths of his imagination.

CELEBES
1921, oil on canvas, 49 x 42½ in 125 x 108 cm, Tate Gallery, London

Ernst had seen a photograph of a Sudanese storage bin and something about its shape suggested to him an elephant. The title, *Celebes*, alludes to a childhood verse about an elephant from Celebes. He elaborates the central image of the sinister mechanical pseudo-elephant with an armored cuff and provides it with a horned head. A headless figure, eerily reminiscent of a mannequin, entices us towards an encounter with the beast, while fish swim in the sky and a tower of coffee-pots, spouts upturned like anti-aircraft guns, teeters by the side. Nothing in this painting is what it seems.

ERNST HAS SEEN *these arbitrary and accidental shapes as strange, petrified forms – a primeval forest, where there is no life or greenery, just these haunting sharp-edges and towering spikes. He attempts an illusion of realism by setting these sinister forms against the pale blue of the sky, but the center of the work is the caged bird, which some strange alignment of shapes has enabled him to see and elaborate.*

THIS IS THE MEREST *pictogram of a bird, with its buttonlike eye, round head, and body, and with a tail like the clasping fingers of a hand. Yet the bird, imprisoned in that airless, lightless world, seems to lift the red beak of its head despairingly towards the life and growth that the forest has forgotten.*

FOREST AND DOVE
1927, oil on canvas, 39 x 32 in (100 x 82 cm), Tate Gallery, London

EVERDINGEN, CAESAR VAN

c.1617–87
b. Netherlands

TROMPE-L'OEIL
WITH A BUST OF VENUS

AT FIRST SIGHT, IT SEEMS THAT EVERDINGEN has simply painted two marble heads: there is Venus, wreathed with laurel, and the small head of a child or cupid. But as we take a longer look, we see that Venus is an ambiguous image. She is clothed, or semi-clothed, in the softest pink, and her creamy bosom and swan neck might well be the living flesh of this most lovely of the gods. Even the lack of color in her lips could be excused, as she holds her face so resolutely in the shadows. Only the hair, perhaps, is a give away, but even the palest of gold does not have that marble-like fixity that we see. This is not a rhetorical question, and the more we look the more we wonder – a living Venus with the living leaves, or a statue?

DIOGENES LOOKING
FOR AN HONEST MAN
1652, oil on canvas, 30 x 41 in (76 x 104 cm)
Mauritshuis Museum, The Hague

The philosopher Diogenes said that he would have to go through the day with a lantern to find an honest man, and here is Diogenes in his peasant integrity. He stands in the market square, looking not, we are grateful to know, at us, but obliquely. The onlookers have been chosen from every strand of society, from wealthy cavalier to boy in rags. The painter is imagining how society would react to a presence from another era – the man who searches for truth. Despite the element of myth, Everdingen sets the scene solidly in the real world, on cobblestones upon which people cast real shadows.

THERE IS NO QUESTION *about the small head – that is clearly man-made. In its very lack of animation, the surprising absence of a neck, which makes it look as though the head has somehow poked through the flooring, it makes us all the more aware of the ambiguity of its lovely partner. Behind her rises a stately Grecian pillar, while the child, or cupid, has only an obviously carved decoration.*

VENUS WAS BORN OF THE SEA, *and there is a suggestion that we are looking out over the dark sea, perhaps the "wine-dark sea" of Homer. Evening falls and the goddess turns her exquisite head longingly to the waters from which she came and in which she is whole, not merely a portrait bust. This sense of the mystery of personality, matched by the dramatic play of light, gives this work a profound fascination.*

TROMPE L'OEIL WITH A BUST OF VENUS, *1665, oil on canvas, 29 x 24 in (74 x 61 cm), Mauritshuis Museum, The Hague*

EWORTH, HANS c.1520–after 1573 b. Netherlands, active England
SIR JOHN LUTTRELL

FEW PORTRAITS ARE AS AMAZINGLY UNCONVENTIONAL as Eworth's *Allegorical Portrait of Sir John Luttrell*. It is both a portrait in the full Renaissance sense and a medieval image of thanksgiving, which would have been commissioned to hang in a chapel by someone who had recently recovered from an illness. The threat of sickness or accident was omnipresent in 16th-century life, and with this painting Sir John Luttrell is celebrating his rescue from shipwreck and drowning. He does not, of course, express his gratitude as medieval man would do, with an image of saints sweeping him up into safety. Sir John Luttrell, as far as we can ascertain, is saved by a mental image of beauty and peace – a world of the gods to which he clearly aspires. He has received a scarf from his mistress at some more fortunate time and sworn, as was the custom, always to wear it. It is that scarf, and the remembrance of his mistress, that he feels saved him from disaster. Eworth portrays Luttrell as a Hercules figure, majestic in his power. He does not swim to safety but soars straight up from the water, while all around him we see images of the disaster that has struck lesser mortals – those without the mental capacity that inspired Sir John to superhuman feats.

PORTRAIT OF A LADY
c.1565–68, oil on wood, 39 x 24 in (100 x 62 cm),
Tate Gallery, London

Eworth painted for the Elizabethan Court iconic images in which the emphasis was not on power – as were Holbein's portraits of Henry VIII, for example – but on decoration. For an unbuttoned age like our own, this portrait is alarming. The sad and inward-looking face, with its downcast eyes that meet no others, is wholly human; so too are the lady's hands, but the rest of the body seems encased in armor, and all of its natural curves are crushed by the stiffness of the extraordinarily rich costume. We cannot see any of the vulnerability that, to us, is such an intimate part of being human, and this is precisely the effect Eworth is aiming for.

THE SHIP, WITH *lightning still cracking over it, is visibly disintegrating – masts are falling and waves are threatening. Ahead of Sir John is the rock of safety, towards which he is advancing, not with his eyes cast down upon the lowliness of earth but with his unflinching gaze on his heavenly inspiration.*

DESPITE THE EMPHASIS *on the tragedy, this remains emphatically a portrait. If it is not a depiction of what Sir John Luttrell actually looked like, it is certainly an image of how he wanted to be seen. He was clearly proud of his massive physique and sees himself as a man of destiny and of strong convictions, a man of fate who has been chosen by heaven.*

ALLEGORICAL PORTRAIT OF SIR JOHN LUTTRELL, *1550, oil on wood, 44 x 31 in (111 x 78 cm), Luttrell Collection, Dunster Castle, Somerset, UK*

EYCK, JAN VAN c.1390–1441 b. Belgium
ANNUNCIATION

WHETHER OR NOT VAN EYCK was the first artist to use oil paint, he was certainly the first to exploit its special and luminous qualities. Here, in a great medieval church, he depicts Mary interrupted in her prayers by an angel who has come to announce that she is to be the Mother of God. Mary's look of wonder and her elegant upturned hands are beautiful in themselves, but her beauty is heightened by the waterfall of blue material that envelops her. The robe's only ornamentation is its gold-edged hems, and yet, in its simplicity, it emphasizes the single-minded purity that is expressed in her face. The angel is a complete contrast: where Mary's expression is one of submissive wonder, his face is alight with what one can only describe as heavenly amusement. From the tip of his rainbow-colored wings and his jewelled crown, set over luscious curls that contrast with Mary's plain locks, the angel expresses completely the difference between heaven and earth. He is all splendor, color, and excitement, whereas she is earthly and quiet.

THE PICTURE is rich in symbolism. Above Mary, a stained glass window represents the God of the Old Testament. Adjacent to it are three plain windows that symbolize the Trinity of the New Testament. Above the angel, rays of light stream from the uppermost window, along which the Holy Spirit glides to rest upon Mary.

THE FLOOR is covered with images of Old Testament stories. Every detail we look at in van Eyck is fully focused; there is no blurring at the edges. The painting works on every level: on that of spirituality and religion, on the sheer wonder of its color and shape, and on the awareness that it gives us of material realities in an age long past.

ANNUNCIATION
c.1425–30, oil on canvas, 37 x 14½ in (93 x 37 cm), National Gallery of Art, Washington, DC

A MAN IN A RED TURBAN
1433, oil on wood, 13 x 10 in (33 x 26 cm), National Gallery, London

Before we look at *A Man in a Red Turban* we ought to look at the frame. Along the top is written Jan van Eyck's personal motto, "As I can", and at the bottom, "Jan van Eyck made me, 21 October 1433", recording the special day on which van Eyck finished this assured portrait. The half-humble, half-mocking "As I can" – "I" in Dutch is "Eyck" – suggests "As I can, but not as I would" (a Flemish proverb), or we could read it, "As I, and only I, can". The interpretation is up to us.

FABRITIUS, CAREL 1622–54 b. Netherlands

VIEW OF DELFT WITH A MUSICAL INSTRUMENT SELLER'S STALL

CAREL FABRITIUS HAS THE UNUSUAL DISTINCTION of being both a pupil of Rembrandt and the teacher of Vermeer. Also memorable is his untimely death in a gunpowder explosion. This fatal accident cut short an artistic career that might well have rivalled that of his master and of his pupil. *View of Delft with a Musical Instrument Seller's Stall* is astonishing in its originality. So bizarre is its perspective that it has been suggested that the work was meant to form part of a peepshow box – a construction occasionally employed by Dutch artists of the period to produce the illusion of three-dimensionality in their painting. Fabritius is certainly known to have used such devices, but whether this painting formed the image of a peepshow or not remains a mystery. In the center is the main church of Delft and curving around the church are buildings that still exist today much as they appear here.

VIEW OF DELFT WITH A MUSICAL
INSTRUMENT SELLER'S STALL
*1652, oil on canvas, 6 x 13 in (16 x 32 cm),
National Gallery, London*

THE GOLDFINCH
*1654, oil on wood, 13 x 9 in (34 x 23 cm),
Mauritshuis Museum, The Hague*

Fabritius painted this appealing picture of a goldfinch in the year of his death. It is an unforgettable image, partly for the visual interest the artist creates from depicting the ebb and flow of light on the wall, and partly because although the bird's perch is painted with precision, the bird itself is blurred and smudgy, as though at any moment it is about to attempt an escape. This is a bird quivering with desire, chained to earth, but longing for the sky.

ALL OUR ATTENTION *is concentrated on the street booth that sells musical instruments: a lute leans against the wall and gleams like a Surrealist pumpkin, while a viola da gamba, painted with fascinating attention to detail, stretches out in the foreground.*

FLANKED BY HIS MUSICAL *instruments, the sober and reflective merchant sits waiting for passing trade. Beyond the integrity of the foreground space, Fabritius has exaggerated the perspective of the cityscape, curving and compressing familiar landmarks.*

IT COULD ALMOST BE SAID *that this painting is an embodiment of music itself, rising and falling as a melody and harmoniously transforming this scene. The swooping flow of the painting melds the very fabric of the city, and the stone and wood become almost liquid.*

FANTIN-LATOUR, HENRI 1836–1904 b. France
STILL LIFE: CORNER OF A TABLE

FANTIN-LATOUR WAS FRIENDS with those impressive personalities Courbet, Whistler, and Manet, and yet he seems to have been extraordinarily immune to their influence. He did his own thing, which was the often under-appreciated art of painting still lifes and flower compositions. Here he combines both, with an intriguingly low view of a gleaming tablecloth. The foreground is filled with the wild extravagance of a rhododendron plant – the paleness of the exuberant white and pink blossoms is almost eclipsed by the rampant greenery of the leaves and stems. It forms an extraordinary counterpart to the human elaboration of the sedate table top. Here, we have flagon, wine glass, cup, sugar bowl, decanter, and fruit containers, all carefully ordered, all the product of human fashioning.

STILL LIFE: CORNER OF A TABLE
1873, oil on canvas, 38 x 49 in
(97 x 125 cm), The Art Institute of Chicago

PORTRAIT OF EDOUARD MANET
1867, oil on canvas, 46 x 35 in
(118 x 90 cm), The Art Institute of Chicago

Sometimes Fantin-Latour is so inept in dealing with the human figure that one could wish he had always stuck to depictions of flowers. When painting his friend Edouard Manet, however, he almost seems to regard him as having the beauty and poetry of a great flowerhead. The only strong note of color is that flashy blue cravat, but from the uppermost point of his tilted top hat to the elegant droop of his kid gloves, Manet is the gentleman to perfection: elegant, aristocratic, and at ease – a man of charm and grace.

FANTIN-LATOUR *has set up this whole scene with the care and ingenuity of a stage designer, and from the white expanse of tablecloth to the solid and somber wall-covering that encloses it, he has brought off* a tour de force *of visual pleasure.*

THERE IS A *demureness about this table top that is deceptive. The silver lid laid casually by the sugar basin and the strip of orange peel in the glass bowl may lead us to be convinced of the realism of the setting. But what is to go into the teacup? Where is the small glass for the liqueur decanter? Where is a plate on which to put the lemons or oranges?*

FEININGER, LYONEL
1871–1956
b. US, active Germany

MARKET CHURCH AT EVENING

LYONEL FEININGER IS UNUSUAL in that he was an American artist who spent most of his working life in Germany, only returning home when the Nazis came into power. He lived in Weimar, teaching in the famous Bauhaus school, where Klee and Kandinsky were fellow teachers. Feininger developed a vision of the world that is specific to himself, although dependent on Cubism for the fractured nature of its expression. He depicted the world in great slanting triangles. It is a world portrayed obliquely, formed, as it were, out of angled spotlights that meet and thicken and coalesce. Here, he is painting a market church in the evening light. It is a great Gothic sculpture, with black, indeterminate marks at its base – mere notations that manage to convince us of worshippers passing into the church, and which emphasize the massive scale of the building itself.

SAILING BOATS
1929, oil on canvas, 17 x 28 in (43 x 72 cm), Detroit Institute of Arts

In *Sailing Boats*, Feininger puts his vision of diagonals, triangles, and fractured light to superb use. Sailing boats moving rapidly over a broken sea lend themselves well to Feininger's triangular scheme, and the swooping movement here is exhilarating. We are buffeted by the overlapping diagonals of the sails and air, with the slanted waves underneath, and with the almost audible whistle of movement as the air hurls past; this is one of the most invigorating experiences in 20th century art.

MARKET CHURCH AT EVENING *is painted from a low perspective so that, as the church soars up with its pointed, triangular towers, our eyes follow the diagonals of color skyward. There is an extraordinary sense of height and grandeur. Feininger manages to simultaneously convey the strength of stone and the lightness of all things material.*

FEININGER'S VISION *extends beyond the architectural to the natural. The sky, too, is fractured and slanting, deepening the impression of a world that we see only in flashes and glimpses – a world that will never stand still for our contemplation. While in Paris, Feininger met the Orphic Cubist Robert Delaunay, whose experimentation with fractured color had considerable influence on Feininger's work.*

MARKET CHURCH AT EVENING, *1930, oil on canvas, 38 x 33 in (101 x 85 cm), Alte Pinakothek, Munich*

FETTI, DOMENICO c.1589–1623 b. Italy
MELANCHOLY

DOMENICO FETTI WAS A HIGHLY ORIGINAL ARTIST, but because he died young we will never know the full scope of his genius. *Melancholy* was painted at the very end of his life, and it is perhaps a picture touched with foreboding. We are reminded of Dürer's great etching *Melancolia I*, which sees melancholy not as mere depression but as the painful frustration felt by the deeply gifted. Fetti's Melancholy broods alone in a ruined and barren landscape, among gloomy, earthen colors. Her attention is focused on a skull, that inescapable emblem of mortality, reminding us that all we achieve is impermanence. She is surrounded by images that stress both the power to create and the lack of control that humanity has over its achievements. We see a painting, a book with crumpled pages, discarded emblems of astronomy, and a disregarded globe. The subject's melancholy is mental and spiritual. It is a compound of the essential loneliness of the human being and our ability to use our life as we wish – free will is both a blessing and a burden. This woman is beautiful, wealthy, intelligent; yet it is not what she has, but what she wants, that obsesses her.

AN ACTOR
c.1620s, oil on canvas, 42 x 32 in (106 x 81 cm), Hermitage, St Petersburg

Fetti was best known for his paintings of the parables. This portrait shows us the telling details of real life. The actor displays with great dignity the mask that signifies his calling, and yet there is a sinister conjunction between the hands pressing down inside the empty head of the mask and the finger thrust through the open mouth. There seems little in common between that long, narrow, rather aristocratic head (surely crowned with a wig) and the dark hollow eyes of the mask. That may be Fetti's point: the actor is removed from the characters he plays. In himself, he is an elegant gentleman; when he dons his mask, he becomes a creature of another kind.

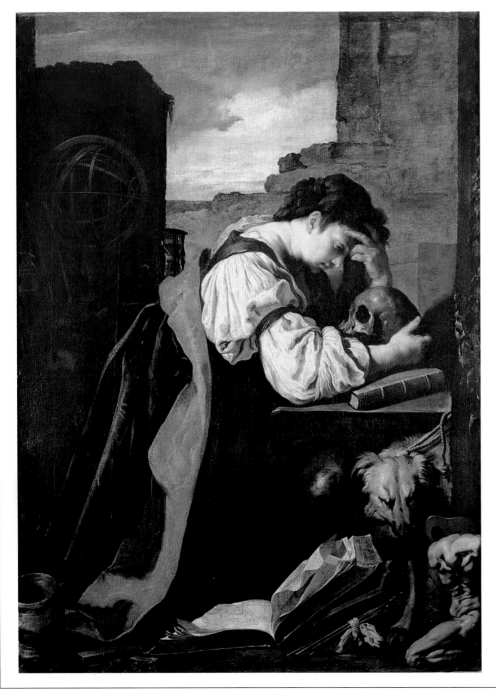

TIED TO THE TABLE, *the woman's only companion in loneliness is a dog, unkempt and unhappy, tense with hostility, apparently towards the plaster image of a human body on the lower right. The dog's coiled tension contrasts with the weary posture of the woman, who slumps in her misery, with drooping head and heavy limbs.*

THE DOG MAY BE *a reference to Sirius, the Dog Star, which the ancients thought exerted a powerful influence over mood, especially over temperaments given to melancholy. The woman does not share the distress of her animal companion – the dog is unhappy because it does not understand, and therefore feels threatened, whereas it is precisely her intellect, her capacity to understand, that generates her melancholy and sets her apart.*

MELANCHOLY, *c.1620, oil on canvas, 67 x 50 in (171 x 128 cm), Musée du Louvre, Paris*

FONTAINEBLEAU, SCHOOL OF c.1530–1560 active France

GABRIELLE D'ESTRÉES AND ONE OF HER SISTERS

THE SPLENDID AND EXTENSIVE decoration of the royal château at Fontainebleau was an ambitious project initiated by Francis I of France in 1528. French artists were not used for the project but a number of great painters from Italy were employed instead, and they were responsible for introducing the Mannerist style to France. The Mannerist painters and sculptors adapted their own techniques to the demands of the French court, creating slender and sensual images in a style that is distinctive in itself, and somehow typically French. Forty years later, there was another influx of major artists to create the second School of Fontainebleau. Here, we see Gabrielle d'Estrées and one of her sisters in the bath – an artistic pretext for displaying nudity while maintaining some modesty. "Display" is the key word: a curtain has been drawn aside and the two naked women pose for the viewer's pleasure. While Gabrielle delicately holds the ring that must be a gift from the King, her sister – with extraordinary directness – draws our attention to Gabrielle's sexual attributes that have brought her to the position of royal favor in which she glories.

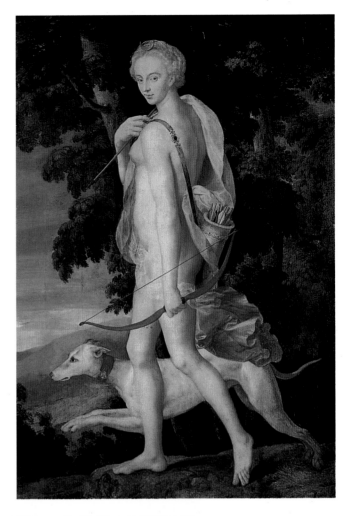

DIANA THE HUNTRESS
c.1550, oil on canvas, 75 x 52 in (191 x 132 cm), Musée du Louvre, Paris

This splendid work belongs to the first phase of decoration at Fontainebleau. The strongest personality at the court of Henry II (successor to Francis I) was his mistress, Diane de Poitiers. Here, she is depicted as the goddess Diana. Her legs move with grace across the hillside, while the dog beside her bounds energetically forward. Diana strides on with speed – this is Diana the Goddess of Hunting in pursuit of her prey.

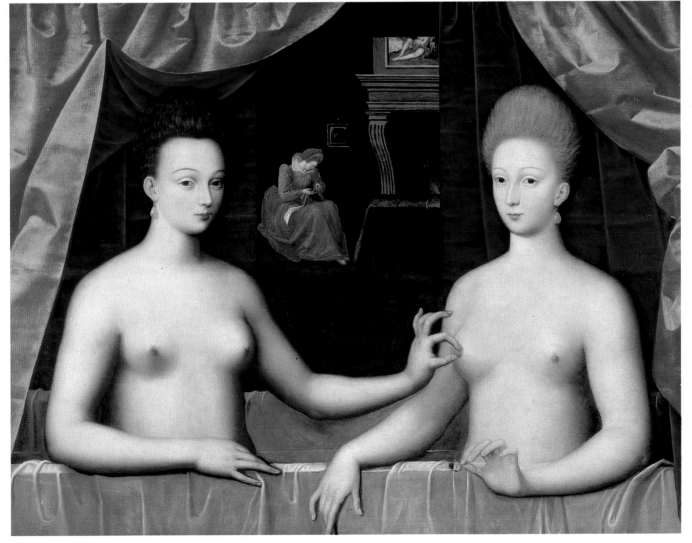

A FULLY-DRESSED *maid in the background makes it even more apparent that this nude display is only common behavior for the favorites of King Francis. Yet the two gentlewomen hold our gaze with ladylike indifference to their naked state. It is the activity of their fingers that remains the most baffling element in this extraordinary image.*

ON ONE HAND *this image seems perfectly unambiguous – two beautiful, well-bred ladies in the bath displaying their womanly charms. Yet neither lady seems aware that this is what she is doing, and we feel that there is some hidden message in their pose that the modern-day viewer cannot understand.*

GABRIELLE D'ESTRÉES AND ONE OF HER SISTERS *c.1590, oil on wood, 38 x 49 in (96 x 125 cm), Musée du Louvre, Paris*

FOUQUET, JEAN c.1420–81 b. France

ESTIENNE CHEVALIER WITH ST STEPHEN

ESTIENNE CHEVALIER WAS ONE OF THE GREAT authority figures of mid-15th-century France. He was also a great patron of the arts and the first to see the profundity of Jean Fouquet's graphic powers. Here, Fouquet portrays him in the company of St Stephen. St Stephen was stoned to death, and so, to recall his terrible martyrdom, on his great copy of the Scriptures, he carries nothing so inferior as a pebble but a large, sharply gleaming rock – an object worthy of the distinction of smashing so distinguished a skull as that of St Stephen. The saint presents a noble, austere semi-profile, aloof in his concentration on the spiritual reality beyond the confines of the painting. Yet one saintly hand rests with tender delicacy on the quilted back of his aristocratic companion. Fouquet does not flatter his patron, and the grim and ungenerous face of Chevalier is shown in all its swarthy power.

ESTIENNE CHEVALIER WITH ST STEPHEN, c.1450,
panel, 37 x 34 in (93 x 86 cm), Staatliche Museum, Berlin

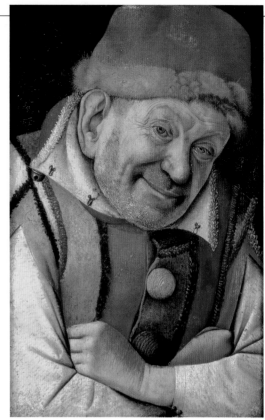

PORTRAIT OF THE FERRARA COURT JESTER GONELLA
c.1442, panel, 14 x 9 in (36 x 24 cm),
Kunsthistorisches Museum, Vienna

If Fouquet seems an artist drawn to the aristocratic and powerful, this little picture of a court jester shows another side of his character. Here is the face of a man without the need to massage his ego, a face wholly benign with its small twinkling eyes, bulbous nose, and wry smile above the unshaved jaw. It is the picture of a man of little importance in the world's eye, but of much warmth and value as a human being. This is humanity without trappings – an extraordinarily attractive image – and it sheds a light on Fouquet's sensibilities that he could recognize it.

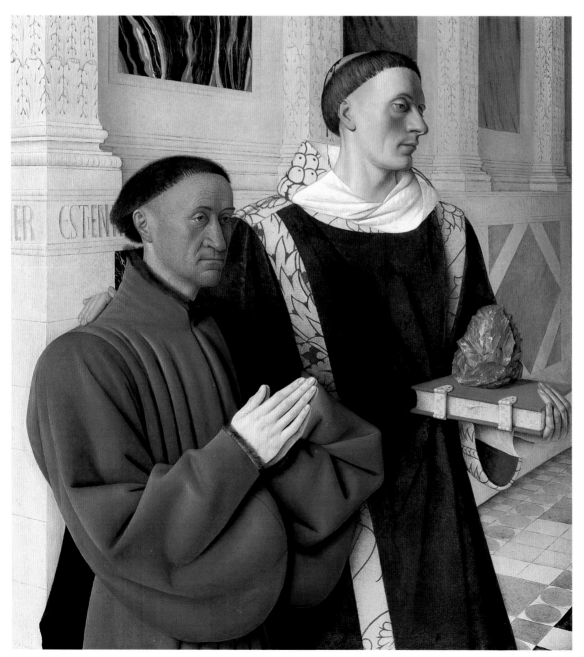

CHEVALIER'S IS A FACE *that gives nothing away, and even his voluminous and thick garment displays only the most subtle hints of luxury at the neck and sleeve. His white, praying hands rhyme with the whiteness of St Stephen, although his face is ruddy and dark. Fouquet makes no disguise of St Stephen's martyrdom: the saint not only carries the stone, but a trickle of blood snakes from his crown to his neck.*

DESPITE THE SUBTLE *reminders of his death, the saint seems invulnerable; by implication, the same implacable strength, resistant to all except rock as hard as themselves, applies to Chevalier. The whole setting is of hard stone, with marble floor and walls. Looking at the blood trickling down Stephen's neck, we become aware that only a rock as adamantine and glossy as that which he displays on his Bible could dent the surface of so chiselled a figure.*

FRAGONARD, JEAN-HONORÉ 1732–1806 b. France
A YOUNG GIRL READING

FRAGONARD IS THE GREAT MASTER of the style we call Rococo (the very sound of that word suggests that this is not a wholly serious way of painting). It was the style beloved by the *ancien régime*, the world of France that came to end with the Revolution. It was all soft colors, curves, gaiety, a delight in frivolity and pleasure, yet it was practised by truly great painters such as Fragonard. The world in which he feels at home is that of beautiful youth, but even the most charming of young women has more in her life than flirtations or party going, and here Fragonard is in a more reflective mood. *A Young Girl Reading* shows the full extent of his gifts. The very tilt of that little nose, the uprush of that warm, brown hair with its ribbon, and the positioning of the fingers, tell us that this is not a young woman reading philosophy or studying her Bible; she is more likely reading poetry or a novel, happily rapt in a world of imagination.

THE STOLEN KISS
c.1788, oil on canvas, 18 x 22 in
(45 x 55 cm), Hermitage, St Petersburg

The Stolen Kiss is what we think of as an absolutely typical Fragonard. He depicts in all its gentle drama the moment in which the young woman, who has left the crowded salon on her right to pick up her scarf, is surprised by an embrace from her lover. Fragonard maintains a delicious ambiguity: one hand seems to half repel the girl's suitor, and yet her body bends towards him. As always in such a situation, Fragonard sets up an implicit narrative. Is she keeping quiet so as to avoid scandal – her friends, after all, are very close – or does she welcome this embrace?

WE SEE THE SILKS *tighten over the young breast, with the flurry of ruffles removing the image from anything that savors of heavy sexuality. We see the tender neck with its laces; we see how the artist's eye was attracted as much to the cushions with those wonderful broad streaks of paint that make them so tangible as it was to the bunches and flounces of the deep yellow of her gown.*

THIS IS A WORK BY *a master painter who fully understands the technicalities of his craft and who directs them quietly and brilliantly to achieve the impression that he seeks. What Fragonard seeks here is to show us the innocent bloom of young beauty, and its capacity for reverie. He depicts a young woman on the brink of leaving behind the tranquilities of domesticity and about to launch into the world which, at the moment, she knows only through books.*

A YOUNG GIRL READING, *c.1776, oil on canvas, 32 x 26 in (81 x 65 cm), National Gallery of Art, Washington, DC*

FRANCIS, SAM 1923–94 b. US
RED AND PINK

DURING WORLD WAR II, SAM FRANCIS was a pilot serving in the American Army Air Corps. He had an accident towards the end of the war which developed into spinal tuberculosis, and he was forced to spend several years on his back in army hospitals. It was this prolonged period of illness and convalescence that gave him the opportunity to investigate painting. At first, his work was conventional, but then as he grew in confidence he began to express himself in original works that were predominantly blood-red in color and suggestive of bodily tissue. This concern with his own blood, his fear about his future health, slowly modified into works such as *Red and Pink*, which he painted later, released from the hospital and healthy. On this very large canvas, Francis has slowly created for himself a sense of space and freedom.

AROUND THE BLUES
1956/7, oil and magma on canvas, 43 x 76 in (108 x 192 cm), Tate Gallery, London

The title of this very large picture suggests an analogy to jazz. Just as the jazz musician creates around a theme – sweeping up and down, a crescendo here, a diminuendo there, following solely the push of his interior music – so is Francis playing with color. The white is actually that of the canvas itself, the ground, and on it he has lavished oil with complete yet controlled freedom.

THIS IS A VERY EARLY *painting, and it has been suggested that its hazy fluidity may owe something to the artist's move to Paris in 1950. Californian light has a brilliance very different to the soft, almost watercolorlike luminescence of* Red and Pink *– so expansive, so gentle, and so subtle.*

WE CAN STILL SEE HERE *a suggestion of blood cells, but Francis has moved from an anxious personal involvement to an understanding that behind the pink and the red is a translucency of white. This is not a painting by a man controlled by his body, but a man controlled solely by his own imagination.*

THERE IS ENORMOUS *balance here, enormous patterning. Francis floats the picture, softening here, thickening there, understanding that what he is doing is to create an image of shimmering light over which flow soft areas of both almost transparent pink and more intense red. Francis uses color purely to create and the creation is an act of joyful freedom.*

RED AND PINK, *1951, oil on canvas, 82 x 66 in (208 x 167 cm), San Francisco Museum of Modern Art*

FRANKENTHALER, HELEN 1928– b. US
MOUNTAINS AND SEA

THROUGHOUT ART HISTORY, ARTISTS HAVE painted on a support: wood or wall or canvas. Helen Frankenthaler changed the whole story of painting when, in 1952, she created *Mountains and Sea*, not by painting on her canvas but by painting in it – by staining it. She laid an enormous piece of canvas on the floor and onto its porous surface poured thin paint from coffee cans. It was by no means an exercise in sheer abstraction. She had visited the mountains and sea and came back knowing that, as she put it, "the landscapes were in my arms". In her mind, it was clear that she was creating not a representation of landscape (she says the title is merely a "handle with which to grasp the painting"), but an experience of landscape, a sense of being there, amidst the vastness of the sunlit mountains and the vastness of the great expanse of sea.

MOUNTAINS AND SEA, *1952, oil on canvas, 87 x 117 in (220 x 298 cm), National Gallery of Art, Washington, DC*

FRANKENTHALER CREATED *an incredibly daring way to paint. There was clearly control in her method, but she took risks and used no brush to guide her. The picture struck all who saw it and immediately gave rise to a new kind of painting; she, however, has not been bettered.*

BRIDE'S DOOR
1967, acrylic on canvas, 82 x 61 in (210 x 154 cm), Collection Becy and Pete Smith, Sun Valley, Idaho

This is a majestic painting of great confidence. It is not, we feel, a work planned and composed, but one that took on its meaning for the artist as it took shape on the canvas. Frankenthaler seems to paint from a deep poetic instinct. There is a great opening here – a door if we like – giving way to the complete unknown that is marriage. Frankenthaler does not paint bridal experience, and yet the title is not inappropriate for this image.

FREUD, LUCIAN 1922– b. Germany, active UK
THE PAINTER'S MOTHER

MANY PEOPLE WOULD SAY THAT LUCIAN FREUD is the greatest British painter of the 1990s; others might even say the greatest painter anywhere. He may be a great painter, but he is never a comfortable painter. He makes us confront nakedly the truth of our bodies, and perhaps that is where his greatness lies. He is the great painter of flesh, which he seems to see with an objective intensity that reminds us of a scientist and his microscope, or even, perhaps, a pathologist and his scalpel. Here, he is painting his mother. Every mark, every bruise, every wrinkle, every arthritic swelling on that ancient flesh is scrutinized with almost brutal candor. The subtleties of gray in her thin hair, the loose skin around the neck, the tight mouth, and the eyes looking ahead – confronting, surely, nothing now but death – are all put before us with a ruthlessness that yet conveys infinite respect. We do not feel that this is his mother and he loves her, but that this is matter infused by spirit, and he pays it the reverence of the keenest attention. The work is a tribute to the capacity of the eye truly to look and of the hand truly to transcribe what is seen. All artists strive to achieve this, but few succeed.

CYCLAMEN
1964, oil on canvas, 18 x 19 in (45.5 x 49 cm), Private Collection

Freud's extraordinary awareness of the physicality of the body responds equally to the physicality of nature. These are not consoling cyclamen, aloof and beautiful, but aggressive – the great fleshy blossoms almost blood-stained as they struggle to raise themselves above the leaves. It is nature in combat, and yet wonderfully controlled by the artist's power.

THIS IS A *picture structured on one great horizontal, and then a succession of verticals: from the head of the bed, the blinds, the mother's bony arm, the chair, and then finally petering-out in the long, oblique line of her foot and ankle.*

ONE OF *the wonders of this painting is the subtle use of white: the creamy off-white of a crumpled pillow; the wisps of hair; the light and shadows of the dress; and the window-blinds, where white has flowered into the gold of sunlight.*

THE PAINTER'S MOTHER
1982–84, oil on canvas, 50 x 142 in (105.5 x 127.5 cm), Private Collection

FRIEDRICH, CASPAR DAVID
1774–1840
b. Germany

MONK BY THE SEA

RENAISSANCE ARTISTS FELT THEY HAD TO justify a landscape by providing a religious theme. However, for an 18th-century artist like Friedrich, the positions were precisely the opposite: religious themes were considered threatening. The genius of Friedrich was to show nature as nature and yet have it convey a religious meaning. *Monk by the Sea* may well be his masterpiece. At one reading, it is a naturalistic image of sky, shore, sea, and a figure standing there alone; it needs no great insight to see the symbolic force of this. But the figure is a man of God (this is a monk, remember, not a knight or a merchant), and he presents himself alone before the great drama of nature. He turns his back on the semi-cultivated enticements of flower and field as he stands on the barren sands, confident in the human ability to accept the immensity of the world, without flinching and without diminishment as a human being. It is a picture that proclaims the work of the individual and the individual in contact with his God. *Monk by the Sea* conveys the sublime translucency of nature's forces and portrays a world that speaks to us of a mystery beyond it.

MONK BY THE SEA, *1809, oil on canvas, 43 x 68 in (110 x 172 cm), Staatliche Museum, Berlin*

THE MONK IS IN CONTACT *with his God, although there is no religious iconography or specific appeal to Christianity. Later artists have delighted in the color, the abstract play of paint, and surely this amounts to an enforcement of Friedrich's message – that the world in itself is so beautiful that it proclaims something greater than itself.*

WINTER LANDSCAPE
c.1811, oil on canvas, 13 x 18 in (33 x 45 cm), National Gallery, London

Here, Friedrich's religious symbolism is more obvious. In this world of emptiness and snow, we see in the distance the faint outline of a Christian church and, in the foreground, a discarded crutch. We are left to infer for ourselves that some pilgrim, struggling through this hostile world, has been healed by the Christian vision and enabled to discard his crutch. Only close scrutiny reveals the man himself, praying before the crucifix in the recesses of the tree. Significantly, the clump of trees presents a similar silhouette to that of the church.

FROMENT, NICOLAS
active 1450–c.1490 b. France, active Italy

THE BURNING BUSH

THE BIBLE TELLS US THAT WHEN MOSES came upon a bush that burnt and yet was never consumed, he took off his shoes because he knew that he was in the presence of holiness. Froment has taken this incident as the basis for a remarkable narrative. At the bottom right there is the figure of Moses, awed and bewildered, struggling to remove his second shoe. His knowledge that he is on holy ground comes from the presence of an angel – radiant in his dignity and superbly beautiful. The very presence of the announcing angel reminds us, of course, of the Annunciation, and, in fact, it is the Virgin who forms the true center of the picture. Froment has had the visionary audacity to raise the bush into the skies. Flames can be seen flickering around the edges, and it stands not upon a trunk, but on several large tree trunks on a steep plateau, totally dominating its surroundings. It is a surreal bush, completely out of proportion to the landscape. Its message was one that the Church was quick to seize upon: the bush was seen to signify Mary's virginity, always on fire, never consumed, and it is Mary the Virgin with her Child who sits enthroned, as it were, in the bush, floating free in the heavens.

THE BURNING BUSH
1476, tempera on wood,
161 x 120 in (410 x 305 cm),
Cathédral Saint-Sauveur,
Aix-en-Provence, France

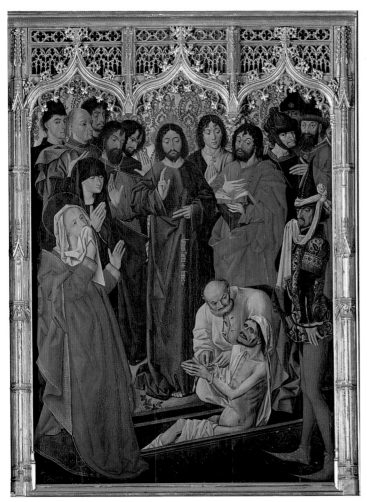

THE WORLD BENEATH *the vision is lovingly detailed – a landscape of infinite variety, which in itself adds a sense of strangeness to the scene, because the bush completely overshadows not only Moses, the sheep, and his angel, but also the entire world beyond.*

THE PICTURE MOVES *with almost comic intensity from the spotlit bare foot of Moses at the bottom, through the dog and the sheep, to the little cave into which we cannot see, and then on and upwards and outwards to the serene image of Virgin and Child.*

THE RAISING OF LAZARUS
1461, oil on wood, 69 x 53 in (175 x 134 cm), Galleria degli Uffizi, Florence

Froment sees the raising of Lazarus as the great drama that it is. Jesus stands serene and commanding, while the dead man – visibly a corpse – is raised to a sitting position. On either side, his sister and a courtier make it clear that the body is in a state of decay. The Gospel says simply, "Lord, he stinketh". This Lazarus is worn away, repulsive, and yet Jesus and His apostle Peter regard him with the tenderest and most supportive compassion. This is not a miracle out of time and place but a very real one with very real effects.

GADDI, AGNOLO active 1369–96 Italy

CORONATION OF THE VIRGIN

AGNOLO GADDI WAS POSSIBLY TOO YOUNG to have been taught by Giotto himself, but he was certainly in the tradition of Giotto. This we can see in his marvelous *Coronation of the Virgin*, in which heavenly bodies have a glorious, Giottoesque solidity. The medieval mind could not bear the thought of Mary's life ending with her death, and believed she was assumed, body and soul, to heaven. Once there, as the medieval imagination loved to contemplate, she was welcomed by her Son and crowned by Him as Queen of Heaven. Agnolo shows us the closeness of Mother and Son through the tenderness with which Jesus sets the crown upon her head, and this intimacy is also indicated by their almost identical dress. These garments are superlatively beautiful, but neither Mother nor Son, despite all this splendor, are seen as clotheshorses.

CORONATION
OF THE VIRGIN
*c.1370, tempera on wood,
64 x 31 in (163 x 79 cm),
National Gallery of Art,
Washington, DC*

GADDI, TADDEO c.1300–66 b. Italy

ANNUNCIATION TO THE SHEPHERDS

IT WAS TADDEO GADDI, FATHER to Agnolo, who had the privilege, or so we are told, of being not only pupil to Giotto but also godson to him. The influence of Giotto is very marked here: the chunky weight of the shepherds' bodies; the incredulity of the dog; and the almost comic realism of the water bottle, staff, and bowl. Like Giotto, also, is the drama of the scene. The angel appears hovering in the night sky. One shepherd wakes in astonishment, while the other is yet to stir and witness the miracle. However, there is an element here that we never find in Giotto: Giotto was, above all, a man of the earth. This extraordinary depiction of a night scene, in which all the light comes from a heavenly vision, has a mystical quality peculiar to Taddeo. He has seen through the eyes of realism how rocks, trees, men, and animals are lit by moonlight, but he has imagined something other than moonlight; this is angelic light, and it is extraordinarily convincing.

THE ANNUNCIATION
TO THE SHEPHERDS
*after 1328, fresco, dimensions not known
Baroncelli Chapel, Santa Croce, Florence*

GAINSBOROUGH, THOMAS 1727–88 b. England
"THE BLUE BOY"

GAINSBOROUGH'S *"THE BLUE BOY"* IS AN IMAGE that everybody thinks they know. In the popular mind it is the icon of the young aristocrat, splendidly overdressed, confronting the plebeian world. In actual fact, *"The Blue Boy"* is a painting of Jonathan Buttall, the son of an ironmonger who was one of the artist's friends. He was a perfectly ordinary boy who, in theory, served as the occasion for the artist to investigate the splendors of blue silk, silver tinsel, and feathers. But what makes this image so memorable is that, in fact, Gainsborough was unable to treat Jonathan merely as a clothes-horse and has responded to the reality of the boy standing before him with warmth and affection. He has set him in an imaginary and romantic setting, possibly intended to suggest the far-stretching domains of the young lordling, but the more he looked at that stern, determined young face, the more interested he became in Jonathan Buttall as a person – and a personality in his own right.

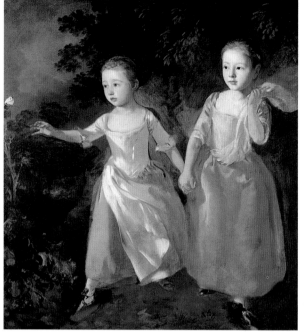

THE PAINTER'S DAUGHTERS CHASING A BUTTERFLY
c.1775–76, oil on canvas, 45 x 41 in (113.5 x 105 cm),
National Gallery, London

Gainsborough had only two children, Margaret and Mary, whom he called "Molly" and "the Captain". He had realized early on that neither was a balanced child, that they were likely to have a difficult and unhappy maturity, and there is a deep pathos in the way that they combine to chase the butterfly. It is a futile pursuit, and yet with what earnest attention the two set about it. Part of the sadness of the painting, to us, is that as they grew older a hostility grew up between them, and the father would grieve that he no longer saw hands clasped affectionately, as here.

G

"THE BLUE BOY" comes across as a deeply affectionate portrait. The glory of the costume, with its dazzling blue and silver, remains, but it is dominated by the head of the boy: the ruddy cheeks; the fine silks and lace; the broad forehead; the level glance; and the sensitive, vulnerable mouth.

THE BOY IS NOT *confronting his inferiors, he is confronting life. He is majestically ignoring the trappings in which the artist has decked him, and looks straight and searchingly into the possibilities for a young man with little behind him except his family's affection. The wild, swirling landscape and the dark, threatening sky seem appropriate to the condition of the true Jonathan Buttall.*

JONATHAN BUTTALL
"THE BLUE BOY"
c.1770, oil on canvas,
46 x 48 in (118 x 122 cm),
Huntington Art Collections, San Marino

GAUGUIN, PAUL 1848–1903 b. France
NEVERMORE

IT IS HARD TO UNDERSTAND Gauguin's art without being aware of the extraordinary journey he undertook to the South Seas, which he felt compelled to take to escape conservative Paris and his wife and children (who struggled in great poverty thereafter). Gauguin fled to the wild romance of the Tahitian islands to live as a creative bachelor in the sunshine. This longing for a distant paradise colored all of his work as did this need to escape from the constraints and commitments of life and find an impossible fulfilment in the never-never world of sun, pleasure, and free love. Like all human beings, Gauguin pursued his romantic ideals at a cost. By the time he painted *Nevermore*, he had come to realize that the South Seas were not his for the taking. His nubile young mistress gave him her body, seen here in its gleaming green–gold beauty, but her spirit would evade him forever. The girl lays her head on the glorious buttercup-yellow of her pillow, but her eyes are narrowed with fear and suspicion. This was an exotic world that Gauguin could only inhabit at a superficial level, and this painting is a lament for his exclusion.

NEVERMORE
1897, oil on canvas,
24 x 46 in (61 x 116 cm),
Courtauld Institute Galleries, London

THE MEAL
1891, oil on canvas, 29 x 36 in (73 x 92 cm), Musée d'Orsay, Paris

The Meal was painted in the year in which Gauguin deserted his family. The children depicted here may be an unconscious recollection of his own children. They sit before a richly laden table, which is too high for them, and wait dejectedly for food that does not come. Outside, we see golden sands, and sunlight hits the front edge of the table; yet, as one moves into the picture, the considerable sense of sadness deepens.
The Meal shows, perhaps, the essential contradiction at the heart of Gauguin's psyche: the urge to create art at any cost and, yet, a conscious unwillingness to accept how his life decision took its toll on others.

THE PICTURE'S ENIGMATIC *title, Nevermore,*
alludes to Edgar Allan Poe's poem "The Raven". Here,
the weird strutting figure of a bird looms at the center
left of the painting. This is perhaps the South Seas
version of a raven, colored and slightly contorted, but,
for Gauguin, it is still very much a bird of ill omen.

" BY THE MEANS OF A SIMPLE NUDE
I WANTED TO SUGGEST A CERTAIN
BARBARIC LUXURY OF ANCIENT TIMES "
Paul Gauguin

THE TWO WOMEN WHISPERING
together in the background add to the tension.
We feel, as perhaps Gauguin did himself,
that something is going on behind the scenes –
something dark and frightening, against
which the girl is unprotected.

GEERTGEN TOT SINT JANS c.1460–c.1490 b. Netherlands

ST JOHN THE BAPTIST IN THE WILDERNESS

GEERTGEN WAS A LAY BROTHER OF THE ORDER OF ST JOHN, hence his full title, Geertgen tot Sint Jans (Little Gerard of the Brethren of St John). Had he lived past his twenties, Flemish art of the 16th century might have been quite different. This tiny painting of his patron saint has a wonderful pathos and charm. Who, once they have seen it, can forget those bare feet, rubbing shyly against each other, or the despondency of the dear saint, slumped in his rough monk's habit, pondering some holy mystery. For all his air of dejection, this small saint is enveloped not by the desert of history but by the meadowlands within which Geertgen delights to depict him.

ST BAVO
late 15th century, oil on canvas,
15 x 12 in (37 x 30 cm), Hermitage, St Petersburg

St Bavo was a local saint, a knight who became a Christian and then a monk in the monastery of St Peter's at Ghent. Geertgen shows him on the brink of conversion. It is a most imaginative depiction of a foreigner, with his strange fur and jewelled hat, his armor, his elegance, and his restrained, almost Hassidic, looks that set him apart from the Flemish world of the time. The hooded falcon is probably an enciphered reference to the spiritual flight that the saint will soon be making. At this moment, the bird is still hooded and stationary. Geertgen imagines Bavo looking forward with a visionary intentness towards his new life.

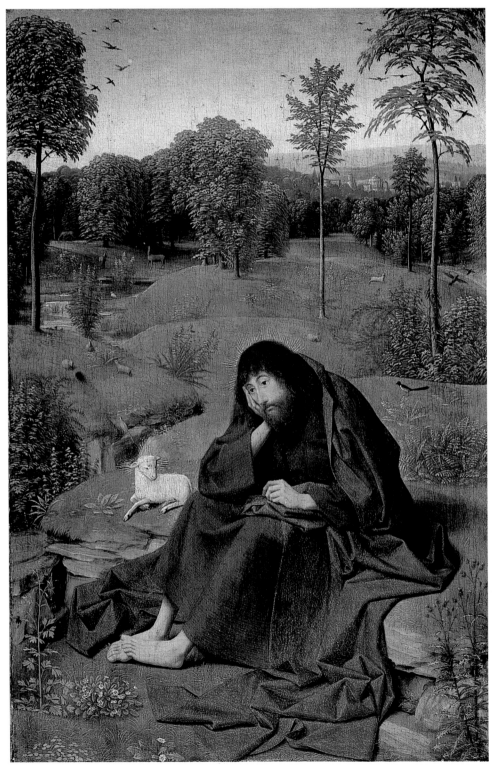

FLOWERS GROW ALL AROUND, *trees bloom in the sunshine, a little stream widens out to provide refreshment for the birds and liquid for the animals that are timidly approaching. Rabbits and birds feel at home with the saint; close by him on the banks of the Jordan is his own private attribute – the Lamb of God.*

THE LAMB OF GOD *is a symbol of Christ and of His sacrifice, but in this wholly delightful image, the lamb seems rather like the beloved pet, the private friend, who, when the sun sets, will be wrapped up in the warm folds of St John's voluminous cloak and carried home in his bosom.*

ST JOHN THE BAPTIST IN THE WILDERNESS, *late 15th century, oil on wood, 17 x 11 in (42 x 28 cm), Staatliche Museum, Berlin*

GELDER, AERT DE 1645–1727 b. Netherlands
SIMEON'S SONG OF PRAISE

AERT DE GELDER WAS PROFOUNDLY INFLUENCED BY REMBRANDT, his friend and master. In *Simeon's Song of Praise*, one can recognize Rembrandt's influence, as well as appreciate Gelder's individual response to the subject. We are told in the Gospels that when Mary brought the infant Christ to be circumcized, there was present at the temple a very old priest who at once recognized the baby for what He was. He took Him in his arms and sang to God, rejoicing that now he could depart in peace because his eyes had seen the salvation of the Lord. Gelder almost blots out all the others in the scene; we can see only vague faces looming out of the darkness. Even Mary is a dark figure, enveloped in a veil and lost in prayer. Significantly, Simeon seems to need no sign from either Child or mother that his recognition of divinity is valid. He validates it from within himself, and looks up only to his God. His eyes seem to brim with tears. This is a most moving image of a man completely lost to all sense of self as he is touched by the presence of holiness itself.

SELF-PORTRAIT AT AN EASEL PAINTING AN OLD WOMAN
1685, oil on canvas, 56 x 66½ in (142 x 169 cm), Städelsches Kunstinstitut, Frankfurt

Gelder can also be a repulsive artist, and this painting is both brilliant and off-putting. The old woman has been dressed in sumptuous attire, à la Rembrandt, and sits there proudly holding an oriental fruit. Gelder looks at us, smirking. We are meant to collude with him in the difference between the woman's view of herself and his own.

GELDER'S SIMEON *is not a man decrepit with years, clinging on to life just long enough to have his dream of the Messiah realized. This Simeon is still vigorous in age, a man illuminated by a long-awaited, almost despaired-of, answer to his deepest desire. The two protagonists of the old priest and the young child join together in mutual recognition.*

THE FLIMSY *and transparent veil that drapes Simeon's head is a prayer shawl and, significantly, all that is clear to us is the uplifted face, gently overshadowed by the radiance of the baby that lies almost stern in its serenity in Simeon's arms. His hands are veiled because he is holding that which is sacred.*

SIMEON'S SONG OF PRAISE *c.1700, oil on canvas, 37 x 43 in (95 x 108 cm), Mauritshuis Museum, The Hague*

GENTILE DA FABRIANO c.1370–1427 b. Italy
VIRGIN AND CHILD ENTHRONED

EVERY ITALIAN PAINTER FROM THE LATE MIDDLE AGES on seems to have painted the Virgin and Child but none perhaps with the wit and enchantment of Gentile da Fabriano. Not only is this gentle Virgin exceptionally attractive with her head on one side and her vivacious Child in her arms, but the whole setting has an originality that is accomplished with the utmost brio and skill. Flanking the Virgin are two trees, an oak and a laurel, and perched like small, pink birds on each are hosts of angels, their golden instruments creating subliminal music for their own delight. In front of the music-making trees stand the solid forms of St Nicholas of Bari and St Catherine of Alexandria. They are a bewitching combination of male and female, old age and youth, ugliness and beauty.

ADORATION OF THE MAGI
1423, tempera on wood, 111 x 119 in (282 x 303 cm), Galleria degli Uffizi, Florence

Gentile created this great work for the Strozzi family and, although he is indeed faithful to his theme, we are more conscious of the rich diversity of medieval life he has set before us than of the sacred significance of the scene. This is the life that the Strozzis knew themselves, with costly garments, exotic pets, courtiers, and servants. Depicting the Three Kings offered the artist the opportunity to show the manner and dress of upper-class Florentines, and they wind their way in a rich procession between castles that are very much like those of the Strozzi family.

G

166

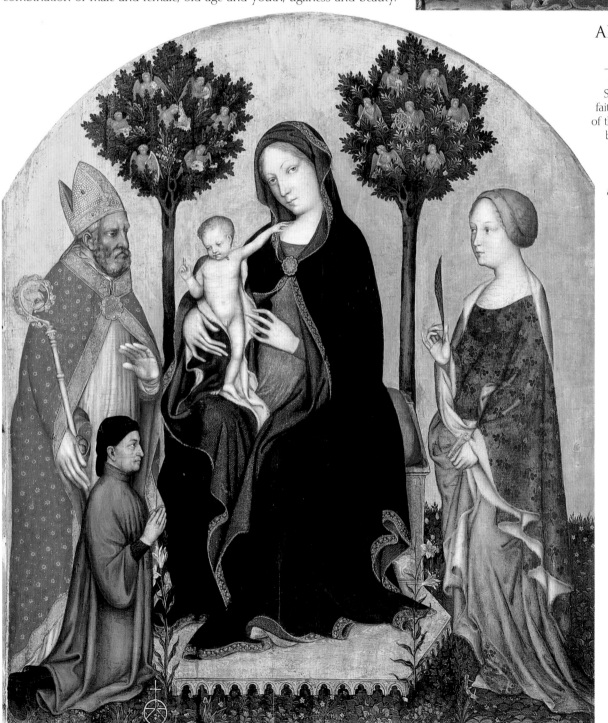

GENTILE DA FABRIANO *pulls no punches with his portrayal of St Nicholas: he has a big, glowering nose and a bishop's tiara that is eerily reminiscent of a fish (St Nicholas being one of the great patrons of sailors). The saint carries three golden balls, which were his signature – he used them to rescue three young girls from a life of prostitution.*

IF ST NICHOLAS IS ALL *rough integrity, St Catherine is all suave elegance. She holds the palm of martyrdom with a dainty sense of decorum, and under her little golden slipper is the shattered wheel – the emblem of her martyrdom. The donor, a dire intrusion on this happy company, keeps his eyes strictly to himself.*

VIRGIN AND CHILD ENTHRONED WITH SS NICHOLAS OF BARI AND CATHERINE OF ALEXANDRIA AND A DONOR, *c.1395, tempera on wood, 52 x 44 in (131 x 113 cm), Staatliche Museum, Berlin*

GENTILESCHI, ARTEMISIA 1593–c.1653 b. Italy

JUDITH SLAYING HOLOFERNES

JUDITH WAS THE JEWISH GENTLEWOMAN who inveigled herself into the company of the invader Holofernes – with a chaperone to protect her virtue – made him drunk, and then beheaded him. Gentileschi shows Judith gripping the head and wielding the sword with a ferocity of concentration as she applies herself to the grisly but necessary task like a practical housewife gutting a fish (there is none of that one stroke and it's off, beloved of the male painter). The maid might feel qualms – not Judith. Of course, what makes the picture particularly fascinating is that Gentileschi's paintings always seem to be self-portraits. It is tempting to see paintings in the context of the artist's life, and in the case of Gentileschi it is particularly relevant – she was raped and betrayed by an artist friend of her father's. Allowing for biographical bias, it seems interesting that she so frequently tackled the subject of a heroine defeating a villain, and that her heroines are endowed with such vigor. This is unmistakably Artemisia avenging betrayal and injustice; if we abstract from that, it remains an extraordinary picture.

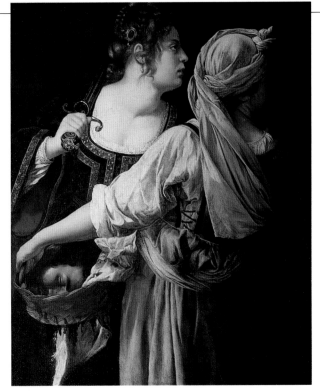

JUDITH AND HER MAIDSERVANT
c.1612, oil on canvas, 45 x 37 in (114 x 94 cm),
Palazzo Pitti, Florence

This is the second act of the drama: Holofernes is dead. Sensible woman that she is, Judith has brought a basket in which to put the head, and her maid dutifully swings it at her hip before they set out on their triumphant journey back to the camps of Judah. However, the picture suggests that the most difficult part of the heroine's task still lies ahead: they have to make their way through the enemy camp, silently and unnoticed. Judith (whose hair has come loose in the struggle) carries her sword unsheathed and ready. Both women look intently to the right – models of concentration.

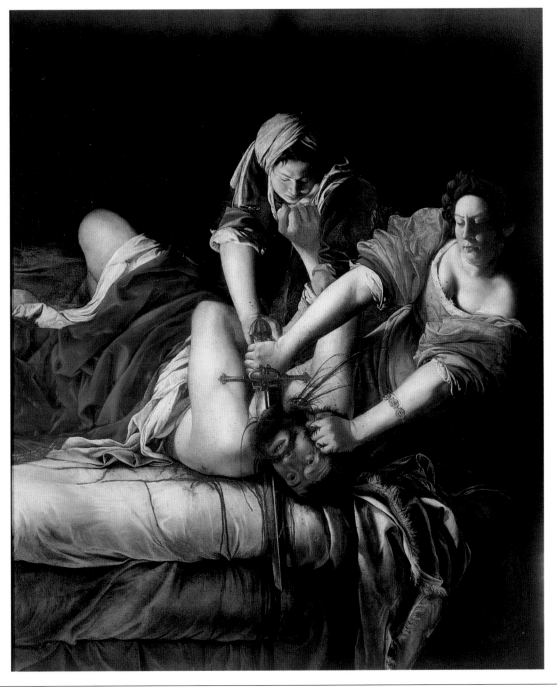

THE HORRIFIED FACE *of the butchered male is balanced by the grimly composed face of the butchering female. She has rolled up her beautiful sleeves and sways away from the body as much, one feels, for muscular power as to evade the unpleasantness of the spurting blood. Her muscular arms are thrust forward in parallel, one delicately ornamented with a bracelet.*

ALMOST A THIRD *of the picture is bed – three mattresses placed one over the other, all thick and soft and gleaming in the light. The waterfall of feathery cloth on the right is balanced by the scarlet robe that covers Holofernes's torso, and the three heads – anguished, triumphant, and suffering – form an odd triangle, balanced by that pathetic and naked knee that juts up into nothingness.*

JUDITH SLAYING HOLOFERNES
c.1620, oil on canvas,
78 x 64 in (199 x 163 cm),
Galleria degli Uffizi, Florence

GENTILESCHI, ORAZIO 1563–1639 b. Italy

REST ON THE FLIGHT INTO EGYPT

THE FLIGHT INTO EGYPT was often idealized by artists who enjoyed the lyricism of the event: man, woman, and child fleeing from the known world into the mysteries of the Far East. The rest on this flight is generally depicted as being equally idyllic; often the Holy Family are shown surrounded by angels in a romantic woodland glen. Gentileschi, however, sees the event in its possible actuality. Joseph, past his first youth and responsible for the physicalities and the logistics of the journey, has flaked out, unable to do more than prop up the family luggage and fall into a deep slumber. Mary, one imagines, must be equally exhausted. A mother, however, puts her child's welfare above all else and, unfortunately, the little Jesus is by no means worn out by the excitements of the journey. One bright eye regards us alertly, and He suckles at His mother's breast with great enthusiasm. The stance of those plump baby legs suggests He is in no haste to be bedded down for the night, and the resignation with which Mary holds him suggests that she is aware of this.

THE LUTE PLAYER
c.1610, oil on canvas, 57 x 51 in
(144 x 129 cm), National Gallery of Art, Washington, DC

Gentileschi could enjoy the histrionic and render it with verve, but he was also capable of responding to something more profound. This is one of the most wonderful depictions of silence: the girl's face is bent towards her music as she ponders her fingering, and the impression is of stillness, concentration, and the ability to listen.

REST ON THE FLIGHT INTO EGYPT, *1628, oil on canvas, 62 x 89 in (157 x 22 cm), Musée du Louvre, Paris*

GENTILESCHI HAS TAKEN *great pleasure in the fall of material, the swells of the baggage, and the sway of human limbs with their implicit messages. We smile at Joseph's exhaustion, at Mary's controlled impatience, and at the baby's eagerness to explore the wonders of life, and yet we feel a human sympathy, an awareness of what these stories, which seem so mythical, might well have meant in practice.*

GÉRICAULT, THÉODORE 1791–1824 b. France
THE RAFT OF THE MEDUSA

GÉRICAULT DIED YOUNG IN A RIDING ACCIDENT and one feels that this event was almost preordained. He lived life with such intensity that it seemed inevitable that he would die young. His great artistic strength was to focus on specific events that would enable his passionate desire for justice, for love, for the fullness of life to be expressed. The shipwreck of the *Medusa* was the great national scandal of 1818, when the vessel was lost due to the ignorance and cowardice of its officers, who saved themselves at the expense of their crew and passengers. The survivors built a raft on which they drifted for days. When they were picked up, only the hardiest were still alive and able to return to France and an outraged public.

THE MADWOMAN
1822–23, oil on canvas, 28 x 23 in (72 x 58 cm), Musée des Beaux-Arts, Lyon, France

Géricault lived so intensely that it is not surprising that at times he felt uncertain about his own sanity. Seeking psychiatric help, he came into contact with the sad subculture of those condemned to life in the 19th-century asylums. Just as the artist had made heroic art out of a newspaper report of a shipwreck, so he honored the rejected and flawed human beings of the world who were shut away in asylums and labelled "mad". He approaches this portrait with reverence and a terrifying objectivity.

THE RAFT OF THE MEDUSA, *1819, oil on canvas, 193 x 282 in (491 x 716 cm), Musée d'Orsay, Paris*

GÉRICAULT SEIZED *upon this tragedy, read up on all the newspaper reports, borrowed corpses from the infirmary so that he could depict the dead truthfully, and finally produced a work so harrowing that it is a masterpiece of its genre.*

THE COMPOSITION *is built around two pyramids: that of the billowing sail with a great wave rising behind it, and that of the desperate lookout, signalling frantically to the passing ship on the far horizon.*

THIS WORK *has a terrible power because we know that Géricault is not reporting on the external tragedy, but protesting against human cruelty and ignorance, lamenting with a deep savage cry, the state of helplessness in which most of us live.*

GHIRLANDAIO, DOMENICO 1449–94 b. Italy
BIRTH OF THE VIRGIN

GHIRLANDAIO SEEMS TO BE THE TYPICAL FLORENTINE Renaissance artist – cultured, sophisticated, technically adept, never bearing us away on the wings of wild ecstasy, but, equally, never letting us down into the depths of despondency. Perhaps the most important commission in his life was for the Tornabuoni family: a series of frescoes for the great church of Santa Maria Novella in their native city. The commission dealt with the lives of Mary and of Saint John the Baptist, but the high point, the masterwork, is this – *Birth of the Virgin*. The Gospels tell us nothing of Mary's background, but Christian piety eagerly fabricated interesting details, such as that her mother's name was Anne, and that Anne and Joachim had lived in a barren marriage until, almost miraculously, Mary was conceived. It is a picture of enormous splendor and brilliance, of resolved bodies, standing in beauty and dignity for us to admire. But it is only with a certain leap of the imagination that we can see this as a scene of sacred meaning.

BIRTH OF THE VIRGIN, *1479–85, fresco, dimensions not known, Santa Maria Novella, Florence*

PORTRAIT OF AN OLD MAN AND A BOY
c.1485, tempera on panel, 25 x 18 in (63 x 46 cm), Musée du Louvre, Paris

I always want to entitle this picture "Portrait of Grandfather with Grandson". The most striking element in this tender painting is the relationship between the child, so sublimely fair, and the old man with his terrible disfigurement. The marvel is that neither seems to notice. They look into each other's eyes – the old man smilingly, the child with the utmost trust. One feels that the winding path in the distance will hold no fears for either.

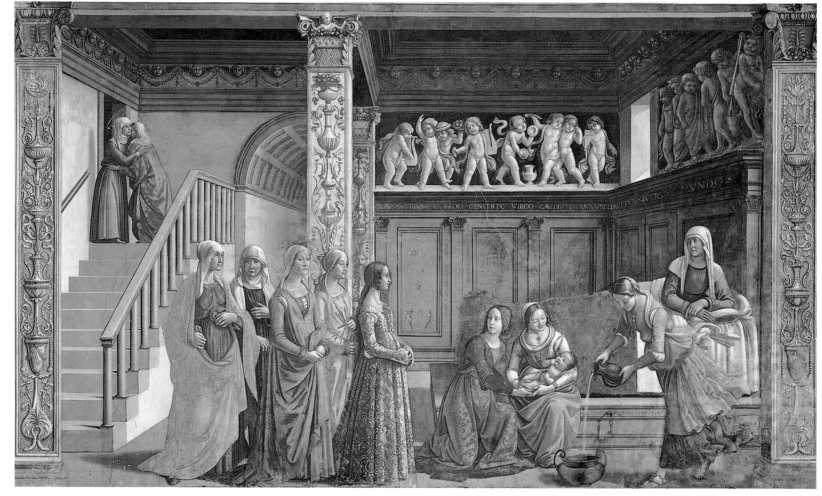

ABOVE, AT THE TOP *of the stairs, Ghirlandaio reminds viewers of how Anne is said to have met her future husband, Joachim, at the Golden Gate of Jerusalem, where they embraced. It was from that kiss that they drew the courage to try to conceive a child.*

THIS IS THE HOME OF *the Tornabuoni themselves, and the young Lodovica Tornabuoni and attendants are impassive witnesses to the scene. The women stand there, vaguely congratulatory, but more concerned, it would seem, to show off the splendor of their attire.*

THE MOST IMPRESSIVE FIGURE *is not the little countess Lodovica, standing erect to be painted by the artist, but the serving maid with her skirts all aflutter and her eyes intent on the task of filling a bowl of water with which to bathe the newborn child.*

GIACOMETTI, ALBERTO 1901–66 b. Switzerland, active France
JEAN GENET

WE ALWAYS KNOW WHEN we are confronted with a portrait by Giacometti. The manner in which he presents his work is completely different to that of any other artist. Giacometti was haunted by a desire to understand what it meant to be alive. His own life he could dismiss, but faced with another, the mystery of this alien being – how it filled up space, how it battled with the hostile elements of its existence – seemed to Giacometti infinitely mysterious and marvelous. It was, above all, the head that perpetually challenged him, and more specifically the gaze – the look that another person exchanges with us, which Giacometti saw as both unfolding the mystery of that personality and yet, perpetually concealing it. He had known Jean Genet for a year when he painted this impressive picture. It was Genet's appearance that had first drawn Giacometti to him, especially the shape of his head, so bald, so round – a skull in which the whole mystery of personality resided. He avoids the allure of color; instead the picture is brown and white, with just the faint streaks of earth red to enliven it. Yet never is it more clear that a human being is a creature of majesty.

ANNETTE
1954, oil on canvas, 25½ x 21 in (65 x 54 cm), Galerie Maeght, Paris

Giacometti's wife, Annette, was another object of his obsessive interest. Here, we can see him striving to come to terms with this person who, in theory, was the closest to him. It is almost as though he has scratched her portrait out of a world of white into which she would otherwise disappear. These black markings claw her back. She seems as riveted and horrified by the experience of encountering her husband's gaze as he is by hers. Those great eyes glare at us without emotion, the lips are pursed, and, although the body is sketchy, there is an uncanny sense of presence. He has caught her, as if in a momentary flash of light, and there she stands transfixed forever.

AS WELL AS *his physical appearance, Giacometti was intrigued by Genet the writer and poet who had led a life of great degradation. Here, the artist sees Genet as almost overwhelmed by the world in which he lives. The figure of Genet is squashed into a corner, and that gaze, the focus of Giacometti's interest, is directed up at us, both anguished and remote. The figure of Genet appeals to our sense of compassion.*

WHEN HE SAW THIS *picture, Genet wrote, "I have the impression that the painter is pulling back the meaning of the face". This is a strange but perceptive comment. Giacometti does pull back from the face with fear and reverence. He seems to shrink back from encountering the full force of the face, not so much because it is this particular face, but because it is any face, just somebody else.*

JEAN GENET
1955, oil on canvas, 26 x 21 in (65 x 54 cm), Tate Gallery, London

GIORDANO, LUCA 1634–1705 b. Italy

PERSEUS TURNING PHINEAS AND HIS FOLLOWERS TO STONE

LUCA GIORDANO WAS KNOWN AS "LUCA FA PRESTO" (Luke work quickly) because of his extraordinary speed of execution. In his great works, the speed reminds one of the cinema, in which the drama rolls past us with such immediacy that we are swept away with the story. Here, he has a theme that is precisely to his liking, the great soap opera of Perseus and Andromeda. Andromeda was chained to a rock for a sea monster to devour, until the hero Perseus flew down on Pegasus, the winged horse, and rescued her. The hero always gets the girl, and so she broke her engagement to Phineas and agreed to marry Perseus. Here, we see the point during the wedding feast where Phineas, smarting from his rejection, has burst in to kill Perseus and steal back Andromeda. Giordano is not attempting to convince us that this is actual history – it is romantic drama, the epic, the blockbuster, brought miraculously to life with enormous brio and pleasure.

THE FALL OF THE REBEL ANGELS
1666, oil on canvas, 165 x 111 in (419 x 283 cm), Kunsthistorisches Museum, Vienna

The greatest conflict of the warrior-angel St Michael was with the angels cast out from heaven to become devils. Giordano seizes upon the moment in which the angels fall and are transformed. Michael's foot rests upon the magnificent torso of an angel whose wings have already become the bat wings of a devil.

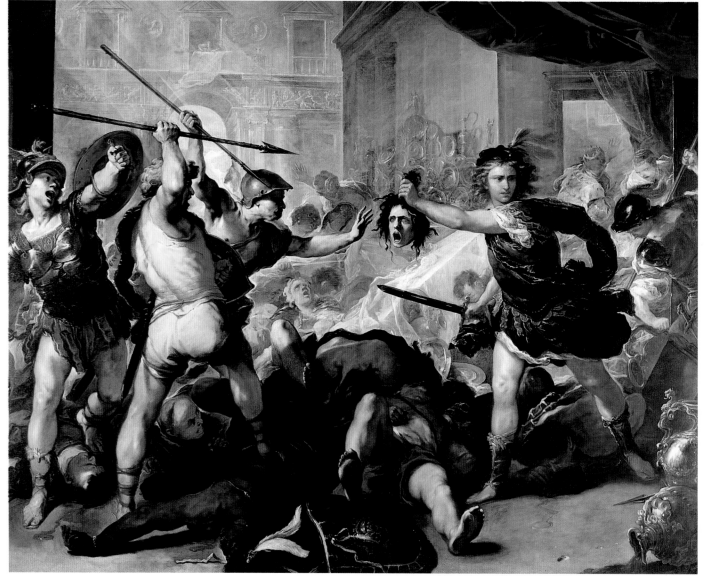

PERSEUS *had previously slain the terrible Medusa, whose very look turned men to stone. Snatching up the severed but still lethal head, which he had kept hidden, he cleverly turned it to face his enemy who, upon meeting the Medusa's gaze, were vanquished.*

THE SUPPORTERS *of Phineas are shown in varying stages of their transformation into stone. They freeze in mid-air and topple as Perseus sweeps through the room dangling his grisly trophy, which is underlined by the blade of his sword.*

PERSEUS TURNING PHINEAS AND HIS FOLLOWERS TO STONE
early 1680s, oil on canvas, 112 x 144 in (285 x 366 cm), National Gallery, London

GIORGIONE (GIORGIO DA CASTELFRANCO) c.1477–1510 b. Italy

THE TEMPEST

GIORGIONE DIED YOUNG, but the sheer quality of *The Tempest* makes one think that this was a painting of his maturity. It has astonished and haunted viewers over the centuries. Books have been written trying to explain its mystery. What is the man – apparently a soldier – doing on the left? What is the naked woman suckling a baby doing on the right? Why is a ruined temple behind them? Why are they in the wilderness outside the city walls? Giorgione gave the picture no title, and "The Tempest" comes from the fascination we feel for that jagged streak of lightning that flares this whole scene into brightness. Perhaps we are on the wrong track if we try to order these images into a coherent whole; perhaps Giorgione's point, original thinker that he was, is that life is not coherent, and that scattered incidents and wandering people mix and mingle without ever coming together to form a story. Time spent on wondering about the woman's nakedness may well be wasted; instead, we should be enjoying the poetic power of this enigmatic scene, the strange landscape, that mysterious city. The man looks wonderingly aside into the distance, the woman seems to look at us under lowered eyelids. We look back, bemused and enchanted.

LA VECCHIA
c.1502–03, oil on canvas, 27 x 23 in (68 x 59 cm), Accademia, Venice

Perhaps only Giorgione would have painted a picture, not of a beautiful young woman, or even a beautiful old woman, but of an old woman who had once been beautiful. He has painted beauty vanished; and yet we can imagine how it was once overwhelmingly present. She holds a small scroll: *Col Tempo*, "With Time". This is what time will do to all beauty. It will thicken the body, coarsen the skin – in Giorgione's day it would destroy the teeth. Her eyes look blearily out at us as she remembers that once she was beautiful.

> " HE CREATED LIVING
> FORMS AND OTHER IMAGES
> SO SOFT, SO HARMONIOUS,
> AND SO CAREFULLY SHADED
> OFF INTO THE SHADOWS
> THAT MANY OF THE MOST
> SKILLFUL ARTISTS OF THOSE
> TIMES AGREED HE HAD
> BEEN BORN TO INFUSE
> LIFE INTO HIS FIGURES "
> Giorgio Vasari

GIORGIONE WAS A *pioneering painter, and his priority here was clearly to evoke an atmosphere rich in intrigue. The subject of this painting is secondary; it is elusive and haunting. The painting both captivates and tantalizes us, suggesting much but never revealing its mysteries.*

THE TEMPEST
c.1510, oil on canvas, 31 x 28 in (78 x 72 cm), Accademia, Venice

THE LAMENTATION
OF CHRIST, c.1305,
fresco, 79 x 73 in
(200 x 185 cm), Cappella
dei Scrovegni, Padua, Italy

GIOTTO BRINGS TO LIFE *the painful reality of
a death. Before we can reach the dead body of Jesus,
we must bypass the great hulks of two figures who
sit cloaked and mourning. They give depth to the
work and draw us in to Jesus and His mother.*

EACH PERSON RESPONDS *in accordance with
his or her own temperament. Mary is intent and
questioning; Mary Magdelene, seated at His feet,
is weeping; and St John stretches out his hands,
apparently with an incredulous cry of grief.*

GIOTTO DOES NOT DEPICT *only human pain;
a great rocky diagonal leads up to a bare tree,
linking the foreground scene to the extraordinary
lamentations of the angels, fizzing and swooping
in an acrobatic crescendo of heavenly sorrow.*

GIOTTO DI BONDONE c.1266–1377 b. Italy
THE LAMENTATION OF CHRIST

IN ONE VERY REAL WAY, IT ALL BEGAN WITH GIOTTO: from him, Western art has drawn much of its inspiration. After the delicate traceries of Gothic art, Giotto's revolution shocked artists into an awareness of the solidity of the body, of how human emotions were expressed through that body and, most of all, of the artist's ability to communicate this in a way that involved the spectator in the reality of the scene. All these innovations, which seem to us so obvious, sprang essentially from the genius of Giotto. His great opportunity came with the commission to decorate two windowless walls of a small chapel in Padua with scenes

from the lives of Christ and Mary. Everybody who saw *The Lamentation of Christ* on the chapel walls would have known the story well – that Jesus had died on the Cross and that a profound sorrow ensued. Giotto took that intellectual conviction and made it throb in the nerves. He involved the spectators and showed them that the people in the Gospel story were people just as they were, emotionally fraught as they attempted to express their grief; for the first time, spectators could empathize with the characters in such painted narratives. Giotto brought to life the mysteries of faith, and art was never the same again.

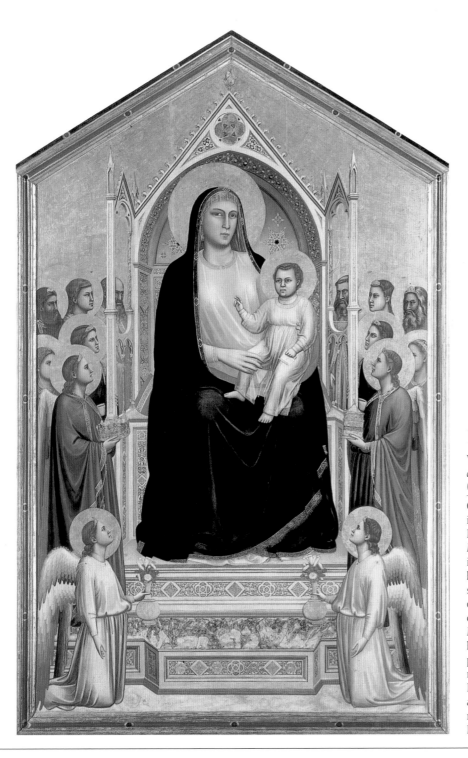

"WHEN I SEE THE GIOTTO FRESCOES AT PADUA I DO NOT TROUBLE MYSELF TO RECOGNIZE WHICH SCENE OF THE LIFE OF CHRIST I HAVE BEFORE ME, BUT I IMMEDIATELY UNDERSTAND THE SENTIMENT WHICH EMERGES FROM IT, FOR IT IS IN THE LINES, THE COMPOSITION, THE COLOR"
Henri Matisse

ENTHRONED MADONNA
WITH SAINTS AND ANGELS
c.1305–10, tempera on wood, 128 x 80 in (325 x 204 cm), Galleria degli Uffizi, Florence

Giotto was a supreme dramatist. He seized instinctively on action and made it convincing. Here, he has been challenged by a static subject: *Enthroned Madonna with Saints and Angels.* Nothing, it would seem, is actually happening here, yet how pregnant with potential is this scene. A sense of expectation is created, represented most emphatically by the attentive angels, their gaze converging on the central focus. Giotto's queenly Mary sits prominently on her elaborate throne, holding the small figure of Jesus, who is not portrayed as a baby, but as a young emperor, ruling from her knee with a mature power. His body is small, and the little feet are pressed against the mother's knees; He needs His mother's supporting hands, but He surpasses His human condition with divine composure.

GIOVANNI DI PAOLO c.1399–1482 b. Italy

ST JOHN THE BAPTIST RETIRING INTO THE WILDERNESS

IN FOUR PANELS, GIOVANNI DI PAOLO portrayed the four key events in the life of John the Baptist: his miraculous birth, his retirement to the desert, his Baptism of Christ, and his death at the hands of Herod. The second of these panels shows, with an enchanting lack of realism, the young saint's decision to leave the paternal mansion and live alone in the wilderness. We see John first setting out with an extraordinarily small bundle of possessions over his shoulder, and then we see him again, far from home, amid the barren rocks of the mountains, embarking upon a lifetime of solitude and penance. The world below is small and perhaps sweet, with its neat fields and pink and white houses, but it is to be utterly rejected. This act of renunciation is seen in the context of a great stretch of rocky landscape, a difficult and desolate world, in which the heroic young John will live until, in the next episode, he encounters Christ and his career is radically changed.

ST JOHN THE BAPTIST RETIRING INTO THE WILDERNESS, c.1453, tempera on wood, 12 x 15 in (31 x 39 cm), National Gallery, London

THIS PICTURE, WITH ITS CHARMING *courage and eccentricity, is framed by two flower panels. Perhaps Giovanni is indicating that John leaves behind the blossoming that is natural to humanity, or perhaps he is suggesting the very opposite – that the life that awaits him can flower more richly than any other.*

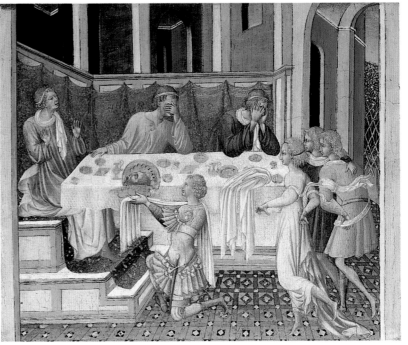

THE FEAST OF HEROD
c.1453, tempera on wood, 12 x 14½ in (31 x 37 cm), National Gallery, London

The fourth panel, depicting the death of John the Baptist, is both the most dramatic and the most oblique. Drunk with lust, Herod had promised to give his step-daughter Salome anything she wished if she would dance for him. At the request of her mother Herodias, Salome demanded the head of the Baptist. Salome is still twirling with pleasure as she follows the progress of the executioner and his grisly burden. But Herod lifts his hands in horror, and his guests are unable to face the bloody reality of what his drunken promise to an irresponsible youth has brought upon them.

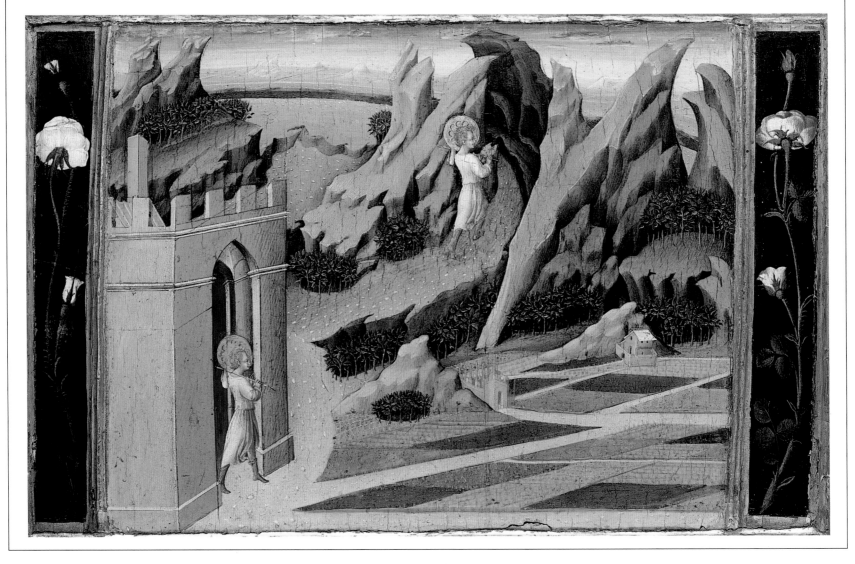

GIRTIN, THOMAS 1775–1802 b. England

THE WHITE HOUSE AT CHELSEA

THE TWO GREATEST ENGLISH WATERCOLORISTS J.M.W. Turner and Thomas Girtin were born in the same year, but whereas Turner marched steadily onwards into his late seventies, poor Girtin died when he was just 27. Turner is said to have confessed that had he lived, Girtin's talent would have overshadowed his own. Yet it is difficult to see how the length of years could have improved upon a painting such as *The White House at Chelsea*. The maturity of execution and of expression displayed in the work suggests the distillation of years of experience. Girtin understood the meaning of space, the power of simplicity, and the grandeur of light. Here, a brightness gleams on the quiet waters and concentrates on the white wall of the central house. It is a picture of silhouettes against a vast and tender sky, and of water of such deep translucency that it seems that nothing could disturb its stillness.

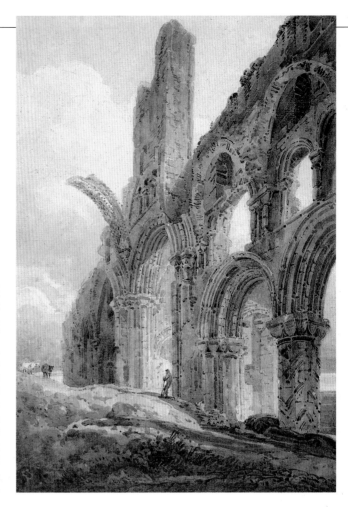

LINDISFARNE

c.1798, watercolor on paper, 16 x 11 in (41 x 29 cm), Fitzwilliam Museum, Cambridge, UK

Girtin angles across his page the ruins of this great abbey. The magnificence of desolation has rarely been shown with such haunting truth. One tragic arm of a broken arch still fumbles blindly for its lost partner, and wandering cows and herdsman bring to mind the monks, who would once have given this architecture its meaning. Just two arches show us the whiteness of the sky, while the white foam of the sea reminds us that we stand on an island – an island in space, and, through Girtin's magic, an island in time.

THE WHITE HOUSE AT CHELSEA, *1800, watercolor on paper, 12 x 20 in (30 x 51 cm), Tate Gallery, London*

THIS IS A VIEW *of the River Thames, looking from Chelsea Reach in the direction of Battersea. Girtin presents a panorama – a great vista in which essentially nothing happens – and yet that very nothingness is of such intense interest and compulsion that we sense this is reality at its most profound.*

IT IS NOT THE VIEW IN ITSELF *that matters but the view as an expression of Girtin's understanding of the meaning of life – a pretentious phrase, which the simplicity of this picture mocks. Nevertheless, it is hard to find a way to do justice both to the austerity of the means and the glory of the achievement.*

GIULIO ROMANO c.1499–1546 b. Italy

MARY MAGDALENE BORNE BY ANGELS

LEGEND HAS IT THAT after the Resurrection of Christ, Mary Magdalene lived naked in the desert until her death, when she was carried to heaven by angels. Here, Giulio Romano has rendered the episode with unconscious humor. The angels form a floating chair and offer a kind of aerial fireman's lift to the lady as they carry her up to heaven. Mary Magdalene seems unaware of the angels but looks longingly to heaven. The expressions on the angels' faces, however, lack enthusiasm for their sacred duty – they neither seem to have a cheerful disposition nor appear honored by this task. The circular composition is like a wheel, and wings and legs seem to revolve in all directions. The buoyant clouds offer a delicious sense of movement through the sky – familiar territory to the angels, but still a source of interest to Magdalene and to us.

MADONNA AND CHILD
c.1520–22, oil on wood, 41 x 30 in (105 x 77 cm), Galleria degli Uffizi, Florence

Giulio Romano was Raphael's pupil, but more heavy-handed than his master. Here, we see one of his most pleasing works, where his skills are put to good use and both Mother and Child are unmistakably flesh and blood. Mary holds open a page of the book, which presses uncomfortably against her Child's toes. The Child is eager to wrestle the bunch of grapes – a symbol of the Passion – from Mary's hands. There is an irony here, as Mother and Child seem unaware of what the future holds.

THIS IS ONE *of the four lunette frescoes that tells the life of Mary Magdalene, which Giulio Romano (helped by his assistant Gianfrancesco Penni) painted for the SS. Trinità de' Monti Church in Rome. The fresco has been detached from its setting, but remains a powerful image in its own right.*

MARY MAGDALENE BORNE BY ANGELS
c.1520, fresco, 65 x 93 in (165 x 236 cm), National Gallery, London

THE FRESCO HAS SUFFERED *from being removed from the other three lunettes in the Magdalene story. Yet one cannot fail to enjoy the pale fleshiness of the beautiful Mary Magdalene, the faint rose and purple hues of the angels' garments, and the sense of freedom, of floating above the clouds – elements that make this fresco so exhilarating.*

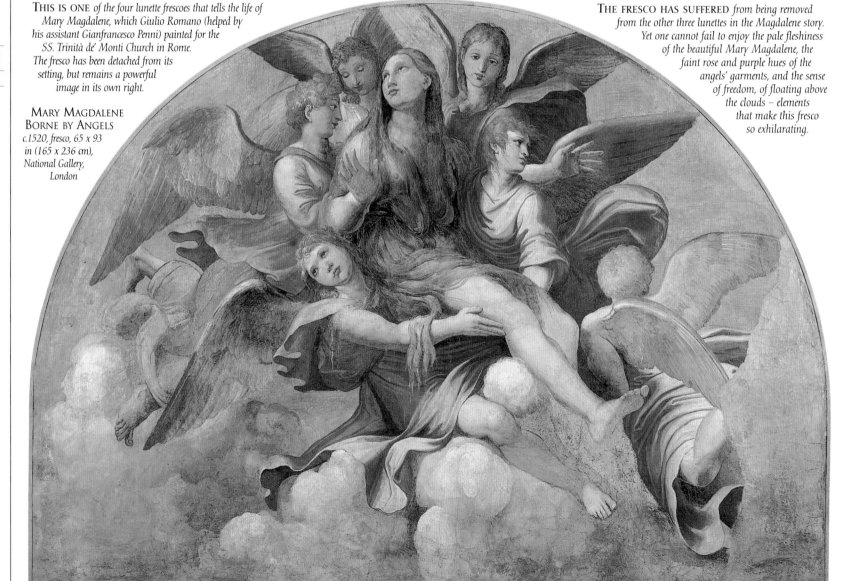

GOES, HUGO VAN DER c.1440-82 b. Netherlands
THE FALL OF MAN

VAN DER GOES'S TREATMENT of this traditional theme surprises us. Adam modestly shields the parts of his body that he was not to know were private until after the Fall. Here, we see the Fall in progress with a seductive little Eve who has already plucked her own apple and is about to take another and hand it to Adam who, like an automaton, reaches up an obedient hand. Eve's swollen belly reminds us that she will become the mother of all people, while the strategically placed blue iris flower reminds us that the Virgin Mary (whose color is blue) will supersede Eve as mother. The charm of the picture lies in the bizarre science-fiction creation of the half-lizard, half-human serpent. The artist uses gorgeous acidic hues to paint his belly, offering the most exciting use of color in the work. The serpent arouses compassion as his expression suggests a longing to enter Paradise, when, in reality, he is drawing Adam and Eve into sin.

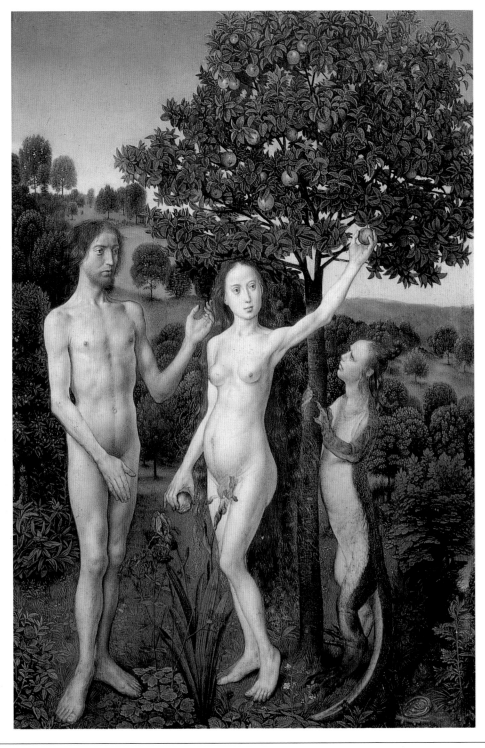

THE PORTINARI ALTARPIECE (DETAIL)
*c.1475, oil on wood, 100 x 55 in (253 x 141 cm),
Galleria degli Uffizi, Florence*

This altarpiece painted for the Portinari family was one of the last commissions van der Goes accepted before, overwhelmed by the anxieties of contemporary life, he retreated to a monastery. This right-hand panel shows the donor's wife, Maria, and her daughter Margaret, a serene figure imitating the pious decorum of her mother. These small human figures are overshadowed by their respective patron saints, who stand behind them. At the feet of St Margaret lies the dragon that she vanquished – one little black shoe rests contemptuously on its head. St Margaret looks with interest at the alabaster jar that the child's patron, St Mary Magdalen, carries as her symbol.

IN THE SCRIPTURES, *the serpent is punished for destroying the happiness of Paradise. He is no longer allowed to walk upright but must crawl on his belly. To remind us of his fate, the artist has included a small lizard, coiled inconspicuously near the serpents's tail. Van der Goes delights in the color of the serpent's belly, perhaps imagining that it will soon be pressed against the ground.*

THE FALL OF MAN
(PANEL FROM A DIPTYCH)
*c.1475, panel, 13 x 9 in (32 x 22 cm),
Kunsthistorisches Museum, Vienna*

GOGH, VINCENT VAN 1853–90 b. Netherlands
PEACH BLOSSOM IN THE CRAU

VAN GOGH IS PROBABLY THE BEST LOVED of all artists, partly for the sheer power of his work and partly for the pathos of his story. The two, of course, are not unconnected. His work derives its power from the intense frustration of his loneliness and from his inability to find those who would love his work and buy it. Everything van Gogh paints seems a receptacle for an ever-increasing psychic urgency. In itself, *Peach Blossom in the Crau* is an extraordinarily beautiful landscape, but it is a landscape made so quiveringly alive by the artist's intensity that it transcends all description and becomes something greater than artifice, something held on the canvas only by an immense psychic pressure.

PEACH BLOSSOM IN THE CRAU
1889, oil on canvas, 26 x 32 in (65 x 81 cm),
Courtauld Institute Galleries, London

SELF-PORTRAIT
1889, oil on canvas, 26 x 21 in (65 x 54 cm),
Musée du Louvre, Paris

If even a landscape is representative of van Gogh the man, what are we to make of a genuine self-portrait? The sense of conflict and encroaching madness, controlled with the utmost intensity, is almost overpowering here. The world behind the artist whirls and is kept at bay only by the sharp outline of the figure; within that outline, the same frightening tumult threatens, again, to overwhelm the painter. But the wild strokes are forced by the artist to cohere into a meaningful pattern.

THE BLOSSOMS *are not allowed to fill up their world. Beyond them stretch bare fields, with the closed houses pressed down by their roofs, and, beyond that, the ridge of mountains hemming in the world. A dense and speckled sky – each paint mark visible – presses down upon the scene.*

VAN GOGH *used painting as a way to find a precarious mental balance, and his raging insecurities, focused, channelled, and given visible expression, are what make his paintings unique. They are, in a most moving sense, variations of self-portraiture.*

GONÇALVES, NUÑO active 1450–71 Portugal

THE ADORATION OF ST VINCENT

THE WORK OF THE PORTUGUESE artist Gonçalves was forgotten for hundreds of years until he was rediscovered in the 20th century. All his work has been lost except for the *St Vincent* altarpiece in Lisbon. St Vincent was the patron saint of Lisbon and the altarpiece was painted for the Convent of St Vincent. This panel is one of the main central sections of the polyptych (of which there are six panels in total). Here, we see the saint in the splendor of the deacon's garment, the dalmatic, surrounded by the King of Portugal's champions. A coil of nautical rope lies in the foreground to remind us that St Vincent is the patron saint of sailors. Historians find this picture fascinating for the detailed portrayal of 15th-century costumes.

ST VINCENT'S *beautiful face appears thoughtful, as though he is aware of his impending martyrdom. Gonçalves shows the saint as introspective and absorbed in spiritual matters. The kneeling prince seizes St Vincent's hand in an attempt to capture his attention.*

EVERY FACE *in the painting is a portrait: the Archbishop is depicted in gold robes, with the authoritative air of an important administrator; the royal historian has his book tucked under his arm, and the doctor's fur collar distinguishes him as a medical man.*

GONÇALVES *impresses us with his ability to arrange a large group of figures with convincing reality. Even though everyone is posing for the painting and Gonçalves makes no attempt to illustrate an actual event, he has brilliantly captured the personalities that make up the royal court.*

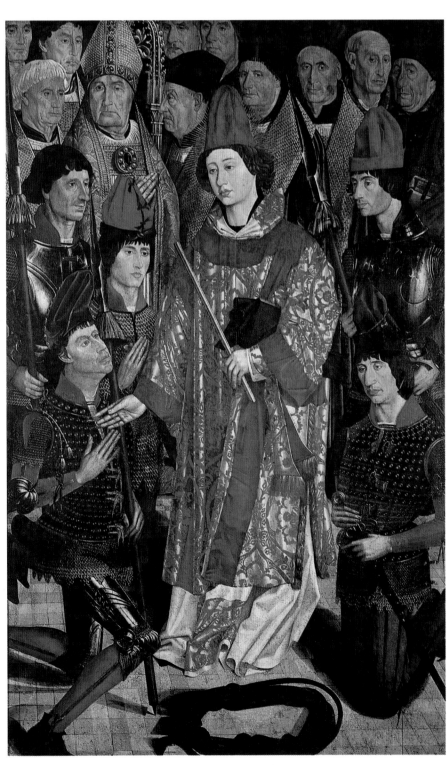

THE ADORATION OF
ST VINCENT, *c.1467,
oil on wood, 82 x 50½ in
(207.5 x 128.5 cm),
Musée Nacional d'Art
Antiga, Lisbon*

THE RELIC
*c.1467, oil on wood, 120½ x 25 in (306.5 x 64 cm),
Musée Nacional d'Art Antiga, Lisbon*

In this side panel from the *St Vincent* altarpiece, the priest displays the sacred relic – part of St Vincent's skull – while, behind him, the head of the local Jewish community presents the Pentateuch, the most sacred first five books of the Bible. To the left stands a dirty, ragged pilgrim who represents the poor of the world. His head is framed by another important relic – wood from St Vincent's coffin. The event is witnessed by two solemn clerics, whose eyes force attention back onto the kneeling priest.

GONCHAROVA, NATALIE 1881–1962 b. Russia
THE LAUNDRY

AT THE BEGINNING OF THE 20TH CENTURY, when Russia was a hotbed of Tsarist oppression and Communist frenzy, there was a golden age of painting. Russia was blessed with an exceptional number of highly gifted artists, although many of them fled the country as conditions became intolerable. One of these talented artists was Goncharova. She became famous working as a theatrical designer for Diaghilev, the great Russian impresario, and spent most of her life working at the Opera in Paris. Perhaps her greatest works are her early paintings, such as *The Laundry*, which she completed just before her exile from Russia. Goncharova was a Futurist and as such, believed that art must not just accept machinery, but celebrate it. The original title of this work was *Linen (Futurist)*, and we can see that she is wittily playing with the concept of a traditional activity such as laundry being transformed into a modern, commercial venture. Later in her career, Goncharova celebrated folk art and painted peasant girls at their toilet, but in this painting she is entirely enthralled by a humble activity and the modern-day machinery that seemed set to ease the burden on so many fellow women.

THE LOOKING GLASS
1912, oil on canvas, 35½ x 26½ in (90.4 x 67.5 cm), Private Collection

The Looking Glass has the same domestic ambience as *The Laundry*. Goncharova looks up at a chest of drawers, delighting with Cubist freedom in splintering the flatness of the visual world. This is not Cubism as Picasso and Braque practiced it, although the same sense of power over the subject matter exists. The glass reflects the wall and ceiling, yet we can also interpret that it reflects an angled reality, a world that is not as simple and solid as one first thinks.

THE LETTERS IN RED *Cyrillic script read: "Prache" and "Bot". "Prache" is the beginning of the word for laundry; "Bot" might well be the name of this particular commercial enterprise as would be seen etched on a shop window. Goncharova's interest is in the geometry and patterns of machinery. The items of laundry have an extraordinary whiteness, a white that becomes almost blue in this atmosphere dedicated to fastidious cleanliness.*

THOSE STARCHED CUFFS, *those collars, those petticoats, the lace, all representing hours of work in the home, are here almost effortlessly and perfectly cleansed by modern science. This was the intellectual justification, but the emotional justification – the real artistic reason that compelled Goncharova to paint the laundry – was her delight in the sheer spectacle of these diverse objects.*

THE LAUNDRY
1912, oil on canvas, 38 x 33 in (96 x 84 cm), Tate Gallery, London

GORKY, ARSHILE 1904–48 b. Armenia, active US

HUGGING/ GOOD HOPE ROAD II

ALTHOUGH GORKY BECAME an American citizen whilst still in his teens, he was by birth and temperament an Armenian. No label seems to fit him, and there is no category on which we can rely to explain the strange magic of his best works. For much of his early life, Gorky copied other artists – above all Picasso – obviously at some level fearful of his ability to "go it alone," as it were. Even in this wonderful picture, where he clearly is going it alone, we might well wonder whether there is a debt to Kandinsky. Gorky, an inveterate liar, claimed to have studied with Kandinsky, but there may be a subliminal truth beyond the factual. He had certainly studied Kandinsky, and understood that strange use of color as emotion that was Kandinsky's special gift.

THE ARTIST AND HIS MOTHER
1926–9, oil on canvas, 60 x 50 in (152 x 127 cm), Whitney Museum of American Art, New York

So many of Gorky's stories turn out to be fictitious, and yet, whatever the truth behind his mother and her death from starvation, she mattered enormously to him. He had a photograph of himself as an adolescent, in a foreign country with his mother. The image of the "strong woman", with her big Armenian eyes, and the pathetic child trying to take "strong man" position beside her, haunted him. He painted it more than once, always with the same weight of repressed emotion.

THE TITLE *does not shed much light on what is happening here. Imaginative commentators have seen roads, windows, and mountains – and these readings may well be true. Equally, we can write them off as fantasy, which in the end discredits the power of the work.*

WHAT GORKY *has given us is a great rectangle that encloses a small dark square; but it also encloses strange magical shapes, colors, squiggles, and circles. It takes us into a world where we float free, where we do indeed feel embraced, where our hope becomes almost tangible.*

HUGGING/GOOD HOPE ROAD II (PASTORAL), *1945, oil on canvas, 26 x 33 in (65 x 83 cm), Thyssen Bornemisza Museum, Madrid*

GOSSAERT, JAN (MABUSE) c.1478–c.1533 b. Netherlands
NEPTUNE AND AMPHITRITE

JAN GOSSAERT WAS ESSENTIALLY a profoundly sensual artist. He shared with his seafaring patron, Philip of Burgundy, an overriding belief in the power of human flesh. Here, in tribute to his overlord, Gossaert depicts Neptune and his wife Amphitrite. It is an extraordinary picture. Neptune is an enormous male, and his attempts at modesty backfire loudly, since the shell that masks his genitals is remarkably suggestive. The extraordinary masses of his curly hair, writhing in waves to an excessive height, are adorned by a semi-halo of black leaves, reminiscent of mussels. Amphitrite, drooping despite her considerable amplitude, also boasts the singular adornment of a scallop-shell "bonnet", and, like her husband, also wears small black leaves tucked into her golden curls. Their mutual adoration is portrayed in the gentle touch of their hands, their wreathed arms, and their tender expressions. And yet, the final impression is of exaggeration, almost of play-acting, of imposture. Neptune's face is unconvincing in its sweetness when allied to the massive bull-like neck that swells out into that great torso. But whatever we make of the picture's details, the overall effect is entirely memorable.

NEPTUNE AND AMPHITRITE, *1516, oil on wood, 74 x 49 in, (188 x 124 cm),Staatliche Museum, Berlin*

A NOBLEMAN
c.1525–28, oil on wood, 22 x 19 in (56 x 43 cm), Staatliche Museum, Berlin

Here, Gossaert is painting a nobleman, possibly Adolphe of Burgundy. The inscription on his dagger reads: "I love you only"; his hat bears a Venus and Cupid; one hand brackets a ring, while the other draws attention to his codpiece. But this sexual emphasis is contrasted with his strangely remote expression, producing a disturbing and schizophrenic picture.

NEPTUNE AND AMPHITRITE *stand in a small, gold-embellished classical temple. Neptune's trident is a reminder to us that he is the god of water, and skulls of oxen line the walls, perhaps suggesting that for those who go to sea, the creatures of the land have no vitality.*

GOTTLIEB, ADOLPH 1903-74 b. US
ASCENT

GOTTLIEB'S GREAT FEAR WAS THAT the contemporary artist, living in an industrialized and overly sophisticated society, might lose touch with the ancient forms of art, the primitive expression – the symbols, myths, and legends that have nourished the imagination throughout the centuries. Living in Arizona with the starkness of the desert landscape helped him to reduce this longing for his imaginative roots to a stark simplicity. In a series called *Bursts*, he refined his art to two forms against a white or pale background. First there was the circle, the sun; in *Ascent* Gottlieb has flattened it into a dull red oval, and set it in a heavy black surround. This is a threatened sun, for all its self-possession. Beneath it is the "burst", a blast of form, wildly hurling its energy into infinity. This strange, tattered shape has the clear red that the "sun" lacks, and casts a mysterious shadow. These two contrasting shapes seem, to him, to epitomize that dramatic opposition that is at the heart of life: the sun unassailable in the heavens, the sea surging wildly on the earth; the female, characterized as a closed ball, and the male exploding wildly in all directions – day and night, life and death, and good and evil.

ASCENT
*1958, oil on linen, 90 x 60 in
(229 cm x 152 cm),
Adolph and Esther Gottlieb
Foundation, New York*

GOTTLIEB NEVER CAME *to the end of playing with the strange dichotomy of being. In the end, of course, the dichotomy is subsumed in experience – it is not either/or but both that make up human existence. Reducing the essence of life to these pictograms set Gottlieb free to create art of the profundity to which he felt drawn.*

ROMANESQUE FACADE
*1949, oil on canvas, 48 x 36 in (122 x 91 cm),
Krannert Art Museum, Illinois*

The *Burst* series represents the climax of Gottlieb's creativity, and yet, in its austerity it loses something of the extraordinary imaginative richness of his earlier work. In work such as *Romanesque Facade*, Gottlieb attempted to draw together symbols from various cultures – imaginary signs and forms that had a significance to him, and which he felt primitive man would understand and sophisticated man would find challenging. Gottlieb created a pictographical vocabulary with which to express what is inexpressible but essential.

THE HEIR, PROMINENT IN GREEN, *short and stupid, is paired with the young woman whose head is turned away – Goya's solution to the problem that the heir had not yet chosen his bride. Between the Infante and his presumed bride pokes the shrewish face of the King's sister, perpetually displaced from positions of power, perpetually, as we can see, in a peevish fret about her unimportance.*

THE QUEEN PRIDED HERSELF *on her dress sense and on the beauty of her arms (having little else, one feels, with which to comfort herself). Goya dutifully displays the arm in all its imaginary glory, but we, of course, are riveted by that strong, self-willed face, plain and elderly – mutton determined to coerce the world into accepting her as lamb.*

IT IS A WELL-KNOWN FACT *that it was the Queen who ran the family; the poor, unintelligent King, weary and bloated, stands there in magnificent apparel, not exactly putting a good face on the situation, and unable to realize that a good face is called for. In fact, his face is good enough in its rustic bovinity, and pleases more perhaps than the self-seeking and empty expressions of the relatives behind him.*

GOYA, FRANCISCO 1746–1828 b. Spain

THE FAMILY OF CHARLES IV

GOYA WAS COURT PAINTER TO CHARLES IV and this full-scale picture of the entire royal family in all their glory was his crowning achievement. We may be astonished to hear that they were delighted with the way Goya had painted them, but, in fact, one can see with tragic irony why this might have been so. These people, who possessed unlimited power over Spain, are simply too stupid to see how truthfully Goya has shown up their deficiencies. What he has also done (and this is what captivated them) is to paint, with the most splendid magnificence, the glory of their trappings. Not one of this extended family suggests a personality capable of intelligent conversation, nor is there any indication that these people are anything other than small-minded – they jostle for position, all pushing forward to be prominent in the picture, all subliminally unconscious of the spectacle they present. An added twist to the picture is given by the presence of Goya himself, lurking in the shadows of the background. The sheer disagreeability of the family has always struck the viewer, but perhaps one can admit that there is a certain dignity here as well. At least they have presented themselves to be painted by an artist who was known to be unable to flatter. But Goya is not only the most truthful of artists; his technique is also supremely beautiful. One can almost understand why the Queen doted on her picture when one looks at the ravishing array of hues and the glitter and gleam of color through that diaphanous tissue.

THE FAMILY OF
CHARLES IV
*1800, oil on canvas,
110 x 132 in (280 x 336 cm),
Museo del Prado, Madrid*

THE COLOSSUS
*c.1808, oil on canvas, 46 x 41 in
(116 x 105 cm), Museo del Prado, Madrid*

In mid-life, at the height of his success, Goya had a serious illness that left him profoundly deaf and deepened his natural tendency to cynicism. The plight of the poor and the helpless obsessed him. In the forefront of *The Colossus* we see a world of terror and flight and mindless despair. We may read the Colossus itself as the source of this despair – the gigantic force of evil that with one hand could wipe out human endeavour and happiness. This, after all, was what Goya's countrymen were experiencing day by day as Napoleon's armies and the guerrillas fought with inconceivable barbarity.

GOYEN, JAN VAN 1596–1656 b. Netherlands

A WINDMILL BY A RIVER

JAN VAN GOYEN WAS ONE OF THE FIRST Dutch landscape painters to realize that it was the quality of the air that gave the land beneath the sky its somber beauty. He avoided using vivid colors, and his paintings appear so muted in tone that later admirers suggested that his work had actually been faded by the sun. However, this quietness of palette, this lack of any abrupt tonal movement, was deliberate. Van Goyen radically limited his colors to monochrome gray, brown, black, and white hues. Here, only the soft yellows of the sand dunes offer a contrast to the superb drabness of the flat Dutch landscape. All the glory is in the sky. Again, van Goyen creates the effect by the most subtle blending of his tones of gray. At its very palest, it is infused with an underlying luminosity, while the dark grays and black spread across the width of the panel with varying degrees of thickness. The landmark, of course, is the windmill, balanced on the left side by the small dark figure of a fisherman. The human activity we can pick out in this seascape is of little significance; it is the artist's use of an infinite amount of subtly different hues that make this work so appealing.

AN ESTUARY WITH FISHING BOATS AND TWO FRIGATES
c.1650–56, oil on wood, 20 x 27 in (50 x 69 cm), National Gallery, London

Here, Jan van Goyen has taken on a more ambitious subject. Again, the colors are strangely muted and extremely narrow in range; impossible, perhaps, for him to imagine scarlet sails or even a dazzling blue sea or sky. The sails are shades of brown and the sea is calm, reflecting and complying with the subtle gray harmonies of the large sky that dominates the whole work.

MORE THAN THREE *quarters of this picture is sky. This, of course, is the glory of a flat land like Holland: it enables us to see the sky's full majesty – its rolling splendor. Van Goyen's sky is particularly impressive. Dark masses of cloud are smudged and streaked by rain, and our attention is drawn to them by the wild flight of birds.*

THE EARTH, *in contrast, seems almost an object of pathos. The windmill – the proud invention of the human mind, harnessing nature to our needs – is strangely frail. The plains and marshes seem desolate, populated only by hunched and crouched inhabitants. Only the city on the skyline serves to restore the balance.*

A WINDMILL BY A RIVER, *1642, oil on wood, 11 x 14 in (29 x 36 cm), National Gallery, London*

GOZZOLI, BENOZZO c.1421–97 b. Italy
PROCESSION OF THE MAGI

THE MEDICI SET THEIR HEARTS on creating a palazzo of unique brilliance. Next to the audience chamber was a small chapel, and around its three walls Gozzoli was commissioned to paint a fresco of the procession of the Magi to Bethlehem. This great journey of the three kings had long delighted Christian imagination, with its scope for including portraits of reigning monarchs. The Medici were quick to utilize this potential, and Gozzoli rose to the occasion with a power of invention that still amazes and delights. All the Medici are here, but most of the attention is given to the imposing figure of Lorenzo the Magnificent. Shown here is a detail of Gozzoli's complete fresco; Lorenzo appears centrally within an enormous procession that winds around three sides of the chapel culminating in a figure of the newborn Christ. As an example of portraiture, it is approximate at best, and the handsome youth, dressed in lemon and silver with flowing curls, bears little resemblance to the large-nosed, hawk-faced Lorenzo. Nevertheless, everybody would have understood whom it was meant to portray.

PROCESSION OF THE MAGI (DETAIL), 1459–61,
fresco, dimensions not known, Palazzo Medici-Riccardi, Florence

THE DANCE OF SALOME
1461/62, tempera on wood, 9 x 13 in (24 x 34 cm), National Gallery of Art, Washington, DC

Gozzoli had a special gift, it would seem, for domesticating the biblical. Here, Herod, with an elaborate scarlet hat and Renaissance courtiers standing grandly on either side, watches in amazement the erotic dance of his stepdaughter Salome. The onlookers seem embarrassed, but so impressed was Herod that he offered her anything she wanted. Her mother, Herodias, told her to ask for the head of John the Baptist, and on the left of the picture we see the beheading about to take place. Salome brought the head to her mother on a dish, and there Herodias sits in the background, splendid in scarlet, to receive the offering.

AS THE ROCKY road meanders around the mountain, men chase stags with eager dogs, and eagles fly overhead. There are conversations, vignettes of castles, and distant towns to enliven the scenery. One's eye is perpetually delighted with new faces, new events, fresh colors, and strange oriental shapes.

IT IS AS IF the whole world, in all its splendor and glamor, had been brought forth, cluttering and chattering into the chapel. Because this is a sacred journey, Gozzoli was able to incorporate all the worldly elements that normally would seem inappropriate.

GRECO, EL (DOMENIKOS THEOTOKOPOULOS) 1541–1614 b. Crete

THE BURIAL OF COUNT ORGAZ

IF THE REPORTS ARE TRUE, COUNT ORGAZ was a saint who was never canonized. His reputation, though, for piety was so great in his native Toledo that a small church was built to enshrine El Greco's large and extraordinary depiction of his burial. According to local legend, St Augustine (on the right with miter and bishop's cloak) and St Stephen (the young deacon on the left in his dalmatic) came from heaven themselves to lay the saintly Count in his grave. The upper part of the picture is a swirling mass of the papery clouds to which El Greco was addicted, besprinkled with angels and saints and leading up inexorably to the majesty of Christ. Extraordinarily, the picture divides the world into two – the unseen and spiritual above, the visible material below – and yet unites it. But the vision is purely theoretical, heaven and earth interchange.

LAOCOÖN
c.1610, oil on canvas, 54 x 68 in (138 x 173 cm), National Gallery of Art, Washington, DC

Laocoön, a Trojan priest, distrusted the wooden horse in which – as we know from the Homeric wars – the Greeks were hiding to spring out in ambush. The gods turned the Trojans against their priest, and a huge serpent emerged to destroy Laocoön and his sons. The figures on the extreme right are mysterious: perhaps the three fates, or goddesses who favo0red the Greeks and brought about the destruction of Troy, which lies in the distance under a flickering, ominous sky. It is an eerie picture, one that neither intellectually nor visually makes perfect sense, but which leaves us with a sense of mortality and the inexorability of fate.

ONLY THE PRIEST, *with his back to us, looks up to heaven. Standing at a distance, he seems to take in the full tableau. He is us, as it were, spreading his hands in astonishment. If the child with childish solemnity indicates to us that we should pay attention, the priest, in the glorious diaphanous whiteness of his alb, expresses for us the due astonishment at the miracle.*

HERE WE SEE *the cream of Toledo society. The faces of these dignified Spanish gentlemen are clearly portraits. This was the world in which El Greco lived. Not only the material world, but the spiritual world, in which heaven was very close to earth. A label saying "El Greco made me" sticks out of the pocket of the small boy in front. Not only is it the artist's signature, but also an indication that the child is El Greco's eldest son.*

THE BURIAL OF COUNT ORGAZ, *c.1586, oil on canvas, 192 x 142 in (488 x 360 cm), Church of Santo Tomé, Toledo, Spain*

GREUZE, JEAN-BAPTISTE 1725–1805 b. France
THE SPOILED CHILD

GREUZE IS A BRILLIANT PAINTER, who is at odds with our contemporary sensibilities. He is a manipulator, and a deep streak of moralizing sentiment runs through his paintings. *The Spoiled Child* is a perfect example. The whole kitchen scene is brought most vividly before us, with splendid touches that must at first seem merely realistic but which, on further investigation, disclose themselves as having a deeper value. The meal here, for example, has been served in a condition of considerable squalor, with washing dangling from the large pot in the foreground and unwashed pots on the table behind. The maid, or mother, is too wrapped up in her private dreams to notice how the child is flaunting authority and secretly feeding the dog from his spoon. Greuze, ever alert in responding to female charms, pays particular attention to the young woman's bosom, and he takes pleasure in the child's complete disinterest in anything but the chance to get his own way and dispose of an unwanted supper.

BOY WITH LESSON BOOK
*c.1757, oil on canvas, 24 x 19 in (62 x 48 cm),
National Gallery of Scotland, Edinburgh*

This child has that apparently ineradicable note of the sentimental that distinguishes Greuze, and yet this is a very strong image. This is a pale child, with a drawn face and shadowed eyes. There is no attempt to show him as anything but burdened and dutiful. He is not actually reading the book, but his air of concentration suggests that he may well be repeating in his mind what he has learned. It is a much-used book, and his clothes, too, are a little threadbare. He appears to be from a lowly background, and he must plough a rather lonely furrow.

THE SPOILED CHILD SEEMS a rather harsh title. The Negligent Nursemaid might be more to the point. Perhaps the most interesting character is the dog, which is brilliantly painted with the superb curve of his tail and the well-observed dip of the head as he licks from the spoon, which the child – naughty, yet charmingly innocent – holds down under the table, while keeping a watchful eye on his guardian.

THE CHARACTERS here are too prettified to be completely convincing. The boy is a cherub and the girl a rustic Venus, but if we abstract from all but their clothes and their bodies, we can admire the virtuoso skill with which Greuze has responded to every nuance of color and texture, and he has presented us with a scene that, with slightly less charm, we might well have believed in.

THE SPOILED CHILD
*1765, oil on canvas, 26 x 22 in
(67 x 56 cm), Hermitage, St Petersburg*

GRIS, JUAN 1887–1927 b. Spain, active France
FANTÔMAS

ALTHOUGH PICASSO DID NOT TAKE TO HIM, Juan Gris was not only a fellow – if much younger – Spaniard, but also the only Cubist whose name could be mentioned in the same breath as Picasso and Braque. He is the least of the trio, and yet in some ways the most attractive, and his version of Cubism was in no way a copy of that of his seniors. He had a playful spirit, and we can see him here almost mischievously imitating in oil the wood grain and the linoleum, the wallpaper and newspaper, the real substances – the found objects – which his seniors had delighted to collage directly onto their works. He has called it *Fantômas* after a paperback thriller, and something of the mock melodrama of the genre infuses this bright and witty work. We see the faint transparency of a glass outlined in white, and a ghostly still life of fruit. He has outlined, seemingly illogically, parts of his image with thick, soft black lines, which may or may not refer to anything in the material world. They have a unitive function, and, with gay independence, seem to maintain the air of intellectual and amused detachment with which Gris handles his painting.

PORTRAIT OF JOSETTE
1916, oil on board, 46 x 29 in (116 x 73 cm), Museo del Prado, Madrid

Cubism, perhaps, does not lend itself to the greatest seriousness and, certainly in Gris, there is often what we might call the trickster element – a play of shapes without profound intentions, but rather to engage with the surface. He may show us his wife Josette, but he is also determined to hide her. He plays with sharp angularities and offsets this with the strange, enlarged commas – round egglike shapes – that perhaps suggest another aspect of her character.

THE NEWSPAPER *changes color with gay abandon and there are mysterious geometric shapes, like traffic signals, in yellows and blacks, that punctuate the picture – perhaps another reference to the excitement of a cops-and-robbers thriller.*

THE PIPE, *with its green background, belongs perhaps to the world of Fantômas, or is it actually resting on the table top in its own right? The table itself is a mere phantom structure, its substance both there and not there, with only the slightest outlining in white.*

FANTÔMAS, *1915, oil on canvas, 24 x 29 in (60 x 73 cm), National Gallery of Art, Washington, DC*

GROS, ANTOINE-JEAN 1771–1835 b. France

PORTRAIT OF MADAME BRUYÈRE

It is all too easy to think of Gros as solely a painter of those great epic machines that chronicle, with an admiring lack of judgment, the triumphs of Napoleon. Clearly this desire to paint big, to attract attention, was something very real to Gros, but he could also be a painter of classical sensitivity. Here, in his mid-twenties, we see the Gros that might have been, in this pure and sensuous *Portrait of Madame Bruyère*. He has had the wisdom not to "over-egg his custard", and contrasts the deep, creamy tactility of her flesh with the sober density of her black dress – with just that small and modest frill at her cleavage to offset the opulent splendor of her beautiful body.

NAPOLEON ON THE BATTLEFIELD AT EYLAN, FEBRUARY 9, 1807
1808, oil on canvas, 210 x 315 in (533 x 800 cm), Musée du Louvre, Paris

Here is Gros in more familiar mode: the Gros that became one of Napoleon's painters. This is propaganda at its most unabashed. Napoleon has won the Battle of Eylan with tremendous cost to the national armies, and Gros goes out of his way to show the dead and the suffering not as French but as Prussian. He shows Napoleon as adored by his troops (the reverse of the attitude that was beginning to spread throughout his army). On the lower right, an enemy, with a ludicrous hat and wildly popping eyes, fights off the attentions of a heroic French doctor.

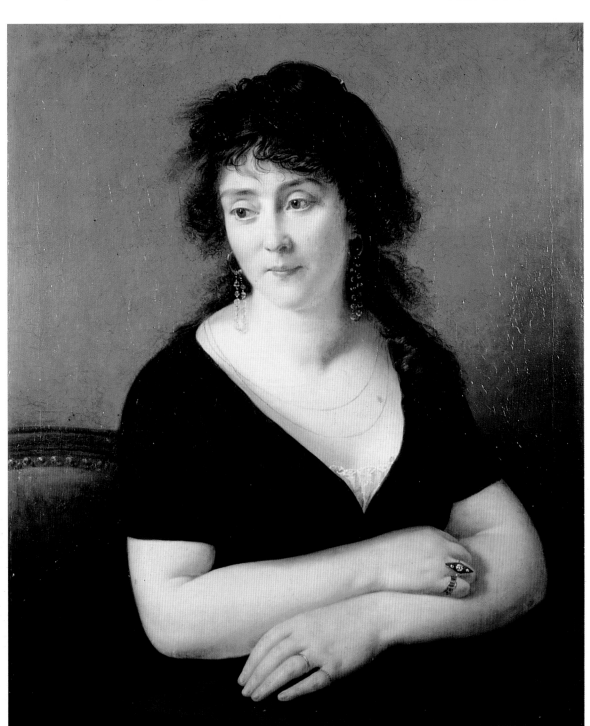

MODESTLY, MADAME BRUYÈRE *averts her eyes – those large, sparkling, unforgettable eyes – both from the artist and from us and looks with a pensive smile at something visible only to herself. Although she clasps her arms, we have no sense of a woman deprived of scope. Gros communicates affectionate admiration and respect and produces a splendid icon of femininity.*

THE WILD STRAGGLES *of black curls, those alluring, looping earrings, the thin gold chain, the great lozenge of her ring – these details all suggest hidden fires within Madame Bruyère. Her face, with its secret inner smile, is that of a woman who is well aware of her charm and its power, but everything about her body language indicates that this is a power she knows how to control.*

PORTRAIT OF MADAME BRUYÈRE, *1796, oil on canvas, 31 x 26 in (79 x 65 cm), Bristol Museums and Art Gallery, UK*

GROSZ, GEORGE 1893–1959 b. Germany
PILLARS OF SOCIETY

GROSZ WAS ONE OF SEVERAL German artists to be driven to a mental breakdown by the horrors of World War I. Having been court-martialled, nearly shot, and then invalided from the army after a year of mental agony, he emerged from this ordeal bitter and angry, convinced that society had become rotten to the core. The war's end brought no respite for Grosz; in fact, things seemed to get even worse, due to the rise of pro-military organizations – who had already, as Grosz believed, destroyed his country – and the near-hysterical level of nationalist fervor among such groups. *Pillars of Society* is a frightening work. Aged and repulsive soldiers rampage through the streets, buildings burn, and a well-fed cleric fans the flames. In the foreground, three pillars of society form an unholy Trinity: the swastika-wearing, nationalist drinker is too old to fight himself, but his mind is full of a foolish romanticism of war; a well-known journalist holds a blood-stained palm branch and wears a chamber pot for a hat; behind him is the Social Democrat politician (who may well be the president of the Republic), whose hollowed head is filled with steaming dung.

> " MY DRAWINGS EXPRESSED MY DESPAIR, HATE, AND DISILLUSIONMENT. I HAD UTTER CONTEMPT FOR MANKIND IN GENERAL "
>
> George Grosz

PILLARS OF SOCIETY, 1926, oil on canvas, 79 x 42 in (200 x 108 cm), Staatliche Museum, Berlin

SUICIDE
1916, oil on canvas, 39 x 31 in (100 x 78 cm), Tate Gallery, London

Suicide, painted during the middle of the war, expresses Grosz's feeling of utter despair and disillusionment. From a lamppost – which itself leans drunkenly forward – a man hangs by the neck. In the foreground, a well-dressed dandy in a green silk coat, still holding his cane, lies dead on the street. His face has already become a skull, as if to acknowledge that the playful life of the prewar days has been crushed forever. Looking out from a window, there is perhaps a third kind of suicide – the moral suicide of the woman who prostitutes herself to the bloated profiteer lounging behind her.

THESE ARE THE MEN *Grosz believes control his afflicted country, whose cynical complacency and corruption fuel the chaos. The artist's disgust permeates the painting, which appears filled with confusion and incoherence. The painting's title is an ironic reference to a stage play of the same name by the Norwegian dramatist Henrik Ibsen.*

GRÜNEWALD, MATHIS c.1475–1528 b. Germany
CRUCIFIXION

THERE ARE MANY VERSIONS of the Crucifixion undertaken by some of the greatest artists in history, but the central panel of the *Isenheim Altarpiece* is unique in its depiction of Christ's suffering. Grünewald painted this image for the hospital at Isenheim, which cared specifically for those suffering from leprosy, the scourge of the Middle Ages. Here, Christ is not only suffering from the torture of being nailed to the Cross, but He also has leprosy. His skin is disfigured by green boils, and it is Grünewald's aim to offer an image of empathy and comfort to the hospital patients. The artist ventures into this abyss of sacred agony with terrifying realism.

CRUCIFIXION, c.1510, oil on wood, 106 x 121 in (269 x 307 cm), Unterlinden Museum, Colmar, Germany

GRÜNEWALD IS HAMMERING *home the stark message that it is this Jesus, this despised and tortured man, that Christians must accept as their role model and savior. This is a truly medieval painting in sentiment – even the background is a sea of desolation, with no comfort but that of faith.*

RESURRECTION
c.1510, oil on wood, 106 x 56 in (269 x 143 cm), Unterlinden Museum, Colmar, Germany

In this side panel from the *Isenheim Altarpiece*, the resurrected Jesus is light personified and the sun itself is overshadowed by His brightness. Christ's wounds are transformed and glorified, and His twisted, diseased limbs are now healed and strong. This is a version of the Resurrection with a specific, uplifting message for the sick for whom it was painted.

GUARDI, FRANCESCO 1712–93 b. Italy

VIEW OF THE VENETIAN LAGOON WITH THE TOWER OF MALGHERA

DURING THE 18TH CENTURY, anyone returning from the Grand Tour would proudly bear home a view of Venice by the celebrated Canaletto. Strangely enough, Francesco Guardi, who was also a specialist in Venetian views, never attained the same popularity. Perhaps it is because the actual buildings never seemed as important to Guardi as the whole Venetian setting. Here, he shows the Venetian lagoon with a perfectly recognizable Tower of Malghera, but it is the sparkle on the water, the shimmer of the air, the fading grandeur of this great watery city that has so intrigued him. There is a lightness in Guardi's views and a sadness that is never present in Canaletto's grand topographical perfections. Guardi is both lighter and deeper than Canaletto, and some of his flickering magic may well have escaped the well-fed, rich English tourist. Here, we see Guardi at his most poetic, with the actual tower merely acting as an anchoring point for the expanse of water, slashed by the curving horizontal of the gondola. The sky entrances Guardi, not for the grandeur of its cloud formations, but for the serene beauty with which pale blue and white play against each other.

VIEW OF THE VENETIAN LAGOON
WITH THE TOWER OF MALGHERA
*c.1770s, oil on wood, 8 x 16 in
(21 x 41 cm), National Gallery, London*

AN ARCHITECTURAL CAPRICE
c.1770s, oil on canvas, 9 x 7 in (22 x 17 cm), National Gallery, London

Artists who painted views of the great Italian cities often delighted in the caprice: here, Guardi has taken the features of three identifiable Venetian landmarks and combined them into a view that is purely fictitious. This imaginary scene attempts to encapsulate the essence of this architecturally rich city distilled through Guardi's intimate knowledge of Venice.

EMPTINESS ATTRACTS THIS PAINTER
as much as fullness – for its absence and its potential – and, here, the fleeting efflorescence of the light of Venice is made visible in the implicit efflorescence of the scene.

GUARDI COULD DO *the grand scene as magnificently as Canaletto, but he had a special gift for the humble, where nothing much is happening, and yet what we see entrances and delights us.*

THIS VIEW OF THE LAGOON *has the quality of a snapshot that has captured a single moment so crisply that we are compelled to stare at the image, despite the lack of any really dramatic event within it.*

GUERCINO, IL (GIOVANNI FRANCESCO BARBIERI) b. Italy

1591–1666

THE DEAD CHRIST MOURNED BY TWO ANGELS

GUERCINO IS THE MOST DRAMATIC OF ARTISTS. He has an instinctive feel for bodily and psychic reactions. We know he had a squint, because that's what his name means (*guercino*: squinty-eyed), but this defect never seems to have impeded his wonderful delight in the shapes and the colors that human beings provide in their interactions. *Christ Mourned by Two Angels* is dramatic in the purest sense; Guercino is showing us the moment just before the dead body of Christ stirs and the resurrection has happened. Guercino is so often unusual, and here is a superb example. He shows us not the dead Christ, nor the risen Christ, but Christ at a moment in between, a moment on the brink of transformation. It is a supremely beautiful picture, where light and shade in themselves are used to tell a story; the darkness, the shadow, is passing away to the upper right, and light is coming in, flooding over Jesus and calling Him back to the warmth of the world.

THE LIBERATION OF ST PETER BY AN ANGEL
c.1622–23, oil on canvas, 41 x 53½ in (105 x 136 cm), Museo del Prado, Madrid

While his guard sleeps, St Peter is awakened by the summons of the angel, calling him to freedom. The square hulk of St Peter rests upon massive forearms as he stares into the half-darkness, uncertain whether this is a dream or reality. The angel is a surprisingly physical presence, but his radiant beauty indicates an angelic status, as does the feathered wing, which crowns the picture and counterbalances the surrounding darkness.

THE ANGELS *are puzzled; one in particular has a questioning look, marvelling at how the Son of God could have died as all men die. But it is the fine point of the uncertainty that gives this superb picture its particularly beautiful edge.*

UNAWARE OF *what is to come, the angels' grieving faces are yet becoming luminous with the new life that is beginning to glow in Christ's body. The dead head is about to lift, and their profound sorrow is on the point of changing into an ecstasy of joy.*

THE DEAD CHRIST MOURNED BY TWO ANGELS
c.1617–18, oil on copper, 14½ x 17 in (37 x 44 cm), National Gallery, London

GUSTON, PHILIP 1913–80 b. Canada
BLACK SEA

PHILIP GUSTON WAS AN ABSTRACT PAINTER, and a successful one, but he came to feel he was losing touch with reality, that he was too wrapped up in his own subjective reactions. His change from abstraction to realism lost him nearly all his supporters, because it was a strange, Surrealistic, half-comic, half-tragic view of the world that he decided to paint. He became obsessed with the lowly boot, and this painting, *Black Sea*, shows a great, flat expanse of ocean and a great crowded sky, dominated by the majestic arch of a boot heel. The boot heel looms there in space, affirming its identity as an object; all the nails are visible, but without any pretence at a rational signification. Its importance rests on the idea of the boot heel as representative of the most lowly part of a human's attire: even lower than the foot is the boot, and even lower than the boot is the heel. This is what we press into the earth and now Guston re-presents it, rearing up like a Roman arch to dominate sea and sky. It is an attempt, clumsy, but deeply sincere, to enter into the philosophical reality of the material world. It is because Guston is a great artist that this attempt has produced an image both vivid and awesome.

THE NATIVE'S RETURN
1957, oil on canvas, 165 x 193 cm, Phillips Collection, London

At the end of the 1940s, Guston had spent a year in Italy. *The Native's Return* may well celebrate his coming back to the United States. Whereas in America somber colors had often come spontaneously to his brush, memories of the beauty of Italy – its white walls, its bright, hard light, its flowers – evoked, as we see here, the palest of subtle backgrounds, all white and pink. It is rather as if color was reflecting on a whitewashed wall, deepening and becoming brighter towards the center of the canvas.

BLACK SEA
*1977, oil on canvas,
68 x 117 in
(173 x 297 cm),
Tate Gallery, London*

WHICH CATCHES OUR ATTENTION MORE, *this strange and threatening image or the loose, choppy handling of the paint? Guston handles his oils as if the material world itself were in flux, had no stability, and entirely lacked direction. For some reason, it is not the sea or the central shape that is most alarming, but that incoherent and very disconcerting sky.*

Hals, Frans c.1580–1666 b. Netherlands
Young Man with a Skull

Frans Hals is a far more complex artist than he may at first seem. This great picture gives off two equally powerful, but contradictory, signals. The young man is life-assertive, animated, and vital, and yet he holds in his hands the gleaming emptiness of a skull; life and death are thus drawn together before us. The young man wears that extraordinary feather, a great symbol of personality and self-possession, stuck haphazardly into a splendid red cap, from which his hair springs with an almost contemporary informality. His neat white collar is obscured by the histrionic wrappings of an enormous and impractical cloak, suggesting that he is here merely to play a part. Indeed, his distracted expression (that one feels could so easily spread into a smile) suggests that he is no more able to believe in the possibility of his own death – his own metamorphosis from living flesh to dry bone – than he is able to believe in the charade he is acting out, and he holds the skull with an almost playful casualness. His eyes are not turned towards us, but towards an invisible audience, one eye in full sunlight, one eye darkened, as if to emphasize the dual character of the youth.

MAD BABS
*c.1629–30, oil on canvas, 29 x 25 in
(74 x 64 cm) Staatliche Museum, Berlin*

With the wild genius of his brushstrokes, Hals has summoned out of the shadows an utterly convincing picture of an old, unbalanced woman carousing with her tankard. The tankard, strangely, has a fluidity of form that "Mad Babs" does not; as if the metal is real and she has drunk herself into a state of only semi-reality. The picture progresses from the integrity of the tankard, through the wavering reality of the elderly woman, to the surreal vision of the owl – the Dutch symbol of dirtiness – perching so incongruously on her shoulder.

THE MARVELLOUSLY *painted
hand that juts towards us into our
space is less a summons than a
rhetorical gesture. The youth is unaware
of us, the half-amused vitality of his
expression takes no account of the
viewer, who is perhaps anxiously
brooding on the meaning of the skull.*

THE YOUTH HOLDS *the skull with
one hollow socket turned towards the
viewer, and despite the profound emptiness
of the eyes, the skull seems to address us
in some way. The teeth gleam whitely
with implicit threat, a reminder that this
is a "vanitas" picture and that underneath
that red beret and brown hair lies a
similar skull, biding its time, but
ultimately waiting for the youth to die.*

YOUNG MAN WITH
A SKULL (VANITAS)
*1626–28, oil on canvas, 36 x 35 in
(92 x 88 cm), National Gallery, London*

HAMMERSHØI, VILHELM 1864–1916 b. Denmark
STUDY OF A WOMAN

HAMMERSHØI WAS A LEADING LIGHT in Denmark at the dawn of the 20th century. Only now are we beginning to appreciate the strange beauty and individuality of his vision. What is so remarkable about Hammershøi's work is his confidence that merely looking at a simple figure would be artistically satisfying. He shows a daring disregard for the support of narrative, color, and contemporary relevance. His *Study of a Woman* could have existed in almost any era; the figure transcends the image and it is the quality of light that is all-important. The wall in the background gleams in luminous gold, pale and beautiful, as it outlines all that stands before it. There is a timeless quality to the work, and the artist clearly does not want to involve himself in the details of examining what people are like, or in revealing how people are feeling by the expression on their face. Here, the woman stands before a table, her face obscured, intent on some domestic activity, the intricacies of which the artist feels are irrelevant. Hammershøi's belief in what he sees is even more radical than Vermeer's, with whom one instinctively compares him. Nothing is happening in this composition, yet the picture is heavy with significance.

INTERIOR, SUNLIGHT
ON THE FLOOR
1906, oil on canvas, 20 x 17 in (52 x 44 cm), Tate Gallery, London

The profound silence of this picture is perhaps its most appealing quality. This is not diminished by the knowledge that the painting originally had a figure in it (a woman standing between the table and the wall on the far left). The first owner felt the figure to be intrusive and folded the canvas, thereby destroying most of the image. But the chief actor, here, is not a human being, but the sunlight on the floor; it is the room itself, with its golden warmth and quiet austerity – a scene so typical of Hammershøi.

THIS SOLID FEMALE FORM *stands in the light, which gleams on her neckband, then delicately catches her thickset nape and hair bun. A picture such as this is intended to challenge the viewer. There is nothing here to say clever things about, little to understand, and nothing on which to hang a story. The picture simply declares, with visual conviction, that light is supremely beautiful, and that a body viewed in the light is, irrespective of physical attractiveness, something that demands reverential study.*

INTERESTINGLY, HAMMERSHØI *often chose to paint figures from the back. It was not looking at the person that mattered but observing how they viewed the world around them. Their individual features were unimportant, but their silent presence was significant for the artist. Here, a chair is turned obliquely, angled out of the picture, while the curve of the armrest and the slight elaboration of its decoration deepen the sense of space. It is the mystery – the secrecy of the human being – that he celebrates, and that we are forced to contemplate by the sheer austerity of his art.*

STUDY OF A WOMAN, *1888, oil on canvas, 25 x 22 in (64 x 56 cm), Statens Museum for Kunst, Copenhagen*

HECKEL, ERICH 1883–1970 b. Germany

BATHERS
IN THE WOODS

HECKEL, LIKE MANY 20TH-CENTURY GERMANS, looks back
wistfully to an imagined age of primitive simplicity. *Bathers
in the Woods* is a dramatic expression that imagines a time
of freedom. The great pine woods of Germanic imagination
have always played a part in German myths, and woods –
with their overpowering intricacy, their dark, mysterious
interior and brooding quality – had a special appeal to the
Expressionist temperament. Here, Heckel has imagined men
and women set free to live in nakedness, emerging from a
hollow in the dense forest to plunge into the intense blue
of a secret lake. He is expressing his emotions, his longings,
all within him that felt inhibited and deflated by the urban
world in which he found himself entrapped. The bright
and almost ecstatic harmonies of this picture provide for
the artist a compensatory world in which he is free and
creative, able to shape both form and color to his will,
and where rock and forest are a setting for the deep,
unfathomable waters of the lake.

BRICKWORKS, DANGAST
1907, oil on canvas, 68 x 86 cm, Thyssen Bornemisza Museum, Madrid

Here, Heckel confronts the present: the actuality of the factory. He sees it in
a visionary light. We advance to it over a meadow streaked with brilliance,
and, although the red roof flattens down the buildings and there is a sense
of the squat and the ugly, all is redeemed by the chimney standing proud
amid a sky of extraordinary brilliance. Heckel is using color with emotional
freedom so confidently and so happily that we accept his vision.



HEDA, WILLEM CLAESZ. 1594–1682 b. Netherlands

BREAKFAST WITH CRAB

DUTCH ARTISTS TENDED TO SPECIALIZE. They found a theme that appealed to them and then devoted all their energies to exploring the potential of that theme. William Claesz. Heda was a great still-life painter; indeed, one could nail this down even further: he was one of the two most important painters of the *ontbijt* – the "breakfast piece" – along with fellow Haarlem artist Pieter Claesz.. The opulent, discarded breakfasts that Heda painted were of an almost inconceivable grandeur. The owners of this painting would have wanted such a breakfast to be seen as their usual fare, with all their glorious possessions laid out to be duly admired.

BREAKFAST
WITH CRAB
*1648, oil on canvas,
46 x 46 in (118 x 118
cm), Hermitage,
St Petersburg*

STILL LIFE
1631, oil on wood, 21 x 32 in (54 x 82 cm), Gemäldegalerie, Dresden

Here, there are faint vestiges of narrative: the glass on the left has been broken, but why? There is a watch, opened to reveal to us its inner workings; again, why? Is Heda suggesting the passage of time? There is a subtext here that intrigues us, even while we fall under the spell of the sheer beauty of the painting.

HEEM, JAN DAVIDSZ. DE 1606–c.1683 b. Netherlands

VASE WITH FLOWERS

THIS GREAT DE HEEM is almost a living world in miniature. Flowers, of course, predominate, but there are also luscious fruits and insects. A curve of ripe corn boldly marks the limit of the composition, and other flourishes of corn rear up on the right and at the lower left, as if to anchor the sophisticated arrangement of flowers in the real countryside. Butterflies of varying size and splendor hover all around. A caterpillar undulates beguilingly from beneath a leaf, and the weird surrealistic black and yellow of a snail decorates the stem of blackberries. Even the container expands the world beyond the simple flower, because reflected in the dark rotundity of the glass is the window, with the outside world of sun and shade.

VASE WITH FLOWERS
*c.1670, oil on canvas, 29 x 21 in
(74 x 53 cm), Mauritshuis
Museum, The Hague*

STILL LIFE
WITH BOOKS
*1628, oil on wood, 14 x 19 in
(36 x 48 cm), Mauritshuis
Museum, The Hague*

This is a picture of nuances: of light falling upon paper, upon the old calf covers, and upon a violin that lies on a book, as if to suggest there is music here, even while it is silent. Its subject, perhaps, is less the world of literature than that of light and shade. It is a visual extravaganza, albeit one with a very small gambit of tones.

HEEMSKERCK, MAERTEN VAN

1498–1574
b. Netherlands

PORTRAIT OF A LADY WITH A SPINDLE AND DISTAFF

HEEMSKERCK TRAINED WITH JAN VAN SCOREL, and so great was the influence of teacher upon pupil that, in some paintings, it is difficult to differentiate the work of one from the other. However, if Scorel affected Heemskerck's technique, it was Italy that most influenced his spirit. Early in his career Heemskerck spent three years in Rome and came back to Holland deeply impressed with the classical grandeur that Raphael had made seem contemporary. Here, we see how well he has learned his lesson. *Portrait of a Lady with a Spindle and Distaff* is like one of the great figures of mythology – one of the three Fates, perhaps, such as Clotho, the goddess who spins the very fabric of life itself – although any allusion to the supernatural world is made without hint of the uncanny. The woman dominates her limited space and looks out at us with serene confidence.

FAMILY PORTRAIT

c.1530, oil on wood, 46 x 55 in (118 x 140 cm),
Staatliche Museen, Kassel, Germany

Heemskerck's interest here seems to be divided almost equally between the family and the rich array of foodstuffs on the table before them. The artist dwells with fascination not so much on the human faces and their relationships as on the cheeses, the fruits, the bowls, and the jugs which spread with kaleidoscopic exuberance on the table. With a further touch of genius, he has set this family portrait against one of the strangest skies in art: a blue and white wash in which clouds thicken behind the parents, and then dissolve to re-combine in an overall chaos that, perhaps ironically, counterbalances the chaos of foods on the table.

HEEMSKERCK GLORIES *in the great flow of those white sleeves, the close-fitting black bodice, and the green skirt with its wrinkles and folds. The artist takes great delight in spelling out for us the intricacies of the spindle, which is an extraordinarily elaborate construction – surely an upper-class spindle deluxe – which she controls with assurance.*

THE LADY INHABITS *her own body with such authority that it seems only natural she should handle her machinery with the same certainty. Heemskerck needs no grandiloquence to convince us that this woman – with those bare wooden walls behind her and her full and rich, but relatively unadorned, dress – is somebody who holds real authority.*

PORTRAIT OF A LADY WITH A SPINDLE AND DISTAFF, *c.1531, oil on wood, 41 x 34 in (105 x 86 cm), Museo Thyssen-Bornemisza, Madrid*

HICKS, EDWARD 1780–1849 b. US
THE PEACEABLE KINGDOM

HICKS SEEMS TO BE PROOF of the need within humans to make art. Completely untaught, he wandered around 19th-century America sharing his vision of *The Peaceable Kingdom* (he is said to have painted over one hundred versions of this image). Ironically, his need to paint the Kingdom of Peace seems to have been aroused by divisions among the Quakers – that religion so committed to pacifism. Hicks himself, we are told, was not so pacific, and it is said that the lion – always predominant in this image – was a disguised self-portrait. Whether true or not, there is immense charm in these images of a world in which wild animals and tame are at peace together and, as prophesied, are able to be led by children. To make the message quite clear, Hicks has painted four children, frolicking happily among the rather bewildered beasts. Even less credible, although greatly to the artist's credit, is the scene of native Americans and colonists, for whom the peace of the animals is meant to be a symbol.

THE PEACEABLE KINGDOM, *c.1837, oil on canvas,*
29 x 36 in (74 x 91 cm), Museum of Art, Carnegie Institute, Pittsburgh

THE CORNELL FARM
1848, oil on canvas, 37 x 49 in (93 x 124 cm), National Gallery of Art, Washington, DC

The Cornell Farm is an image of the restfulness of order, the annihilation of chaos, and the control of the wilderness – the ideal of the early settlers. All the animals stand still and obedient, from the cattle and sheep on the left to the splendid equine family at the right. Trees stand still in obedient rows, fences are white and straight, and the farms and houses pile themselves up in obedience with the dictates of balance. The only hint of disorder is that one thing Hicks cannot control – the sky.

THE EARLY COLONIST
William Penn acted with peaceful affection towards the native Americans, who, as we know, were soon to be dispossessed. Hicks himself seems to waver in his certainty as to the truth of this historical affection – he paints the group with a sketchy, cartoon-like quality, as opposed to the solid, richly charactered images of his animals.

HICKS DELIGHTS *in the patterns and varieties of his animals: the curve of the buffalo's horns and the delightful bear, nibbling as he shares the maize with a theatrical cow. All this is deeply realized – the popping eyes of the tiger urged on by the child, the leopard controlling his energy, the patient goat, and a wolf looking with an interested stare at those luscious hindquarters.*

HILLIARD, NICHOLAS c.1547–1619 b. England
QUEEN ELIZABETH I

IF ELIZABETH I DOES NOT LOOK FULLY HUMAN, that was precisely Hilliard's intention. Above all, the Queen needed to impress her image on the world as a magnificent symbol of power – just as her father, Henry VIII, had done. As a woman, the physical dimensions of power were not available to her, but she was very clear about how she wanted Hilliard to paint her. This is an image, not of a woman but of a goddess – a creature that is not subject to the ebbs and flows of human uncertainties. She is bejewelled to an almost unbelievable extent with gold, pearls, and rubies. The great jewel above her hand shows the phoenix, the mythical bird that was consumed by fire and rose again from the ashes – a symbol of immortality. Perhaps more significantly, it was also a symbol of chastity; it was contrary to her policy that she should be considered a pawn in the marriage market. The great Elizabethan frill around her neck seems to set that strange white face afloat, as if even the Queen's body has a mysterious and superior shape of its own. It was a picture that achieved exactly what Elizabeth had hoped: it inspired awe and wonder. With this portrait, Hilliard achieved the status of her most favored painter.

YOUNG MAN AMONG ROSES
c.1590, watercolor and bodycolor on vellum,
5½ x 3 in (14 x 8 cm), Victoria & Albert Museum, London

The motto at the top of this picture reads: "My praised faith is what makes me suffer". The faith, of course, is faith for his beloved – who evidently has not reciprocated his feelings. Clearly, this was painted to be given to the obdurate lady to soften her heart. It would be hard to resist such a lovely, lovesick young dandy, with his long, beautiful legs and his curly head bent so beguilingly against the tree. And yet, one wonders, does true faith need to attest so much? Is the young man not enjoying too rapturously the joys of feeling disappointed?

ELIZABETH IS THE *glorious phoenix and she is also the rose – the symbol that the Catholic world associated with the Virgin Mary. The rose was, of course, the emblem of the Tudor dynasty, but for Elizabeth it became much more – the perfect sign of her own perfection, her own deathless beauty, her allure, her status as the precious jewel that men must seek to please but could never hope to win.*

QUEEN ELIZABETH I
c.1575, oil on wood,
31 x 24 in (79 x 61 cm),
Tate Gallery, London

HOBBEMA, MEINDERT 1638-1709 b. Netherlands
THE AVENUE AT MIDDELHARNIS

THIS PAINTING IS SO FREQUENTLY reproduced that one might think it is the only picture Hobbema ever painted. Although this is far from the truth, it is clear that something about this long, straight avenue, with its tall, spindly trees, caught his imagination, and the image became uniquely personal for him. The date of the work may give a clue to its significance. Hobbema struggled to make a living as a landscape artist until he was 30, when he was given a job as an excise officer. With a modest income assured by this position, he found the freedom to paint the subjects with which he felt most comfortable. The steady, well-marked path leading towards his settled future seems to resonate in this painting's linear progression towards the horizon. There is nothing that surprises us about the avenue of trees, with fields set on either side, but, far in the distance, ships' masts indicate that the road leads to the sea. The gloriously subtle colors of the well-trodden path are bathed in an afternoon sunlight that seems to convey fulfilment. It is hard to pinpoint the appeal of this picture: it seems simply to stem from the artist's joy in painting something harmonious and reassuringly familiar.

THE AVENUE AT
MIDDELHARNIS, *1689, oil on
canvas, 41 x 56 in (104 x 141 cm),
National Gallery, London*

A STREAM BY A WOOD
c.1663, oil on wood, 12 x 16 in (31 x 40 cm), National Gallery, London

Hobbema was in his mid-twenties when he painted *A Stream by a Wood*, which is in fact a study for a larger painting. He was still struggling to make a living as an artist, but his studies show his potential for greater artistic expression. The stream meanders deliciously through the silvery trees, reflecting the red jacket of the man who walks with his companion. Somehow, the bare, broken branch of the dead tree that juts out abruptly from the left of the landscape adds drama; the artist is aware that nature is not as benign as the rest of the composition would suggest.

THE CHURCH OF *St Michael's that we see to the left and the agricultural activity in the foreground tend to suggest that the setting is securely inland. But Middelharnis is a village on the north coast of an island in the mouth of the River Maas, and only when we know this do we begin to understand that those frail lines on the horizon to the right are the masts of ships.*

THERE IS A RATHER *sad irony attached to this painting: this long avenue leads off into the obscurity of the horizon's vanishing point, and Hobbema was the last of a long line of 17th-century Dutch landscape painters. As in art, so in life, here the road comes to an end.*

HOCKNEY, DAVID 1937– b. England, active US

A BIGGER SPLASH

ADMIRERS SUGGEST THAT DAVID HOCKNEY is at his greatest as a stage painter. His numerous stage sets for Glyndebourne and the Metropolitan Opera House certainly have a magnificent presence and enhance the activity that takes place before them. Perhaps *A Bigger Splash* deserves pole position as his most reproduced painting, precisely because it is conceived as a stage set. Here is the California one imagines: a perfect blue sky, two faultless palm trees, a stylish avant-garde residence, and glass doors that reflect a sophisticated urban world. Central to this is the deep blue water of the private swimming pool and the splash created by the main actor, who has just dived out of view. One lonely chair sits in front of the house. The great yellow plank of the diving-board quivers forlornly in the foreground. All else is exuberant white spray, indicating a subaqua presence. It is a brilliant image of love and absence – the teasing delights of affection. The stage is set, the story is told, the invisibility of the hero is the essence of the plot. Hockney pays us the compliment of expecting us to respect his reticence and respond to the emotional challenge.

DIVINE
1979, acrylic on canvas, 60 x 60 in (152 x 152 cm), Museum of Art, Carnegie Institute, Pittsburgh

Divine's public persona was as a large, exuberant, corseted transvestite. He was a scandalous performance artist, who relished in gossip and sending up his audiences. Hockney, as a close friend, saw beneath the performer's mask to the bald-headed, oversized, masculine presence in his theatrical, striped dressing gown. Hockney sets the figure against a jazzy backdrop that serves only to heighten the loneliness in Divine's face. This is a superb portrait, observed with both love and compassion.

HOCKNEY, *like his fellow Englishman Constable, paints well when he is deeply involved with the subject matter. The viewer does not see the beautiful boy who has plunged out of Hockney's life; we only witness the psychic and physical disturbance that his leaving has left in its wake.*

A BIGGER SPLASH
1967, acrylic on canvas, 96 x 96 in (244 x 244 cm), Tate Gallery, London

HODGKIN, SIR HOWARD
1932– b. England

RAIN

HOWARD HODGKIN IS A CONTEMPORARY British painter who becomes irritated when his work is described as abstract. To him, it is highly concrete. If we look at the date of his compositions, nearly always we see that they encompass several years. *Rain*, for example, was painted from 1985 to 1989, which means that for four years the artist thought, rethought, and worked on this particular image. What Hodgkin attempts to do is to recall an experience. Memory, composed as it is of fragments, never comes with clear outlines and exact eliminations; it comes in moods and feelings, in little scraps of remembered image. It is that gallimaufry of unstable, whirling memory that Hodgkin somehow hopes to stabilize into an image. Here, he has painted an experience of rain. What more there is to this experience – whether there was some event or encounter that happened in the rain – he does not spell out. So much has been concentrated into these swoops of the brush, but, after four years, he will have reached the moment when he felt that his experience had been sufficiently captured; only then did he consider the painting finished.

MR AND MRS JAMES KIRKMAN
1980–84, oil on wood, 41 x 48 in (104 x 121 cm), Private Collection

Strangely enough, Howard Hodgkin takes great pleasure in portrait painting. However, it is not a subject's physical dimensions that he remembers and seeks to convey, but the shape of their personalities, the dimensions of their uniqueness. Here, he is giving us the feel of his friends, the emotions they engender, and their vivid, happy, exciting characters.

HODGKIN SAYS *that his paintings are finished "when the subject comes back". By this he means that he explores all the ramifications, meanings, signs, and emotions, until he can get back to what he feels is the nub of the experience. We can then extrapolate from this condensed and succinct image.*

NO ARTIST – *unless, like the writer Marcel Proust, he embarks upon several volumes of minutely-honed text – can ever hope to spell out the nuances that accompany the complexities of living. Hodgkin does not expect us to take his picture and go through it back to the original experience. What he produces is valid in itself, and in it our own imagination is free to produce its own thoughts, memories, and experiences.*

RAIN
1985–89, oil on wood, 65 x 70 in (164 x 179 cm), Tate Gallery, London

HODLER, FERDINAND 1853–1918 b. Switzerland
SILENCE OF THE EVENING

HODLER IS THAT RELATIVE RARITY, a great Swiss artist. He was a Symbolist, which meant that he saw the visible world as expressive of an invisible meaning, an attitude both nourished and encouraged by the mountains and lakes among which he lived. Here, in *Silence of the Evening*, one can catch this breath of Symbolism. This is not just a tall, strong woman moving with deliberate pace along a path strewn with flowers; everything about the picture suggests some deeper meaning. The path that rolls upwards through the canvas with such certainty signifies a way of living, as does the perfectly controlled greenery – nothing is truly wild here, and all the chaos has been netted, as it were, into a flowery order. This could be rather off-putting, hinting at that Swiss passion for order; in fact, it is delightful, and the woman is far from the willowy heroine with drooping fingers and floating locks that one associates with the Symbolists.

LAKE OF GENEVA FROM CHEXBRES
1905, oil on canvas, 32 x 41 in (82 x 104 cm), Kunstmuseum, Basel, Switzerland

Hodler frequently painted Lake Geneva, a sublime subject in itself, and to him even more so as a symbol of the vastness of the spiritual world. Here is a perfect example of Hodler's passion to organize, to see the whole world as following some inner rule, which he expressed visually by what he called parallelism. His clouds are arranged in an orderly manner above the controlled waters of the lake, which, in turn, harmonize with the ordered nature of the meadow. He does not overdo this, but, fundamentally, this is the world seen as a unit, made whole and entire by its creator.

THIS IS A STRONG, *virile woman, with a massive neck and shoulders, and she strides with an air of inner certainty along the mystical path. Hodler's parents died when he was very young, and it could well be that this figure, a young model who he painted several times, represented to him the ideal of female support and companionship.*

THE WOMAN'S HANDS *are placidly folded together and she makes no demands. She is, in the most modest sense, stripped for action – she wears no jewels or adornments – and yet, in that long, blue, flowing robe, with gaps down the center adding the slightest erotic touch, she stands as an ideal, a noble woman, mistress of a noble and idealized countryside.*

SILENCE OF THE EVENING, *c.1904, oil on canvas, 39 x 31 in (100 x 80 cm), Kunstmuseum, Winterthur, Switzerland*

HOGARTH, WILLIAM 1697-1764 b. England
THE GRAHAM CHILDREN

THIS APPEARS TO BE AN ACCURATE PORTRAIT of the four privileged and happy children of Dr Graham, the apothecary at Chelsea Hospital, London. Hogarth clearly colludes with the children's innocent vanity as they pose in front of the viewer in their fine clothes. The two girls – Henrietta Catherine and Anna Maria – wear flowers in their hair, and the two boys – big brother Richard Robert and little brother Thomas – appear enchanted by the singing bird. Hogarth, however, makes us aware that the bird is not singing in response to the instrument that is being played for its delight by Richard Robert, but in fear of the cat that creeps up the back of the chair. Images of death surround the children: Cupid, holding the scythe of Father Time, appears on the clock, and the baby's carriage shows a bird frozen in flight.

THE SHRIMP GIRL
c.1745, oil on canvas, 25 x 20 in (64 x 51 cm), National Gallery, London

Hogarth struggled throughout his life for recognition and wealth. Ironically, it was this rough and vigorous work that his widow used to show to visitors, saying, "They said he could not paint". Nothing else in his life's work – those great story-telling paintings – has the immediacy of this portrait painted from life. Atypically of Hogarth, he has preserved the spontaneous energy in the brushstrokes of his first impression.

ON CLOSER examination, this is a quietly disturbing picture, with a sinister subtext lurking beneath the apparent serenity. Although the children stand in the light, the world directly behind them is dark and threatening. Hogarth makes it clear that only the ignorant can smile with such assurance, because they have misread the signs of the times.

THE PLUMP, healthy baby, who reaches out for the cherries his big sister is holding, died soon after the painting was completed. Our knowledge of this fact gives the underlying theme of the work – life's uncertainty – an added poignancy.

THE GRAHAM CHILDREN
1742, oil on canvas, 63 x 71 in (161 x 181 cm), National Gallery, London

HOLBEIN, HANS 1497/8-1543 b. Germany
LADY WITH A SQUIRREL AND A STARLING

THIS IS AN EARLY MASTERPIECE. We do not know who the young woman is, and whether the squirrel is merely an idiosyncratic pet or has a dynastic significance (likewise the starling, which in Britain was often a domestic pet). She wears the fashionable fur hat, but for the rest, her dress is simple with its white scarf and modest color. Hers is the face of youthful gravity, brooding, intent on her interior speculations. She is by no means a beauty, with that long sharp nose, but the mouth is strong and sensitive. One is drawn to the drama of her personality: the hint of sadness, the suggestion of being in touch with the wild vivacity of the squirrel, although she herself seems so demure and solemn. The bird, too, seems to point to aspects of this quiet and somber young woman that she does not wish to show us and that Holbein is too reticent to explore.

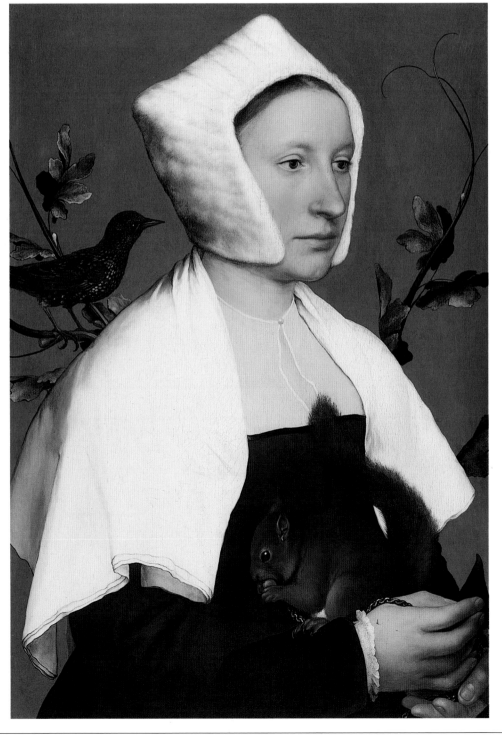

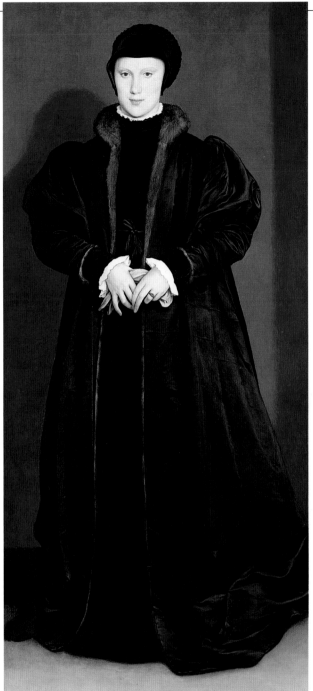

CHRISTINA OF DENMARK
c.1538, oil on wood, 70 x 33 in (179 x 83 cm), National Gallery, London

Having lost, by design or misfortune, three wives, Henry VIII was in the market for a fourth. He sent Holbein to paint the portrait of the potential candidate, Christina of Denmark. Widowed at the age of 13, she is presented here at the age of 16 in mourning clothes – still a young girl, but with extreme self-assurance. Her face is still rounded by the baby fat of girlhood, and yet with what control her eyes look at us, a half smile on her face, her hand resolutely holding her glove, prepared to be seen but divulging nothing. She might well have been strong enough to handle the tempestuous English King, but, with the benefit of hindsight, one cannot help but think that she was wise to refuse his subsequent advances. Her rejection of Henry was met, predictably, with royal fury.

> "HE [HOLBEIN] IS NOT A POET, BUT A HISTORIAN, FOR WHOM THE LIVES OF MEN CONTAIN NO FAIRY TALES AND NO SECRETS"
> **Herman Grimm**

LADY WITH A SQUIRREL AND A STARLING *c.1526–28, oil on wood, 22 x 15 in (56 x 39 cm), National Gallery, London*

HOMER, WINSLOW 1836–1910 b. US
SNAP THE WHIP

FOR AMERICANS, WINSLOW HOMER'S works glow with nostalgia. *Snap the Whip* is perhaps his most famous image – the little red schoolhouse set amidst the glory of New England woods. The line of boys, vigorously intent on their game, country faces alive with effort, bodies taut, bare feet pressed into the meadow grass, is not perhaps as innocent as it may appear – the aim of the game, after all, is to snap off those who cannot hold on with sufficient energy, and the pleasure of the game is to see, as we do here, the two boys at the end falling helplessly under the momentum of their friends. There may even be another agenda – is it pure accident that the boys who are put on the end of the whip in the most vulnerable position are the boys with shoes? It is the barefoot boys who triumph. But leaving aside the narrative of the picture, one can only rejoice in the immensity and splendor of the scene that Homer sets before us: in the way that light catches the raggedness of clothes or the gleam of a shabby shirt, where buttons are lost, where a hat has fallen off, where there is a tear, and then, how all this visual excitement has been set in an extraordinary stillness.

SNAP THE WHIP
1872, oil on canvas, 22 x 36 in (56 x 91 cm),
Butler Institute of American Art, Ohio

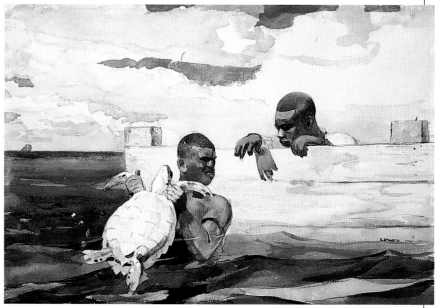

THE TURTLE POUND
1898, watercolor over pencil on paper, 15 x 21 in (38 x 54 cm), Brooklyn Museum, New York

Homer is one of the greater watercolorists in the history of painting. His art took on a new radiance of color after his time in the Caribbean. *The Turtle Pound* is extraordinary in its immediacy and its overwhelming sense of a sunlit brightness that dazzles as we look. The artist clearly found great visual pleasure in contrasting the skin tones of the fishermen against the dazzling underbelly of the turtle and the bleached wooden enclosure. Water and sky are painted with a wonderful freedom, and with rich, pure colors to produce a sense of water lifting and falling and changing hue as the light hits it.

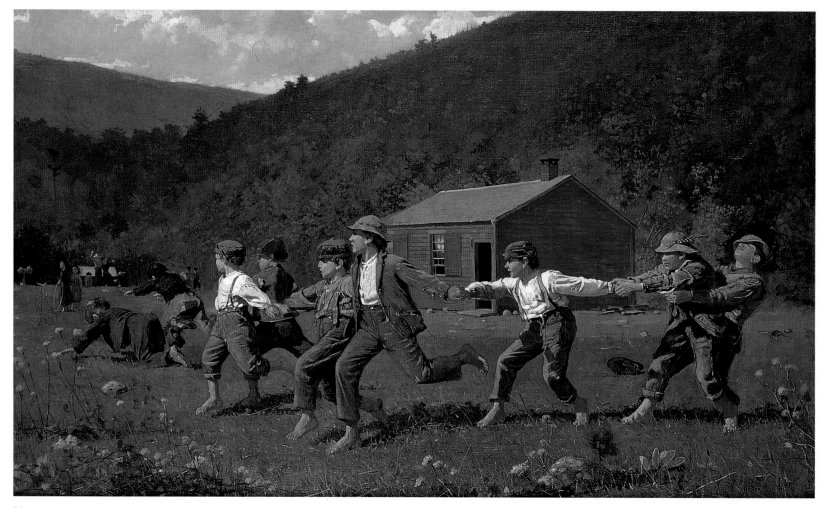

NO VISIBLE ROAD LEADS *us out of this enchanted hollow. The crude physical delights of rough play seem eternal here as if boyhood was all there is, and the dark little schoolroom merely a backdrop to the joy of young bodies exerting themselves to the full.*

GENERALLY SPEAKING, *Homer has not individualized the boys, but sees them as generic youth – thoughtless, happy, unaware of their privilege. Whatever the future of these barefoot boys, they have started life in the sunlight.*

ONE BOY – THE ELDEST, *the leader, with his boots and the slight suggestion of stubble above his lip – is on the point where he must leave this carefree existence, and perhaps he tilts his head back and shuts his eyes as if to say, as Homer does, a sad goodbye.*

HONDECOETER, MELCHIOR D' ^{1636–95}

1636–95
b. Netherlands

A COCK, HENS, AND CHICKS

HONDECOETER IS NOTABLE for his well-observed paintings of birds. He specialized in capturing the lively environment of the domestic farmyard. It may be a strange attribute, but he had a genius for painting chickens: no artist has shown with greater aplomb and power the glory of a cock in full canopy, seen here ruffling its feathers and crest as it advances with majesty towards his domestic harem. The hens are exceptionally alluring, one could almost describe them as beauty-queen hens, so fluffy and seductive are they, and the regal cock looks down on them with approval. But this is not purely a study of sexual politics in the farmyard; it is also a lively observation of how the chickens of all temperaments coexist, from the most aggressive and hectoring to the most passive and reticent.

BIRDS, BUTTERFLIES AND A FROG AMONG PLANTS AND FUNGI
1668, oil on canvas, 27 x 22 in (68 x 57 cm), National Gallery, London

Here, Hondecoeter has left the farmyard and ventured into the woods to observe the flora and fauna in the natural world. But his affinity with bird life remains paramount. Hondecoeter paints four glorious, richly-colored bullfinches, setting them amidst a flutter of butterflies and frogs that gives a wonderful impression of the teeming variety of the natural world that too often passes unnoticed.

A PIGEON *perches on an overturned basket and a finch hovers overhead, but clearly the main protagonist of the drama played out before us is that grand Turk of a cock. Hondecoeter involves us in the relationship between the birds. As well as a beautifully observed study of the birds' anatomy, Hondecoeter offers us an insight into the codes of behavior that exist in the animal kingdom.*

A COCK, HENS, AND CHICKS
c.1668–70, oil on canvas, 34 x 43 in (86 x 110 cm), National Gallery, London

HONTHORST, GERRIT VAN 1590–1656 b. Netherlands
CHRIST BEFORE THE HIGH PRIEST

GERRIT VAN HONTHORST WAS ONE OF SEVERAL DUTCH ARTISTS who travelled to Italy to study art and was profoundly influenced by his experience. Caravaggio's paintings showed Honthorst the dramatic possibilities of light and shade, and the Italians even nicknamed him Gherardo delle Notti (Gerrit of the night) because he developed a great skill for painting dramatically lit night scenes. *Christ Before the High Priest* was a celebrated painting in its own day, deservedly so, as it may well be his masterpiece in this genre. The candle spotlights the warning finger of the High Priest, who colludes with authority and the powers invested in him to harangue and condemn the Son of God, standing with patience and humility before him.

PRINCE RUPERT OF THE RHINE
1636, oil on wood, 30 x 24 in
(76 x 60 cm), Wilton House, Salisbury, UK

When painting portraits, Honthorst also employed the subtle and dramatic qualities of light that he had learned from studying Caravaggio's work. The face of Prince Rupert is dramatically lit, and the contrast of light and shadow seems to divide his long, narrow countenance into two distinct parts. The two sides to Prince Rupert's face may be a reference to the two well-known Ruperts of the period: the dashing cavalier and hero of the English Civil War, and the scholarly scientist. Although this man wears the uniform of an aristocratic cavalier, the other, secret Rupert, who invented and dreamed, is made miraculously present within this single image.

THE TWO PROTAGONISTS, *the High Priest and Christ, are brought to our attention by the candlelight that falls on their faces, hands, and garments. All the other people witnessing the event are obscured by the shadow of darkness. The two onlookers who stand behind the High Priest's chair (a reference, perhaps, to those false witnesses described in Matthew's Gospel) appear hostile, and, in contrast to Christ, their expressions appear cynical.*

HONTHORST SHOWS *us an encounter between small-minded power and large-minded submission. The drama and the irony are both intense, yet the artist does not overplay the deeper significance of the event. Instead, he uses his understanding of light and shadow to present a confrontation, the outcome of which we know. He leaves us to experience the subtle nuances of atmosphere and character that he lays out before us.*

CHRIST BEFORE
THE HIGH PRIEST
c.1617, oil on canvas,
107 x 72 in (272 x 183 cm),
National Gallery, London

HOOCH, PIETER DE 1629–1684 b. Netherlands

TWO SOLDIERS AND A WOMAN DRINKING

THE REALIZATION THAT THE SMALL DUTCH TOWN OF DELFT was home at the same time to two painters as great as Vermeer and de Hooch fills one with a sense of awe. De Hooch is inevitably overshadowed by his contemporary, and yet he is a most wonderful artist. Like Vermeer, he takes endless delight in tracing the effect of sunlight on the variety of textures: iron, wood, tile, brick, and stone. Within the neat confines of this Dutch courtyard, we see a serving girl good-humoredly drinking from a tall glass, while a military gentleman watches her with amusement. His companion, at ease with his fancy boots and his discarded coat, puffs on his pipe. Midway across the courtyard, a child advances carefully towards them with a brazier of hot coals. However, despite this interplay of relationships, it is not the humans so much as the courtyard itself that fascinates de Hooch, and he has responded to every aspect of its familiarity, seeing it both as a setting and as a subject.

WOMAN LACING HER BODICE BESIDE A CRADLE
c.1661–63, oil on canvas, 36 x 39 (92 x 100 cm), Staatliche Museum, Berlin

De Hooch is equally wonderful with the interior world. Here, we see a Dutch house through a succession of rooms leading from the bedroom to the doorway, at which a child stands, one foot slightly raised in longing for the outdoor world. Light is the true protagonist, however, flooding through the open door, peeping through the window, foiled in its attempt to enter the sleeping chamber, but falling on the mother as she laces her bodice, having fed her sleeping child. All is quiet, and in this reverie there is a sense of the moment being held, fleetingly, out of time.

THE TRUE FOCUS *of the artist's attention is in the detailed elements of this courtyard scene: the mottled white that is spread unevenly over the far wall, the undulating paving bricks, the strange heraldic pattern on the window shutters, and the bizarre order of the brickwork as it nears the top of the canvas.*

DE HOOCH SAVORS *the intimacy of this small walled enclosure; but it is an intimacy that is dependent on a visual recognition of the outside world. A door and passageway lead out of this scene and to the street beyond, and above the wall, we can see trees, a roof line, and a church steeple. These signs of the outside world add to the sense of seclusion within the courtyard.*

TWO SOLDIERS AND A WOMAN DRINKING IN A COURTYARD, *c.1658–60, oil on canvas, 27 x 23 in (68 x 59 cm), National Gallery of Art, Washington, DC*

HOOGSTRATEN, SAMUEL VAN 1627–78 b. Netherlands

A MAN LOOKING THROUGH A WINDOW

REMBRANDT MUST HAVE BEEN the most charismatic of teachers, because his great influence is evident in nearly all of his pupils' work. Hoogstraten is an exception to this rule however, for although he learned his technique from Rembrandt, the uses to which he put his considerable skills were peculiarly his own. He was a specialist in the technique of *trompe l'oeil* – the painting of objects in a way that deceived the eye (a skill to which Rembrandt seems never to have been attracted). This rather extraordinary painting was produced in Vienna, and it is said to have been of the famous Rabbi Jom-Tob Lipmann Heller (though, in fact, the Rabbi – who did work in Vienna – was not there in the year that this was painted). If by some means this is the great Rabbi, this most extraordinary depiction of a man looking through a window to the outside world takes on an added edge.

TOBIAS'S FAREWELL TO HIS PARENTS
c.1650, oil on canvas, 26 x 29 in
(65 x 73 cm), Hermitage, St Petersburg

Hoogstraten shares his teacher's fascination with the biblical story of Tobias, the young man who was protected by the angel Raphael as he travelled to distant lands to help his father. He has highlighted the tablecloth, drawing our attention to what will be the empty chair of the only son as, hat in hand and coat on shoulder, Tobias says goodbye to his parents. This is a moment of crisis, a turning point for the young man. It is his first venture away from the home and out into the world; Hoogstraten shows him taking this step with great seriousness and religious solemnity. We do not see the angel, but Tobias's faithful dog waits in the shadows for the journey to begin.

HOOGSTRATEN IS NOT *concentrating on the Jewishness of this interesting face, with its bush of grizzled beard, but on the contrast between stone, glass, and human being. The head pokes through, forcing itself upon our attention, and yet, this man is oblivious to our gaze, because he fixes his own on something below, something that we cannot see, but which tantalizes our imagination.*

HOOGSTRATEN HAS *delighted in the textures of the stone – almost four great slabs of abstract painting. He has delighted in the quality of the glass, in which we can see the wood of the interior dimly reflected. He has spotlit the wise, wrinkled, inscrutable face that looks out onto our world from the recesses of his own. This is a triumph of trompe l'oeil, and an oddity among masterpieces.*

MAN LOOKING THROUGH A WINDOW, *1653, oil on canvas, 44 x 34 in (111 x 87 cm), Kunsthistorisches Museum, Vienna*

HOPPER, EDWARD 1882–1967 b. US
EARLY SUNDAY MORNING

HOPPER OBJECTED VOCIFEROUSLY to being characterized as a painter of the American scene and said instead, "I always wanted to do myself". Ironically, in painting himself and his own lonely image, Hopper poignantly evoked the essence of what seemed to be American urban life and the growing isolation of individuals within the great melting pot of the cities. *Early Sunday Morning* is vintage Hopper. It is a street in what could be a small town or the suburbs of a large town. People live over rows of small shops, and each window is subtly different. The street is bathed in a brilliant, early-morning light and it is completely empty. The space is occupied by a fire hydrant and a barber's pole; of human beings, there is not a trace. Nevertheless, human beings are implacably present: it is they who have chosen the varieties of lace curtains, hung the blinds, and lowered or lifted them. It is they who have opened or shut the windows.

EARLY SUNDAY MORNING, 1930, oil on canvas, 35 x 60 in (89 x 152 cm), Whitney Museum of American Art, New York

WITHIN THE SMALL CONFINES *of those box-like rooms lives are being lived, shuttered against other lives. Despite its almost stone-faced reticence, this is a picture of moral inhibition, of waste, of potential frustrated by circumstance. Light may shine, but there seems to be nobody to enjoy it.*

SECOND STORY SUNLIGHT
1960, oil on canvas, 40 x 50 in (102 x 127 cm), Whitney Museum of American Art, New York

Second Story Sunlight shows the neat, trim exterior of a well-kept house in the country. Again, Hopper focuses on the lonely windows and empty rooms behind them, but here there are two human beings to emphasize the mood. A beautiful girl sunbathes on the balcony and at a distance, disconnected, an older woman sits reading. Physically, they share the same space, emotionally they travel strange seas, continents apart. The older woman may be her mother or even her grandmother, but it is more than generations that separate them. Each inhabits a sealed world to which the other has no access.

HUNT, WILLIAM HOLMAN 1827–1910 b. England

THE AWAKENING CONSCIENCE

THIS EXTRAORDINARY PICTURE PROVOKED an equally extraordinary reaction, with critics taken aback by Holman Hunt's temerity in tackling the hidden problem of prostitution. Men might keep mistresses, but what right had an artist to dare to present this on canvas? Holman Hunt has seized upon a moment when, playing the innocent tunes of childhood, the kept woman suddenly realizes the state of degradation to which she has sunk. Her lover – that insouciant Victorian, lounging back on his chair, with his frilly little sidewhiskers and air of ineffable male superiority – may think he has made her completely content by providing such a comfortable nest – mirrors, carpets, a piano, even a cat to make her happy – but the girl, struggling away from his embrace and symbolically pushing away from her the luxurious Eastern shawl (a sign of prostitution in such a painting), is reminded of better things. Hunt encapsulates the whole drama in one moment.

ISABELLA AND THE POT OF BASIL
*1866–68, oil on canvas, 74 x 46 in (187 x 117 cm),
Laing Art Gallery, Newcastle, UK*

Keats, the greatest of Victorian poets, had written a poem about Isabella, an Italian maiden who fell in love unsuitably, and whose brothers murdered her beloved and secretly buried him. She dug up the head and kept it in an urn in which she grew basil. It was a sinister and unpleasant story, and Hunt paints a sinister and unpleasant picture. Here is a full-bodied sensual woman, whose life has become morbidly centred on death. Yet one can only admire the skill and force with which Hunt conveys the nastiness of this Freudian scenario:

HUNT UNFOLDS THE SCENE *with
the irritating attention to detail that was the
hallmark of the Pre-Raphaelite. Everything in
this picture – from the innocent garden reflected
in the mirror to the clock with its sorrowing
nymphs, the discarded glove, or the cat toying
with a bird – points to a specific moral
message and is pushed upon our attention.*

IF WE FIND THE WOMAN'S *rather pop-eyed
expression off-putting, it may console us to
remember that she originally looked so much
worse – in fact, the owner of the picture pleaded
with the artist to soften her expression. This, then, is
the revised view of what it meant to come to a sudden
awareness of an inner, spiritual transgression.*

THE AWAKENING
CONSCIENCE, *1853, oil on
canvas, 30 x 22 in (76 x 56 cm),
Tate Gallery, London*

HUYSUM, JAN VAN 1682–1749 b. Netherlands

HOLLYHOCKS AND OTHER FLOWERS IN A VASE

JAN VAN HUYSUM WAS ONE OF THE MOST FAMOUS of the Amsterdam flower painters, and the immense visual pleasure afforded by *Hollyhocks and Other Flowers in a Vase* makes a compelling case for his reputation. The painting has a composition that is almost architectural in its structure: on one side are the hollyhocks, with their surging buds above wide–open blossoms; on the other side, the delicate spray of wild flowers, loose and fragile, balancing the picture. A rare tulip, with frilled and scarlet edges, hovers like a floating star in the middle, and on the carnations and the great cabbage–like leaves of the hollyhocks we can pick out an insect or two.

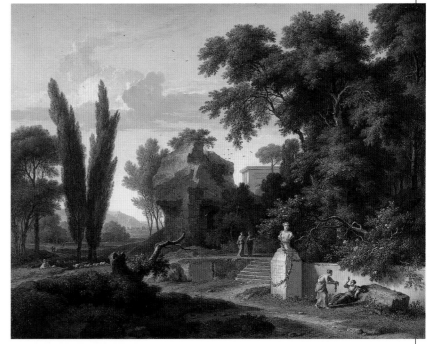

CLASSICAL LANDSCAPE WITH A WOMAN REFUSING A WREATH
c.1737, oil on copper, 9 x 11 in (22 x 28 cm), Peterborough Museum and Art Gallery, Cambridgeshire, UK

Van Huysum also produced very small works on copper – romantic landscapes, which have a faint nostalgic tone that one finds subliminally in the larger flower pictures. Here, we have a classical civilization clearly in decay. The plinth with the stone bust of a lady has been draped with wreaths, and we are left to wonder why the woman in blue so vehemently refuses to accept a wreath herself. We are given no hint of the story, just a glimpse of a world gone by.

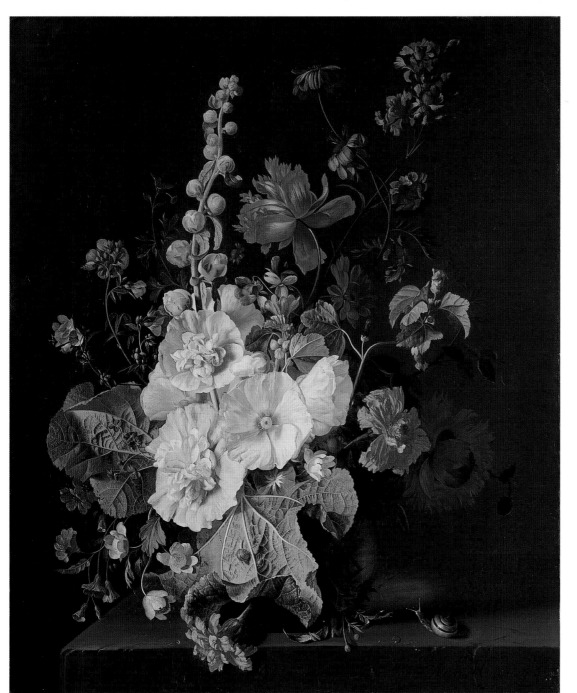

VAN HUYSUM IS *playing with light and shade, as well as with color, shape, and texture. It is as if his flowers were a world unto themselves and all the diversities and ambiguities of human life were contained therein. He sets them against a black background, sublimely confident that their intrinsic beauty needs no setting.*

THE PATHOS INHERENT *in the vulnerability and frailty of human life might well be the unstated theme of this work, which gives it its power. If this is so, van Huysum is not merely decorating his canvas to charm an audience; he is also making a statement, albeit through the exquisite and subtle vehicle of flowers.*

HOLLYHOCKS AND OTHER FLOWERS IN A VASE
c.1702–20, oil on canvas, 24 x 20 in (62 x 52 cm), National Gallery, London

INGRES, JEAN-AUGUSTE 1780–1867 b. France
MADAME MOITESSIER

INGRES WAS INTRIGUED BY THE POWERFUL image of a woman presented by Madame Moitessier. He imagined her as the classic idol *par excellence*, a woman who in her massive, marbled beauty expressed a sinister power that ancient myth attributed to the female form. Ingres worked on this painting over a period of 12 years, constantly reworking and rethinking the composition, adding and subtracting elements. It became almost an act of religious dedication for the painter as the great female idol finally and monumentally took shape on his canvas. Having invested so much emotion in this image, it is hard to comment objectively upon its undoubted power. Ingres shows the lady from two different angles: once looking directly at us with that limp, starfish of a hand fanning her impassively beautiful face; and once dimly lit and in profile like a Grecian goddess, enabling us to see the ribbons cascading down her back. Her clothing alone is almost too elaborate with its wealth of tassels, embroidery, and ribbons – a splendid celebration of the act of dress.

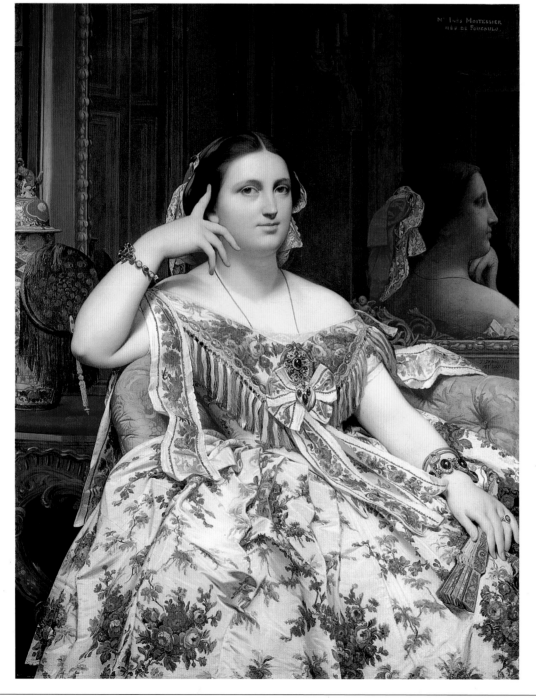

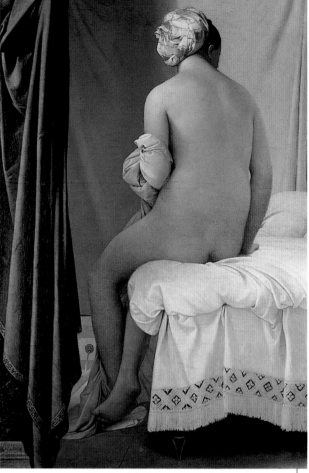

THE VALPINÇON BATHER
1808, oil on canvas, 146 x 98 cm, Musée du Louvre, Paris

Ingres is an instinctive classicist and when we compare his work with Romantic painters of the time, such as Géricault and Delacroix, it may seem that his work lacks immediate passion and romance. This is the opposite of the truth. One of Ingres's great obsessions was the beauty of the human back. *The Valpinçon Bather* is a celebration of the curve of the spine, upholstered in soft, flawless female flesh. From the luscious folds of the cap that holds up her hair down through the curve of her body and on to the wonderful whites of the crisp sheets and folds of the Valenciennes lace, Ingres is celebrating his irrepressible joy in studying the woman's form, and it is this that he communicates to the viewer unalloyed.

ONE INSTINCTIVELY *feels that if Madame Moitessier had posed naked for this portrait she would have had little appeal for Ingres. It is the elaborate garments she chooses to wear and how she presents herself before us, as an object to be admired and perhaps worshipped, that enthralled the artist. The woman and her surroundings exude wealth, and this habitat seems natural for this strong female figure, who accepts her lifestyle unquestioningly, as though it were her due.*

MADAME MOITESSIER
1856, oil on canvas, 47 x 36 in (120 x 92 cm), National Gallery, London

INNESS, GEORGE 1825–94 b. US
THE LACKAWANNA VALLEY

ALTHOUGH THE PICTURE IS ENTITLED *The Lackawanna Valley*, with all its rural associations – and, indeed, we have here a strong, superb image of the countryside – the actual center of the picture, the reason for its commissioning, was the roundhouse at Scranton. The president of the Delaware and Lackawanna Railroad Company commissioned Inness to paint the roundhouse, and the four lines of traffic and four engines that were the proud boast of this new-born company. Inness found these requirements irksome; clearly in his mind, the ideal picture was the spreading lushness of the valley, with its background of misty hills and one lone engine chugging its brave way through the cornfields. That is still the dominant image, but the original picture was rejected because it did not show enough of the railroad's holdings.

JUNE
1882, oil on canvas, 30 x 45 in (77 x 114 cm), Brooklyn Museum, New York

THE LACKAWANNA VALLEY, *1855, oil on canvas, 34 x 50 in (86 x 127 cm), National Gallery of Art, Washington, DC*

THIS WAS THE *compromise that Inness produced, and yet, is it a compromise? The need to hold to somebody else's line often results in a superior work of art: Inness was forced to think out his picture with great deliberation, to balance it. As such, he achieved a greater work.*

THIS IS A PICTURE *that shows both past and future: America as it had been – relatively uncultivated along the small, remote towns and villages; and America as it was about to become – the land of the railway, and the unification and progress that that implied.*

Inness said that the aim of art is "to awaken an emotion", and *June* seems to hit that button with great success. The emotion here is peace, contentment, a great feeling of security; it is a sunny awareness of the eternal foundations of life, a gratitude that we live in a world where there are still clear water, green fields, and trees. However modest, the pleasures of this picture are inexhaustible.

JAWLENSKY, ALEXEI 1864–1941 b. Russia
HEAD: RED LIGHT

ALTHOUGH JAWLENSKY WAS A COMPETENT landscape artist capable of great coloristic freedom, the predominant motif throughout his life was the human face. He felt that in the face, the very essence of life could be made visible. On one level, Jawlensky had an interesting career as a portrait painter, but on a deeper, philosophical level, he wanted to uncover what was real. With the onset of World War I, he was forced to look with more intense curiosity at the face. He felt that painting the exact likeness of a person's features did not do justice to the essence of the human being. He was greatly influenced by Constructivism, which attempted to strip down life and forms to their basic structure. By applying this reductive philosophy to the face, which up until now he had painted with chromatic freedom, the elderly Jawlensky entered into his most significant artistic period. *Head: Red Light* functions as a luminous icon, offering simply the essence of the face. It is a spiritual recreation of the secret majesty within each being.

HEAD: RED LIGHT
1926, oil and wax on cardboard,
21 x 19 in (53 x 48 cm),
San Francisco Museum of Modern Art

JOHN, AUGUSTUS 1878–1961 b. England
THE SMILING WOMAN

THIS WAS THE PORTRAIT that brought Augustus John into the public eye. *The Smiling Woman* shows off the gypsy magic of his wife Dorelia. Her blouse is suggestively undone, her hands rest on her thighs, her head is aslant, and her face is alive with a secret familiarity between herself and the artist. It was a promising beginning to his artistic career. As we can see from this portrait, Augustus John had all the necessary qualities to become one of the great artists: graphic power, a strong colour sense, and an instinctive feeling for personality. Early on, he enjoyed a reputation as the classic bohemian (even living with gypsies for a time) and then became a highly fashionable portrait painter. Unfortunately, *The Smiling Woman* represents an all too rare moment when he was motivated to extend his artistic gifts to the full. It is a beguiling image, which should have heralded a career of deepening understanding, but instead it led almost nowhere. It seems that natural talent only works if one understands what one wants to do with it.

THE SMILING WOMAN
c.1908, oil on canvas,
77 x 38 in (196 x 97 cm),
Tate Gallery, London

JOHN, GWEN 1876–1939 b. England
GIRL HOLDING A ROSE

A GWEN JOHN IS UNMISTAKABLE; there is what one can only describe as a tentative certainty in her paintings. Within them, we can perhaps sense a defeat that still will not surrender, but which forces the artist against her fear of failure into producing gentle, yet astonishing, images. *Girl Holding a Rose* is astonishing in more ways than one. The sad, beautiful, introspective face could seem wholly realistic, but then one notices the misalignment of the shoulders and the peculiar elongations of the body. It is as though John was stretching her out like plasticine and molding her in rough paint, with a desire more to make visible the presence of this young woman and the impact she made upon the artist than to depict the actual lines of her figure and the outward appearance of her form.

INTERIOR (RUE TERRE NEUVE)
c.1920s, oil on canvas, 9 x 11 in (22 x 27 cm), City Art Galleries, Manchester, UK

Gwen John painted from the reality of her own private life. Again and again she dwelt upon the features of her friends and the intimacies of her own surroundings. She was always poor, so this is a poor attic home, yet it is made lovely by the sunlight. The table dazzles under its brightness, and all we can distinguish with complete clarity is that very British-looking teapot. Perhaps significantly, in the view of her deepening commitment to religion, the window seems to resemble a crucifix. Whatever its austerity, this is clearly a refuge in which the artist delighted.

JOHN'S DESIRE *to convey to us the presence of her friend has led her to structure the body almost like a giant pyramid, with an enormous base that almost fills the width of the canvas, tapering up through the thick arms to the final clarity of the domed head.*

THE LARGE CLUMSY *hands seem almost indistinguishable from the rose. This is not a trophy rose – the flower has no function outside the folded and melancholy fingers. Around the young woman rise the vaguely adumbrated walls of an interior, luminous and glowing with a comforting sense of enclosure and protection.*

GIRL HOLDING A ROSE
c.1910–20, oil on canvas, 18 x 15 in (45 x 37 cm), Paul Mellon Collection, Yale Center for British Art, New Haven, CT

JOHNS, JASPER 1930- b. US
WHITE FLAG

JASPER JOHNS IS A POP ARTIST in the sense that his themes are taken from popular culture. However, it is not because they interest him that he chooses them, but because he is able to disregard them. The flag, for example, appeals to Johns, not for its symbolism, but for its bare materiality, which everybody understands and takes for granted. It is a given. He has abstracted from the flag its physical shape, the familiarity of which frees the viewer from any undue interest in theme. His wish is to free art from narrative interest, from an obsession with meaning. He sees art as utterly independent and of itself – a creation of the beautiful that can only be weakened by anecdotal elements or any engrossment with the actualities of life.

WHITE FLAG, *1955, encaustic and collage on canvas, 79 x 121 in (200 x 307 cm), Leo Castelli Gallery, New York*

0 THROUGH 9
1961, oil on canvas, 54 x 41 in (137 x 105 cm), Tate Gallery, London

If the bare materiality of *White Flag* is without anecdotal interest, then *0 Through 9* is even more the case with a series of numbers. Johns imposes one numerical over another, and it is possible to trace out, with the help of color, the ten numbers. But his obsession is not with the shapes themselves or the color, but how the figures can be seen as abstract patternings woven together, each number allied with the others in the unity of their form. He creates a visual ensemble from elements almost invisible in their artistic interest, and yet, seen by him as compatible with dazzling pattern making.

THE DEEPLY FAMILIAR *flag, map, or target is the foundation for the creation of something beautiful. In this encaustic and collage on canvas, sometimes the collage newspaper even becomes visible; this near transparency creates a rectangle of ethereal beauty.*

WHITE FLAG EXISTS IN A PLATONIC *universe. The stars and the stripes accept the extraordinary grandeur of Johns's color: creamy, speckled with black, and luminous not with meaning but with the sheer factuality of the paint.*

THIS WORK ABSORBS *the attention, undiluted and absolute. Johns's interest is in the creation of an art so austere and pure that it needs no support and inheres within its own making. This is what engrosses Johns – the thing in itself.*

JONES, THOMAS 1742–1803 b. Wales
A WALL IN NAPLES

A WALL IN NAPLES
c.1782, oil on paper,
4 x 6 in (11 x 16 cm),
National Gallery, London

THOMAS JONES WAS AN OXFORD MAN who lived in Naples before inheriting his father's estate in Wales. One may regret this, for had he needed to earn his living as an artist, this man of extraordinary invention and originality might have left more to posterity than a few remarkable oil sketches on paper. For an 18th-century artist to feel that what he saw from his window – a plain wall, adorned with the family washing – was in itself a worthy subject for his art is unusual and significant. Jones seemed to need neither pretext nor narrative to mark this wall as in some way special. The mere sight of it – with its hollows and lost bricks, and with the sun's brightness battering against its various textures – was enough for him. Such a naked awareness of the extraordinary nature of the visual world was not to become common artistic currency for another century.

JONGKIND, JOHAN BARTHOLD 1819–91 b. Netherlands, active France
RUINS OF THE CASTLE AT ROSEMONT

RUINS OF THE CASTLE
AT ROSEMONT, 1861,
oil on canvas, 13 x 22 in
(34 x 57 cm), Musée d'Orsay, Paris

JONGKIND IS AN ENCHANTING ARTIST, who painted small luminous landscapes, which are both true to nature and imbued with the subjective passion of the artist. Midway through his career, he came across the young Monet, who immediately recognized Jongkind's ability; in fact, Monet attributed his final education of the eye to Jongkind. Monet's was a highly-educated eye – a doctorate of an eye, one might say – and when we look at a work like *Ruins of the Castle at Rosemont* we can see what Monet meant by that education. Jongkind has truly regarded this scene. His gaze has dwelled lovingly and faithfully over those rocks, those weeds, those patches of vegetation, that far-flung plain, those beasts, and above all, over that echoing sky.

JOOS VAN CLEVE c.1480–1540 b. Netherlands
VIRGIN AND CHILD WITH ANGELS

WHAT IS STRIKING ABOUT Joos van Cleve's *Virgin and Child with Angels* is the sheer brio with which he paints his figures. There is a sweetness about the image, an innocent vitality that gives it an immense charm. His Virgin is not the standard model, gentle and remote, but a young woman of decided individuality. Her face does not offer an enigmatic smile, but instead, like a proud young mother's, looks lovingly at her Child. An angel, dressed in elaborate clothes, hurries across to the Mother and Child carrying cherries; his pink sash swirls in his haste. The cherries are symbolic of heavenly bliss, and other items – such as the grapes and wine on the table – recall the Eucharist. Pointing away from Christ and towards the viewer is a knife, which rests by a lemon; together, they symbolize the bitterness that this happy Child will one day suffer. The scarlet canopy bears an inscription from the Song of Songs, which makes reference to the love of Christ for the Church.

QUEEN ELEANOR OF FRANCE
c.1530, tempera on panel, 14 x 12 in (36 x 30 cm), Kunsthistorisches Museum, Vienna

Eleanor of France was a very grand lady. She was the sister of the Holy Roman Emperor and second wife of Francis I of France, the lifelong rival of Henry VIII. It was in this atmosphere of political ambition and great dynastic hopes that she sat for this portrait. Her hair is swept back, while her splendid clothes and jewellery draw attention to the creamy whiteness of her skin, setting off the unsmiling dignity of her countenance. In its subdued beauty, tone subtly playing against tone with nothing forced or extravagant, van Cleve conveys both the Queen's personality and reticent presence.

EVERY ELEMENT IS SPLENDID: *the glorious carpet with its intricate and varied patterns, the intricately carved table, and the great tapestry backcloth behind the Virgin. Three angels sing to entertain the Virgin, or rather two warble away, and the third looks on with a confused expression. Although the work is an undisputed masterpiece, van Cleve seems to have got his proportions slightly wrong with the third angel, whose baby face is too fat for our modern tastes. Or is this face meant to indicate that this is a baby angel, companion to the Child?*

HERE IS THE SECRET WORLD *of spiritual happiness, while far beyond the heavenly enclosure stretch the bleak mountains and valleys, the rivers and the buildings of the earthly world that we inhabit. The significance of this painting for all those who saw it was the hope that one day they would pass from the cold outer world, over the divide, and into this world of song, warmth, and cherries.*

VIRGIN AND CHILD WITH ANGELS, *c.1520–25, oil on wood, 34 x 26 in (86 x 66 cm), Walker Art Gallery, Liverpool, UK*

JOOS VAN GENT (JOOS VAN WASSENHOVE) active c.1460–80 Belgium and Italy

PORTRAIT OF ARISTOTLE

FEDERIGO DA MONTEFELTRO became Duke of Urbino in northern Italy by virtue of his success as leader of a band of mercenaries. He made haste to consolidate his position by exhibiting more stately qualities than the virtues that he had displayed in battle. Within the Ducal Palace he set about building a small study and lined the walls with large portraits of the great intellectuals he admired, including the great Greek and Roman scholars. Surrounded by these inspirational figures, the Duke transformed himself from a rough soldier into an educated politician. Here, Joos van Gent paints Aristotle, perhaps the greatest of the Greek philosophers. Aristotle is shown listening and considering with care, poised, it seems, before offering his thoughts. His left hand rests on a weighty book, while the other quivers with intellectual eagerness. His bright eyes look out beyond the viewer and are both eager and alert.

PORTRAIT OF SOLON
c.1475, oil on wood, 95 x 54 in (95 x 54 cm),
Musée du Louvre, Paris

The life of Aristotle is well documented, but that of Solon is less well known. Solon was the legendary law-giver of the Atheneans – the man who laid down the code of conduct that made the Atheneans, in their own judgment, the best governed and wisest men of all the cities in Greece. Joos van Gent imagines Solon as a relatively young man, dressed in a fashionable hat and with tassels on his cloak. But Solon is fundamentally a scholar, and he holds his laws reverentially, his lips parted and his eyes searching. The artist depicts the great law-giver as a humble man searching for the truth.

HERE, ARISTOTLE IS CONFINED *to a small chamber, and perhaps as a devout Christian, Joos van Gent regarded the wisdom of the Greek pagan world as much more limited than the world of Christian enlightenment. The colors, too, are very subtle: the pale, washed-out pink of the robe set against the green awnings behind.*

ARISTOTLE IS NOT SHOWN *as an ancient Greek scholar in classical robes but is portrayed through the eyes of an artist of the late 15th century; he wears the garb of a refined man of taste, bejewelled on hat, cuffs, and belt. For the Duke, this would have been an inspiring image of democratic rule, for Aristotle's hand is lightly raised to encourage rather than discourage discussion.*

PORTRAIT OF ARISTOTLE
c.1475, oil on wood, 41 x 21 in
(104 x 54 cm), Musée du Louvre, Paris

JORDAENS, JACOB 1593–1678 b. Belgium

THE ARTIST AND HIS FAMILY IN A GARDEN

THERE IS A TOUCHING CHARM about Jordaens' picture of himself and his family, arrayed in a garden courtyard. The artist himself stands a few paces back, holding his lute and placing a foot upon an elaborate stool (and in a rather elaborate manner, in fact, since by predilection he tended to paint the robust peasant and the bucolic splendors of country life). Jordaens wants us to understand clearly that he is a gentleman of unimpeachable intellectuality. Despite his ruffs and lace cuffs, all the family splendor seems to be concentrated in his wife and little daughter, who sit to the left. We recognize his wife at once. He has used her again and again as a model, which may partly explain the straight look she gives us and the sense of self-assurance she communicates. She is richly but tastefully attired, with only her scarlet petticoat billowing beneath her gown to show us hidden depth. But her very position suggests that her true glory is to be mother to the little girl, who undermines the solemnity of the occasion with her childish twinkle.

THE ARTIST AND HIS FAMILY IN A GARDEN, c.1621,
oil on canvas, 71 x 73½ in (181 x 187 cm), Museo del Prado, Madrid

THE FOUR EVANGELISTS
c.1625, oil on canvas, 53 x 46 in (134 x 118 cm),
Musée du Louvre, Paris

Matthew, Mark, Luke, and John have been frequently depicted, especially in the middle ages, usually as four scholars: saintly, noble, impressive, and rather removed from the hurly-burly of ordinary life. Jordaens gives us an extraordinary image of the relationship between these four men. Despite the generation gap, the four are surprisingly close; and, equally surprisingly, so casual. The message seems to be that each needed the others, was fond of the others, and worked with the others.

THE EVIDENCE of culture, the classical statue, and – to delight the family – parrots on a perch, is everywhere in the rich and pleasant garden. The maid, too, hovering shyly in the background, is a social index. She is extremely well-dressed, and holds a basket overflowing with luscious-looking grapes.

THE FATHER IS SECURE enough to be able to stand at a distance, proud of his family. The relationship between mother and daughter is warm and supportive. This is a delightful child – clearly the apple of their eye – nestling back, holding the little basket, one little foot clearly visible in an expensive shoe.

JUAN DE FLANDES c.1465–1519 b. Netherlands, active Spain

THE RESURRECTION OF LAZARUS

PERHAPS WE SEE AN ARTIST'S PERSONALITY most clearly when he is dealing with an often handled theme. Juan de Flandes centers his resurrection of Lazarus not so much on the beckoning Christ as on the terror of the man, safe in the sleep of death and now suddenly called back into the light. Lazarus is, as yet, quite unaware of what has compelled him into consciousness. His eyeballs protrude in astonishment, and he looks, not at Christ, but at a nothingness – the long, austere face riven by incredulity at what has befallen him. His face shows not joy but almost horror and consternation. Christ, for His part, with the somber apostles huddled behind Him, looks down with compassion. Lazarus's sister, who has implored Jesus to work this miracle, stretches out a trembling hand to her resurrected brother, equally weighed down by the gravity of the incident. Not one of the three is anything but somber at this reversal of nature.

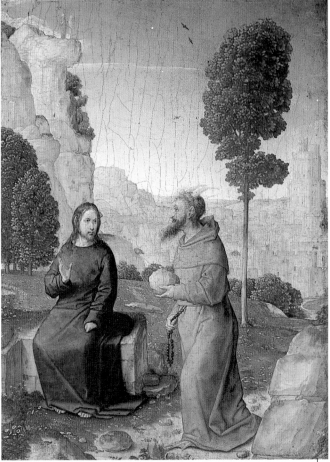

THE TEMPTATION OF CHRIST
c.1500, oil on panel, 8 x 6 in (21 x 16 cm),
National Gallery of Art, Washington, DC

After His baptism, Jesus went into the desert and fasted for forty days. While there, we are told in the Bible, he was tempted by the devil. Juan de Flandes imagines the devil dressed as a Franciscan monk (in accordance with the well-known philosophical adage that the worst often appears in the guise of the best). The monk offers Christ a stone and suggests that he turn it into bread. One does not need, however, divine insight to recognize that this monk is a little off-key – sprouting visibly from his head are the two horns that indicate that this Franciscan is, in fact, the devil.

IT IS THE STRANGENESS, *the sheer incompatibility with normality that Juan de Flandes seems to be emphasizing. The enemy lurk outside; they do not enter the ruined enclosure that symbolizes the ruined body of Lazarus, and they likewise fail to enter into a sense of wonder and joy. They skulk darkly, wholly unimpressed by the miracle.*

IT IS A MIRACLE BUTTRESSED *by the authority of the church on the left, and, on the right, by the great tree – the authority of nature. The two forces seem to be set in opposition. Men die, and only divine power can overthrow that natural sequence. The church, here a symbol of the Jewish faith, is in sad disrepair, with broken windows and missing tiles; the resurrected Lazarus will symbolize the reparation of faith.*

THE RESURRECTION OF LAZARUS, *c.1514–18, oil on wood, 43 x 33 in (110 x 84 cm), Museo del Prado, Madrid*

KAHLO, FRIDA 1907–1954 b. Mexico
THE TWO FRIDAS

FRIDA KAHLO HAS BECOME A CULT FIGURE: the beautiful, suffering Mexican woman, whose career circled around that of her husband, Diego Rivera, and who suffered emotionally from his cruelty as much as she suffered physically from the accident that damaged her irrevocably as a schoolgirl. Most of her work is self-portraiture, and one sometimes feels a twinge of sympathy for Rivera when one becomes aware of her intense self-absorption. After years of mutual infidelity, Rivera insisted on a divorce, and this weird masterpiece was painted immediately following that event. Frida sees herself with a two-fold identity: on the right, she is the Mexican Frida in traditional dress, holding a miniature of her beloved Rivera as a child; on the left, she is the sophisticated Frida, dressed as a European lady.

SELF-PORTRAIT WITH THORN NECKLACE AND HUMMINGBIRD
1940, oil on canvas, 24 x 19 in (62 x 48 cm), University of Texas, Austin

This picture draws on many strands of the tradition that makes up Mexican consciousness. For example, around the supreme indifference of her head, Kahlo has arranged a necklace of thorns that recalls the South American interest in Jesus's Crown of Thorns, while the hummingbird refers to the Aztec belief that spirits of dead warriors return in this form. Kahlo deliberately makes herself into an icon, claiming a status as woman-martyr, as heroine.

THE HEARTS OF BOTH *Fridas are linked by a single artery, a thin connecting wire. The European Frida has severed her artery by the act of divorce, and the blood is seeping steadily out onto her dress, but the Mexican Frida has her artery still attached to the image of her ex-husband. It is a protest against Rivera's desire to keep her primitive and treat her as a simple peasant wife at his bid and call.*

DESPITE THE SEPARATION, *she is not free. Only in contact with Rivera does her blood flow into her veins, keeping death at a distance. What makes this picture almost repulsive is the sheer physicality of the hearts. Kahlo is revealing what is naturally hidden. The heart may well be an unattractive cluster of muscles, but its secrets lurk within the breast. Kahlo insists on bringing into the light what nature hides.*

THE TWO FRIDAS, *1939, oil on canvas, 69 x 68 in (174 x 173 cm), Museo de Arte Moderno, Mexico City*

KALF, WILLEM 1619–93 b. Netherlands

STILL LIFE WITH DRINKING-HORN

STILL LIFE WAS A GENRE DEEPLY appreciated by the Dutch, since it exhibited with meticulous respect the material objects that were of importance to them. This still life is dominated by two majestic forms: the great parabola of the horn and the great diagonal of the lobster. Both objects are masterworks, although the creators differ: the horn is a masterwork of the silversmith, the lobster is a masterwork of nature. The splendid horn was the prized possession of the Amsterdam Guild of Archers. It glitters with silver filigree and is supported by a figurative group depicting the martyrdom of St Sebastian. Yet Kalf has looked as lovingly on the scales, claws, and feelers of the magnificent lobster as he has on the elaborations of the horn. The great crustacean sprawls in splendor, perfectly balancing the fine craft of the silversmith.

STILL LIFE
c.1665, oil on canvas, 25½ x 21 in (65 x 54 cm),
National Gallery of Art, Washington, DC

The intense blackness in which Kalf sets his still-life paintings gives them a dramatic appearance as they emerge, glowing and vibrant, seemingly out of nothingness. Here, he directs his light with theatrical skill, so that it shines fully on the tilted plate and on the lemons that spill off it, and just highlights the glasses and the orange blossom, which flutters like a captured butterfly above the gnarled fruit. A dying glow illuminates the carpet, which streams down into the nothingness in which it is set.

AROUND THE TWO MAIN protagonists, as it were, Kalf sets out an array of contrasting textures. Glittering out from the darkness is the goblet, with its elaborate stopper, and to the left of the lobster, in a glorious color contrast, is the dampness of a freshly peeled lemon. Beyond that are other glories, the whole thing laid out on the richly bunched-up folds of a Turkish rug.

THE CONTROLLED CHAOS of the rug is balanced by the sharp wooden precision of the underlying table. Everything on this table is seen by Kalf with an intensity of vision that lifts these objects onto a higher plane. Some of these creations are fleeting – the food and the drink will decay; others have the potential to last eternally. But here and now, in this moment, they coexist, and Kalf shares his reaction with us.

STILL LIFE WITH THE DRINKING-HORN OF THE ST SEBASTIAN ARCHERS' GUILD
c.1653, oil on canvas,
34 x 40 in (86 x 102 cm),
National Gallery, London

KANDINSKY, WASSILY
1866–1944 b. Russia, active Germany and France

ST GEORGE I

MANY PAINTERS HAVE BEEN PROCLAIMED the first abstract artist, but perhaps Kandinsky's claim to this mantle is louder than anyone's. Kandinsky was a deeply spiritual man, a theosophist, and he was totally committed to the idea of life as a struggle between light and darkness, good and evil. His was a world in which every shape had a symbolic meaning. The archetype of the struggle – and this was especially true for a Christian of Russian orthodoxy – was the battle of St George with the dragon. St George represents life, goodness, light, and springtime; the dragon stands for death, evil, darkness, and winter. St George always conquers, but then the battle begins again. *St George I* shows Kandinsky beginning to paint abstractions, yet, at this stage, he does so within the context of a theme in which he deeply believes.

SEVERAL CIRCLES
1926, oil on canvas, 55 x 55 in (140 x 140 cm), Solomon R Guggenheim Museum, New York

Here, Kandinsky has plunged fully into abstraction, with colored circles set in darkness and incoherence. For him, the circle had a profoundly spiritual meaning. He saw it as the perfect shape – it had complete integrity and utter serenity – and he believed that contemplating the circle would draw the viewer into understanding the significance of its unending form and its function within the psyche as something eternal.

THE SAINT *is on the right, thrusting down the long pole of his lance into the great extended shape of the brightly colored dragon. The abstract brackets of the horse's legs oppose the pale form of the dragon's tail. St George floats in and the dragon flashes into extraordinary color as its life is leeched away.*

THE DRAMA *is held in focus by the huge, shapeless masses that push all the action into the center of the picture. It is an almost unreadable setting, which serves solely to highlight this combat unto death. Kandinsky was trying to convey a meaning not so much by story as by shape and color – through the total feel of the picture, not by its individual parts.*

ST GEORGE I
1911, oil on canvas, 107 x 95 cm, State Museum of Russia, St Petersburg

KATZ, ALEX 1927- b. US
VARICK

IT IS ALWAYS TEMPTING TO DIVIDE contemporary painters into Realists and Abstractionists, but for the artists themselves this is often a false dichotomy. Many artists seek to do both, and nobody walks this dangerous line with a greater sense of balance than Alex Katz. His work is both realistic, in that he acknowledges the existence of real things, and it is abstract, in that he abstracts from this reality patterns and simplicities that please his aesthetic sense. *Varick* is an extraordinary landscape painting. High up in the blackness of night are six lighted windows of some office block or industrial concern. Isolated as they are, we are forced to study these rectangles with interest. All have neon strips and one window is much brighter than the others; then the corner turns and illumination is over. The final windows on the left show one neon strip, suggesting variation and division of the interior space. We may assume that someone, or several people, are working inside this lit office, but what is the subject here – the windows, or the darkness of night? Which matters more, the small thrusts of human endeavor, or the great enveloping darkness of the environment? Where do we rest in such a picture?

*VARICK, 1988, oil on canvas,
60 x 144 in (152 x 366 cm),
Saatchi Collection, London*

ADA AND ALEX
1980, oil on canvas, 60 x 72 in (152 x 183 cm), Private Collection, New York

This double portrait of Katz and his wife has that baffling quality that makes Katz so major an artist. At one level, it is almost vapid, yet how unforgettable are those faces! Again we are forced to ask, what are we seeing? No woman could be so perfect, so wrinkle-free, and no man could exist as such a minimal collection of form and color. Yet from these austere building blocks, Katz has erected a structure that forces us to accept its integrity.

THIS STRANGE STRIP OF ACTIVITY, *high in the sky, is isolated for us by the artist as he stands outside. It is almost impossible not to think of Katz driving by, looking up, seeing this strange high strip of light, and then recreating that enigmatic image back in his studio.*

THE WORLD IS SO LARGE *and so dark; the strip of industrial or scientific activity is so small and intense. Katz poses no questions and suggests no answers. Yet, in the audacity of this vast picture – an enormous statement by the artist – we cannot but be aware of power and duty. Such a painting haunts us.*

KATZ HAS FORCED US, *by using up so minimal a section of his huge canvas, to contemplate reality in a way that is completely without the egoistic bombast of the more obvious abstract painters. The work is representational, and it is also, in its own strange, personal way, an abstraction.*

KAUFFMANN, ANGELICA 1741–1807 b. Switzerland

SELF-PORTRAIT HESITATING BETWEEN THE ARTS OF MUSIC AND PAINTING

THE 18TH-CENTURY LADY was expected to have some musical and artistic talent. Angelica Kauffmann seems to have felt herself embarrassingly over-gifted. All through her life, she seemed aware of this crossroads, realizing that she could have opted for the ladylike seclusion of the musician as opposed to the public stresses of life as a painter. Here, in her fifties, she paints this portrait of herself, hesitating between the characters of Music and Painting. Painting is given the more determined profile, challenging Kauffmann and pointing towards the distant mountain – a reference to advice she was once given that painting was a difficult hill to climb.

PORTRAIT OF A YOUNG WOMAN AS SIBYL
18th century, oil on canvas, 35 x 28½ in (89 x 72 cm), Gemäldegalerie, Dresden, Germany

One of the affectations of the 18th century was to have one's portrait painted in the guise of some distinguished figure. This young woman is posing as a Sibyl, a wise woman. She unrolls the scroll with which she has foreseen the future and looks out with a now weary wisdom at the viewer. Light catches the parchment, gleams off the headdress, and then disappears as Sibyl looms out of the darkness to confront us with her prophecies.

SELF-PORTRAIT HESITATING BETWEEN THE ARTS OF MUSIC AND PAINTING
1791, oil on canvas, 58 x 85 in (147 x 216 cm), Nostell Priory, near Wakefield, Yorkshire, UK

THE YOUNG ANGELICA *looks longingly towards Music, who sits sedately with a manuscript unfolded on her lap. Although they clasp hands affectionately, Angelica gestures apologetically towards the brush and palette – her choice is made.*

A FAVORITE THEME *of the Renaissance was Hercules choosing between vice and virtue. Kauffmann transposes this theme onto her own artistic dilemma, imbuing the path of painting with the arduousness and heroism of climbing a mountain.*

KELLS, BOOK OF c.800 Celtic
ILLUMINATION
OF THE CHI RHO PAGE

ALTHOUGH THE MIDDLE AGES SPANNED many hundreds of years, the Book of Kells stands out as one of the greatest works of this period. It is one of the high points of human achievement and as an artistic milestone it is on a par with the Sistine Chapel in Rome or the pyramids of Egypt. The anonymous illuminators who worked on this copy of the Gospels have used their Celtic genius to honor the Word of God. Decorative motifs are intertwined and interwoven with miraculous precision into a complex but carefully orchestrated symphony. This page from the Book of Matthew is devoted almost entirely to three Greek letters, *XPI* – a monogram of *Chi Rho Iota*, which are the first three letters of the Greek *Khristos* (Christ). The Greek letters may be unfamiliar to us, but the fluid ripples of their shapes spread out over the page with incredible magnificence. The illumination of the Chi Rho page is worthy of almost endless contemplation.

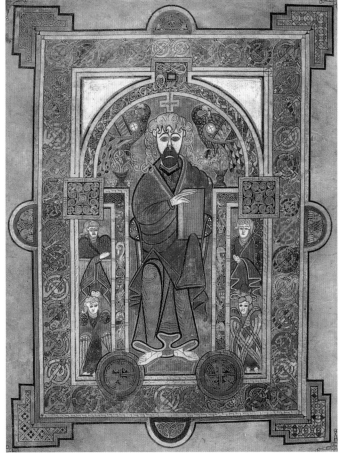

BOOK OF KELLS
(A PORTRAIT OF CHRIST)
c.800, tempera on vellum, 13 x 10 in (33 x 25 cm, manuscript size),
Trinity College, Dublin

The Book of Kells is a conscious attempt to create a masterwork. Although there were few precedents, the illuminators achieved this complex image of Christ using their trademark skill of extraordinarily rich color and interlaced patterning. Christ is flanked by angels and peacocks (symbols of immortality). It is an attempt to convey the majesty of the Lord, and the illuminator presents Christ as a decorative icon more than as a fleshy being. But, amid the wild curlicues of hair and stylized robes, a haunting face with hollow eyes emerges, capturing, not how Christ actually looked, but rather how it may have felt to gaze at Him.

CONCEALED WITHIN *the intricacy of this decorative work are several figurative elements. Although never congenial to the Celtic mind, figures were used in grand designs. Stray, disembodied heads and the occasional animal (cats, kittens, and mice) can be picked out and examined, but none detracts from our appreciation of the majesty of the whole.*

IT IS ALWAYS *the work that matters to me rather than how it is executed, and yet the means here can only arouse astonishment. Work of such delicacy and precision was carried out without the aid of a magnifying glass or even eyeglasses. This is the Celtic genius at its most charming.*

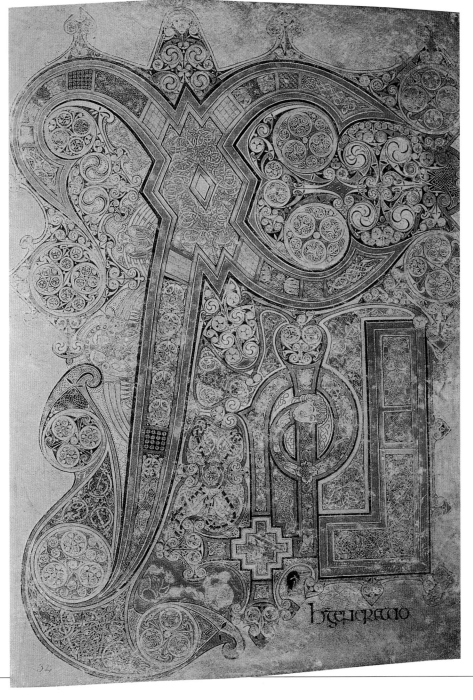

BOOK OF KELLS (ILLUMINATION OF THE CHI RHO PAGE)
c.800, tempera on vellum, 13 x 10 in (33 x 25 cm, manuscript size), Trinity College, Dublin

KELLY, ELLSWORTH 1923– b. US
REBOUND

ELLSWORTH KELLY CAN SEEM at first to be a purely abstract artist, who invents shapes and colors and plays with them. This is not, in fact, the origin of his art. He has always moved from some specific shape that he has seen, either natural or constructed, which he then isolates with its appropriate color. The colored shape in itself, he feels, is a source of pleasure, an intellectual satisfaction – even an emotional one. It is this movement from observation through imaginative involvement to the final result that makes his art truly creative. *Rebound* shows us two curved triangles in opposition. The quivering intensity with which they reach towards each other may remind us of Michelangelo's great fresco, where God's finger stretches out to Adam, sparking him into life. *Rebound* has the same tension, the same implicit movement, although here it is concentrated, distilled – the lower swooping up with passion, the upper moving down with more regularity but equal force.

RED CURVE IV
1973, oil on canvas, 100 x 100 in (254 x 254 cm), Anthony d'Offay Gallery, London

There is an amplitude in Kelly's imagination that is deeply satisfying. These shapes seem natural to the human imagination. They were known to prehistoric man; the building blocks of the natural world, even. Kelly draws us back to the innocence of pure shape, lovely in itself, and without allegiance to subject matter or story. Here, for instance, they recall for Kelly an actual fanlight in his house, but it is the forms in themselves – irrespective of memory – that are beautiful to us.

IT IS EQUALLY POSSIBLE *to read this picture as two great white curves – one far more rounded than the other – which will soon be severed, as we feel it must be, when the black confirms its need for, and relationship with, the corresponding black. If taken literally, one could imagine the points have met and were now in the stage of moving away – a conclusion that, strangely enough, we find ourselves reluctant to accept.*

WHAT DO THESE *shapes mean? They mean what we make of them. In the minds of those who view them, they arouse ideas, suggestions, memories. There is implicit pathos, need, desire, and passion, but by leaving such emotions implicit – by asking us to provide what is here only intimated – clearly involves us in the creation of this work, so strangely called Rebound.*

REBOUND, *1959, oil on canvas, 68 x 72 in (173 x 182 cm), Anthony d'Offay Gallery, London*

KESSEL, JAN VAN 1626–79 b. Belgium
AMERICA

SEVENTEENTH-CENTURY EUROPE was fascinated by the Americas and especially by Brazil. The romance of this otherness drew the kingdoms of Europe to fantasize about that strange and distant land and to gaze with awe on objects, both natural and crafted, that travellers brought back and displayed with pride. Van Kessel imagines a great Baroque hall that has been set aside to celebrate the strange marvels of America. He has adorned the walls with artefacts of the noble savage. Incidents from Brazilian encounters with native inhabitants are intermingled with imaginary depictions of their social life. He brings on natives too, splendid in the happy abandon that the sophisticated European presumed proper of his "less sophisticated" American counterpart.

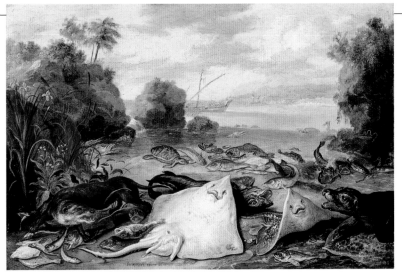

FISH ON THE SEASHORE
1661, oil on copper, 7 x 11 in (18 x 28 cm),
Galleria degli Uffizi, Florence

Fish on the Seashore has that blend of the real and the fantastic peculiar to van Kessel. Spread out, almost as if on a fishmonger's slab, is a vast array of fish, with an otter on one side balancing the excited seal on the other. Beyond the powerful immediacy of the foreground lies the sea, in which monsters are astir – the fish of the imagination.

AMERICA
1666, oil on copper,
19 x 27 in (49 x 68 cm),
Alte Pinakothek, Munich

EVERYTHING IN THIS *room is American – the strange and exotic animals, the shells, jewellery, musical instruments, and precious stones. In itself, this eclectic jumble might seem clumsy, yet it is redeemed from the ponderous by van Kessel's genuine interest.*

VAN KESSEL HAD A *naturalist's eye, and he seizes with the utmost enthusiasm on the shapes and colors of man and beast that are unknown to him. He may unconsciously be patronizing but, consciously at least, the artist is paying tribute.*

KIEFER, ANSELM 1945– b. Germany

TO THE UNKNOWN PAINTER

KIEFER, THE GREATEST OF CONTEMPORARY GERMAN PAINTERS, was born in the year that World War II ended. He has, then, no immediate knowledge of the evils that Hitler brought, and yet all his work is directed to confronting this terrible legacy. *To the Unknown Painter* refers to the tombs erected in both world wars to honor "the unknown soldier". Here, Kiefer's theme is the Nazi destruction of art that they considered degenerate, and the whole foreground represents a black, yellow, and red field (the colors of the German flag), scorched and destroyed by the fires of hatred; nothing is left but debris. To emphasize the physicality of this field, Kiefer has incorporated straw, a raw material that will naturally decay. This temporal presence in the painting implies that the canvas is not worthy of immortality. The mausoleum also (and again with a bitter irony) is a collage – a woodcut print on paper that has been glued onto the canvas. Like the straw, it attests to the inexorable passage of time.

MARGARETHE
1981, oil, acrylic, emulsion, and straw on canvas,
110 x 150 in (280 x 380 cm), Marion Goodman Gallery, New York

One of the German myths that has obsessed Kiefer is that of golden-haired Margarethe and dark-haired Shulamith, the Jewess. History has sundered the two, and the Aryan beauty can never now embrace with innocence the Semitic beauty. Kiefer laments this wound in the German psyche with unique vision.

THIS GREAT TOMB, *this bunker shape, could also be seen as a crematorium, not only marking the horrific destruction of existing art, but also the elimination of so much potential art – a commemoration of all the painters who were sucked up by the concentration camps, or by war itself, and were never free to create.*

THE SKY SURGES *with fury, fires seem to break out from behind explosions, and everything we see recalls the horrific violence of Germany's destruction. If this was all, we would have a painting of pure negativity, but, of course, this is not all that Kiefer achieves.*

KIEFER HAS CREATED *this image in honor of art itself. Even if the painter is forgotten and the work itself is destroyed, art will endure, nevertheless. In daring to create a work of such dramatic violence, of passion and perhaps of sorrow, Kiefer is expressing the intensity of his hope that whatever the stupidity and evil of human actions, art can always take experience and from it create beauty.*

TO THE UNKNOWN PAINTER, *1983, oil, emulsion, paper, shellac, latex, and straw on canvas, 110 x 110 in (279 x 279 cm), Museum of Art, Carnegie Institute, Pittsburgh*

KIRCHNER, ERNST LUDWIG 1880–1938 b. Germany
STREET SCENE IN BERLIN

KIRCHNER WAS A RESTLESS AND AGGRESSIVE MAN who felt he had come into his own when, two years before this picture was painted, he moved to Berlin and entered into the hectic pressures of big-city life. The elegant promenaders he has depicted here bear down upon the viewer, every face exquisite but indifferent and stamped with the mask that Kirchner seemed to feel was essential to triumphant survival in a world of such competitive pressure. His colors are sharp and dissonant, and his brushmarks have a febrile quality that adds to the anxiety of the picture. His figures seem squeezed through the keyhole of opportunity – narrow and tense, and yet somehow unfocused. Eyes are darkened or blurred, and, although he entitled this *Street Scene in Berlin*, it seems more like an alley, with people pouring through the archway on the left into this tightly-packed corridor of space.

SELF-PORTRAIT AS A SOLDIER
1915, oil on canvas, 27 x 24 in (69 x 61 cm),
Entwhistle Gallery, London

Although Kirchner had a medical discharge for psychiatric reasons in 1915 (the year in which this picture was painted), there was another sense in which he did not survive the war. The long, dejected visage of this mutilated soldier, holding up the gangrenous stump of one hand and the strange hook of another, is a self-portrait. Lost forever, he seems to think, are the uninhibited joys of sex and his world has become fragmented and threatening. Strange forms and shapes loom up behind him and his eyes look into the future with opaque despair.

THESE CENTRAL FIGURES, *with their expensive footwear and bizarre millinery, seem to represent what Kirchner himself sought to find in the city: an equilibrium of spirit that would enable him to jostle with the crowds and somehow remain unscathed. This is a sad, jagged picture and we are aware that the following year World War I will begin, Kirchner's fragile mental control will shatter, and that eventually, unable to compete, he will kill himself.*

THE WOMEN AND THE DANDYISH *male seem like predatory birds, poised to devour. The strident yellow that surrounds them is equally ominous, slashed as it is by black feet that spread out like pointed talons. This is a street scene from hell, albeit a refined and Germanic underworld.*

STREET SCENE IN BERLIN
1913, oil on canvas, 48 x 36 in (121 x 91 cm),
Museum of Modern Art, New York

KLEE, PAUL 1879–1940 b. Switzerland
DEATH AND FIRE

FOR MOST OF HIS LIFE, Klee taught in the great German art schools. An immensely prolific and inventive painter, his small works on paper explored every facet of the wonder of a painterly vocation. Then came the rise of Nazi tyranny and Klee retreated to his native Switzerland. Not only was he heartbroken, but he found himself, while still comparatively young, dying of a painful disease. Under the stimulus of personal and worldly tragedy, his art changed. The earlier pictures, with their fragile and enchanting colors, loomed into much larger canvases, carrying one stark and inescapable message. *Death and Fire* has as its center the eerie gleam of a human skull, the features of which spell out *Tod*, the German word for death. But it is not merely a personal death: to the left we see another "T" and another "O", with the "D" formed by the skull, symbol of universal finality. These are the elements that can be most easily read, but this painting contains further mysteries. What, for instance, is the significance of the three prongs at the top of the picture, or the strange and pathetic human on the right? It is such questions that motivate our further consideration.

ANCIENT SOUND
1925, oil on board, 15 x 15 in (38 x 38 cm), Kunstmuseum, Basel

As a young man Klee had to choose between a career as a professional musician or as an artist. He chose to paint, but always remained deeply attuned to that parallel creative life. *Ancient Sound* might look like an inspired playing with dimly colored squares, but Klee is trying to recreate a whisper, an echo, an evocation of all the music of the past, the papyrus music, the ancient music that, some might say, still lingers unheard on the soundwaves of the world.

THIS GLORIOUS PICTURE *glows with an inner fire, and the stark, implacably solid reality of death gleams at its very center. The hollowed-out body of that strange symbolic human on the right is a frail token of life that progresses awkwardly and uncertainly towards the bright, grinning head of death.*

THE SKULL MAY BE *balanced on the pale green of the earth, but this is a world that is alive despite its preoccupation with death. The skull that proclaims our mortality wears a triumphant, though maybe mocking, smile, and the darkened ball perhaps represents the sun, balancing immobile and precariously on a ridge that seems to be an extension of the figure of death.*

DEATH AND FIRE
1940, oil on canvas, 18 x 17 in (46 x 44 cm), Kunstmuseum, Bern

KLIMT, GUSTAV 1862–1918 b. Austria
FRITZA RIEDLER

SOME ART CRITICS REGARD "DECORATIVE" as an insult and would have little time for Klimt, for whom decoration is central. What makes Klimt's use of the decorative so powerful is that, as must be in all great masterworks, it is never decoration for the sake of decoration but exploited to its fullest capacity in the search of beauty. His greatest decorative exploits (and the note of daring suggested here does not go amiss) are in his portraits in which he has most cunningly played off the specifics of a human face and body against the extreme elaborations of his very particular sense of design. Fritza Riedler shows her fleshliness, her mortality, only in head and neck, arms, and hands. All the rest is subsumed into this closely integrated scheme of decoration. Fritza herself barely holds her own amidst this avalanche of exquisite craft. She is there though, and Klimt has not blotted her out, merely using his unique creative imagination to enfold her in layer after layer, not just of chiffon, but of decorative setting. The emergence of her rosy patrician face from this great wealth of invention seems almost like a triumph of the human spirit.

THE KISS
1907–08, oil on canvas, 71 x 71 in (180 x 180 cm), Österreichische Galerie, Vienna

Art Nouveau is more quickly recognized than defined. It delights in the outline, the curve, the bold and fantastic use of decoration and colour. It regards the picture in its entirety as important, rather than privileging the picture's meaning. Klimt was one of the style's major practitioners. His lovers' glorious costumes blend into each other amidst a riot of carefully composed plant shapes and a background of gleaming blurs and rectangles. Their erotic closeness is repeated and emphasized by the decorative coherence of what they wear, but there is no attempt to suggest that this passionate encounter takes place anywhere but in the imagination.

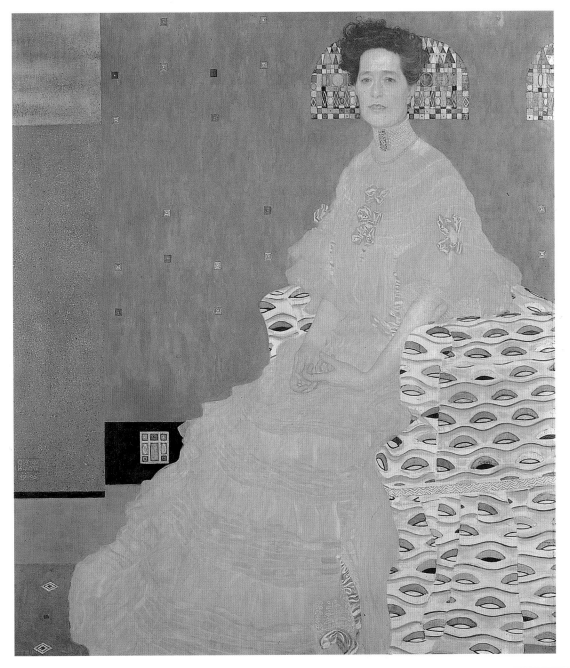

FRITZA RIEDLER'S *head is set against a patterned shape suggestive of a stained-glass window, and which at first sight looks like an extraordinary headdress. The soft frills of her dress flow down in a loose stream, held, as it were, in its bed by the equally extraordinary design of the chair, in which a subtly modulated eye pattern contrasts with the gentle pink of the arm and the twisting hands.*

ALL THIS IS SET AGAINST *an extraordinarily nuanced pink: the deep, wild pink of the background, with its black squares, and then the solid two-color pillar on the left. Little grace notes run throughout the composition, from the intricate squares on the carpet to the strangely fascinating rectangles on the black skirting of the wall.*

FRITZA RIEDLER, *1906, oil on canvas, 60 x 52 in (153 x 133 cm), Österreichische Galerie, Vienna*

KLINE, FRANZ 1910–62 b. US
MAHONING

FOR MANY ABSTRACT EXPRESSIONISTS there was always the danger of becoming formulaic: think of Rothko's rectangles or Pollock's canvases covered with flicked and dripped paint. As with these artists, the work of Franz Kline is also easily recognizable. He too had what one could call a formula, but he used his with a freshness and a perpetual reinvention that kept him from ever becoming uninteresting. *Mahoning* is a splendid example of Kline at his strongest. Basically, his work consists of thick, black strokes against a white background, although this is a poor oversimplification of the complexity and subtlety of his work at its best. He seems to take us into something of the mystery of form – that objects exist, or can through the artist's skill be made to exist, and in existing can delight the spirit. He said the final test of the painting is this: "does the painter's emotion come across?"

MAHONING
1956, oil and paper collage on canvas, 80 x 100 in (203 x 254 cm), Whitney Museum of American Art, New York

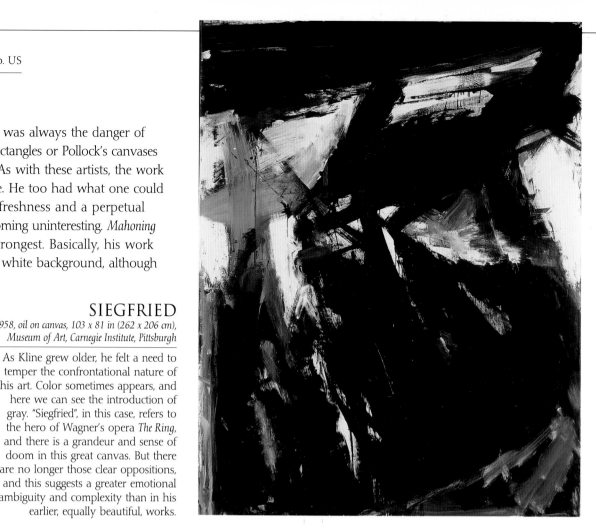

SIEGFRIED
1958, oil on canvas, 103 x 81 in (262 x 206 cm), Museum of Art, Carnegie Institute, Pittsburgh

As Kline grew older, he felt a need to temper the confrontational nature of his art. Color sometimes appears, and here we can see the introduction of gray. "Siegfried", in this case, refers to the hero of Wagner's opera *The Ring*, and there is a grandeur and sense of doom in this great canvas. But there are no longer those clear oppositions, and this suggests a greater emotional ambiguity and complexity than in his earlier, equally beautiful, works.

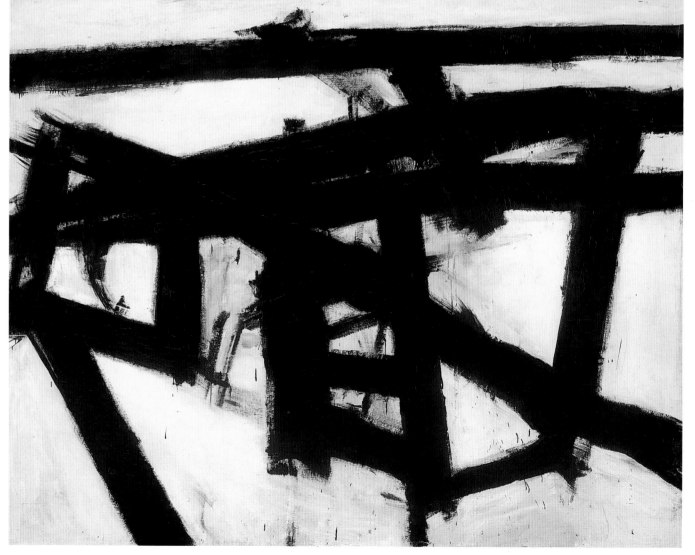

KLINE'S WORK *has been compared to Chinese calligraphy blown up large, but, in fact, what inspired Kline were very simple images seen in outline. Moving around New York at a time that it was expanding rapidly, he was captivated by the sight of scaffolding against the sky – the patterns it made, the sense of complexity that the maze of poles and ladders could evoke in the spectator.*

TO LOOK *at Mahoning and see in it only ladders and scaffolding would be a sad failure of the imagination. Kline is creating large, powerful shapes, indicative of a greatness of spirit and of a lack of constriction (we notice how the shapes are not confined to the canvas, but continue on either side). The artist's emotion does come across, but what that is remains purely subjective.*

KNELLER, SIR GODFREY 1646–1723 b. Germany, active England

PORTRAIT OF JOHN BANCKES

KNELLER WAS THE FIRST BRITISH PAINTER to become not just a knight but a baronet, and this portrait of John Banckes was painted at the very beginning of what would be a long and illustrious career. He owed some of that luster to Banckes himself, who, as a wealthy merchant banker, took the young Kneller into his house and publicized his talents. As Kneller achieved fame and wealth in his own right, he was to paint with great splendor many of the most influential people of his day. But this early portrait depicts a friend and benefactor, and its aim is merely to celebrate the sheer goodness and kindness of Banckes, not to publicize to the world the social significance of the sitter – that boring occupation with which Kneller's later years were filled, bringing to him a surfeit of wealth. This is a rare instance of a professional portrait that communicates, above all, respectful affection.

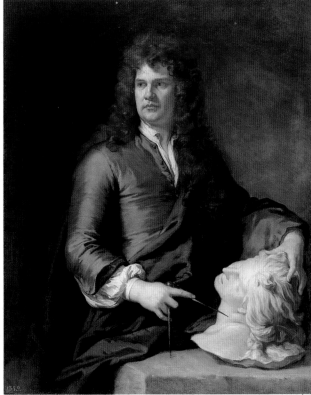

GRINLING GIBBONS
c.1690, oil on canvas, 49 x 35 in
(125 x 90 cm), Hermitage, St Petersburg

The great English country house is frequently distinguished by a Grinling Gibbons' carving. Gibbons was one of the most powerful and inventive carvers of wood, although, strangely enough, Kneller has shown him poised – callipers at the ready – over a marble head. Perhaps we are meant to assume that this is to be copied in wood, his chosen medium. He is far from a humble craftsman; Gibbons is "the artist", with deliberately casual attire and an air of command that would daunt clients who lacked respect for his achievements. It is a superb portrait of a man of genius at the height of his powers.

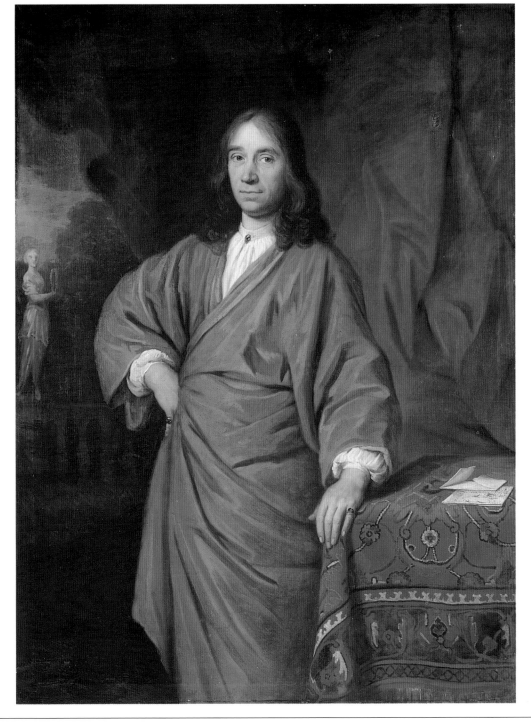

KNELLER SHOWS Banckes as a man of business, with papers on the table that seem to refer to his affairs in Holland. But Banckes is not tied down to business; he is not a runner in the rat race, but a free spirit. Dressed informally, he stands with a slight smile on his face as he tucks his loose gown around him and waits, with easy confidence, for his young friend to immortalize him.

ON THE LEFT we can see Banckes's garden, with a fine piece of garden statuary – a light touch to indicate his artistic interests. But what distinguishes the picture – despite the artist's interest in the Turkish rug that covers the table, and the great swag of silk and curtain behind – is the character of Banckes, which effortlessly dominates the painting.

PORTRAIT OF
JOHN BANCKES
1676, oil on canvas, 36 x 71 in
(91 x 180 cm), Tate Gallery, London

KØBKE, CHRISTEN 1810–48 b. Denmark

A VIEW OF ONE OF THE LAKES IN COPENHAGEN

WHAT DISTINGUISHES CHRISTEN KØBKE is the originality with which he chose his subjects. The picturesque, as such, seems to have held little attraction for him. That said, *A View of One of the Lakes in Copenhagen* does happen to be a view that could claim to be picturesque, and yet this lovely tranquillity is less the focus of Købke's attention than it might at first seem. The picture is dominated by that flagstaff on which the Danish flag flutters not triumphantly but with sufficient significance to make its mark. Typically for Købke, nothing is happening here. Two women, emphatic in their solidity, stand half in shadow, half in light, as the boat rows slowly towards them over water already reflecting the delicate pinks of the sunset. It is difficult to put one's finger on what makes this scene so noble. The picture comes to us like balm.

A VIEW OF ONE OF THE LAKES IN COPENHAGEN, *1838, oil on canvas, 21 x 28 in (53 x 72 cm), Statens Museum for Kunst, Copenhagen*

KØBKE HAS CAUGHT A MOOD; *he has taken us into an experience that is wholly undramatic and yet important. He is a visionary, but a secular visionary. He does for 19th-century Denmark what Corot does for 19th-century France and Italy; he makes us believe that here is a man who can see.*

A VIEW OF A STREET IN COPENHAGEN
1836, oil on canvas, 42 x 64 in (107 x 162 cm), Statens Museum for Kunst, Copenhagen

We have seen the Copenhagen lake in early evening, and here we have a view of the streets of Copenhagen in the light of morning. Again, nothing is happening: people are going about their normal vocations – carriages arrive, cattle move down the road – and yet, the extraordinary beauty of that morning light transforms the scene. For one moment, we are aware of a specific place and time. This seems such a marvel to us because we are so bound by time and unable to ever hold it still.

KOKOSCHKA, OSKAR 1886-1980 b. Austria
BRIDE OF THE WIND

SOME ARTISTS ARE RADIANTLY WELL-BALANCED individuals whose work reflects their equanimity; others, however, reveal themselves through their work as being neurotic to an alarming degree. Kokoschka most emphatically belongs to this latter group. No artist was ever more ego-driven or more soul-searching in his creativity than Kokoschka. Perhaps his greatest masterpiece is *Bride of the Wind* in which he celebrates with visionary intensity his love affair with Alma Mahler, the widow of the composer Gustav Mahler. She was the archetypal *femme fatale* and, although she never married Kokoschka, she captivated his emotions so completely that when she ultimately rejected him he made a life-sized replica of her, which he carried around with him. The *Bride of the Wind* was painted the year before Alma rejected Kokoschka, and perhaps the grim look on his face indicates his awareness of the fact that the love affair was doomed. She sleeps contently, while Kokoschka, unacknowledged and, one fears, unloved, acts both as her bed and her support. As they whirl together through the skies his body visibly disintegrates.

POLPERRO II
1939, oil on canvas, 24 x 34 in (61 x 86 cm), Tate Gallery, London

If Kokoschka's portraits seem almost invasive in their emotional nudity, it is not so of his landscapes. The port of Polperro in Cornwall, England, glows with Celtic color under a troubled sky. Although the port is recognizable, Kokoschkas's treatment of it is absolutely subjective. There is a sublime and individualistic quality that recalls Turner; the colors are heightened and wild.

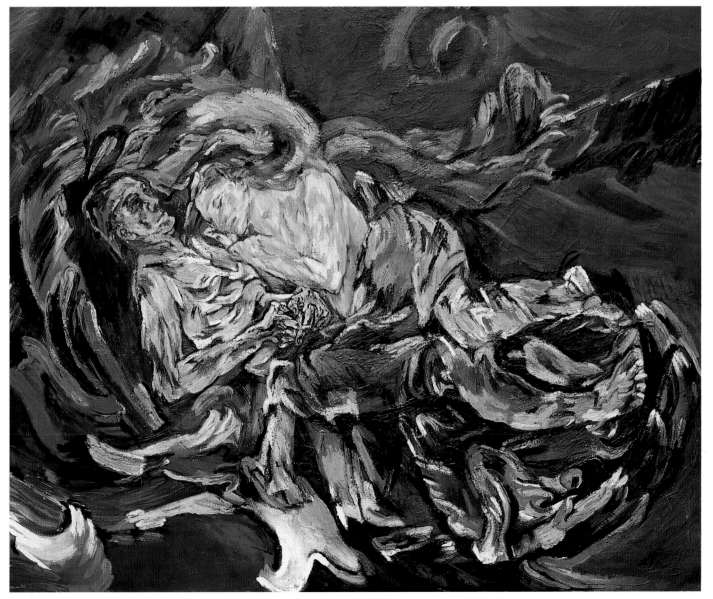

ALL IS A *maelstrom of twisting colors and forms, of bodies barely holding together under the strain of intense passion. The storm that lifts the lovers high above the ground – symbolizing the sublime nature of their love – will also dash them down to earth again.*

BY DEPICTING *such intensity of feeling, Kokoschka meant to lay bare the closeness of his relationship with Alma, but the actual handling of the paint, its looseness and volatility, suggests just the opposite – that this love affair will be swept away. This work is almost disturbingly memorable for its emotional turmoil.*

BRIDE OF THE WIND, *1914, oil on canvas, 71 x 87 in (181 x 221 cm), Kunstmuseum, Basel*

KONINCK, PHILIPS 1619–88 b. Netherlands

PANORAMIC LANDSCAPE

PHILIPS KONINCK WAS ONE OF A GROUP of great Dutch artists who concentrated on landscape and who loved without subterfuge the flatness of their own personal world. He shows us a panoramic landscape, painted from an elevated viewpoint, so that the world stretches out as if to infinity. Here, the foreground is bathed with a warm light, and the details – the cattle, the windmill, the farms – gleam golden. Then, abruptly, the world is slashed in two and over half of the picture concerns itself with the splendor of the sky, its blueness compatible with the golden light. Two birds soar aloft, reminding us that we, too, soar aloft in order to see this panorama.

EXTENSIVE LANDSCAPE WITH A TOWN IN THE MIDDLE DISTANCE
c.1665–68, oil on canvas, 17 x 21 in (44 x 54 cm), National Gallery, London

PANORAMIC LANDSCAPE
1665, oil on canvas, 54 x 66 in (138 x 167 cm), J. Paul Getty Museum, Malibu, California

What seems to have intrigued Koninck is how the same kind of world – flat land and great sky – could express the tranquil happiness of sunlight at one moment and, at another, convey threat and vulnerability. Above the town lowers the smudgy darkness of a coming storm. Cattle stand motionless, and the town, still sunlit, waits. The whole picture conveys expectation, with a hint of threat.

K
246

KONRAD VON SOEST c.1360–1422 b. Germany

THE NATIVITY

KONRAD VON SOEST painted an altarpiece for the small German town Wildungen, and it remains one of the most enchanting vignettes of family life that the Middle Ages has left us. All the work for the Holy Family is done by an eager and industrious Joseph. Despite his grey beard, he has lit the small fire, procured a chunky saucepan, and is preparing some mysterious meal for his dependants, with bowl and spoon at the ready. St Joseph's expression – the intent look of a man who does not know how to cook – is both delightful and touching. The whole figure is gloriously rendered, from his blue cap down to his blue stockings and natty little bootlets, and particularly close attention is lovingly given to his belt, with its serpentine curves.

THE NATIVITY
1403–04, tempera on panel, 28 x 22 in (71 x 56 cm), Church of Saints Maria, Elisabeth, and Nikolaus, Bad Wildungen, Germany

ST PAUL
c.1400, tempera on panel, 21 x 7½ in (53 x 19 cm), Alte Pinakothek, Munich

St Paul can usually be recognized by his sword of faith, and he is often seen as a pugnacious, almost aggressive, character. But Konrad, with his fervent interest in psychology, depicts him almost as tragic. Paul stands there, wary and hesitant, a strangely vulnerable apostolic figure.

KOSSOFF, LEON 1924- b. England
HERE COMES THE DIESEL

WHEN I FIRST SAW *HERE COMES THE DIESEL, EARLY SUMMER, 1987* I was overwhelmed. It was not the painting itself but a reproduction, and I can recall vividly how the beauty of it made me gasp, and how I had to stand up and walk around to come to terms with the extraordinary impact of this image. It still seems to me that, while ours is not one of the great centuries of art, works like this give one hope. Kossoff is in one way a profoundly unromantic painter. He paints the familiar – his family, his friends, his surroundings. There are several paintings of London underground stations and his local swimming baths, and here, it is a diesel train that has attracted his attention. It is depicted with that vulgar yellow frontage with which we are all familiar, passing along a completely ordinary London line. Yet, if his theme is unromantic, the manner with which he treats it is pure poetry. It is not a poetry that comes easily to him – he paints and repaints, compelled to destroy, create again, scratch out, and rebuild. Out of the anguished attempts, almost incessantly reiterated, he sees it again – the sheer wonder that drew him into this moment of artistic creation – and is finally enabled to share it with us.

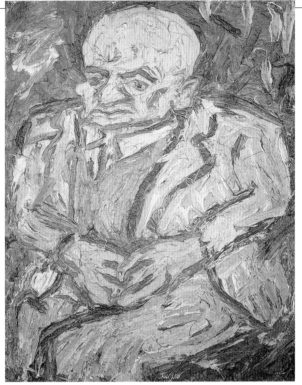

PORTRAIT OF FATHER
1978, oil on panel, 48½ x 38½ in (123 x 98 cm),
Scottish National Gallery of Modern Art, Edinburgh

We feel that Kossoff paints both what he sees and what, over the long years, he has known and grown to love. He shows us how deep we need to dig to keep true the image of those we love, how they are always in danger of falling back into the mass of events that fill and overfill our daily life. What image of his father is the true one – young father or old father? Kossoff is digging into the mass of potential, excavating the image of this elderly man from the deep morass of materiality, clawing out from it, almost painfully, the great solidity. In so doing, he is producing a true portrait.

IF WE ASK WHAT MAKES this picture so exciting, one might point to the controlled chaos of the brushwork, maybe the flurry of color that valiantly maintains a descriptive integrity, or the rush of almost ecstatic joy that funnels itself down into this particular image. Kossoff holds us at a distance from the train itself, making us grapple through the undergrowth and pass through the posts of the destroyed fence before we encounter the machine itself, groping like a blind caterpillar along the trail of its destiny.

KOSSOFF INVOLVES US in the sheer excitement of the world as it is, not smoothed out for the vulgarities of illustration, nor left in the selfish sprawl of pure abstraction. But both possibilities – the glory of color in itself and the wonder of image in itself – are somehow combined and made incandescent by the sheer power of the artist's imagination.

HERE COMES THE DIESEL,
EARLY SUMMER, 1987
1987, oil on board, 24½ x 22 in
(62 x 56 cm), Private Collection

KRASNER, LEE 1911–84 b. US
POLAR STAMPEDE

LEE KRASNER WAS A GENIUS WHO HAD THE MISFORTUNE not only to marry another genius but to marry one whose work peaked before her own. Artistically, Krasner was exploring in the same direction as her husband, Jackson Pollock, but whereas he had made a decisive breakthrough, soaring free of all traditional constraints, flinging and dripping paint with wild spontaneity, Krasner moved more slowly, seeking and seemingly needing more control. Pollock's violent death in a car crash seemed to liberate her, however, and while *Polar Stampede* has an uncanny relationship with Pollock's work, it remains, unmistakably, Krasner's own. In this painting, which seems to be the work of a profoundly angry artist, Krasner has almost abdicated color, attacking the canvas with great thick swathes of white and dark umber. In the crashing cascades of furious paint, she seems to suggest a long-gone catastrophic time, bringing to mind visions of the Ice Age, the freezing of the seas, and the transformation of the known world. Yet, for all its aggression, this is the work of a highly controlled artist.

RISING GREEN
1972, oil on canvas, 82 x 69 in (208 x 175 cm), Metropolitan Museum of Art, New York

Throughout her life, Krasner tended to paint or draw, cut up her work, and then reassemble the pieces. Even when she did not go through the stages of this process entirely, a work such as *Rising Green* comes from that same desire to create, destroy, and recreate. It is a work of surprising hopefulness. Images of flowers, the moon, and the green of springtime pass through our minds, and we notice the inexorable emphasis on the vertical, the rising.

KRASNER HAS LEARNED TO ACCEPT *accident, as Pollock did, but to accept it as an element to be included in the overall scheme that underlies the wild passion of such a painting. This is Krasner exploding into art, expressing in visual form her grief at the loss of Pollock, her anger at her treatment by the art world (which never once admitted that here was a major talent), and her furious determination to create regardless.*

POLAR STAMPEDE
1960, oil on canvas,
94 x 160 in (238 x 406 cm),
Private Collection

KUPKA, FRANTIŠEK
1871–1957
b. Czech Republic, active France

PLANS DIAGONAUX

PLANS DIAGONAUX IS A SPLENDID ILLUSTRATION of how Kupka's mind was able to seize upon elements in the real world and intellectualize them into an abstraction. Nothing here is either random or self-indulgent. Kupka's Slavic imagination found a rare visual form: he composed his harmonies of color and structure with rigorous attention to an inner logic that we cannot follow. We see astonishing alternations of bare white and black, complex chromatic forms, and of varying greens and yellows with the surround of blotchy blue. It is as if the artist attempts to satisfy some need or compulsion to create a structure akin to a private, inner music. In fact, many of his early abstractions had titles that revealed specific links with the constructs and harmonies of music. Here, there is a suggestion of the pipes of some towering organ, and a sense of form being built upon form, recalling the complex and disciplined patterns of Bach's great fugues.

PLANS DIAGONAUX
*1925, oil on canvas,
17 x 14 in (43 x 36 cm),
Musée de la Ville de Paris*

LA HYRE, LAURENT DE 1606–56 b. France

ALLEGORICAL FIGURE OF GRAMMAR

THE 17TH CENTURY DELIGHTED in the apposite wit that could create a form to express an abstract concept. La Hyre represented the seven liberal arts in seven major works, and this is his figure of grammar. For this work, La Hyre makes use of a gardener to exemplify the role of grammar, equating the rules of language – through which humanity has imposed control upon the chaos of the world – with the activities of an orderly garden. Here, primulas and anemones are set in pots, which the gardener tenderly waters so that their wild growth will be nurtured into full flowering. She is a gracious and benign figure, set between the great pillars of human authority and the tree trunks of natural stability, and she holds out to us a ribbon that explains that for words to have meaning they must be spoken clearly and in grammatical order. There is something wonderful for us to see in so barren a concept, so remote a philosophical construct, yet made human and appealing by La Hyres female gardener. There is a soft dignity in the purples and mauves of her clothing, and even the jug with which she waters is of the finest blue and white porcelain.

ALLEGORICAL FIGURE OF GRAMMAR
*1650, oil on canvas, 41 x 44 in
(103 x 113 cm), National Gallery, London*

THE FOUR TIMES OF
THE DAY: MORNING
*1739, oil on copper,
11 x 14½ in (29 x 37 cm),
National Gallery, London*

LANCRET, NICOLAS 1609–1743 b. France

MORNING

SOMETIMES ONE CAN ALMOST MISTAKE LANCRET for his
model Watteau, but there is a material solidity in Lancret,
without Watteau's nostalgic romanticism. *Morning* is filled
with witty observation – a delightful young woman (who
is clearly no better than she should be) is entertaining a
young cleric, seemingly unaware of the temptation offered
by that casually exposed bosom. He holds out his cup,
but his eyes are fixed, alas, on that region of the feminine
anatomy that his profession forbids him. The maid
watches the interplay and laughs to herself. For all the
sly humor, Lancret provides us with a charming vignette
of an 18th-century world of leisure and privilege.

THE FOUR TIMES OF THE DAY: MIDDAY
1739–40, oil on copper, 11 x 14½ in (29 x 37 cm), National Gallery, London

Lancret loved painting groups of works. Here, he has moved
on from *Morning* to *Midday*. The characters have paused at a
sundial, and it is the genuine sense of the day passing, of
time receding and age approaching, that imbues these light-
hearted – even frivolous – pictures with a certain weight.

LANDSEER, SIR EDWIN 1802–73 b. England

THE MONARCH OF THE GLEN

Landseer was the essential Victorian, and he responded with emotional fervor to
the wildness of the Scottish Highlands. In an increasingly industrialized world, the
Highlands remained radiantly free, a land of poetry and vision. This romance was
encapsulated for the epoch in Landseer's *The Monarch of the Glen*. Here is the wild stag,

utterly in command of a wild
world, a world that is not precisely
delineated: mists swirl, rocks arise,
clouds descend. All that is clear is
the grass springing at the stag's
feet and the triumphant upsweep of
those great antlers, the listening ears,
and the nostrils sniffing a scent
untainted by industrial pollution.
Landseer was painting an animal,
but he was also painting what the
Victorian male longed to be – a
hero, a monarch with responsibility
for no desires but his own.

THE MONARCH OF
THE GLEN, *c.1851,
oil on canvas, 64½ x 66½ in
(164 x 169 cm), United
Distilleries Ltd, London*

DEATH OF THE WILD BULL
*c1833, oil on canvas, 88 x 88 in (224 x 223 cm),
Forbes Magazine Collection, New York*

In the early 1830s, Landseer was commissioned
to paint the famous Chillingham wild cattle, which
are almost pure white. It was decided that, in order
for him to accomplish the task, one should be shot.
The plan went wrong when a bull attacked the
gamekeeper, and only the courage of a deerhound
saved the man from death. The picture, then, was
not as Landseer had intended. He had meant to show
the beauty of this unique beast. Instead, the picture
celebrates the courage of the dog and laments the
great bull's death. Lord Ossulston, who owned the
herd, stands with aristocratic hauteur, looking down
on the drama, with his deerhound and the keeper –
still breathless from his narrow escape – at the left.

LARGILLIÈRE, NICOLAS DE 1656-1746 b. France

ELIZABETH THROCKMORTON

NICOLAS DE LARGILLIÈRE WAS THE GREAT society painter of early 18th-century France. If it seems strange that he should be painting a nun, we must remember that Elizabeth Throckmorton was a member of the Catholic gentry – those recusant upper-class families who sent their children to the Continent to be educated in the religion that was still legislated against and despised in their own country. This portrait was painted when Elizabeth was the Mother Superior of her convent. Records suggest that she was a woman of frail health, but that is not how Largillière saw her. She sits there, calm, resolute, and powerful - aware, perhaps, of her critical allure, but completely unimpressed by it. She is a woman who has her destiny in her own hands and means to keep it there. This experienced and sophisticated portrait painter clearly found Elizabeth Throckmorton alarming, seductive, and, in the end, admirable.

PORTRAIT OF A MAN
c.1710, oil on canvas, 36 x 28 in (91 x 71 cm), National Gallery, London

In itself, the identity of this unknown man should not matter (possibly, he is the poet Jean-Baptiste Rousseau), and yet the picture clearly suggests that this is an interesting man, a man, moreover, who knows quite well that he is interesting. Largillière has painted him in the elaborate, so-called casual attire that a man of genius often adopted. But it is his face that catches our attention – that half-smile, that look of complicity, that air of being in the know. One of the ironies of art history is that so many sitters who knew they were being immortalized have been remembered, not for their names, but for their appearance.

ELIZABETH DAUGHTER OF Sʳ ROBᵀ THROCKMORTON BARᵀ.

AS A NUN MYSELF, *I find several things of great interest in this portrait. I am struck by how impressively Largillière has rendered the religious habit – how it has served to highlight Elizabeth's beauty. Would she have looked so enthralling had she been in secular attire? I am also struck, as clearly was the artist, by the dense folds of the Augustinian habit, as they swell over her bosom.*

THE YOUNG, HYBRID FACE, *with its elegantly arched eyebrows and rosy looks, is magnificently framed by the transparent glow of the black veil and the white wimple. This could be a sensual picture, were it not for the resolute gaze of those hazel eyes, and that firm, working hand, which clutches with such authority a book of devotion.*

ELIZABETH THROCKMORTON
1729, oil on canvas, 32 x 26 in (81 x 66 cm), National Gallery of Art, Washington, DC

LARIONOV, MIKHAIL 1881–1964 b. Russia

SOLDIER ON A HORSE

LARIONOV WAS BORN IN THE SAME YEAR as Natalia Gontcharova. They met and fell in love while still in their teens and together left Russia in 1915 to pursue a successful career as stage designers. But, before they left, both had contributed substantially to the artistic life of their country. Larionov, like all Russian men, did his military service, and the result was a series of almost satirical works dealing with the life of the soldier. He took for his inspiration wooden toys, and painted Russian folk-art pottery – folk art became increasingly important to the cluster of gifted artists emerging in Moscow and St Petersburg. *Soldier on a Horse* is one of the most important of these strangely vigorous works. The saturated colors and almost caricatural simplicity are the means towards achieving an impressive image.

SOLDIER ON A HORSE
c.1911, oil on canvas, 34 x 39 in (87 x 99 cm), Tate Gallery, London

RAYONISMUS
1913, oil on canvas, 49 x 40 cm (19¼ x 15¾), Private Collection, Lugano, Switzerland

From folk art, Larionov turned to the other extreme: Rayonism, a movement influential in the development of abstract art. Literally, this was not an abstraction but an attempt to paint the rays of light or rods of color that form the intricate mosaic that the eye sorts into order. The Rayonists fervently believed in the supremacy of science and the new dimension it brought to painting.

LARIONOV *disdains any attempt at realism, and he has scribbled graffiti on the work (often, I am told, with a bawdy implication) to emphasize that this is a mental construct, that this is how it felt to be a soldier – to become a marionette, a wooden thing, an object, for whom even trees were either dead or felled.*

IT REQUIRES *no great insight to deduce that Larionov hated his military service and that he saw it as emblematic of what was wrong with Russia. There was too much play-acting and foolish subservience. The soldier on horseback holds the reins with a slack and nervous grasp, his big stupid eyes staring vacantly into the future.*

LASCAUX CAVES c.15,000–10,000 BC France
WOUNDED BISON ATTACKING A MAN

AS WE KNOW, IT HAS TAKEN MILLENNIA for science to progress from the discovery of fire and the invention of the wheel up to the extraordinary proliferations of today. Art, however, is very different. Art does not depend upon the accretion of knowledge; knowledge can bring us awareness of new techniques, but it leaves unaffected the fundamental artistic genius. As a great scholar said of the Greek vases, it is possible to paint differently but not to paint better. *Wounded Bison Attacking a Man* is unusual in that it is one of the very few paintings in the Lascaux caves to show a human being. The human being is depicted with a certain element of compassionate hilarity – a stick figure who lies on his back with an unmistakable erection, helpless before the majesty of the bison. Yet, this is a wounded bison; its entrails fall from a great body, a catastrophe that seems to leave the beast still wholly in command of its superior powers. Clearly, man is able to wound a bison, and yet it is the bison that inflamed the artist's imagination.

HORSE
c.15,000–10,000 BC, powdered pigments, Lascaux caves, the Dordogne

High up in the Lascaux caves, in obscure places beyond the reach of the unaided hand, are images like this wonderful horse. It is an animal of supreme delicacy that reminds one of the most eloquent productions of the scholarly artists of China. The delicate and impressionistic handling of the legs and hooves is balanced by the equally impressionistic size of the body, tapering off to that narrow and aristocratic head. The color, that glorious glowing ocher, is spread across the body with a freedom that is independent of those wavering outlines. This is an impressionistic horse, yet one that is wholly convincing.

WOUNDED BISON
ATTACKING A MAN
c.15,000–10,000 BC, powdered pigments, 43 in (110 cm, length of bison), Lascaux caves, the Dordogne

THE GREAT, GOLDEN BISON *is seen as an almost god-like creature. The human body was to dominate the art of later centuries but, right at the beginning, great art was empowered by the animal – free, strong, quick, and at home in the world, as man could never be.*

LASTMAN, PIETER 1583–1633 b. Netherlands

JUNO DISCOVERING JUPITER WITH IO

LASTMAN'S CLAIM TO FAME is usually taken to be that he was Rembrandt's teacher, but he was also a considerable artist in his own right, as well as a great dramatist. In Greek mythology, Juno comes off badly and is rarely in control. Here, with ironic pleasure, Lastman situates her at the very peak of the broad diagonal that slopes from Juno, in righteous glory, down to Jupiter at the bottom. The story is a complex one: Jupiter fell in love with Io, arousing Juno's suspicions. Lastman shows the moment at which Juno just misses catching Jupiter in the wrong. He has seen her coming and with the help of Fraud – the figure in the back who is whisking the curtain of transformation away from Io – has transformed his love into this bewildered and beautiful cow. Foiled at the last moment, Juno cleverly asks of Jupiter the gift of the heifer.

JUNO DISCOVERING
JUPITER WITH IO
1618, oil on wood,
21 x 31 in (54 x 78 cm),
National Gallery, London

WHAT MAKES LASTMAN'S *picture so arresting is its composition; here is narrative made palpable. Granted, we need to know the story, but when we do, we find here irony, mischief, comedy, and tragedy, and essentially, conflict between wife and husband, with the innocent victim in the middle.*

ABRAHAM ON THE WAY TO CANAAN
1614, oil on canvas, 28 x 48 in (72 x 122 cm), Hermitage, St Petersburg

Abraham, we read in the Bible, was a respected citizen of the Mesopotamian town of Ur. He was called by God to leave everything behind and set off, in trust, to the Promised Land. Lastman typically seizes on the moment of drama, as Abraham, about to set out on his journey, commits the enterprise to God. His less enlightened wife and servants reel in astonishment from the divine call. But perhaps the most arresting figure in this picture is the goat on the far right.

LA TOUR, GEORGES DE 1593-1652 b. France
JOB AND HIS WIFE

JOB WAS THE GREAT SUFFERER ON WHOM God heaped affliction after affliction. Here he is, having lost wealth, health, and family, sitting in naked misery with broken pieces of pot by his feet, with which to scrape his repulsive boils. His wife, unfortunately, feels he is completely to blame for all these disasters. She has sought him out, monumental in her righteousness (clearly some of the Job family income has remained under the wife's name), to reproach him for not acknowledging to God that he has brought his evils on himself. Job's whole position was that he had not, and that righteousness demanded he suffer disaster without reproaching God or falsely assuming blame. What La Tour shows us is husband and wife irrevocably sundered by different theologies. Job's wife only wants what will work, what will bring them back to their former state of comfort. She holds the candle, the light shines up over her great swelling robe and the blazing white of her kerchief. Job believes in being truthful to his own experience, which does not involve acknowledging false guilt. He looks up at his wife, miles away, in disbelief, his mouth a gaping hole of astonishment, the great cloud of his beard jutting out in wordless denial of her voluble accusations.

> "ARE YOU STILL TRYING TO MAINTAIN YOUR INTEGRITY? CURSE GOD, AND DIE"
>
> Book of Job 2:8

JOB AND HIS WIFE
1632–35, oil on canvas,
57 x 38 in (145 x 97 cm),
Musée Departmental des
Vosges, France

LA TOUR WAS ARTISTICALLY *enraptured by the effects of candlelight, and the theatrical contrast of light and dark that it created. This enduring fascination brought him great success in his day. However, he was completely forgotten after his death, only to be rediscovered in our own day. It is hard to believe that an image as extraordinary as Job and His Wife should ever have disappeared from view, but La Tour is an astonishing example of how artists can pass in and out of favor.*

THE NEWBORN
c.1645, oil on canvas, 30 x 36 in
(76 x 91 cm), Musée des Beaux-Arts, Rennes, France

La Tour is one of the few artists who seem really to have looked at a baby face without the idealizing we find in so much Italian art. He gives us this most convincing and real picture of an infant, with its little pudge of a nose, its gaping mouth and lack of chin. Although we instinctively see this as a picture of the infant Christ and Mary His mother, its title is simply *The Newborn*; and perhaps La Tour is saying every child is Christ and every mother is Mary. The older woman directs the candle towards the swaddled child and the wondering joy of the new mother. Fittingly, behind is simply darkness, because this is a symbolic picture, set in the mystery of giving birth and cherishing new life.

LA TOUR, MAURICE-QUENTIN DE

1704–88
b. France

MME DE POMPADOUR

MAURICE-QUENTIN DE LA TOUR WAS BORN at the beginning of the 18th century and had the good fortune to die one year before the French Revolution. He would not have felt at home in the world of liberty, fraternity, and equality. La Tour was essentially a man of the aristocracy, and no one rendered better the intellectual charm of the king's mistress, Madame de Pompadour. She dominated the court, not only by her physical appeal, which the king was to outgrow, but by the strength of her personality, the depth of her learning, and the genuine versatility of her artistic leanings. Here, La Tour has overcome the temptation of all who use pastel to smudge the deep, rich, emphatic colors. Her dress is a triumph of understated magnificence, and she sits in her boudoir, not seductively enthroned, but busy at her intellectual pursuits – music in her hands, literary tomes on the desk, and a working portfolio of prints at her feet.

SELF-PORTRAIT
*c.1751, pastel on paper, 22 x 18 in (56 x 45 cm),
Musée Picardie, Amiens, France*

La Tour uses pastel with such exquisite control that it can come almost as a shock to see his self-portrait. Here is no great gentleman, but a grimy craftsman, grinning happily out at us in the undress of his working uniform. He wears no wig or cravat, and seems to possess no pretensions, or harbor any secret agenda. Here is a man at ease with himself, happily working with his chalks. He is unpressured by any need except that which comes from his own desire to work at the height of his ability.

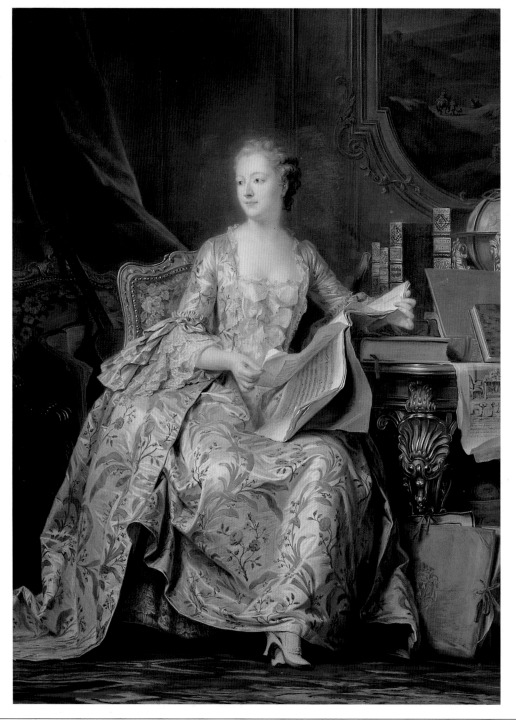

ONLY THAT SMALL, *fastidious shoe peeping out of that wonderful skirt indicates that this lady's success also lies in physical appeal. La Tour seems to imagine Madame de Pompadour looking up to welcome her king, as he comes to share with her the delights, not of dalliance, but of thought. We intuit that her role as the king's mistress, partaking in this communion of spirit, is a duty she carries out with equanimity for the country's benefit.*

MADAME DE POMPADOUR
*1755, pastel on paper, 70 x 51½ in
(178 x 131 cm), Musée du Louvre, Paris*

LAWRENCE, SIR THOMAS 1769–1830 b. England
ELIZABETH FARREN

LAWRENCE WAS AN INFANT PRODIGY and, at the age of 20, was summoned to London to paint the highly unappealing features of Queen Charlotte. Here, barely 21, he rejoices in the fragile beauty of the actress Elizabeth Farren. Her face, pink and beguiling, peeps out at us, framed by the soft fur of the collar and the ruffled mass of her hair, which is fashionably powdered to a delicate gray. Behind her stretches the summer beauty of an English meadow, and she is silhouetted not just against the trees, but against a great expanse of sky, where the blue is riven with little streaks of white cloud. It is an enchanting "come hither" portrait, both seductive and dignified – a society picture that had implications of depth, which Lawrence could do with such apparent ease.

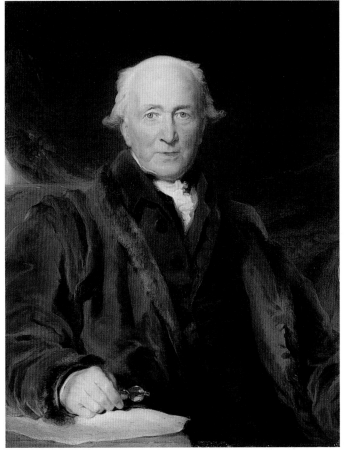

SIR JOHN JULIUS ANGERSTEIN
c.1823–28, oil on canvas, 36 x 28 in (91 x 71 cm),
National Gallery, London

Lawrence had painted the young Angerstein when the great banker and art collector was just beginning his life in Britain. Here is Angerstein over 20 years later. Lawrence shows us a face that is old, weighty, experienced, and wise. Angerstein has lived to fulfil all the promise of his youth, but he remains alert and dignified, gazing back at the artist with bright eye and tense posture. Lawrence is so often thought of merely as a society painter – a pleaser – but here we see how he can rise to the challenge of a truly powerful personality.

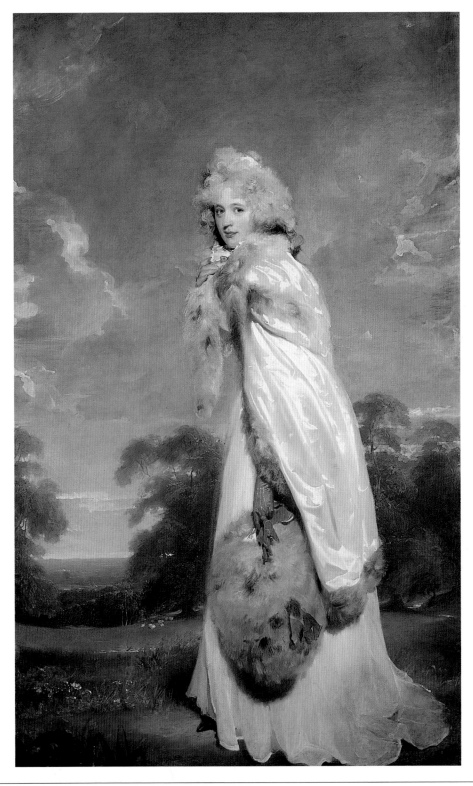

ONE CAN SEE *that Lawrence is obviously delighting in showing what he can do. His brush lingers lovingly over the exquisite glitter of Elizabeth's silver cloak, over the thick and luscious fur with which it is decorated, and over the muff, which she holds in one elegantly gloved hand. He is playing with small and subtle contrasts, between silver, gray, and the most delicate of browns.*

WHEN THIS PORTRAIT *was painted, Elizabeth Farren was still a much-admired actress on the London stage. All the vivacity and dramatic impulse of an actor is matched here by the young Lawrence – who clearly is excited by his own brilliance and eager to dazzle his own audience. Elizabeth Farren was later to marry the twelfth Earl of Derby, which marked the end of her theatrical life.*

ELIZABETH FARREN
1790, oil on canvas, 94 x 57 in (239 x 146 cm),
Metropolitan Museum of Art, New York

LEBRUN, CHARLES 1619–90 b. France
THE CHANCELLOR SÉGUIER

WHILE NOT A POLITICAL PAINTER, Lebrun understood politics. He was an obedient servant of the French crown in its efforts to publicize the exquisite civilization that France felt was peculiar to their nation. Here, Lebrun celebrates his first patron, the Chancellor Séguier. It is a marvellous picture, both for what it states and for what it suggests. To us, it can only seem ambivalent. Here is a Chancellor complacently beaming down at us from his splendid horse and expecting only reverential awe from all who behold him. He is clad in the most expensive cloth of gold – as is his horse – and shielded from the sun by those ridiculous umbrellas. Usually, the attention of contemporary viewers fastens on that host of beautiful young men, curvaceous adolescents, who step around him, proudly aware of their importance and clad with a costly exuberance that modern taste must decide is over-the-top.

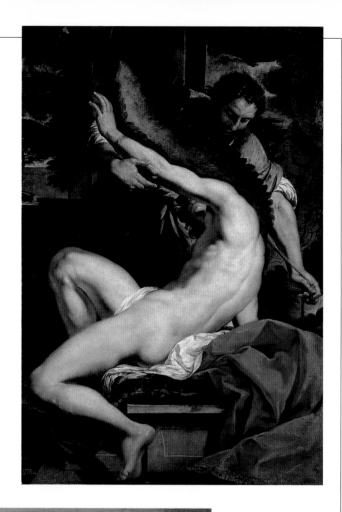

DAEDALUS AND ICARUS
1642–46, oil on canvas, 75 x 49 in (190 x 124 cm), Hermitage, St Petersburg

Daedalus and Icarus is a great mythical tragedy. The son, Icarus, insisted that his inventor father should strap on his arms the wings of flight. Although Daedalus feared the foolhardiness of his son, he agreed. But Icarus disobeyed his father's instructions and flew too near the sun; the wax holding his wings together melted, and the boy plunged into the sea and was drowned. Lebrun shows us this useless ambition and reveals the tragedy in the making.

ONE WONDERS *why the chancellor feels it necessary to parade this endless circle of overdressed young men. Those severe and lovely faces, so haughty, so aware of their own importance, clearly relate in some way to the elderly celebrity who rides gloriously above them.*

WE ARE *involved in the enigma of what Lebrun thought he was actually painting. Is this a coded picture? Are there homosexual implications? Or is it simply what the conservative mind would expect – lord and pages, with little contact between them, except for the éclat of their presence.*

THE CHANCELLOR SÉGUIER, *1660–61, oil on canvas, 116 x 138 in (295 x 351 cm), Musée du Louvre, Paris*

LÉGER, FERNAND 1881–1955 b. France
THE WEDDING

THIS IS AN EXTRAORDINARY PAINTING. It is obviously heavily influenced by Cubism, but this is Léger's own personal version, which was described sarcastically as "Tubism" since he tends to fracture reality into curves as well as straight lines. It takes some time to realize the intense physicality of this painting. There is, of course, a considerable element of the abstract, but Léger's concern for volume, for solid forms, can be seen in the unifying image of the naked body of the bride, which permeates the entire canvas. It spreads out – breasts, buttocks, thighs – in pale splendor from the top to the bottom of the canvas with outlying body parts on the sides as well. Around and through this naked bride swirl the guests who have come to celebrate the wedding. Their faces and bodies have been dislocated and fragmented as if by the excitement of the occasion, and the whole celebration is glimpsed – as it is in actuality – through flashes and passing experiences. Léger spells out nothing. Is the man at the lower left striding in imagination towards the confirmation of his marriage, or is the groom already in position beside his bride, standing straight-legged and angular in his formal suit, as concealed and contained as she is naked and diverse.

FLÉGER

THE TWO SISTERS
1935, oil on canvas, 25 x 18 in (64 x 45 cm),
Staatliche Museum, Berlin

Léger said that it was World War I that taught him fully to be an artist. It showed him the strength of the common man and the strange magic of efficient machinery. These sisters are, in a sense, robotic, yet that is in no sense a denigration. By seeing them without color, without fleshly vulnerability, Léger is able to emphasize their dignity, and the fact that there are two of such giant stature generalizes his admiration for the majesty of womanhood. Even the flower has an air of the mechanical, seen by Léger as a triumph of material animation, and never, despite the lack of color, as something dead or inferior.

SOME IMAGES ARE SHARPER *than others. For instance, the little town where celebrations are taking place is very visible, tucked between the angular forms of the groom and the soft, fleshly pale area of the canvas. Are those shapes trees by a church on the middle right or are they bottles ready for pouring? It would be a mistake to try to make logical sense of every figure and form.*

LÉGER DELIBERATELY SWIRLS *his images, creating an ambience of white body and celebrating guests almost to commemorate the essence of an early 20th-century wedding. The central face of the bride, partially obscured by wine glasses, has a dazed look that may sum up Léger's intention to portray the passing from virginity into sexual fulfilment.*

THE WEDDING, *1912, oil on canvas, 101 x 81 in (257 x 206 cm), Musée National d'Art Moderne, Paris*

LEIBL, WILHELM 1844–1900 b. Germany
THREE WOMEN IN CHURCH

IT IS DISCONCERTING TO LEARN THAT LEIBL, now the most revered of 19th-century German artists, was disregarded in his lifetime and, in his late twenties, left Munich to live in remote Bavarian villages. The quiet strength of *Three Women in Church* seems quintessentially Nordic. Leibl has painted each character with an intensity of detail that would make them overbearingly real were it not for the distancing effect of the cruel light. Each woman is distinct in herself and in her attitude towards God. Do we admire more the complexity of the portraiture or the superb distancing of the artist from over-involvement in the human characteristics of the sitters? This is a work of such dignity that we can only view it with a certain humility.

DER SPARGROSCHEN
1879, oil on wood, 15 x 12 in (39 x 31 cm),
Von der Heydt-Museum, Wuppertal, Germany

Once again, I find myself struck by the extraordinary dispassion of Leibl's view – his ability to reveal, without emotional involvement. The title is difficult to translate. It means something like "spare change" or "the nest-egg", and refers to the custom among the poor of saving the smallest of coins and tucking them away for safekeeping until need arises. The husband is intent on this lowly task, so unimportant in absolute terms, but so important for them relatively. The wife stands beside him, hand on hip, with an air of modest triumph, as if the coins he tucks away with a slight, satisfied smile have been painfully gained by her toil.

THE WOMAN IN LATE *middle-age to the left is starkly profiled against a white wall. Leibl notices the fine bones of her face, worn with toil. The old woman in the center is bent over her Bible. Clearly her eyes have dimmed, and, for her, prayer is not a personal encounter with her divinity, but a reverent reading of His word. Leibl traces the creases of the face and the flow of stripes that delineate the small, cramped body.*

IN REFRESHING CONTRAST *on the right is a beautiful young woman, dressed in her Sunday finery – exquisitely embroidered linen, rich, blue plaid, and the white pleats of a peasant apron. Yet Leibl does not idealize: she has the huge hands of the peasant and her face, under the extraordinary brim of that traditional hat, is gaunt, for all its freshness.*

THREE WOMEN IN CHURCH
1881, oil on wood, 44 x 30 in (113 x 77 cm), Hamburger Kunsthalle, Hamburg

LEIGHTON, FREDERIC, LORD

1830–96
b. England

CIMABUE'S MADONNA

LORD FREDERIC LEIGHTON WAS THE GRAND OLD MASTER of the Victorian era, and it was this picture, which he painted in his early twenties, that set him on the road to fame and fortune. Both Queen Victoria and her consort Prince Albert hailed the painting as the masterpiece of the century. In his famous book, *Lives of the Artists*, Giorgio Vasari – the first art historian – tells how the first artist to be famous, in our modern sense, painted a Madonna that was carried through the streets of Florence, with its creator, Cimabue, walking in the center and his pupil Giotto behind him. The great procession is filled with dignitaries: Dante is there, so too is the King of Naples; Leighton went to enormous trouble to get the costumes right, and to convey the sense of the city as it gloried in this great masterpiece. This was precisely the civilized and cultured approach to the creative arts that Prince Albert wished to see flourish in his new country.

FLAMING JUNE
c.1895, oil on canvas, 48 x 48 in (121 x 121 cm), Museum of Art, Ponce, Puerto Rico

Flaming June, painted a year before he died, is Leighton's absolute masterpiece. In itself, the work is very simple. A young woman, in a gown of diaphanous orange, is curled up asleep on a balustrade, with a silver sea behind her. Those who regard Leighton as merely a Salon painter are here forced to regard him as capable of creating an icon that appeals to something deep within us. Here is a sensuous being, relaxed, innocent, chromatically glorious, and evocative.

CIMABUE'S MADONNA CARRIED IN PROCESSION THROUGH THE STREETS OF FLORENCE
1853–55, oil on canvas, 87 x 205 in (222 x 521 cm), National Gallery, London

THE SMALL BRIGHT FIGURES *are individualized, and convincing, and although in retrospect we might judge this primarily as an example of illustrative art, it is a glorious example. It is 13th-century Florence seen through the eyes of 19th-century Englishman.*

THE PROCESSION IS *moving through the streets on the way from Cimabue's house to the Church of Santa Maria Novella. Many of the Victorians who admired this work had passed along that street themselves, and this vision of the past stirred their imaginations.*

IT IS A VIVID, ENTERTAINING *procession and Leighton draws us in with infectious enthusiasm into the imaginary life of that faraway Renaissance. It is romanticized, the past seen only as beautiful and shapely, but Leighton carries it off in grand style.*

LELY, SIR PETER 1618–80 b. Netherlands, active England

BARBARA VILLIERS, DUCHESS OF CLEVELAND

CHARLES II WAS A NOTORIOUS HUNTER of attractive women and his Royal Court was well stocked with renowned beauties. Not having access to the modern-day fashion photographer, the women were recorded by portrait painters such as Lely. This is not to suggest that Lely was a trivial artist. He rose superbly to the challenge, as we can see in this portrait of the Duchess of Cleveland. The Duchess held the King's affections for longer than any of his other mistresses. She was a voluptuous, enticing brunette, witty, amoral, and a delightful companion in his all-too-frequent moments of abandon.

TWO LADIES OF THE LAKE FAMILY
c.1660, oil on canvas, 50 x 71 in (127 x 181 cm),
Tate Gallery, London

Lely's peculiar gift lay in painting all great ladies as if they had the capacity to kick over the traces. These two ladies of the Lake family may well be wholly respectable but still they show an enticing amount of bosom, gaze at us alluringly, and let ringlets of hair trail seductively to draw attention to their rosy bosoms. However, the silks, the curls, the pretty hands, and the "come-hither" glances are not overplayed. Set against a dark landscape, the ladies' appearance becomes almost poignant, reminding us that not all of life is silken.

LELY PLAYS *deliciously on the notoriety of the Duchess's misconduct by presenting her in the guise of a saint. While the broken wheel of St Catherine lurks inconspicuously in the background, the Duchess holds the executioner's sword in one hand and the palm of martyrdom in the other – neatly between the two, a shameless bosom peeps out.*

THE FULL, FLESHY *attractions of the Duchess are unmistakable, and yet we feel that she is not merely a kept woman but has style to go with her pretensions. Samuel Pepys, the famous diarist, wrote once that he had sat before her, "and filled my eyes with her, which much pleased me." Lely's portrayal of the woman enables us to understand the diarist's enthusiasm.*

BARBARA VILLIERS, DUCHESS OF CLEVELAND
c.1665, oil on canvas, 50 x 38 in (126 x 101 cm), Collection of the Earl of Bathurst

LE NAIN, ANTOINE (c.1600–1648), LOUIS (c.1600–1648), AND MATHIEU (c.1607–77) b. France

A LANDSCAPE WITH PEASANTS

THE THREE LE NAIN BROTHERS, between whose work it is nearly impossible to distinguish, are the great painters of the 17th-century peasant. This painting haunts us with a sense of ambiguity. It is clear enough that the artist has painted the wide and flat French countryside that abuts Belgium; he has caught exactly the feel of the wintry sky and the low light slanting across the fields. But what are the three young peasants doing? One looks at us smiling, one dourly contemplates on his pipe, and the little girl stands with stolid incomprehension beside what must surely be her big brother. To the side, an old woman – perhaps their grandmother – sits on a chair that seems to have appeared from nowhere, and in the background another youth walks by with an air of purpose. The building also is enigmatic in the context of a landscape with peasants. It may make agricultural sense, but, for the non-historical eye, that strange stone structure, with its great pillar and its dovecote roof, has a strange allure. The artist gives a sense of a countryside with its own secret business.

A WOMAN AND FIVE CHILDREN
1642, oil on copper, 10 x 13 in (26 x 32 cm), National Gallery, London

Here, in contrast to the landscape, there is no ambiguity. This group is clearly posing. What gives this picture an uneasy edge is that the woman seems dwarfish in relation to the children. Significantly, it is not a "mother" and her five children but a "woman", and the children seem to have only the most tenuous relationship to her, as she sits squat and impassive in their midst. The children, however, are physical and real. Even their suspicion of the artist means that they present themselves completely without expression and in poses stiff with the importance of the moment.

L
263

IT IS DIFFICULT *to come to conclusions about this painting and so we remain engrossed. We try to find a series of events for this scene. Are we meant to assume that the two musicians are playing for a passer-by? Are they playing for the viewer or are they merely posing for the painter? Each position can be argued and none can be proved.*

IT IS NOT *that we are given insight into the lives of the peasants as that we are shown a life that is beyond our understanding. The children may pose, but we do not comprehend their background or their future. It is this lack of the easy label that makes the work of the Le Nains of abiding interest.*

A LANDSCAPE WITH PEASANTS
c.1640, oil on canvas, 19 x 22 in (47 x 57 cm), National Gallery of Art, Washington, DC

LEONARDO DA VINCI 1452–1519 b. Italy
VIRGIN OF THE ROCKS

PERHAPS THE MOST PAINTED THEME IN ART IS MARY and her Child, frequently with St John the Baptist and an attendant angel. It is a theme that Leonardo worked with many times, including a recreation of this very composition some twenty-five years later. In this instance, the characters have been made almost translucent, endowing them with a sublime bearing. The very setting removes them from our own world; in this place of strange, primeval rocks, stretching back as if to the beginning of time, the group appears perched on a rocky ledge, as if oblivious to discomfort, let alone danger. Silvery foliage and flowers surround them, in themselves magical and with an other-worldly presence. It is perhaps the extraordinary hair, with its glimmering ripples, that links these personages to a world that is closer to our own; even the babies have a riot of curls that is as enchanting as any of the flowers that festoon the hard rock. Rock and flowers, intimacy and distance, gestures that are so meaningful and yet so hard to understand – one can never come to the bottom or to the end of the potential meaning of this outstanding painting, which could, indeed, be regarded as a definition of great art.

> " …A PAINTER CAN ONLY BE PRAISED IF HE IS UNIVERSAL "
> Leonardo

THE PICTURE IS DOMINATED *by hands: Mary's, outstretched and in blessing over the head of her Son; the angel's pointing with enigmatic directness towards little St John (who here may be our representative); and those of the small Jesus, His fingers lifted in blessing. John's clasped hands on the other side seem almost anticlimactic – he is the passive recipient. It is Mary, the angel, and Christ who initiate the mysterious and redemptive action.*

MARY'S HAND SEEMS TO BE *blessing of its own accord, while the angel – the most exquisite of creatures billowing in scarlet and green – looks from under hooded eyes while her hand rises, again of some mysterious volition, and points the way. Only the little Jesus seems to concentrate on what He is actually doing, and yet His is the most serious and sorrowful face of the four. Both the angel and Mary have that faint secret smile so typical of Leonardo.*

VIRGIN OF THE ROCKS
c.1483, oil on canvas, 78 x 48 in (199 x 122 cm), Musée du Louvre, Paris

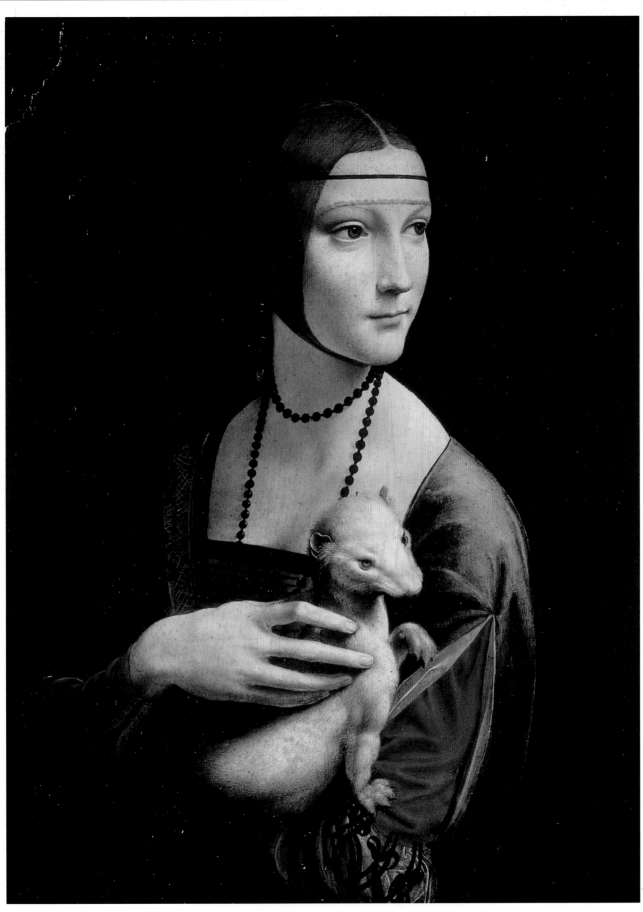

THE LADY WITH AN ERMINE

c.1483, oil on walnut wood, 21½ x 16 in (55 x 40 cm), Czartorysky Museum, Cracow

Leonardo had a peculiar genius for dealing with the enigmatic young woman. Cecilia Gallerani was said to be mistress to the Duke of Milan, but nothing in that tight pale face, outlined against the stark black background, suggests the voluptuousness associated with such a role. Cecilia was, in fact, a noted intellectual, and one gets every impression here that she is fully aware of her worth. Perhaps the most daring stroke is to link her with the ermine, whose body twists sensuously round her; yet the emphatic straight lines at her breast and brow, and that of her mouth, convey to us little but austerity.

LEYSTER, JUDITH 1609–60 b. Netherlands

A BOY AND A GIRL WITH A CAT AND AN EEL

ALTHOUGH IT IS IMPOSSIBLE TO DEDUCE FROM A WORK OF ART the gender of the artist, it is tempting, all the same, to think that it is because Judith Leyster is a woman that she has such understanding of the ways of children. This is a baffling picture, in that something is clearly going on. Both children are lit up with the excitement of some secret that they are sharing with the adult onlooker. The little boy's eyes twinkle mischievously and the little girl cackles to herself, tugging on the tail of the long-suffering cat. She wags her finger at us as if, smilingly, to admonish the folly of the adult. Surely the artist expects us to be conversant with the code, but we are not; the little girl and the boy know better. The boy is holding up an eel, which may refer to the Dutch proverbs about holding an eel by the tail or being happy as an eel, both of which refer to the notorious uncontrollability of this wriggling creature. The child seems to enjoy the feel of the eel, writhing between his fingers, and chuckles.

MAN OFFERING A WOMAN MONEY
1631, oil on wood, 12 x 9 in (31 x 24 cm), Mauritshuis Museum, The Hague

The title of this painting indicates a seduction scene, and certainly the man is a would-be Don Juan. His body language says it all – one hand resting gently on the woman's arm, the other hand offering money (which in itself might well have been welcome). The woman, however, seems a most unlikely candidate for seduction, with her high blouse and the rigidly controlled hair of the virtuous; it is with an almost painful intensity that she concentrates on her needlework. The girl, plain, embarrassed, and earnest, wants only to have done with him. She resolutely ignores his proposition.

THE FUNCTION *of the cat is even more mysterious than that of the eel. It holds its paws braced for flight but the child is holding it very firmly, quite apart from his little sister's grip on the tail. One can only presume that this is the household pet, forcibly inducted into the comic drama that is being played out so delightedly before us.*

IT IS THE ANIMATION *of the faces that makes this picture so memorable – the delightful simplicity with which they appeal to the viewer, the upturned eyes suggesting a big person looming over them who is yet accepted wholly into the foibles of whatever game is being played. Leyster employs light and shadow with a cunning that reminds one of Caravaggio.*

A BOY AND A GIRL WITH A CAT AND AN EEL, *c.1635, oil on wood, 23 x 19 in (59 x 49 cm), National Gallery, London*

LICHTENSTEIN, ROY 1923–98 b. US

M-MAYBE (A GIRL'S PICTURE)

THE GREAT REALIZATION OF THE POP ARTISTS that has transformed late 20th-century art is that even the vulgarities of our culture have their own beauty. Artists have no need to flee into ivory towers but can find engrossing images on the streets and in the supermarket. What stimulated Lichtenstein was the work of the comic book, that form of art familiar to everyone and yet unconsciously despised. He took the comic book images and blew them up to an enormous size, reworking them so that their appeal was treated and regarded with respect. There is also, of course, the saving grace of irony. But he is, most emphatically, not mocking. For all its deliberate unreality, this remains a haunting image. Lichtenstein does not pretend to show us a real woman but rather the idea of a real woman mediated through the comic book and then passed through the further medium of an ironic modern artist. It is an image that still manages to maintain its power.

YELLOW AND GREEN BRUSHSTROKES
1966, acrylic on canvas, 108 x 182 in (274 x 462 cm), Museum für Moderne Kunst, Frankfurt

Lichtenstein also turned his attention to the art against which he had reacted – the wild, free brushstrokes of the Abstract Expressionists. Here, he deliberately seems to hold up to mockery the deeply personal and, to him, self indulgent nature of this art. Calmly, deliberately, wittily he copies a typical brushstroke of past artists, who he said he actually admired.

THE DISTINCTIVE DOTS – *a characteristic of the printing technique used in the production of comic books (and which would be almost invisible in the original comic) – are preserved by the artist, but only in carefully selected areas: the girl's face, parts of the background, and the window curtain. The rest is flat, solid color, striking in its power and forcing us to examine the painting with critical attention. It is hard to see how the girl relates to the actual space. Her body seems to diminish beyond the ideal oval of her face and the perfect Cupid bow of her lips.*

FAITHFUL TO THE *comic book ethos, Lichtenstein provides us with a narrative line. The girl is distressed; she is pondering over the absence of her hero and, more than likely, making excuses. But the hero here is the artist, who is unable to leave the studio. The attitude of codified despair and the general air of abandonment suggest the traditional role of the frail woman, dependent on the might and salvation of the absent hero-artist.*

M-MAYBE (A GIRL'S PICTURE), *1965, Magma on canvas, 60 x 60 in (152 x 152 cm), Museum Ludwig, Cologne, Germany*

LIEVENS, JAN 1607–74 b. Netherlands

PORTRAIT OF THE ARTIST'S MOTHER

JAN LIEVENS WAS AN ALMOST EXACT CONTEMPORARY of Rembrandt. They had the same teacher, Lastman, and they both were recognized as precocious talents. Informed opinion considered them equally gifted, with perhaps Lievens just a touch ahead. Yet Rembrandt was to go on to become one of the world's greatest artists, and Lievens, despite all his gifts, remains in relative obscurity. The unfairness of this can be proved by this so-called *Portrait of the Artist's Mother.* It seems that this was an elderly model who sat for both Lievens and Rembrandt, and this picture was previously thought to be one of Rembrandt's masterpieces. When attributed to Rembrandt, it was praised and much visited, but since being demoted to a *mere* Lievens, it has been relatively neglected. Yet it remains a splendid picture of an old lady concentrating on her Bible, pince-nez firmly fixed, and her wrinkled face alight with the pleasure of reading the Word of God. We are spectators but not voyeurs, for Lievens involves us in the scene.

OLD MAN IN ORIENTAL GARB
c.1628–30, oil on canvas, 53 x 40 in (135 x 101 cm),
Stiftung Preußische Schlösser und Gärten, Berlin

Ironically, all the best works by Lievens have been snaffled by museums claiming them as Rembrandt's. The critic Constantin Huygens, who first acclaimed these two young men, recorded that this work was by Lievens, and yet for a long time the museum that owned it proudly labelled it as a Rembrandt. That glorious feather reiterating the man's arrogance, as he clasps his belt and extrudes a majestic chest and belly, does indeed remind us of the splendor of Rembrandt, as does his skill at indicating temperament. But this skill is obviously enjoyed in equal measure by Lievens and shows to what heights he could reach, even in his twenties.

L
268

IN THIS PORTRAIT, *we encounter not just the reality of old age but a specific old person, fully aware of the pleasures of life, even though those pleasures are now confined to the pages of a holy book. Lievens, like Rembrandt, understood the uniqueness of personality and the drama of an individual's encounter with the great things of life.*

THE LIGHT HERE *is mainly concentrated on the pages of the book – a symbolic recognition of the Word of God as light. But the light is more than symbolic – it gleams on the pince-nez, sparkles on the tassel, glows faintly on the wall, and glitters on the turban. Light unifies the picture and balances it.*

PORTRAIT OF THE ARTIST'S MOTHER, *1629, oil on canvas, 30 x 25 in (76 x 64 cm), Wilton House, Salisbury, UK*

LIMBOURG BROTHERS
active 1399–1416 b. Belgium
THE ZODIAC MAN

THE MOST FAMOUS ART COLLECTOR of the Middle Ages was the Duc de Berry, and he employed the most famous book illuminators, the Limbourg brothers, to create the *Très Riches Heures du Duc de Berry*. The brothers – Paul, Jean, and Herman – all died suddenly in the same year, leaving unfinished their greatest work. They had done enough, however, to show us that this is a medieval masterpiece. This page, known as *The Zodiac Man*, introduces the calendar, which every Book of Hours set at the beginning so that the dates of various feasts could be assessed correctly. However, the Limbourgs take this further than a mere list of dates. Around the great mandorla are painted the twelve signs of the zodiac. In the center, they have painted a man, beautiful and young, seen both coming and going, as is appropriate for a calendar. They have set him in the context of eternity, amidst a sky that is changing from the blue of summer to the pallor of winter, with strange clouds scudding endlessly from top to bottom. The body is marked with the signs that were believed to dominate the various areas. For us it may merely be an image of immense charm, but to the medieval mind it meant much more.

TRÈS RICHES HEURES DU DUC DE BERRY (FEBRUARY)
1413–16, illumination on vellum, 14 x 8 in (29 x 21 cm, page size), Musée Condé, Chantilly, France

The Limbourgs provided a picture for each calendar month, above which was painted the sign from the zodiac that accorded with that part of the year. Here is a small Bergundian village in the month of February. One farm is laid open to our inspection. The lady owner sits in state before the fire, warming her legs, and the peasants sit in another area, warming a more extensive area of their anatomy. Seldom has the deep chill of winter, with both its delights and its inconveniences, been more strikingly conveyed.

IT WAS BELIEVED THAT *the Ram controlled the head; Taurus affected the neck and upper shoulders; the Twins of Gemini – here shown delightfully peeking out at each other – dominated the arms; Cancer affected the lungs; strong, brave Leo the heart; and Virgo the liver, considered the seat of love. The Scales were connected with digestion and the bowels.*

SCORPIO WAS CONNECTED *with the genital organs; Sagittarius shot his arrows from the upper leg; Capricorn was associated with the knees (perhaps because the amount of praying in the Middle Ages meant knees often became shell-hard); Aquarius was in liquid flow in the lower legs, and the Two Fish supported the feet.*

TRÈS RICHES HEURES DU DUC DE BERRY (THE ZODIAC MAN), *1413–16, illumination on vellum, 11 x 8 in (29 x 21 cm, page size), Musée Condé, Chantilly, France*

LINDISFARNE GOSPELS c.698 England
CARPET PAGE

THE *LINDISFARNE GOSPELS* ARE ALMOST CERTAINLY NORTHUMBRIAN. We know their approximate date – the end of the seventh century – and it is even possible that we can identify the artist who created this magnificent work as Eadfrith, the then Bishop of Lindisfarne. But even if created on British soil under the auspices of a bishop with an Anglo-Saxon name, this is still fundamentally a Celtic work. This great book has six pages wholly devoted to a most extraordinary form of art, one in which abstract patterns are traced with extreme complexity around some central and unifying theme. Incorporated within the fabric of the patternings on this page are dragons and serpents. This is called the *Carpet Page*, and it is obvious that the central theme is that of the Cross. But this is a cross and not a crucifix – there is no Christ here and no hint of suffering nor suggestion of bodily involvement at all. It is a magnificent abstract design, worked out with a mathematical perfection that staggers the imagination.

THE LINDISFARNE GOSPELS (INCIPIT PAGE, ST MATTHEW'S GOSPEL)
c.698, illuminated manuscript, 13 x 9 in (34 x 24 cm, page size), British Library, London

This is the opening page of St Matthew's Gospel. On and around the Greek letters, the illuminator has created elaborate patterns that would have been difficult for the medieval eye to read. In fact, we take it for granted that the meaning of the words would have been memorized and that what is set before the viewer is a play around the shapes of the letters. A later reader, doubtless with the highest of intentions, has written in the meanings, brutalizing the glory of this work of art and yet reminding us of its original purpose.

AT NO MOMENT *is the work still, and yet – as pattern writhes into pattern, twisting and turning in complex gyrations – at no moment is the work out of control. Like a great symphony, every part is organized and orchestrated with incredible skill and power of invention, showing honor to the god of complexity.*

A LATE MEDIEVAL *cleric described the Book of Kells as the work "not of men, but of angels". He would have said the same of this Celtic masterpiece, where the precision and extraordinary formal perfection of the interlace is almost incomprehensible. These artists worked without the use of magnifying glasses, and it is no wonder that many scribes lost their sight in this glorious enterprise.*

THE LINDISFARNE GOSPELS (CARPET PAGE)
c.698, illuminated manuscript, 13 x 9 in (34 x 24 cm, page size), British Library, London

LIOTARD, JEAN-ÉTIENNE 1702–89 b. Switzerland
THE CHOCOLATE POT

FOR MOST OF US, PASTEL RECALLS the smudgy richness of Degas, but it is a medium that can be put to a very different use. Liotard is a supreme master of the pastel and here, in the almost incredible precision of *The Chocolate Pot*, we can see the subtleties that this medium can accommodate. Everything about this picture carries realistic conviction. The girl's intent face is matched by her body language, as she carries with great care the small tray, with its precious pot of chocolate. This was, we remember, a rare and expensive delicacy, taken with a glass of water to dilute its bitter richness. From the pink silk of her exquisite cap, ribboned with blue and trimmed with lace, down to the simplicity of her apron (with its bodice and full skirt) and small high-heeled shoes, the neat little body of the maid is a perfect example of Rococo beauty, convincingly real in her shapely solidity.

SELF-PORTRAIT WITH BEARD
*1749, pastel on paper, 38 x 36 in (97 x 91 cm),
Musée d'Art et d'Histoire, Geneva*

Liotard seems to have been an eccentric. During his time in Constantinople, he was so overwhelmed by Turkish culture that he could not lay it aside when he returned, hence, the great beard and exotic clothes for which he became notorious. He offers us, not just a self-portrait, but a *Self-Portrait with Beard*, just to make it clear that he is no common man. But it is the face and its nervous vitality that holds us, the eyes in darkness, contrasted by highlights on the forehead and flowing hair. The red lower lip is very visible above the curly cascade of the beard, and the artistic hand is poised delicately in the air.

THE CHARM OF THE IMAGE *does not reside merely in the maid's good looks and comely form, nor does it dwell in the astonishing precision with which each detail of the simple scene is set before us. It is the combination that is so impressive – it brings us to an understanding of the times, makes us aware of what it meant to order such a drink and have it brought on a small tray by a maid.*

SHE IS SO CHARMING, *this little visitant from the 18th century. We can feel almost tangibly the creased linen of her apron and the smooth enamelled porcelain of the pot in its container. So convincing is she, that we too are persuaded to share her calm and simple world, in which a pot of chocolate is a great event.*

THE CHOCOLATE POT, *c.1745, pastel on parchment, 32½ x 20½ in (82 x 52 cm), Staatliche Kunstsammlungen, Dresden, Germany*

LIPPI, FILIPPINO c.1457–1504 b. Italy

THE VISION OF ST BERNARD

FILIPPINO LIPPI WAS ONLY TWELVE when his artist father, the ex-monk Filippo Lippi, died. It was the painter Botticelli who took him on as an apprentice and became his mentor. All of Filippino's paintings seem imbued with a tremulous melancholy. He is a great painter, never as solid as his father, nor as ethereal as his teacher, and with an intense lyricism and profound sensitivity that lie somewhere between his two great influences. Here is his first masterwork in which he illustrates the legend of St Bernard, a leading intellectual and religious figure of the Middle Ages. St Bernard was particularly devoted to the Virgin Mary and Filippino shows the Virgin appearing as a vision to the scholarly saint as he tries to describe in a sermon what she means to him. It is a crowded picture, with almost too much extraneous activity: great slabs of rock rear up behind St Bernard, symbols perhaps of his austerity, and in front of him stands a pillar of books, symbolizing his learning. The clear brightness of the Virgin's face is perfectly outlined against the rocks and shimmers with an unmistakable radiance.

THE WOUNDED CENTAUR
c.1500, oil on wood, 31 x 27 in (78 x 69 cm), Christchurch Picture Gallery, Oxford, UK

The centaur has a dubious reputation. By being half-animal and half-man, he could behave with the innate nobility of the horse or the ignobility of humanity at its worst. The most famous and revered centaur in Greek mythology was Chiron who became the star constellation Sagittarius, the Archer (an ironic reference to the arrow that killed him). Here, Chiron is accidentally wounded, yet it is an event he seems unable to comprehend. Central to the understanding of this work is the artist's comment on the nature of accidents, which wound indiscriminately. It is an image of great pathos, of tragedy even, in the sense that no one can avoid the inevitability of fate.

L

272

WHAT REMAINS *unforgettable in this busy composition is the image of St Bernard in his long, white Cistercian robe. He is gazing at the fleeting vision of the Virgin with an ineffable expression that mingles anguish and joy, as he knows that she will not stay. This spiritual world is the world to which he ardently aspires but, at present, he is enmeshed in the manifold responsibilities of everyday life.*

IN THE DISTANCE, *we see the Cistercian monastery where two monks have been alerted to the miraculous event. The picture's donor appears (at the bottom right corner of the frame) and stakes his claim to eternal life by praying to be included in the heavenly event. Crouching in darkness behind the saint, a chained demon peers out at the vision, its eyes wild with despair.*

THE VISION OF ST BERNARD
c.1486, tempera on wood, 83 x 77 in (10 x 195 cm), Badia Fiorentina, Florence

LIPPI, FRA FILIPPO c.1406–69 b. Italy

THE ADORATION WITH THE INFANT BAPTIST AND ST BERNARD

THE SETTING FOR THIS extraordinary painting is a strangely surrealistic forest, and it is as if the praying Virgin – so simple and pure in her intensity as she adores her newborn Child – has called into being the flowered meadow. Directly above the Child, God the Father with hands out in blessing, radiates stars and light, and the dove that symbolizes the Holy Spirit directs rays of divinity down towards the Child, where they explode in jewelled smoke. To one side, amid the fir trees, is St Bernard (patron saint of the Cistercian Order, which probably commissioned this picture). St Bernard is painted as a bust, propped up on the rocks; he has no logical connection with the scene. Beneath St Bernard, a young St John turns his face out of the picture (rather than towards Mary and the Child) as if to confirm that he is only there in spirit.

MADONNA AND CHILD WITH STORIES OF THE LIFE OF ST ANNE

c.1452, tempera on wood, 53 in (135 cm) diameter, Palazzo Pitti, Florence

With astonishing economy, Filippo Lippi creates a tondo, a circular painting, in which he tells the story of St Anne, the mother of Mary. The events are set within the austere splendor of a Renaissance house. In the background St Anne greets her husband Joachim when, in old age, they realize that she is to bear a child. In the middle ground, we witness the birth of that child, Mary. The foreground is dominated by the Mother Mary, to make explicit the meaning of St Anne's life: the birth of her daughter has culminated in this beautiful adult woman, who has now given birth to Jesus.

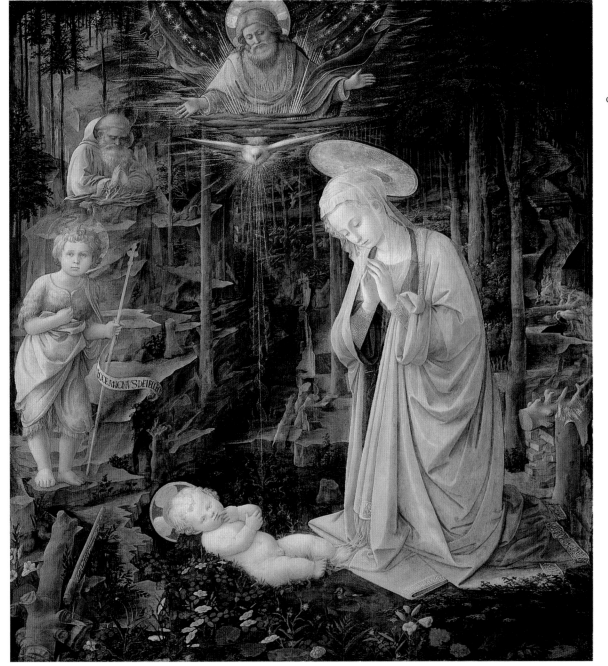

THE VIRGIN *dominates the scene – a tall, slender figure whose blue cloak cascades in folds around her. The Child, like a true baby, sticks a pudgy finger into His mouth as if to wonder at the nature of the flowers among which His mother has lain Him. Amid a pile of chopped wood lies an axe. On the axe handle, Fra Filippo Lippi has inscribed his name as if to claim some of the strange deformations of the craggy landscape as his own invention.*

THE ADORATION WITH THE INFANT BAPTIST AND ST BERNARD
c.1459, tempera on wood, 50 x 46 in (127 x 116 cm), Staatliche Museum, Berlin

LISS, JOHANN c.1597–1631 b. Germany, active Italy

THE DEATH OF CLEOPATRA

THE NEGRO PAGE WHO HOLDS OUT TO THE LIGHT the basket of fruit in which the asp coils its sinuous lengths is the only clear indication that this painting is of the death of Cleopatra. When Egypt was conquered by the Romans, Cleopatra chose suicide rather than face the infamy of captivity, and her chosen method was poison from an asp. Liss shows, not the highly dramatic moment of choice, but the moment when the poison begins to work, and Cleopatra starts to drift insensibly from life to death. She is shown as the only actor in the drama still fully in the sunlight. Both the horrified pageboy and the serving woman are mere spectators, and it seems less a drama of a heroic queen and more that of an isolated woman who is losing her grasp on life. As she drifts away to the coming darkness, she seems to question her choice. It is a deeply tragic picture in all its quietness and lack of pomp. Liss paints the inevitability of death, even while he celebrates, and pauses to reflect upon the beauty of Cleopatra's young body.

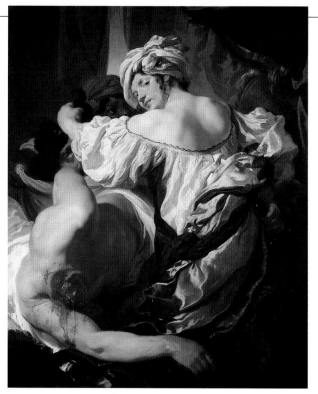

JUDITH IN THE TENT OF HOLOFERNES
c.1622, oil on canvas, 51 x 39 in (129 x 99 cm),
National Gallery, London

What makes Liss's treatment of this subject so spectacular is that he shows Judith from behind. Her splendid, muscular back confronts us in ironic contrast to the still more muscular back of the decapitated Holofernes, whose bleeding neck is thrust unpleasantly in our faces. We look up from this horror to the gleaming triumph of the young woman leaving the scene, holding the head and looking back with an ambiguous expression. Does she triumph? Does she grieve? Or is that merely the implacable look of one who has performed an unpleasant task successfully?

CLEOPATRA HAS MADE *a choice. She has deliberately opted for death. Liss shows her at the moment when her choice becomes actual – made real in the very substance of her flesh. She ponders sadly on the inescapability of the outcome, perhaps wondering whether what she did was right.*

FOR ALL THE BRILLIANCE *of light, shade, and color that makes this picture so spectacular, what lingers most in our minds is its emotional truth. Each actor in the drama is differently affected: the African pageboy looks on in stoic dismay, while his older companion displays a growing horror. Cleopatra is beyond dismay or horror, as she slips silently into death.*

THE DEATH OF CLEOPATRA
c.1622–24, oil on canvas, 39 x 34 in (98 x 86 cm), Alte Pinakothek, Munich

LOCHNER, STEFAN active 1442-51 Germany

SS MATTHEW, CATHERINE OF ALEXANDRIA, AND JOHN THE EVANGELIST

WE KNOW VERY LITTLE about the life of the 15th-century German artist Stefan Lochner, but we do know that he was greatly admired by Dürer. There is a sweetness and gentleness about Lochner, however, that seems alien to the Teutonic intensity of Dürer. Lochner's work is not so powerfully focused, but it is profoundly self-contained and at peace with itself – evocative of a world of innocence rather than struggle. Here, he paints three saints. On the left, wearing garments of the most subtle green and lilac, is St Matthew, and peeping out behind his outstretched leg and bare foot is his symbol: a tiny angel, with blue wings curling above his head. In the center is St Catherine, who wears a crown to indicate that she was Princess of Alexandria and carries a sword as a symbol of her martyrdom. The third saint, on the right, is St John. The three do not communicate, either with one another or with us, but rather stand before us, lost in the contentment of their heavenly joy.

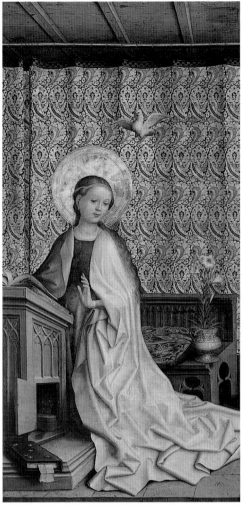

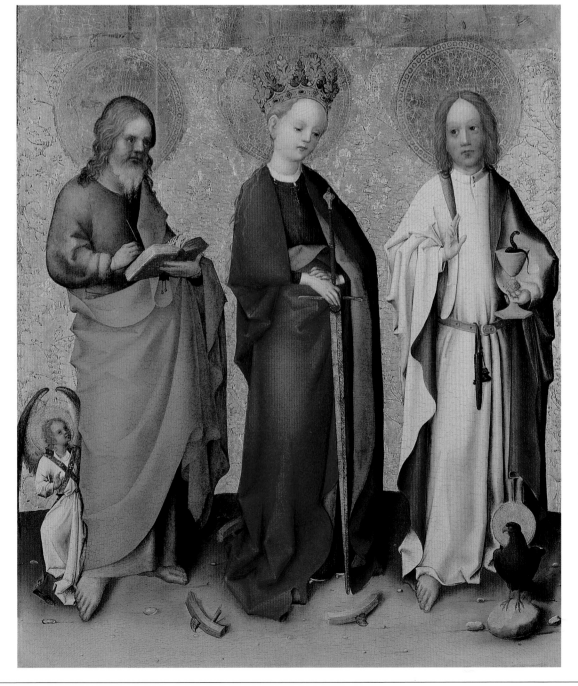

ANNUNCIATION
c.1440–45, oil and tempera on canvas, 102 x 112 in (260 x 285 cm), Cologne Cathedral, Germany

Every fabric in this picture has been made tactile. Mary is silhouetted against a golden brocade, emphasizing the purity of her cascading robes. That whiteness of the cloth is echoed by the Holy Spirit, an unusually realistic dove, which flutters above her. The same white is picked up in the lilies, in the pages of her prayer book, and in the bookmark on the lower left. This device draws our attention to the privacy of her cupboard, which, with its open door, is symbolic of her own receptivity to the invitation of God.

BEFORE ST CATHERINE'S *beheading, she was bound to a wheel that miraculously burst asunder – hence the Catherine Wheel firework – and here, curved fragments of the wheel can be seen at her feet.*

ST JOHN'S SYMBOL *is the eagle, and here it perches with domestic familiarity before him. The chalice that he holds contains a coiled snake – a reference to the apocryphal story that claims he was given poison and yet drank it without injury.*

SS MATTHEW, CATHERINE OF ALEXANDRIA, AND JOHN THE EVANGELIST
c.1445, oil on wood, 27 x 23 in (69 x 58 cm), National Gallery, London

LONGHI, PIETRO (PIETRO FALCA) 1702–85 b. Italy

EXHIBITION OF A RHINOCEROS AT VENICE

LONGHI PRESENTS THIS SCENE as a factual event, and yet, no Surrealist could better it. This wholly bizarre and exotic animal, with its dark body plates and its prehistoric-looking head, is juxtaposed with those Venetian revelers – masked, dark-hatted, and as bizarre in their own way as the animal itself. Here are two worlds that seem to have nothing in common: the natural world of animal vigor and the extravagant mannered world of the aristocratic reveller; both are masked, each is wholly opaque to the other. The animal has at least the limited freedom of its enclosure, but the revelers are hemmed in by the tighter constraints of a society that allows freedom only under precise conditions. The dark facial masks seem more sinister to us than the brute incomprehension of the wild beast. It is this strange intermingling of incongruous existences, confined by the rigid geometry that runs throughout this picture that makes this image such a terrifying icon.

NOBLEMAN KISSING A LADY'S HAND
c.1746, oil on canvas, 24 x 20 in
(61 x 50 cm), National Gallery, London

Always with Longhi we feel there is something subtly disconcerting. On the surface, here is a Venetian nobleman in formal black attire kissing the hand of a lady, while a less formally attired man and a female companion look on. However, there is a claustrophobic sense in this domestic interior that presses down upon the actors, involving them in some stately formality, the implications of which are unclear. The only innocent actor within the drama seems to be the small dog, and yet we have no explanation for the pervading sense of unease. Longhi is a master at arousing our suspicions, without giving them any peg on which to hang.

THE RHINOCEROS, *vast unwieldy creature though he is, started life, historically, as the unicorn – that mythical creature that has long haunted the European imagination. This poor rhinoceros has lost his horn, but the keeper behind the barrier holds it triumphantly aloft. Is Longhi suggesting that this mutilation – this theft of the horn – has transformed the white unicorn into the dark rhinoceros?*

IT WAS ONLY IN 1741 *that a living rhinoceros was first brought to Europe. This is ten years later, and the creature is being exhibited as a spectacle to enliven the carnival – the three days of merry-making before the close of Lent. Each of the masked figures wears a bauta (a Venetian carnival mask).*

EXHIBITION OF A RHINOCEROS AT VENICE
c.1751, oil on canvas, 24 x 19 in
(60 x 47 cm), National Gallery, London

LORENZETTI, AMBROGIO
active 1319–c.1348 b. Italy

EFFECTS OF GOOD GOVERNMENT IN THE CITY

THE COUNCILLORS OF SIENA, eager to decorate the town hall, were inspired to commission Ambrogio Lorenzetti, to paint a frieze celebrating government and, above all, to praise its good effects. The commission was daring – a real city was to be painted, with all the actuality of its buildings and inhabitants. Or it may have been that the daring was wholly Lorenzetti's, for perhaps he alone saw what could be made of this opportunity. For the first time, a metaphysical idea – that only within a well-ordered state can a happy citizen exist – became actualized in this panorama of medieval Siena.

ALLEGORY OF GOOD GOVERNMENT: EFFECTS OF GOOD GOVERNMENT IN THE CITY (DETAIL), *c.1338–39, fresco, 117 x 550 in (296 x 1398 cm), Palazzo Pubblico, Siena*

ALLEGORY OF GOOD GOVERNMENT: EFFECTS OF GOOD GOVERNMENT IN THE COUNTRY (DETAIL)
c.1338–39, fresco, 117 x 555 in (296 x 1398 cm), Palazzo Pubblico, Siena

Lorenzetti's vista extends beyond the city into the fertile countryside beyond Siena, a world still recognizable with small hillocks and castles, and laborers busy in the fields. Above, the winged figure Securitas bears a sinister image of the gallows, and the message is clear: peace and security can only be maintained at a cost; there must be punishment for the villain as much as there is reward for the virtuous.

HIGH UP ON THE SKYLINE *we can see builders at work, and the hustle and bustle in the streets suggests a thriving and expanding community. The duomo (cathedral) is right at the far edge, as if to make it clear that it is the whole of Siena that is blessed by order and not only its religious places of worship.*

THIS IS A WHOLLY *secular work in which the artist has striven to show a real place in its true setting. Lorenzetti shows us its citizens dancing, haggling, chatting, buying, and selling, within the glorious geometry of the architecture, and the sweet bright colors with which the inhabitants have painted the walls of their city.*

NO COMMUNE HAS *ever looked so blissful, or been given such a secure setting in which to live, prosper, and make friends as Lorenzetti's Siena. There seem to be no beggars and no villains, and even the poor have occupations. This is, of course, the precise message the Sienese councillors fervently desired to convey.*

LORENZETTI, PIETRO active 1320-c.48 b. Italy

BLESSED HUMILITAS HEALS A SICK NUN

THE MIDDLE AGES PROLIFERATED with minor local saints. They rarely reached the heights of solemn canonization by Rome, but they were profoundly venerated by their proud townspeople. The Order of the Women of Faenza had a deep devotion to Blessed Humilitas and commissioned an altarpiece from Lorenzetti to tell the story, in 14 panels, of her various saintly exploits. The details of these are now lost in the mist of history, but this makes little difference to the power of Lorenzetti's painting of Blessed Humilitas healing a sick nun, and we can, in fact, follow the narrative. Lorenzetti makes real to us the drama of the situation – the almost Lazarus-like recall from death – and he ballasts the drama with a solid understanding of human psychology.

THE REFECTORY
c.1341, tempera on wood, 18 x 13 in (45 x 32 cm), Galleria degli Uffizi, Florence

Because Lorenzetti was a very great artist, the fall of light on the monastic walls, the pink roof, and the floor is as engrossing as the narrative. He knows, and we know, that there is little attempt here at realism. The gold background is medieval code for the supernatural, but the sheer visual strength of the image leads us to believe not that such a place and event existed but that this is reality transformed to another plane, where it can be enjoyed aesthetically, without the groggy clumsiness of the mundane.

THERE IS THE *learned doctor, expressing the greatest apprehension and despair over the likely outcome. But, through the door in the nun's cell has appeared Blessed Humilitas, summoning the nun from her sickbed. While the other two look on with eyes popping, the nun surges forward and receives from the saint the gift of health.*

IT IS IMPOSSIBLE *to exaggerate the charm of such a work. Lorenzetti has set it in a wonderful geometry of architectural shapes, surmounted by the monastery roofs and a symbolic flourishing tree that makes visible the nun's return to health. The austerity of the habits gives little scope, chromatically, but the doctor is a symphony of pinks and greens.*

BLESSED HUMILITAS HEALS A SICK NUN
c.1341, tempera on wood, 18 x 22 in (45 x 55 cm), Staatliche Museum, Berlin

LORENZO MONACO (PIERO DI GIOVANNI) c.1370–c.1425 b. Italy
THE ANNUNCIATION

LORENZO MONACO SIMPLY MEANS LORENZO THE MONK, and one can sometimes sense a deep emotional involvement in this artist's work. Here, in this central panel from the Badia Altarpiece, he paints *The Annunciation* with a purity and conviction that is particularly appealing; few artists have understood so well the non-materiality of the Angel Gabriel. The angel floats with a fluidity and grace that is in wonderful contrast to Monaco's Mary, who is equally gracious, and yet is a creature of our world. Monaco has delighted in the patternings of their garments: Mary's cloak ripples and falls with the most exquisite folds, and the wind created by Gabriel's motion through the air carries his tunic, which flows backwards into ripples of light and shade that have a fascination that is almost independent of the story.

ST ANTHONY ABBOT MEETS PAUL THE HERMIT
c.1400–10, tempera on wood, 9 x 10 in (22 x 25 cm), Vatican Museums, Rome

St Anthony and Paul the Hermit were fathers of the remote desert, who were urged by the Holy Spirit to meet. Lorenzo Monaco imagines this encounter happening amid rock formations. The visual center of the picture is the scarlet and gold of the Bible that Paul carries with such evident love. The celebration of friendship was something dear to the early monks, and we can see that Monaco understands fully that love depends not on physical closeness but on emotional bonds.

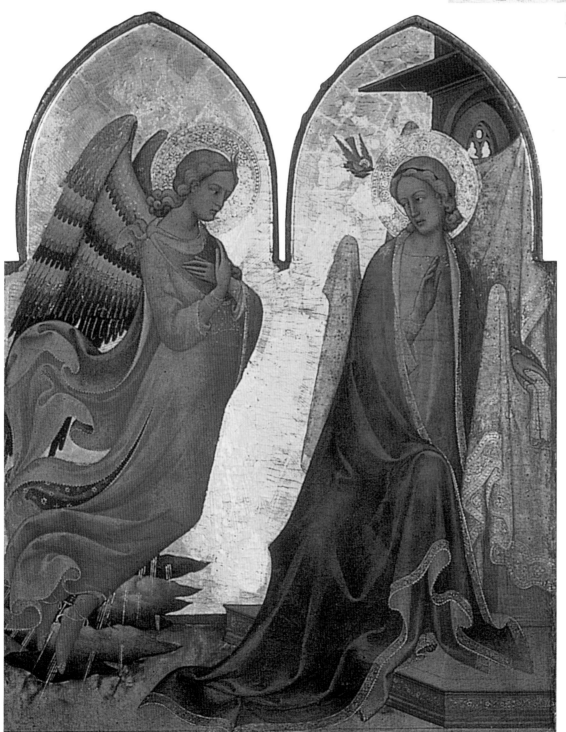

MARY IS SOLIDLY *seated – almost anchored to the ground by the dense blue of her long cloak. The angel, in contrast, is a creature of air, floating on clouds of light as the two worlds encounter each other.*

LORENZO MONACO *involves us at two levels: in the interaction between those two tender and pondering countenances and in the cascades and patternings of blue and pink, which surge in and out of the light, seemingly carrying a message all of their own. This is one of the great Annunciations, both for its beauty and for its piety.*

THE ANNUNCIATION, *c.1410–15, tempera on wood, 90½ x 51 in (230 x 130 cm) Galleria dell' Accademia, Florence*

LOTTO, LORENZO c.1480–1556 b. Italy
LADY WITH A DRAWING OF LUCRETIA

HISTORIANS SUGGEST THAT THE LADY IN QUESTION is Lucrezia Valier, bride of a Venetian nobleman. In one hand she is seen brandishing a drawing of her Latin namesake, Lucretia, and with the other points to a piece of paper bearing an inscription from Livy's history of Rome. The inscription is a reference to Lucretia's decision to commit suicide after she had been raped by Tarquin (to expiate what she felt was a loss of honor, despite her acknowledgment that she was not responsible for her shame). The strange, sad story of Lucretia was, in the climate of Renaissance Italy, held to be an example of unimpeachable virtue. Lotto was an artist of enormous subtlety, and here we cannot but wonder what exactly he is telling us. Could it be that this lady had been the subject of a scandal? She is, almost defiantly, engaging with the viewer, but does not the fervent proclamation of virtue make one somewhat suspicious of her motives – as an overzealous response to an accusation, perhaps? And does the cut flower represent a blossom plucked from the garden of chastity? Alas, her mildly reproachful expression reveals no answers.

CHRIST AND THE ADULTERESS
c.1530 oil on canvas, 49 x 61 in (124 x 156 cm), Musée du Louvre, Paris

Ancient Jewish law decreed that a woman caught in adultery should be stoned to death. Here, the accused woman has been brought before Jesus to be condemned. Lotto confronts us with a tableau: the shouting, clambering accusers gesticulate wildly; we see looks of contempt, base curiosity, and a barely contained violence. The woman, vulnerable and tragic, awaits her fate, while Jesus, a point of stillness amid the hubbub, raises his hand in a simple gesture to calm the accusatory mob.

LUCREZIA'S extremely elaborate orange-and-green gown is low cut at the bosom. As if to draw our attention to this, Lotto has painted an elaborate gold chain with a jewel spilling out of her frontage, and a diaphanous golden scarf falls loosely off her shoulders. She, however, tilts her head and fixes us with a gaze of stern and conscious rectitude.

LUCREZIA is not presented as a woman with much opportunity for freedom; Lotto places her in a strange, narrow setting, wedged in between the table and the wooden chair. The finger pointing to the inscription is rigidly clamped to her body, and we feel under pressure to respond to her silent communication.

LADY WITH A DRAWING OF LUCRETIA, *c.1530–33, oil on wood, 38 x 43½ in (96 x 110.5 cm), National Gallery, London*

LOUIS, MORRIS 1912–62 b. US

GAMMA EPSILON

NO ONE KNOWS FOR CERTAIN HOW MORRIS LOUIS painted because he never allowed anyone to see him, not even his wife. He was too poor to have a studio, and so, in their small living room, he painted huge canvases that, by some extraordinary dexterity, he managed to manipulate. Having met fellow artist Helen Frankenthaler, Louis received a dramatic conversion to her method of staining paint into the canvas. Frankenthaler created landscapes with a vaguely beautiful, abstract quality. Louis used this new technique quite differently. He painted a series that we now call the *Unfurleds*, in which he allowed the paint to flow down the edge of the canvas. It took its own path, hence the resemblance of the curve and flow of nature. The role of the artist was to choose the right colors and to manipulate the canvas so that the flows remained as distinct as he desired – the paint flows met and separated as seemed aesthetically right to Louis.

TET
*1958, synthetic polymer on canvas, 95 x 153 in (241 x 389 cm),
Whitney Museum of American Art, New York*

Before he embarked upon the *Unfurleds*, Louis created another series of works, now known as *Veils*. Here, each one is differentiated from the other by Hebrew letters. Louis has simply poured very dilute paint down the canvas, producing a luminous veil of color that is not on the canvas, of course, but in it, the paint having stained the canvas. Again, the art was partly to control the flow of paint, but, even more importantly, to choose the shades that would blend and flow together to create this diaphanous hanging veil. It seems to rise before us with an almost mystical beauty.

GAMMA EPSILON
*1960, acrylic on canvas,
34 x 75½ in (86 x 192 cm),
Private Collection*

THIS WORK WAS PRODUCED *using an extremely difficult technique, in which the artist's control over the spreading stain was so minimal that canvas after canvas was considered inadequate and discarded. The work is extraordinary because of the daring that allows a painting of such a dramatic scale to be completely empty for almost its entire surface.*

LUCAS VAN LEYDEN c.1494–1533 b. Netherlands

CHRIST HEALING THE BLIND MAN

THIS REMARKABLE IMAGE IS THE LEFT-HAND WING of an altarpiece, the main panel of which shows Christ healing the blind man of Jericho. The function this outlandish gentleman performs is to hold out before us the armourial bearings of the family whose generosity has provided the church with the funds for this altarpiece. The great masculine body and the extraordinarily grim face with its manic expression of worldly ambition seem wildly unsuited to flank a scene of Christian healing. It is superbly painted; the shadows seem almost to have a life of their own. Nevertheless, one cannot help wondering at the artist's lack of discretion. Those who saw this well-dressed thug adorning the walls of their church must have longed to tap the healing Christ on the shoulder and direct His attention to the left.

LUCAS VAN LEYDEN'S *almost demonic energy cannot rest with providing merely a vehicle for an armorial bearing. This man flaunts position and power: his head bristles with osprey feathers, his neck jerks out flamboyantly from an opened collar, and his fashionable and elaborate sleeves flap and swing.*

CHRIST HEALING THE BLIND MAN OF JERICHO, *1531, oil on canvas, 35 x 13½ in (89 x 34 cm), Hermitage, St Petersburg*

A MAN AGED 38
c.1521, oil on wood, 19 x 16 in (48 x 41 cm), National Gallery, London

For good or ill, Lucas van Leyden is always an extremist. It is this inner passion that makes the portrait of *A Man Aged 38* so unforgettable. That bony face with its long, pointed chin, its great jut of a nose, and its staring eyes seems burnt up from within by some obsession. The paper that he clutches rigidly to his bosom merely serves to impart his age.

LUTTRELL PSALTER England c.1330–40

SIR GEOFFREY LUTTRELL

SIR GEOFFREY LUTTRELL WAS NOT ONE of the great magnates of 14th-century Britain. He was a relatively unimportant Lincolnshire knight who has become immortalized through his good fortune in finding an unknown and anonymous genius to decorate his family psalter, or book of psalms. Where this artist came from, and why no more of his work is known, remains a mystery. The only name firmly and clearly attributed to this masterpiece is that of Sir Geoffrey, who commissioned it. The artist, however, had a sense of humor and a power of invention that is unique among the great manuscript illuminators of the world. At the beginning, after due praise to God, there is a dedication miniature, in which we see Sir Geoffrey, with his stern Norman profile, majestically aloft on an impossibly high horse; he is receiving a helmet from his equally aristocratic Norman wife, while his daughter-in-law waits with his shield. Both ladies wear heraldic gowns, and those knowledgeable in heraldry will be able to distinguish the precise relationship between the Luttrells, the Suttons, and the Scrotes of Masham. The three families are all interconnected by marriage, and each figure proudly wears the combined coats-of-arms of their ancestry.

HARDLY ANY OF THE HORSE remains plainly equine, except for the spindly legs, a stretch of belly, and that delightful grin of the open mouth. The miniature is both a tribute to Sir Geoffrey's sense of his own and his family's importance, while at the same time, very gently, it shares a secret guffaw with the horse. Just above Sir Geoffrey, a monster with a rippling fin and delightfully serrated edges sprawls astonished across the page. Beneath, in the elegant and sumptuous calligraphy of the day, is written: "The Lord Geoffrey Luttrell caused me to be made."

LUTTRELL PSALTER
(SIR GEOFFREY LUTTRELL
ATTENDED BY HIS WIFE AND
DAUGHTER-IN-LAW), c.1330–40,
illumination on vellum, 14 x 10 in
(36 x 25 cm), British Library, London

LUTTRELL PSALTER (SOWING)

c.1330–40, illumination on vellum, 14 x 10 in (36 x 25 cm), British Library, London

Although it was usual for artists to decorate the margins of a manuscript, the Luttrell Psalter is unique in the insight it gives into the working life of the peasant. Here, we see the sower at work with his basket and his seed, which the wind is carrying rapidly forward. A bird on a sack of seed thrusts its head in, gobbling up grain as quickly as the sower can sow it. Then, comically, we see the bird soaring aloft with a majestic lack of concern, while the sower's dog gives chase.

MACKE, AUGUST 1887-1914 b. Germany
PROMENADE

IT IS DIFFICULT TO GET A CLEAR VIEW OF MACKE, because we are inevitably influenced by his early death in World War I. The very date of this picture, *Promenade (with Half-Length of Girl in White)*, which Macke painted in 1914, reminds us of how little time was left to him, and perhaps it is all too easy to romanticize his images as encapsulating the world that would be forever lost after the carnage of that war. Macke shows us an enchanting vista of people walking at ease in the park, well-dressed people, with hats, and yet, strangely, no faces. The only face, in the full sense, is that of the young woman in white, who looks obliquely across as if bewildered by the strangeness of the male world, with its armor of coat, high collar, and bowler hat. Behind and around her rise the enthralling and luminous greens of the trees in the Munich park. Macke responded with instinctive delight to the beauties – not of wild nature but of tamed nature, a nature still lovely and glowing, but in which a young girl – in virginal white, with her dark hair neatly tied at the back of her neck – could feel completely safe. She is the only one who dares to look, and the artist may be suggesting, with just that tinge of sadness that we seem to pick up in his work, that the adult, especially the adult male, hardened to the rough and tough of life, cannot afford to wear a face, but can only present to the world a defensive mask.

M
284

GARDEN ON LAKE OF THUN
1913, oil on canvas, 19 x 25½ in (49 x 65 cm), Städtisches Kunstmusem, Bonn

Before the war swept him up into destruction, Macke had one last period of blissful freedom, painting in Tunisia with his friend Paul Klee. This picture of a garden overlooking the lake of Thun, is clearly influenced by Klee, and yet Macke has made his own statement, as it were, with Klee's language. The abstract blocks of color, the stylized palm, the childlike triangles of the mountains, all somehow come together to make a harmonious and joyous image of a sheltered, magical world.

" MY ENTIRE JOY IN LIFE COMES ALMOST ENTIRELY FROM PURE COLOR "
Macke

ONE LONGS *to know how Macke would have developed, whether he would have continued to gaze, astonished, at the business world, or whether he would have turned and gone down that path through the trees and out into open space.*

PROMENADE (WITH HALF-LENGTH OF GIRL IN WHITE)
1914, oil on canvas, 19 x 24 in (48 x 60 cm), Staatsgalerie, Stuttgart

MAES, NICOLAES 1634–93 b. Netherlands
"THE IDLE SERVANT"

MAES HAD BEEN A PUPIL OF REMBRANDT and his earliest works are religious scenes with something of Rembrandt's spiritual emotion. But this was not the type of painting most natural to Maes and his own temperament led him to specialize in the domestic interior. He liked the condensed drama of the domestic scene and the opportunity to view through the key hole, as it were, a house and its activities. This scene is deliberately staged, with the mistress appealing to the viewer to share her wry amusement at the idleness of the housemaid. In the background, we can see the company still being entertained, while the maid, confronted with a discouraging array of dirty pots and pans, has slumped on her stool and fallen asleep. We gather that, with the feast in full flow, the mistress was not expected, but she has come out, possibly to refill the wine jar and to her amusement has caught her servant napping. But there is a more dramatic consequence, in that the maid has allowed the cat to steal a bird, and sooner or later there will be retribution.

A YOUNG WOMAN SEWING
1655, oil on canvas, 22 x 18 in (56 x 46 cm),
Harold Samuel Collection, London

Here is Maes in contemplative mood – all is silent, virtuous, and at a remove from the dramas of the kitchen or the dining room. We do not see the source of light but clearly it comes from above, bypassing that hanging map (which we know so well from Vermeer) and falling full on this virtuous child. The girl's hair is held precisely within the confines of the white band and her white collar is as pristine as the cloth on which she labors. The girl sits alone, on a small dais, which again suggests her removal from life's hubbub. On the chair rests the lace-makers' bobbins, but the basket suggests work of a more domestic nature.

MAES WAS A KINDLY FELLOW, *and one feels the smiling housewife will not be too stern with her delinquent servant. What makes this painting so successful is the artist's depth of interest – both in the domestic clutter and in the reality of the two people whom it concerns – and the way in which he uses the light to make maid and mistress real to us.*

MAES FOLLOWS EVERY PLEAT *in the woman's apron, with its many folds and gathers. One shadowed hand holds the jar and a clear light shines on her other hand, which is open in a gesture of exasperation as she points towards the maid. It is a small world made visible and almost tangible, a world very different from ours, and yet still convincing.*

INTERIOR WITH A SLEEPING MAID AND HER MISTRESS ("THE IDLE SERVANT")
1655, oil on wood, 28 x 21 in (70 x 53 cm), National Gallery, London

MAGNASCO, ALESSANDRO 1667–1749 b. Italy
THE ROBBERS' LAIR

VIEWERS OF A CONTEMPLATIVE BENT will regard Magnasco with a certain distaste. There is so much going on in his paintings. Here, he presents us with a scene of hectic activity, vulgar activity. People scurry like rats in and out of the pillars, scratching here, bickering there – all up to no good. The visual interest of the picture rests on the contrast between the ruins of majestic architecture and a debased and feverish life that now swarms around its pillars, which have become depositories for the bandits' bric-a-brac. Apparatus for loading ships at the far left bears a resemblance to the gallows and the central figure, engaged in some ploy of his own, reminds us of the writhing figures from battle scenes. Magnasco's genius is to arouse unease by sketching a transient population set against the validities of stone.

THE ROBBERS' LAIR, 1710–20, oil on canvas 44 x 64 in (112 x 162 cm), Hermitage, St Petersburg

THIS SCENE OF *relative degradation is overlooked by the wonderful Venus in the central columns. From the scrawny figures beneath her, our eye is directed upwards to the great herald at the top, who, ironically, proclaims the importance of the site, which of its nature the robbers need to keep secret.*

CHRIST SERVED
BY THE ANGELS
c.1715, oil on canvas, 76 x 56 in (193 x 142 cm), Museo del Prado, Madrid

Only Magnasco could have as his theme Christ served by angels and yet turn it into a whirlpool of anxious activity. Not surprisingly, the Gospels record no such scene. Christ ate the bread of daily living, but the artist's imagination conjures up a great swirl of tree and wind and scattered sunlight. Angels crowd with nervous activity around a relatively tranquil Christ – He is not quite the still point of a turning world, but is so in relation to the angels' fluttering wings, as they scoop up the water and rush it across to Him.

MAGRITTE, RENÉ 1898–1967 b. Belgium
EMPIRE OF LIGHTS

MAGRITTE COULD BE CALLED A SURREALIST PAR EXCELLENCE. He approached the subjects of his work with what we may consider to be a typical Belgian stolidity, and yet those subjects themselves were bizarre and poetic in the extreme. It was for his work that the phrase "magic realism" was coined, and the artistic thrill comes from precisely the dichotomy between the down-to-earth literalism of the technique and the strange lineal concepts that he illustrates. *Empire of Lights* is one of a series, all with the same title, all dealing with the same, very simple but extraordinary, idea. He imagines that on earth it is night, but in the sky it is still day. To creatures of convention, as we are, the very notion that day and night can run parallel, yet disassociated, is disturbing in its implications.

EMPIRE OF LIGHTS
1949, oil on canvas, 20 x 23 in (50 x 60 cm), Private Collection

REPRODUCTION PROHIBITED (DETAIL)
1937, oil on canvas, 31 x 26 in (79 x 65 cm), Museum Boymans-van Beuningen, Rotterdam

Reproduction Prohibited gives us a psychic jolt. Most of us, at times, find it difficult to believe completely in our own reality. Who are we? What do other people see? Which is true – how I appear or how I am? And how do I know what I am? This is the role of the Surrealist – to stir up such uncertainties and make us look at the ordinary with fresh understanding. Here, a man looks into the mirror and is confronted by an image of himself from behind. As a concept it is terrifyingly simple, and one cannot come to terms with it in any logical manner.

THIS IS THE WORLD *as it could never be, and yet the imagination plays with the impossible made seemingly real to us. On the darkened earth, the curtains at the house are drawn and we can see light shining faintly from within. But in the sky, it is high noon – a soft and gentle blue with luminous white clouds.*

TOO OFTEN IN *Magritte's work the conception is more interesting than the execution. The most brilliant of ideas is presented with such straight-faced realism that the paint ceases to fulfill its role of sensual stimulus. But Empire of Lights seems to contain one idea that held, for Magritte, a constant fascination.*

MALEVICH, KASIMIR 1878–1935 b. Russia

BLACK SQUARE ON WHITE GROUND

MALEVICH IS THE GREAT RUSSIAN SUPREMACIST – one of a group of artists who made abstract art a genuine and exciting alternative to figurative. *Black Square on White Ground* is a perfect example of the kind of picture that alarms many people. There is almost nothing to it. Admirers may claim that it is the contrast of the black square on white that is so exciting, that we have here the supremacy of pure sensation. Yet, why should a black square on a white ground be considered of such artistic importance? We need to step back and understand what Malevich was doing. It is more the idea behind the work than the work itself that matters, yet it must be through the painting that we see shapes and tone as significant in themselves. With this black square set on a background of the utter non-color - white, Malevich was trying to get away from seeing art as story; he was escaping from the human tendency to get involved in themes, irrespective of how a painting is painted.

BLACK SQUARE ON WHITE GROUND
*c.1929, oil on canvas, 42 x 42 in (106 x 106 cm),
State Russian Museum, St Petersburg*

TAKING IN THE RYE
*1912, oil on canvas, 28 x 30 in (72 x 75 cm),
Stedelijk Museum of Modern Art, Amsterdam*

Before he came to the exacting purity of the austerely abstract, Malevich painted with a rich delight in color. The apparent naivety of this painting should not deceive us; *Taking in the Rye* shows a highly sophisticated understanding of the natural world and the structure of the body. But the artist has rewritten the world. He has stylized his small and gleaming peasants, geometrified them into cylinders, and we can see clearly the shape of the future.

THE TRADITIONAL *Russian icon sets its face against any originality on the part of the artist; all is subordinated to the subject, the religious content. The artist had only to repeat with fidelity the familiar picture so that the worshipper could move through the image and out into prayer. Malevich does much the same in a non-religious content, yet the result is equally spiritual.*

MALEVICH WANTS *the viewer to see the bareness of form and tone as majestic and capable of freeing us from the smallness of incident. He wants to take us out into that great world that he called liberated nothingness, in which one can enjoy for its own sake the dark, non-reflective depth of this black and the pure, radiant white that acts as servant to set it off.*

MANET, ÉDOUARD 1832–83 b. France
OLYMPIA

THIS WAS THE PAINTING WITH WHICH MANET shocked the art establishment of Second Empire Paris. They were accustomed to the female nude, but always in a setting that made it innocuous; it was a goddess, or a symbol, or an allegory – never in the brutally honest form with which most adult males were secretly accustomed. Manet confronts, head-on, the hypocrisy of his times, which refused to admit to the presence and the fascination of the prostitute. Olympia herself, clearly, feels no need for disguise. She rears herself up on her pillows, those glorious white-gray pillows that Manet explored with sensuous delight, and looks straight and challengingly at the customer who is entering. He may have thought to have sweetened his approach with the glorious bouquet that the maid holds up for her attention, but Olympia ignores it. Like the round-eyed kitten with erect tail, Olympia is ready to challenge the client who comes in ostensibly as her superior. Her small and witty feet, the magnolia in her hair, the air of a grand lady at leisure, all combine to make this one of the most delightful of paintings.

THE FIFER
1866, oil on canvas, 63 x 39 in (160 x 98 cm), Musée d'Orsay, Paris

This small child, eyes looking inward as he concentrates on his music, is almost a cut-out set in an indeterminate space into which the clarities of military life do not completely fit. Manet never painted with more stringent reduction of what he saw to its strong and beautiful basics.

OLYMPIA
1863, oil on canvas, 51 x 75 in (130.5 x 190 cm), Musée d'Orsay, Paris

THE TRUE GLORY *of the picture is in the color: we see the dark-brown of the maid contrasted with the darkness of the curtains, the inky black of the kitten against the whites of the sheets, the pinky-lemon of Olympia against that glorious oriental shawl, and it is hard for us to understand how anybody could have failed to respond.*

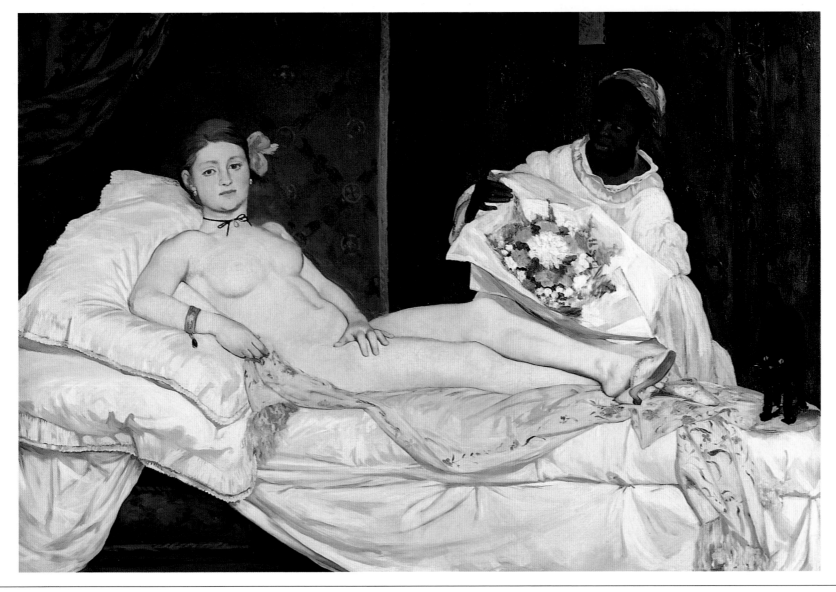

MANGOLD, ROBERT 1937– b. US

FOUR COLOR FRAME PAINTING No.1

MANGOLD HAS SAID THAT HIS AIM is to make simple, direct statements. *Four Color Frame Painting No. 1* seems anything but simple and direct. It hardly seems, at first glance, to be a statement, and yet Mangold is being completely sincere. He is asking us not to regard the painting as a depiction of something but as an object in itself, as something he has created and formed through the play of colour and shape. It is, in a way, pure creativity. If we pay the artist the respect he deserves and look at the work, we will find interest in the simple statement that he has created for us. He wants us to look at the four-color frame – where it fits; where it falls short; how the oblongs meet, each reinforcing the color of the other and making us aware of its "objectness," and how they are integrated by the artist's passion for the thin, clear curve that encircles them.

RED X WITHIN X
1980, acrylic, graphite on canvas, 133 x 133 in (288 x 288 cm), San Francisco Museum of Modern Art

In *Red X Within X*, Mangold opposes four red canvases, creating not a pure X but a false X. Onto the dominant form of the red X, he has drawn, with an undeviating thin black line, another cross. Eventually, we see that this black X is, in fact, the true X, which supports the red X, as stated in the title.

THIS IS A WORK THAT SEEKS *to fly off in all directions, to disintegrate, to be disunited. The four separate panels are held together by the fragile line of the continuous oval that overlaps and unites these strong oblongs of color – drawing our attention to the great vacancy at its center.*

FOUR COLOR FRAME PAINTING No. 1
1983, acrylic and graphite on canvas, 111 x 150 in (282 x 381 cm), Pace Gallery, New York

MANTEGNA, ANDREA c.1431–1506 b. Italy
DEATH OF THE VIRGIN

WHETHER THE VIRGIN DIED LIKE OTHER HUMANS or had the privilege of being taken directly up to heaven was a theological issue still unsettled in the 15th century. Mantegna is clear about where he stands. He sets the bier at a distance from us, so that we can take in fully the deadness of that elderly body – the face, lined and sagged and closed in its final sleep. Around Mary stand the apostles, holding the palms of victory and the candles that symbolized hope in Christ. One apostle, probably St John, sprinkles Mary with holy water, the last rite before her body is carried to burial. Dominating the picture is the great window looking out onto lakes and fortifications, and, above all, onto the height and luminosity of an evening sky. It is not a spiritual world that we see through the window, but the active world of men, with buildings for commerce as well as for prayer. But the sheer expanse of that view lifts the picture from a scene of grief into a scene of hope. It is a great imaginative leap to set this holy death in a background of classical pillars and physical immensity.

DEAD CHRIST
c.1480, tempera on canvas, 27 x 32 in (68 x 81 cm),
Pinacoteca di Brera, Milan

For many people, the first reaction to this picture is one of astonishment and admiration. Its technical virtuosity is overwhelming. Yet once we have adjusted to the extraordinary foreshortening, we can respond to the reason why Mantegna has chosen to use this effect. This viewpoint enables him to show the physicality of Jesus and the sacrifice that so complete and mature a man has made in accepting death. It is only after the initial and unavoidable contact with this evidence of suffering that we reach the sad and darkened face.

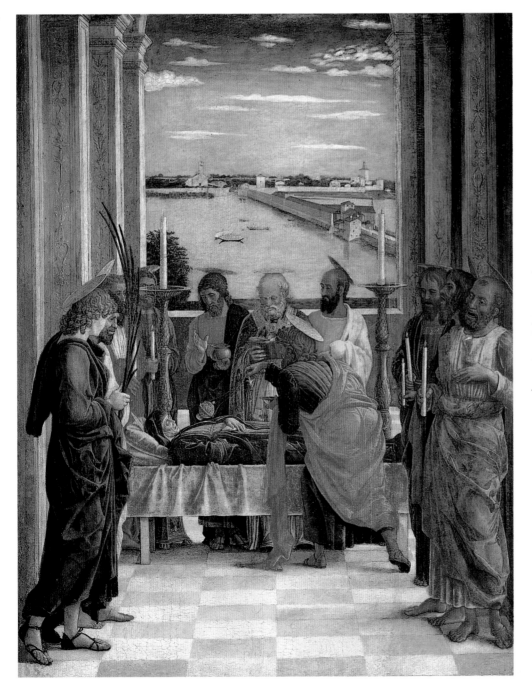

THE DEEP PINK of the bier and the rich variety of the apostles' garments – ranging from green, through reds and primrose yellow, to pinks and blues – emphasizes the difference between the living and the dead. Their faces, sunburnt and bearded, also contrast with the corpse-like pallor of Mary's face and hands. Yet Mantegna does not silence in their grief either the apostles or their Lord's mother.

DEATH IS PART of a larger pattern, even for Mary. Bodies will lie on charming floors of orange and white tile, and be mourned with song by men who enjoy the color and excitement of life. There is no sense of closure here, only of openness and expectation.

DEATH OF THE VIRGIN
c.1460–65, tempera on wood,
21 x 16½ in (54 x 42 cm),
Museo del Prado, Madrid

MARC, FRANZ 1880–1916 b. Germany
THE TIGER

FRANZ MARC WAS ONE OF THE German artists destroyed by
the actions of humanity-turned-animal in World War I.
He was killed on the field of battle at the age of 36. Ironically,
it was the innocent power of the animal that had been the
dominant theme of his art. Here, in *The Tiger*, we see how
the fractured planes of Cubism have been integrated with a
radiance of color and an insight into the pure ferocity of the
animal to create an unforgettable image. His tiger is coiled and
supple amidst the wild variations of a chromatic world. It has
been radically simplified, reduced to an elemental form. The
brightness does not even entertain the pretense of realism; it
rather expresses the animal's spirit, undaunted, inventive, sharp,
and beautiful. The body bends back on itself, with the bright-
eyed head and all the muscles poised for immediate action.

THE MANDRILL
1913, oil on canvas, 36 x 51½ in (91 x 131 cm),
Staatsgalerie Moderner Kunst, Munich

When Marc was killed in 1916, his art
was just verging on a more absolute
abstraction. In this painting, *The Mandrill*,
we can see the shape of things that
would have come had he lived. The
great baboon is still visible, its arms
clutching the branches in the forefront,
the great ridged snout of its face turned
diagonally, and with trees crowding
in on either side. Yet, equally, we can see
how easily one step further would
have moved this swirl of colors into an
abstraction so profound that image, as
such, would have been entirely lost.

M
292

MARC SAW *humanity as flawed –
an insight that was not mistaken.
He felt that humanity abused the
animal world, was blind to its virtues
and crude in its exploitation of earth's
creatures. The tiger is a figure of
menace, but it is a directed menace,
and its ability to kill functions
purely in relation to the animal's
hunger, as made clear by those
lean, thin shanks.*

MARC PAINTED *with an almost
frightening lack of sentimentality
or anthropomorphic identification
with the animal. Instead, what comes
across most powerfully in these
paintings is painful admiration and
great wonderment at animal beauty.*

THE TIGER
*1912, oil on canvas, 44 x 44 in
(111 x 111 cm), Stadtische Galerie
im Lenbachhaus, Munich*

MARDEN, BRICE 1938– b. US
HUMILIATIO

ALL ARTISTS TAKE THEIR WORK SERIOUSLY, but not all are willing for that seriousness to be known. Brice Marden is an exception. For him, the artist's role is priestly, mediating between the divinity of beauty and truth and the waiting world. The artist is the medium, as it were, through which these great realities can come together. This sense of the sacred in no way makes his work heavy or pretentious, but it does provide an insight into a significance that is not obvious at first sight. *Humiliatio* is one of a series based upon a theological meditation about how the Virgin Mary reacted when the Angel Gabriel announced to her that she was to be the mother of God. The theologians imagined the different emotions that passed through her heart – surprise, fear, joy, resignation, and a sense of her own unworthiness. *Humiliatio* relates to the last of these emotions. The word implies an acknowledgement of one's unimportance or inadequacy for a task.

CORPUS
1991–93, oil on linen, 71 x 53 in (180 x 135 cm), Matthew Marks Gallery, New York

Whereas *Humiliatio* seems almost untouched by human hand, in *Corpus* – the body – Marden is eager to show the precise movement of his hand. He uses an exceptionally long brush so that great control is needed as the line wavers over the large surface. We are watching the slow movements of his thought within this accepted frame. *Corpus* is not a body in any fleshy sense, but it is as if this is the texture of the nerves, the whole complex of the inner workings of the body.

ALL THESE EMOTIONS *are shown purely in color, from the very palest blue on the left, through the darker blue-black that graduates until it settles in the purplish-blue on the far right. The whole gamut of the emotions appear: innocence confronted with inadequacy, the pain of accepting that inadequacy, battling through it, and finding, in the end, a contented awareness.*

HUMILIATIO *is a very large painting. Marden's idea is that we do not encompass the work and control it; rather we are encompassed by it. The very size is part of the message. We are absorbed by the smoothness and depth that appears miraculously before us – a great wall of pure color that is meant to convey the artist's message.*

HUMILIATIO, *1978, oil and wax on canvas, 84 x 96 in (213 x 244 cm), Ludwig Museum, Cologne, Germany*

MARGARITO D'AREZZO
active c.1262
b. Italy

MADONNA AND CHILD ENTHRONED

WE TEND TO THINK OF BYZANTINE ART as impersonal, focused solely on the iconic image rather than in the individuality of the artist. That may be generally true, but beneath this picture of the Virgin is written "Margarito of Arezzo made me." Margarito was clearly proud, as well he might have been, of this majestic image of the Virgin enthroned. In it, the Byzantine influence, which renders her as a great monolithic idol – an icon rather than a living, breathing woman - has been partially subsumed into the excitement of a highly individualistic personality. This is not the Madonna we are accustomed to seeing in Renaissance paintings – that lovely and human young mother, with whom we can establish a personal relationship. This is Mary and Son as abstractions - as ideas of grandeur, power, and maternity. On her lap reigns the small Emperor – no child, but a Christ whose only admission of his infantile status is his size. Strangely, the work seems all the more powerful for these retrograde elements, and manages to stop us in our tracks.

MADONNA AND CHILD
ENTHRONED (DETAIL)
*1260s, tempera on wood, 38 x 17½ in
(97 x 45 cm), National Gallery of Art,
Washington, DC*

THE VIRGIN SITS IN MAJESTY *on a throne formed by two lions – carved lions, one presumes – and yet they have sparky personalities which tempts us to wonder if she might not be taking risks by riding these wild beasts. Her clothes are formulaic – a blue cloak, spattered with orderly stars, and a majestic red gown, in which vulgar necessities, such as knees, are tactfully occluded.*

ON EITHER SIDE OF THE VIRGIN, *angels swing censors, their tiny forms emphasizing her greatness. In the corners are the symbols of the four evangelists: Matthew's angel in the upper left; John's eagle flapping agitated wings in the upper right; in the lower left the winged and rampant Lion of St Mark; and on the lower right the ox of St Luke.*

ST MARGARET AND THE DRAGON (DETAIL)
*1260s, tempera on wood, 17½ x 17½ in
(45 x 45 cm), National Gallery, London*

Around the central image of the Madonna, Margarito has set eight small narratives. This one celebrates the story of St Margaret, who, as the patron saint of childbirth, was of intense interest to medieval women. Margaret had spurned the advances of the Emperor, and was cast into a dungeon where she was swallowed by a dragon. Sensibly, she took her crucifix with her into the dragon's belly, and, by dint of violent knocking, finally exploded the dragon's bowels and escaped in triumph.

MARMION, SIMON

active 1449–1489
France and Belgium

SCENES FROM THE LIFE OF ST BERTIN

St Bertin is hardly a household name, but the Benedictine monks of the great Abbey of St Omer claimed him as their founder. In turn, Simon Marmion produced magnificent paintings for an altarpiece that focused on incidents (real or legendary) in the life of the saint. Here are the final stories from the right-hand wing of the altarpiece. On the left, we see St Bertin, looking grave and concerned in his black habit. He is asking St Martin of Tours to expel from the monastery all temptation to carnality. The lady who represents lust, charming though she may seem in her courtly gown and headgear, has, if we look closely, clawed feet. This was St Bertin's last act of service to his community, purifying them and setting them safely on the way to God. The next and last scene shows St Bertin lying peacefully on his deathbed, while his grieving brothers throng around.

SCENES FROM THE LIFE OF ST BERTIN (DETAIL)
c.1459, oil on wood, 22 x 58 (56 x 147 cm), Staatliche Museum, Berlin

THE SOUL OF ST BERTIN CARRIED UP TO GOD

c.1459, oil on wood, 23 x 8 in (58 x 21 cm),
National Gallery, London

Two angels bear aloft the soul of St Bertin. He is about to pass through a great darkness that divides man from God, to a place where, resplendent and welcoming, God the Father awaits his faithful servant. The play on the physicality of death (as in the detail from *Scenes from the Life of St Bertin*) and the salvation and glory of the soul (as depicted here) is fundamental to Marmion's art. One without the other is incomplete.
If we find the image delightfully naive, we must remember that it is an image – a symbol of something vast and eternal.

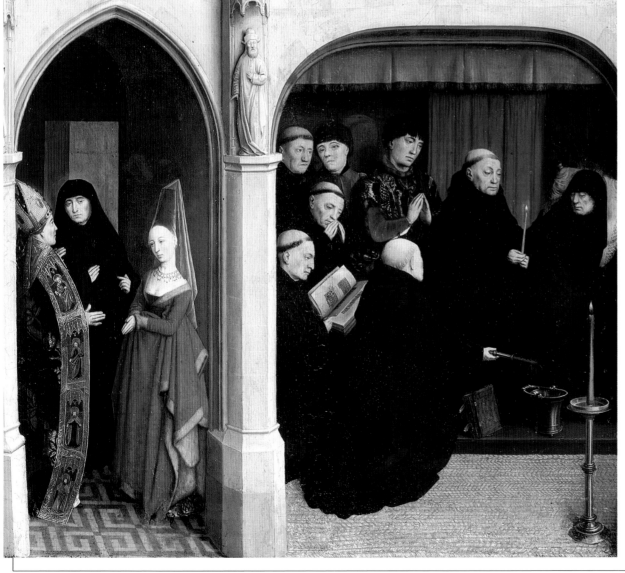

DESPITE THEIR GRIEF, *the monks who cluster around St Bertin on his deathbed express a serene confidence that their founder and abbot will go straight to God. One kneeling in the foreground sprinkles him from a font of holy water; others turn pages of liturgical writings to console themselves with a reminder of eternal truths.*

THE MONK NEAREST *to St Bertin holds aloft a candle and dominant in the forefront is the great brass candlestick, stretching indomitably upwards, indicative of the direction that the saint's soul is soon to take. The altarpiece was sawed apart after the abbey closed, and the upper parts of the wings were removed. The roof that is visible here continues in the painting above, which shows the saint's soul being carried straight up to God.*

MARQUET, ALBERT 1875–1947 b. France
LE PONT-NEUF

ARTISTS WHO MET MATISSE tended never to get over it. Matisse's extraordinary grasp of the sheer power of color – an understanding that he taught at the beginning of the 20th century – was a revelation to a moderately timid artist such as Marquet. The example of Matisse drew him beyond his natural limitations, and in *Le Pont-Neuf* we can see with what intelligence he has understood the Fauvist doctrine. The term was coined, contemptuously, by a critic who regarded Matisse and his followers as "fauves" (wild beasts). Yet here is a wild beast tamed and yet still muscular. Marquet leads us with superb authority along the bottom of the picture and round and out onto the great bridge. His perspective remains true; it is color that provides the vehicle for his expression. He uses color to make us aware of architecture and atmosphere. It is not a realistic color – we notice how the road changes abruptly from blue to radiant white – but it expresses a truth that is greater than bare fact.

LE PONT-NEUF, *1906, oil on canvas, 20 x 24 in (50 x 61 cm), National Gallery of Art, Washington, DC*

ANDRÉ ROUVEYRE
1904, oil on canvas, 36 x 24 in (92 x 61 cm), Musée d'Orsay, Paris

Marquet was primarily a landscape painter, but this is a most memorable portrait. The gleaming monocle and the touches of white on the neck and cuffs are almost the only relief from the impact of the black. Yet, this is enough to make us certain that we are not encountering a cut-out, a black silhouette, but a living personality whose very clothes are alive with the intentness of his being and his gaze, which is channelled by that monocle.

SHADOW AND LIGHT *alternate, and the cut-off line makes us aware of the brilliance of the sunlight as the road passes over the somber, gray-green fluidity of the river. The buildings below have already passed into the shadows of evening. They loom as a backdrop, an architectural validation of the massive stonework that Marquet makes so real to us.*

THIS IS A POETIC *evocation of one of the great romantic Parisian bridges, shown as evening falls. In its freedom from the constraints of narrow realism, it is a splendid example of the use of color and shape to give visible form to an artist's vision.*

MARTIN, AGNES 1908– b. Canada, active US
LEAF in the WIND

AGNES MARTIN OFTEN SPEAKS OF JOY; she sees it as the desired condition of all life. Who would disagree with her? Her works have been to me a source of ever-deepening joy, and yet, with ever-deepening sadness, I have found myself unable to explain to sceptics why her work is so beautiful. Fortunately, I have realized that explanation is impossible. Agnes Martin does not deal with ideas; there are no concepts here for one to respond to; it is a work that depends upon the willingness of the viewer to contemplate. All art to some extent demands from us a surrender, an openness to what is before us. In a work like *Leaf in the Wind*, where there seems to be nothing before us but a succession of delicately-ruled pencilled rectangles on the palest acrylic background, the search for meaning is futile. The work has a meaning and will communicate that meaning in its own time and in its own way. No-one who has seriously spent time before an Agnes Martin, letting its peace communicate itself, receiving its inexplicable and ineffable happiness, has ever been disappointed. The work awes, not just with its delicacy but with its vigor, and this power and visual interest is something that has to be experienced. But with words one can do practically nothing to coax the viewer to this encounter. It is a personal matter, an experiential matter – only time enables us to respond to it.

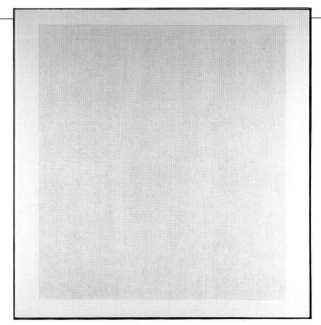

UNTITLED No. 3
1974, acrylic pencil and shiva gesso on canvas,
72 x 72 in (183 x 183cm), Des Moines Art Center, Iowa

Whatever delight the eye takes in the color of *Untitled No. 3* will be subsumed in the looking into an experience of something deeper – the color is there to take us somewhere. Her works (and this may sound strange) are supremely functional – aids to contemplation that, without being religious, are overwhelmingly spiritual.

AN ARTIST *once told me that* Leaf in the Wind *always suggests to her how a leaf flickers on a tree in almost a cinematic fashion, and that these lines are perhaps suggestive of that flicker of the film itself when it is slowed to the point where we become aware of each individual frame. Since my image has always been of a leaf floating free and wild, carried by the wind, I am unable to enter into this reading.*

AS WITH ALL ART, *there is no single interpretation, and anyone who comes with good will can have a valid response. All the critic can do is to encourage people to dare, to refuse to be put off by the apparent non-meaning of the work or by the unfamiliarity of its language, and to take time to allow it to speak to them.*

LEAF IN THE WIND
1963, acrylic, graphite on canvas,
75 x 75 in (191 x 191 cm), Norton Simon Museum, Pasadena, California

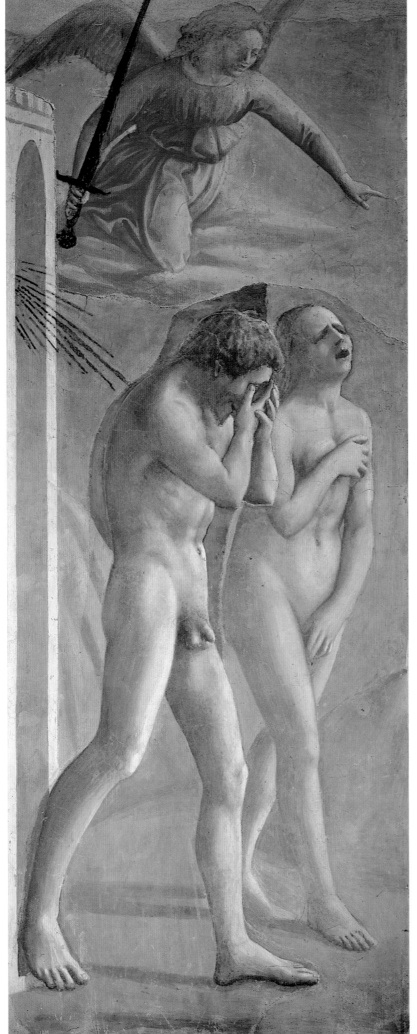

MASACCIO (TOMMASO DI GIOVANNI) ^{1401–28} b. Italy

THE EXPULSION FROM PARADISE

NO ARTIST HAS ENTERED MORE DEEPLY into the horror of the expulsion from paradise than Masaccio. It is a refugee situation that he portrays: home and happiness swiftly turned into loss and misery. It is this position of exile, so painfully familiar to our own times, that we can well appreciate. Adam and Eve pass through the thin strip of a gate as they exit Eden; from this point, their life must narrow from infinite space to the small compass of their daily labor. Adam is overwhelmed with shame and hides his face in the bitterness of remorse. Eve shields her breasts and her genitals, unable to bear this terrible exposure, and lifts her face in a rictus of anguish. One can almost hear the primal scream with which, slant-eyed and unbelieving, she enters into the barrenness of the real world. They have in fact been born, passing from the security of a paradise womb into the struggle of becoming fully human, with work and suffering as daily bread.

THE EXPULSION FROM PARADISE
c.1427, fresco, 84 x 35 in (214 x 90 cm), Brancacci Chapel, Santa Maria del Carmine, Florence

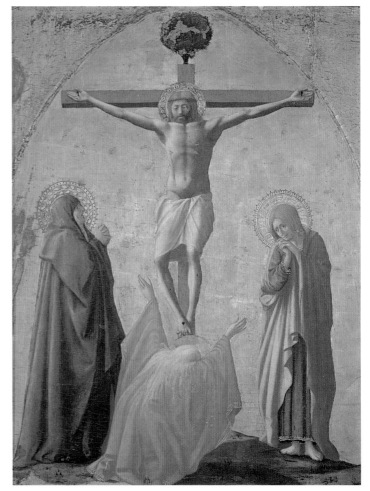

CRUCIFIXION
1426, tempera on panel, 30 x 25 in (77 cm x 64 cm), Museo di Capodimonte, Naples

This small panel is pregnant with intensity of emotion, expressed through dramatic body language. Mary stands rigid with prayer, John sinks into an introspective grief, while Mary Magdalene makes a wild and passionate gesture that we must partially imagine, as her body faces into the pictorial space and towards the tortured form of Christ looking down upon her.

MASO DI BANCO active mid-14th century Italy
ST SYLVESTER SEALING THE DRAGON'S MOUTH

VERY LITTLE SURVIVES OF THE WORK OF MASO DI BANCO, and this is a pity because, on the merits of architecture alone, his work carries a unique impact. Sylvester was the pope who baptized Constantine the Great. Maso di Banco painted famous stories from his life in a great fresco cycle in the Santa Croce Church in Florence. One of these stories was of a dragon that had made its den in the ruins of the Roman Forum, and Sylvester, with heroic courage, went not to slay the dragon but to tame it. We see him stroking the rather horse-like head of an obedient monster, but most of the picture is taken up with a still greater miracle. The dragon's breath had poisoned two Roman citizens, and Sylvester is about to raise them back to life. On the far right, Constantine expresses astonishment and admiration. Although the faces are impassive and the action, however thrilling in itself, is relatively static, the picture is memorable for the strong clarity of Maso's style.

THE DESCENT OF MARY'S GIRDLE TO THE APOSTLE THOMAS
c.1330s, tempera on wood, 20 x 9 in (52 x 23 cm), Staatliche Museum, Berlin

At Mary's ascension to heaven, Christian legend says that all the apostles were present except Doubting Thomas. He came too late to see the miracle, and to console him Mary dropped down for him her girdle. It is a symbol of the permanent connection between God and humanity, the bond that will always tie the hungry heart to the image of salvation. Later artists were to treat the same scene with Baroque splendor, but none cut so cleanly and surely to the heart of the message as does Maso di Banco.

ST SYLVESTER SEALING THE DRAGON'S MOUTH
c.1340–50, fresco, dimensions not known, Santa Croce, Florence

THIS IS AN ARTIST WHO UNDERSTANDS *that less is more and that the inanimate elements of a composition can be more dynamic than the human participants. It is the gaping ruins, the broken arches, and the shattered walls that haunt the viewer, and give a sense of the perfect city, even in this state of destruction.*

MASOLINO DA PANICALE c.1383–c.1447 b. Italy
MADONNA of HUMILITY

MASOLINO – "LITTLE TOM" – was one of the great figures of Renaissance Florence until he was overshadowed by his fellow artist Masaccio. It has taken time to disentangle these two great Florentine painters and for Masolino to be recognized as a great artist in his own right. The title of this early painting refers to the humble position of the Madonna, who is seated on the ground. Regardless of her position, the Madonna towers up, a majestic column of pink, gloriously covered with the blue-black swathes of her cloak, which contrasts with her delicate veil and gown. She holds the small Jesus, whose shawl is the strongest note in this harmony of colors.

MADONNA OF HUMILITY,
*c.1415–20, tempera on wood, 44 x 24 in
(111 x 62 cm), Galleria degli Uffizi, Florence*

ST JOHN THE EVANGELIST AND ST MARTIN OF TOURS
*c.1423, tempera on wood, 39 x 20 in (100 x 52 cm),
John G. Johnson Collection, Philadelphia*

John the Evangelist and Martin of Tours, both strong individuals, are shown here in an intense, almost confrontational relationship. Martin holds his bishop's crozier, and John, who as a simple Christian has no trappings of rank, seems almost to challenge him. It is Martin who wears the splendid vestments and the insignia of episcopal authority; John relies only on the authority of his Gospel.

THIS VIRGIN IS *more than just an ambulant source of nourishment for her Son; here, she is also the Queen holding her royal heir. Masolino is profoundly receptive to her dual role as Queen of Heaven and nurturing, earthly mother. The Madonna's long, beautiful face looks down serenely as the Baby Jesus sucks greedily at His mother's breast like any child.*

MASSYS, QUENTIN 1466–1530 b. Belgium
THE MONEYLENDER AND HIS WIFE

THIS GLORIOUS DOUBLE PORTRAIT is perhaps less an image of the moneylender and his wife than of their entire way of living: their office, their business, their faiths, and their personal relationships. Some have thought that man and wife are here opposed – the male occupied with material things, while the wife represents matters spiritual. Yet, the integrity and seriousness with which the moneylender weighs his coins is surely a noble activity, just as the wife desires to give God His due. Significantly, the original frame bore the inscription, "Let the balance be just and the weight be equal."

PORTRAIT OF A CANON
c.1515, oil on wood, 24 x 29 in (60 x 73 cm), Collection of the Prince of Liechtenstein, Vaduz

Although this canon is clearly a wealthy man, with fur on his sleeves and a fur-lined cloak over his arms, his face is a spiritual one – strong, intelligent, and with those deep-set hazel eyes fixed upon the unseen. He holds his glasses and his breviary (a book of psalms or hymns), and his unadorned black canonical biretta makes a lovely visual contrast with the thin creases of his clerical vestment. But the power of this portrait is infinitely enhanced by that spreading richness of landscape and sky.

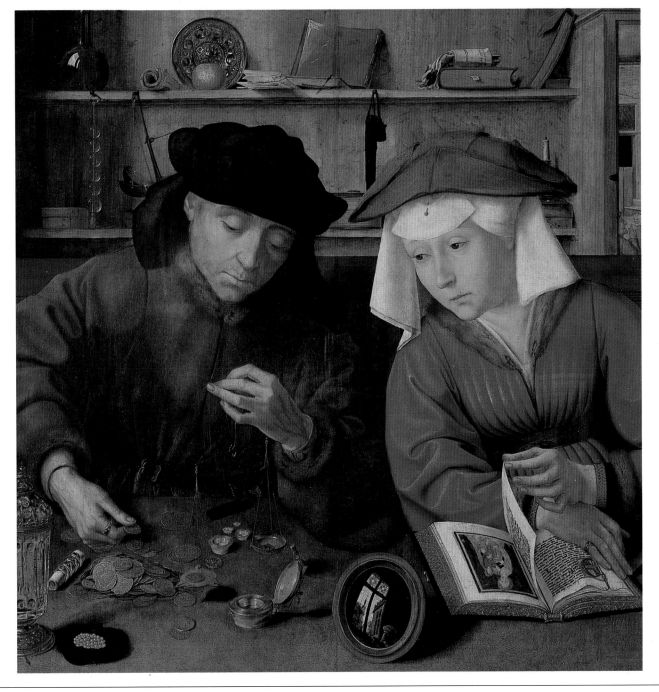

THE COINS *and jewels shining on the table are as worthy of our attention, Massys suggests, as the illuminated script, with its manuscript picture of Mary and her Child. The artist has dwelt on every aspect of this small room: the grain of the wood and the glimmer of light on silver, glass, fruit, and paper. Behind the wife, two people gossip in the street, but that trivial behavior is distanced behind their backs.*

ON THE TABLE, *made splendidly real to us, is the reflection in the convex mirror of a man reading a book. Behind him, the great cross of the window suggests the religious framework of all of this activity, and then the world beyond that miniature window reveals what seems to be a church steeple.*

THE MONEYLENDER AND HIS WIFE
1514, oil on panel, 29 x 27 in (74 x 68 cm), Musée du Louvre, Paris

MASTER OF 1310 active c.1310–25, in Italy
MADONNA AND SAINTS

WE KNOW NOTHING whatsoever about the Master of 1310 except the approximate date at which he painted. This is a pity because his work suggests that he was a highly unusual personality. His Madonna looks out at us with sultry eyes; she slants an oblique glance as if resigned or even apprehensive. The little Jesus, in His extraordinary purple clothing, is certainly apprehensive – His shoulders are tense, His arms are clutching not at His mother but at His own chest. The saints on either side have that same haunting presence.

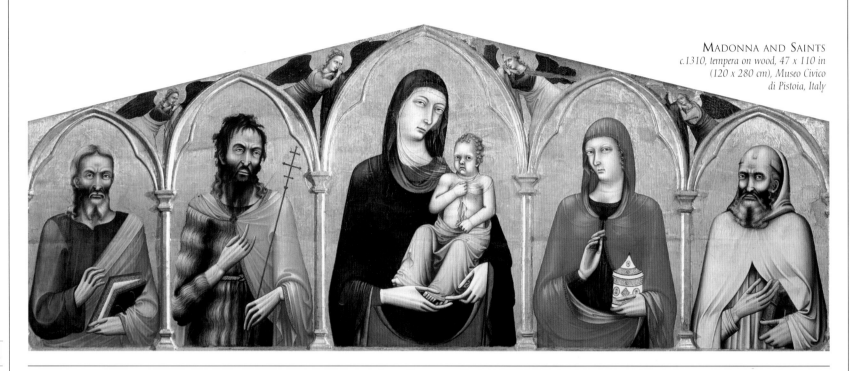

MADONNA AND SAINTS
c.1310, tempera on wood, 47 x 110 in (120 x 280 cm), Museo Civico di Pistoia, Italy

MASTER OF THE TŘEBOŇ ALTARPIECE active late 14th century
THE RESURRECTION

NOTHING IS KNOWN of the life of the Master of Třeboň. His name refers to Třeboň in the Czech Republic, one of the few places where his work – or, rather, fragments of his work – survived. The power and vitality of *The Resurrection*, now in the National Gallery, Prague, make us aware of just how much we have lost. It is a highly unusual image: the guards are not asleep, as Scripture suggests. If the guards were sleeping, they have woken in astonishment as the luminous vertical of Christ rises from the dead. His shroud is a vibrant vermilion that is echoed both in the sky, spangled with golden stars, and in the livid wounds on His body. Raising His hand in benediction, He seems to have come through the stone of the sarcophagus, which remains resolutely shut, and He appears to be bringing the whole world of nature (the background is radiant with birds) into the freedom of His newly resurrected life.

THE RESURRECTION
c.1380–90, tempera on wood, 56 x 36 in (132 x 92 cm), National Gallery, Prague

MASTER FRANCKE c.1380–c.1436 b. Germany
THE MAN OF SORROWS

DURING THE MIDDLE AGES, Christians experienced a growing need to draw emotionally on the sufferings of Christ. Preachers set the image before their congregations, using all the pious rhetoric at their command to make them aware of the evils of sin and the love of God. Artists treated the same themes visually. This tiny picture by Master Francke would have been intended for a private owner or for a small chapel, where the pathos of the image could be contemplated and the heart moved. This Christ is both dead and alive – His body is livid, and an angel, whose bright living hands contrast with the dead flesh, holds Him in space before us, while agonized eyes look out to challenge the viewer. The three angels seem more symbolic than real; Master Francke includes them for their function and nothing more. But the central figure is an overwhelming image of human grief, almost unbearable to behold.

ST BARBARA ALTAR
1414, tempera and gilt on wood, 36 x 21 in (91 x 54 cm), National Museum, Helsinki, Finland

Master Francke did a whole series that told the story of St Barbara. She was one of the most popular medieval saints, who was persecuted and ultimately beheaded by her own father (in turn, however, he was struck dead by a bolt of lightning). Here is one of the more dramatic episodes, when the evil father and his henchmen are pursuing the saint. In true medieval fashion, Master Francke shows the king and his horse towering above the trees and the simple humanity. The shepherds point out St Barbara's hiding place and, in punishment, half their flock is transformed into locusts.

AROUND CHRIST *are arrayed instruments of the Passion. One angel holds the spear that pierced His side, to which Christ Himself draws attention, and the sponge on the reed from which Christ was offered to drink. He also holds the bound rods with which Christ was whipped. Christ Himself holds the knotted scourge, and the angel behind Him extends the pillar to which He was tied for that scourging.*

THIS IS NOT A REALISTIC *body, twisted as it is, but an icon of religious faith, and its possessors would not have regarded it as a work of art. Rather, it was part of their religious service. They would have been horrified to think that something so private and so personal should hang in an art gallery to be judged on its aesthetic quality.*

THE MAN OF SORROWS, *c.1425, tempera on wood, 17 x 12 in (43 x 31 cm), Museum für Bildenden Künste, Leipzig, Germany*

MASTER OF THE ROHAN BOOK OF HOURS
active c.1420
France

OFFICE OF THE DEAD

THE MASTER OF THE ROHAN BOOK OF HOURS is one of the most original and electrifying artists of the Middle Ages. The dead before their Judge was not an uncommon theme in the time of the Black Death, when the prevalence of plague made the insecurity of life painfully prominent in the human consciousness. But no artist ever showed a corpse and his Creator in such a relationship. The dead man lies amid a plethora of skulls and bones, the long, emaciated diagonal of his corpse stretching pitiably across the frame in contrast to the rich cloth in which he has been interred. The Master of the Rohan Book of Hours understands human dignity *in extremis*, reduced at the last in the graveyard of disillusionment. The dead man's head is lifted up to God, to whom, as the scroll attests, he commends his spirit, trusting in His power of redemption.

THE ROHAN BOOK OF HOURS (LAMENTATION)
c.1430–33, illuminated manuscript, 11 x 8 in (29 x 21 cm), Bibliothèque Nationale de France, Paris

Many artists have painted Mary's lamentation over her dead Son, but none have approached the almost insolent originality of this artist in his depiction of the interaction between St John and God the Father. The Father seems bewildered and taken aback by the effect of death on His Son, and while the Divinity still rocks on His throne under the shock of this unwelcome insight, John turns to Him with a reproachful and accusing countenance. This is not the face of a man at prayer but of a man who blames. The artist shows God accepting that blame, and acknowledging that humanity has a right to its grievance.

GOD, A MASSIVE *warrior figure, leans down from heaven. Although He holds the sword, His face expresses compassion. God's answer to the dead man is that he will suffer for his sins, but He adds the promise that on Judgment Day they will be together.*

THE WHOLE DRAMA *of death and salvation is enacted in the far corner. A bat-winged devil has claimed for hell the soul of the dead man; but a gleaming St Michael plunges from the skies, seizing the devil's horns with contemptuous ease, and we feel assured that the outcome will be a heavenly victory.*

THE ROHAN BOOK OF HOURS (OFFICE OF THE DEAD), *c.1430–33, illuminated manuscript, 11 x 8 in (29 x 21 cm), Bibliothèque Nationale de France, Paris*

MASTER OF THE ST LUCY LEGEND active 1480-90 Netherlands

MARY, QUEEN OF HEAVEN

A PICTURE AS WONDERFUL as this makes it all the more astonishing that we know nothing about its painter, not even his name. It is only because this artist painted some exceptional works about St Lucy that he is so named. Here is Mary being taken up into heaven, shooting up, in fact, like a great scarlet rocket, so enclosed within herself that there is little sense of the angels actually lifting her. They accompany her, floating in the air with extraordinary visual splendor. Not only do they pray and sing but the angels on the periphery also play musical instruments with such precision that musicologists can learn not only the shape of the instruments of the time but even how those instruments were fingered in the 15th century.

VIRGIN AMONG HOLY WOMEN
c.1490, oil on wood, 42 x 67 in (108 x 171 cm), Musée Royaux des Beaux-Arts de Belgique, Brussels

Here, we see again a wonderful display of textural richness. Each of these women would have been recognizable to the contemporary viewer. St Agnes, for instance, sits on the right with her lamb; Mary Magdalen partners her, holding up the alabaster cup that is her symbol. But the artist's intention is less to draw our attention to the specific identities of these saints than to show the reward of a life of holiness. In the distance, St George fights the dragon, but these holy women have been removed from that world of peril and sit at peace with the Mother of God.

THE PAINTER HAS USED *the relativity of size magnificently. Mary and the angels, immediately before us, are large; behind them, all diminishes until far, far away in the skies of a heavenly court, equally real and yet not in our world, the Trinity waits to welcome her. Only a crown differentiates Father from Son, and the Holy Spirit in the form of a dove flutters between them, above the crown they hold out in readiness to honor the ascending Mary.*

THERE IS ALMOST TOO *much to see in this picture. Each of the angels is completely distinct in color, attire, and activity, even the wing forms differ. My own gaze tends to linger on the four most prominent: two wearing robes of papal splendor with enormous jewelled fasteners; one in luxuriant dark green and gold brocade; and one daringly in pure white. The music is almost audible as they soar heavenwards.*

MARY, QUEEN OF HEAVEN
c.1485, oil on wood, 85 x 73 in (216 x 185 cm), National Gallery of Art, Washington, DC

MASTER OF THE VIRGO INTER VIRGINES active c.1470–1500 Netherlands
THE ENTOMBMENT

WE DO NOT KNOW THE NAME of the artist who painted *The Entombment*. He is known as the Master of the Virgo Inter Virgines after one of his most popular paintings showing a seated Virgin Mary surrounded by a circle of well-born young ladies. Historians think that he lived at the end of the 15th century in the Netherlands, but whoever this unknown artist really was, he clearly had a unique vision and he remains a profoundly impressive painter. No other artist could paint the Entombment with such passionate originality. The actuality of the death of Jesus is forced upon us, the body bleeding and the hair falling loose over the slack arm. Joseph of Arimathaea and Nicodemus, who carry the body, thrust Him almost grimly towards His grieving mother. The impression of passion, of genuine involvement in the scene, is almost overwhelming. The set expression on their faces, echoed by that of Mary Magdalene behind, is emphasized by the extraordinary richness of their garments.

THE ENTOMBMENT
*late 15th century, oil on wood, 23 x 18 in
(58 x 46 cm), City Art Gallery, St Louis, Missouri*

Nothing can show the originality of this painter better than his second version of *The Entombment*, in which he does not concentrate on the dead Christ and even distances himself slightly from the grieving Virgin. The emphasis here seems to be on the view. All takes place in the context of this gentler, yet still wild and complex, world of many levels. A spire rises heavenward from a landscape of rivers and trees, and people walk along the road unaware of the sacred event.

BEHIND MARY ARE *her supportive women, but she herself is held by a strange St John, who has a swollen head and gaunt features. His hands are clenched fiercely around the grieving Virgin, whose protector he will be. One bony foot, almost deformed, thrusts out as if to meet Christ's dangling hand. But it is the intensity of the faces that is most impressive: St John's is almost a caricature and yet, remains utterly convincing in the intensity of its gaze.*

BEHIND ST JOHN, *Mary, and the mourning women towers a cliff. Behind the other group – the dead Christ, the men, and Mary Magdalene – ripples a soft, warm rock, at the top of which, lost in the heavens, is the Cross. On another level, removed from the intensity of the foreground, the spectator carries away the ladder that helped to bring Christ down from the Cross in order for Him to be taken to the stony valley for burial.*

THE ENTOMBMENT, *late 15th century, oil on wood, 22 x 21½ in (56 x 55 cm), Walker Art Gallery, Liverpool, UK*

MASTER OF THE WILTON DIPTYCH c.1395–99
THE WILTON DIPTYCH

WE DO NOT KNOW WHO PAINTED *The Wilton Diptych* or even his nationality. The date, though also problematic, is almost certainly within the years when Richard II was King of England, 1377–99. It is a picture of elegance and grace, rich with symbolism. The left-hand panel shows the young King supported by his patrons: John the Baptist, holding a lamb, and behind him two canonized English kings, St Edward the Confessor holding the ring that he is said to have given to a pilgrim, and St Edmund the martyr who was shot with arrows by the Vikings. The intense blue and the blossoming meadow of the right-hand panel is indicative of the heavenly joy with which Mary and the angels are enveloped, in contrast to the rocky, infertile ground of reality in the left. Like the Magi, the three kings and John the Baptist look towards Mary and the infant Christ. King Richard's longing hands extend towards the blessing hands of Christ – affirmation of his kingship, which was to be denied by his people. Each angel, in a touch of peculiar vulgarity, carries Richard's emblem of the stag, and one holds the standard of St George, patron saint of England.

THE WHITE HART
*c.1395–99, tempera on wood,
21 x 14½ in (53 x 37 cm),
National Gallery, London*

When closed, *The Wilton Diptych* displays the white hart, Richard's emblem. Seen in isolation, this is a touching image. Around the noble column of the stag's neck is a collar in the form of a golden crown attached to a golden chain, suggesting that the great privilege of kingship remains a form of servitude.

THE WILTON DIPTYCH, *each panel, c.1395–99, tempera on wood, 21 x 14½ in (53 x 37 cm), National Gallery, London*

MASTER THEODERIC, active mid-14th century b. Czech Rep.
ST GREGORY

SOME PICTURES ARE PECULIARLY DEPENDENT upon their setting to achieve their full effect. Just as images from the Sistine Chapel lose something of their power when seen in isolation, so the set of over a hundred paintings of saints, originally in the Chapel of the Holy Cross in Karlstein Castle, may not carry for us the full strength of their numinous quality. Yet, even snatched out of that sacred place and transferred from dim candlelight to full daylight on the page, an image like this shows how great a craftsman was Master Theoderic. Pope St Gregory was one of the four great theologians of the Church. It was he who wrote the Gregorian chant, which was sung in all the monasteries, and he is one of the great scholarly saints. Here he is writing, one hand holding the horn of ink; above him is the desk with his writing equipment, and, below, his sacred books. What comes across is the passion of the face and the intense vigor of the hands. Here is a teacher of almost terrifying eloquence.

ST JEROME
c.1360–65, tempera on wood, 44 x 41 in
(113 x 105 cm), Národní Galerie, Prague

St Jerome is more conventional than St Gregory, yet here too is a picture of extraordinary conviction. Jerome was not, in fact, a cardinal, since cardinals did not exist in his day. The later Church found this hard to believe, and bestowed upon him a scarlet cardinal's hat and robe. Typically of Master Theoderic, he gives the hat a bright green lining and carries it down, dramatically silhouetting the craggy face with the large jut of the nose and the firm lips.

WHAT MAKES THIS image so extraordinary is the angle at which Master Theoderic has set the great tome in which the Pope is writing. It has a surrealistic quality: seeming to cover his cheek, to jut right into his face and mouth, as if emphasizing that it was by the spoken word as well as by the written that the saint taught. His head seems detached from his body, floating, as it were, with a great golden glow.

THE DISJUNCTION between head and hands, which might seem disconcerting, is, in fact, extraordinarily powerful, and emphasizes the mystery of this picture. The frame forms part of the image, as if, for Master Theoderic, frames were there to be ignored at will – used, as it is at the bottom, functionally, and set at zero at the sides and the top, as a hindrance to the artist's intention.

ST GREGORY
c.1360–65, tempera on wood,
44 x 41 in (113 x 105 cm),
Národní Galerie, Prague

MATISSE, HENRI 1869–1954 b. France
THE PINK NUDE

WITH MATISSE AND HIS RIVAL PICASSO, the 20th century can boast artists as great as any of those in history. The great glory of Matisse is his sense of color and design. One marvels at the intelligence of his art, the glorious coherence of every part in a triumphant whole. Matisse has simplified *The Pink Nude* to a monumental elegance, so completely that she dominates the canvas; she is, he implies, too immense to fit into any circumscribed space. She lays her long, slender beauty along a simple blue-and-white-squared pattern, which sets off the subtleties of her flesh without challenging them. The one radiant mark is the simplified bunch of mimosa that decorates the center of her couch. Matisse felt that drawing in itself had color, that the passion of the artist's calligraphy could subsume the monotony of black and white, and perhaps we can see that in her face. Without color in her hair, eyes, or (except minimally) her mouth, we still feel that we are in the presence of a dazzling blond.

THE SNAIL
1953, gouache on paper, 112½ x 113 in (286 x 287 cm), Tate Gallery, London

Matisse had a long life and, at the end, disease made it impossible for him to stand before his easel. Nothing daunted, he invented a new way of painting, getting his assistants to color paper to his exact specifications, which he then cut out and formed into pictures. *The Snail* is one of the most astonishing of these, every piece precisely placed to give an impression of circularity in motion.

THE PINK NUDE
1935, oil on canvas,
23 x 37 in (66 x 93 cm),
Baltimore Museum of Art,
Maryland

THE PINK NUDE *has the distinction of having gone through many preparatory stages, each of which was recorded in photographs. It is an abiding fascination of art historians to see how slowly but, one feels, inevitably, this great shape formed itself.*

MATTEO DI GIOVANNI active c.1452–1495 b. Italy
ASSUMPTION OF THE VIRGIN

EVEN A MASTERPIECE CAN GO OUT OF FASHION, Matteo di Giovanni's *Assumption of the Virgin* was commissioned in 1474 by monks who later lost interest in it and stored it away in their woodshed. It is a splendid illustration of a story concerning the ascent of Mary's body to heaven after her death. The story is not contained in the Bible, but has been held in Christian faith from earliest times. Here, we see a whole array of angels, effortlessly propelling the serene and eternally youthful Mary up into the gold sky of heaven. Mary, with her celebrating angels, forms the center of the picture, and at the very top is her Son, leaning down to receive her. Beneath Him, at either side, cluster the saints and prophets who have already entered into heaven. Perhaps the most interesting figure is at the very bottom of the picture, the base, as it were, on which the whole grand contraption balances. The story has it, that when Mary rose from her tomb all the apostles were there except for Thomas (who, characteristically, once more refused to believe). When Mary was almost lost from sight, her girdle snaked down to earth for "Doubting Thomas" to catch, visible proof that she still listened and that she remembered him from heaven.

THOMAS STANDS *beside the empty tomb, with the real world, infinitely small, stretching on either side. His isolation is brought home to us by a clever distortion of perspective; the tomb rests solidly on the ground, but takes on vast proportions as the ground dwindles away into the distance. It is as if the whole world is looming out of perspective under the impact of the vision, and Matteo makes us aware of the utter division between earth and heaven.*

ASSUMPTION OF THE VIRGIN
c.1474, tempera on wood, 130½ x 65½ in (331.5 x 174 cm), National Gallery, London

CHRIST CROWNED
1480–95, tempera on wood, 9 x 9 in (22 x 22 cm), National Gallery, London

Around the edge of this picture is written the quotation from St Paul: "That at the name of Jesus every knee should bow, of things in heaven and things in earth, and things under the earth". Clearly this panel was painted for private prayer, and yet despite the inscription's authoritative voice this is not an image to awe or to induce excessive reverence, rather it is one to console. Christ wears His crown almost as a decoration rather than as a torment, and the emphasis is less on His suffering than on His benign compassion.

MELÉNDEZ, LUIS 1716–80 b. Spain

STILL LIFE WITH SALMON, A LEMON AND THREE VESSELS

MELÉNDEZ PAINTS HIS STILL LIFES with a serious sense of reverence. It is not grand themes that attract him, but the ordinary stuff of daily life, which he studies with an enormous visual interest in the everyday normality of form. Here, he has made a composition out of five objects. Three utensils are heaped together – a battered copper jug, a bowl, and a flagon – all huddled to one side. In front of them lies, at leisure, the most succulent slice of salmon in art history. The very look is moist to the eye, and Meléndez has traced the veining and the roughness of the skin with intense concentration. Then, set apart, not a complete oval, but swollen in places and darkened in others, lies a lemon, resting on the plate of its shadow. There is nothing here that clamors for attention, yet Meléndez makes us realize that, just in the perfection of their being, in the way that light hits their surface, and in their individual foibles, these forms are, of themselves, interesting and worthy of contemplation. There is no hint here that the fish will decay, or that the lemon will rot, while the battered pots will surely stagger on into the future. Meléndez's interest is solely in the actuality of these things and their claim on our attention.

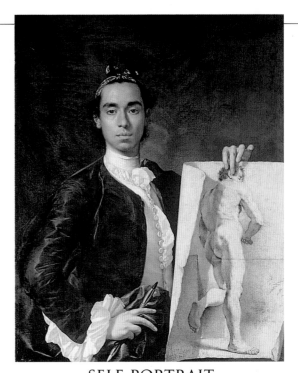

SELF-PORTRAIT
1746, oil on canvas, 39 x 32 in (100 x 82 cm), Musée du Louvre, Paris

This is Meléndez as a young man, proudly holding up a life study to show with what excellence he embarks on a lifetime as an artist; every line of his body proclaims a well-deserved arrogance. The confidence of this superb portrait was soon to be shattered, however, as his father fought with the Academy in Spain, resulting in the blackballing of Luis. Whatever his skill, few opportunities to shine would be offered to Meléndez.

STILL LIFE WITH SALMON, A LEMON AND THREE VESSELS
1772, oil on canvas, 16½ x 24 in (42 x 62 cm), Museo del Prado, Madrid

THE WHOLLY DELECTABLE SLICE *of salmon has not been gutted. The gut of the fish, dark and straggly with light catching silvery threads in it, has for Meléndez as much visual interest as the rich, pink flesh that surrounds it or the gleaming ivory of the spine that goes through the center. He makes us aware of a humble world that, were we to see it as he does, would stop us in our tracks with its significance.*

MELOZZO DA FORLÌ 1438–94 b. Italy
ST MARK'S SACRISTY

WE WILL NEVER KNOW HOW MANY MASTERPIECES have been destroyed, or how many great artists have been completely forgotten. Of those who have barely made it, the most significant is Melozzo da Forlì. So little of his work is left, and yet there is just enough to make us conscious of how supreme were his gifts. His decoration of the Dome in St Mark's sacristy in Loreto remains intact. It is a most extraordinary creation, not only in the glorious precision and invention of its decoration, but in the sheer brilliance that envisaged the eight faces of the dome as eight ledges on which to seat the great prophets of the Old Testament. Above them is the clear blue of an illusionistic window through which there seem to have flown eight magnificent angels, who now seem to be hovering above us in mid air. The prophets Jeremiah, Isaiah, Amos, Baruch, King David, Obadiah, Zechariah, and Ezekiel all hold a tablet on which, with dazzling clarity, is written a quotation from their works, referring to the Passion. Each angel carries an emblem of the Passion – the chalice, the scourge and the pillar, the Cross, the nail and the pliers, the branch of hyssop, and the sacrificial lamb.

AN ANGEL PLAYING THE LUTE
1480s, fresco (fragment), dimensions not known,
Vatican Museums, Rome

One of the most important paintings of 15th-century Rome was the monumental fresco with which Melozzo decorated the dome of the Church of the Holy Apostles. Now little of it remains, and even that little, detached and fragmented, we do not see from the intended angle, looking up into the great bowl of the cupola. Yet, with all these disadvantages and mutilations, *An Angel Playing the Lute* remains serenely beautiful. The angelic eyes are fixed on a scene now destroyed, probably the Virgin and Child, but he plays on for our delight.

WHAT MAKES *this dome so memorable is not just its beauty, though that in itself is overwhelming, but its sense of immediacy – its physical reality. It is hard not to believe that the prophets really sit there overhead and that these massive winged figures, in the fullness of their robes and the great sweep of their wings, truly hover above us.*

ST MARK'S SACRISTY
1480s, fresco, dimensions not known,
Basilica of the Santa Casa, Loreto, Italy

M
312

MEMLING, HANS c.1433–94 b. Germany, active Belgium

THE VIRGIN AND CHILD WITH AN ANGEL

HERE, WE SEE ALL THE CLARITY AND STRENGTH that make Memling's art so attractive. The donor, wrapped in prayer, is apparently oblivious to the sacred presences before whom he kneels. The Child stretches across with a baby's joyful inquisitiveness, entertained by the musical angel. St George, glittering in his armor, rises like a pillar behind the donor. St George brings with him the pathetic corpse of the legendary dragon, which dangles like a dead sheep at his feet – obvious proof of the inflated reputation of evil's power. St George's banner, the Christian emblem, proclaims to the world that this enclave, however affected by the winds of the world, is still dedicated to heavenly peace.

BATHSHEBA
c.1482, oil on panel, 76 x 33 in (192 x 85 cm),
Staatsgalerie, Stuttgart

Perhaps Memling should have been more alert to the possibilities of the secular. Although Bathsheba is a firmly biblical character, his painting of her diverges from the sedate altarpieces that are his usual fare. Instead, we see a woman of exciting energy, a married woman all too ready to accept King David's summons to his harem; here we see that eagerness for sensual experience drawing her into a world far removed from her own.

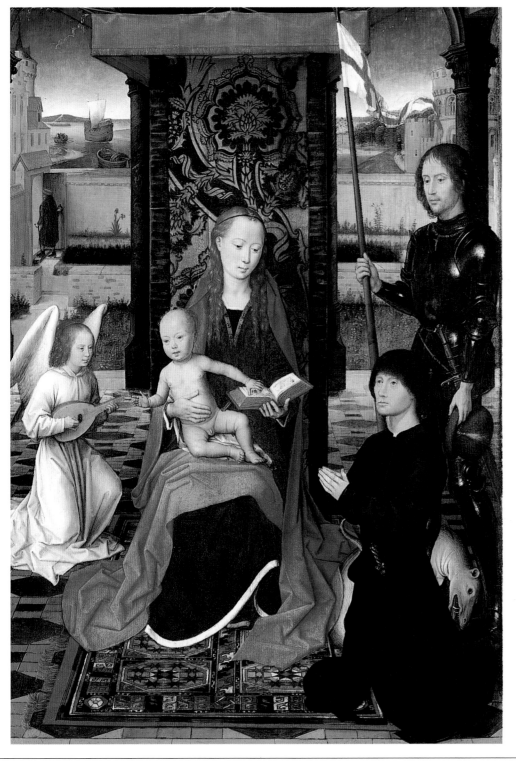

THE VIRGIN *sits on a splendid oriental carpet, the white curve of her hem drawing our attention to its patterning. Behind her rises an elaborate cloth of gold, and behind that the walls of a sacred enclosure for silent prayer, protected against the encroachments of the world we see beyond.*

THE VIRGIN AND CHILD WITH AN ANGEL, ST GEORGE AND A DONOR *c.1470–80, oil on wood, 21 x 15 in (54 x 38 cm), National Gallery, London*

MENGS, ANTON RAFFAEL 1728–79 b. Germany
MARÌA LUISA OF PARMA

MENGS HAD THE BAD FORTUNE TO BE BORN to a father who had decided that his child was to be a great artist. The pressure of such parental expectations drove him more than once to the brink of a breakdown, and one imagines that perhaps he was relieved to receive the summons from the King of Spain to become Court Painter. His father's ambition forced the artist too often into gigantic and wholly unconvincing mythological narratives, but, as is clear from this painting of Marìa Luisa of Palma before she became the Spanish queen, he had a natural gift for portraiture. The little queen comes across as radiant in her unselfconscious charm. She holds the carnation that for centuries symbolized betrothal and indicated that man and woman offered each other committed affection. One cannot but feel that if little Marìa Luisa does not fully understand the responsibilities to which she so joyously gives herself, the painter does. But the slight figure of Marìa Luisa sparkles out at us, convinced of her attraction, jewelled and gleaming in the sunlight.

SELF-PORTRAIT
1779, oil on wood, 22 x 18 in
(57 x 45 cm), Staatliche Museum, Berlin

At various times during his life Mengs turned a clinical eye on his own face, and on each occasion produced an impressive self-portrait. This is his last, painted in the year that he was to die, though he does not look 51. Mengs was a handsome man, and the hair is still thick and glossy, the eyes bright. It is impossible to know whether this was sentimental vanity or whether, as the portrait suggests, this was a true image. He looks at us and himself with such intensity, the brow furrowed as if seeking to grasp the truth of this familiar face.

BESIDE MARÌA LUISA
stands an urn, a solid presence in the sunshine, filled with the flowers that symbolize the children a queen must expect to bear. On her right two tall trees grow together, but are clearly asunder at their trunks.

SHE IS A STRANGELY LONELY
little figure, although not yet aware of this. Mengs compensates by dwelling on the alluring contrast between, on the one hand, that rosy, smiling face and the stylishness of her powdered hair, and, on the other, the gray and silver of her most exquisite gown. The sumptuous costume conceals her small body, which makes us all the more poignantly aware of the rigidities that corset the tender and hidden flesh.

MARÌA LUISA OF PARMA
1756, oil on canvas,
19 x 15 in (48 x 38 cm),
Museo del Prado, Madrid

METSU, GABRIEL 1629–67 b. Netherlands
THE DOCTOR'S VISIT

FOR US *THE DOCTOR'S VISIT* IS A SERIOUS TITLE. But in the 17th century, it was an occasion more for mirth, because the visit was restricted to one particular contingency: was the lady pregnant or not? Here we have what looks like, one is sad to say, a young woman of rather dubious virtue. The clothes she is wearing are of such grandeur that one would expect papa and mama and a retinue of servants to be assiduously in attendance when the doctor comes. However, she only has a Chihuahua – the kind of small dog that the upper-class prostitute favored – a knowing old maid, and a highly visible chamber pot. The doctor has taken a urine sample with which it was claimed a possible pregnancy might be clarified. His rather cavalier stance and his dashing hat suggest a certain lack of compassion for the predicament of the unfortunate young woman – one hand held in a certain position indicates that he knows well what is causing her morning sickness. Yet one cannot but feel compassion for the young woman (even though she goes to bed wearing her earrings), trapped in a situation that amuses the two elders, but which for her might well mean disaster.

A DEAD COCK
c.1655–59, oil on wood, 21 x 16 in (54 x 40 cm),
Museo del Prado, Madrid

We may begin by admiring the wonder with which Metsu has made this dead bird tangible: the feathers, the judicious limitation of color, with the black background, white body, and scarlet coxcomb. But as we look, the pathos of the situation becomes more and more unavoidable. One dead leg flops pathetically, the ropes that hang the bird look like a hangman's noose, and that glorious coxcomb that must have been strutted so proudly through the farmyard is here laid pathetically low. The sheer color makes this picture a miracle of subtlety, but Metsu's compassion for the dead bird carries the pictorial weight a stage higher.

THIS IS A PICTURE BRILLIANTLY PAINTED: *the gleaming and over-the-top bed; the extravagant Turkish carpet, which serves as a table cloth; the clothes catching the light so that the fur is soft and downy; and the underdress, its satin almost transparent – all are rendered with a technical perfection that astonishes. If one travels up from the border of the lady's diaphanous gown, through the luxurious pillow, one comes to the posts of the bed, which end triumphantly, not in one cherub, but in two.*

METSU DOES NOT OFFER *a scene of compassion. The unstated moral seems to be that the lady deserves what she brings upon herself. Yet Metsu consistently revealed a tenderness in his paintings, which perhaps we can see in the small dog. It is only the dog that responds to her dejection and physical misery, and for those of hopeful disposition, it may suggest a brighter future than the actuality of present circumstance.*

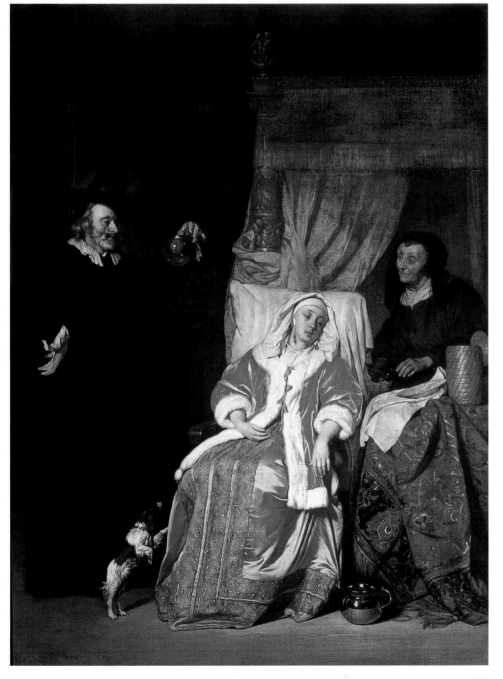

THE DOCTOR'S VISIT
1660s, oil on canvas, 24 x 19 in
(62 x 48 cm), Hermitage, St Petersburg

MICHELANGELO BUONARROTI 1475–1564 b. Italy
THE CREATION OF MAN

PERHAPS IT IS APPROPRIATE THAT MICHELANGELO'S frescoes in the Sistine Chapel are so far above our heads that we have to crane our necks to look at them, because they are the most sublime of all paintings. By common consent, the greatest of them is *The Creation of Man*. Michelangelo had a particular love and reverence for the naked male body, and saw it as God's finest creation – something purely splendid in itself and yet inadequate and incomplete without being matched by an equal splendor of the spirit. Adam, in his glorious male beauty lies sprawled across the newly created world. His head, however noble its features, is still relatively inanimate; this is body just on the point of receiving soul. Without clear understanding of what is at stake, he reaches out one languid, flaccid arm, and a finger rises just enough to be present for the electrifying charge that is soon to meet it from the creative hand of God. That tiny space is the distance between superb animal and superb human being. God parallels Adam, but from above, glorious in his mature power and encompassed with the spirits of heaven. The majesty of God becomes visual in Michelangelo's intensity of imagination: that benign and fatherly head – stern, but just and loving – leads us down to the hand, vibrant with creative electricity, and the stretched finger, ready to awaken Adam.

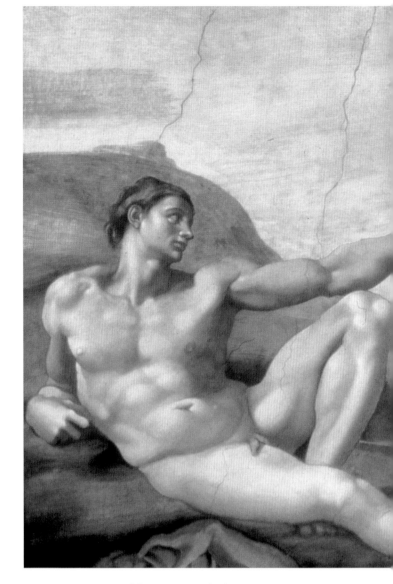

MICHELANGELO'S ADAM IS THE quintessential image of young masculinity. It is an ideal beauty, a perfection that expresses, for the artist, the glory of the unfallen world. This man, about to be summoned by God to his full psychic power, has such a potential for nobility (look at the intellectual brow, the firm chin, the sensitive mouth) that the subsequent story of his fall and self-despoliation becomes all the more tragic.

THE DONI TONDO
c.1504–07, oil on wood, 47 in (120 cm) diameter, Galleria degli Uffizi, Florence

Michelangelo always insisted that he was a sculptor – not a painter, and here, we sense the statuesque central trio of the Holy Family, no mere living-and-breathing humans. The gesture of Mary's arms towards the Child, the Child's arms towards Joseph, and Joseph's upper-left arm almost seamlessly joining Mary's keep the central figures perpetually in equilibrium, perpetually in motion. Behind these central figures are the naked youths of antiquity, setting the birth of Christ, and what it meant to humanity, into a historical context. Michelangelo saw all human history as a unit, and the connection here, between those who know only the classical gods and those who know Christ, is John the Baptist.

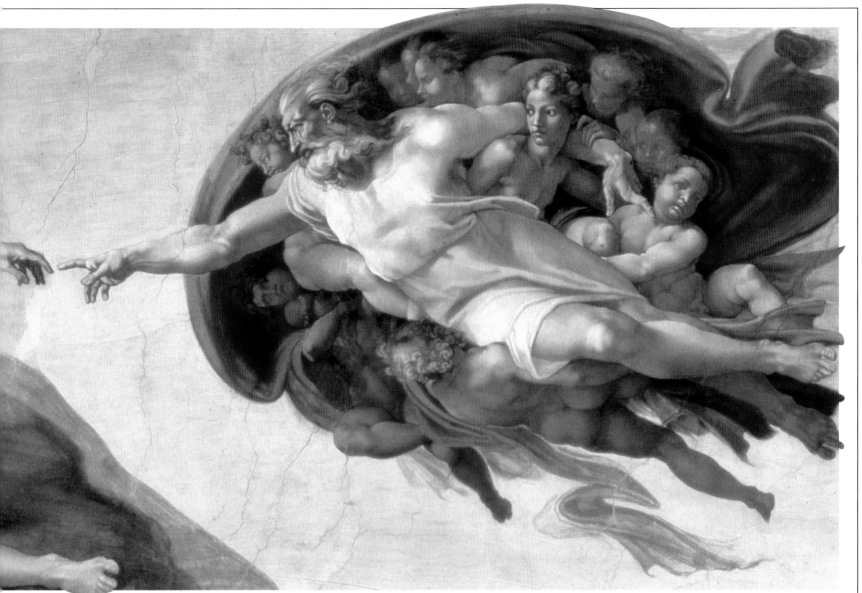

IT IS ALMOST IMPOSSIBLE *to paint God the Father, who, by definition, is invisible. All Michelangelo can do – and he does it with astonishing success – is present us with an image of power, goodness, and creative force. God swoops in from another world, and in so doing brings our world into being.*

GOD DOES NOT COME ALONE *but in a dense throng of angels, who bear him up and are somehow enveloped in a cloak of mystery. The swirling hollow of this cloak is Michelangelo's symbol for God's ineffable and unknowable being. Adam lies on recognizable earth, but the skies have rolled back for God to appear, and will shortly roll shut again.*

IS THIS EVE WAITING, *hidden within God's protective embrace? Surely no angel would have that indefinable look of mischief. It may be innocent enough – this is Eve before the Fall, of course, and still close to God – but there is a considering look in those big eyes that suggests not so much "woman the temptress" as "woman the huntress": Eve is weighing Adam up while he lies at her mercy.*

THE CREATION OF MAN *1508–12, fresco, Sistine Chapel, Rome*

"OH, TRULY HAPPY AGE OF OURS! OH, BLESSED ARTISTS! FOR YOU MUST CALL YOURSELVES FORTUNATE, SINCE IN YOUR OWN LIFETIME YOU HAVE BEEN ABLE TO REKINDLE THE DIM LIGHTS OF YOUR EYES FROM A SOURCE OF SUCH CLARITY, AND TO SEE EVERYTHING THAT WAS DIFFICULT MADE SIMPLE BY SUCH A MARVELOUS AND SINGULAR ARTIST!"
Giorgio Vasari

"WHO IS SO BARBAROUS AS NOT TO UNDERSTAND THAT THE FOOT OF A MAN IS NOBLER THAN HIS SHOE, AND HIS SKIN NOBLER THAN THAT OF THE SHEEP WITH WHICH HE IS CLOTHED?"
Michelangelo Buonarroti

MIERIS, FRANS VAN 1635-81 b. Netherlands

A YOUNG WOMAN IN THE MORNING

THIS DELIGHTFUL WORK provides a glimpse of a playful domestic scene that strikes us as highly convincing. The young lady, despite the beauty of her early morning attire, has a plain, homely Dutch face. The towel over the arm suggests the girl is not long risen and is about to begin her morning washing, but first, of course, she must pay attention to the small cosseted dog, rising (as it has clearly been trained to do) to receive its morning treat. The gentleness of the scene, its unhurried air of good humor and relaxed domesticity, makes it not only pleasant to look at, but also gives one almost a sense of participating in the intimacies of someone's life – though without voyeuristic vulgarity. Van Mieris makes us long to open that painted window a little wider to see the scene outside. We are certain it is there, we can see the leaves above; we can see the light coming through – a whole world of existence and experience and potential lies enclosed within this rectangle.

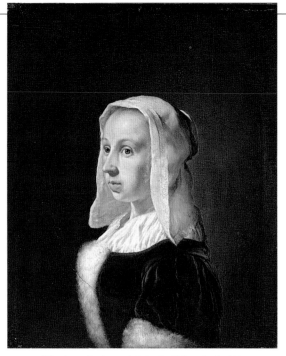

CUNERA VAN DER COCK
c.1657–58, oil on vellum, 6 x 5 in (16 x 13 cm),
National Gallery, London

Artists were often tempted to glamorize their wives when painting their portraits; the mere suggestion seems never to have crossed van Mieris's mind. This was the actual woman he had married, with her long nose and unsmiling mouth, and this is what he is proud to show us. The hollows in her forehead and the flow of her simple cap framing that rather suspicious little face are observed with loving and careful attention. One sees something of the hesitance of a young bride here, and perhaps the delight of a young husband. In its unpretentiousness and precision it is one of the great love portraits of an artist's life.

WHAT ATTRACTS *the artist is the play of light in the room: how it glimmers on the gold tassels on the bed, how it plays over the sheets and the blankets, how it catches the gold on the girl's night cap and enlivens the rich textures of her clothes, how it catches the embroidery in the Turkish rug and comes to rest on her shoes, which are waiting for her when she is ready to start her day.*

THE DOG IS ABOUT *to receive his treat but will be forever held in a state of delighted frustration. Likewise, we will forever peer into the picture, searching out its secrets, wondering what is written in the letter that lies on the table, what is in the little locked box, and what are the maid's feelings as she looks at the cossetted animal.*

A YOUNG WOMAN
IN THE MORNING
c.1659–60, oil on wood,
20 x 16 in (52 x 40 cm),
Hermitage, St Petersburg

MIGNARD, PIERRE 1612–95 b. France

THE MARQUISE DE SEIGNELAY AND TWO OF HER CHILDREN

THE HEAD OF THE FRENCH ADMIRALTY, the Marquis de Seignelay, died in 1690. A year later, his wife commissioned this extraordinary portrait from Pierre Mignard, the most revered and successful portrait painter of his times. The scene plays upon her late husband's involvement in affairs of the sea. The Marquise is presented as the sea nymph Thetis, one of the Nereids (daughters of the sea god Nereus), and sea shells are strewn beneath her feet to make the imagery clear. She holds aloft a cameo of shell and a string of pearls, both tributes of the sea that her lamented husband had won for France and for his widow. She has at one side her eldest son, dressed as the sea-faring Achilles, the son of Thetis. The youngest child is shown as Cupid, raising aloft a nautilus shell filled with pearls and branches of coral. There is a certain unconscious humor in the play-acting: the elaborate clothes, the studied pose, and the intellectual reference to a world of myths in which no one any longer believed.

PORTRAIT OF THE ARTIST
c.1690, oil on canvas, 93 x 74 in (235 x 188 cm), Musée du Louvre, Paris

As we can see from this self-portrait, Mignard took himself very seriously. Here, he is flanked by classical sculpture and literature; his palette and brushes rest by the side of the chair, and he depicts himself in action, sketching. Even if there is an element of the pretentious in this portrayal, we are still riveted by the impact of his gaze. His is a strong, dominant face that faces us with implacable concentration. The velvet swags with their hanging tassels make it clear that this is a deliberately staged portrait; it is as a revelation of the artist, resplendent in his expensive gown, concentrating on the activity that matters most to him.

THE WIDOW'S FACE *commands serious attention. She is a radiant beauty and seems genuinely to grieve. Her son, despite his exotic attire, leans on his mother's knee with the air of an orphaned child forced into responsibility too soon. The historical circumstances explain the imagery, but the power of the picture goes much deeper. These two – the Marquise and her eldest son – come before us in the starkness of loss, and possess the great advantage of physical beauty.*

THE BABY, WHO WAS *to die shortly after this picture was painted, is exempt from the prevailing sorrow. Mignard's genius is to take on board all the relative silliness of this scenario and still produce from it the most beautiful painting. The only obvious forewarning of disaster is the volcano in the background. This, we feel, is an emotional expression of how the Marquise must have experienced the sudden death of her husband – it speaks of a world exploded, a world in ruins.*

THE MARQUISE DE SEIGNELAY AND TWO OF HER CHILDREN
1691, oil on canvas, 76 x 61 in (194 x 155 cm), National Gallery, London

MILLAIS, SIR JOHN EVERETT
THE BLIND GIRL

IT WOULD NOT BE TRUE TO SAY THAT MILLAIS was a sentimental artist, and that this is a sentimental picture. The theme is, indeed, susceptible to sentimental treatment – a blind girl who is unable to see the rainbows that arch in the sky behind her – but Millais treats it with genuine emotion. He contrasts, with great brilliance, the glory of the world that lies behind the blind girl – the intricately detailed flowers and grasses that she can touch but not see, and then the whole expanse of meadow, ending in the little town in the distance – with the dark sky, cut through with a double rainbow. The little companion, hiding from the past storm under the girl's cloak, alerts us to what the girl herself is missing, while the concertina, silent on her lap, reminds us of the birds in the background, and that sensual joy to which this girl is still fully open. The butterfly is a miraculous color contrast to the gleaming auburn of one head and the silky golden brown of the other.

AUTUMN LEAVES
1856, oil on canvas, 41 x 29 in (104 x 74 cm),
Manchester City Art Gallery, UK

Millais once told his friend Holman Hunt that the odor of burning leaves in autumn brought back to him, very intensely, memories of days that were past. These four young girls gathering leaves are like four priestesses symbolizing the death of the year; but their youth also reminds us of the year to come. Millais set the picture in the Scottish Highlands, and the dark blue hills, luminous in the twilight, make this a haunting image of the passing of youth and the death of pleasure.

ONLY THE BUTTERFLY *and the birds are free; humanity is weighed down by clothes and boots, and the sheer pain of individual circumstance. Yet the girl's face is upturned to the light she cannot see, and, despite the fact that she probably begs for a living (the note pinned to her dress and the concertina indicate this), she seems fully acceptant of her lot.*

IN THAT STRANGE *brilliance of light after a storm, Millais sees the world as all the more glorious for being a privilege not vouchsafed to every human being.*

THE BLIND GIRL, *1854–56, oil on canvas, 32 x 24 in (81 x 62 cm), Birmingham Museum and Art Gallery, UK*

MILLET, JEAN-FRANÇOIS 1814–75 b. France
THE GLEANERS

MILLET WAS ONE OF THE FEW PAINTERS who knew the life of the peasant at first hand. His work baffled and annoyed his contemporary art world, which was not accustomed to such realism. But Millet claimed that in portraying the physical brutality of peasant life he was also proclaiming the nobility and dignity with which that life was often lived. His gleaners have the classic grace of ancient sculpture. So beautiful are the trio – with their blues and pinks and tender grays, with the gracious stance of their leaning bodies, and the self-absorption with which they work – that we need, perhaps, make an effort to understand the precise nature of what we are watching. In the background is the full harvest, with men on horseback and the security of farm buildings; in the foreground are the gleaners. These are the poorest of the poor, the women who have no proper work, but who pick out, one by one, the pitiful scraps left behind by the harvesters. Millet's sympathy and compassion are clear to us, but so is his admiration; what a true center to this great scene of harvesting are these three peasant women, who labor with such silent dignity.

THE SOWER
1850, oil on canvas, 40 x 36 in (101 x 83 cm), Museum of Fine Arts, Boston

Millet's sower seems to be a man of darkness. If his step is large and his gesture free, that is because of the exigencies of his labor. His face is half-obscured and his features are brutalized from sheer bodily endurance; yet this is a heroic figure, an image of the eternal springtime on which human life depends. At his right, two oxen, almost monolithic in stature, are urged on by another laborer.

ALL THREE, *even the stooping woman, are contained within the horizon of the field. They have no other world, the sheer pressure of keeping alive forces them to the unending labor from which they are never free to stand upright and look into the distance – to the sky, or to the heaped hay wains of the more fortunate people.*

MILLET HAS GIVEN *us space to understand the full reality of the women's task: they must struggle, must bear the pain of the bent body and the bleeding fingers, in order to feed their families. In the distance the fields look smooth. It is only in close focus – as we see it – that we understand what the task of gleaning truly entails.*

THE GLEANERS
1857, oil on canvas, 33 x 43 in (83 x 110 cm), Musée d'Orsay, Paris

MIRÓ, JOAN 1893–1983 b. Spain
LE PORT

MIRÓ DEDICATED HIS LIFE as a mature painter to exploring the mysteries of Surrealism. His earliest work was almost frighteningly realist, and it was as if in reaction to this that he began to paint works in which glorious fields of color serve as a background for blackly mysterious splodges. These weird markings had a definite, if strange, significance for Miró. The title of this picture makes perfect – if Surrealist – sense; this is a port, but not in any traditional meaning of the word. The "port" to which it refers is the sexual harbor, the place where the frustrations of the human psyche come to rest. The whole green-gold expanse, with its suggestion of the open sea, has at its center a dark, vaguely sexual hole. Yet that hole is just part of another form, and as our eyes traverse the picture we see strange breasts and testicles – delicate allusions to the miracle of our human anatomy as harbor and resting place for those of the other sex. Nothing in this picture stands still, however, and shapes constantly metamorphose into one another. The port, the harbor, is not static; it is rocked by the waves of an emotional sea, and the searcher, after repose, must constantly travel, investigating, reacting, and moving on.

LE PORT, *1945, oil on canvas,*
51 x 64 in (130 x 162 cm), Private Collection

THE RED SUN GNAWS AT THE SPIDER
1948, oil on canvas, 30 x 37 in (75 x 95 cm), Private Collection

Here is Surrealism at its furthest edge. We presume that on the lower right, the red-and-black creature with six legs is the spider; but what gnaws at it? On the left is what looks like a demented penguin, and at center and right are two grand images of some exotic calligraphy, with assorted eyes floating around. Miró does not intend to make sense but to titillate, to fascinate, to draw the eye around his canvas.

THERE ARE *sinister elements here: at least five strange eyes seem targeted, as if Miró is drawing attention to the significance of the eye in recognizing where the vessel of the spirit can find refuge. Yet, these eyes are also ringed targets, exposed for the arrows and bullets of those who focus their sights on them.*

AT THE FAR LEFT *there seem to be jagged teeth and below them Miró's symbol for a star – the artist had many symbols that were private to himself. Those who feel the need to impose the grid of Miró-rationality on such a picture can work out different shades of meaning, as Miró both celebrates and castigates the human body.*

MODERSOHN-BECKER, PAULA 1876–1907 b. Germany

LIEGENDE MUTTER MIT KIND

PAULA MODERSOHN-BECKER COULD BE DESCRIBED as a victim of circumstances. She was a major artist married to a lesser painter, Otto Modersohn, and it was Otto who pressed her to bear his child; when she finally capitulated, the childbirth killed her. The growing pressure which ended in her death in 1907 is reflected in this powerful picture of a mother lying with her child. The painting is almost a wish-fulfilment, with a large, strong, protective mother suckling a small, perfect, needy baby – the mother is in control. The whole drama has been concentrated onto the mat on which they lie, and if on either side stretches infinity, this does not matter. The mother has fulfilled her function; she has brought forth a healthy and vigorous baby and has the means to nourish it. The great cliff of the mother's body, her towering physical vigor, overshadows the tender face – a tenderness Modersohn-Becker knew she too could produce.

SELF-PORTRAIT
1906/7, oil on wood, 24 x 12 in (61 x 31 cm), Folkwang Museum, Essen, Germany

This self-portrait painted in the year of the artist's death has a vulnerability that is rare in art. Modersohn-Becker seems to expose herself, with that tremulous mouth and those big eyes gazing so wistfully into the future. Few self-portraits so clutch at the heart with their doomed and beautiful hope. As is typical of her wit and imagination, she not only rings her neck with a dark necklace but shows a camelia branch unheld and unassisted, floating, as it were, before her bosom.

LIEGENDE MUTTER MIT KIND, *1906, oil on canvas, 32 x 49 in (82 x 125 cm), Ludwig-Roselius-Sammlung, Bremen, Germany*

IT WAS THE GIANT *progenitive force that Paula Modersohn-Becker doubted, and we can feel that, here, she is urging herself forward, convincing herself against her fears that this is what the future will be: big mother, small child, and her career as artist unhindered. One can hardly look at it without distress, knowing the reality of her future.*

MODIGLIANI, AMEDEO 1884-1920 b. Italy
PAUL GUILLAUME

IF RUBENS STANDS FOR THE ARTIST who had it all, Modigliani stands for the artist who lost it all. He started life with enormous gifts: he was handsome, intelligent, charming, and an artist of the utmost sensitivity. By the age of 35 he was dead, the result of excessive drinking, drug-taking, and the general wretchedness of dissipation. But he had an insight into character, and an ability to portray it, which makes him one of the world's great portrait painters. Paul Guillaume was an art dealer, a category of humanity not always regarded by artists with benignity. Yet, this is not a hostile portrait. For all the arrogance of that large, square, tilted face and that supercilious nose, Modigliani still acknowledges the mystery of another personality.

NUDE ON A BLUE CUSHION
1917, oil on canvas, 25½ x 40 in (65 x 101 cm),
National Gallery of Art, Washington, DC

For centuries, the nude has been a central theme in art. Typically, Modigliani painted nudes that were regarded as obscene and banned from exhibition. His prime fault was to have been aware of the existence of pubic hair, and the narrowness of the minds that refuse to accept the reality of the body is depressing even today. This nude, sprawled out at ease, looks smilingly past the painter into her own visions of the future. There is a strange sexlessness in Modigliani's response to the globes and curves of the female body, and he seems as interested in the long, lemon shape of the elbow as he is in the round narrow shape of the adjacent breast.

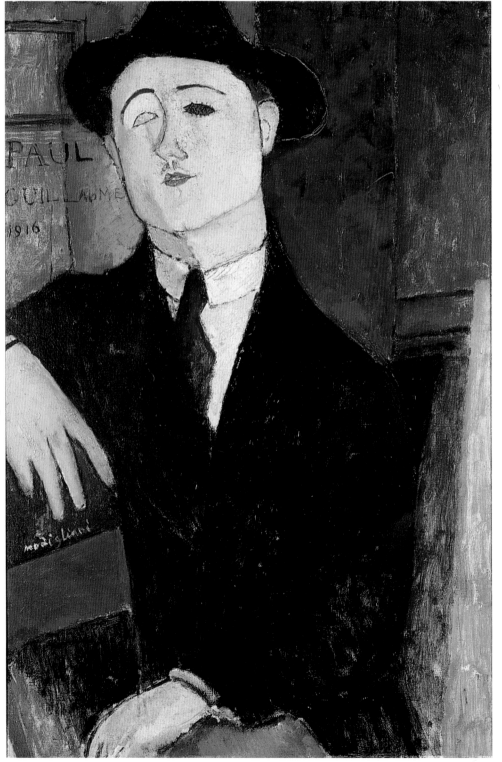

MODIGLIANI DELIBERATELY *portrays Guillaume as asymmetrical, recognizing that even the most villainous art dealer would have his other, contrasting, side. Thus, one eye is dark, thick lashed, and impenetrable, while the other is a lucid blue. Above the blindly staring blue eye arches a noble eyebrow, while over the black of his other eye is a much less elevated line.*

MODIGLIANI HAS SET *the sitter off-center so that he is encompassed by the chair, with its strange and luminous green on the right. But, to the left of the picture, the sitter edges out into his own secret world. Highlighting, almost to excess, Guillaume's pale, fleshy, and impressive head, the artist creates an image that haunts us with its mixture of certainties and uncertainties.*

PAUL GUILLAUME, *1916,*
oil on canvas, 33 x 22 in (83 x 55 cm),
Galleria Civica d'Arte Moderna, Milan

MONDRIAN, PIET 1872–1944 b. Netherlands
COMPOSITION, 1929

FOR THE TRUE ARTIST, art is probably his or her life, but Mondrian could also add that it was his religion. Art to him expressed the moral code, the way the world ineluctably was, even though humankind refused to admit it. So his art is an art of the utmost morality. Mondrian refused to admit diagonals into his paintings; in fact, he considered them deeply suspect morally. No, for him art was all noble verticals and pure horizontals, lines, of varying lengths and widths, and framed oblongs of only the purest primary colors – for Mondrian, mixing colors was also a no-no. In creating an art of the utmost severity and austerity, he would seem to be abandoning all that has made the art of painting beautiful and seductive, but, paradoxically, his paintings are profoundly satisfying.

COMPOSITION, 1929
1929, oil on canvas, 20 x 20 in
(52 x 52 cm), Kunstmuseum, Basel

PIER AND OCEAN
1915, oil on canvas, 33 x 43 in
(85 x 110 cm), Kröller-Müller
Museum, Otterlo, Netherlands

One of the fascinations of Mondrian is how he came by stages to the severity of the art by which he is best known. *Pier and Ocean* shows him as moving from his early art, which was purely realistic, through a stage of semi-abstraction. The title is hint enough for us to pick out the central pier, and then the rippling waters – rippling, of course, even at this early stage, in severely straight lines.

THERE IS, *surprisingly, great visual interest in contemplating a Mondrian. Even though there are only two colors here – a red and a black – the balance of the forms, their narrowness or breadth, the length or shortness of the lines, the lack of frame, all somehow combine to make a statement of affecting and uncompromising beauty.*

AS MONDRIAN *profoundly believed, something deep in our psychological make-up does indeed respond to these simple shapes. We are moved by something in the sheer frontality of these squares and oblongs, which the artist sets before us without the slightest subterfuge.*

MONET, CLAUDE 1840–1926 b. France

THE PETIT BRAS OF THE SEINE AT ARGENTEUIL

THE IMPRESSIONISTS WANTED, above all, to give us an impression of a particular moment in time, of a particular light and mood, to give the feeling of what it was like to be somewhere specific. The greatest of the Impressionists is Monet, and in this picture we see him in an uncharacteristically gentle mood. We are standing with him on the banks of a narrow stretch of river that glimmers away into the distance. It is a scene absolutely without drama. Nothing is happening except for the silent activity of those two small, black figures on the near side. And yet, each element of the scene – the great pure, pale sky; the trees barely leafed, the sandy banks without even the allure of grass – combines to create a feeling of the utmost tranquillity. Monet's genius is in taking a scene that, in actuality, we might well have passed by without a glance and dwelling on it long enough to make us aware of the wonder of this privileged moment.

THE PETIT BRAS OF THE
SEINE AT ARGENTEUIL
*1872, oil on canvas, 21 x 28 in
(53 x 72 cm), National Gallery, London*

"MONET IS ONLY AN EYE, BUT
MY GOD WHAT AN EYE"
Paul Cézanne

THE JAPANESE BRIDGE
1918–24, oil on canvas, 35 x 39 in (89 x 100 cm), Musée Marmottan, Paris

Monet's eyes dimmed as he aged, which had a strangely wonderful artistic consequence. Knowing the theme of this work – that it is the bridge over his Japanese pool – we can just make out the bridge and the waters and the foliage, and understand that the glorious scarlet comes from the setting sun. And yet, without the title, might we not have thought that this was an abstract painting?

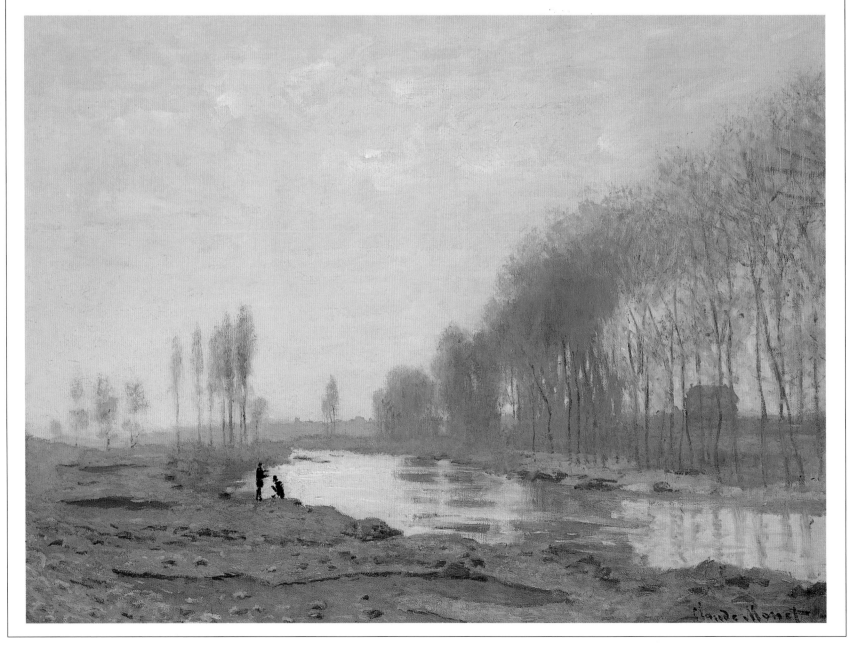

MONNOYER, JEAN-BAPTISTE
1634–99
b. Netherlands

FLOWERS AND FRUIT

STILL-LIFE PAINTINGS TEND to be rather repetitive, but the works of Jean-Baptiste Monnoyer are a wonderful exception. If Monnoyer was renowned as the greatest painter of still life in 17th-century France, a work such as *Flowers and Fruit* explains why. He treats his theme with daring originality: here is no vase with its seasonal flowers, but a strange spill across a stone ledge, with light glinting on silken fringes, and two surprising swoops of a tassel dangling above. The flowers and the fruit have not been set out to stand still and, as it were, have their portrait painted; they spill from the up-ended bowl, and what is spilled seems a wild combination of the familiar and the exotic. Extraordinary blooms from the Americas spray out from among the more common carnations and roses, with spring daffodils and the rich fruits of autumn. Monnoyer makes no attempt to suggest that such a scenario is possible. Even the strange folds and bends of what seems to be an open purse hint that the artist is making a statement here, rather than seeing the beauty of flower and fruit as an end in itself.

ROSES, POPPIES AND CARNATIONS
17th century, oil on canvas, 22 x 18½ in (55.2 x 46.4 cm),
Rafael Valls Gallery, London

The vanitas picture, with its customary skull and hourglass, is over-obvious for Monnoyer. Here, with sophistication and skill, he makes the same statement, beautifully and subtly. Here again, he can astonish us with the sheer exuberance of his flowers, which seem to burst out of the confines of the canvas, thrusting forth their blossoms with an almost animal presence.

FLOWERS AND FRUIT
17th century, oil on canvas, 29½ x 48 in (75 x 122 cm), Hermitage, St Petersburg

THERE IS OPULENCE IN THE VELVET *curtains, the golden bowl, and the rare flowers; there is sensual pleasure, too, in the almost tactile fullness of the fruit and the rich, bright colors of the flowers. While the stone will endure, Monnoyer is reminding us that neither money nor sensual pleasure will last.*

MOR, ANTHONIS c.1517–c.1576 b. Netherlands
QUEEN MARY OF ENGLAND

ELIZABETH I HAD BETTER FORTUNE than her elder sister Mary in every respect except one: it was Mary who had the good luck to find a portraitist of genius. Elizabeth had her icon painters, but Anthonis Mor gave us Mary I in all her angular pathos. He has been fair by the Queen, who, like all the Tudors, adored dressing up. But the personality that we are confronted with is an unhappy one. We see a pinched mouth; anxious, watchful eyes; and, although her hair has an auburn gleam, the parting is suspiciously wide. She seems to have no bosom, and it is easy to believe that the child for which she so longed was not conceivable. Mary is withered and old before her time, but she is still intent on grasping the sceptre of power, much as she grasps her jewelled gloves; yet she finds in the exercise of authority no womanly comfort. All of this, Mor conveys with the utmost tact and subtlety. There is nothing here for the Queen to find objectionable, because – truthful woman as she was – she would have recognized her true countenance; the artist has also displayed her splendor with a dedication that she would have appreciated. If Mor shows us a queen, he also shows us a queen who wanted to be a woman, but was unable.

PORTRAIT OF A GENTLEMAN
1569, oil on canvas, 47 x 35 in (120 x 88 cm,)
National Gallery of Art, Washington, DC

Mor's gentleman would remain hostile in his arrogance and aristocratic disdain, frowning at us, and all too conscious of his good looks and social position, were it not for the dog. The dog humanizes the gentleman. Pretend as he will that the dog is simply there as an adjunct, that great noble head (compared to which the human head appears relatively insignificant) clearly represents something of great importance. The fingers that caress the dog suggest a chink in the gentleman's armor, and also point out the splendor of the dog's collar.

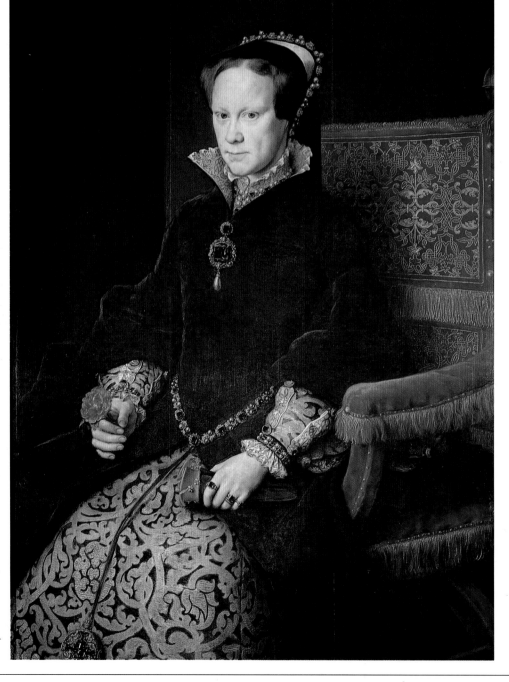

MOR CAPTURES THE *splendor of Mary's pearled headgear, the embroidered ruff, and her jewels, treasured because they had often come from her adored and frequently unfaithful husband, Philip II of Spain. He also dwells on the detail of her jewelled girdle, her gorgeous sleeves, and the carnation, which she holds pathetically as an emblem of affection for Philip.*

EVEN THE CHAIR *is of Tudor splendor, almost vulgar in its scarlet and gold, tasselled and buttoned with great splaying legs. Yet Mary does not fill it – there are great spaces, for which her bodily capacity is too meager, and the tense uprightness with which she sits suggests unhappiness.*

QUEEN MARY OF ENGLAND, SECOND WIFE OF PHILIP II
1554, oil on wood, 43 x 33 in (109 x 84 cm),
Museo del Prado, Madrid

MORALES, LUÍS DE c.1509–86 b. Spain
MATER DOLOROSA

LUÍS DE MORALES WAS ALSO KNOWN AS *"Il Divino"* (the Divine one) because his devotional paintings, such as *Mater Dolorosa*, were so pious and spiritually affecting. His depiction of Mary is peculiar to him: the face is exceptionally long and thin, as if worn down by sorrows; the cheeks are hollowed; and the eyes are deeply recessed and shadowed. Mary's beauty is indestructible, but pain has diminished it. Perhaps this is clearest in the anguished hands, which are as expressive of grief as the face itself. The long, bony fingers are thrust out at us with an almost Surrealistic passion, bringing to mind the legs of a frantic crab or some other such scurrying creature. Those anxious fingers speak more loudly of her inner tension than the quivering lips or the hunched and tense shoulders. While her hands are held towards us, Mary looks away, her eyes cast down to the dead Son that we cannot see.

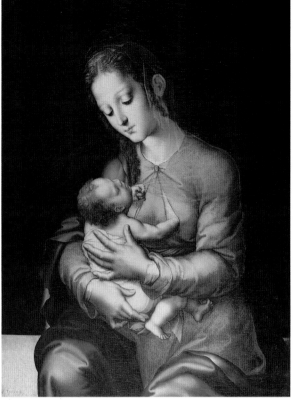

MADONNA AND CHILD
1568, oil on wood, 33 x 25 in
(84 x 64 cm), Museo del Prado, Madrid

This is Mary before her world is destroyed: curly haired, lightly dressed with a veil, and with her full, young body radiant in a glowing pink that shimmers from beneath her rich, blue cloak. The Child searches for the mother's breast while she, in no hurry to meet His physical needs, focuses intently on the precious burden that she clasps to herself. The great difference between this young Mary and the Mary of the *Mater Dolorosa* can be seen in the hands. Here, they are rounded and strong – the capable hands of a working woman.

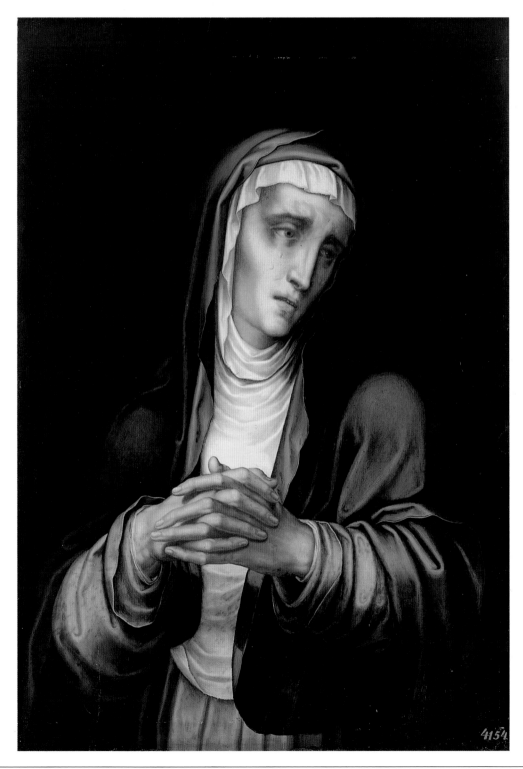

APART FROM THOSE *tensely clenched fingers, Mary's emotions make no overt display. This stillness – this compressed intensity – is far more evocative of grief than the melodramatics of de Morales's Italian contemporaries. Here is a woman who is almost incandescent with her sorrow.*

THE COLORS *de Morales has used here are extraordinarily subtle – the faintest of blues and purples, bleached yellows, and an almost translucent white – all set against a dark, somber background that reinforces the idea of human tragedy.*

MATER DOLOROSA
c.1570, oil on wood,
33 x 23 in (83 x 58 cm),
Hermitage, St Petersburg

MORANDI, GIORGIO 1890–1964 b. Italy
STILL LIFE

FOUR BOTTLES, A JUG, AND A JAR, all painted in whites, browns, or blacks, do not constitute many viewers' idea of a masterpiece. What, after all, are we looking at? The miracle of Morandi is that we seem to be looking at the secret of the universe, the mystery of creation: here is all life in this humble, unassuming, material form. He never wanted to extend his repertoire beyond simple, poor bottles and jugs. He found in them an endless display of interest and wonder. These six objects, huddled together in the center of a background that is distinguished only by different shades of gray, seem infinitely vulnerable. They quiver on the canvas before us. At the front, as if protecting the rest, is a jug that juts its handle out at the world. Without the slightest vulgarity of humanizing the objects, we still feel drawn to them – fellow victims, exposed and unprotected against the ravages of life.

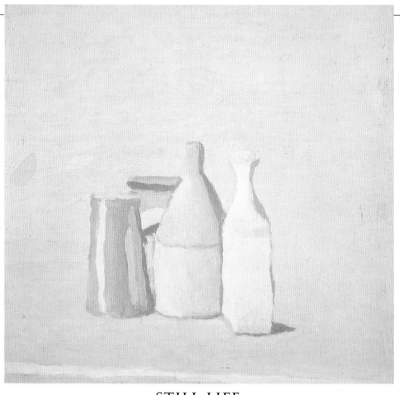

STILL LIFE
1957, oil on canvas, 11 x 16 in (27 x 40 cm), Kunsthalle, Hamburg

Typically, these objects are perched on the very edge of their table, and yet what seems to await them, if they fall, is a luminous eternity, not destruction. They stand with a quasi-human readiness and, like the poor or dispossessed, seem unable to resist the gaze of attention. Morandi is clearly sympathetic to the radiant beauty of this peasant pottery.

STILL LIFE
1948, oil on canvas,
17 x 19 in (44 x 48 cm),
Fondazione Maghani,
Rocca, Parma, Italy

THE OBJECTS ARE PAINTED *with such tentative beauty that we feel Morandi only holds them together by a supreme effort of will – if he were to relax they would fly apart and disintegrate not into shards but into the most delicate dust. Perfection is no part of his world, but reverence is.*

MOREAU, GUSTAVE 1826–98 b. France

HESIOD AND THE MUSE

MOREAU WAS A PROFOUNDLY POETIC ARTIST, influenced by myths, by dream theory, and by a belief in the power of reverie and hallucination. His is a world lost in an opium haze, with hints of decadence and of the overripe. Along with Homer, Hesiod was one of the first Greek poets, and Moreau shows him as if trapped in a somnambulistic trance, walking towards a deep ravine, down which waterfalls tumble and strange bright birds flutter and cry. But the poet is directed and protected by his guiding star, the Muse – that pure, strong presence of his inspiration.

HESIOD AND
THE MUSE, 1891,
oil on canvas, 23 x 14 in
(59 x 35 cm), Musée
d'Orsay, Paris

ORPHEUS
1865, oil on canvas, 61 x 39 in
(154 x 100 cm), Musée d'Orsay, Paris

Orpheus, the mythical inventor of music, came to a brutal end when he witnessed the Thracian women at their secret worship of Bacchus. Maddened with wine and lust, they tore him to pieces and threw his head into the stream. Moreau imagines the aftermath of this event as an exquisite young girl, elegant and composed, recovers Orpheus's beautiful head and his lyre.

MORETTO DA BRESCIA (ALESSANDRO BONVICINO) c.1498–1554 b. Italy

PORTRAIT OF A YOUNG MAN

THIS YOUNG MAN HAS BEEN IDENTIFIED as one of the Martinengo family, but our knowledge of this adds little to the impression of romantic longing that the picture communicates. On his hat Moretto has inscribed in Greek, "Alas I desire too much." The young man has been set before a splendid background, leaning on soft cushions as if to suggest that this romantic unfulfilment might contain a certain element of role-playing. The face is over-melancholic, over-intent to impress upon us the immensity of his desires and the impossibility of their fulfilment. Moretto subtly meets the demands of his client, and yet also hints at a more objective reaction to the sitter's posturing.

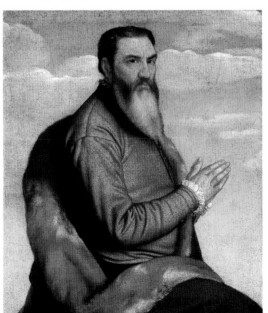

PORTRAIT OF
A MAN AT PRAYER
c.1545, oil on canvas, 41 x 35 in
(103 x 89 cm), National Gallery, London

It is unusual to find a portrait of a man at prayer, especially in the middle of the 16th century. Most probably, Moretto painted this fine picture for a family burial chapel, as a memorial of this man in his most private and sacred moments. He is seriously intent upon the direction of his prayers, and around him floats the background of Heaven.

PORTRAIT OF A
YOUNG MAN
c.1542, oil on canvas,
45 x 37 in (114 x 94 cm),
National Gallery, London

MORISOT, BERTHE 1841–95 b. France

THE HARBOR AT LORIENT

BERTHE MORISOT WAS AN UPPER-CLASS YOUNG WOMAN who, without any obvious necessity to paint other than for her own enjoyment, turned out to have a genuine artistic talent, comparable to many of the best Impressionists. She married Manet's brother and was inevitably borne into the sphere of that family's influence. *The Harbor at Lorient* seems to me to be head and shoulders above all her other work. Here, she achieves a solidity, a power, and a ravishing sense of atmosphere that owes less to the stylistic influence of the Impressionists and more to her own innate visual ability. This is her sunlit world – a world of order and precision and clear bright color. Morisot feels completely at home here, and the picture draws us into its depths.

IN THE DINING ROOM
1886, oil on canvas, 24 x 20 in (61 x 50 cm), National Gallery of Art, Washington, DC

This picture provides a fascinating insight into Morisot's strengths and weaknesses. The one solid figure is the maid – solid, at least in her face, hands, and body (although even her apron is drawn into the swirling and tremulous chaos of the material world that surrounds her). Morisot was both drawn to the tremulous and indecisive and repelled by it. Her weakest works give way to the fluttering beauty of vagary and whim; her strongest works affirm the power of her personality. Here we see both, as the maid emerges all the stronger in her control of the indeterminate looseness of her context.

THE HARBOR AT LORIENT
1869, oil on canvas, 17 x 29 in (44 x 73 cm), National Gallery of Art, Washington, DC

THE LADY SITTING COYLY *on the harbor wall with her pink parasol directs us back into the vast glimmer of the blue waters, above which are the harborside buildings and the ships and the great sky that arches over all.*

THE CONSTRAINTS THAT CURVE *around in the foreground and angle at the back are barriers that set the waters free, and it may be that Morisot saw here an emblem of her own need for self-control, without which her artistic powers would be lost.*

MORONI, GIOVANNI BATTISTA c.1520–78 b. Italy

PORTRAIT OF A GENTLEMAN

MORONI WAS NOT ONLY A PORTRAIT PAINTER but much of his strongest work is in this genre. *Portrait of a Gentleman*, traditionally called *Il Cavaliere dal Piede Ferito* ("the man with the wounded foot"), is a picture that is unforgettable in its realism. Before we take in the fact that this man is crippled – that one leg needs the support of a mechanical brace and that he rests his arm on his helmet as much out of necessity as for play – we are struck by the arrogance of his lean, aristocratic countenance. He challenges us to feel pity for him. That thin, disdainful mouth defies all-comers to meet him on any terms but his own. He is a wealthy young man, a long thin emblem of superiority, sprouting a flurry of egret feathers from his modish hat. His left arm rests on the extravagant helmet, which explodes with status symbols and is crowned with a star-like jewel. His helmet and sword – the marks of a warrior – are clearly important to him, and at his feet are his warrior's gloves and the elements of his armor that he has reluctantly removed for this portrait.

PORTRAIT OF
A GENTLEMAN
*1555–60, oil on canvas,
80 x 42 in (202 x 106 cm),
National Gallery, London*

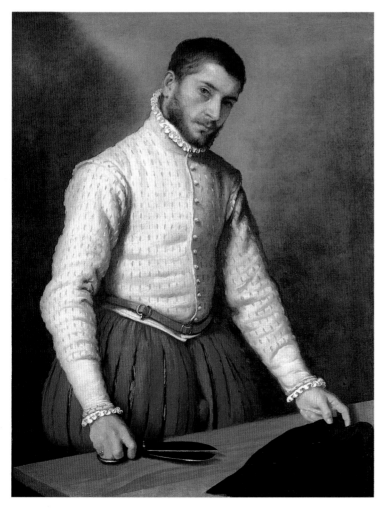

PORTRAIT OF A TAILOR
*c.1570, oil on canvas, 39 x 30 in
(98 x 75 cm), National Gallery, London*

Here, Moroni paints a man at work: a tailor. Sociologists delight in these details, but for the rest of us the great appeal is Moroni's awareness of what it means to be a professional. The tailor does not draw his confidence from rank or wealth but from the sense of knowing his job and performing it well. It is a long, level glance we are given from a handsome man, on whom the light falls, illuminating the patterning of his doublet and the frill outlining the gentle and friendly face.

THE BACKGROUND is two-fold: above is the stained and decaying marble of antiquity, prey now to the ravages of vegetation; below, there is a different marble, chipped in parts but still magnificently assured of its place in the modern world. Does Moroni take secret note of the flaws that are not disguised but not flaunted? Does he admire them? We understand that that forbidding gaze denies compassion, but is there more to the portrait than its superb realism? We are left with our questions.

MOTHERWELL, ROBERT 1915–91 b. US
UNTITLED (ELEGY)

NOT MANY ARTISTS HAVE THE TIME, DESIRE, or intellectual capacity to be philosophers or scholars, but Robert Motherwell was exceptionally gifted. Much of his intellectual energy was centerd on Spain – its history and its folklore. Something about that tempestuous country moved him poetically, and he perpetually came back to the theme of the elegy. Originally seen as great symbols of grief for the Spanish Civil War (and for the poets, such as Lorca, who were destroyed in it), his elegies broadened out to become laments for all beauty wantonly brought low by human cruelty. Motherwell's elegies make use of a recurrent shape, reminiscent of the horns of a bull or the head of a matador. Behind such a form, painted in a wholly extraordinary black, lurk other colors – hints of the luminous, the scarlet of blood – that provide a context of relativity. Motherwell combines them in a crescendo of artistic fervor.

DRUNK WITH TURPENTINE No. 38
1979, oil on handmade paper, 16 x 20 in (41 x 51 cm), Private Collection

Drunk with Turpentine is a witty comment on the way Motherwell actually painted this image. By using unprimed paper, he made certain that the paint would ooze into the turpentine splodges, and the word "drunk" suggests his delight in this controlled destruction. The image he created – at once wild and directed – has a beauty that is both undeniable and inexplicable.

UNTITLED (ELEGY)
1988, acrylic and charcoal on masonite, 24 x 36 in (61 x 92 cm), Private Collection

THESE PARTICULAR SHAPES *became almost Motherwell's trademark; forms and colors through which he felt able to express, over and over again, with renewed vigor and without repeating himself, his grief and his exultation in human tragedy.*

MUNCH, EDVARD 1863–1944 b. Norway
THE SICK CHILD

As his art leads us to expect, Munch had a shadowed childhood. First, his mother died, and then his elder sister suffered a protracted and painful death. Munch's father was a doctor, and it was when he accompanied him on visits to the sick that Munch felt sufficiently distanced from his own experience of death and grieving to create his own images of sickness and despair. The child stricken by illness and her anguished mother constitute almost an icon of human helplessness, and Munch was temperamentally receptive to such despair. The sad mourning of life and hope is very visible in this tragic painting. The girl is painted in the lurid colors of fever, her red hair in sickly contrast to the unhealthy gleam of her pallid skin. Her bodily form is a mere outline as she leans against the cruel brightness of the bedhead, with its pathetic attempts at decoration. It is the mother – that great, black, bowed image of grief – who bears the implacable message that the child has no certain future. The work is saved from melodrama by Munch's insight into early death; he does not paint as a spectator here, but as one who knows what it means to grieve hopelessly.

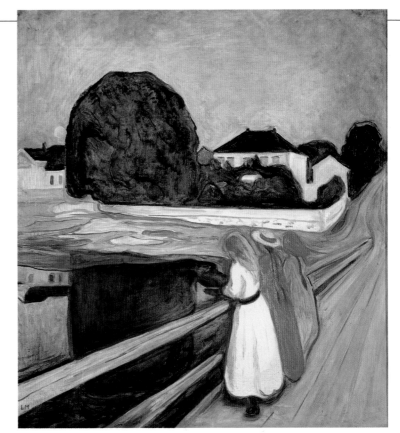

GIRLS ON THE JETTY
1899, oil on canvas, 54 x 49 in
(136 x 125 cm), National Gallery, Oslo

In itself, this image could be a message of hope: young women looking to their future. In Munch's hands, however, it achieves the dead weight of the ominous. He made no secret of his subjectivity – he painted, not what he saw, but what he felt, and his emotions were almost wholly dark. These three schematic young women seem less like the three Graces than the three Fates, those enigmatic creatures that watch over human conduct. Always in Munch, we intuit more than we can really perceive.

Although Munch *presses us up against the foot of the bed, we are protected from the full impact of infected breath by the cabinet on one side, with its seemingly useless bottle of medicine, and by the bedside table on the other, upon which sits a half-empty, and equally futile, drinking glass.*

The constant *verticals pressing downwards, the lack of any clear definition except that of wood and glass, the feverish unhealthy and unearthly color, all spell out a message of funereal gloom. But if we can stand back from the narrative of* The Sick Child *and look at the picture objectively, these strange slashes of color have a weird beauty peculiar to themselves.*

THE SICK CHILD
1885–86, oil on canvas,
18½ x 18½ in (47 x 47 cm),
National Gallery, Oslo

MURILLO, BARTOLOMÉ 1618–82 b. Spain
THE YOUNG BEGGAR

IN THE 17TH CENTURY, no artist's reputation was higher than Murillo's. Subsequently, however, he has been condemned as a sentimentalist, and his reputation is still struggling to return to its former heights. *The Young Beggar* shows the injustice of this blanket condemnation. Granted, he has a facile predilection for the pretty, but when he can conquer it, as he does here, he reveals himself as an artist of massive power. Not only is the theme of this painting one of utmost realism, as the young beggar hunts through his shirt for a persistent flea, but the whole work is painted with masterly control. The light plays over the boy, highlighting his cropped hair, shabby clothes, and dirty feet, revealing him as utterly solid. Visually it convinces, and all that surrounds him, from the discarded shrimp on the right to the dull apples spilling out of the basket and the ewer on the left, make his situation real to us. Perhaps the most wonderful touch in the picture is the window, in which the light blazes on the roughness and discolouration of the wall and then spotlights the boy with a crooked rectangle. Murillo is in contact with the child's personality; there is an understated pathos and courage in the loneliness here and in the poverty also. But more impressive still is the truthfulness of the scene.

THE VIRGIN OF THE ROSARY
c.1649, oil on canvas, 65 x 43 in
(164 x 110 cm), Museo del Prado, Madrid

It was in his religious pictures that Murillo was most at risk from sentimentality. However, he can present a majestic image, as here, of Mother and Child. This Virgin is monumental. The relationship of trust and affection between Christ and His mother is unmistakable, but Murillo does not overdo it. The impact comes not just from those tender gestures but from the sheer riot of color, solid and rich, which the artist sees as fundamental to his image. Murillo sees Mary, not just as a young woman with her first child, but as an archetypal mother, whose powerful figure will support and strengthen Christ throughout His life.

THIS IS AN EARLY WORK, *and, although we may regret that Murillo subsequently found it more profitable to paint religious work, the world of the poor was a theme that continued to fascinate him throughout his life. Here, he depicts authentically dirty feet, and the rags, we sense, are not merely dramatic costume.*

MURILLO HAS AN *instinctive response to texture. Few artists could make us so aware of tactile qualities. We can almost feel the stubby roughness of the child's head, the coarseness of the straw basket with its prickly handle, and the cold weight of the large earthenware jar.*

THE YOUNG BEGGAR
c.1645, oil on canvas, 54 x 45 in
(137 x 115 cm), Musée du Louvre, Paris

NATKIN, ROBERT 1930– b. US
ISADORA

THE LONGER WE GAZE AT THIS CANVAS, in which layer upon layer of color floats over the surface, the more subtleties arise from the depths of the image. The title refers to the dancer Isadora Duncan, who was killed when her long, flowing scarf caught in the wheels of a car and strangled her. Natkin does not descend to the vulgarity of explicit illustration, and it would be untrue to suggest that the thick pink line floating at the top is a reference to the scarf, or that the heavy, white oblong at the bottom refers to her gravestone. Yet, these possibilities do drift through one's mind when contemplating this picture, which rises like a memorial to the transient beauty of one of the great dancers of our century. The deep maroon of the framework, unusual in Natkin's work, forces us to concentrate on this ethereal pillar. A scarf borne aloft by the wind, an image of the pale pink beauty of the human body, a gravestone erect and translucent in the light of eternity – none of these meanings are true, and all of them are possible. Natkin is the poet of the infinite.

ISADORA
1997, acrylic on canvas,
73 x 35 in (185 x 88 cm),
The Reece Galleries, Inc.,
New York

NEER, AERT VAN DER c.1603–77 b. Netherlands
FISHING BY MOONLIGHT

IT IS NOT THE LANDSCAPE as such that intrigued Aert van der Neer, but the dramatic conditions under which it could be viewed. He liked to see the world transformed by snow or, as here, lit by the eerie gleam of a shadowed moon. *Fishing by Moonlight* is a dramatic and poetic scene in which we are shown boats, fishing nets, and fishermen hard at work. Yet van der Neer's interest is focused solely on the drama of sky and water – on the great kaleidoscope of the heavens and its reflection in the silent waters of the night. Although the fishermen seem to be conversing, they have so little importance in the picture as a whole that the overwhelming impression is of silence and even of stillness. There are two centers of color: the moon, stained pink by the sunset, and, almost like a reflection of it, the fishermen's fire below. .

FISHING BY MOONLIGHT
c.1665–70, oil on canvas, 26 x 34 in
(67 x 87 cm), Kunsthistorisches
Museum, Vienna

NEWMAN, BARNETT 1905–70 b. US

ADAM

BARNETT NEWMAN WAS THAT RARE BIRD – an intellectual painter who could articulate his ideas with clarity and force. The ideas can be almost spellbinding, and sometimes it is difficult to distinguish between what Newman says he is doing and what he has actually done. *Adam* is a huge picture – about eight feet high and well over six feet wide – and it is intimately related to his sense of the artist as mini-creator, linked closely with "The Creator", God. Newman, who had studied the cabbalistic writings and brooded on the mystical meanings of the Old Testament, was always struck by the primordial chaos out of which God threw order. He saw that as a paradigm for the artist, who looked at the chaos of experience and on it imposed the fertility of order. *Adam* is a work to be approached with caution. Newman was very well aware that the Hebrew word *adamah* meant "earth", and this rich earth-colored painting echoes that. "Adam" also means "man", and then again, the Hebrew word *adom* means "red", to which the artist pays tribute in the three red stripes that arrow through the great dark brown of his canvas.

MOMENT
1946, oil on canvas, 30 x 16 in (76 x 41 cm), Tate Gallery, London

Newman's full-time career as a painter came relatively late, and it took him some years of searching before he discovered the style that, for him, could represent the sacred significance of art. This was the first work he considered successful. By painting a soft, nuanced wall of blue and gray, and then slashing it with a luminous white "zip", Newman felt he had solved the problem of chaos and harmony. There is an irony here, in that it is by this division – this attack on the canvas, as it were – that Newman achieved the integrated "oneness" of the painting.

NEWMAN REFERRED *to the stripe as a "zip". He would create a great field of color through which a band of light would pass, like the creating power of God, giving meaning to the work, and activating it. In Adam, the band of cadmium at the far left might, perhaps, be regarded as the creative presence of God – He who would activate the dense, inert adamah that is earth.*

ORIGINALLY, NEWMAN *had painted only one other zip in this picture: the narrow, perfect, arrow-straight line on the far right. But later, he added a third, this time far from perfect. It is a brighter cadmium red, the line thick and wobbly, and redolent of human fallibility.*

ADAM, *1951–52, oil on canvas, 96 x 80 in (243 x 203 cm), Tate Gallery, London*

NICCOLÒ DELL' ABBATE c.1509–71 b. Italy
THE ABDUCTION OF PERSEPHONE

NICCOLÒ DELL' ABBATE WAS ONE OF the Italian artists summoned to Fontainebleau to decorate the palace of Francis I. He was a good choice: a mannerist who was keenly alive to the demands of a great narrative, and who celebrated for the French court the mysteries of myth with elegance and enthusiasm. Here, he is telling the story of the rape of Persephone. She was the archetypal maiden, the daughter of Ceres, the Italian corn-goddess and goddess of fertility. Persephone was picking flowers with her fellow maidens in the meadow when Dis, the god of the underworld and symbol of death and darkness, seized upon her and carried her off to his kingdom under the earth. The maidens realize the disaster that has befallen Persephone only gradually; some are still gathering flowers, others are alerted and terrified. Persephone appears three times: once struggling in Dis's arms, then in Dis's chariot as it trundles away into the mouth of the cave, and lastly in the foreground, already under the earth. Approaching in the distance is her mother, who will soon be wild with grief and left to roam the world in search of her lost daughter.

THE DEATH OF EURYDICE
c.1552–71, oil on canvas, 74 x 94 in (189 x 238 cm), National Gallery, London

With great elegance and sustained interest, Niccolò unfolds, apparently contemporaneously, the events surrounding the death of Eurydice. We see her famous husband, Orpheus, consulting his mother about the death of his bees. The sea god, Proteus (on the right), will tell him that it is his bees that have caused the death of of Eurydice: they provoked her into flight (shown in the foreground) when she was bitten by a snake and died.

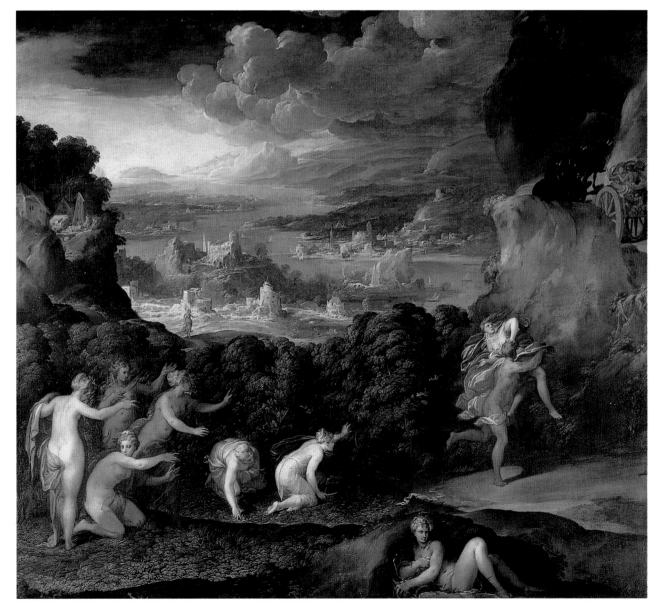

ACCORDING TO THE MYTH, *winter reigned during the period in which Persephone was held captive under the earth – there was neither spring nor summer, only death and sterility, until the maiden could be restored to the light. At the very bottom of the picture we see Persephone in the underworld, drained of color and crouching in a cave. But as she does so, she waits, alert and expectant.*

CERES, GODDESS OF LIFE *and equal in power to Dis, forced him to restore Persephone, but not without compromise. For half the year – autumn and winter – Persephone would remain like the dormant seed, buried in the earth, and then, in spring and summer, the maiden would come out into the sunshine, and the earth would bloom.*

THE ABDUCTION OF PERSEPHONE
c.1560, oil on canvas, 77 x 85 in (196 x 215 cm), Musée du Louvre, Paris

NICHOLSON, BEN 1894–1982 b. England
PAINTING, 1937

BEN NICHOLSON IS AN ARTIST WHO SEEMS to return continually to the same basic theme, though treating it from a different angle each time. His subject is simple – cups and glasses on a table top – and the infinite variety of their arrangement seems never to be boring or repetitive. Even here, where we might feel we have the most pure abstraction, it has been suggested that the work arises from objects placed on a table. Whatever its origins, this abstraction, which Nicholson simply calls *Painting*, is profoundly satisfying in its balancing of squares and oblongs. Nicholson, artistically, seems to have the equivalent of perfect pitch. Everything here strikes us as right and fitting, as expressing the inner coherence of the world. It may not be an exciting work, but that is not its intention. Far from arousing passions, making statements, or provoking a response, Nicholson offers a superb balance that, to him, was of supreme importance.

PAINTING, 1937
1937, oil on canvas, 63 x 79 in
(159 x 201 cm), Tate Gallery, London

STILL LIFE, JUNE 4, 1949
1949, oil on board, 24 x 18 in (60 x 46 cm), Hirshorn Museum and Sculpture Garden, Washington, UK

It is easy enough to pick out the still life of glasses on a table that Nicholson has arranged in this painting, but the delicacy of the work – its rich and lyric quality – has little to do with the classic elements from which this art form takes its origin. Nicholson is playing with shapes, bathed in a rich and golden glow, centering his work on a strong and jagged scarlet that functions, figuratively, as the base of a cup and, abstractly, as an anchor for the graphic and controlled shapes that roam, seemingly at will, across the board.

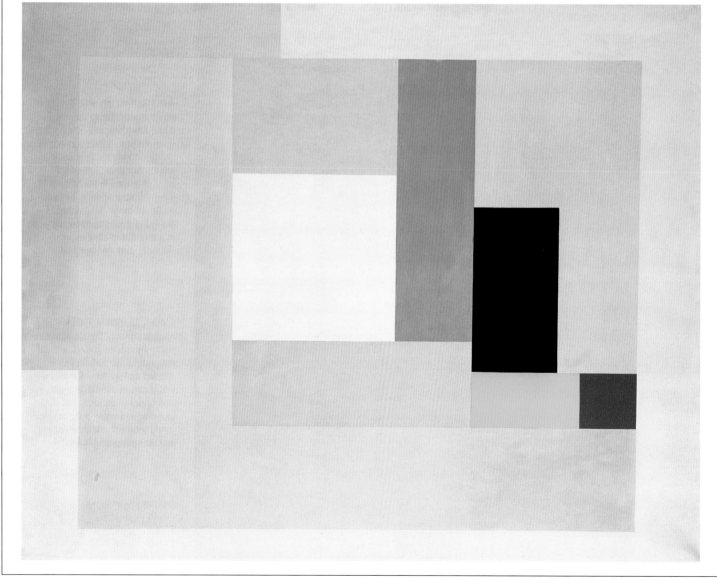

"A SQUARE AND A CIRCLE ARE NOTHING IN THEMSELVES AND ARE ALIVE ONLY IN THE INSTINCTIVE AND INSPIRATIONAL USE AN ARTIST CAN MAKE OF THEM IN EXPRESSING A POETIC IDEA"
Ben Nicholson

NICHOLSON *has painted grays of subtly differing shades and tones that surround the intensities of red, yellow, black, and a soft, mediating blue. The colors are content to fit together in a pattern that calms the spirit without pretending to any false resolution.*

NICHOLSON, SIR WILLIAM 1872–1949 b. England
THE LOWESTOFT BOWL

THE LOWESTOFT BOWL
*1911, oil on canvas, 19 x 24 in
(48 x 61 cm), Tate Gallery, London*

SOME TRADITIONALLY REACT against their fathers, and this gloriously assured painting by Sir William was precisely the art against which young Ben Nicholson reacted. Yet one is bound to ask, how far does the apple fall from the tree? The grand simplicity of that bowl, dependent for its beauty on nothing but the perfection of its shape, and that single line of color around the rim are elements so reminiscent of the cups and bowls that Ben Nicholson transformed into abstraction. Sir William has added a handful of tulips, their shapes closed in and resistant to the world, offering a contrast to the bowl's openness. He sets the soft, mortal flower and the hard glaze of the imperishable clay against a stark, black-and-white background, as if to force us to accept that life is not a case of either/or, but is about the acknowledgment and inclusion of both.

NICHOLSON, WINIFRED 1893–1981 b. England
HEBRIDEAN ROSES, EIGG

WINIFRED NICHOLSON was a visionary artist. In this delightful painting she contemplates the glory of a few simple flowers in a glass vase, standing upon a windowsill with the whole world behind them. This was her favorite theme, constantly renewed but never repeated. *Hebridean Roses* is an ironic title, as if on those bare Scottish islands any flower might be called a "rose". Her real interest was always in the effects color and the play of light. Here, it is not the flowers in themselves that catch her attention but their position against a backdrop of glimmering sea and distant hills, great cumulus clouds, and the golden-purple of the Hebridean hillside. Her work springs from the literal into the spiritual to acclaim the glory of color, the singularity of creation, and the wonder of light that enables us to see these things. For Winifred Nicholson, sight and vision were interchangeable.

HEBRIDEAN ROSES, EIGG
*1980, oil on canvas, 56 x 45 in
(142 x 114 cm), Private Collection*

NOLAN, SIR SIDNEY 1917-92 b. Australia
THE TRIAL

THERE REALLY WAS A NED KELLY but, like Robin Hood, he has become the occasion of creative myth. Nolan painted Ned Kelly, in reality a crude and violent bandit, at various times and in various settings. What fascinated him was Kelly's makeshift armor, and here Nolan depicts him, even at his trial, completely hidden from his enemies. The forces of law and order are massed around, but Kelly retreats behind his disguise. If the clenched hands hint at tension, this is the only evidence of emotion that his hero allows to be seen. There is more emotion in the face of Judge Barry, and Nolan sees him as fearfully aware of the almost mythical powers of this strange outlaw. Kelly stands alone amidst the hostility of the Establishment, the well-dressed jury glaring at his impervious back, and the whole weight of the building intended to diminish him. Conversely, it gives him heroic stature. In Nolan's mind, however, that status and power to overawe comes solely from the disguise.

CAMEL AND FIGURE
1966, oil on board, 47½ x 48 in (121 x 122 cm), Tate Gallery, London

Camel and Figure alludes to the heroic journey of Burke and Wills from Melbourne into the unexplored Australian interior. Both died of thirst and starvation, having separated and missed rescue by the shortest of margins. Nolan concentrates on the death of Burke, stranded in the immensity of the Australian outback, arms extended in surrender to the hostile earth.

THE TRIAL
1947, enamel on board, 36 x 48 in (91 x 121 cm), National Gallery, Canberra

THIS IS AN EXTRAORDINARY *picture of the power of the solitary will to abash authority. It is the man whose face we cannot see that dominates the courtroom. In a way, Kelly is a stand-in for the artist, who conceals his personality within the motif of his work with almost disproportionate force.*

NOLDE, EMIL 1867–1956 b. Germany
YOUNG BLACK HORSES

NOLDE WAS A LONER, A MAN WHO LEFT every group to which he was associated, often at their suggestion. Shortly before he painted *Young Black Horses*, he had gone roaming around the world as far as China, deepening his sense of personal responsibility as an artist. It was he alone who saw what he saw, and it was his privilege to make that vision visible to others. This was only possible for him when he felt that there was no division between what he was and what he saw, when he could paint the external world from within. It is this interior passion that gives a work like *Young Black Horses* its mysterious power. In itself, the painting is extremely simple. The world divides into two: a dense expanse of dull green meadow and a slightly larger expanse of blurred sky, all purple and orange, and layered for dramatic effect. Outlined against this ethereal drama stand the ponies – solid chunks of deepest black, with only a touch of white on the head of one and a gleaming stripe down the face of the other.

YOUNG BLACK HORSES, *1916,*
oil on canvas, 29 x 39 in (73 x 100 cm),
Museum am Ostwall, Dortmund, Germany

COUPLE
c.1932, watercolour on paper, 21 x 14 in
(53 x 36 cm), Detroit Institute of Arts

The overriding impression of this double portrait (from a series of watercolors called *Fantasies*) is not of the personalities and the conditions of these two 20th-century Germans but of the reference back to ancient Egypt. This is how the heretic Pharaoh Ikhnaton was depicted with his wife, the classically beautiful Nefertiti. Nolde deliberately recalls those famous profiles. The eyes also are painted in the Egyptian manner, with the full eyeball even in profile. It is an extraordinary *tour de force*, and Nolde's triumphant smile indicates that he is well aware of this.

IN THE GLOW *of this rather sinister evening, the young animals stand as if pressed together, supporting each other, alone in the universe of threat, yet unafraid. Both horses are alert and, in their intent gaze, we see light just touching their eyeballs.*

NOLDE HAS *been able to express his own personal loneliness, courage, and need of vigilance, without the slightest recourse to a symbolic language. We warm to the horses, to their youth and bravery, to their rough beauty, and to their independence upon the plain.*

OCHTERVELT, JACOB 1634–82 b. Netherlands

A YOUNG LADY TRIMMING HER FINGERNAILS

GENRE SUBJECTS CAME TO BE FAIRLY TRADITIONAL – people feasting, flirting, interrelating. Here, Ochtervelt scores a triumph by seizing on a subject of the utmost originality. This domestic activity, essential though it is to the person concerned, is of very little interest to the rest of us. But Ochtervelt fixes on the bodily image – the girl illuminated and luminous in her silks and satins, nibbling away with the scissors at her nails. She has kicked off one dainty slipper, and an alluring ankle displays itself before us; one can judge that act two of this enthralling drama will be the young lady trimming her toenails. It is the whole *mise en scène* that fascinates Ochtervelt: the rich Turkish carpet that is draped with such nonchalance over the table and the way the light is angled so that we can hardly make out the tapestry on the back wall, which shows Hagar in the wilderness.

A WOMAN PLAYING A VIRGINAL
c.1675–80, oil on canvas, 33 x 30 in (85 x 75 cm), National Gallery, London

At face value, here is a charming genre scene of a domestic concert. A young woman, resplendent in a scarlet dress, plays on the virginal, while another sings, leaning close to a shadowy man who plays the violin. As usual with Ochtervelt, however, there is more than meets the eye. The map that silhouettes the head of the woman at the virginal shows the Americas, that new-found world that was opening out to the Dutch of the 17th century. The girl's head bends, intrigued by a new world of romantic possibility before her, and yet it is the singer to whom the young man leans confidingly. The implicit possibility of female rivalry is transferred to the action of the two dogs, which face each other across an expanse of carpet, alert and hostile.

HOWEVER DOMESTIC and dull her actions, the young woman is dressed to kill, and is concentrating on aspects of her own body. The discarded slipper may indicate recklessness, and the large uncovered bowl could be seen as a symbol of female vulnerability. All these possibilities drift through our minds as we contemplate the actuality of what Ochtervelt sets before us.

THE UNWRITTEN TEXT in the story of Hagar is that the cause of her downfall was her sexual relation with Sarah's husband, Abraham. The tapestry reminds us that there are two women here: the young lady in the foreground and the silent maid in the shadows. Perhaps this makes a coded reference to Hagar and Sarah, stressing the need for sexual tact.

A YOUNG LADY TRIMMING HER FINGERNAILS, ATTENDED BY A MAIDSERVANT, *c.1670–75, oil on canvas, 30 x 23 in (75 x 59 cm), National Gallery, London*

O'KEEFFE, GEORGIA 1887–1986 b. US
RANCHOS CHURCH

GEORGIA O'KEEFFE, WHO WITH TYPICAL PIONEER STAMINA lived to be nearly one hundred, is one of the great originals of American art. Like her or loathe her, she has her own take on things. As she once said, "I found I could say things with color and shapes that I couldn't say any other way." This is the feeling we get from her work, that whatever she paints conveys something intangible; it is what makes her work so personal. She is seeking not to describe but to clarify an interior meaning. She sought, for most of her life, the isolation of New Mexico, finding its vast, spare landscape a constant imaginative stimulus. Her natural tendency to almost oversimplify was encouraged by the austerity of the land and its native buildings. *Ranchos Church* has become abstracted into molten shapes of rock, while remaining true to the squat severity that we can see in photographs of the building.

WHITE IRIS NO. 7
1957, oil on canvas, 40 x 30 in (102 x 76 cm),
Museo Thyssen-Bornemisza, Madrid

O'Keeffe is best known for her flower images. Nothing annoyed her more than to have these paintings referred to in sexual terms. She does, of course, paint what, for a flower, are its sexual organs, but it is the drama of the flower's structure that interests her. Looked at just in itself, this is a monstrous image, extraordinary in its imaginative construct. But this is not O'Keeffe's monster; it is nature's monster. Her decision has been to thrust it in our faces, to paint it so large that the viewer is forced to come to terms with its texture and complexity.

**RANCHOS
CHURCH**
*1929, oil on canvas,
24 x 36 in (61 x 91 cm),
Phillips Collection,
Washington, DC*

HERE IS A CHURCH *without an entrance (O'Keeffe herself was not a believer), its strength quivering on the brink of liquefaction. It is windowless, doorless, and purposeless, as O'Keeffe sees it, except for the way in which the clear stone has caught the light and shadow and silhouetted itself with blunt force against the piercing clarity of the midday sky.*

OLIVER, ISAAC c.1565–1617 b. England
THE BROWNE BROTHERS

OLIVER HAS PAINTED THREE identically dressed brothers of the Browne family standing in the gallery of the Browne's country home; the fourth man is unknown. The effect is of intense family loyalty. The brothers' grandfather, the First Viscount Montague, had been suspected of involvement in the Ridolphi Plot in 1571 to free Mary, Queen of Scots, and the eldest brother, Anthony Maria (center) was later implicated in the Gunpowder Plot in 1605 to destroy Parliament. Guy Fawkes, himself, had been a servant in the house, a circumstance all the more sinister to Parliament as the Brownes were known to be an ardently Catholic family. As depicted here, then, the brothers are expressing not only affection but family solidarity in the face of persecution.

A MELANCHOLY YOUNG MAN
c.1590, watercolor on vellum, 5 x 3½ in (12 x 9 cm), Collection of Her Majesty The Queen

This young man is exquisite in his black and gold, the fashionable colors of the time. We particularly admire his frilled and laced garters, which draw attention to the contours of his legs. Elizabethan young men were only melancholy for romantic reasons, and perhaps the source of his distress is figured by the couple at the far right, seen walking in the elaborate gardens of a mansion. Do they signify a lost love? The young man fixes us with a melodramatic stare and leaves us, as so often with Oliver, to brood on the personality and history of his sitters.

O

346

OLIVER MAY mean to imply that the brothers are supporting one another in loyalty to their mutual faith. It may also be that, in the posture of the three brothers, there is an unusual reference to those classical images of harmony, the three Graces, invoking a somewhat bizarre religious iconography.

THE UNKNOWN man serves mainly to mark the exclusivity of this family group, for he can never enter the close-knit circle of brotherly affection. Although he is well dressed, his inferiority to the brothers is marked by the removal of his hat. One feels that the excluded fourth has some mysterious part to play, which we are left to puzzle over.

THE BROWNE BROTHERS
1598, gouache and watercolor on vellum, 9 x 10 in (24 x 26 cm), Burghley House, Lincolnshire, UK

OSTADE, ADRIAEN VAN 1610–85 b. Netherlands
RUSTIC CONCERT

LIKE MOST 17TH-CENTURY DUTCH artists, Adriaen van Ostade had one theme that he made peculiarly his own. His subject could be roughly defined as "carousing peasants". For us, this may be a strange, even displeasing, choice of theme. There was the implicit contrast between the highly skilled and sophisticated artist and – as the people who bought these pictures would have thought – the vulgar and uneducated rustics. That element of snobbery is inescapable – the superior taking amusement in the antics of a lower order. Yet Ostade infuses his scenes with an infectious good humor, and seems to delight in the energy that men who have labored long in the fields can still find at the end of the day to join together, as here, in making a rustic concert.

RUSTIC CONCERT
1638, oil on wood, 15 x 12 in (37 x 30 cm), Museo del Prado, Madrid

A PEASANT COURTING AN ELDERLY WOMAN
1653, oil on wood, 11 x 9 in (27 x 22 cm), National Gallery, London

This picture is both pathetic and humorous. An elderly woman, flattered and pleased by the attentions of a peasant, looks down to hide her pleasure. The peasant, however, is clearly a villain – a fox courting a goose – who is seeking a place for himself through the credulity of a relatively well-to-do and elderly woman. Before him on the table is a pipe and his gift of a salted fish. It is the juxtaposition of pipe and fish that interests Ostade; it is as incongruous a relationship as that of the couple themselves.

THE FIVE ARE *engrossed in their music making, as they enjoy some ditty unmentionable to more polite ears. Certainly there are salacious grins, and the central character, with legs asprawl, enters with drunken and uninhibited enthusiasm into the spirit of the song.*

THIS MAY *have started out as a parody, but Ostade has been drawn into the pathos of these lives, so vigorously intent on making the most of what is within their power. The picture is marvellously organized, with the cottage's great beams and, behind them, the haystack.*

OTTONIAN MANUSCRIPTS c.10th century Germany

OTTO II RECEIVING HOMAGE FROM THE FOUR PROVINCES OF THE EMPIRE

ABOUT THE TIME OF THE FIRST MILLENNIUM, German illuminators achieved a peak of manuscript illustration that has rarely been equalled. Ottonian art is extraordinarily solid and massive and receives its name from the three principal emperors who presided over most of this period: Otto I (936–973), Otto II (973–983), and Otto III (983–1002). Here we see Otto II receiving homage from the four provinces of the Holy Roman Empire. The Emperor himself is shown as young and yet responsible for the weight of his position. The perspective is decidedly skewed, but the genius of the Ottonian illuminators was not to get their visual facts right but to overwhelm us with the weight of pictorial splendor. This would implicitly convey the importance of the Emperor. Otto II is a splendid figure, worthy of his dignity.

ABBESS HITDA AND ST WALPURGA
early 11th century, ink and colors on vellum, 11 x 6 in (29 x 14 cm),
Hessische Landes-und Hochschul-Bibliothek, Darmstadt, Germany

The abbess Hitda of a convent near Cologne commissioned a copy of the four Gospels, and here she offers them to her monastery's patron, St Walpurga. Again, we see the specific qualities of Ottonian art – its architectural weight, its majesty, its sense of authority borne with dignity. A gesture towards realism is made with the rocks and foliage in the foreground – this is the land of earth where Hitda herself must stand. The saint is raised up monumentally on an elaborate plinth in front of the monastery, and is enclosed by a golden arch.

THE FOUR PROVINCES, *significantly represented by females, edge timidly forward, offering the Emperor their tribute. They are calm and quiet in their submission to the overlord who has pacified their boundaries. Otto takes no notice of the supplicants; his function is to reign, and, even if one foot teeters rather unsteadily, reign he most convincingly does.*

THE EGBERT CODEX
(OTTO II RECEIVING HOMAGE FROM THE FOUR PROVINCES OF THE EMPIRE)
c.983, watercolor on manuscript, 11 x 8 in (27.3 x 20 cm), Musée Condé, Chantilly, France

OUDRY, JEAN-BAPTISTE 1686-1755 b. France
THE WHITE DUCK

OUDRY WAS A PORTRAIT PAINTER who was also accomplished at still-life painting. It was only after receiving royal commissions to commemorate the hunt, however, that it seems to have dawned upon him that his true subject was the animal. He remains, perhaps, the greatest animal painter in art history, even when, as here, the animal is dead, and even when, as here, his intention was not primarily to paint the creature. Oudry was intensely sensitive to light and tone, and here it is whiteness itself that he is painting, in all of its subtle degrees of variation. There is white porcelain filled with white cream, a glorious creased white damask cloth, and the crisp white of the paper that proudly bears the artist's name and date. There is the tall, white candle standing erect against the soft, stone-white of the wall, and in the center of this harmony, the tender, nuanced whiteness of the dead bird.

THE DEAD WOLF
1721, oil on canvas, 77 x 103 in
(196 x 261 cm), Wallace Collection, London

In the brilliance of the scene before us, we are never distracted from the true focus of the picture – the animals. Still afraid, the hounds cluster, curious but timorous, on the other side of the painting from the dead wolf. Oudry laments the death of courage, and the stilling of those padded feet. However, he is no sentimentalist – he sympathizes too with the embarrassed hounds, who seem aware that they are in the presence of greatness. The picture is dissected by the fierce jut of the gun, and its potential for violence is intentionally emphasized by the pure whiteness of the shroud-like cloth.

IF OUDRY'S INTENTION *was to display the virtuosity with which he could paint the subtleties of white, it is the arrangement of his tableau that sets off the colors so perfectly. The vertical of the candle is echoed by the lines in the stone, the cord, and the duck's foot. This vertical is then contradicted by the bend of the sweet, dead neck and the curves of the porcelain bowl.*

THE DIAGONALS *add softness and fluidity. The wings, the feathers, the paper, the crisp folds of the damask all combine to ravish the eye wherever we look. The glory of the picture is not just this technical perfection, however; rather it is to have harnessed both form and color for a more serious end, which is to make us aware of the bird itself.*

OUDRY'S VIRTUOSITY OF *technique does not play against meaning; here, technique serves meaning, and the blank eye of the dead bird and the droop of the strong but lifeless wing is immeasurably enhanced by the artist's awareness of technical device.*

THE WHITE DUCK
1753, oil on canvas, 37 x 24 in
(94 x 61 cm), Private Collection

PACHER, MICHAEL c.1435–98 b. Austria

CHURCH FATHERS' ALTAR: ST AUGUSTINE AND ST GREGORY

PACHER WAS ONE OF THOSE GIFTED ARTISTS of Renaissance Germany who was equally skilled both as a carver and a painter. His great work, the *Church Fathers' Altar*, combines both of these skills. The work depicts the four doctors of the Western Church: St Augustine, St Jerome, St Gregory, and St Ambrose. Each is seen as wholly individual and yet each is relevant to the Church mainly as the recipient of divine inspiration. The central panels of the altar portray St Augustine and St Gregory. The white dove of the Holy Spirit flies towards St Augustine and hovers whispering at te ear of St Gregory. Both are shown as great scholars and are flanked by a lectern on which are set scholarly tomes; the niche in which they sit is adorned with the painted sculptures of apostles bearing the sword of the Spirit. Each saint is depicted with his most closely associated attribute.

CHURCH FATHERS' ALTAR: ST AMBROSE
c.1480, oil on wood, 83 x 39 in (212 x 100 cm), Alte Pinakothek, Munich

Of the four, St Ambrose is perhaps the most attractive figure, shown at a writing stand, with a pen in each hand as he listens smilingly to the whispered instructions of the Holy Spirit. His ability to write effortlessly with both hands was seen in the Middle Ages as proof of the sanctity of this great scholar. Legend has it that bees placed the honey of theological knowledge on his lips while he was an infant in his cradle. Pacher portrays the infant already haloed.

THE CHILD THAT *here accompanies St Augustine refers to the legend in which Augustine came across a child with a bucket, running back and forth between the sea and a hole he had dug. When asked what he was doing, the child replied that he was trying to empty the sea into his hole. Augustine pointed out that this was a fruitless activity, to which the child replied that it was as sensible as Augustine's attempt to understand the Trinity.*

ST GREGORY *is engaged in the extraordinary activity of forcibly yanking up from purgatory the Emperor Trajan – purgatorial fires still flickering around his legs – so that he can be baptized, die again, and go to heaven. The narrowness of the medieval theologian, who placed such emphasis on the physical act of baptism seems to us unfortunate, yet Pacher shows the saint, however deluded, as a figure of great compassion.*

CHURCH FATHERS' ALTAR: ST AUGUSTINE AND ST GREGORY *c.1480, each panel, oil on wood, 83 x 39 in (212 x 100 cm), Alte Pinakothek, Munich*

PALMA VECCHIO (JACOMO PALMA) c.1480–1528 b. Italy
A BLONDE WOMAN

VENICE WAS KNOWN AS THE CITY OF SENSUAL DELIGHT, famous for its pleasure-seeking courtesans. It is within this tradition that Palma Vecchio has painted his generic Venetian beauty, *A Blonde Woman*. He has a special affinity for the opulent blonde, fair-skinned and generous. Here, he paints her holding flowers, and something in the loose drape of that white blouse – with its ribbons deliberately untied so as to emphasize the rounded expanse of bosom – suggests that this might be a representation of Flora, the Roman goddess of plenty. Flora brought the spring, nurtured the summer, and her warmth and sweetness went hand-in-hand with the sunlight, as is suggested by those richly flowing locks of golden hair. Like the great Venetian courtesans, Flora was a woman of immense dignity, and Palma Vecchio paints his magnificent blonde more as a goddess than as a woman of easy virtue. The breasts she displays are nurturing breasts to be worshipped by those who depend upon the earth for fruit and flowers. She looks out at the viewer with a sweet gravity, appropriate to a goddess who knows her own worth, and she will hand her small bouquet only to those who approach her with reverence.

PORTRAIT OF A POET
c.1516, oil on canvas, 33 x 25 in
(84 x 64 cm), National Gallery, London

This thoughtful young man holds a book and behind him springs a laurel bush, both suggesting that he is a poet. Since the date is contemporary with the publication of *Orlando Furioso*, this might even be the poem's author, Ludovico Ariosto. But even if it is merely a generic poet, Palma Vecchio has understood poetic vocation – the need to look long and seriously at life and to accept its shadows as well as its sunlight. He is richly clad, yet it is his ungloved hand that attracts our attention. His gaze, reticent, defensive, sensual, and intense, conveys the subtle complexity of his emotion.

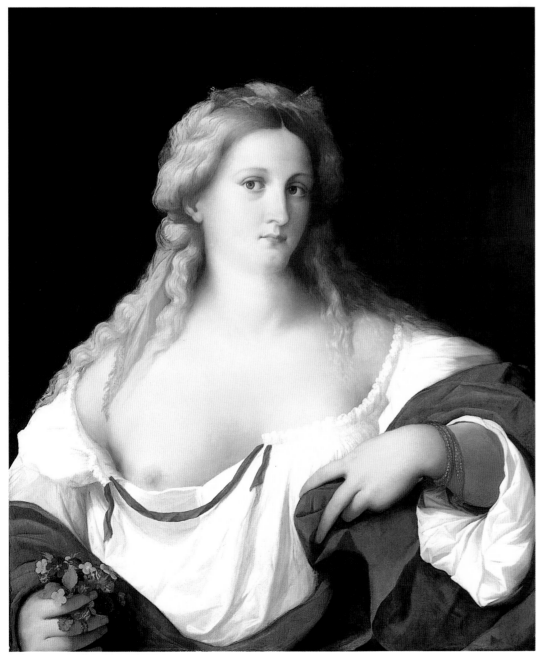

PALMA VECCHIO'S WORK is far more varied than it might at first appear. He responds with sensuous immediacy to the little bunch of flowers in the woman's hand, to the chiffon veil that interweaves with her blonde hair, and to the contrast of bright blue ribbon and soft pink nipple.

PALMA VECCHIO never regards the human body (male or female) as an object for lascivious display. Rather, he treats his theme with the utmost seriousness and asks us to worship with him at the shrine of beauty. The white of sunlight is complemented by the green of new spring vegetation. This is Flora, indeed.

A BLONDE WOMAN
c.1520, oil on wood, 31 x 25 in
(78 x 64 cm), National Gallery, London

PALMA GIOVANE (JACOPO PALMA) c.1548–1628 b. Italy

THE MASS OF PASQUALE CICOGNA

PALMA GIOVANE SEEMS to have been interested in people – their activities and interrelations. This unusual picture shows the Venetian senator Pasquale Cicogna – the splendid gentleman kneeling at the left – who is said to have been told, during the service of the mass, that he was soon to become doge. There is a subtle play here on scenes of the Annunciation, in which an angel announces the Incarnation to the Virgin. But here it is an elderly woman who announces to an elderly man. Palma composes a pyramid, formed by the senator, the announcing woman, and the priest offering Communion. The Communion scene emphasizes that this too is a sacred event – and Palma clearly felt that to become a doge was also to receive a sacred command.

MARS AND VENUS
c.1585–90, oil on canvas, 51½ x 65¼ in (131 x 166 cm),
National Gallery, London

Venus was married to Vulcan, the god of fire, and her relationship with Mars was an adulterous one. The lovers do not seem to be united in spirit. Mars's hand, clutching the bed instead of embracing Venus, suggests the ambivalence of the scene. Venus seems almost to be devouring her lover – his face is almost lost under the passion of her kiss. This is parodied by Cupid, who bends over the leg of Mars, as if he too is devouring the god of war.

THE MASS OF
PASQUALE CICOGNA
1586–87, oil on canvas, dimensions not
known, The Oratory of the Crociferi, Venice

INTERIOR OF THE
PANTHEON, ROME
c.1734, oil on canvas,
50 x 39 in (127 x 99 cm),
National Gallery of Art,
Washington, DC

PANINI, GIOVANNI PAOLA 1691/2–1765 b. Italy

INTERIOR OF THE PANTHEON, ROME

THE NEED FOR THE PICTURE POSTCARD seems to be ineradicable from human nature, and the fortunate rich in the 18th century were able to possess this genre exalted to the level of masterpiece. Giovanni Panini specialized in architectural views, especially Roman interiors. The emphasis here, however, is on the small bright figures dwarfed by the immensity of the building. This busy world of conversation is perhaps not what one would expect of a church, but it is, indeed, a sacred space: there are people on their knees, and, as we look up, we are aware of a silent majesty.

ROMAN RUINS
WITH FIGURES
c.1730, oil on canvas, 19½ x 25 in (50 x 64 cm),
National Gallery, London

Here, Panini has felt free to invent. There were enough authentic ruins in Rome for him to blend them together into what was called a *capriccio* (or caprice), an invention that was felt to give more of the exotic sense of a setting than the setting itself could. Panini has set the pyramid of Caius Cestius dramatically amid broken pillars and against an evening sky. His figures are in contrast to the statue: the warm against the cold, life against death.

PARMIGIANINO (GIROLAMO FRANCESCO MAZZOLA) 1503–40 b. Italy

THE CONVERSION OF PAUL

PARMIGIANINO HAD A CHEQUERED and pressured career, beset by misfortunes not of his own making. He died a worn-out figure while still in his thirties. His own sensitivity enabled him to enter with dramatic tension into the story of the conversion of St Paul. The Bible tells us that Paul, persecutor of the Christians, was thrown from his horse and admonished by a vision of Christ in the heavens, resulting in his blindness. It is hard to tell here, whether the hero of Parmigianino's extraordinary painting is St Paul or the horse; each clearly competes for the center of attention within the frame. Paul stretches out an astonished hand, his blind eyes still searching the heavens, in which we can see the lingering radiance of the vision of Christ. The world which he is called upon to convert stretches behind in all its multitudinousness and its potential for salvation.

SELF-PORTRAIT IN A CONVEX MIRROR
c.1523, oil on wood, 9 in (24 cm) diameter,
Kunsthistorisches Museum, Vienna

When he was barely twenty, Parmigianino – the essential Mannerist painter – produced this extraordinary *Self-portrait in a Convex Mirror*. We are enchanted by the sheer wit of this painting – the curve of the mirror forces the artist's hand into unnatural prominence, thus enabling Parmigianino to make an implicit statement about what it means to create, manually, under the control of the spirit. His young face is alive with humor, calmly aware that he has embarked on a daring piece of illusionism, and yet confident in his youthful ability to carry it to a triumphant conclusion.

P
353

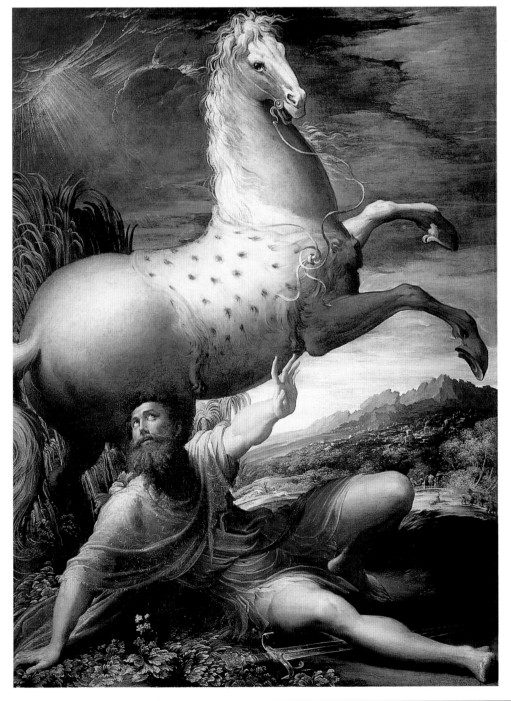

THE WONDERFUL HORSE *prances aloft, master of the situation – a glorious comparison to the figure laid low at its feet – with its strange, diaphanous spots, its mane rippling with the excitement of the occasion, and its noble head, with that bright blue eye, alive to the world that is closed to Paul.*

HERE ARE TWO *splendid creatures, one susceptible to humiliation – because the human spirit can fall and rise again – the other tossing its tail and kicking its legs, serenely unaware of the religious dimensions of the crisis. Parmigianino clearly warms to both.*

THE CONVERSION OF PAUL, *c.1530, oil on canvas, 70 x 51 in (178 x 129 cm), Kunsthistorisches Museum, Vienna*

PATINIR, JOACHIM c.1485–1524 active Belgium
LANDSCAPE WITH ST JEROME

WE, WHO HAVE CONQUERED THE AIR, might find it difficult to realize what a feat of imaginative study it was for Patinir to visualize how the landscape would look from above. Here we have the delightful story of St Jerome and the lion. St Jerome, seen with his friend in the foreground, actually lived in the monastery behind him, and it was there that the lion appeared one day with the thorn in its foot, howling so dismally that all the monks fled in fear. Only St Jerome realized that the lion had come for a purpose. He removed the thorn and gained for the monastery a faithful friend. Every morning the lion set out with the monastery donkey, until the day came when the lion returned alone. The monks immediately sprang to the conclusion that what they had always feared had come to pass: the lion had eaten the ass. Only St Jerome remained faithful to his friend. In fact, the donkey had been stolen by passing travellers, and the lion (who was a somewhat sensitive soul) disappeared and rescued it, bringing the donkey triumphantly back home. On the right of the picture we can see the lion bounding towards his friend, while the thieves flee from the picture and out of history.

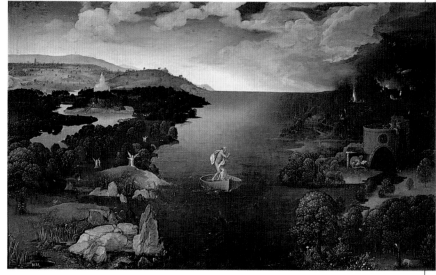

LANDSCAPE WITH CHARON'S BARK
c.1521, oil on wood, 25 x 40½ in (64 x 103 cm), Museo del Prado, Madrid

This is a glorious picture, again seen from some mysterious viewpoint in the sky that looks apparently upon heaven and hell, both seen in a worldly context. On the left, the angel guards the world of heaven; on the right is hell. In between these two domains goes Charon, the mythical figure that the Greeks imagined taking the soul across the River of Forgetfulness to the underworld. In biblical terms the picture does not make sense – the soul goes from Earth to heaven or hell, not from heaven to hell, as it appears to do here. Perhaps its very incomprehensibility makes this strange landscape all the more effective.

PATINIR HAD THE *desire to see the world as a bird did, or even perhaps as God did – from above, spreading out below in all its detail and variety. Here we see a great vista that Patinir himself could not possibly have seen. Because Patinir lived at a time when landscape in itself was not regarded as sufficient theme for a work, he always wove a story into the picture.*

THE CLUMSINESS OF *man and beast is somehow illustrated and made compatible through the strange rock formations that jut out unexpectedly from the green meadows. All the story's elements, which spread out over the whole picture, serve to emphasize the charm of the countryside, with its lives being lived, with their dramas and disappointments unseen and unknown.*

LANDSCAPE WITH ST JEROME
c.1515–24, oil on wood, 29 x 36 in (74 x 91 cm), Museo del Prado, Madrid

PECHSTEIN, MAX
1881–1955 b. Germany

NELLY

THE GERMAN ARTISTS WHO WERE MEMBERS OF Die Brücke ("The Bridge"), at the beginning of the 20th century, harked back wistfully to primitive times and remote civilizations; then and there, they felt, life was more authentic. *Nelly* is a superb expression of Pechstein's longing to be part of a world that lived more intensely, more passionately, and with greater truth. The focus zooms in to concentrate on those bushes of dark hair, those dangling earrings, and those dark eyes that keep their secret. Small smudges of white paint gleam on her nose and brow, and above all on those slashes of red that form the great smiling mouth, and the scarlet curves on the straps of her dress. *Nelly* is an absolute: black and red and white; no subtleties and no hesitations.

SEATED NUDE
1910, oil on canvas, 31 x 28 in (80 x 70 cm), Staatliche Museum, Berlin

Here, Pechstein imagines an exotic nude – clearly a wish-fulfilment figure. With her flowing dark brown hair, her emphatic behind, seductively pursed lips, and parted legs, this girl is an icon of perpetual availability. Her face suggests not innocence but experience – that the luscious body, like ripe fruit, is there for the taking. All may not be as simple as it seems, however, because the scene is filled with mysterious and jagged shapes that remind us that this is illusion and not reality.

HERE IS A WOMAN *that Pechstein shows as alive with the passion after which he himself hankers. Here is somebody disdainful of timidities – of the compromises and hesitations that the artist felt were so much a part of life in the modern city.*

CLEARLY *Pechstein is idealistic in this portrayal. At some level he is aware of this because the setting is merely notional. Nelly presents an image of life as Pechstein would like it to be, and yet, for all the vitality and exuberance, we are left with a faint feeling of grief. We sense that the artist is aware that this is an imaginary Nelly, and that her own private life, as lived to herself, might be very different to the appearance.*

NELLY
1910, oil on canvas, 20 x 21 in (52 x 53 cm), San Francisco Museum of Modern Art

ARCHANGEL
RAPHAEL WITH TOBIAS
c.1496–1500, oil on wood, 44 x 22 in
(113 x 56 cm), National Gallery, London

Perugino is not an artist at home with blood
and sweat. His style is specifically attuned to
depict the angelic, beautifully exemplified here.
The grave majesty of Archangel Raphael, as
he turns affectionately to the young Tobias, is
essential Perugino. Tobias, with hand on hip,
looks up winsomely at his angelic guardian,
and yet so profound is the dignity with which the
artist paints that there is no hint of the trivial.
Tobias is presented as an admirer and the angel,
accompanying him on his journey, is the protector.

PERUGINO, PIETRO (PIETRO VANNUCCI) c.1445–1523 b. Italy
MARY MAGDALEN

ANYONE WHO HAS GONE THE ROUNDS of the Pitti Palace in Florence
will have noticed, low down in the display of pictures, the
sparkling beauty of Perugino's *Mary Magdalen*. This is the artist's
work at its most perfect. It seems to be the same face that
Perugino always paints: a beautiful, serene oval bathed in light,
with large eyes, a wide forehead, and a mouth whose beauty
was equalled only by the work of his pupil Raphael. So dearly
does Perugino love this face that he is able to imagine with
complete conviction that this was how the Virgin herself looked,
and all the other saints, as well. Here, without contradiction, he
attributes it to Mary Magdalen. If this is "Mary the penitent", as
it seems, then this attribution is befitting. There was always an
element of sadness – a grave weighing up of the responsibilities
of life – in Perugino's women, and this young creature, with her
dark curls and her fur-trimmed bodice, holding her beautiful
hands demurely, suggests a deep yet peaceful involvement with
the responsibilities of being human. The face glows out of the
darkness, alive with an inner radiance. Of all the masterpieces
of this great artist, this small panel is the most unforgettable.

MARY MAGDALEN, *c.1490s,*
oil on wood, 19 x 13 in (47 x 34 cm),
Palazzo Pitti, Florence

PESELLINO (FRANCESCO DI STEFANO) c.1422–57 b. Italy
THE TRIUMPH OF DAVID

PESELLINO WAS AN EXPERT IN THE PAINTING OF *CASSONE*, those splendid chests in which a Florentine bride stored her wedding linen. The Pazzi family commissioned from him a pair of *cassone* for the wedding of their daughter Elenora, and the subject chosen – whether by Pesellino or the patron – was the story of David and Goliath. Nearly always, *cassone* paintings have a reference to marriage, and the imagination can play with what reading was intended here. David, as we know, was the shepherd boy who killed the giant Goliath with his sling. Perhaps Elenora is being reminded of the difficulties of married life, the need to realize that although she has not the weapons of a male, she has the sling of her femininity with which she can conquer in the apparently unequal battle. This, however, may be a cynical view; it may merely have been Pesellino's intention to tell, in delightful detail, this fairytale epic of heroism and the victory of cunning over brawn.

DAVID TENDING HIS FLOCK (DETAIL)
c.1440–50, tempera on wood,
17 x 70 in (43 x 178 cm),
National Gallery, London

This small detail is from the very beginning of the story. We see David, the mild shepherd boy, sitting dreaming. But a shepherd in Israel faced dangers from wild beasts, and in the foreground we see him again, almost girlish with his curly hair and slender legs, gathering stones for his sling as the threatening lion and lioness advance.

THE TRIUMPH OF DAVID (DETAIL), *c.1440–50, tempera on wood, 17 x 70 in (43 x 178 cm), National Gallery, London*

HERE IS THE END OF THE STORY, *when David comes home in triumph, and his prominence parallels that of the bride. Behind him is a delightful vignette, and one notices how clear are the paths, how visible is the castle on the hillside, and how easily navigable is this landscape – all elements reassuring for a new bride.*

PIAZZETTA, GIOVANNI BATTISTA 1683–1754 b. Italy
REBECCA AT THE WELL

THE 18TH CENTURY TENDED TO FAVOR sumptuous display. Piazzetta went against the grain, however, which may be why he died practically penniless. His work has an inner quiet, a sweetness that is never dull and yet never makes the large gesture. *Rebecca at the Well* refers to the biblical story in which Abraham sent his servant to find a bride for his son, Jacob. The servant devised a simple test. He would ask for water at the well, and the girl who offered water not just for himself but also for his camels would be the one God intended as Jacob's wife. Here we witness the encounter. Rebecca has the natural caution of a country girl accosted by a well-dressed stranger, but we see no fear. This slender woman is at the threshold of great things, and even those who know nothing of the story can sense that this is no trivial encounter. Soon she will dip that jug into the well and go to the waiting camel that thrusts a hopeful muzzle into the picture.

ASSUMPTION
OF THE VIRGIN
*1735, oil on canvas, 204 x 96
(517 x 245 cm), Musée du Louvre, Paris*

Piazzetta treats this theme with considerable drama. Mary is remote from the excitement, but the apostles on earth grieve with expansive gestures. The apostle lifting his arms in dismay is probably Thomas, who has come too late to see the miracle and can only fix grieving eyes on the empty tomb. Piazzetta orchestrates darkness and light and draws us deep into the picture and upwards into glory.

REBECCA AT THE WELL
*c.1740, oil on canvas,
54 x 40 in (137 x 102 cm),
Pinacoteca di Brera, Milan*

THE EROTIC CHARGE IS MUTED, *because here is a suitor who comes on behalf of another. Piazzetta uses the lightest of colors for his women and a reticent and somber splendor for Abraham's ambassador. The general effect is both lighthearted and contemplative – a rare achievement.*

PICASSO, PABLO 1881–1973 b. Spain, active France

LES DEMOISELLES D'AVIGNON

THIS IS THE PICTURE WITH WHICH PICASSO, as it were, broke the mold and claimed for the Western artist the same freedom from objective truth as has always been practised in Africa and Latin America. It is an extraordinarily large painting, on which Picasso labored for a long time. The five women were prostitutes, and the title refers to a brothel in Avignon. At first, Picasso had not intended to show them as such monsters, but his natural attitude towards women, disguised by extreme machismo, in reality seems to have been one of fear. They were somehow the enemy, and the prostitute, who could infect the customer with venereal disease, was the enemy at her ugliest. Those of Picasso's friends who saw the picture were deeply distressed by its ugliness. It is, indeed, a masterpiece of the ugly, carried to such a height and with such conviction that it becomes the beautiful. Although the images do not coalesce, the painting's charge of sexual dismay and creative aggression leaves no viewer untouched. It has certainly left no twentieth-century artist untouched – from this point on, the possibilities of wrenching the true out of joint, of twisting it to suit the artist's psyche, became overwhelmingly tempting.

THE DREAM
1932, oil on canvas, 51 x 38 in (130 x 97cm), Private Collection

The only person Picasso consistently painted with tenderness was Marie-Thérèse, the teenage blonde whom he seduced in the 1930s and whose life thereafter revolved around him. Something about her vulnerability and her large, moony beauty offered less of a threat to him than any other of his relationships. Here, he paints her in the abandon of sleep. Although he has fractured her face, both views – the green profile and the pink and green full face – are strong and beautiful.

(caption continues)

THE TWO CENTRAL *figures are still basically recognizable as human women, and even the face of the woman on the left has a certain tragic beauty. Her body, however, is like hard metal, as vicious and unappealing as the scimitar of watermelon or the colorless fruit that streams down and out of the picture.*

IT IS THE WOMEN *on the right who most clearly reflect Picasso's fascination for African and Iberian sculpture. Their distortions are extreme and horrifying – so much so that it is difficult to make out whether the woman on the lower right is exposing herself to us or is half turned away.*

LES DEMOISELLES D'AVIGNON
1907, oil on canvas, 96 x 92 in (244 x 234 cm), Museum of Modern Art, New York

PIERO DELLA FRANCESCA 1410/20–92 b. Italy
RESURRECTION

IT IS HARD TO ACCEPT THAT FOR CENTURIES PIERO WAS FORGOTTEN, regarded, at the most, as a very minor Renaissance painter. Now he seems to us to loom effortlessly above the rest. No artist has ever rivalled the majesty of Piero, or achieved that sense of inner stillness that our anxious century finds so deeply appealing. Here is the risen Christ as the young hero – nature god, as it were; on His left, the bare trees of winter, on His right, leafed trees, called into fertility by the vitality of His risen presence. His is an implacable face, making no judgements, but in its austere purity perhaps calling us to judge ourselves. Piero softens the grand severity of the image by showing the blood-stained wound in Christ's side and, in a lighter mood, throwing around the heroic torso of his Christ a robe of the most delicate flowery-pink. The four sleepers are monumental in their own right, and although Piero's main concern is to show the profundity of their slumber (which enabled the earth-shaking resurrection to take place unobserved), they also provide a human contrast to the physical glory of Jesus. Their muscular glory is unused, wasted; Christ stands erect, holding His banner, tense with restrained motion as He readies Himself to rise and leave the tomb.

MADONNA DELLA MISERICORDIA
c.1447, oil and tempera on wood, 53 x 36 in (134 x 91 cm), Museo Civico, Sansepulcro, Italy

The *Madonna of Mercy* was commissioned by a guild whose aim was to help the poor and unfortunate. Here, the guild members admit their own need, and huddle under the great protective mantle of the Virgin. She is like an eastern idol, a great goddess with an impassive face, silently spreading wide the cloak of protection to those beneath it. The man who buries the dead, with the black hood over his face, is as in need of the Virgin's sheltering love as is the girl with her maidenly hair streaming down her back. The Virgin's protection is offered to all who pray for it.

P
360

ALTHOUGH the background may not be familiar to us, these small hills with scattered clumps of bush represent with amazing accuracy the landscape around Borgo Sansepulcro, the town in which Piero lived most of his life. The sky, significantly, is streaked with the cirrus clouds of early morning – the world will soon awaken to a new day.

EACH OF THE FIGURES seems to be in a different degree of slumber: the man on the left could be rubbing his eyes, about to awake; equally, the man on his right is in a position that is not conducive to deep sleep. The man above him is not as deeply sunk in slumber as his hapless companion. Morally then, each of these men is more or less guilty of wilful ignorance of the event to which, physically, they are so close.

RESURRECTION
c.1463, fresco, 89 x 79 in (225 x 200 cm), Museo Civico, Sansepulcro, Italy

PIERO DI COSIMO c.1462–c.1521 b. Italy

A SATYR MOURNING OVER A NYMPH

PIERO DI COSIMO WAS A MAN around whom legends gathered. He was said to be a recluse and extremely eccentric and, although it is wise to take apocryphal stories with a pinch of salt, his paintings are certainly unlike those of his Renaissance contemporaries. This picture is usually considered to show the mythological tale of the death of Procris, who was killed mistakenly by her husband Cephalus when he was out hunting. Piero di Cosimo's interpretation of the story, however, is so original that the actual subject has been questioned, and the National Gallery, London, refers to it as simply *A Satyr Mourning over a Nymph*. What interests Piero di Cosimo, however, is not the death of the nymph herself but the reaction to her death of the satyr and perhaps the noble dog that watches. The satyr is kneeling down, and it is only his pointed ears that reveal that this mourner is not fully human. The satyr is puzzled. This beautiful woman, slain in her prime and lying as if asleep on the grass, makes no more sense to him than it does to his canine counterpart.

A SATYR MOURNING OVER A NYMPH, *c.1495, oil on wood, 26 x 72 in (66 x 184 cm), National Gallery, London*

"THIS YOUNG MAN [PIERO DI COSIMO] HAD FROM NATURE A VERY LOFTY SPIRIT, AND HE WAS VERY SET APART AND VERY DIFFERENT IN HIS THOUGHTS AND FANCIES FROM OTHER YOUNG MEN"
Giorgio Vasari

FOREST FIRE
c.1505, tempera on wood, 71 x 203 cm, Ashmolean Museum, Oxford, UK

This is Piero di Cosimo at his most inventive and challenging. He imagines a landscape at a very early time in the history of the world, in which fire is still a relatively new phenomenon and beasts flee from its destruction. He has peopled this world with creatures true to his vision, and it is the nature of these beasts that is so striking. This is a time, he suggests, before divisions between man and animal were absolute, and many creatures are shown with human heads.

WE KNOW THAT THE NYMPH *is dead because we can see her wounds, but it is as if the satyr, gingerly holding her shoulder, feels that he can rouse her back to life. Piero's underlying theme is mortality: the suddenness, the injustice, and the mystery of death. He sets this encounter between the immortal satyr, the mortal woman, and the animals in a great expanse of grassland, sand, sea, and sky.*

THE ANIMALS VISIBLE *in the middle distance mainly go about their own business unperturbed by the tragedy. The satyr is just human enough to realize something dreadful and incomprehensible has happened, and the dog whom long companionship has taught to feel at home in the world of humans is, like the satyr, somewhere halfway between confusion and understanding.*

DESPITE THE FACT *that we can interpret so much narrative in this painting, it remains deeply mysterious. Piero di Cosimo's special gift was to make us aware of the strangeness of life and to leave it at that – without attempting to provide answers.*

PISANELLO (ANTONIO PISANO) c.1395–c.1455 b. Italy

THE VIRGIN AND CHILD WITH ST GEORGE AND ST ANTHONY ABBOTT

NEVER DID TWO SAINTS seem to have less in common than St Anthony Abbot and St George. They view each other across a considerable space with incredulous astonishment. St Anthony, defiantly crowned by a large golden halo, is dressed as befits a monk, with rough habit, long beard, staff in one hand, and bell in the other. This was the bell that his followers rang as they walked through the streets to collect alms for the poor. The large boar that lolls peacefully by St Anthony's side is the saint's particular symbol. St George, on the other hand, is a stylish aristocrat, who has substituted for the archaic halo the large circle of a straw hat. This remains slightly unconvincing, as does the overelaboration of his armor. All that marks St George as a saint is the silver cross embroidered on his back. Here is a youthful warrior, with two extravagantly bridled horses behind him, and at his feet the scaly dragon that he vanquished – his personal symbol. Yet, while Anthony glowers and George raises his eyebrows, to them both appears a vision of the Virgin Mary, floating in a nebulous mandala, golden and beautiful. She clasps her Child to herself, and He is occupied solely with the nearness of His beloved Mother. Strangely enough, or perhaps not, neither of the saints, eyeball threatening eyeball, has the sense to look upwards.

THE VIRGIN AND CHILD WITH ST GEORGE AND ST ANTHONY ABBOT
c.1450s, tempera on wood, 18½ x 11 in (47 x 29 cm), National Gallery, London

THE ANIMALS ARE AS DISSIMILAR *as their respective patrons, and the rough brown hair of the boar is off-set against the dragon's gleaming scales. The boar may well be the descendent of the famed devil with whom St Anthony is said to have done battle in the wilderness. Over time, this original hog devil became completely domesticated. St Anthony's monks were said to have tended herds of swine, which roamed freely around the woods and the streets, their devilish antecedents completely forgotten.*

THE VISION OF ST EUSTACE

c.1450s, tempera on wood, 22 x 26 in (55 x 66 cm), National Gallery, London

The Vision of St Eustace depicts the incursion of human cruelty into a paradise of animal peace. Eustace was a great hunter, and the story goes that while hunting on Good Friday, he caught sight of a large stag and pursued it into the depths of the wood. The stag then turned around and faced him; bearing between its antlers a crucifix that silently summoned the hunter to repentance and to conversion. It is this precise moment of the great encounter that Pisanello shows us. It is clear that he is almost as interested in the animals as he is in the man. One is particularly drawn to the dog that turns its head, and looks towards his master quizzically.

PISSARRO, CAMILLE
1830–1903
b. West Indies, active France

THE CLIMBING PATH, L'HERMITAGE, PONTOISE

FOR MOST OF HIS LIFE Pissarro was too poor to travel very widely in search of motifs, but it also seems to have been congenial to his domestic temperament that he should take great pleasure in painting his own environment. It was when he had moved to the village of Pontoise on the River Oise, just to the northwest of Paris, that he embarked on a series of magnificent landscapes. *The Climbing Path, L'Hermitage, Pontoise*, is a picture of extraordinary daring. What has seized the artist's attention as he climbs the steep hill is not just the view but the actual path that continues its way precipitously upward. Pissarro's sense of composition, the necessity to integrate all the elements, is so intelligent and deep-rooted that looking at this double vision, as it were, we never feel that what we see is a painting in two parts. The winding sunlit path is echoed by the sunlit walls on the left, by the sunlit trees, and by the grass, shimmering and golden in the distant fields and close by at the bottom left.

VIEW FROM LOUVECIENNES
1869–70, oil on canvas, 21 x 32 in (53 x 82 cm), National Gallery, London

Before his move to Pontoise, Pissarro lived in another village near Paris, this time seemingly much flatter. Yet, here again, he makes pure poetry out of a road. Another artist, less of an Impressionist, might have seized upon the ruin on the distant hill; but Pissarro's genius is to take what is ordinary and unimposing, and paint it with such truth and love that we see its beauty. This insignificant road glows in the sunlight with such serenity that one envies the artist and is grateful that he should share with us his experience.

LITTLE TOUCHES *orchestrate the painting so that we can fully believe in this great swooping view that descends from the pink wall and the trees in the foreground to the meadows below. The distant white house and the three poplars, framed by a gap in the trees, balance the curve of the ascending path.*

PISSARRO *gives us a sense of movement, carrying the eye up and out of the picture. The view is delightful and, while it lacks drama, there is a profound beauty in its colors and shapes. It is this, together with the hint of intrigue as the path leads out of the canvas, that makes this an early masterwork.*

THE CLIMBING PATH, L'HERMITAGE, PONTOISE
1875, oil on canvas, 21 x 26 in (54 x 65 cm), Brooklyn Museum of Art, New York

PITTONI, GIOVANNI BATTISTA 1687–1767 b. Italy

THE CONTINENCE OF SCIPIO

IF ONE WANTED TO PAINT UNABASHED MELODRAMA with a grand, theatrical gesture and yet still keep a straight face, this would be the way to do it. Pittoni makes no pretence of realism; he has translated this story to the realm of the operatic but without insulting our sense of what is fitting. *The Continence of Scipio* is often treated with great seriousness. Scipio was one of the greatest Roman military heroes, and from among the loot of a captured city he is said to have acquired a virgin, who was handed to him although she was betrothed to another. Scipio held back from ravishment and summoned her betrothed, whom he then reunited with his beloved. This act of self-denial seemed so heroic to the chroniclers that its fame has reverberated down the centuries; perhaps Pittoni is right to treat the subject with a certain colorful brio.

THE CONTINENCE OF SCIPIO
18th century, oil on canvas, 22 x 38 in
(56 x 96 cm), Musée du Louvre, Paris

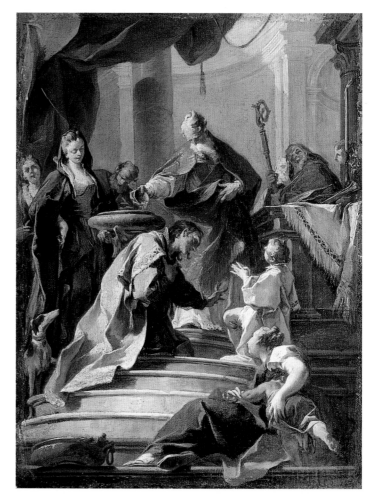

ST PROSDOCIMUS BAPTIZING DANIEL
1725, oil on canvas, 22 x 16 in
(55 x 40 cm), City Art Gallery, York, UK

St Prosdocimus may be a household name in Venice, but for the rest of us, perhaps, we must be content to take Pittoni's assurance that here was a saint indeed. From the child's foot at the base of the stairs, up through the woman's arm and the boy at prayer, Pittoni – with great confidence of execution and sense of drama – has created a pyramid structure, the modest peak of which is the baptizing saint, with the bishop's staff and attendant lady on either side.

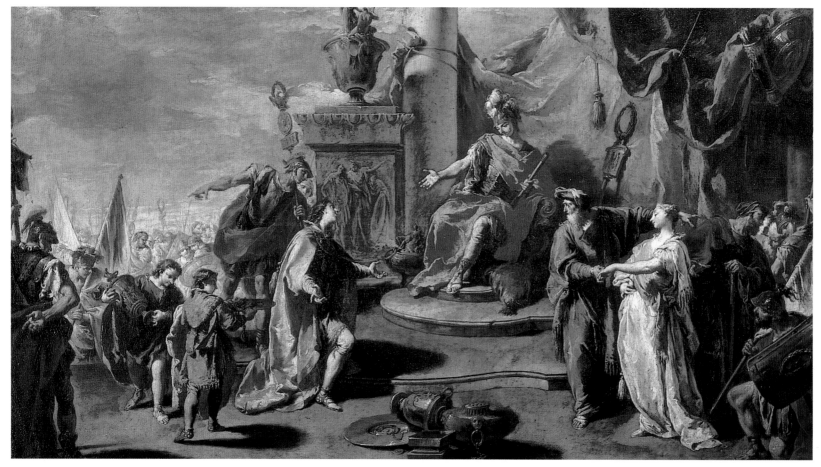

SCIPIO, RESPLENDENT *in full military headgear and scarlet cloak, makes the great gesture of renunciation. The fiancé responds in kind with hands lifted in gratitude and astonishment. The men's thunder is stolen, however, by the virgin herself, in flowing white draperies and blue sash.*

THE VIRGIN, PALE AND DROOPING *from the dramatic turn of events, has a neat line and elegant gesture. She arches back her head on its swanlike neck and extends the daintiest of hands as she waits to be passed from the miseries of captivity to the bliss of married life.*

IT IS THE SUBTEXT *of sophisticated amusement and the enthusiasm with which Pittoni sets up the context that make this picture so delightful. The scene is dressed with pillars and curtains roped rather uncertainly into place and a whole entourage to provide admiration for Scipio. The vastness of Pittoni's imagination is a thing of splendor.*

POLLAIUOLO, ANTONIO c.1432–98 b. Italy
APOLLO AND DAPHNE

POLLAIUOLO WAS FASCINATED BY THE MOVEMENT of the human body, and we are told that he even practised dissection – a daring venture in the 15th century – so as to understand better its mechanism. (Perhaps this knowledge is behind his athletic and muscular portrayal of Apollo.) Yet, ironically, this small masterpiece is all about surrendering the powers of the human body to become a tree. Apollo, the sun god, fell in love with the nymph Daphne, and when she rejected him he pursued her with implacable ardour. Daphne prayed for rescue to her father, the river god (and we notice the river snaking its way through the landscape in the background). In the foreground, Apollo clasps Daphne triumphantly, but we see that her prayer has been answered and that she is becoming transformed into a laurel tree. This is the reason why Apollo wore a wreath of laurel forever after.

HERCULES AND THE HYDRA
c.1470, oil on wood, 7 x 5 in (17 x 12 cm),
Galleria degli Uffizi, Florence

In this small panel, Pollaiuolo depicts Hercules fighting the Hydra, a many-headed monster that lived by Lake Lerna. As soon as one head was severed another grew – a terrible image of multiplying disaster with its nightmare consequences. But Hercules, in his wonderful male vigor, is purely heroic. He stands on the commanding heights clearly undaunted, battering not with sword but with club, while the hydra weaves its sinister coils around his leg. Pollaiuolo expresses the greatness of masculine courage with triumphant effect. The dark sky brightens as it reaches down to the river-ribboned earth, which is Hercules' inheritance.

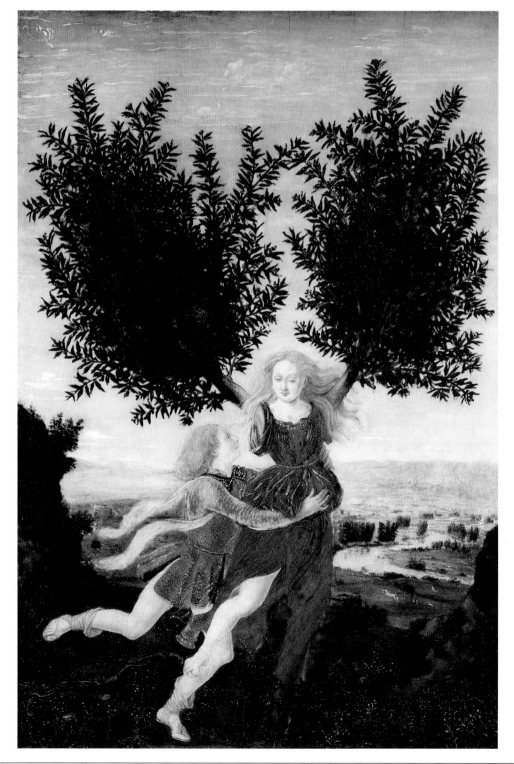

IT IS IMPOSSIBLE TO SPEAK *about this magical painting without remembering Wordsworth's warning in* The Tables Turned, *"Our meddling intellect Mis-shapes the beauteous forms of things: We Murder to Dissect". Apollo's pursuance has pushed Daphne to this point of transition; in grasping the object of his desire, he has destroyed what it was. Daphne's face looks down with benign triumph as she exchanges the soft vulnerability of womanhood for the protected life of a tree.*

UNUSUALLY, POLLAIUOLO *shows the transformation working downwards, although Daphne's feet are already taking root in the dark soil. To maintain her integrity – to be free from violation, even by the sun god – is of such overriding moral importance that the transformation comes to her as a blessed relief.*

APOLLO AND DAPHNE
c.1470–80, oil on wood,
12 x 8 in (30 x 20 cm),
National Gallery, London

POLLOCK, JACKSON 1912–56 b. US
BLUE POLES: No. II

A FILM WAS MADE OF JACKSON POLLOCK at work: his canvas was spread on the floor, as he created a seemingly mad kaleidoscope of colors and lines. He insisted, however, that at all stages he was in control. He had gone beyond consciousness into a state of semi-trance in which the designs and patterns of what he was creating seemed to come irresistibly as he swung his arm and moved around his space. Whereas all other painting had shown us the finished image – evidence that a painter once stood before it and with his brushes created a picture – a Pollock shows us the actual process of creating the work, the traces of the artist's physical and mental activity. This ecstatic dance was the literal outpouring of inspiration, and so we come very close, in looking at a Pollock, to understanding what it means to make something out of nothing. There is an incandescent magic about a great Pollock that has to be experienced to be believed. Perhaps it expresses for us our deepest hopes and fears about life itself – that the chaos and lack of control in which we all live will somehow, at the end, become a thing of organized if erratic beauty.

BLUE POLES: No. II
1952, oil and synthetic polymer paint on canvas, 83 x 180 in (211 x 458 cm), National Gallery of Australia, Canberra

THE DEEP
1953, oil and enamel on canvas, 87 x 59 in (220 x 150 cm), Musée National d'Art Moderne, Paris

The sheer creative energy that Pollock needed for his drip paintings could not sustain itself. Here, we see him modulating to a mood of greater serenity. *The Deep* could be the depth of the sea or the depth of the sky, or perhaps the depths of the psyche. Pollock is magically suggesting a mystery beyond. Underneath that wholly satisfying surface of creams and blues lies a completely different world, of which we are conscious only because he has opened up gaps and spaces.

BLUE POLES: No II IS UNUSUAL in that there is a visible structure enforced by the eight great totems that rear up and, as it were, wind the fabric of the painting around them. In their darkness and heaviness, they draw attention to the wandering freedom and the lightness of the red, yellow, and white, and the fugitive colors that show themselves, gleam, and then disappear in the vast expanse of this congested work.

PAINTINGS SUCH AS THIS *were a kind of work that the art world had not seen before, and yet, with amazing speed, the marvelling viewers came to feel that the enormous electric energy here – the sheer outpouring of creative power that was yet inexplicably controlled – was something of enormous interest. To use de Kooning's famous and often-quoted remark, "He broke the ice".*

POLLOCK WAS NOT TRYING *to paint "something"; he was "painting". It was the activity – the miraculous interplay between the mind and the imagination, the hand and the brush, the paint and the support – that intrigued him. Those who think that anybody could do a Pollock will be interested to hear that many have tried and yet never been successful at imitating him.*

PONTORMO (JACOPO CARUCCI) 1494–1557 b. Italy
DEPOSITION

PONTORMO IS THE QUINTESSENTIAL MANNERIST, an artist for whom style can seem more important than theme. Here, with startling originality, he undertakes a very sacred and often repeated theme – or does he? If this is a deposition, where is the Cross from which Christ has been lifted? If this is an entombment, where is the grave to which He is to be carried. Pontormo abstracts from the literal and asks us to consider, primarily, the condition of being lifted, of being carried, of being – in the most sublime sense – baggage. Extraordinary acid pinks lead us into a circular motion from the male figure at upper right, through the pink arm of the contemplative woman, through the fluttering veil of the woman bending, and down the length of St John's body on the left to end, for the moment, in the strange, lurid pink of the man who crouches in an extraordinary contortion to support the legs of Christ. The circle of pinks then rise up across the back of the grieving Mary Magdalen, until the eye rests on Mary the Mother, who alone is without pinks. The journey then starts again through the headwear of the attendant Mary, and we are kept in a whirling circle, rising and falling with the strange sense of continual movement.

DEPOSITION
c.1526, oil on wood,
123 x 76 in (313 x 192 cm),
Santa Felicità, Cappella
Bardori, Florence

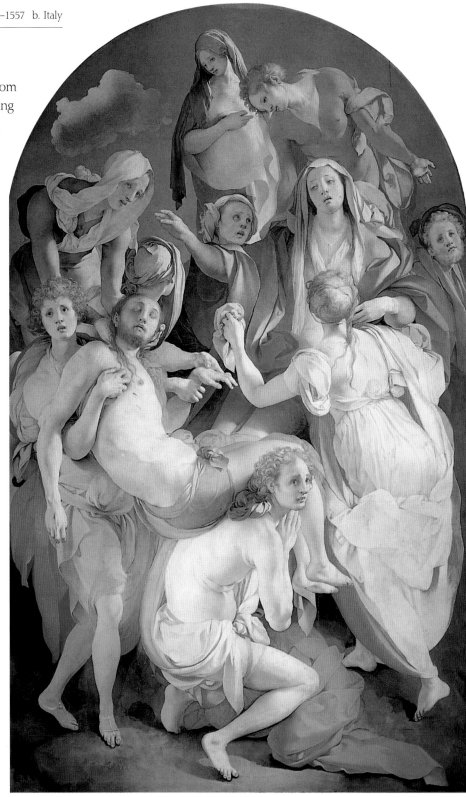

PORTRAIT OF MARIA SALVIATI
c.1537, oil on wood, 32 x 28 in
(81 x 71 cm), Galleria degli Uffizi, Florence

This is the mother of Cosimo I de' Medici, painted when he was, in all but title, absolute ruler of Florence. Pontormo has stressed her sobriety and religious convictions, and he depicts her, in fact, almost as a nun. It is not a nun's habit that she wears, but in its simplicity and strength, its modesty and lack of all adornment, it suggests the attire of the convent. Unless, of course, this is politically motivated – Cosimo was eager that he should seem neither to be battling for Florence nor to be flaunting ducal riches.

THIS IS A SERIOUSLY *religious work, and the staring eyes and fixed expressions are not the idiosyncrasies of style alone, but a way to express that what is happening here is beyond human comprehension. As well as the windmill effect of the pink, the arms, too, twirl the picture in constant motion. The fact that we can only distinguish for certain Christ and His Mother (the identification of Mary Magdalen and St John is a matter of guesswork) adds to the sense of confusion.*

POPOVA, LIUBOV 1889–1924 b. Russia
RELIEF

LIUBOV POPOVA WAS ONE OF a brilliant generation of Russians who lived at the time of the Revolution; like many of them, she died young. One can almost feel that such energies were fated to burn themselves out quickly. To appreciate this extraordinary picture, we need to step back from it a little, hold it at arm's length, and allow the eye to roam around until the mind makes a jump of recognition. Against the tiled background, a man is standing. At the top is the black tube of his hat, and then splendid triangles and irregular shapes of color angle down to form a head with a pointed chin; one eye is suggested by arcs, the other by a vague half circle. Then, there is the pipe, a curl of gray and white under the orange angle of the nose and above the orange and white of the necktie. The portrait broadens out to encompass the wide blue of the shoulders and the upper body. The man's identity has been fractured, subsumed, but the joyous color suggests a celebration nonetheless.

PICTORIAL ARCHITECTONIC
1917, oil on sacking, 28 x 28 in (71 x 71 cm),
Museo Thyssen-Bornemisza, Madrid

Popova's art tended naturally to the abstract, but it was an abstract that was of such weight and geometric power that she coined for it the term and title *Pictorial Architectonic*. Huge, dark pyramids collide and overlap, striding across the canvas with the gliding majesty that convinces us, paradoxically, both of their weight and their lightness. There is a sense in which we feel that at any moment each dark shape might be materialized and explode into the brightness, to radiate with the same luminosity that surrounds them.

THERE IS NO ONE–TO–ONE *correspondence here, and nothing is certain. It is a free, humorous, and affectionate depiction of a man, composed from a succession of brightly colored shapes that somehow cohere and rear themselves in triumph against the competition of a bright background.*

POPOVA IS FULLY IN CONTROL *of her unusual medium and, if the work suggests colored curls of paper or gleaming tin strung together, she holds it together with such firmness and aplomb that we take far more interest in the man than we would if he were rendered more conventionally.*

RELIEF, *1915, oil on paper,*
26 x 19 in (66 x 49 cm),
Ludwig Museum, Cologne, Germany

POTTER, PAULUS 1625-54 b. Netherlands
THE BULL

PAULUS POTTER DIED BEFORE HE WAS THIRTY, after a career devoted almost entirely to painting domestic animals. It sounds dull, but it is, in fact, some of the most interesting and even exciting art that has come down to us. He was only 22 when he painted this magnificent study of a young bull. The farmer, lurking proudly behind the tree, has little significance in the artist's reaction to the sheer power and glory of this, the greatest of farm animals – one hesitates to say domestic, since, even now, a bull is unpredictable and dangerous. Against a fence clusters a small family of sheep, beautiful in their way, but one cannot help but feel that Potter sees them as predictable, timid, humanoid animals, who simply exist, as opposed to being alive. It was the immediate empathy that the young artist felt with the young bull that so impressed the early viewers of this picture. It made him famous and showed that here was an artist able to understand the strange rhythms of the animal world at its most intense. He does this without any sense of histrionics, far less any foolishness or sentimentality; rather, he makes us truly respond to this animal.

WATCHDOG
c.1650–52, oil on canvas, 38 x 52 in (97 x 132 cm), Hermitage, St Petersburg

Potter is famous for his cattle, and yet, as we can see here, he was able to empathize with any powerful animal. The Russian Wolfhound was accustomed in his native country to roam free as a hunting dog. Here, some unimaginative Dutchman has chained him to a wooden shed and set him as a guardian over a small domestic farm. The dog accepts its fate with a sad majesty, the alert brown eyes scanning the horizon for its master's enemies, the fine head uplifted against a vast expanse of sky.

THE BULL
1647, oil on canvas,
93 x 133 in (236 x 339 cm),
The Mauritshuis, The Hague

POTTER HAS LOOKED AT EVERY DETAIL, *not just the dappling of the hair, but the skin beneath, how it ruffles around the neck, rough and rugged, and then bellies out smoothly over the sides. How the tail is tufted, how the bones jut in the hind legs, and how the massive male genitalia declares itself in uninhibited power.*

POUSSIN, NICOLAS 1594–1665 b. France

LANDSCAPE WITH THE ASHES OF PHOCION

THE STORY OF PHOCION THE ATHENIAN GENERAL was one that drew from Poussin two of his greatest works. Phocion, a profound believer in peace, was unjustly condemned to death by the Athenian authorities. His body was burned so that there would be no resting place for his spirit. However, it is the heroism of Phocion's wife – who secretly scooped up her husband's ashes and bore them away to be preserved in honor – that Poussin celebrates. He shows a landscape dominated by a great classic temple, representing the great civic forces of law and order – human authority in its power. Above soar the eternal rocks, representing a far greater power. The little sunlit figures in the middle distance are oblivious to Phocion's widow, and, by extension, also to the hideous act of injustice committed by the authorities (it was legal, they accept it blindly). Only the grieving wife, in the shadows outside the city walls, appreciates how power can be turned to evil usage. Her action was illegal, and yet true justice was on her side.

LANDSCAPE WITH THE ASHES OF PHOCION
c.1648, oil on canvas,
46 x 70 in (117 x 179 cm),
Walker Art Gallery, Liverpool, UK

THE SHEPHERDS OF ARCADIA

c.1638–40, oil on canvas, 33 x 48 in (85 x 121 cm), Musée du Louvre, Paris

The Shepherds of Arcadia was also entitled "Et in Arcadia ego" – "I too have lived in Arcadia" – and its meaning is not as simple as it might appear. A group of shepherds find a tomb enscribed in Latin with those words. Arcadia, of course, is the name of a mythical pastoral heaven so beloved by poets in which there was no sorrow, no sin, and no destruction. These beautiful young people have never seen a tomb, death comes to them as a frightening surprise, and they seem baffled by the thought of their own mortality. The enigma is in the meaning of the words: is the tomb announcing that the skeleton within had once lived in Arcadia, or is it Death speaking, saying that even in Arcadia there must be death and the grief that it entails?

A SUPPORTER *watches in terror lest Phocion's wife should be discovered, but the only other witnessess to her heroism are the trees. They, however, are merely impassive onlookers who have, equally impassively, witnessed the martyrdom of her husband. Ultimately, as Poussin makes clear to us, the human conscience is alone. We take responsibility for ourselves and for our actions, and we make decisions under the searching light of our conscience.*

PHOCION'S WIFE *comes down to us through history nameless, famous for her act of loyalty and courage, rather than for her family name. She is heedless of what is accepted by the majority and is aware only of what she knows in her heart is just. The ignominity of her position, the animal-like stance, and the desperate urgency of her movements – as she crouches low, gathering her dead husband's ashes – are at odds with the haughty grandeur of the temple.*

POUSSIN SHOWS US *a great settled world of order and season and implacable movement. This clear, hard world was deeply compatible to Poussin, a highly moral artist. But the absolutes of light and dark, law and punishment, honour and shame that Poussin has dwelt on here so profoundly, serve also to illuminate the obscure half-lit world where activities that cannot fit into this regime must abide.*

> "MY NATURE LEADS ME TO SEEK OUT AND CHERISH THINGS THAT ARE WELL-ORDERED, SHUNNING CONFUSION WHICH IS CONTRARY AND MENACING TO ME AS DARK SHADOWS ARE TO THE LIGHT OF DAY"
> Nicolas Poussin

PROCACCINI, GIULIO 1574–1625 b. Italy
THE MYSTICAL MARRIAGE OF ST CATHERINE

THE MYSTICAL MARRIAGE OF ST CATHERINE, *1609, oil on canvas, 53 x 41 in (134 x 105 cm), Hermitage, St Petersburg*

WHENEVER WE SEE A SPIKED WHEEL, we know that we are in the presence of St Catherine of Alexandria, because such a wheel is the grisly symbol of her martyrdom. As well as her spectacular demise (she was beheaded after the wheel had exploded with a great display of pyrotechnics), St Catherine was famed for what has been called her mystical marriage. She had a vision of a mystical betrothal, as it were, in which Christ was initially reluctant, saying "Catherine does not love God enough," which so distressed her that she set herself upon a course of heroic sanctity until finally she was accepted. The story is spelt out for us by the hands at the bottom right – the Infant Jesus sets the ring upon the hand of St Catherine, which, in turn, rests upon the saint's attribute, the wheel of her martyrdom. However, our attention is drawn to the three ecstatic heads of Mary, Jesus, and St Catherine, pressed together with almost stifling closeness. At the back broods St Joseph, the Virgin's husband, who seems to have no part in this intimate relationship of young women and Child.

PROVOST, JAN c.1465–1529 b. Belgium
A CHRISTIAN ALLEGORY

IN PICTORIAL TERMS, AN ALLEGORY is an image in which every element has an intellectual meaning. For us, the pleasure lies in attempting to decipher what those meanings are. This is a Christian allegory, and the broad outlines are clear enough: at the top is the all-seeing eye of God, on one side the Lamb of Redemption, and on the other the Bible. A great hand, surely the hand of God, holds the terrestrial globe, which is surmounted by a cross. But readings of this kind, though not untruthful, deny the glorious ambiguity that characterizes allegory at its finest. For those to whom Christian iconography is a closed book, such an image can seem surreal, contrived, unable to convey a sacred meaning except in the most theoretical sense. Yet despite all this, who can be indifferent to this strange and haunting picture, to those hands that press up, to that peculiar and sinister eye below them, or to the expressions – Christ's, questioning and uncertain, Mary's, sunlit and hopeful?

A CHRISTIAN ALLEGORY
c.1500, oil on wood, 20 x 16 in (51 x 40 cm), Musée du Louvre, Paris

PRUD'HON, PIERRE-PAUL 1758–1823 b. France

JUSTICE AND DIVINE VENGEANCE PURSUING CRIME

PRUD'HON'S VERSION OF ROMANTIC DRAMA became very popular in Napoleonic Paris. This enormous canvas was commissioned for the central hall of the Palais de Justice. There are clearly echoes here of Cain and Abel. Prud'hon depicts the murderer as dark and villainous, clutching his knife and scowling as he flees his crime. If Cain is the creature of darkness then Abel is the creature of light; the full moon shines brightly on the outspread nakedness of the victim to make the contrast more telling, and we are asked to see one as the personification of evil and the other as the personification of good.

JUSTICE AND DIVINE VENGEANCE
PURSUING CRIME, *1808, oil on canvas,*
96 x 116 in (244 x 294 cm), Musée du Louvre, Paris

THE EMPRESS JOSEPHINE
1805, oil on canvas, 96 x 70 in
(244 x 179 cm), Musée du Louvre, Paris

The Empress Josephine was a patron of Prud'hon, and this portrait of her is perhaps the only image that shows her as defeated. In her early forties, continually barren, a disappointment to her husband who needed an heir, Josephine is here facing up to the possibilities of personal disaster. Prud'hon sees her as still beautiful, sensually alluring, in fact, with that half-revealed bosom, the transparent gold gauze of her gown, and the gorgeous red of her shawl. But she sits alone in a forest glade, melancholy, her mood in tune with the setting sun and the cold stone.

ABOVE THIS *terrible tableau, Justice and Divine Vengeance zoom onto the scene. Justice holds the torch of truth, and, though Crime seeks to hide in the darkness, the light of justice will search him out. Justice stretches out a hand as if to grasp Crime by the head and haul him roughly back to meet Divine Vengeance.*

VENGEANCE HOLDS *a sword in one hand and the scales in the other, so that the crime will be weighed fairly in the eyes of God. There is a scene of intense melodrama, exaggerated and overheated in its emotionalism in order to impress upon those who stood at the bar in that great court that divine justice, of its nature, could not be evaded.*

PUVIS DE CHAVANNES, PIERRE 1824–98 b. France
THE POOR FISHERMAN

ALTHOUGH PUVIS DE CHAVANNES might seem to us the most bland of traditionalists, nearly every avant-garde artist of the 19th century admired his work. The edge that they saw in Puvis's work, and that is unmistakably there if we search for it, comes down to an almost over-simplification of form. His broad, strong clarity enabled him to express himself with an unthreatening power that his contemporaries found novel and arresting. *The Poor Fisherman* was the work that brought him to general attention. Puvis has employed the support of geometry in the long diagonal of the mast, which plunges down through those arches of the fish trap, and in the sweeping lines of the boat that carry on past the fisherman to wife and child, who hold stylized positions as if frozen in time and space. "Poor" is the operative word in the title. The meagerness of the picture, with no material softening except for the flowers on the meadow, is hammered home by the barren setting.

YOUNG GIRLS BY THE EDGE OF THE SEA
1879, oil on canvas, 81 x 61 in (205 x 154 cm), Musée d'Orsay, Paris

Young Girls by the Edge of the Sea has a note of sensuality that is unusual for Puvis. The beautiful curving back of the standing girl playing with her long hair is a wonderful image of the virgin, ready for sexual encounter but still hesitating on the brink. There is a chalky element always to his work – the paint is never luscious – but for once this austerity is transcended in the gleam of the girl's hair and the ripe contours of her hips.

THE FISHERMAN'S *very position, cramped and melancholy, recalls Christ crowned with thorns, and there are echoes of the Pietà in the woman and the child. These religious associations are deliberate: Puvis is comparing the hardship of the life of a working man with that of Christ, but the impact of the message is infinitely stronger because it is unstated.*

NOTHING HERE *affords sensual pleasure, and even the flowers are scattered and faint. It is an art that depends upon the graphic rather than the chromatic. The Christ crowned with thorns and displayed before the people is traditionally entitled Ecce Homo ("Behold the Man"), and that, of course, is Puvis's intention. Here is indeed a man, displayed before us in his poverty and inadequacy.*

THE POOR FISHERMAN
1881, oil on canvas, 61 x 76 in (155 x 193 cm), Musée d'Orsay, Paris

PYNACKER, ADAM 1622–73 b. Netherlands

THE BRIDGE AT GRANCHEVILLE

LANDSCAPE PAINTERS WHO HAD BEEN BROUGHT UP in the flat terrain of Holland felt they had discovered a new dimension when they first travelled to Italy and saw its precipices and scenic dramas. Pynacker is a superb example of the Italianist-Dutch landscape painter. The world that he paints is not only beautiful in itself but also carries a charge of nostalgia and longing. Pynacker is painting from his imagination. This evening scene, in which the foreground is filled with the quiet play of boats, oxen, and riverside activities, is a prelude to what lies beyond – the small business of humankind is framed by the great world of nature. The river flows, calm and gleaming, while arching over all, and reflecting in the quiet water, is the perfect half-circle of the stone bridge. It is the artist's sense that a world seen framed by an arched bridge is the world at its most memorable – that becomes our conviction too.

BOATMEN MOORED ON THE SHORE OF AN ITALIAN LAKE
c.1660, oil on wood, 38 x 33 in (97 x 83 cm), Rijksmuseum, Amsterdam

This glorious picture, in which the full blaze of the Italian sun at noon is defeated by the thick shadows of the encircling wood, needs no narrative content to give it significance. The prominence of the husband, wife, and baby has led to a belief that this is intended to represent the flight into Egypt, but this seems as ludicrous as it is unnecessary. Pynacker simply responded to the Italian atmosphere. His lake almost smokes in the midday heat, and the over-arching mountain is lost in the haze. This is what excites him and what he seeks to communicate: the feeling of heat, of place, of a journey interrupted, of work being carried out within this idyll.

TO THE LEFT, THE LANDSCAPE *rears up into a rough hillside, crowned by the solidity of architecture. On the right, there are houses, too, but lower down. It is as if the bridge is there to take us from the world of authority and business, as seen below in the foreground, to a more mythical land, where houses are sparse and the great hills rise solemnly to the mountains, and where the main activity is the movement of clouds in the sky.*

PYNACKER COMMUNICATES *a sense of peace, a sense of the world being right with itself, of nature and humanity working together in harmony. Beneath this peace, however, we sense the artist's nostalgia. Interestingly, the bright accents in the picture are on the sleeve of the woman working in the center and on her gleaming forehead. Pynacker will not subordinate humanity for the sake of the natural world but seeks equality for both.*

THE BRIDGE AT GRANCHEVILLE, *c.1640s, oil on canvas, 30 x 25 in (77 x 63 cm), National Gallery of Scotland, Edinburgh*

QUARTON, EGUERRAND
c.1410–c.1461
b. France

CORONATION OF THE VIRGIN

THE *CORONATION OF THE VIRGIN* is one of those extraordinary pictures about which theologians could write volumes. Central is the Trinity: God the Father and God the Son (who are here indistinguishable) are shown crowning Mary, the mother of God, as Queen of Heaven. Quarton has organized the picture into two sections, the upper two-thirds showing heaven, the lower-third depicting earth at the time of the Last Judgment. The two worlds – the one below with its fading, naturalistic light, and the one above, with its great areas of black mystery – are linked by the figure of the crucified Jesus. It is an attempt by Quarton to get the entire world of Christian belief into one great picture, and every detail repays exhaustive examination. Yet Quarton is really making a bold and simple statement: that the world is small and passing, that it is important to use life well so that one can move out of the anonymous insignificance of our cramped earth into the glory of heaven. There, every face is individual and every saint is recognized for whom he or she is. It is a work of great daring and soaring imagination.

THE PIETÀ
c.1460, tempera on panel, 64 x 85 in (162 x 217 cm), Musée du Louvre, Paris

There are only five actors in this scene; all seem immersed in a world of private intensity. The mourners have passed beyond the extremity of pain, into a strange limbo of peace, echoed in the empty landscape. The donor, Jean de Montagnac does not contemplate Christ, but looks intently into the distance, making it clear to us that what we see are the thoughts of his heart.

GOD THE FATHER *and God the Son are linked by the dove of the Holy Spirit, whose wings extend to each of their lips. Their scarlets are backed by the brilliant reds of the cherubim; behind them stretches the endless gold of Heaven. Mary's rippling gold and blue is circled by a cloud on which the blue heads of the seraphim rhyme with her cloak.*

IT IS A WORLD *in miniature, and the souls arising from the dead, being escorted by the angels up to Heaven, are seen as tiny white floating figures. Down below, all is terrible and dynamic action. The Carthusian donor, in his white robes, kneels at the foot of the Cross, oblivious to the human drama raging beneath him of souls being lost or won.*

CORONATION OF THE VIRGIN
1453–4, tempera on wood, 72 x 87 in (183 x 220 cm), Musée de l'Hospice, Villeneuve-Les-Avignon, France

QUEEN MARY PSALTER c.1310 England
CHRIST IN THE TEMPLE

A PSALTER IS A BOOK OF PSALMS, and in the days before the invention of printing, such a book would have been a precious possession. The wealthier the possessor, the more eager he or she would have been to have the psalms decorated and set out in beauty. There was the added advantage, of course, that should devotion flag, the possessor could enjoy the charm of the pictures. The *Queen Mary Psalter* shows precisely why these books were treasured. For us, part of the delight of such a work is the contrast set up between the piety of the images so splendidly spread across the upper half of the pages and the unaffected secularity of the images that decorated the bottom and the margins. Here we see the story of Christ, who, having been mislaid by His parents in Jerusalem, was discovered in the Temple.

QUEEN MARY PSALTER (BAILIFF WITH HUNTING HORN BERATING PEASANTS)
c.1310, illuminated manuscript, 11 x 7 in (28 x 18 cm, page size), British Library, London

Here, one of the secular marginal decorations has been isolated. The bailiff proudly announces his status with that unnecessary hunting horn swinging at his side and raises an imperious stick. But the artist is not merely depicting life in the fields. By setting the scene against a patterned background of red and white, he lifts the incident out of the ordinary and makes it apt for a prayer book. Those who read the book might contemplate the parables of the harvest and appreciate the need expressed in the Gospels to be dutiful and hardworking.

THE TEMPLE IS IMAGINED *with scarlet pinnacles and images of the Jewish prophets. The doctors of the law listen astounded, as the Gospel tells us, to the small Jesus expounding the meaning of the Scriptures. He is very small indeed, perched on an extraordinarily high chair, and His mother, who has just tracked Him down with St Joseph, is peering in at the entrance to the Temple with consternation.*

THE READER OF THE *psalter was meant to meditate here on the story of Jesus – on His power, even as a baby, to preach the truth, and His proclamation that if ever He was thought to be missing He could always be found in His Father's Temple.*

QUEEN MARY PSALTER (CHRIST IN THE TEMPLE) *c.1310, illuminated manuscript, 11 x 7 in (28 x 18 cm, page size), British Library, London*

RAEBURN, SIR HENRY 1756–1823 b. Scotland

THE REVEREND ROBERT WALKER SKATING

BRITISH ARTISTS HAVE ALWAYS BEEN FASCINATED by two things: the landscape and the face. Henry Raeburn was a brilliant Scottish portrait painter whose ability to capture likeness was, at its best, unrivalled. This is his masterpiece, the extraordinary and daring picture of Reverend Robert Walker ice skating. Here, the landscape – never a major interest of Raeburn's – is completely subordinated to a misty background, against which this solid black figure in its balletic pose impinges powerfully on our consciousness. At first, it might seem a fairly frivolous occupation for a senior cleric, demurely clad in black from head to foot except for the white collar and the extraordinary pink skates; but the force of this image comes from its concentratedness. The Reverend Walker does not only balance himself with superb insouciance on the frozen waters, but, to great effect, walks upon the waters as clergymen should, moving implacably towards a goal that only he can see.

MISS ELEANOR URQUHART
c.1793, oil on canvas, 30 x 24 in (75 x 62 cm), National Gallery of Art, Washington, DC

What makes this one of Raeburn's masterpieces is its spontaneous élan and certainty. No brushstroke has been corrected nor addition made; there are no mistakes. Something of the fresh beauty of this young Scottish woman seems to have inspired him to a certainty that has guided every line with unfaltering power. Many portraits depend for their success on reworking and rethinking. This one, in its clear, light color, depends on the opposite. Nothing is truly solid in this painting except for the girl herself, whose presence has inspired a joyous reaction in the artist.

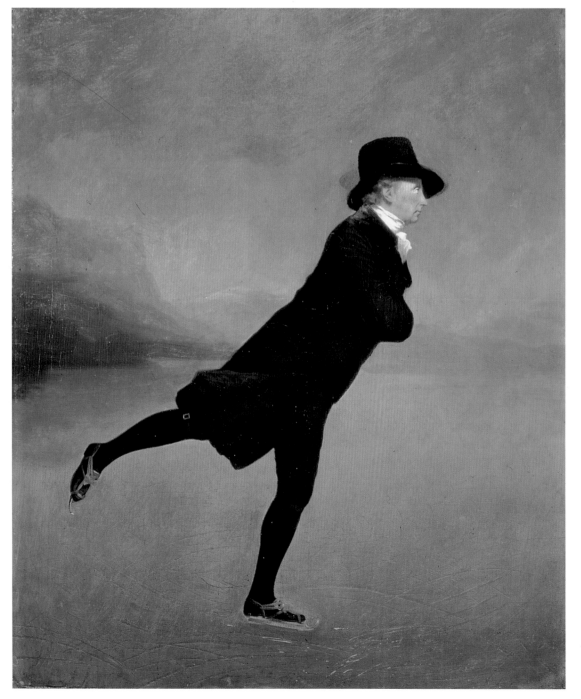

THE AUSTERE NOBILITY of Reverend Walker's countenance assures us that this is not the minister at play, but the minister driving forwards towards a worthy goal. The originality of the concept is typical of Raeburn; it is a brilliant idea, masterfully carried through to a triumphant conclusion.

RAEBURN'S PAINTING is so simple and yet its sense of completeness is deeply satisfying. Even in terms of color, the pink skies, heavy with impending snow, and the dull blue of the ice that is scored with lines made by the passage of skates, works wonderfully as a counterpart to the fresh color and the vivid black dynamism of the Reverend Walker.

THE REVEREND ROBERT WALKER SKATING, 1784, *oil on canvas, 30 x 25 in (76 x 64 cm), National Gallery of Scotland, Edinburgh*

RAMSAY, ALLAN 1713-84 b. Scotland
"THE RED MAN"

IT WAS ONLY IN THE 18TH CENTURY that Scotland shook off its image of being no more than a horrid wilderness of barren rock inhabited by the poverty-stricken. Almost overnight it would seem – thanks principally to Sir Walter Scott – it became romantic, with the tartan greatly to the fore and ancestral loyalties seen as a form of contemporary poetry. Allan Ramsay seems to be playing it safe here. *Norman "The Red Man", 22nd Chief of Macleod* portrays, from the face down, a romantic chieftain wearing the ancestral tartan. The cloth is swathed around him in toga-like folds to remind the viewer of the essential nobility of the Scottish clans. Norman stands with a backdrop that suggests the vastness, remoteness, and poetic beauty of his Highland inheritance; his gesture is commanding – as a chieftain's should be – effortlessly secure in the loyal obedience of the followers that Ramsay asks us to imagine. But from the neck up, all is different: Norman's head is that of a sophisticated 18th-century gentleman, with a neatly-curled wig, a complexion that has seen little buffeting by sun and wind, and that controlled expression of non-enthusiasm that became so typical of the English gentleman.

NORMAN "THE RED MAN",
22ND CHIEF OF MACLEOD
c.1747, oil on canvas, 100 x 63 in (254 x 160 cm), Collection of John MacLeod, Dunvegan Castle, Isle of Skye, Scotland

THE PAINTER'S WIFE, MARGARET LINDSAY
c.1760, oil on canvas, 30 x 25 in (76 x 64 cm), National Gallery of Scotland, Edinburgh

Allan Ramsay was an intensely affectionate man and the premature death of his first wife left him deeply apprehensive about the well-being of the lovely young woman who became his next wife. He sees her in a shower of fragile lace and quivering silks, with a fair, vulnerable face that is set beside flowers that will soon fade. However, the second Mrs Ramsay was a fairly tough young woman; she bore him many children and, in time, outlived him. Nevertheless, Ramsay's concern here resulted in one of his major masterpieces.

RAMSAY'S SKILL, *and he was indeed a very skilled portrait painter, is to make Norman "The Red Man" convincing, both as "red man" and as red-clad gentleman. The gentility may be more apparent than the manliness – the chest dimensions seem rather meager – but he sports a shapely pair of legs and the air of command is worthy of a clan chieftain.*

CASTIGLIONE'S FORM *is massive and yet amazingly delicate. His bearing has a surprising lightness, and his clasped hands and enigmatic expression bring a subtle complexity to a work that is remarkable both for its simplicity and its depth. Looking at this noble face, with its dignity and vulnerability, one can easily understand just how impressive and influential Castiglione was.*

FORMALLY, CASTIGLIONE *seems to rear up before us, like a fact of nature, almost a great rock formation, solid and impassive with that sunburnt face and wiry growth of beard. Yet, despite its reserve, this is the most human as well as the most visually pleasing of portraits.*

ANY DEMANDS *this portrait makes are those made by Raphael on himself as he sought to render the different textures and qualities of the animate and inanimate materials before him: the exquisite softness of the black velvet hat, the black and grey hairs of that fluffy beard, the glorious thickness of those black sleeves with the great, puffed, over-sleeve. The brilliant whiteness of the undershirt is, in itself, a miracle of painting.*

PORTRAIT OF BALDASSARE CASTIGLIONE
before 1516, oil on panel, 32 x 26 in (82 x 67 cm), Musée du Louvre, Paris

RAPHAEL (RAFFAELLO SANZIO) 1483–1520 b. Italy

PORTRAIT OF BALDASSARE CASTIGLIONE

IT WOULD BE IMPOSSIBLE TO SAY WHICH ARTIST is the greatest painter of portraits, but many would award the palm to Raphael. He had that combination of qualities that the portrait painter needs: a keen awareness of the sitter's personality – an insight into what made the sitter "tick" – combined with the great painterly skills that can create forms and colors, that of themselves alone would give us pleasure. We get a double delight from a portrait – insight into another's personality, together with an experience of pictorial beauty. Raphael's great portrait of Baldassare Castiglione is by common consent peerless. The two men were friends, and this was more than a commission; it was a choice on Raphael's part. Castiglione was a highly cultivated man, an ambassador of the Court of Urbino and a writer. He was a philosopher of behavior and had written *The Courtier*, an influential book on how gentlemen ought to conduct themselves. It is clear from Raphael's respectful and dignified treatment of him as a subject that Castiglione applied these high standards of gentlemanly conduct to his own life. He is looking not at us, which might embarrass, but just past us, with an air of gentle detachment. Here is a man who is making no demands, and who accepts our gaze with dignified ease.

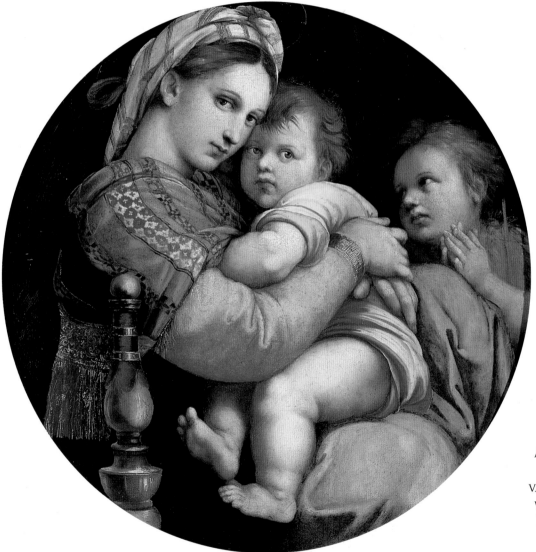

MADONNA OF THE CHAIR
c.1513, oil on panel, 28 in (71 cm) diameter, Galleria degli Uffizi, Florence

Raphael is best known for his madonnas, that sequence of beautiful, serene young women cradling even more beautiful, and more self-controlled, young children. This is one of the most human of Raphael's madonnas, superbly composed within the circle of a tondo. Mary bows her turbaned head to clasp to herself a chubby and rather apprehensive little Jesus. Her shawl has an oriental extravagance, but the Child Himself is dressed simply, and the little John the Baptist, who perfectly complements the composition, has already donned his rough hair-shirt.

"NATURE CREATED HIM AS A GIFT TO THE WORLD: AFTER HAVING BEEN VANQUISHED BY ART IN THE WORK OF MICHELANGELO BUONARROTI, IT WISHED TO BE VANQUISHED THROUGH RAPHAEL BY BOTH ART AND MORAL HABITS AS WELL"
Giorgio Vasari

RAUSCHENBERG, ROBERT 1925- b. US
BED

SOMETIMES AVANT-GARDE ART CAN BE EXASPERATING in its perversity. But when it works, it is transformative. Rauschenberg has been one of the great original influences of our century, and *Bed* is a staggering picture - both for the wild originality of its conception and for the pleasure that this apparent chaos of color and form provides. He took the bedclothes off his bed and poured, dripped, and puddled his paints over them. Improbable though it sounds, this activity produced a minor masterpiece. Mounted and hung on the wall, the lower half is the colorful bedspread, untouched except for an occasional dribble here and there; above, we can still see the stripes of the pillow; and from then on, sagging and bending, the furniture of his bed acts as canvas for the artist's invention. Despite the apparent confusion, the innate aesthetic has controlled every mark that Rauschenberg has made. This is not to say that he has thought out each movement in the painting, but, at some subliminal level, he is always in control and has daringly brought his work to a triumphant finish. As with all abstract art, one cannot say why the puddle of red there, the splashes of blue here, the yellow trickling over black, or the white expanse veined with yellow and purple, should please us; but, it is impossible to look at *Bed* without admiration. This, of course, is a one-off, but then is this not true of all art?

> " PAINTING RELATES TO
> BOTH ART AND LIFE.
> NEITHER CAN BE MADE. I
> TRY TO ACT IN THE GAP
> BETWEEN THE TWO "
> Robert Rauschenberg

FOR SOME PEOPLE
(Thomas Hoving, former Director of the Metropolitan Museum of Art is one), this is one of the defining images of our times. It is a bed that also seems a battlefield, which in itself has profound implications. "Bed" cannot but be a suggestive word, but the suggestions here are incalculable. All the wild confusions of contemporary life and the brave attempts to control them seem somehow present here.

BED
1955, combine painting, 74 x 31 in (188 x 79 cm), Leo Castelli, New York

110 EXPRESS
1963, oil, silkscreen on canvas, 72 x 120 in (183 x 305 cm), Museo Thyssen-Bornemisza, Madrid

Most commonly, Rauschenberg's method is to silkscreen diverse images to create an effect of collage. Intersecting worlds are formed, which seem implicitly to comment upon one another, their visual disparity united by the addition of painted areas. Often the title is the only key to a reading of Rauschenberg's work. *110 Express* holds our attention with its skill and its sense of speed - life being lived frantically and to the full. But any desire to impose strict logic on such a work must be resisted.

REDON, ODILON 1840–1916 b. France
THE SHELL

REDON WAS ALMOST AN EXACT contemporary of Degas, but, unlike that great realist, Redon believed that what mattered most was the world of the imagination. He used his imagination not to evoke an unreal world but to enter, sensitively into strange and beautiful shapes, as he does with the shell. Few things are more ravishing than that pink flush at the heart of such a shell lying in the sands. Redon's imagination was profoundly compatible with the thought of the underwater world, hidden from us and yet luminous with its own secret beauty. The shell seems to pose a challenge to humanity, for while we conceal our skeletal structure in the softness of flesh, the shellfish hides its soft form within a bonelike casing. The mysteries of this coiled shell suggest an inner vulnerability while its protective strength stresses the mortal danger inherent in all life.

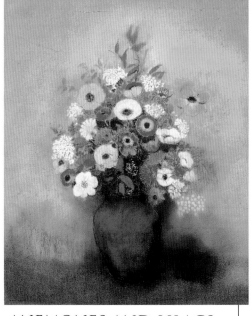

ANEMONES AND LILACS IN A BLUE VASE
1914, pastel on paper, 29 x 21 in (73 x 54 cm), Petit Palace, Paris

A still life by Redon is unlike that of any other artist. These may be real flowers, but their sweetness comes from the world of the imagination. The inner glow of a Redon flower arrangement has an almost mystical grace, and the sweet, smoky pink of the background sets the vase apart from the real world.

THE SHELL
1912, pastel on paper, 20 x 23 in (51 x 58 cm), Musée d'Orsay, Paris

REINHARDT, AD 1913–67 b. US
UNTITLED (COMPOSITION No. 104)

ABSTRACT ART IS ALWAYS A CHALLENGE but few artists confront us with a starker challenge than Ad Reinhardt. Looking at a work as austere as this, it helps to remember that the artist was almost fanatically devoted to his minimalist form of abstraction. He wrote that he thought abstract painting was "the first truly unmannered and untrammelled and unentangled, styleless, universal painting. No other art or painting is detached or empty or immaterial enough." For him, painting was a pure exercise in selflessness, and even if here we can see a Greek cross slowly emerging from the darkness, this is not Reinhardt's intention.

UNTITLED (COMPOSITION No. 104)
1954–60, oil on canvas, 108 x 40 in (275 x 102 cm), Brooklyn Museum of Art, New York

TIMELESS PAINTING
1960–65, oil on canvas, 60 x 60 in (152 x 152 cm), PaceWildenstein, New York

Look as we will at *Timeless Painting*, no shape will form itself in the depth of this canvas. The only "activity" resides in the dark borders, thickening here and lessening there. However, if we gaze long enough at this sizable square, we will lose ourselves in the intensity of the color, and experience the mystic freedom that the artist intends to communicate.

REMBRANDT (REMBRANDT HARMENSZ. VAN RIJN) 1606–69 b. Netherlands

KING UZZIAH STRICKEN WITH LEPROSY

OF ALL ARTISTS, Rembrandt seems to see deepest into the heart of the human being. However marvellous is his depiction of the glories of the material world, it is what makes the sitter be what he or she is, that really interests him: the conscience, the soul – Rembrandt paints the human interior. In *King Uzziah Stricken with Leprosy*, both aspects of his genius strike us. Rembrandt delighted in exotic splendor, and an ancient Jewish king, he imagined, would have worn his riches with overstated magnificence. But however intense has been Rembrandt's pleasure in the King's apparel, the center of his interest is in the King's emotions. Uzziah, at the height of his power, with that old, thick, experienced face, has found that he has leprosy – God's punishment for the sin of pride. Rembrandt shows us the hunched and brooding stance of a powerful man who is being forced to face the unimaginable.

SASKIA AS FLORA
1635, oil on canvas, 49 x 38 in (123.5 x 97.5 cm),
National Gallery, London

It has been suggested that Saskia's attraction for Rembrandt was her money. At one stroke, he changed from an impecunious artist to a very rich Amsterdam citizen. However, looking at this delightful picture, it is obvious that he took a lover's pleasure in her freshness and unaffected charm. He has decked her up as a goddess – Flora, to judge by the flowers – a sad irony in that Saskia's fertility was to be limited. Here, however, she is without that knowledge. She smiles at her husband, posing for him with a child's innocence in the gorgeous robe with which he has bedecked her.

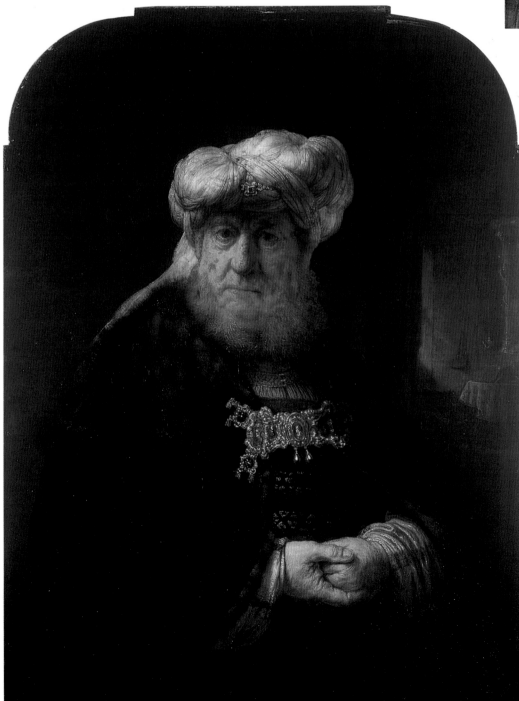

R
384

THERE ARE JUST *the faintest blotches on his cheeks, and a gnarled texture to his hands, to indicate the horror of Uzziah's condition. The true horror is shown in those pouched and staring eyes, the lips set against disaster. Behind the King we are shown glimpses of royal magnificence, but Uzziah himself is shrouded in darkness.*

REMBRANDT'S EYE *focuses with loving care on the intricate folds of that silken turban with its central jewel; on the silver vest with the different textures; and, above all, on the great elaborate and gleaming clasp that is all the more splendid for the darkness of the velvet cloak.*

KING UZZIAH STRICKEN WITH LEPROSY, *1663, oil on panel, 40 x 31 in (101 x 79 cm), Chatsworth House, Derbyshire, UK*

RENI, GUIDO 1575–1642 b. Italy
ATALANTA AND HIPPOMENES

KINGS AND POPES PLEADED TO POSSESS a work by Guido Reni. Fortunately for them, he was an inveterate gambler (his sole vice) and the constant need to refill his coffers kept the dignitaries of Europe happy. His art is not, today, held in such esteem, and yet in the cycle of time it must regain its reputation because he had a truly astonishing imagination and an extraordinary power when depicting the vulnerabilities of human flesh. Here, his theme is the great race between Hippomenes and Atalanta. She had refused to marry unless her suitor could beat her in a race. The penalty for coming second was death, and it was only Atalanta's great beauty (and, perhaps even more so, her great wealth and royal status) that drew a constant supply of victims to the arena.

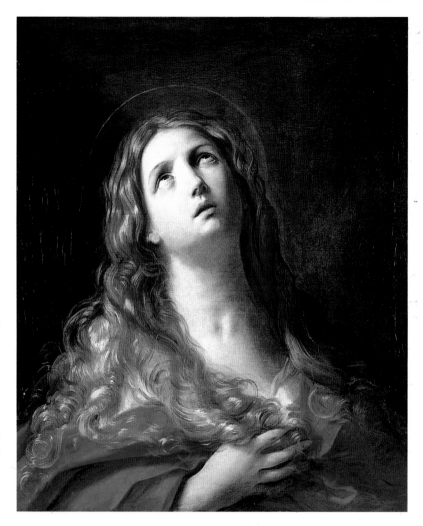

ST MARY MAGDALENE
c.1634–45, oil on canvas, 31 x 27 in (79 x 69 cm), National Gallery, London

Reni often painted saints with their eyes turned piously to heaven, and his fame meant that he was much copied. The inferiority of these copies too often became attributed to Reni himself. But a true Reni contains nothing of the formulaic; it is filled with a genuine and moving piety. Reni's ability to paint human flesh is one of his great gifts, and Mary Magdalene, looking to heaven for forgiveness, is a figure of beauty and of most convincing integrity.

ATALANTA AND HIPPOMENES
c.1618–19, oil on canvas, 81 x 117 in (206 x 297 cm), Museo del Prado, Madrid

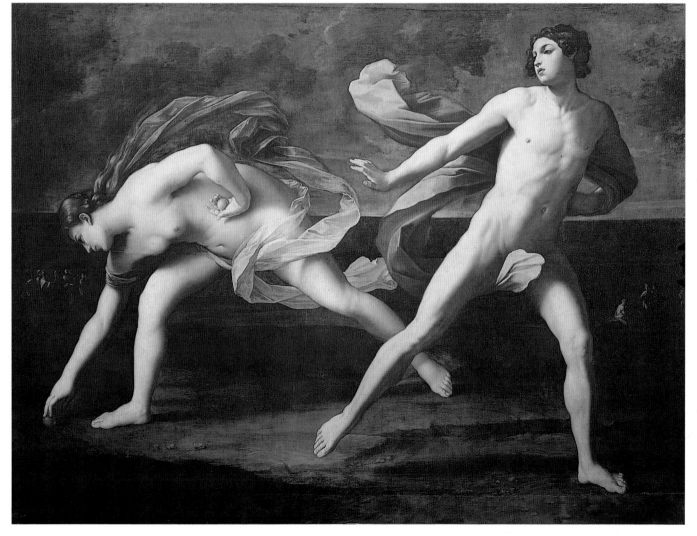

HIPPOMENES *cunningly provided himself with three golden apples, and at crucial stages of the race bowled them at Atalanta, who was unable to resist the temptation to stop and retrieve the apples. Here, Hippomenes pauses briefly, already prepared to race on, while Atalanta stretches in the opposite direction to snatch up the second of the golden apples.*

THEIR GARMENTS *flow and ruffle in the intensity of the race, and the criss-cross of their opposing bodies expresses more than a momentary tableau. They are at odds, not just as opponents, but in their desire for different goals: Atalanta does not want a husband, but Hippomenes is determined that she should be his wife.*

RENOIR, PIERRE-AUGUSTE 1841–1919 b. France
THE GUST OF WIND

SAY TO PEOPLE THE NAME RENOIR and frequently the image that springs to mind is that of the solid and voluptuous nude basking in the sunlight. Renoir did indeed have a special interest in the naked female – perhaps something of his vigorous spirit responded to the challenge – but here is Renoir at his most tender and sensitive. Looking at this picture, one is immediately aware of the young man who walked across a field one morning and suddenly saw the trees quiver under the impact of a gust of wind. He communicates to us most vividly and perceptibly how nature shivers for the moment as the wind ruffles the grasses, sways the trees, and seems to be reflected in the uncertainties of the white clouds and blue sky. It is as if, while we look, shapes move and sway. He paints a blur that is almost imperceptible and yet wholly real. We believe in this moment – this ordinary, but intensely realized, experience of one man at one moment over a hundred years ago.

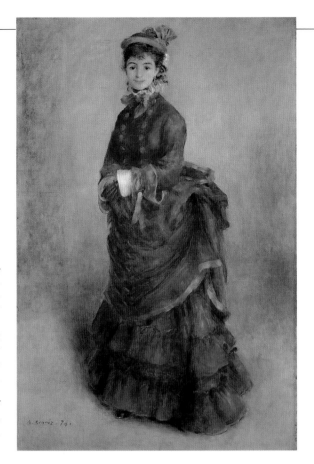

THE PARISIENNE
1874, oil on canvas, 63 x 41 in (160 x 105 cm),
National Museum of Wales, Cardiff

Renoir took intense pleasure in naked female flesh, yet his greatest works, like *The Parisienne*, are of clothed women. Here, he captures the essence of the young woman of Paris – her stylishness, her modish hat, the flirtatious exuberance of her curl, and the gown that both clings to her body and bursts out into the absurd bustle. All the defences of modesty are maintained, and yet the soft form within those great swathes of blue is made perfectly clear.

THE GUST OF WIND
c.1872, oil on canvas,
20 x 32 in (52 x 82 cm),
Fitzwilliam Museum,
Cambridge, UK

IT IS BECAUSE OF RENOIR *that grass will always quiver and the trees will always sway. The gust of wind (by its very nature, passing and uncontrollable) has been miraculously held, not statically but in motion – that most challenging of art's possibilities.*

EVEN THE SHAPE OF THE *hillside seems to reform itself under our eyes, as the wind sweeps over it. The horizon dips and rises in an almost oceanic motion and the swirls of the grass, seemingly pulled by the power of the wind, are echoed by the clouds, scattered and scuffed across the blue of the sky.*

REYNOLDS, SIR JOSHUA

1723–92
b. England

COLONEL BANASTRE TARLETON

REYNOLDS, AS BEFITTED A POOR BOY, responded enthusiastically to the romance of the British aristocracy. He understood the need of upper-class personages – frequently undistinguished in either intellect or appearance – to seem far more interesting than they actually were, and he collaborated most energetically with this innocent desire. Here, he really has something to work with. Banastre Tarleton was one of the most famous British heroes of the late 18th century. His American contemporaries would have scowled at the appearance of that green jacket, because Tarleton had actually raised a cavalry troop against them during the War of Independence. His troop was known as Tarleton's Green Horse – it is surely the battalion flag that waves overhead. Reynolds, who was profoundly a man of peace, depicts the young hero being heroic: the thunder of the guns is all around him, horses rear up in terror at the noise and confusion of the battle, while Tarleton, in a pose of the utmost negligence and composure, positions his left hip insouciantly on the edge of a cannon and calmly awaits the outcome of whatever skirmish his battalion is currently engaged in. The general air of calm self-command and poise makes this a memorable image.

> " HE WHO IS IN THE PRACTICE OF PORTRAIT PAINTING…DRESSES HIS FIGURE SOMETHING WITH THE GENERAL AIR OF THE ANTIQUE FOR THE SAKE OF DIGNITY, AND PRESERVES SOMETHING OF THE MODERN FOR THE SAKE OF LIKENESS "
>
> Sir Joshua Reynolds

REYNOLDS PAINTED *this delightful picture of the "hero" when Tarleton had returned to England, after his American exploits, as a very young Lieutenant-Colonel. He shows us a young man of charm and grace, with his great plumed hat, his elegant boots, and his sword jutting down the center of the picture.*

COLONEL
BANASTRE TARLETON,
*1782, oil on canvas,
93 x 57 in (236 x 146 cm),
National Gallery, London*

SELF-PORTRAIT SHADING THE EYES
*c.1747, oil on canvas, 25 x 29 in (64 x 74 cm),
National Portrait Gallery, London*

Reynolds painted Tarleton towards the end of his career, but here he is at the beginning, a very young artist setting out to take the world by storm. Light shines on that appealing face – eager, vulnerable, still unaware of the honors that were to come his way. He holds his mahlstick and shades his eyes, squinting at us to enable him to fully understand the geography of his subject and convey it to the canvas behind him. Even so young, he had a lovely sense of color, with that bright blue at the center and the rustic ruddiness of his rounded cheeks. He is still a boy, but an anxious boy: hopeful and persistent, but uncertain of his future.

RIBALTA, FRANCISCO 1565–1628 b. Spain

ST FRANCIS COMFORTED BY AN ANGEL MUSICIAN

THIS IS ONE OF THOSE EXTRAORDINARY pictures, almost impossible to like, but which nevertheless leaves an unforgettable impression. The title announces it to be St Francis comforted by an angel, but the saint's face expresses awe and bewilderment rather than satisfaction. What Ribalta shows so brilliantly is the incursion into the bare life of Francis, and the color, light, and glorious sound of heaven. Everything in the world of Francis expresses austerity. His bed is a plank with one shabby blanket, a wooden cross hangs above it, and his habit is patched in clear segments. The extraordinary visitation of the bright and laughing angel – all curls, joy, and voluptuousness, as he makes music with gay abandon and kicks his legs as if to dance in the air – is paralleled by the extraordinary appearance of the lamb. This is no domestic pet, this is the Lamb of God, the image of Christ, in whose honor the angel sings. The absorption of Francis, the terror and wonder in that emaciated face, is deeply moving even for those who regard the story as mythical.

THE VISION OF FATHER SIMON
1612, oil on canvas, 83 x 44 in (211 x 111 cm),
National Gallery, London

Father Simon was a priest in early 17th-century Valencia, who believed that he saw Christ carrying His Cross through the streets of his city. Ribalta painted this picture, as he proclaims at the bottom, in 1612, the year in which Father Simon died. Whether or not the visionary had described this scene to the artist, Ribalta here creates his impression of what the holy man might have seen. It seems to have been an interior vision, because the pale face is raised heavenward, and it is only the clasped hand that makes contact with the figure of Christ. Father Simon's luminous face is almost unreal in its concentration.

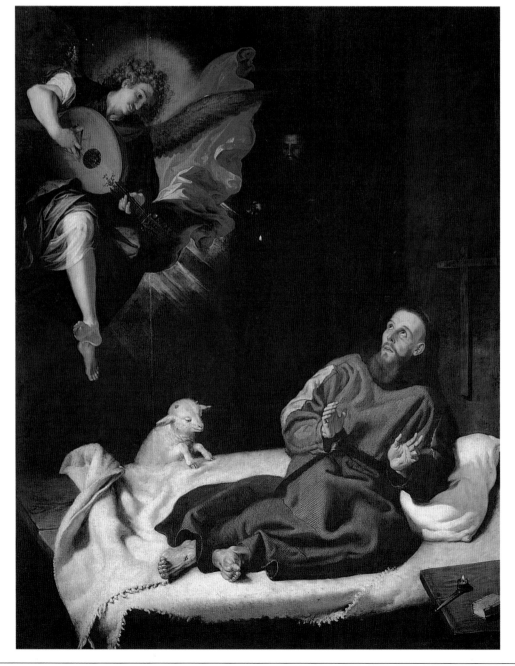

IN THE PRIVACY *of his bare cell, St Francis feels no need to hide the wounds of Christ – the stigmata with which he was honored. The only furniture in this austere room is the little wooden table on which the saint's prayer book and a tiny lamp are placed. In case we might think this a fantasy, Ribalta provides us with a witness – there, at the back, an astonished friar looks through the window, catching, if not the vision of the musical angel, at least the glory of the angel's outspread scarlets and the tip of his wing.*

ST FRANCIS COMFORTED BY AN ANGEL MUSICIAN, *1620, oil on canvas, 80 x 62 in (204 x 158 cm), Museo del Prado, Madrid*

RIBERA, JOSÉ DE c.1590–1652 b. Spain
THE BEGGAR KNOWN AS THE CLUB-FOOT

THIS IS ONE OF THE GREAT ICONS of human dignity. Here is a child who, in worldly terms, has nothing to live for. He is poor, misshapen, crippled by a club foot. He stands in a desolate landscape. Nevertheless, he rests his staff jauntily on his shoulder like a soldier's musket, and in his hand he holds a note – not so much a petition as a courteous command: "Give me alms for the love of God". Although he is called the beggar, the name seems derogatory to this free spirit. His gummy smile indicates a happy confidence that humanity will do right by him, and he moves forward with heroic courage, his face lit by both natural and spiritual sunlight.

ARCHIMEDES
1630, oil on canvas, 49 x 32 in (125 x 81 cm), Museo del Prado, Madrid

Sometimes Ribera seems to take a mischievous pleasure in disconcerting us. Here, he has painted the great mathematician Archimedes, whom he has depicted with compass in one hand and a page of mathematical diagrams in the other. But the hands themselves are not only thin, but amazingly grimy – the grime emphasized against the white of the paper. The dishevelled hero himself, the great scientist, twinkles out at us with a carefree enjoyment of life that may well be a truthful depiction of how he set about his studies, but which overturns our preconceptions of how we imagine a genius ought to appear – dour and serious.

RIBERA CLOTHES THE BOY in the most subdued of garments, and all the light and excitement of the picture comes from the boy himself. Ribera preaches no sermons, yet in showing us the uninhibited gaiety of this poor reject, he awes us with an understanding of what makes a person valuable – merely to exist makes a person one of life's winners, and to win with grace and contentment when there are no tangible signs of that victory is the greatest mark of superiority.

THE BEGGAR KNOWN
AS THE CLUB-FOOT
*1642, oil on canvas, 64½ x 37 in
(164 x 94 cm), Musée du Louvre, Paris*

RICCI, SEBASTIANO 1659–1734 b. Italy
ALLEGORY OF FRANCE

RICCI'S ITALIAN SPLENDOR OF COLOR and casual grace is profoundly cultured. The central figure here is an allegory of France – France seen as the wisest of the nations, and so able to be represented by Minerva, the Roman goddess of wisdom. Minerva was also the armored goddess, and her breastplate bears a golden head, a sunburst of her divinity. She treads underfoot the giant of ignorance, the great naked male – all brawn and no brain – whose donkey-ears flap pathetically as he accepts with apathetic stupidity the small foot of the goddess. Minerva does not concern herself with her vanquished footstool; her attention is given to the semi-clad figure of Martial Victory. At one level, this is two beautiful women, gazing ecstatically at one another, with an entourage of congratulatory children. At a deeper level, which is the level Ricci is appealing to, it is a profound statement of what France stood for: culture, prosperity, the promotion of learning, courage, and victory.

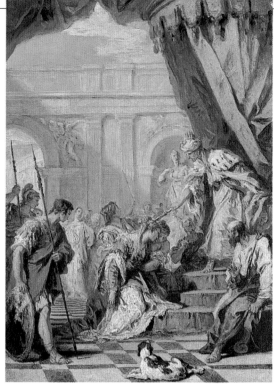

ESTHER BEFORE AHASUERUS
c.1730, oil on canvas, 18½ x 13 in (47 x 33 cm),
National Gallery, London

Ricci's late painting has something of the exquisite fluidity that characterizes the work of Tiepolo. The Persian King Ahasuerus forbode, on pain of instant death, anyone to approach him without first being summoned. Queen Esther, desperate for her people, the Jews, who were being persecuted, broke the rule, laying herself at risk. Here is the moment when the king accepts Esther and allows her to plead her cause. It is a splendid work in its grace and dignity, and we are made aware of the charm of the setting, as well as its biblical significance.

THE GRACIOUS AND *queenly Minerva is awarding a laurel crown and a golden medal to a figure who represents bravery in war – that quality upon which the French have always plumed themselves. The semi-naked woman who receives the laurels carries a lance, and she has clearly ventured into battle with no protection but her courage.*

THIS IS NOT ONLY A *celebration of France and victory, but also a showcase of learning. Around the throne are paint brushes (because France is predominant in art), music, sculpture, and scientific instruments. Behind the crown, a cherub holds a golden fleur-de-lis, and in the upper-left section, sent down from a reclining Jove, is a great cornucopia of prosperity, flowing naturally from such success and such devotion to the arts.*

ALLEGORY OF FRANCE:
THE TRIUMPH OF WISDOM
OVER IGNORANCE, *1718,*
oil on canvas, 44 x 33 in (113 x 85 cm), Musée du Louvre, Paris

RICHTER, GERHARD 1932- b. Germany
WOMAN WITH UMBRELLA

RICHTER IS AN ELUSIVE ARTIST, if only because he alternates between a photographic semi-realism and a passionate abstraction. *Woman with Umbrella* shows him struggling with the mystery of being. In this instance, he has used a photograph of Jackie Kennedy, but he does not want to achieve the immediate recognition of this image. Jackie Kennedy's body language – the expression of spontaneous revulsion and astonishment – had, for Richter, a profound meaning in the context of her personal history. He intends the irony of her involvement in tragedy to be implicit, so that we are distanced from star quality or media approval and forced instead to contemplate the image as it is. We are expected to have the sensitivity to take the image on Richter's terms, to see it as a comment on the human inadequacy of our relationship with all that is external to our own psyche. Richter wants us to see the tragedy of this, and the need to be continually seeking – however poor and shabby the results – to break through the closed circle of our own consciousness into an awareness of the lives of others.

RICHTER HAS DELIBERATELY painted this work as if it were a retouched photograph (there is a wide border to emphasize that this is an image). These layers of ambiguity are the only ways in which he can feel confident about so closely approaching the enigma of the world, and they are essential in that they separate himself and us from life's immediacy. The crude coloring, the blurring, the acceptance of visual poverty – all this explicit failure – is what makes Richter so important a painter.

WOMAN WITH
UMBRELLA
*1964, oil on canvas,
63 x 37 in (160 x 95 cm),
Private Collection*

ST JOHN

*1988, oil on canvas, 79 x 102 in
(200 x 260 cm), Tate Gallery, London*

We find an extraordinary contrast in Richter's abstract paintings. These are personal, definite, and, it would seem, free-flowing. Here, the titles are of little use. *St John* is part of a series referring to chapels in Westminster Abbey. The title's only significance is that the painting expresses the emotions that the artist felt while in the abbey and the whole gamut of associations that relate to his time in London. He has said that abstract paintings are topical: "They are my presence, my reality, my problems, my difficulties and contradictions".

**"ART IS THE HIGHEST
FORM OF HOPE"**
Gerhard Richter

RIGAUD, HYACINTHE 1659–1743 b. France
LOUIS XIV

HYACINTHE RIGAUD LIVED AT THE TIME OF THE GREATEST and most absolute monarch that France has ever known – Louis XIV, the Sun King. Louis, who inherited the throne in childhood, was not only called the Sun King because of his extraordinary power, but also because he had set himself up as the controlling center of all aristocratic and intellectual life in France. The circumstances of this extraordinary figure had been set so far above the ordinary man that he had begun to believe in his own immortality – an idea that clearly fascinated Rigaud. His portraits of Louis XIV epitomize what it means to be a dictator, a lord, and the sole master of all that one surveys. Rigaud has portrayed this bizarre personality without the least hint of irony, although, for us today, this flamboyant pose is undeniably comic. Of course, to have even hinted at this would have been inconceivable at the time when this glorious and triumphant portrait was created.

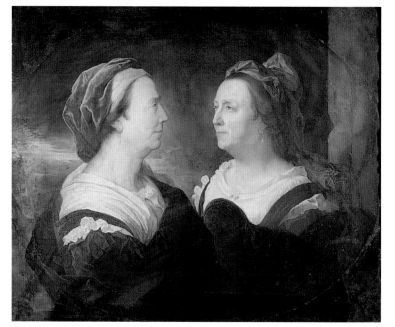

MADAME RIGAUD, THE MOTHER OF THE ARTIST
1695, oil on canvas, 37 x 41 in (93 x 103 cm), Musée du Louvre, Paris

Since Rigaud made his name by the portraits of Louis XIV and his courtiers, it is rather touching to find him presenting us with this remarkable portrait of his mother. He has, in a vein of semi-surrealism, scrutinized that familiar face twice. He has split her into twin mothers, both equally impressive, each facing down the other, seemingly unwilling to admit a rival, let alone an equal. The image arouses a suggestion of schizophrenia: on the left, the face has, perhaps, a touch more compassion; on the right, there is the trace of benign humor. The twin mothers intrigue us with their simultaneous difference and equivalence.

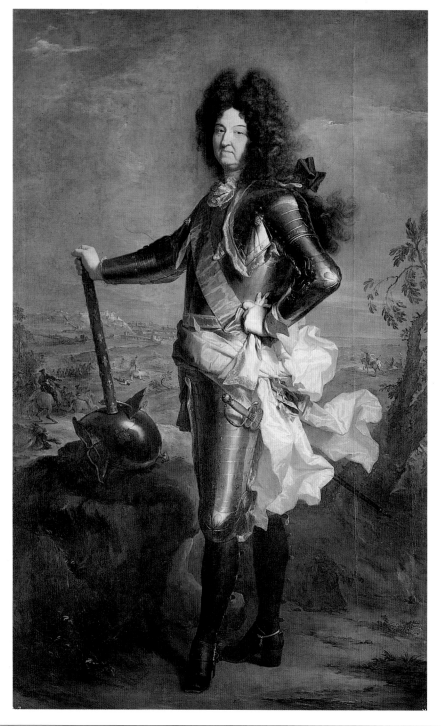

THE KING REGARDS US *with the smiling condescension of one who knows nothing but admiring applause. He looks down at us benignly, the massive grandeurs of his wig rising to heaven and then cascading down on either side of his powdered cheeks. Rigaud is not showing us a portrait of a king, nor even the portrait of a gentleman; he is showing us the portrait of a superman, graciously sent to enlighten the French by his benign example of true majesty.*

RIGAUD SHOWS LOUIS XIV *in military mode, far from the suave elegance of Versailles. In the distance, the actual business of battle is going on, with crude men crudely disposing of one another. There is dust, dirt, noise, and a lot of vulgar excitement; but here, remote and conquering, stands Louis. He has doffed his helmet (after all, who dares attack the Sun King) and uses it as a prop for his baton.*

AS IS USUAL IN PORTRAITS *of Louis XIV, his legs are prominent. These were famous legs, which were said to have been the most beautiful in Europe. Poems had been written to them and painters had looked in awe at their splendor. The glory of the limbs is slightly hidden by the upper armor, but the well-turned lower limbs are visible, prominently displayed in black with gold buckles. Above them, fluttering out behind the royal posterior, are the folds and flounces of a grand sash.*

LOUIS XIV, *1694, oil on canvas, 94 x 59 in (238 x 149 cm), Museo del Prado, Madrid*

RILEY, BRIDGET 1931– b. England
FALL

In the sixties, several abstract artists became interested in visual illusion: how shapes can change as we look at them, how they can dazzle the eye and flicker in and out of recognition. This art became known as Optical Art (shortened to Op Art), and it was as an Op-Art practitioner that Riley first became known. *Fall* is a dangerous work for those who have a tendency to epilepsy. The thin black and white swirls are a perfect example of visual illusion. As they curve in and out, they seem to pulsate with an inner rhythm, which can actually affect our brainwaves. Riley does not need the seduction of color for what she is attempting here. The work is totally concentrated on shape and patterning, with deliberate pleasure taken in their psychedelic effects. There is a general sense of falling as the lines curve gently at the top, gather momentum, and swerve downwards, quicker and faster, until there is a crushed concentration of curve – the gentle modulations of the top have fallen indeed.

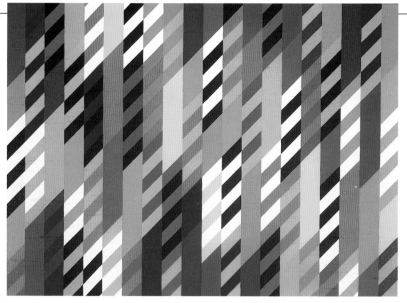

CONVERSATION
1992, oil on linen, 34 x 47 in (86 x 119 cm), Abbot Hall Art Gallery, Kendal, UK

Fall is an early triumph in black and white. Riley's later work centers on the interaction of colors – something most artists see as fundamental. The "conversation" here is between colors. The whole painting sings in different voices, each modulated by its neighbor, and her attempt is to bring these stripes and diagonals into a unity of subtle relationships.

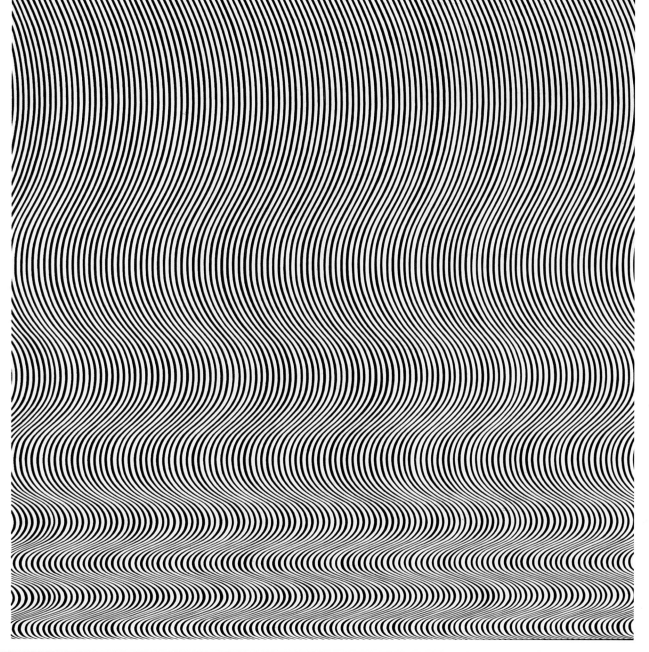

This work has been spoken of as providing a sense of spiritual drama, and this reading is not without its truth. The slow deliberations of the top, bending gently and obliquely, do hint at an encounter with temptation. Then, as interest gathers, the pace quickens and desire becomes heated. The descent is rapid, landing with a thump at the bottom.

A physical fall, a spiritual fall, or merely an interesting material pattern – these readings are not in opposition, they are all equally valid. This is conceptual art at its best. Riley has the concept of a pattern form that seems to actually surge and pulse upon the picture surface. It is brilliantly carried out, with enormous steadiness and skill of hand, and we are cheated into believing that the flat surface plunges and sinks before our eyes.

FALL
1963, emulsion on board, 56 x 56 in (141 x 141 cm), Tate Gallery, London

RIVERA, DIEGO 1886–1957 b. Mexico
THE AZTEC WORLD

RIVERA'S GREATEST COMMISSION WAS TO PAINT A MURAL for the Palacio Nacional in Mexico City. He wanted to show, in gripping and precise detail, the whole course of Mexican history, from the earliest days of the Aztecs to the Spanish conquest and from the conquest to the present and future of his homeland. The story starts on the stairway on the north wall of the building. At the center of this section, we can see the white-skinned creator-god Quetzalcoatl – the plumed, serpent-god, reigning in triumph over his adored people. To the right, the Aztecs indulge in the creative activities that Rivera believed were innate to the Mexican people: dancing, singing, weaving, carving, pottery-making, and painting. To the left, however, the picture is less benign. Rivera was a great believer in the class struggle and he could not but be aware that the early Aztec life was heavily stratified. Here, a plumed warrior – a knight of the Order of Eagles – is berating a row of burdened porters, bent low under their heavy loads. Almost directly beneath Quetzalcoatl, a dissident peasant protests and stirs his brothers to anger. The result of this is seen at the very bottom of the picture, where, amid flames, open warfare has broken out between the ruling and oppressed classes.

R
394

THE FLOWER CARRIER
1935, oil and tempera on masonite, 48 x 47½ in (122 x 121 cm),
San Francisco Museum of Modern Art

Rivera rightly understood that the Mexican economy rested squarely on the shoulders of the peasant, and this over-simplified, almost abstract image – with its starfish fingers and arms depicted as straining pillars – inescapably conveys the pressures put upon the poor. Every detail of the basket weave is emphasized, as if it were another brick weighing down on the figure crouching beneath it. The colors are subtly subdued to the pathos and heroism of the situation. It is a highly symbolic image, and quite unforgettable.

IT IS APPARENTLY IN CONSEQUENCE of the civil strife that Quetzalcoatl fulfils a prophecy by flying away from his people. We see the god riding on his plumed serpent in the upper right of the image as he moves out of the picture. The sun is seen upside-down and a volcano begins to erupt, suggesting that the Mexican world, despite its coherence and creativity, is flawed and destined therefore not to last.

RIVERA HAS organized large groups of people into a readable narrative with power and subtlety. He is not weakly indulging in the pleasures of nostalgia but admitting the potential bliss of a lost world, while indicating the tensions that helped bring about that loss.

THE AZTEC WORLD, *1929,*
fresco, 295 x 348 in (749 x 885 cm),
Palacio Nacional, Mexico City

ROBERT, HUBERT 1733–1808 b. France

IMAGINARY VIEW OF THE GRANDE GALERIE IN RUINS

HUBERT ROBERT WAS ALSO KNOWN AS Robert des Ruines because his contemporaries saw him as having a special gift for depicting the melancholy beauty of a destroyed civilization. *Imaginary View of the Grande Galerie in Ruins* had a surprisingly practical intention. The Louvre badly needed restoration and Robert, who was passionately committed to the idea of this great museum, was asked to take responsibility for it. This picture of the Louvre's Grand Gallery in ruins has a companion piece in which the gallery has been reconstructed (although his imaginative vision of what the Louvre might have become never came to fruition). The picture of the ruins is magnificent: Robert imagines an artist painting in the remains of the great museum, directing his creative energies to those few fragments of the treasures that have survived.

IMAGINARY VIEW OF THE
GRANDE GALERIE IN RUINS
*1796, oil on canvas, 44 x 56 in
(112 x 143 cm), Musée du Louvre, Paris*

LANDSCAPE
WITH RUINS
*1802, oil on canvas, 122 x 58 in
(311 x 147 cm), Hermitage, St Petersburg*

This is another example of the scene that most engrossed Robert – the decay of architectural grandeur, with its inherent implications of a lost culture. Here, a massive and noble edifice has been taken over by a peasant family, who use it to hang out their washing.
They inhabit it seemingly without regard for its dignity and purpose. A little group, laughing and jesting below the arch, ignore the desolate figure of the lonely goddess, who is left alone on her plinth to mourn the desecration of what must have been a majestic edifice.

AT THE FAR RIGHT
we see the remains of Michelangelo's Captive Slave, *now exposed to the sky and unlikely to survive. The Louvre, that palace now dedicated to the display of the glories of civilization, could become, Robert imagines, a desolation, in which thieves squabble and vagrants stroll, and only a few great arches remain to recall the majesty of the past.*

THIS IS A PICTURE *of poignant nostalgia, all the more dramatic for the reality of its setting. The tense, scarlet-clad artist (Robert's own self-portrait) is lost in his desire to preserve, at least on paper, the treasure of the Louvre. This is Robert's cry of alarm, his passionate plea to avert what he has here imagined.*

ROMNEY, GEORGE 1734–1802 b. England
WILLIAM BECKFORD

WILLIAM BECKFORD WAS THE GILDED YOUTH *par excellence* of his time. Immensely rich, he had work published when still in his teens, he was artistically gifted, and, as we can see, exceedingly handsome. He only lacked good judgment and a sensible mother. Romney, probably flattered to have been given this commission, steers a careful line between bored acknowledgement of those extraordinary gifts, and a sly sense that no one is more aware of them than Beckford himself. He lounges, indolent and self-assured, in a classic setting that includes the suggestion of parks and forests, paying tribute to his own immense estates. Here is the arrogance of the 18th century personified. Here is a man to whom all comes easy. This is pride begging for a fall, but Romney will not provide it.

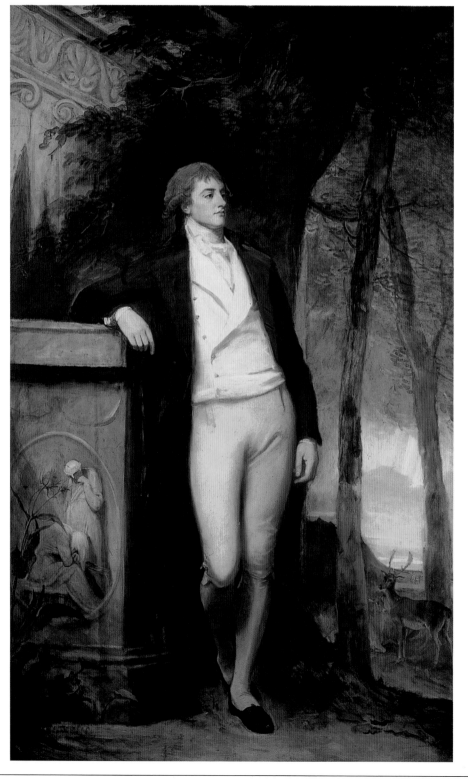

LADY HAMILTON
1782–86, oil on canvas, 68 x 50 in (173 x 127 cm),
Kenwood House, London

Lady Hamilton was the archetypal femme fatale, and Romney was captivated. He was one of many admirers who would gather together to see her taking up her "postures", as she imitated heroines of the past. Here, she is chaste Penelope, the wife of Ulysses, who spent years weaving, unpicking, and re-stitching a tapestry while she waited for her husband's return. Lady Hamilton is idly toying with the thread, intent, not on her work, but on ogling the viewer and displaying her charms. Yet, something of that personal charisma seems faintly to waft out to us over the centuries.

THE SUBJECT CARVED *into the plinth on which Beckford leans has baffled commentators. There seems to be an old beggar man, clutching sticks to his bosom in despair, while the figure who may be a fool (judging by his strange headgear) looks on aghast. Could this be King Lear and his fool? Another suggestion is that it is Job and one of his false comforters.*

WHATEVER THE READING *of the figures on the plinth, the implication seems clear. Poor and broken age is compared to radiant and successful youth. The portrait may have been painted for Beckford's 21st birthday. If so, there was an unintentional pathos because, from that high point of youthful glory, Beckford fell into a steady and foolish decline.*

WILLIAM BECKFORD
1782, oil on canvas, 93 x 57 in (236 x 145 cm), Upton House, Warwickshire, UK

ROSA, SALVATOR 1615–73 b. Italy

THE SPIRIT OF SAMUEL CALLED UP BEFORE SAUL

SALVATOR ROSA WAS A PAINTER, a poet, and a musician. He was also a famed actor, and this histrionic quality finds full expression both in his themes and in his treatment. Here, he has seized on one of the most terrifying and dramatic episodes in the Bible, when King Saul – fearing defeat, and despite having righteously set his face against witchcraft – goes in disguise to consult the last remaining witch in Israel. She calls up from the dead the prophet Samuel, who repays Saul for his disobedience by confirming (one feels with a triumphant smirk) that he was indeed heading for defeat. With an impeccable feeling for Gothic horror, Rosa presents us with a scene of threatening darkness, out of which loom the phantoms of the night. Around the dead Samuel swirl the terrified figures of Saul's followers – those who witness with him the condemnation that he has brought upon himself. Pronouncing over them is the mighty and implacable judge Samuel, a great pillar of righteousness.

SELF-PORTRAIT
c.1645, oil on canvas, 46 x 37 in (116 x 94 cm), National Gallery, London

Salvator Rosa was one of the first to present himself as "the artist", consciously different from other men. His striking and dramatic pose is silhouetted against an interesting sky that is threatening above, and he scowls at us with the aristocratic authority of a Byronic hero. The plaque he carries preaches the virtues of silence – "be still unless what you say is better than silence" – and it has been suggested that his resolutely shut mouth, frowning brow, and left hand held firmly against his chest indicate that the artist is portraying himself, not as himself, but as the personification of silence.

THE WITCH CACKLING *wildly – her hair streaming like serpents in the wind of wickedness and her withered breasts laid bare in the excitement of sorcery – conjures up the noble figure of the dead prophet. He alone bears any dignity. Rosa makes us aware of the sacrilege here enacted, a dead man called from his eternity to face the inquisition of a frightened king.*

SAUL RIGHTLY GROVELS. *The light falls full on his back as if an ironic reference to this forbidden and unnatural activity. Rosa takes exquisite pleasure in the transgressive element of the scene – drama at the edges of reality. Yet somehow the picture lacks solemnity; the transgression is depicted with such excitement that the full moral force is lost.*

THE SPIRIT OF SAMUEL CALLED UP BEFORE SAUL BY THE WITCH OF ENDOR
1668, oil on canvas, 107 x 76 in (273 x 193 cm), Musée du Louvre, Paris

ROSLIN, ALEXANDER 1718–93 b. Sweden
WOMAN WITH A VEIL

ROSLIN WAS A SWEDISH PAINTER who nevertheless spent most of his life in Paris, where, as a great society portraitist, he caught the glitter of aristocratic life on the eve of the French Revolution. *Woman with a Veil* is undoubtedly his masterpiece, and perhaps it is significant that it is of his wife, Marie Suzanne Roslin. He sees her as part of that glittering world. She wears a coquettish head shawl, holds her fan tantalizingly to her cheek, and what little we can see of her garments is in the height of fashion. Light gleams on the black silk of her scarf, the tones subtly modulated by Roslin. Yet there is more to the picture than this. Marie Suzanne flirts with her husband, but she flirts with warm affection. She invites him to admire her, to take delight in the pink and white of her complexion, in the elegance of her clothes, in the gesture with which she half-reveals and half-conceals herself.

WOMAN WITH A VEIL
1768, oil on canvas, 26 x 21 in (65 x 54 cm), Nationalmuseum, Stockholm

ROSSETTI, DANTE GABRIEL 1828–82 b. England
DAY DREAM

THE PRE-RAPHAELITE WOMAN seems so unearthly and idealized that it comes as a shock to discover that there was, indeed, an original human model – Rossetti's wife, Elizabeth Siddal. She seems to have been an approximate model for *Day Dream*, even though she was long since dead. Over time, Rossetti transformed the image of his wife into a archetypal vision of unattainable beauty. She sits there not in her world but aloft in a tree, lustrous of hair, hollow of cheek, her eyes gazing with unfocused emotion into the future. Her red lips droop with the vague unhappiness that Rossetti came to see as endemic to human existence. She has a book, but chooses to ignore the certainties of the written word, preferring the vague wonderings of her mind. Her mood is echoed by the surround of bud and leaf, blossom and tree, and her hand holding loosely onto the material world. What gives Rossetti's picture its edge is that this image of a woman is both unbelievable – almost laughably so – and convincing. It has been conjured with such intensity that we are convinced almost against our will.

DAY DREAM
1880, oil on canvas, 63 x 37 in (159 x 93 cm), Victoria & Albert Museum, London

ROTHENBERG, SUSAN 1945– b. US
UNITED STATES

LIKE MANY YOUNG ARTISTS IN THE 1970s, Rothenberg began by experimenting with abstract art and conceptual art until she realized that she was adding nothing to the world of images. It was then that she turned instinctively to using the image of the horse. She had no emotional relationship with horses, but they seemed to her to fall precisely between the two extremes of object (the thing) and subject (a person). The horse was alive and yet did not challenge her with the demands of its personality. Somehow, the simplified horse – not a horse, but "horse" as image – became, for her, a vehicle in which she could express deep emotions. *United States* is a good example of her double need to simplify, to use the idea of horse, and at the same time to reinterpret it. Here, as the witty title suggests, she has divided her horse into two: a pink horse on a pink background with a black outline, and a black horse on a black background with a pink outline. Rothenberg seems very conscious of the split in personality that is endemic to the human condition, that we are not born integrated but become so through effort and pain; our shadow side and our rosy side have to learn to coexist.

BLUE U-TURN
1989, oil on canvas, 91 x 112 in (231 x 284 cm),
Collection Harry W. and Mary Margaret Anderson, New York

The time came when Rothenberg, reaching the end of the horse theme, moved on to other images – mainly spinners and dancers. Then, she says, she found herself stuck again. At this point, the image that strangely took hold of her was one of a body in an impossible position, twisting up into a U-turn as if it where boneless or floating. *Blue U-Turn* is rapturously beautiful, with its silvers and greens suggesting a body in water; yet this surely is a body of the imagination. Once again, the artist's confidence in the basic image set free her painterly qualities.

UNITED STATES, *1975, acrylic and tempera on canvas, 114 x 189 in (290 x 480 cm), Collection Mr and Mrs Frank Rothman*

ROTHENBERG IS NOT PREACHING, *nor is she illustrating. What strikes one about this huge image, ten feet by over fifteen, is its painterly quality. The image has become a pretext, as it were, for allowing her to enjoy the paint itself. It is as if she needed the security of this image, one that is both simple in outline and complex in implication, in order to launch out into this vast expanse of succulent paint.*

ROTHKO, MARK 1903–70 b. Russia, active US

GREEN AND MAROON

IT WOULD BE CRASS TO SUGGEST THAT ROTHKO painted to a formula. It is true that his work is instantaneously recognizable – long oblongs and squares of color floating in film upon film of chromatic luminosity. The word "formula", however, suggests the mechanistic application of a format, which is the reverse of the truth. Having found a way to express what he referred to as the "timeless and tragic," Rothko approached each canvas in a different mood and seemed to create a different atmosphere, determined to produce a different, although equally profound, effect. He was grieved – in fact, as an irrational man, he was downright irritated – when people responded with unthinking rapture to these superb harmonies of color. He felt each painting should be approached for itself alone or, if in combination with others, it must be seen as forming an ambience in which his vision of the human condition could be realized. *Green and Maroon* originally hung with three other canvases in a room where Rothko carefully orchestrated the light, dimming it so that the viewer, passing from one great picture to the next, would be enveloped by the art and forced to relinquish all ideas of rational control.

GREEN AND MAROON
*1953, oil on canvas, 91 x 55 in
(232 x 139 cm), Phillips Collection,
Washington, DC*

ROTHKO'S PAINTINGS *are of a subtlety that defies reproduction. Nothing is solid; everything floats away, but not into vagueness. Rothko controls and directs his canvas, and, although he insisted that what he produced was unequivocal, he was – like many artists speaking of their own work – mistaken. It is the equivocal – the different possibilities of meaning and being – that Green and Maroon opens up so powerfully before us.*

BLACK ON GRAY
*1970, acrylic on canvas, 68 x 64 in
(173 x 163 cm), PaceWildenstein, New York*

In 1970, the year he painted *Black on Gray*, Rothko committed suicide. It is all too easy to read pessimism and despair into this canvas – a critical temptation that we must usually resist. The division of the canvas is more abrupt than in his earlier work, and yet the line of division is strangely fluid. The picture acknowledges blackness, but surely as a glory – as a deep, mat solidity that harmonizes with the fragile and tender gray-gold beneath. It may speak of sorrow, but we should not necessarily read despair here.

ROUAULT, GEORGES 1871–1958 b. France
THE OLD KING

TWO THINGS DISTINGUISH ROUAULT'S WORK. The first is his original technique – the result of his training as a stained-glass artist. We are made aware of this by the way he outlines figures and divides them up with the thick lines reminiscent of the lead between stained glass. Because he has to do without sunlight, which illuminates the glass and gives it depth, he applies intense colors to the canvas. The extraordinary richness of the reds, blues, yellows, and blacks seen here in *The Old King* is an opaque equivalent to the luminosity of stained glass on a bright day. The second distinguishing feature of Rouault's work is his religious conviction. He painted from an absolute certainty of the centrality of God and the need for humanity to cling with complete trust to the divinity. He believed that we are all inherently sinful and that no one has the right to point a finger at a neighbor. Further, he believed that authority is corrupt and even evil. His saints and heroes are outcasts, prostitutes, and beggars, while his sinners and villains tend to be the judges and kings.

CHRIST IN THE OUTSKIRTS
1920, oil on canvas, 36 x 29 in (92 x 74 cm),
Bridgestone Museum of Art, Tokyo

We do not think of Rouault as a narrative artist nor indeed is he, but there is an unstated narrative here as he depicts Christ in the outskirts of a town. The outskirts was where Rouault felt Christ was to be found: never with the wealthy or powerful, always with the outcast and the poor. The three figures stand motionless – two small children, hunched and waiting, beside the impassive and dignified Christ. The child next to Him has caught the radiant gleam of His very garments, and, in this desolate world where only the moon gives light, Rouault seems to consider that Jesus is the light of the world.

IT IS DIFFICULT *to analyze how Rouault convinces us that this is a bad man. Those hunched shoulders, the black leaded hands selfishly clutching a bunch of fragile flowers, the darkened eyes, the glowering nose, and the downturned mouth, accentuated by his beard – all these elements contribute to this unflattering portrait of a corrupt king.*

THIS PICTURE IS ONE OF *power misapplied, of wealth put to selfish use, of authority oblivious of and indifferent to the poor. The old king turns in on himself. Years have taught him nothing except to harden himself in the use of power. For one who preached compassion with such warm-hearted generosity, the unstated condemnation in this superb portrait is astonishing.*

THE OLD KING
1937, oil on canvas, 30 x 21 in (77 x 54 cm), Museum of Art, Carnegie Institute, Pittsburgh

ROUSSEAU, HENRI 1844–1910 b. France

TIGER IN A TROPICAL STORM

ROUSSEAU WAS UNTRAINED AND RELATIVELY uneducated, yet he maintained, and not unjustly, the highest opinion of his capabilities. He led a vivid fantasy life, convincing himself that what he painted from various postcards and the descriptions of others were real experiences. Such was the hypnotic power of this fantasy that the literal reality of the scenes becomes completely unimportant. The tropical setting here is a reflection of his walks through the botanical gardens in Paris, and the zoo, of course, provided him with images of wild beasts, such as this tremendous and ferocious tiger. But Rousseau had a genuine poetic power – an ability to summon up in great strength a vision of the world, which his belief made believable. Here, he is intent on convincing us that unleashed atmospheric passion is a fact of life. This is a bizarre work, but one of genius.

BOY ON THE ROCKS
c.1896, oil on canvas, 55 x 46 cm, National Gallery of Art, Washington, DC

Boy on the Rocks may indicate how Rousseau saw himself – an enormous, childlike genius, either floating above or seated precariously upon, the peaks of the world's achievements. The face is fully adult and the extraordinary striped garments force us to concentrate on the figure and to see it as a sort of Colossus astride the world. Rousseau sees it as only natural that this is what a portrait should be – whether of a boy, or of Rousseau as boy, is immaterial.

R
402

THE PROPORTIONS *are peculiar, but this adds to the impact of the work. There is no space in Rousseau's pictures for any freedom; all is pressure and savagery. Yet so delicate is the execution that he can achieve this effect while showing, through the slender branches of a most untropical tree, the sky, with its pelting rain.*

THE FOREGROUND *leaves are extraordinary in their bizarre shapes as they bend in the storm. This world is not windswept but gale-swept, and the streak of lightning in the upper right seems hardly necessary. Even the tiger crouches, teeth bared and gleaming, fearful of the great rush and force of the tropical rain.*

TIGER IN A TROPICAL STORM *1891, oil on canvas, 51 x 64 in (130 x 162 cm), National Gallery, London*

ROUSSEAU, THÉODORE 1812–67 b. France
SUNSET IN THE AUVERGNE

THÉODORE ROUSSEAU, LIKE COROT AND DAUBIGNY, spent much of his life painting in the forest of Fontainebleau near Barbizon, hence their joint name, the Barbizon painters. He revelled in the unspoiled beauty of this part of France, though perhaps "revelled" is the wrong word to use for Rousseau, a natural melancholic who was more drawn to evening than morning. *Sunset in the Auvergne* is a very early work, before he settled at Barbizon, and it is not, in fact, a picture finished for the salon but merely one of a group of small sketches painted in the open air. It is impossible not to wish that these early 19th-century painters had been able to feel more confidence in their sketches. The finished works are fine enough. They have been described as "admirable" and "honorable" (tributes they deserve), but the sketches have a rough power, an immediacy and freedom that tended to be lost when they were reworked in the aseptic conditions of a studio with its artificial light. *Sunset in the Auvergne* is wholly beautiful, with its one small figure, standing alone at the edge of the wilderness.

GROUP OF OAKS AT APREMONT IN THE FOREST OF FONTAINEBLEAU
1855, oil on canvas, 25 x 39 in (64 x 100 cm), Musée du Louvre, Paris

It is easy to think one has seen this picture before. But these trees are not generic shapes, their individual peculiarities have been precisely observed, and the Barbizon artists regarded such acute observation as a worthy theme for their art. Rousseau paints these oaks not only with truthful exactitude but with appreciation, seeing them as grand relics from a time when the whole of France was thickly wooded. Thus they carry a charge of nostalgia.

THE SOLITARY *figure looks over fields of liquid gold under the rays of the setting sun, while storm clouds glower overhead. The excitement in the air repeats the excitement in the vegetation that brackets the still, flat acres of plain. Rousseau paints with a sense of awe, a sense of privilege, and an awareness of the mystery of nature which no man can control.*

THIS IS A *lonely painting, almost a sad one, as if the artist acknowledged that the plains of gleaming gold were soon to lose their brightness, which, as we look, seems to be ebbing away as the sun sets. Yet the experience is one of marvelous enrichment.*

SUNSET IN THE AUVERGNE
1830, oil on wood, 8 x 9 in (20 x 24 cm), National Gallery, London

RUBENS, PETER PAUL 1577–1640 b. Germany
THE ENTOMBMENT

TOO MANY PEOPLE UNDERAPPRECIATE RUBENS because they associate him almost wholly with large pink ladies. But the extent of his power, the reason why he is one of the very greatest of artists is perhaps clearer in a picture like *The Entombment*. Rubens himself was an artist who seemed to have every possible human gift: intelligence, good looks, charm, enormous skill, and integrity. But he also had great spiritual gifts – he was a profound believer, and something of that deep and vibrant faith is visible in this terrible depiction of the death of Christ. The bloodless body, not romanticized but seen in its full adult muscularity, slumps across almost the whole diagonal of the painting. It is the sheer impact of emotion that makes this entombment so extraordinary. The body is thrust at us; we cannot escape its immense physicality – the dried blood, the lividity of the body as it turns blue under the grip of death. Rubens makes no attempt to force our emotions, however, and the painting is awesome partly for its reticence. Yet the dead face of Jesus – with the slits of the eyes, the open mouth, and the helplessness of the head on its strong neck – is unforgettable.

CHRIST'S BODY *lies upon straw, which is reminiscent of the manger in which He was laid as an infant. His Mother's face is as bloodless as her dead Son, her eyes, red with weeping, look up to the remote heavens. Only in the hand that curls so tenderly around the dead arm can we see the difference between the living and the dead.*

ST JOHN, *a solid mass of deep crimson on the left, is visibly containing the turmoil of his emotions. He has covered his hands out of reverence for the dead Savior. Christ's hair, reddened and sticky with the blood from the Crown of Thorns, contrasts starkly and poignantly with John's shining hair, which curls down past his flushed cheeks.*

THE ENTOMBMENT
c.1612, oil on canvas 51 x 51 in (130 x 130 cm), J. Paul Getty Museum, Los Angeles

R
405

> **"RUBENS CREATED THE MOST INTENSE SYMPHONIES OF COLOR"**
> Téodor de Wyzewa

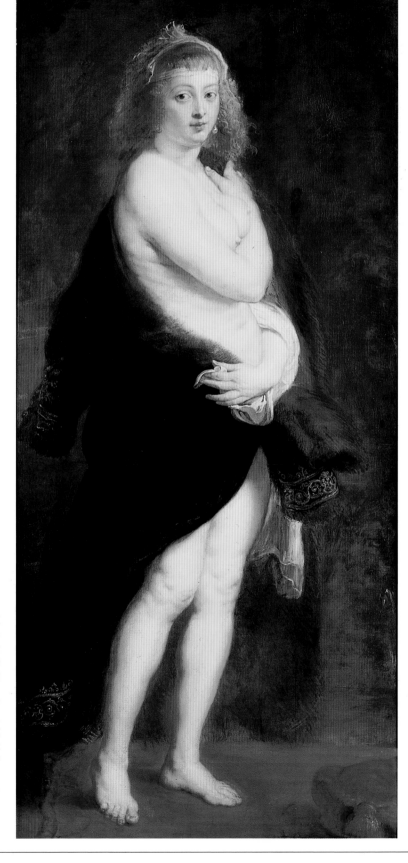

"THE LITTLE FUR"
c.1635–40, oil on wood, 69 x 33 in (176 x 83 cm), Kunsthistorisches Museum, Vienna

After the death of his first wife, Rubens married a very young girl, Hélène Fourment. Here, she stands shyly before her husband in the costly fur wrap that he has given her. Her expression – half-teasing, half-proud – is extraordinarily intimate. Rubens plays with rapturous skill on the delicate fur of the robe, touching the soft yet firm whiteness of her young body, just as the fluff of her brown hair falls delicately on her shoulders. This was not a picture for display, it was personal for the husband and young wife, and it was the only work that Rubens explicitly left to her in his will.

RUBLEV, ANDREI c.1360–c.1430 b. Russia
THE TRINITY

RUBLEV IS FAR AND AWAY THE GREATEST OF THE ICON PAINTERS. The icon must follow a rigid pattern, without any attempt at a unique interpretation of the divine ministry. In such a context, the genius of Rublev shines all the more brightly. He observed the rules, and yet his work is unmistakable in its strength and spiritual insight. Christian artists have grappled with the problem of how to represent the Blessed Trinity: one God, indivisible by definition, in three persons. A brilliant solution was to refer to the Old Testament story that described how the patriarch Abraham, the father of the Jewish people, was visited by three strangers. Abraham was childless, even though God had promised him descendants as numerous as the stars in heaven, but, having entertained the strangers with the utmost generosity, he was told by them on their departure that within a year he would have a son. Since his wife was well past her menopause, the fulfilment of this prophecy was seen genuinely as a miracle. In time, Christian imagination rewrote the story, replacing the three travellers with three angels.

THE SAVIOR
after 1420, egg tempera on wood, fragment, Tretyakov Gallery, Moscow

Rublev is a master of color. With his own ineffable grace, he fuses contradictories to create perhaps the most memorable image of the Savior that we possess. Although the mouth is small and delicate and the eyes are tender, the neck is thick and strong and the nose is long and aquiline. It is not a realistic portrait, with that elongated face surrounded by a fuzz of hair that could equally be a halo. But the impression is of a serenity and self-possession that overawes. It is a face both implacable and compassionate, approachable and remote – the nearest human skill can come to suggesting that here is one who is both man and God.

RUBLEV PAINTS THE ANGELS *with a grace and dignity that makes them worthy of representing the three persons of the Trinity. They are seated at Abraham's table, with a small tree to indicate that he is entertaining them out-of-doors, and with a token structure indicating his house in the background. The dish before the angels appears sacramental, and they commune with silent trust.*

THERE IS A SENSE *in which it is inappropriate to include Rublev's work in a book such as this. Icons were paintings indeed, but they were also much more than paintings. They were visual prayer – paintings for which the artist prepared with fasting and penitence, purifying his heart so that he might be worthy of so divine a task.*

THE TRINITY, *c.1410–20, tempera on wood, 56 x 44 in (141 x 113 cm), Tretyakov Gallery, Moscow*

RUISDAEL, JACOB VAN
1628/9–82
b. Netherlands

AN EXTENSIVE LANDSCAPE WITH RUINS

FLAT COUNTRIES SEEM TO ATTRACT GREAT LANDSCAPE PAINTERS – think of East Anglia with Constable and Gainsborough. Holland, supremely flat, has its own great landscape artist in Jacob van Ruisdael. He felt no need whatever to imagine diversification of the Dutch landscape; it was the sheer expanse of cultivated earth lying under the great drama of the skies that gripped his imagination. Although in the forefront of this landscape there are interesting brick buildings, reflected in the calm waters of a pond or small river, the great excitement that Ruisdael communicates to us comes from the action of the light. Sunlight has caught, and momentarily lit up, the field at the middle right. With the relative darkness of the low-lying trees and the earth on all sides, the ripe harvest gleams gold, as romantic as anything in the old myths. Thrust against the sky is the strong and austere church steeple, in effect, pointing and alerting us to what is above.

OAKS BY A LAKE WITH WATERLILIES
c.1665–69, oil on canvas, 46 x 56 in (117 x 142 cm), Staaliche Museum, Berlin

Perhaps only Ruisdael would have dared to center this picture on a dead tree. That great white curve angling upwards gives the scene its peculiarly poetic meaning. The surviving trees prosper in an autumnal richness, dense ranks of oaks that one would think eternal, were it not for the mutilated stump gleaming before them.

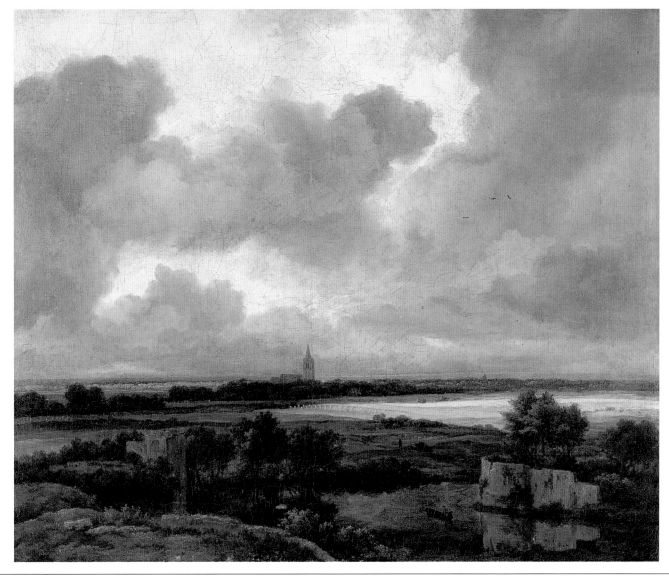

ONLY A THIRD *of this picture is earth, beautiful and intricate as that earth is. Two thirds is devoted entirely to what one might call a heavenly narrative, forewarning an onrush of the rainclouds, where the sun can still spotlight a cloud in the distance and the clear blue sky is not yet completely vanquished. Is this a storm that is coming, or going?*

THE SKIES *are a secret unto themselves, and the dark billows of the clouds are exquisitely modulated, from an almost transparent thinness to a thick impasto. It is a silent landscape, and in that great extent of countryside, with its glimmering field and its still waters, no human being interrupts the spectator's gaze.*

AN EXTENSIVE LANDSCAPE WITH RUINS
c.1665–75, oil on canvas, 13 x 16 in (34 x 40 cm), National Gallery, London

RUNGE, PHILIPP OTTO 1777–1810 b. Germany
THE HÜLSENBECK CHILDREN

RUNGE DIED YOUNG, a devout Protestant who believed firmly that art had a spiritual purpose. He didn't necessarily parade this purpose, but behind the picture of the Hülsenbeck children is a philosophy of innocence and a need of discipline. These two beliefs were fundamental to his personal philosophy and gave him a special interest in painting children. *The Hülsenbeck Children* has an almost eerie fascination as a painting. They are children indeed, yet somehow they loom so large that they dominate their landscape. The little boy fixes us, as does his small sister, with an air of inexorable challenge.

THE CHILD IN THE MEADOW
1809, oil on canvas, 12 x 13 in (31 x 32 cm), Kunsthalle, Hamburg

Runge's most famous picture, of which this is a fragment, is called *Morning*. This is not the infant Child, but an ordinary child, a human being at the start of life. The face is raised smilingly in welcome, prepared by nature to open its arms wide to the morning sunlight. Runge sees this as an attitude of the soul that we are all privileged to experience at the beginning, but which, without care, we will lose as morning darkens into evening.

THE THREE CHILDREN *are hemmed in by a fence that protects them from the outer world, innocuous though that world may seem. The little boy waves the whip in an acknowledgment of the purpose of physical punishment. But they are not rendered spiritless by such rigidities, and we see that the sunflowers opening in the sun are on their side of the fence.*

IT IS THIS DUAL *function – showing youthful innocence and control over it – that makes the picture impressive. The large, serious faces of the children, their gaze fixed, mirrors the artist's conviction that childhood is not a time for running wild. The children are advancing steadily along the straight path which they do not see, but which Runge visualizes on their behalf.*

THE HÜLSENBECK CHILDREN, *1805/6, oil on canvas, 52 x 56 in (131 x 141 cm), Kunsthalle, Hamburg*

RUYSCH, RACHEL 1664–1750 b. Netherlands

ROSES, MARIGOLDS, HYACINTHS, AND OTHER FLOWERS ON A MARBLE LEDGE

RACHEL RUYSCH WAS A FLOWER PAINTER, one of those select few who devoted all their art to preserving, in an eternal stillness, the passing beauty of flowers. With all the sensitivity and skill that is required for such a task, she catches shape and color with affectionate precision. But what seems to distinguish the flowers that Ruysch paints is what some might call their untidiness: flowers sprawl in all directions with a certain impatience of arrangement; frequently they are also overblown. Her roses droop, and, although in this picture there are no loose petals, she shows us a bouquet in which petals are on the verge of falling. The marigold that droops so vividly in the foreground is interesting to Ruysch not just for its color and the perfection of its shape but for that precise quality of the overripe, which makes the petals curl upwards and refuse the constriction of the blossom's tight circle.

FLOWERS IN A VASE
c.1685 oil on canvas, 22 x 17 in (57 x 44 cm),
National Gallery, London

Ruysch is thought to have been in her very early twenties when she painted *Flowers in a Vase* and yet already her overriding concerns are evident. She refuses to over-arrange, and her flowers sprawl in a loose diagonal from the drooping stem at lower left up to the spray of grass at the upper right. The flowers seem almost to be resisting their confinement, and the insects that are found throughout the picture may be painted with a touch of irony, because while they can move on, the only escape for the flowers is to straggle, petal by petal, into death. It is that very movement that attracts this unusual artist.

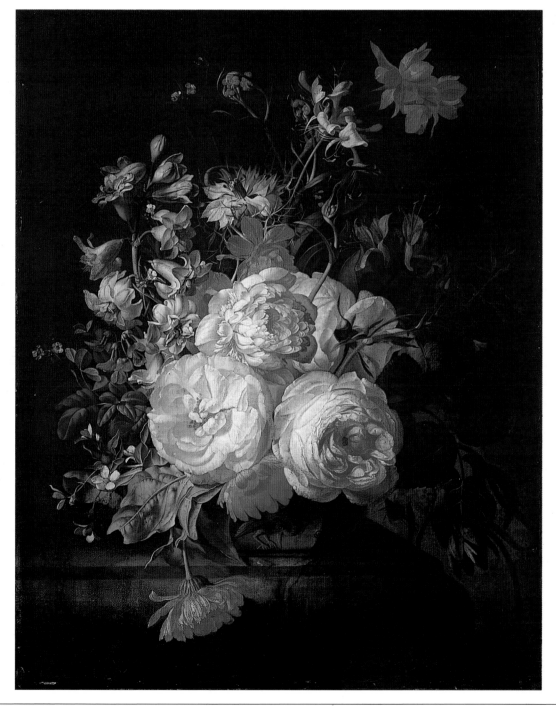

THE ROSES ARE THICK *with maturity, and the flowers on the upper right have passed out of light into shadow as if in preparation for dissolution. We can vaguely make out the outlines of blues that have been drained of color, as if Ruysch is interested in playing off light and darkness, as well as life and death.*

IT IS PERHAPS SIGNIFICANT *that the stone bowl in which the flowers are set is carved with the figure of a stork or heron curling its neck around to peck at some living creature in the earth. This is the image of time, perhaps, which Ruysch does not wish to confound but to accept and incorporate into her work. She is not painting time frozen, but time in control.*

ROSES, MARIGOLDS, HYACINTHS, AND OTHER FLOWERS ON A MARBLE LEDGE
1723, oil on canvas, 15 x 12 in (38 x 31 cm),
Glasgow Museum and Art Gallery, UK

R
409

RUYSDAEL, SALOMON VAN

c.1602–170
b. Netherlands

DUTCH LANDSCAPE WITH HIGHWAYMEN

THE RUYSDAEL FAMILY was outstanding among 17th-century Dutch landscape artists. Salomon van Ruysdael's *Dutch Landscape with Highwaymen* is not only magnificent in itself but carries a secret jolt of electricity that infuses the superb peace of this landscape with its mood. At first sight we have here the tranquil Dutch countryside: trees soar to heaven; peasants converse at the side of the wheat field; a procession of horsemen and cattle wend their leisurely way. But on the horizon, a lofty church spire alerts us to intense and profound activity that is taking place in the middle distance. Unnoticed by the people in the foreground, a group of men run in desperation towards the haystacks while a posse attacks them and the trajectory of the bullets is visible even from afar.

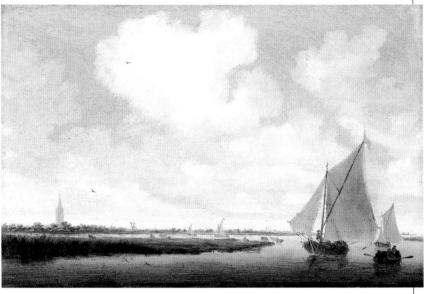

SAILBOATS ON THE WIJKERMEER
c.1648, oil on wood, 16 x 24 in (40 x 60 cm), Staatliche Museum, Berlin

THE COUNTRYSIDE OF RUYSDAEL *is not what it seems: there are secret dramas, hidden violence, and peace cannot be taken for granted. Ruysdael, as it were, sneaks in this element of violence, forcing us to look deep into the countryside and assess it afresh. But at the same time by making the violence so small and distant, he keeps it in proportion.*

DUTCH LANDSCAPE WITH HIGHWAYMEN, *1656, oil on canvas, 42 x 58 in (106 x 148 cm), Staatliche Museum, Berlin*

Despite its title, the focal point of this painting is that great white cloud. Ruysdael leads the eye from the church spire to the bird in flight and then to another, soaring confidently into the cloud. Only the birds seem to move. So still is the air that we can believe that the rowboat will overtake its companion and that the pattern of the clouds will remain unaltered. We are entranced by the slow heaviness of the sky that almost monopolizes the canvas.

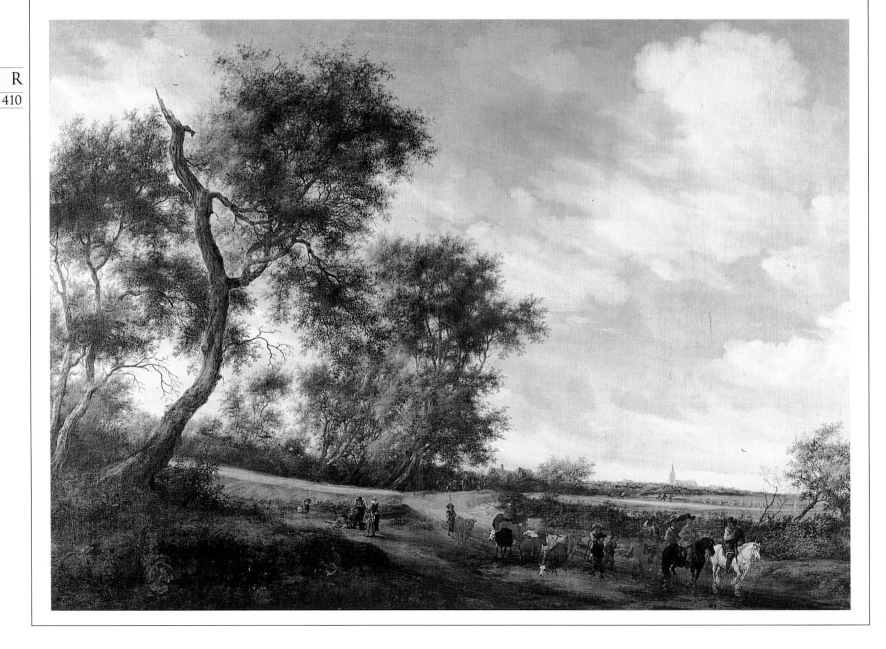

RYMAN, ROBERT 1930- b. US
SURFACE VEIL

RYMAN IS THE KIND OF CONTEMPORARY ARTIST WHOSE WORK CAN, at first, baffle the unaccustomed viewer. What, one may wonder, is he actually doing? What is the surface veil? Ryman, who is a highly articulate artist, has tried to explain, but perhaps we should not be over-quick to turn from looking at the work to reading the explanation. If we just give this work time and look at it, we may well be struck by its extraordinary and fragile beauty. It is the most delicate of works, hardly there at all, which in fact was the artist's intention. Ryman has said he really wants to paint on nothing, just to paint the paint, to show how beautiful paint in itself can be when allowed to exist without being dragooned into forming an image, or made part of a larger scenario, this is why he has used the thinnest, least obtrusive material possible – a mere surface veil in fact – in order to get the work as close to the wall as possible. His works do not exist until they are on the wall, and so have a temporal quality. Here is art floating free, on the fringes, art dependent on human involvement, as of course it always is, but Ryman makes us face it without escape.

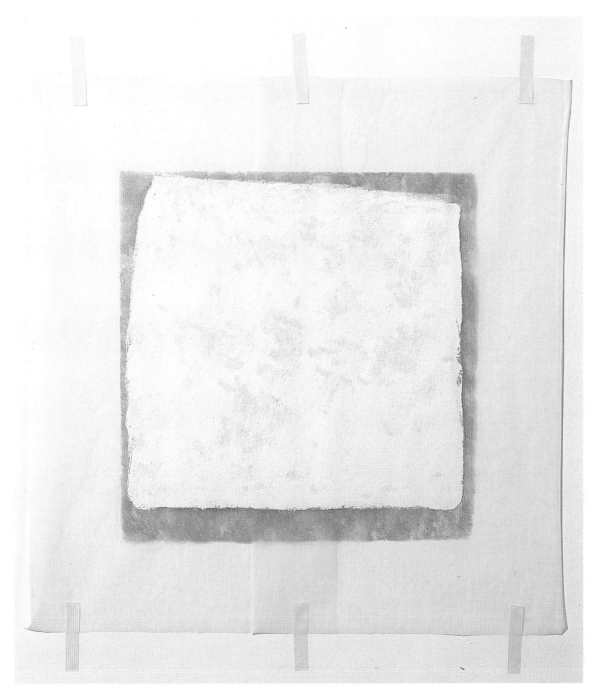

MONITOR

1978, oil on canvas with metal fasteners, 27 x 26 in (69 x 66 cm), Stedelijk Museum, Amsterdam

To get the full impact of *Monitor*, one would need to see it not just from the front but also from the side, because it has been adapted to project a few inches off the wall. Ryman wants us to look, not at what is on the canvas, but at the canvas in itself. Here is an object – the paint is clarifying it – a great rectangle moving from the demure flatness of the wall, out into our space. It is almost as if he is asking us to contemplate a flat, paint-covered sculpture.

> "THERE IS NEVER ANY QUESTION OF WHAT TO PAINT, BUT HOW TO PAINT"
>
> **Robert Ryman**

RYMAN HAS TAKEN *for the surface a fragile and irregular piece of fiberglass, on which he has painted layers of delicate, almost translucent whites. He has then backed this fiberglass – not with canvas or wood or anything solid, but with just two thin sheets of waxed paper, overlapping at the center. The waxed paper support, fragile as it is, has not been backed, but has been fixed directly on to a wall with pieces of masking tape.*

SURFACE VEIL, *1970–71, oil on fiberglass, with waxed paper and masking tape, 22 x 19 in (56 x 48 cm), Private Collection*

SAENREDAM, PIETER JANSZ 1597–1665 b. Netherlands

INTERIOR OF THE GROTE KERK, HAARLEM

DUTCH PAINTERS EACH HAD THEIR OWN SPECIALITY – landscapes, portraits, seascapes, flower pictures. Saenredam's speciality was uncommon: he painted churches, mostly their interiors. He painted them with a silent majesty that suggests the awe of the sacred and dwarfs the presence of the occasional human. Here, in the Grote Kerk of Haarlem, the massive pillars rise, round and bare, except for the great black diamond shape that may be an escutcheon. The interior is filled with light and peace. Nothing disturbs the eye: the image is not focused on altar or Cross or even portrait. It is not the church where people gather to worship that interests Saenredam, but the church per se – this strong, high building that stands inviolate for most of the week, allowing free entrance to light from the high windows, and echoing only an occasional footfall.

ST MARY'S SQUARE AND ST MARY'S CHURCH AT UTRECHT
1662, oil on wood, 43½ x 55 in (110 x 139 cm), Boymans-van Beuningen Museum, London

Saenredam sketched St Mary's Square and St Mary's Church with earnest precision in 1636. This painting, which is based wholly on that sketch, was created 25 years later. The air of immediacy is misleading, a fact that is, in itself, significant. Saenredam convinces us that a church has an element of the eternal and that the passing of time is irrelevant; but plants are sprouting from the church roof and that air of impregnability may not be as it seems.

INTERIOR OF THE GROTE KERK, HAARLEM, *1636–37, oil on wood, 24 x 32 in (60 x 82 cm), National Gallery, London*

WE HAVE TO SEARCH *to see the man in the pew and the woman sitting beside the pillar. They are dwarfed by the sheer stature of the church itself. It is as if Saenredam believes that the simple architectural strength of such a building, without human adornments or indeed attention, is purer praise to God.*

SANDBY, PAUL 1731–1809 b. England

A ROCKY COAST BY MOONLIGHT

PAUL SANDBY WAS ONE OF THE FIRST to show that watercolor is as serious a form of painting as any other. Here is an imaginary scene, painted with the pleasure of a true romantic. This is not a rocky coast uninhabited or desolate; activities are going on despite the lateness of the night. Ships and boats move briskly over the waters, and a fisherman stands there with his net. But this does not interest Sandby and should not interest us; the focus is on the actual setting, the great rocky bay, and, soaring up in rugged majesty on the right, a cliff surmounted by its castellated towers. What attracts Sandby most of all is light shining on the water. It gleams over the wavelets, picking up reflections from the boats and the ships, deepening here, lightening there – an ineffable vision of the serenity of the sea at rest. Crisp evening clouds lit from gleams of moonlight turn a setting (which in daylight might appear commonplace) into a scene of enchantment.

A ROCKY COAST BY MOONLIGHT, c.1790, watercolor on paper, 12½ x 18½ in (32 x 47 cm), Castle Museum and Art Gallery, Nottingham, UK

WE STAND SECURE on a rocky foreground, looking out on the water. We are able to delight both in the liquid gleam in the foreground and the rocky mass, which reflects in its facets the fickle light of an obscured moon. Sandby's awareness of physical realities is the bedrock of his ability to make his imaginings convincing.

AN ANCIENT BEECH TREE
1794, watercolor on paper, 26 x 40 in (67 x 102 cm), Victoria & Albert Museum, London

An Ancient Beech Tree is dense with incident. Sandby seems to have responded to every leaf on the tree, to every knoll in the branch, and the tree effortlessly dominates the overall setting. The three humans on the right seem involved in some mysterious relationship – are they fighting over the girl? They are paralleled by three horses on the left. The tree dominates, not just by physical presence, but by its sense of history – it has witnessed so much that has been lived through in its presence and is now forever lost. Only the tree survives, extraordinary in the complexity of its shapes.

SARACENI, CARLO 1579–1620 b. Italy

MOSES DEFENDING THE DAUGHTERS OF JETHRO

SARACENI HAD THE GOOD FORTUNE to be the almost exact contemporary of that great German painter Elsheimer. They were in Rome together, and Saraceni learned how to hold his dramatic sense and tell a story with clarity and dignity. Moses is the great hero of the first books of the Bible, and one of the stories about him concerns his defence of the daughters of Jethro, the priest of Midian, when they were attacked by shepherds – traditionally a rough and rapacious tribe. When the women tried to water their sheep, the shepherds selfishly drove them away, and the young Moses displayed, for the first time, that gift of leadership that would in the end be the salvation of the chosen people. Saraceni, painting in a small compass on copper, has imagined the scene with precision.

MOSES DEFENDING THE DAUGHTERS OF JETHRO
1609–10, oil on copper, 11 x 14 in (29 x 35 cm), National Gallery, London

ANDROMEDA IN CHAINS
late 16th/early 17th century, oil on wood, 10 x 9 in (26 x 22 cm), Musée des Beaux-Arts, Dijon, France

In this tiny picture, Saraceni depicts Andromeda chained to the rock as prey for the sea serpent. Her long white body snakes sinuously down the full length of the picture. She has heard the splash of the approaching monster, grinning up at her with toothy inanity, and the fear with which she twists to confront him sends what drapery she has fluttering in the wind. What she cannot see is Perseus – one of the great redemptionists – on his winged horse, sword at the ready, charging down to provide her with a happy ending.

S
414

IN THE FOREGROUND, *an impassioned Moses pleads with the shepherd to behave like a gentleman. Saraceni has entered with imaginative sympathy into this encounter, contrasting the dark young Israelite, drawing on all his forces of eloquence, with the rough Egyptian, who is armed with a stick.*

BEHIND THE TWO *disputants is a frieze of interactivity: arguments, despairs, and frustrations are set against an impressive background of dark rock and green trees and the elaborate structure of the watering place. Saraceni makes the scene come alive and invests the biblical episode with an air of contemporary relevance.*

SARGENT, JOHN SINGER 1856–1925 b. US

THE DAUGHTERS OF EDWARD D. BOIT

SARGENT HAD A WEALTH OF IMAGINATION and invention that is often undervalued. Commissioned to paint the four daughters of the wealthy Edward D. Boit family, the artist seems to have intuited something about the family relationships that called for this extraordinary composition. It is impossible to know whether he deliberately posed the four girls like this, or whether it was by their own choice, but one feels that, either way, it was in response to some emotional truth. It certainly was by his choice that they were set in this great, cavernous room, which swallowed them up in its immensities and made them seem homeless in their own home. Disunited, without, one feels, a niche or a nest, they are clearly seen by Sargent as poor little rich girls; they seem lost, children without a place, without a space. There appears to be little love between them, perhaps little love for them, and they are evidently irritated by the presence of the artist. One hesitates to call it a dysfunctional family, but this is a cold, unwelcoming environment for four young women. They are dwarfed by the enormous Chinese vases, expensive objects that are clearly valued and cherished, as the daughters in their drab pinafores do not seem to be. Even the baby of the family, too young to respond to the invisible currents of family politics, sits in isolation.

MRS EDWARD D. BOIT
1888, oil on canvas, 60 x 43 in (153 x 109 cm), Museum of Fine Arts, Boston

Mrs Edward D. Boit (the former Mary Louisa Cushing) was the mother of the four girls whom Sargent had painted earlier. We do not feel that she welcomed her painting – she is putting on a face, tilting her head to encounter the artist. Her dress has the expected magnificence, as does the chair, but Sargent does not gloss over her double chin, her long nose, or her irregular teeth, and he makes a delicious nonsense of her ludicrous head attire.

THE ELDEST *daughter sullenly disassociates herself from the portrait. She stands in the shadows, and we can catch her face only dimly. Daughter number two does not quite have the courage to withdraw herself, but she presents a blank face.*

DAUGHTER NUMBER *three is happy to stand, isolated but at least fully in the light, and confronts the artist with a degree of implacable attention – one feels that this is a young woman to be reckoned with. The youngest merely looks with interest at the amusing man brought in to entertain them.*

THE DAUGHTERS OF EDWARD D. BOIT
1882, oil on canvas, 87 x 87 in (221 x 221 cm), Museum of Fine Arts, Boston

SASSETTA (STEFANO DI GIOVANNI) c.1392–1450 b. Italy

THE MEETING OF ST ANTHONY AND ST PAUL

SASSETTA IS A GREAT STORYTELLING ARTIST. Here we have a touching episode in the life of St Anthony Abbot, one of the great Christian hermits, who lived a life of intense mortification in the desert. St Anthony had a vision that there was a hermit called Paul who loved God more than he, himself, did. St Anthony set out at once to visit the holy man, and at the top of the picture we see him, barefoot, making his way over the stones. In the foreground we see their eventual meeting, at the cave where St Paul lives; both throw down their staffs and wrap their arms around each other with brotherly affection. Their halos combine in a double-helix as a sign of how the two old men are united in a common desire. The bodies, bent towards each other, rhyme with the sides of the cave. This painting is about the search for goodness and the need for love. It is about a refusal to judge and a blessed lack of envy. In its warmth, charm, and spiritual truth, this vision – understood with such sensitivity – is unforgettable.

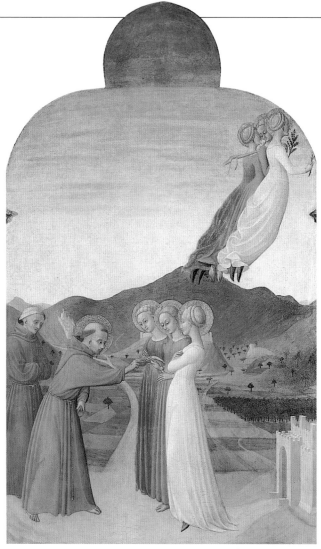

THE MYSTIC MARRIAGE OF SAINT FRANCIS

*1437–44, tempera on wood, 39 x 23 in (95 x 58 cm),
Musée Condé, Chantilly, France*

Among the many stories about St Francis, this is one of the most enchanting. One day, early in the morning, he meets three young women. One wears the white of chastity, one the dark red that symbolizes obedience, and one the Franciscan brown, because she represents poverty (the three virtues to which every priest and nun is vowed). Francis steps forward and gives his ring to Lady Poverty, whereupon the three glide up into the air and disappear. Sassetta, the superb narrator, sees obedience and chastity flitting, undisturbed, heavenward, while poverty cannot resist a look over her shoulder at the man who has given her his heart.

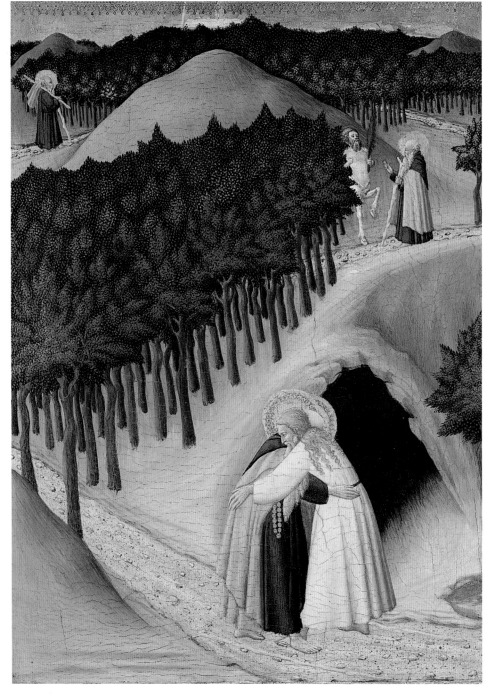

ON HIS JOURNEY, *St Anthony has adventures, one of which involves an encounter with a centaur – a creature left over from pagan civilization. St Anthony does not reject him, but reasons with him, and the centaur beats his breast in penitence. The saint blesses him, unwilling to condemn the pagan past, and, in token of its inevitable disappearance from the world, the centaur, head held high, holds the palm branch of martyrdom.*

THE MEETING OF ST ANTHONY AND ST PAUL, *c.1440,
tempera on wood, 19 x 14 in (48 x 35 cm),
National Gallery of Art, Washington, DC*

SASSOFERRATO (GIOVANNI BATTISTA SALVI) 1609–85 b. Italy
THE VIRGIN IN PRAYER

SINCE MARY IS ONLY OF THEOLOGICAL IMPORTANCE in relation to the Child, it was, for a long time, rare to find pictures that focused on her alone. Counter-Reformation Christians, however, found comfort in thinking of the long years after His Resurrection, in which Mary was alone, and how her union with her Son would have been the same as that of all Christians, a union of prayer. This theme appealed very deeply to Sassoferrato. He painted many versions, showing Mary lost in inward communion, her hands joined in prayer. So innate was the artist's belief in Mary as the most beautiful of women that this is a historically inaccurate picture. Sassoferrato does not show us the old Virgin – as of course she would have been – but one who is both young and beautiful, although she is certainly bereft and grieving. The white cave of her veil shadows her downcast eyes with their air of longing and inward thought, but the artist assuredly conveys that the Virgin is not aware of any allure. The background is the blackness that suggests no particular place, and the Virgin is hidden less by shadow than by her self-forgetfulness. Our eyes are drawn to the artist's treatment of the fabrics: the tight, white veil, the voluminous flow of the blue shawl, and, underneath, the rich, deep pink of her tunic. This is less a portrait than an icon.

THE VIRGIN AND CHILD EMBRACING
*c.1660–85, oil on canvas, 38 x 29 in
(97 x 74 cm), National Gallery, London*

This is a more familiar image of the Virgin and Child; one that might well have been painted in the year of Sassoferrato's death. This is the young Mary, still wearing the colors that seem, to this artist, special to her – whites, pinks, and voluminous blue – but here, prayer is no longer interior. The Child clasps her as she clasps Him, while through the archway is her husband, St Joseph, pictorially excluded from the intimacy of Mother and Child, and yet always privileged to be present.

MARY FEELS HERSELF *alone; she is lost in prayer, peacefully aware of the presence of God. Those who prayed before this image would have felt privileged to share her solitude and peace.*

EVERYTHING IN THIS *image is both soft and strong. The colors, for all the radiant strength of the blue and scarlet, are subtly attuned to the creamy folds of the encompassing veil and the luminous pink of her face and hands.*

THE VIRGIN IN PRAYER
*1640–50, oil on canvas, 29 x 23 in
(73 x 58 cm), National Gallery, London*

SAVERY, ROELANDT c.1576–1639 b. Netherlands

LANDSCAPE WITH BIRDS

SEVENTEENTH–CENTURY DUTCH PAINTING tends not to inhabit the world of the bizarre. Savery, however, is an exciting exception. He seems to have been fascinated by the romance of ruins and equally fascinated by the alien world of the bird. Here, he has indulged his passion for the ruinous by imagining the classic ghost of a Roman temple on the right, balancing it with a more contemporary brick ruin on the left. A dead tree is strewn at the center, as if nature itself is in ruins. If the setting is purely fanciful, this is not so of the birds, which he has studied with the naturalist's attention to detail. However, the assembly in itself is fanciful – even the best-equipped royal aviaries could not have brought together such a collection of bird life, ranging from the domestic cock and the familiar figure of the swan to the rarest of birds, such as the ostrich and cassowary.

LANDSCAPE WITH BIRDS
*1622, oil on wood,
21 x 42 in (54 x 108 cm),
National Gallery, Prague*

FLOWERS IN A NICHE
*1603, oil on canvas, 11½ x 7½ in
(29 x 19 cm), Centraal Museum, Utrecht*

Savery's flowers loom large, almost as self-sufficient worlds. Yet, it is precisely his knowledge that flowers do not exist in a world of their own that impels him to include other forms of nature – the quick lizards, a lurching black beetle, a large bee, a moth and a fly, a butterfly and a snail. Savery shows us nature both exposed, as in the lizards and insects, and hidden, as in the cocoon and the snail. He clearly delights in the contrast.

DESPITE ITS UNREALITY, *the truth with which Savery catches each bird and its personality – the self-satisfaction of the pelican, the tender relationships among a nest of swans, the pride of the cock, and the aggression of the eagle – has the capacity to captivate and convince.*

THERE IS AN EERIE *reminiscence of Chaucer's famous poem,* The Parliament of Fowls *– the word "parliament", of course, refers to speech (derived from the French* parler, *"to talk"). However, Savery's birds are not engaging in civilized dialogue but in that other renowned parliamentary activity – squabbling.*

THE VITALITY AND VIGOR *of the birds is emphasized by the sad wreckage of the pretentious human architecture that forms their background. The trees, too, are in disarray, and the birds seem triumphantly conscious of their superiority.*

SAVOLDO (GOVANNI GIROLAMO) c.1480–c.1550 b. Italy
TOBIAS AND THE ANGEL

AT FIRST SIGHT, THIS EVENING SCENE could be any encounter between man and angel. It is only the fish being invisibly pulled from the water at the lower left that establishes the narrative of Tobias and the Angel Raphael. It is a strangely mature Tobias: a muscular youth who one might think could safely travel by himself. But for all his physical prowess, his face shadows, both literally and metaphorically, and he turns in appeal to Raphael. Tobias's accompanying angel is his travelling companion and protector, and, since the journey they are to take will lead them over the vast world that lies between the trees and the threatening sky, the angel needs bodily solidity. This is no willowy creature of light, but rather love incarnate in angelic form, with great swoops of eagle's wings.

TOBIAS AND THE ANGEL
early 1530s, oil on canvas, 38 x 50 in (96 x 126 cm), Galleria Borghese, Rome

ST MARY MAGDALENE APPROACHING THE SEPULCHRE
c.1530–48, oil on canvas, 34 x 31 in (86 x 79 cm), National Gallery, London

Mary Magdalene is on her way to the sepulchre, where she will anoint the dead body of Christ. Although she is covered with magnificent folds of silver silk, we can see in her face the red-rimmed eyes of grief, and the bowed head and tense posture make it clear that this is Mary in mourning. However, the sun is rising and we know that the sorrow that bows that exquisite form, crumpling and weighing her down, will soon be a thing of the past.

THIS IS SURELY *one of the most beautiful angels ever painted. The face is luminous with compassion and selflessness. Savoldo sees the world as almost wholly dark, and the two actors in the drama appear all the more radiant for that. They are both figures of extraordinary beauty.*

SAVOLDO *seems to understand that this is not just a beautiful angel but a guardian in time of danger. Here is male friendship at its most tender and protective. Without the slightest erotic suggestion, the angel offers brotherly love and support, while the young man turns trustingly to receive it.*

SCHIELE, EGON 1890–1918 b. Austria
EMBRACE

SCHIELE WAS A TROUBLED AND UNSTABLE MAN who had a prolonged adolescence during which he struggled, with immense graphic force, to come to terms with his sexual identity. He had found answers and was advancing towards maturity at the end of his twenties when the great flu epidemic took his life. Nothing in Schiele's work ever comes easy – *Embrace* is all knobbly bones and protuberances, sinews and grapplings. The very sheet seems to rise in sympathy with the lovers, and the counterpane on either side isolates them in this strange little island of erotic passion. Yet it remains a profoundly tender picture. The lovers have no claim to beauty, and Schiele seems to have little interest in anything but the intensity of their relationship – its life-and-death significance. Although we are confronted with the inescapable reality of two straining bodies, this is not, essentially, a picture of sexuality but of affection, of two lost and unhappy exiles finding a haven within each other's arms. The dark, chaotic masses of the girl's hair flow over that of her lover, an ever-poignant symbol of their union.

HOUSES ON THE RIVER (THE OLD TOWN)
1914, oil on canvas, 39 x 48 in (100 x 121 cm), Museo-Thyssen Bornemisza, Madrid

There is an element of the sinister in Schiele's landscape; it is not an innocent description but a statement with psychic undertones. The river, with its broad streaks and its amplitude, makes us aware of how squashed is the small town. Between the ridge of forest behind and the river in front, the buildings are squeezed, opening their eyes at us in astonishment as they crowd together, one seemingly on top of the other in suffocating closeness. The undertones are harsh and shrill, and Schiele's genius is to force us to hear them.

EMBRACE, *1917, oil on canvas, 39 x 67 in (100 x 170 cm), Österreichische Galerie, Vienna*

AS THE WOMAN'S HANDS *reach around to embrace her lover's, they take on the blood-red contours of the male's body, and we feel we are witnessing the mystical enigma of a true embrace. They are uniting and each is becoming the other.*

SOME OF SCHIELE'S *early work was condemned as pornographic, but here we see only a tremulous tenderness. He was to die the year after he completed this work, and it is consoling to see that he had lived long enough to understand the comfort of loving and being loved.*

SCHMIDT-ROTTLUFF, KARL c1884–1976 b. Germany
GAP IN THE DYKE

GAP IN THE DYKE, *1910,
oil on canvas, 35 x 38 in
(88 x 96 cm), Brücke Museum, Berlin*

GERMAN EXPRESSIONISM WAS A BROAD CHURCH, which contained the measured intensities of Max Beckmann, for example, and the passionate emotionality of Schmidt-Rottluff, whose work is an outpouring of emotion expressed in vivid color. Schmidt-Rottluff's skill is to channel these emotional hues, as it were, controlling them just enough to produce a work that is readable. We have to look carefully before we can distinguish two figures amidst the all-pervading redness of *Gap in the Dyke*. They are moving through that redness, their backs to the dyke and the paths that lead up it. At the far left there is the scarlet of a roof and dark green shapes, suggestive of trees. But Schmidt-Rottluff is not concerned with making the topography of his subject clear to us; it is the emotion that enthrals him, the strange blue shape that represents the gap, the people walking through it as if submerged in the red, sucked down by it. The vividness of his color and the febrile quality of his line contribute to a feeling of drama; yet it is drama without a narrative, drama in a scene that one might describe as insignificant. The very wildness of his technique serves to underline the emotional intensity that is the true center of the picture.

SCHONGAUER, MARTIN c.1430–91 b. Germany
MADONNA OF THE ROSE BOWER

ONE OF THE GREATEST DISAPPOINTMENTS of Dürer's life was that he arrived in Colmar just after the death of Martin Schongauer. Dürer had set his heart on learning from Schongauer how to create form with such economy. *Madonna of the Rose Bower* is Schongauer's surviving masterpiece. There is a satisfying balance between the figures – the angels and their flowing blue, Mary in her luminous reds – and the extraordinary detail of the world behind. Practically every part of the picture surrounding the central figures is full of intricacies. The crown that the angels hold is a masterpiece of finely-wrought gold, and the roses clamber and twist around their trellis with a wiry exuberance, framing the occasional bird and then subduing to a stretch of grass, in which foliage and leaf intertwine with equal enthusiasm. Amid this linear activity and the shallow space of the bower, the human faces are especially dominant – Mary's pale oval (sadly regarding not the rose but the thorn) and the Child's loom out with a majesty that is in part dependent on the contrast of the graphic intertwining in which they are set.

MADONNA OF THE ROSE BOWER, *1473, tempera on wood, 79 x 45 in (200 x 115 cm), Church of Saint Martin, Colmar, Germany*

SCOREL, JAN VAN 1495–1562 b. Netherlands
MARY MAGDALENE

THIS ELEGANT CREATURE, with an almost too elaborate style of dress - pearls lacing her sleeves in a highly impractical fashion, gold embroidery, more pearls at her low neckline, and then a riot of colored silks tossed casually over her knees - is intended to be St Mary Magdalene. The "come-hither" look, the eyes sliding sideways to look at us with an unmistakable invitation, the faint curl of the exquisite mouth, and the deliberate informality of the golden tresses make it clear that this is the saint in her pre-sanctified days. One suspects that it might be a portrait of a magdalen who liked to pose as her patron saint, but behind her, in the distance, are such extravagant shapes of rock that one cannot help but feel that Scorel is hinting at a certain element of unreality. Despite the unusual elements, the picture is so rich, Magdalene is so charming, and the set-up so intriguing, that all its personal improbabilities can be overlooked. The graciously enigmatic quality of the portrait recalls that most famously enigmatic Italian, Mona Lisa.

ADAM AND EVE
c.1540, oil on wood, 19 x 13 in (48 x 32 cm), Private Collection

Scorel was a sophisticated painter familiar with much of the most advanced European art. Not for him the talking snake tempting Adam and Eve. He goes further still in interpreting the story – it is Adam who holds out the apple, accosting Eve with an aggressive vigor. Clearly, she has plucked and eaten, but he is by no means willing to follow the female lead, and she visibly sulks. The innocent world stretches out behind them, but they have broken the laws of order that enabled them to live in harmony and Adam is angry.

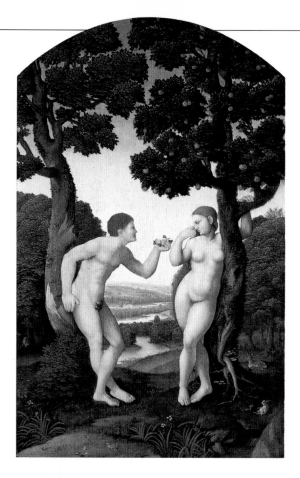

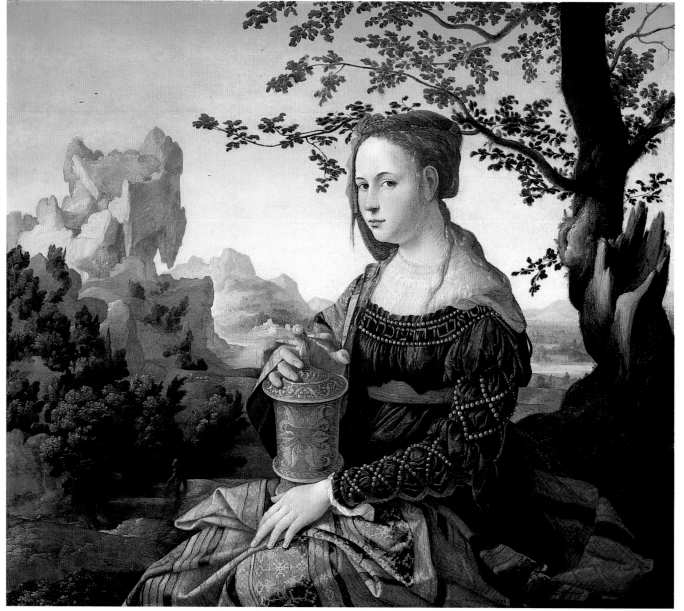

SCOREL MAKES *a highly unsuccessful attempt at locating his sitter in the biblical world by making the golden embroidery around her dress into the shape of what are, or are meant to be, Hebrew letters. Similarly, the great shawl that she flings around her is, perhaps, intended to suggest the rich silks of the Far East.*

THE JAR *of ointment was Mary Magdalene's constant attribute, and, the scripture tells us, was made of alabaster. This fluted and engraved contraption looks like gilt, however, which is more in keeping with the extravagance of the lady's attire. Particularly impressive is the contrivance upon her head, the mechanics of which are not easy to discern; nevertheless, it is undeniably fetching.*

MARY MAGDALENE
1529, oil on wood, 26 x 30 in (67 x 77 cm), Rijksmuseum, Amsterdam

SEBASTIANO DEL PIOMBO c.1485–1547 b. Italy
RAISING OF LAZARUS

SEBASTIANO FELT THAT IN RAPHAEL HE HAD A NATURAL ENEMY. When they were pitted against each other by a painting competition in Rome, he turned to a friend who also nourished a dislike for Raphael, the great Michelangelo. Eager to defeat the young usurper, Michelangelo produced the drawing from which Sebastiano painted his magnificent *Raising of Lazarus*. Christ, in pink and blue, dominates the crowded canvas, summoning with one long finger the dead man to rise. Lazarus, still naked except for his burial robes, is borne astonished into the light. Most subtly, the light has fully enveloped the whole of his massive torso, but not yet the innermost citadel of the person – the face. Around Christ swirls the world, astonished, disbelieving, even angry at such a reversal of the laws of nature. Essentially, however, it is a confrontation between two figures: Jesus, who contains life within himself, and Lazarus, who has been truly dead and who has now, like an enormous child, been brought forward to start life afresh. It is a superbly controlled picture, full of drama and emotion – a masterpiece.

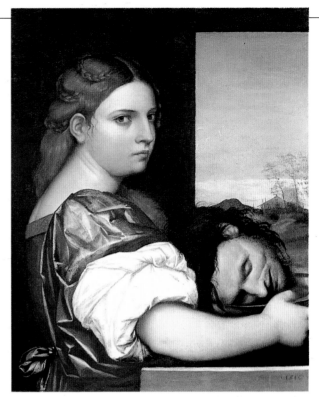

THE DAUGHTER OF HERODIAS
1510, oil on wood, 22 x 18 in (55 x 45 cm),
National Gallery, London

Sebastiano was able to paint with dramatic force and with intense psychological realism. His *Daughter of Herodias* is no beauty, but a solid, sullen teenager, who looks out at us balefully as she carries the remarkably serene head of the murdered John the Baptist. The killing has been done at her behest, and we see here no capacity for contrition. Salome wears the brilliant silks of a princess and stands before a window with an entrancing view of the far mountains. But her soul is eaten up with rancorous displeasure, and Sebastiano depicts her with a realism that is almost cruel. This is the insight of genius – hard to bear, impossible to evade.

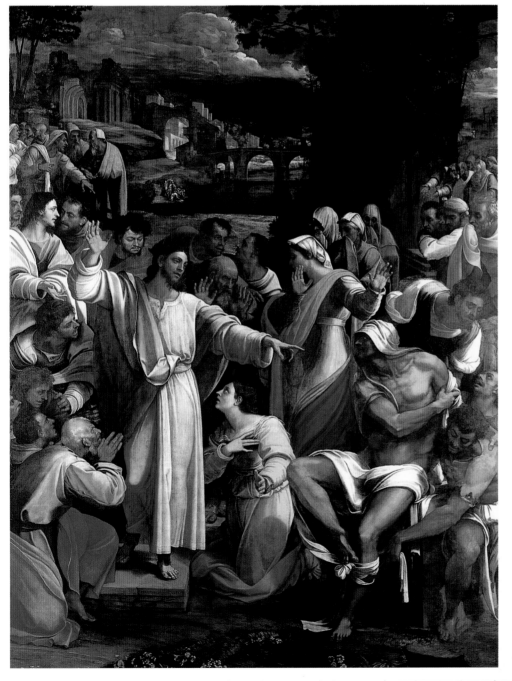

THE PICTURE RAPHAEL PAINTED
in this unacknowledged competition with Sebastiano was the great Transfiguration, now one of the glories of the Vatican. In a sense, however, Sebastiano has also painted a transfiguration. Lazarus has been several days in the tomb, and some of the bystanders make it clear, even by gesture, that he is emitting quite a stench. Yet Jesus has transformed the rotting corpse into a living, although still bewildered, Lazarus.

IT WAS LAZARUS'S SISTERS,
Martha and Mary, who were friends of Jesus, and it was they who told Him of their brother's death. Mary, the contemplative sister, kneels at His feet; Martha, the active housewife, is too disturbed by the prevailing odor to have taken in the extent of the miracle.

THE RAISING OF LAZARUS
c.1517–19, oil on canvas,
150 x 114 (381 x 290 cm),
National Gallery, London

SEGHERS, HERCULES PIETERSZ 1589/90–1633 b. Netherlands
MOUNTAINOUS LANDSCAPE

SOME MUSEUMS HAVE LANDSCAPES once thought to be by Rembrandt that have since been reassessed as the work of Seghers. Yet, the confusion is understandable. Rembrandt was deeply impressed by the poetry with which Seghers viewed the world; it was an almost religious understanding of nature's awesome presence. Seghers' mountains are not real, in an Alpine or Pyrenean sense; they seem more to be magnified rocks, built up to impressive heights by the artist's imagination. Great thunderclouds are rolling back behind the mountains, carrying birds in the wind current, and the world has that strangely luminous brightness that comes after a storm. The little group of peasants, with their sticks and cattle, almost seem in flight, moving out of the picture's landscape, which is strewn with broken trees and other evidence of nature's ferocity.

MOUNTAINOUS LANDSCAPE
c.1620s, oil on canvas, 22 x 39 in
(55 x 100 cm), Galleria degli Uffizi, Florence

S
424

SESTO, CESARE DA c.1477–1523 b. Italy
LEDA AND THE SWAN

ONE OF THE GREAT TRAGEDIES IN ART HISTORY is the loss of Leonardo's painting of *Leda and the Swan*. It is not, however, an absolute loss in that Cesare da Sesto copied it, and from this enchanting image our imagination can rise to the wonder that we may presume the original to have been. This Leda is a typical Leonardoesque figure, with the loose waves of her hair, the enigmatic smile, and the body curving with almost superhuman grace. The myth tells of how Zeus, in the form of a swan, mated with Leda. As an example of both love and longing, the sinuous neck snakes up in a caressing gesture; yet, we are deeply conscious that between the bird and the woman a great gulf exists. Leda holds her lover unambiguously, but her head is turned away. The great wings may embrace her, but there can never be domestic content or a future for this coupling. Perhaps that is why Leonardo set his lovers on a hill, with the whole world, in all its potential, stretching behind and away into the distance. This is the world that is lost to Leda should she persist in her unnatural affection.

LEDA AND THE SWAN
1506–10, oil on wood, 38 x 29 in
(97 x 74 cm), Wilton House, Salisbury, UK

SEURAT, GEORGES 1859–91 b. France
LA GRANDE JATTE

IT IS HARD TO BELIEVE THAT SEURAT was barely 31 when he died. His work has such maturity that it seems the product of a resolved old age, rather than the first fruits of a young genius. Seurat believed that the discoveries of the scientists, especially in the area of optics, were vitally important to the artist, and Seurat made great use of them. His own theory, called pointillism or divisionism, was based upon the idea that we see, physically, in terms of small quivering dots of color, which within the eye are transformed into the solidity of the image. *A Sunday Afternoon on the Island of La Grande Jatte* shows what Seurat accomplished with the security given to him by these theories. He has taken a commonplace Parisian scene and rethought it in terms of architectonic majesty. Everything here has a grandeur and a simplicity that makes it almost awesome. He has looked at, and visually grasped, each person; he has taken contemporary life and transmuted it; it has been rethought in a parallel dimension, and given an eternal stability, a dignity that seems, not imposed, but innate.

A SUNDAY AFTERNOON ON THE ISLAND OF LA GRANDE JATTE, 1884–86, oil on canvas, 81 x 120 in (206 x 305 cm), The Art Institute of Chicago

THERE IS SOMETHING STRANGE *and unnatural about the scene of Parisians at their leisure, a frozen element that Seurat did not desire. Yet, it is this very immobility, in its solemnity and grandeur, that makes this luminous canvas one of the great achievements of the 20th century.*

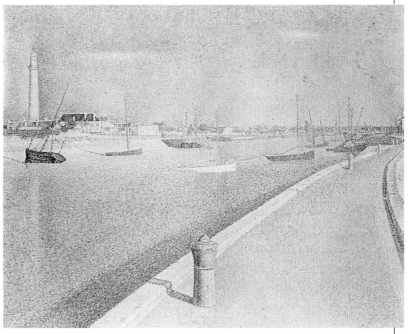

PORT OF GRAVELINES CHANNEL
1890, oil on canvas, 29 x 37 in (74 x 94 cm), Indianapolis Museum of Art

Seurat had only a year to live when he painted this majestic work. Already he was beginning to reject the restrictions of divisionism. The dots are far larger here, far freer, yet the scene seems like a slice of eternity. This may well have been exactly what he saw: promenade, channel, ships, and sky. Yet, this essentially unimpressive view is held forever in an inner light of its own making. It gleams before us under the quiet weight of material existence.

SEVERINI, GINO 1883–1966 b. Italy
TRAIN DE BANLIEUE

TRAIN DE BANLIEUE
ARRIVANT À PARIS
*1915, oil on canvas, 35 x 46 in
(89 x 116 cm), Tate Gallery, London*

ALL THE CONCERNS OF THE Futurist movement find expression in Severini's picture of a train arriving in Paris. It was painted in 1915 when World War I was at its height. Severini had seen trains roll through the countryside, some laden with the wounded coming back from the trenches, some carrying soldiers setting out to fight, others still with a sinister load of munitions. He was urged into a series of train paintings in which the great machine is emblematic of the heroic chaos of war, thundering noisily through the countryside, emitting vast clouds of smoke and moving always forward, out and away. He gives us a view, both from the train as we rock past the houses, and from outside the train. The red danger light is bypassed, and the sanctities of Church and of commerce are discarded, rocked on their side. The advertisement that extols the coffee canister suggests a hand holding a weapon of war, and the timid little brown clouds of smoke from the house afford an ironic contrast to the dense amplitude of the smoke from the war machine.

SHAHN, BEN 1898–1969 b. Lithuania, active US
RIOT ON CAROL STREET

ALL TOO OFTEN POLITICAL ART has so narrow an agenda that it may work as a poster but not as a painting. Ben Shahn's art, however, transcended the genre when he became incandescent with rage over the treatment of the workers in his contemporary America. Here, he shows a helpless crowd of women workers demanding fair wages. They have been blocked out from the fortress-like structure of the office, behind which men in short sleeves look out with condescension and indifference. The strange black-and-white funnels on the building, although constructively realistic, take on a symbolic function as they peer down at the women. The great ribbon of the factory building extends almost indefinitely, with no door to admit those seeking redress or even a window that will open. Shahn, who is always on the side of the oppressed or the minority, silently puts before us the contrast of the casual bosses, secure inside their stronghold, and the agitated group outside, who, nevertheless, stand on a pavement of extraordinary beauty.

RIOT ON CAROL STREET, *1944,
tempera on board, 28 x 20 in (71 x 51 cm),
Museo Thyssen-Bornemisza, Madrid*

Sheeler, Charles 1883–1965 b. US
AERIAL GYRATIONS

CHARLES SHEELER RESPONDED DEEPLY to the glory of industrialism in America. Today, we look with a jaundiced eye on the huge factory but halfway through our century it seemed that the world of industry was on the way to solving all mankind's problems of want and poverty. It seemed that a glorious machine age had truly dawned, heralding the promise of perfection. Sheeler's painterly manner became known as Precisionism because of its hard-edged geometry, austerely committed to the grandeur of industrial architecture. *Aerial Gyrations* shows a massive installation in its steel reality and then in its reflections, so that every movement of those encircling rails is copied by the sun in shadow-form. As an artist, Sheeler knew that we are always uncertain as to what we are actually seeing, and yet this shadow world is intended as a tribute to the complexity and power of the real.

STACKS IN CELEBRATION
1954, oil on canvas, 22 x 28 in (56 x 71 cm),
Dayton Art Institute, Dayton, Ohio

Sheeler saw these chimney stacks from a car and described them as a breathtaking sight. He walked around them for several hours taking photographs, and fifteen years later, using these photographs and remembering his emotion at the time, he painted *Stacks in Celebration*. He is celebrating the glory of American industry but, almost in passing, pays homage to his great hero, the painter Charles Demuth. The window on the right duplicates a Demuth window, and the overlapping stacks – semi-transparent, yet paradoxically solid – recall a Demuth painting called *The End of the Parade*.

THE ARTIST'S EYE *responds with the most intense pleasure to those precise right-angles, those squared-off edges, those calibrated movements, that sense of an intellectual complexity that American ingenuity had fabricated and reared to its productive immensity.*

THE COLORS *are subdued, sparse, and without nuance, as befits the certainties of science. Yet the more we look, the more there is to see. Radiant blues on the upper left, a tender pink at the lower right, that strange faint yellow-green that imitates the black bulk of the edifice, which looms up over half of the painting. This is not the tribute merely of the intellect, this is the intellect vitalized and made lyrical by what it sees.*

AERIAL GYRATIONS, *1953,*
oil on canvas, 24 x 19 in (60 x 47 cm),
San Francisco Museum of Modern Art

SICKERT, WALTER RICHARD
1860–1942
b. Germany, active England

LA HOLLANDAISE

IN DISCUSSIONS THAT ATTEMPT TO PIN DOWN the greatest British painter of the 20th century, the name of Sickert always arises. His was a strange, passionate genius, able at times to subdue itself to the more domestic interests of Victorian life and other times determined, as it were, to push further, to peel back the facade, and to show what the novelist Joseph Conrad referred to as "the heart of darkness". A contemporary murder of a prostitute, which resulted in a long and enthralling court case, gave focus to Sickert's imaginings. Many of his portraits of prostitutes, as here, have a dark undertone; one can imagine these women being brutalized or even killed. He shows the Dutch girl with her face in the shadows – who she is is hidden behind what she does. What she does is made brutally clear: she is framed by her iron bed and the light falls on her breast and thigh. Sickert was a dark painter, but he coaxed miracles of subtlety from his subdued palette, and the sheer visual excitement of *La Hollandaise* is hard to beat.

THE RAISING OF LAZARUS
c.1930, oil on wallpaper on canvas, 96 x 36 in (244 x 92 cm),
Art Gallery of South Australia, Adelaide

This is an image so daring that it is difficult to read. We do not associate Sickert with religious painting, and yet we are aware of sacred exhilaration as the long body of Lazarus, still wrapped in its gleaming shroud, is nurtured back to life. The uppermost figure is tenderly freeing the dead man's face. The blacks and greens suggest the lividity of death, with the hope of new life coming at the bottom of the picture in gleams of pink flesh. The very indistinctness of the image – its capacity to confuse and bewilder us – gives it a strange power.

LA HOLLANDAISE
c.1906, oil on canvas, 20 x 16 in
(51 x 40 cm), Tate Gallery, London

SIGNAC, PAUL 1863–1935 b. France

GAS TANKS AT CLICHY

SIGNAC SEEMS TO HAVE BEEN bowled over by one great artistic principle, which he followed with growing intensity all his life. The principle was that of divisionism, or pointillism – a semi-scientific theory that proffered that painting in the form of colored dots would cohere before the eye into an image that was more beautiful and impressive than paintings produced by more conventional means. Here, in his early twenties, we see Signac beginning to grasp the implications of this transcendent principle. *Gas Tanks at Clichy* could hardly be less enticing as a title, and yet Signac makes of it a wholly splendid picture. He displays to the full that chromatic diversity and integrity that he felt was the overriding glory of divisionism. The dots here are not small and the divisions are barely visible, but he has spotted the canvas with his colors in an almost abstract way. From this pattern of dots, a wonderful image of sand and grasslands has emerged.

GAS TANKS AT CLICHY, *1886,*
oil on canvas, 26 x 32 in (65 x 81 cm),
National Gallery of Victoria, Melbourne

PORT OF CONCARNEAU
1925, oil on canvas, 29 x 21 in (73 x 54 cm),
Bridgestone Museum of Art, Tokyo

Here, forty years after painting the gas tanks, Signac's divisionism is more ardent, but now the method has taken over. We seem to be looking not at nature expressed through a certain artistic lens but at nature transformed into a mosaic, with little pretence at realism.

If one is to see nature as a series of small colored squares, then this work could hardly be bettered. The sky glimmers with the kaleidoscopic purity of variegated color, and the ships have an almost oriental luxuriance they sail through the bright waters.

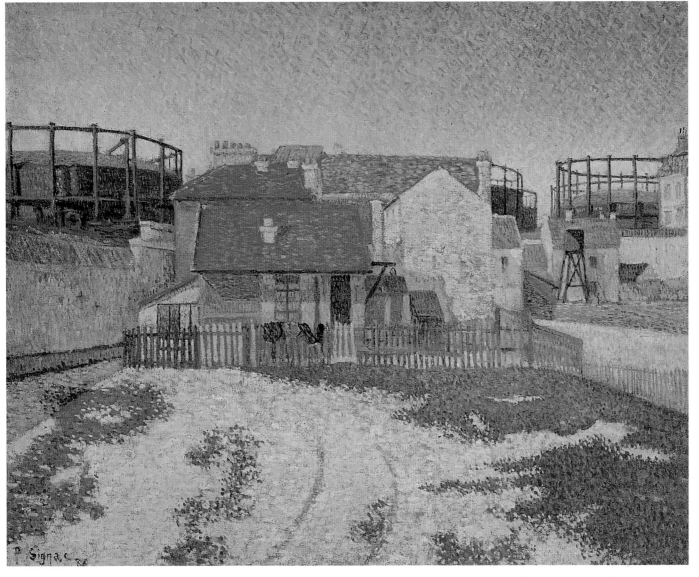

THE GREAT TANKS *on either side, beyond the small dwelling, recall the majesty of the Colosseum. But it is less the architecture that is so exciting here than the way Signac uses color: the wall on the left, for example, is dappled with pinks and blues as if every stone were catching a different light and reflecting a different aspect of the building before it.*

WE ARE HELD *at a distance from the gas tanks and the central block. They are fenced off from us, and to get there we traverse this great extent of sand and rough vegetation. Signac is still experimenting with his new discovery, but what he does with it is already wonderful and exciting, and he conveys a sense of the infinite possibilities of the creative world, whether man-made or divine.*

SIGNORELLI, LUCA c.1445–1523 b. Italy
ST AGOSTINO ALTARPIECE

WE ONLY APPRECIATE WHAT SIGNORELLI has done with these three saints – Catherine, Mary Magdalen, and Jerome – when we look past them to the tiny figures in the background. The sheer scale is bewildering: he has seen the saints as human giants, enormous figures that loom almost to the top of the arch and would fill the horizon were it not for the gap beyond Mary Magdalen to show us the world stretching away to an infinity of lake and sea. This is the left wing of the altarpiece, and all three saints are intent upon the central panel, which, interestingly, is thought to have been a statue of St Christopher, himself a giant. The saints are shown as creatures of extraordinary nobility, almost like statues: the polished torso of St Jerome, against which he beats a stone, suggests the impermeability of copper; his garments fall in creamy swathes that seem uncrushable, like the substance of the saint's body itself; and even the curls of hair and beard look as though they have been fashioned from wire, rather than the soft fibers of human hair.

ST AGOSTINO ALTARPIECE
*1498, oil on wood, 58 x 30 in
(147 x 76 cm), Staatliche Museum, Berlin*

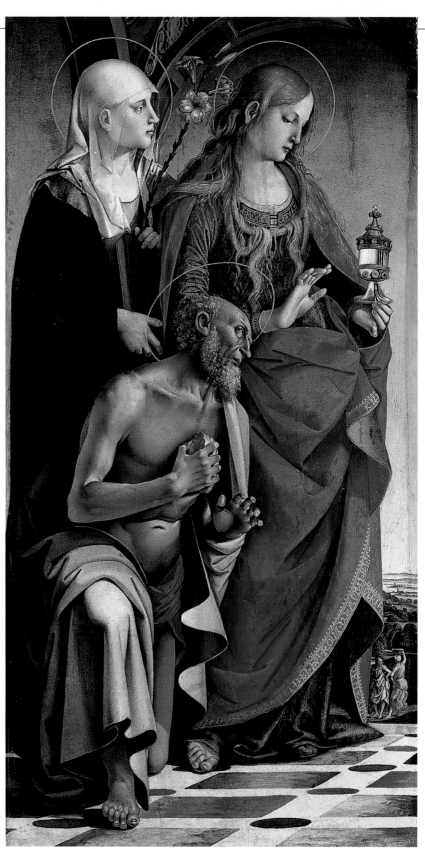

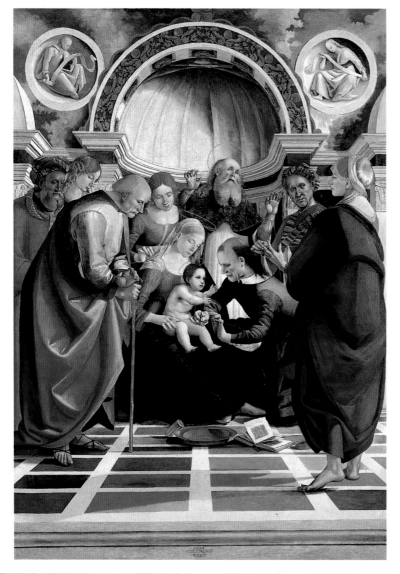

THE CIRCUMCISION
*c.1491, oil on canvas, 102 x 71 in
(259 x 180 cm), National Gallery, London*

Here, the High Priest prepares to circumcize the infant Jesus, who reaches trustingly forward while Mary, Joseph, and a chorus of holy figures are in attendance. Yet, one could be tempted to think that, essentially, Signorelli is interested, not in the sacred scene, but in the marvels of its setting. It is the extraordinary squares of color in the foreground, and the particolored stone behind – a mix of green, yellow, and brown – that dominate this scene.

THE TWO WOMEN *are both beautiful, but St Catherine of Siena, the nun, is clearly reticent. We see only her pale, intent face, with its gauzy veil changing color as it passes over the black habit. St Catherine's composure seems superhuman, and it is the wonderful Mary Magdalen, swaying in a great "S" who is the most susceptible to human interpretation.*

SIMONE MARTINI c.1284–1344 b. Italy
THE ANNUNCIATION

SIMONE MARTINI HAS AN INSTINCTIVE FEELING FOR GRACE, for the elegant gesture and the decorative movement. He has a remarkable ability to make figures seem almost fluid, while at the same time giving them real physicality. His *Annunciation* is distinguished by the extraordinary beauty of the color, and the unearthly elegance of both actors in this heavenly tableau. Mary holds one hand delicately in her book, and the other is raised with just two fingers quivering at her neck. For all her holiness, she is a creature of earth; the angel bears visibly upon his form the glories of heaven. His beauty is not just in that perfect face with its neat cascades of golden hair, nor in the golden robe that sweeps in perfect folds over his feet. Perhaps his glory lies largely in those elegant wings – every feather spotted and glorious – and, above all, in his plaid cloak. It whirls and swirls with a life of its own, signalling the presence of the divine more than the cluster of angels in the center. The angel raises one perfect finger, pointing upward in the direction we have already been summoned by the long, narrow, suavity of the white lilies, symbols of Mary's purity and a sign to us of Martini's intense delight in all that is gracious.

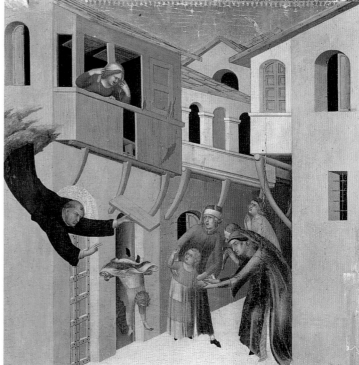

THE MIRACLE OF THE CHILD FALLING FROM THE BALCONY
c.1324, tempera on panel, 25 x 25 in (64 x 64 cm), Church of St Augustine, Siena

Here we see a completely different side to Simone's genius. This is a scene of great drama, every stage detailed as the child falls through the panel, and the blessed Agostino swoops (his underparts still lost in heaven) to catch the baby before it lands on its head and to restore it immediately to the astonished neighbors. The mother has scarcely time to start crying in earnest.

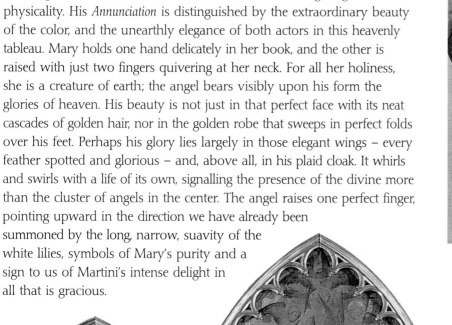

IT IS NOT unusual to find a Mary who shrinks modestly from the challenge offered her, but this Mary shrinks with such fluidity of line and elegance of gesture. Her face might, in fact, present us with a slightly unappealing pout, but that small detail is lost in the gloriously decorative image presented to us.

THE ANNUNCIATION
1333, tempera on panel, 72 x 45 in (184 x 114 cm), Galleria degli Uffizi, Florence

SISLEY, ALFRED 1839–99 b. France

WOMEN GOING TO THE WOODS

WHEN SISLEY PAINTED *WOMEN GOING TO THE WOODS*, he was a wealthy man in his late twenties, who was able to paint for pure pleasure; later, his family was to lose its money, greatly changing his prospects. It remains surprising that he was consistently unsuccessful. To us, he seems one of the most beautiful of the Impressionists. Even here, in this early work, there is a solidity and a power in his painting that any artist would envy. The three women in the center serve to anchor the scene, standing on that wonderful sunlit path that leads past us into the mystery of the woods. But there is sufficient mystery in the village itself. The eye dwells with rapture on that dull, green meadow running down to the stone wall beside the shuttered house, so clear in the brilliance of this early morning. The village is shuttered – no doors are open and no windows visible – and there is a sense of the refugee about each of the women who huddle together to set about their work.

WOMEN GOING TO THE WOODS, *1866, oil on canvas, 26 x 36 in (65 x 92 cm), Bridgestone Museum, Tokyo*

PERHAPS AS A PAINTER *of an art that was unappreciated, Sisley felt rejected. If so, his revenge was to look at that bleak, unwelcoming surface and paint it as supremely beautiful, not needing the support of a brilliant palette, or even the glory of bright sunlight to give interest. There is a sober maturity here that is astonishing.*

FLOODS AT PORT MARLY
1876, oil on canvas, 24 x 32 in (60 x 81 cm), Musée d'Orsay, Paris

In 1876, the River Seine overflowed its banks and flooded the village of Port Marly. Sisley painted the scene of devastation. Tragedy rarely attracted the Impressionists, and what Sisley has actually seen is not the human cost but the natural beauty. He has shown only how the little village is improved by the floods, turning it into a miniature Venice, with light catching on the water. An air of the world set free from its constraints permeates this work.

SITTOW, MICHIEL c.1469–1525 b. Estonia
KATHERINE of ARAGON

THIS IS AN UNUSUAL PORTRAIT. The halo clearly indicates that the sitter is a saint, and yet the elaboration of the headwear and the glory of the golden jewellery make one wonder. The face is secretive, smiling to itself, and it is difficult to determine whether the halo is a genuine effulgence from heaven or merely a section of the headgear. Despite the darkness of her clothes, which blend imperceptibly into the darkness of the background, this is a young woman who clearly loves the ornate. It has been suggested that the alternating "K" and rose motif on her gold necklace reveals that the sitter is Katherine of Aragon, and that might well be so. The small golden scallop-shell studs that decorate the neckline of the young woman's gown also support this notion, as the shell is the emblem of St James of Compostella, patron saint of Spain. But it can only be a suggestion, and such historical possibilities shouldn't blind us to the reality of this intriguing woman, with her shadowed eyes, smooth auburn hair, and look of youth combined with great maturity.

MADONNA AND CHILD
*c.1515, oil on wood, 9 x 7 in
(24 x 17 cm), Staatliche Museum, Berlin*

Every Renaissance artist seems to have accepted the challenge of painting the Virgin and Child, but few have accomplished it with such tenderness and charm. Sittow's *Madonna and Child* is an exquisite picture with a truly youthful Virgin. Her golden curls fall beneath the impudent flap of her headgear, and she holds her baby on a Turkish carpet of glorious patterns, highlighting the plump roundness of the little body. Hands play an important role in this picture: Mary's hold and support her baby; Christ's left hand reaches up lovingly to touch His mother's cheek, while His right clutches a small bird.

WE ARE PRESENTED *here with a highly enigmatic young woman, and British history makes it clear that neither Henry VIII nor his court ever plumbed the depths of Katherine of Aragon's character. This chubby, resolute face looks quite able to defy an angry Henry.*

LITTLE OF HER BODILY *curves are visible, either because this girl is too young or because the artist deferentially confines his attention to that strangely haunting face. She is by no means beautiful, and yet who can see her and pass by uninterested?*

KATHERINE OF ARAGON
c.1503, oil on wood, 11 x 8 in (29 x 21 cm), Kunsthistorisches Museum, Vienna

SNYDERS, FRANS 1579–1657 b. Belgium
WILD BOAR HUNT

THIS IS A TERRIFYING PICTURE OF BRUTALITY, saved from savagery by the human context of the incident. These are not hunters at play, but men grappling with a real danger to their livelihood in the shape of a wild boar. In a sense, Snyders sees the boar rather as early artists saw the dragon – as an image of all that is fierce, ugly, and destructive. It seems almost indestructible, and, despite the courageous attack of the dogs, the boar still surges forward with wide open jaw; both men are visibly terrified. It speaks more for humanity that Snyders shows the men with a degree of courage at least equal to the dogs. Though visibly torn and bleeding, the dog in the forefront still barks in defiance, and turns his head towards the monster. What impresses us, as well as the fearless confrontation with the realities of wildlife, is the sheer energy.

HUNGRY CAT WITH STILL LIFE
c.1615–20, oil on canvas, 34 x 46 in (87 x 118 cm), Staatliche Museum, Berlin

The tone of rich fertility in this splendid still life diminishes as we move leftwards, where death makes its appearance in the glorious horizontal of a scarlet lobster, and then in the pathetic scrawling body of a plucked hen. Into the scene of death creeps the warm body of a tabby cat, eyes aglow with the passion of hunger. We see, again, Snyders's delight in violence.

WILD BOAR HUNT
1649, oil on canvas,
84 x 122 in (214 x 311 cm),
Galleria degli Uffizi, Florence

SNYDERS DOES NOT TELL US *the conclusion of the hunt – half the dogs have been killed or wounded, and, although three still resolutely press home their attack, we are left in genuine doubt as to whether the men, armed only with pitchforks, would also suffer mutilation and death. In this green and pleasant world, untamed ferocity has erupted and like can only be countered with like.*

SODOMA, IL (GIOVANNI ANTONIO BAZZI) 1477–1549 b. Italy

ST GEORGE AND THE DRAGON

SODOMA TACKLES THE THEME of St George and the dragon with a low level of seriousness. Sophisticate that he is, he clearly sees this as a fairy tale with a moral. St George, with flying cloak and elaborate armor, wields a ludicrously small and candy cane-like lance, so slender, so bright, and so enwrapped in a twisted flag that it seems hardly up to the task. Sodoma is at pains to point out to us the gruesome activities of the dragon: prominent in the foreground are two heads, a foot, and an arm. But the pathos of life and death is at a remove here, and the little princess, rescued from a fate worse than death by the mounted hero, recalls the histrionics of opera, rather than the pressures of real life.

ST JEROME IN PENITENCE
c.1535, oil on wood, 56 x 44 in (141 x 112 cm),
National Gallery, London

St Jerome in penitence is a serious subject. The saint has withdrawn to the wilderness to mourn for his sins and to reflect upon death, as indicated by the skull in front of him – it props up the Bible, which he translated. His sole companion is the lion, from whose paw he is said to have drawn a thorn. These are the standard elements for any artist who paints St Jerome, but Sodoma does not seem convinced of either St Jerome's sorrow or his need for sorrow. What fascinates Sodoma is the sight of a mature, muscular male on his knees, intent upon a secret purpose.

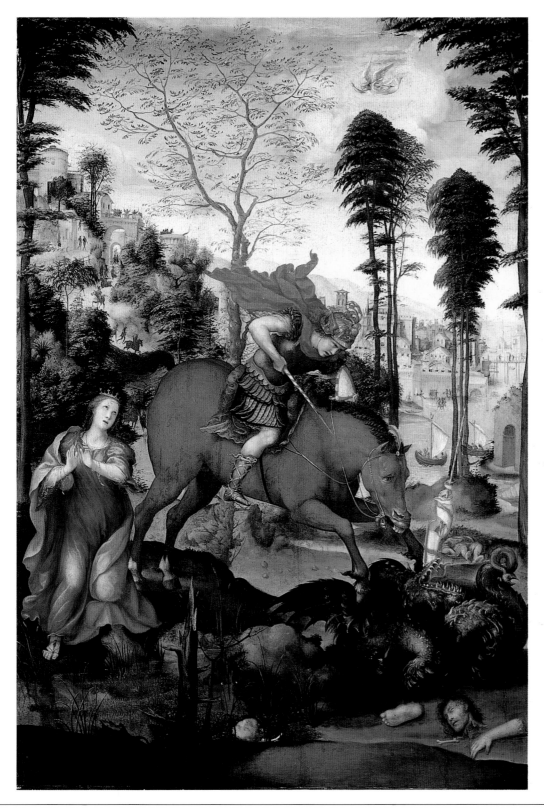

SODOMA IS INTERESTED more in how the princess's red-and-orange robes reflect in the water than how her pale face and uplifted hands speak genuine emotion. Behind the princess, St George, and the dragon is the real world, which seems to exist in another dimension. It is bleached of color, thronging with activity, and strangely remote from the circle in which the princess pleads, St George attacks, and the dragon dies.

ONE FEELS that Sodoma is playing with the stuff of legend like a child, half-frightened and half-gleeful, but never, in the deepest sense, convinced. The real world is remote, monochromatic, relatively drab, whereas the fairy story is alive, vibrant, and multicolored. It is very obvious that Sodoma does not believe in St George and dragons and princesses, but he likes to paint them.

ST GEORGE AND THE DRAGON
c.1518, oil on wood, 54 x 39 in
(138 x 98 cm), National Gallery
of Art, Washington, DC

SOLARI, ANDREA active 1495–1524 b. Italy

MADONNA WITH THE GREEN CUSHION

NOT EVERY PICTURE OF THE VIRGIN is a religious picture. Looking at *Madonna with the Green Cushion* we can understand why the theologians of the Counter-Reformation insisted that religious art should maintain a certain decorum and convey an unmistakably religious message. On the other hand, I could not call this an irreligious picture. Any mother feeding her child is, almost by definition, a sacred subject, and here the Virgin's concentration upon her son and desire to share with Him her bodily substance is moving. Yet what we remember most about this painting of the Virgin is, perhaps, the visual presence of the green cushion. The wonderful, soft, rich green, with its golden-black band and its glittering tassel, is as much a character in the painting as are mother and Child. Ostensibly, it is there solely for support, but it proclaims very loudly the importance of the material and the significance to an artist of color and texture.

HEAD OF ST JOHN THE BAPTIST

1507, oil on wood, 18 x 17 in (46 x 43 cm),
Musée du Louvre, Paris

You could call Solari a surrealist before his time. Although there is the historical evidence that the head of St John the Baptist was laid on a dish, this is, nevertheless, an extraordinary depiction of the subject. The head floats on an enclosed pool, lost, like Narcissus, in his own reflection. On the gleaming highlights around the neck of the dish, Solari has painted a tiny self-portrait, as if somehow to attach himself emotionally to the beheaded John the Baptist.

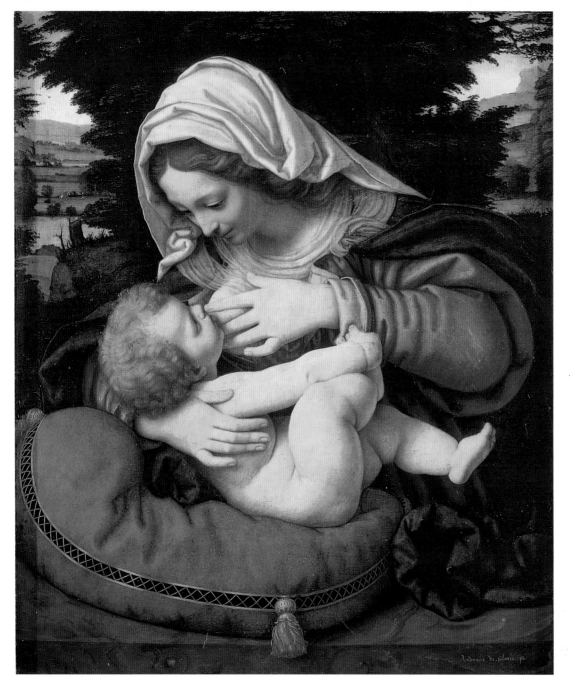

ON EITHER SIDE *of the mother and Child are stretches of the loveliest of landscapes – grass and stream and meadow and mountain – all seen by the artist with a sense of amazed recognition. We circle around, from cushion to landscape, through the dense branches of the tree, to landscape again, and then down past the great folds of Mary's sleeve on to the cushion once more.*

THE GREAT TREE *behind blocks out the world with its activities. There is a sense of exclusivity here, of mother and Child wrapped in a world of their own, cushioned from intrusion as they share this most intimate of meals. The cushion on the parapet also protects the Virgin, alone with her Child, aware of nothing but their own relationship.*

MADONNA WITH THE GREEN CUSHION, *c.1507, oil on wood, 24 x 19 in (60 x 48 cm), Musée du Louvre, Paris*

SOLIMENA, FRANCESCO 1657–1747 b. Italy

AN ALLEGORY OF LOUIS XIV

ALLEGORIES ARE NOT TO CONTEMPORARY TASTE, yet their appeal during the Renaissance and the Baroque eras was tremendous, and Solimena has thought out his allegory of kingship with great care. It is, in fact, a multipurpose allegory, which could be directed to any famous figure, hence the shield in the middle is still empty. Solimena bases it on three figures. At the left, seated on the lion, is Minerva, goddess of wisdom – that image of power and courage. She points to the shield that will immortalize Louis XIV. In the middle, Father Time, with his hourglass and scythe, bends under the weight of the book laid upon his back and in which winged History writes the heroic achievements of the, as yet unnamed, King.

REBECCA AT THE WELL
c.1710, oil on canvas, 28 x 25 in (72 x 63 cm), Hermitage, St Petersburg

This is a well-worn theme. Abraham's servant was sent to find a suitable bride for his master's son. He asked for water at the well, determining that the girl who offered water, not only to the man, but to his beasts as well, would be the one chosen by God. Solimena has a splendid sense of geometry, with three main actors in the dialogue: the boy with the camels, the girl, and the servant offering her the jewels, an act which indicates that she is to be the chosen bride.

THE ALLEGORY *implies that the deeds of Louis XIV will be so famous, so renowned historically, that Time has no option but to protect their truth. Time, the proverbial destroyer, must lay down his scythe, must abandon the measurement of his hour glass, because the triumphs of the king will stand forever.*

THESE ARE NOBLE *triumphs, and it is Minerva's function to point this out. The women are in dialogue; Time slumps, defeated. The circle of activity culminating in the shield involves us in a sense of inexorable cycle: the deeds are recorded, nothing can expunge the everlasting truth of the King's achievements.*

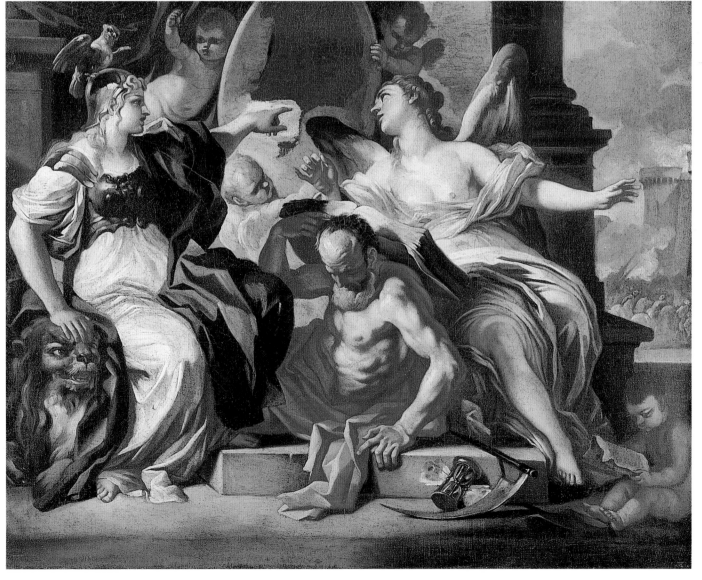

AN ALLEGORY OF LOUIS XIV *c.1700, oil on canvas, 19 x 23 in (47 x 59 cm), National Gallery, London*

SOUTINE, CHAÏM
1894–1943 b. Belorussia, active France
THE PASTRY COOK

SOUTINE, EVEN IN EXILE, SOMEHOW CARRIED WITH HIM the ambience of a wild Eastern European Jew, and his work has that untamed quality that can be almost frightening as we encounter it face-to-face. *The Pastry Cook* is an astonishing image. The young man who stands confronting us is barely contained by the picture frame (in fact one elbow escapes). The hands seem to grapple uneasily with the body – this is not, we feel, a position to which the young cook is accustomed. Those blunt and roughened fingers spend their time rolling dough and beating eggs, rather than posing, with reluctance, for this aggressive artist. The aggression is evident in the way that the artist has attacked this portrait – not just by choosing to isolate the cook against a threatening background, but by setting up, as it were, a conflict between the grubby-whites of his costume and the kitchen-flushed reds of his face and hands. The cook's hat seems to squash down on those black curls, seeking domination, the collar rides up, as though to encompass the neck, and the sleeves seem reluctant to leave the hands free to breathe.

RETURN FROM SCHOOL
*1939, oil on canvas, 17 x 20 in (43 x 50 cm),
Phillips Collection, Washington, DC*

As a title, *Return from School* is redolent of Victorian tranquillity, conjuring up smocked children, trees, and flowers. There are certainly trees, and even flowers, in Soutine's landscape, and children, too, but the wild swirls make this anything but sedate. The two little figures trudge bravely on, amidst the wild exuberance of the natural world. It is astonishing, when one looks closely, how much detail can actually be deciphered: the little school case, the brown stockings, and the children's hands clasped together. But the overall effect is of two little swimmers, courageously keeping their heads above the engulfing tides of Soutine's paint.

> "HE WAS ONE OF THE RARE EXAMPLES IN OUR DAY OF A PAINTER WHO COULD MAKE HIS PIGMENTS BREATHE LIGHT…. THERE WAS A QUALITY IN HIS PAINTINGS THAT ONE HAS NOT SEEN FOR GENERATIONS – THIS POWER TO TRANSLATE LIFE INTO PAINT – PAINT INTO LIFE…"
> Jacques Lipchitz

SOUTINE SLASHES the colors on, overlaying pinks and blues and purples with the wet clay of his pigments, as if challenging the image to stand up and fight back. The cook does his best, pouting, screwing up his eyes, almost flapping an angry ear at us, but the verdict must be that Soutine has won the contest.

THE PASTRY COOK
*c.1927, oil on canvas, 30 x 27 in
(76 x 69 cm), Private Collection*

SPENCER, SIR STANLEY 1891–1959 b. England

SELF-PORTRAIT WITH PATRICIA PREECE

STANLEY SPENCER WAS AN EXTRAORDINARY ARTIST, and this is one of his most extraordinary works. He is painting it from the depth of his own experience. He jettisoned his first wife, Hilda, when he fell deeply in love with the upper-class Patricia. It was a more or less open secret that she married him for his money and they did not live together. Here, we see Spencer contemplating Patricia with the bewilderment of a besotted lover. Whatever his emotions, his artist's eye sees her for what she is: a woman with large flaccid breasts, a lusterless face, and an air of total indifference to the hovering Spencer. He looks upon this unattractive figure with reverence, and yet, the very cock of his head and twist of his neck muscles make us feel that at some level he really sees his infatuation for the folly that it is. We can read this also in the work's title; it is his self-portrait that is important and, however much he may feel under Patricia's spell, she is basically the background against which he positions himself.

THE CENTURION'S SERVANT
1914, oil on canvas, 45 x 45 in (115 x 115 cm), Tate Gallery, London

Although this is entitled *The Centurion's Servant* and illustrates a biblical scene, it is, in fact, one more example of Spencer's deeply personal involvement in his art. The centurion here is Stanley, at home sick in bed, with his sisters watching by his side. The middle figure is Stanley, watching Stanley. This simple picture of an anxious young man has a mythical quality nonetheless.

SELF-PORTRAIT WITH PATRICIA PREECE, *1936, oil on canvas, 24 x 36 in (61 x 92 cm), Fitzwilliam Museum, Cambridge, UK*

THIS IS A PICTURE OF TWO PEOPLE *whose eyes do not meet, whose bodies are in opposition, both more concerned with themselves than each other. It is a picture of self-deception in man and woman, a sad picture, almost tragic; and yet – as is typical of Spencer's genius – there is just that touch of the ludicrous.*

SPRANGER, BARTHOLOMEUS 1546–c.1611 b. Netherlands
VENUS AND ADONIS

SPRANGER WAS A NO-HOLDS-BARRED vulgarian, yet he raised vulgarity to such heights of sublimity that it became transcendent. He worked mainly for that perverse ruler of Poland, Rudolph II, who absolutely delighted in the fleshly contortions of a Spranger drama. Here, Spranger deals with one of the classic Greek love stories: how Venus, most beautiful and desired of the gods, fell in love with a beautiful and youthful human, Adonis, who, for his part, wanted nothing more than to be off with his hounds chasing deer. Through her divine knowledge, Venus foresaw that hunting would bring about Adonis's death and warned him; unwisely, he laughed off her advice. Spranger carries off the narrative with a superb sense of its potential humor, while the almost tangible carnality gives this work an eerie power.

GLAUCUS AND SCYLLA
*c.1581, oil on canvas, 43¼ x 32 in (110 x 81 cm),
Kunsthistorisches Museum, Vienna*

Scylla the sea nymph was pursued by the sea god Glaucus. She rejected him and escaped onto dry land, where he could not follow her. Spranger, while clearly attempting to force himself into compassion for the rejected suitor, chuckles at the ludicrousness of it all. Poor Glaucus, large-bellied and straggly-bearded, points pathetically towards himself as he woos the reluctant Scylla. She, in a swirl of many-coloured veils, graciously removes herself from his attentions and takes her luscious plumpness out of the sea onto the hard rock, where, in the course of time, she will become a monster. It is Spranger's sheer enjoyment in the contrast of these two bodies that makes this a masterpiece.

IN THIS PICTURE, *the only individual conscious of life's responsibilities is the hound who regards us solemnly and forbodingly at the foot of the picture. Venus seems to have forgotten the need to warn her lover and writhes seductively before a fully-clothed Adonis, who has his hunting cap and boots at the ready. He is clearly only waiting for Venus to quieten down before he sets out on that more interesting pursuit – the hunt. We can almost hear the sweet nothings that Venus coos into that unresponsive face.*

VENUS AND ADONIS, *c.1597,
oil on canvas, 64 x 41 in (163 x 104 cm),
Kunsthistorisches Museum, Vienna*

STAËL, NICOLAS DE 1914–55 b. Russia, active France

MEDITERRANEAN LANDSCAPE

DE STAËL, IT SEEMS TO ME, will one day be recognized as among the 20th century's most important painters. He had a most subtle and comprehensive sense of color and an understanding of the geometry of a picture – how shapes exist in relation to each other. He is often thought of as an abstract painter, and yet, as one can see from *Mediterranean Landscape*, he still kept very much in touch with the figurative. De Staël insisted that abstract painting and figurative painting were not in opposition. He said that he thought abstraction was necessary, and that its point was to set limits, while figuration was necessary so that a painter could represent a true space.

LE PARC DE SCEAUX
1952, oil on canvas, 64 x 45 in (162 x 114 cm),
Phillips Collection, Washington, DC

De Staël entitles this painting *Le Parc de Sceaux*, and with that clue we can see the white path leading from pale grays and blues into the shadowy recesses and comforting blue-green masses of forest. Here, once again, the figurative is made abstract and the abstract figurative. De Staël's theme was not the park in itself, but the park experienced as coolness and refreshment – a moving out of bright heat into the peace of the forest.

MEDITERRANEAN LANDSCAPE
1953, oil on canvas,
13 x 18 in (33 x 46 cm),
Museo Thyssen-Bornemisza, Madrid

IN SAYING THAT *abstraction sets limits, perhaps de Staël meant that it enabled him to choose the precise tone of his picture, to determine the extent to which forms and colors in the real world must be controlled for the good of the image.*

STEEN, JAN 1625/6–79 b. Netherlands

SKITTLE PLAYERS OUTSIDE AN INN

JAN STEEN IS NOT ONE OF MY FAVORITE PAINTERS, but this is one of my favorite paintings. I find it hard to exaggerate the charm of this early-evening scene, with people picnicking on the grass and players engaged in the long, serious activity of skittles. The inn garden seems enclosed against the troubles and unhappiness of the outside world. Passers-by look over the tumbledown fence but do not intrude. On the other side of the road, we are protected by the strong architecture of a brick wall and then the angled back wall of a large house. Steen's interest seems equally divided between the seven human beings, who relax in the sunshine with the grazing horse. The trees, motionless in the quiet light, rise with an effortless grace that echoes the relaxed happiness of those outside the inn.

TOPSY-TURVY WORLD
1663, oil on canvas, 41 x 57 in (105 x 145 cm),
Kunsthistorisches Museum, Vienna

This is a difficult painting to like, though the moral is clear enough. The lady of the house, dressed in her expensive jacket, has fallen asleep, and, without the central discipline of the housewife, the world has gone topsy-turvy. Every detail in the picture repeats and emphasizes the wrongness of the scene. In the middle is the worst offence – the husband flirting with the maid – but one could pick upon any detail here and savor its inappropriateness in a well-run household. Steen deals with this complicated unravelling of his moral with great assurance.

THE PLEASURE *this picture gives seems greater than its theme affords, and I have often wondered whether, at some time in childhood, most of us have experienced just such a timeless moment in a summer evening; if so, perhaps this picture recalls that time to our subconscious minds. There is certainly an analogy in the grace of the player in his white shirt and the airy grace of the trees that surround the inn. But how do we prove this? How do we analyze this scene?*

THE CHILD WATCHES *the skittle players, engrossed. Their companions are adult and may well have burdensome lives, involving decisions and heavy responsibilities. But here, in the evening sunshine, life has been reduced to the simple problem of building the skittles and watching them fall; for the moment all the pressures are off.*

SKITTLE PLAYERS
OUTSIDE AN INN, *c.1660–63,*
oil on wood, 13 x 11 in (34 x 27 cm),
National Gallery, London

STEENWYCK, HARMEN 1612–after 1655 b. Netherlands

STILL LIFE: AN ALLEGORY OF THE VANITIES OF HUMAN LIFE

STILL LIFE: AN ALLEGORY OF THE VANITIES OF HUMAN LIFE
c.1640, oil on wood, 15 x 20 in (39 x 51 cm), National Gallery, London

AT FIRST SIGHT, WE SEE A TABLE upon which some eccentric has left an uncoordinated mass of objects. The reality is very much the contrary, however, as everything here has been carefully chosen in relation to a central theme – the vanity of the physical world. This conviction, deep and melancholic, that nothing in life is of lasting value has provided, through the centuries, a grave theme for artists. Steenwyck has centered his collection of treasures around the human skull, spotlit by a brilliant ray of light. Books indicate the vanity of human learning, and musical instruments the vain pleasure of the senses. The shell and the Japanese sword would have been rarities in the 17th century, and here they symbolize wealth. Behind the skull is an expiring lamp, and to its left a chronometer, because time for each of us is limited, and time itself will eventually give way to eternity. The modest clay ewer seems out of place here, until we remember St Paul's words about us carrying our treasures in earthen vessels – Steenwyck is moralizing on the fragility of clay and the ease with which the water of life can be spilt.

STEER, PHILIP WILSON 1860–1942 b. England

GIRLS RUNNING, WALBERSWICK PIER

GIRLS RUNNING, WALBERSWICK PIER
c.1888–94, oil on canvas, 27 x 37 in (69 x 93 cm), Tate Gallery, London

IN TERMS OF TECHNIQUE, this is an interesting painting, but it is its weird visionary quality that makes this picture so extraordinary. Against the blue and white of the sea, two girls float towards us, two sprites almost dematerialized by light. The ostensibly banal theme of girls running along a pier has become portentous for Steer, yet without the least touch of the pretentious. The girls seem to merely skim the surface, holding their hands out as if to bear them aloft, while the three women in the background, equally slender and ethereal in appearance, are solidly anchored to the wood on which they stand. There is an angelic element to the girls running. Why do they run? It does not seem to be a race and the artist gives no indication of a goal. Their faces are impassive. They share both real and ethereal worlds in that their shadows link them firmly to the more solid figures in the background, yet they themselves seem to be escaping from the confines of earth.

STELLA, FRANK 1936– b. US
SIX-MILE BOTTOM

YOUTH IS PROVERBIALLY DARING. Stella shocked the art world in his very early twenties by producing a form of abstraction that was more radical than anything seen before. What he did was to work out a format, as he has done here, and then, on a huge scale pursue the logical consequences of that format with ruthless precision. He painted *Six-Mile Bottom* with commercial paint, a medium that had none of the seductive qualities that are associated with oils or acrylics. This was a deliberate and considered decision – he wanted paint that would almost repel the eye, forcing the viewer to contemplate the starkness of the pattern and its execution. Frank Stella was filled with an almost apostolic zeal to divest painting of what he considered to be its trappings: its desire to be beautiful, its thrust for meaning, and its sense of significance. The semi-mystical talk of the Abstract Expressionists disgusted him. His triumph is to have created a work that is so alien to all the traditions of painting, yet which in its purity and strength is still able to satisfy the eye.

S
444

THE PAINTING'S TITLE REFERS TO *a village in England, and is merely a method of distinguishing this painting from others in the same series. Even the width of the stripe here is determined by the width of the house painter's brush that Stella used. Although the critical intelligence can never be baffled in its insistence on meaning, it is generally acknowledged that Stella's early work offers the ultimate challenge.*

SIX-MILE BOTTOM
1960, metallic paint on canvas, 118 x 72 in (300 x 182 cm), Tate Gallery, London

KHURASAN GATE (VARIATION) 1
1969, poylmer and fluorescent polymer on shaped canvas, 96 x 285 x 3 in (245 x 725 x 8 cm), San Francisco Museum of Modern Art

Nine years on, Stella was still producing work that was very large and that refused to contain a meaning. But now there are brilliant Day-Glo colors, as audacious in their semi-vulgarity as the dull house paint had been in the past. For this series, which Stella felt had been inspired by the circular gateways of the Middle East, he conceived 31 different canvas formats, in which there would be three different designs: the interlaces, the rainbow, and the fan.

STILL, CLYFFORD 1904–80 b. US
1953

IT CAN BE DIFFICULT TO PIN DOWN CLYFFORD STILL because, in later years, he frequently altered the dates and titles of his work, deliberately seeking to frustrate those who sought to analyze it. He insisted that all explanation was complete irrelevancy and that the paintings, if regarded calmly and without what he considered scholastic intimidation, would speak for themselves. Fortunately, the Tate Gallery managed to draw from Still a written commentary, albeit brief, on *1953*. He wrote to them: "...there was a conscious intention to emphasize the quiescent depth of the blue by the broken red at its lower edge". Looking at the picture, one understands what the artist means. That strange blur of scarlet red is not complementary to the blue, but the sheer strength of its contrast makes it behave as such, and, as the eye travels up from it, it draws from the blue its utmost vigor.

UNTITLED
1965, oil on canvas, 100 x 70 in (254 x 177 cm),
Museo Thyssen-Bornemisza, Madrid

I have sometimes felt of Still, "seen one, seen them all". He always seems to adopt the same formula: a great rectangle that he covers with large streaks of impressive color. Here, he has left elements of the canvas untouched by paint, so that the strange jagged color shapes hang, as it were, in nothingness. However, I admit that my general reaction is unfair; each canvas does evoke a nuanced response. He deliberately gives us no clue in his title but there is a sense of majesty and a sense of freedom, of color floating free and independent of formal requirements.

STILL HAS SLASHED *the top of the work with an interesting form of yellow, white, black, and red, and it has been suggested that we can discern in this a view of an American mountain range. This suggestion infuriated Still, who insisted that all his work was intended to be enjoyed without the slightest reference to the world of nature.*

IF WE LOOK AT *1953 purely as a great expanse of color, activated and enlivened by the incursions of the top and the bottom, we can derive from it a great deal of pleasure. Once we have realized that the search for actuality is pointless, we see that the blue is not a plain, solid, uneventful blue, but one of considerable aesthetic interest.*

1953, *1953, oil on canvas,*
93 x 69 in (236 x 174 cm),
Tate Gallery, London

STOMER, MATTHIAS c.1600–after 1650 b. Netherlands, active Italy
ISSAC BLESSING JACOB

HERE, WITH GREAT POIGNANCY, Stomer is telling the story of Isaac and Jacob, in which Jacob cheated his father into giving him the blessing, urged on by his mother, Rebecca, whose ambivalent face is central to this painting. Esau, the first born, had the right to receive the solemn blessing of his father, and so Jacob pretended to be Esau so as to steal the blessing and birthright for himself. Isaac is nearly blind and can see nothing. Jacob is tense with the knowledge of deception, and only the dog is an innocent onlooker. Stomer has a double agenda here, and, as well as telling this story, he is interested in depicting solemn associations between age and youth. Isaac, the old warrior – weak, and dependent for his knowledge of the world on those close to him – represents old age in one of its most painful forms. Despite the grandeur of that forehead and venerability of that aged torso, he is wholly vulnerable to betrayal by those he trusts.

PILATE WASHING HIS HANDS
c.1640, oil on canvas, 60 x 81 in (153 x 205 cm), Musée du Louvre, Paris

Stomer was fascinated by struggles with one's conscience, and Pilate is the prime example of a man who goes against his conscience for the sake of peace. In the Gospel story, he ostentatiously washes his hands, saying that he is innocent of the blood of this just man. Light shines on Pilate, but his inner world is dark, and the full dilemma of this fatal misjudgment is the theme of this picture.

ISAAC BLESSING JACOB
c.1635, oil on canvas, 54 x 72 in (136.5 x 182 cm), Barber Institute of Fine Arts, Birmingham, UK

JACOB IS REPRESENTATIVE OF YOUTH – handsome, vigorous, and still unhardened in the ways of deceit – but, in his posture and in his clothes, we discern his desire to succeed. Stomer's interest in human psychology – what it means to be young and then to decay – enables him to use light and shade with superb dramatic effect.

STROZZI, BERNARDO 1581–1644 b. Italy
THE HEALING OF TOBIT

THE STORY OF TOBIAS IS A GREAT BIBLICAL EPIC, in which the young Tobias journeys on his father's behalf into distant lands, protected by his travelling companion, the Angel Raphael. The episode that most commonly appealed to artists was the story of Tobias battling with a giant fish, which Gabriel helped him to subdue and split open to extract the gall. This peculiar talisman was carried back as a means of healing his father's blindness (it was also to serve Tobias in a later matrimonial adventure). Here, the whole family clusters around as Tobias, with infinite delicacy, squeezes the healing medicine onto his father's eyes. Old Tobit is encircled by love: aged Anna, his wife, holds the remnant of the bladder, should more be needed; Raphael is apprehensive in case Tobias gets it wrong; and Tobias squeezes with loving concentration.

A PERSONIFICATION OF FAME
c.1635–36, oil on canvas, 42 x 60 in (107 x 152 cm), National Gallery, London

This appealing and finely clothed little creature, with her scarlet stomacher and golden skirt, is how Strozzi personifies fame. She is an innocent, who will respond, but not initiate. She holds two trumpets: the golden one, she uses to broadcast deeds of glory; the other, made of wood, is the recorder with which she announces to the world our deeds of shame. Fame is indifferent, she holds both and looks out placidly from the painting, awaiting her summons.

THE HEALING OF TOBIT
c.1635, oil on canvas, 66 x 81 in (158 x 224 cm), Hermitage, St Petersburg

AT THE BOTTOM *on the left, we see the faithful dog who shared in Tobias's adventures, and on the right, the fabled fish. The two animals sum up the story: the dog, as the benign animal, represents our desire to help and serve; the fish, here seen as the evil animal, represents the material spirit of ill will.*

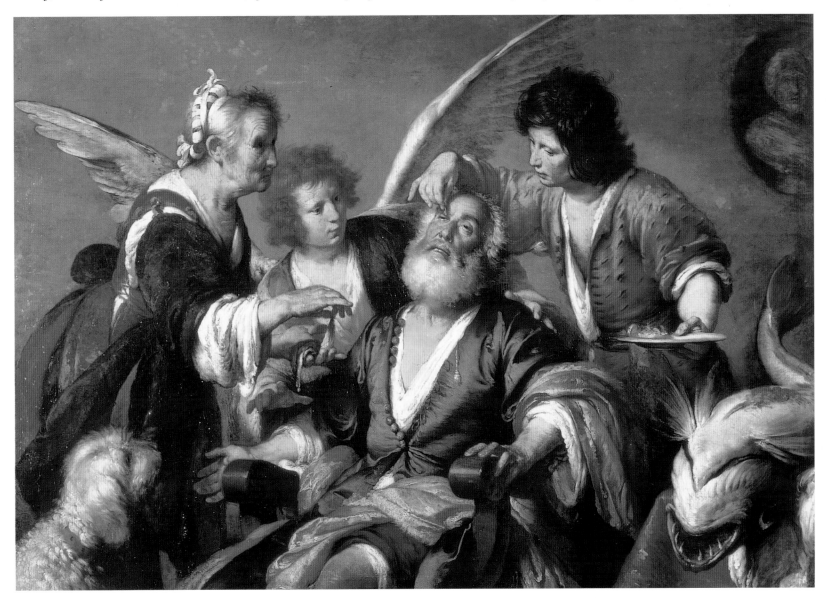

STUART, GILBERT 1755–1828 b. US
THE SKATER

As Stuart himself observed, it is not often that a single painting establishes an artist as a figure of great aesthetic importance. *The Skater* did precisely that for Gilbert Stuart. As an American who travelled to England to study, he was struggling to keep afloat financially and a commission to paint William Grant of Congleton was his first big opportunity. At the time, Stuart was far from confident in his artistic ability to convey the essence of a personality in three-dimensional form. It is said that one day in winter, when Grant suggested that they might be better off skating than painting, Stuart agreed, and the two went off to skate in London's Hyde Park. It was only then that the artist was inspired to paint this remarkable portrait of Grant.

S

448

MRS RICHARD YATES
1793/4, oil on canvas, 30 x 25 in (77 x 63 cm),
National Gallery of Art, Washington, DC

Mrs Richard Yates was the wife of a New York merchant – a successful merchant, as we can see from the high quality of her ivory silks - whose wife dresses with decorum. She looks out at us measuringly. She has an oval face with a long, aquiline nose and firm mouth, her upper lip faintly moustached. Stuart has devoted all his skill to setting her before us in all her integrity. It may seem extraordinary to us that Mrs Yates did not suggest to the painter that he should paint out her faint moustache. Evidently, she had a spirit above such matters, and the noble arch of her eyebrows is a true indication of a woman who enjoys finery but will not tamper with nature.

GRANT'S RUDDY, *very English face dominates the painting, but as we look down, the grace of his pose, the dance-like movement as he slides with such ease across the ice, complements the impassive regularity of the features. All except the skater is dim and imprecise: the indistinct figures in the background lunge clumsily over the ice, clearly out of control, while far in the distance, we can just discern the shape of Westminster Abbey.*

THE WORLD HAS SHRUNK *to the space of this single human being, dominant, striking against the white radiance of an icy sky. The impression made is of a character completely in control, skating not for entertainment or relaxation, but with his mind fixed on other things. The picture, as it deserved, made a very great impression and, from then on, Stuart's career was set for success.*

THE SKATER, *1782, oil on canvas, 296 x 58 in (45 x 148 cm), National Gallery of Art, Washington, DC*

STUBBS, GEORGE 1724–1806 b. England

MARES AND FOALS BENEATH LARGE OAK TREES

STUBBS IS THE GREAT 18TH-CENTURY PAINTER of the horse. He is more than that, of course (if ever an artist transcended a genre it was Stubbs), but it is primarily for his horses that he is known. He spent over a year in the depths of the country dissecting horses to study their anatomy; the exquisite results of these studies were eventually published. Laboriously and lovingly, he came to know precisely how the horse worked, as it were, and we can see the intimacy of his knowledge in paintings such as *Mares and Foals Beneath Large Oak Trees*. Stubbs was an educated painter, who had visited Italy and looked at classical art. The superb frieze of these animals, the distances between them, their relation to the trees and the sky – all this shows an eye that understands not just the working of the animal's body but the patternings that delight the human mind.

MARES AND FOALS
BENEATH LARGE OAK TREES
*c.1764–68, oil on canvas, 39 x 74 in
(99 x 187 cm), Private Collection*

CHEETAH AND STAG WITH TWO INDIANS
c.1765, oil on canvas, 98 x 120 in (250 x 305 cm), Manchester City Art Gallery, UK

The Governor of Madras presented George III with a cheetah. Stubbs was commissioned to paint it, as closely as possible, as if in action. Despite the urgings of the handler, the animal seems reluctant to perform and, typically, Stubbs does not pretend. The cheetah still wears the red cap that may have covered its eyes until the moment before its release for the hunt. The deer stands there astonished, seemingly ignorant of danger. The final effect is enigmatic – the men make gestures, the animals confront each other, and we know no more.

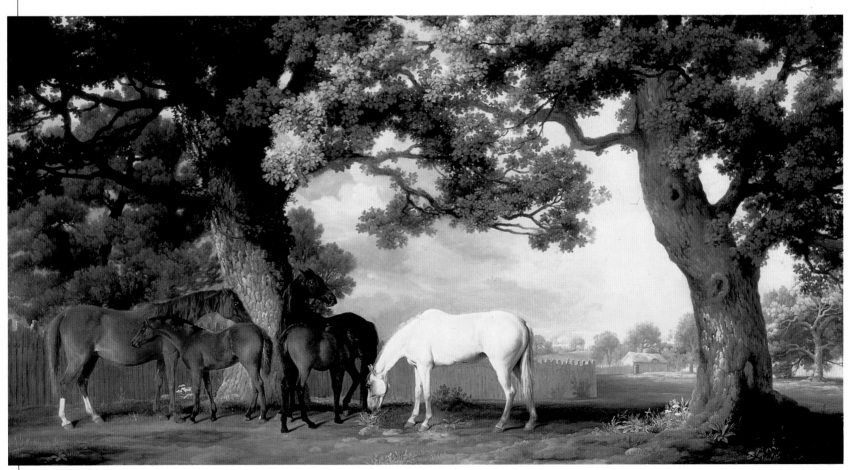

HUMANKIND IS ESPECIALLY *attracted to the horse. It seems an animal of natural nobility. We envy its strength, its speed, and the clarity of its physical contour. The horses that Stubbs painted were mainly the prized thoroughbreds that aristocrats reared and cherished.*

STUBBS WAS CALLED UPON *to produce a series of paintings of mares and foals for various landowners. That these majestic animals were the possession of landowners is not irrelevant; in celebrating the horse, Stubbs also celebrates England. The oak trees and meadows beyond are integral to the picture.*

IF HE INDIVIDUALIZES THE HORSES, *he also looks with concentrated interest at the great trees. Stubbs is painting an image of country peace, of a tranquil evening, from which the viewer can be lifted out of the rush of life into the quiet rhythms of the horse and the simplicity of rural life.*

SWEERTS, MICHIEL 1618–64 b. Belgium
SELF-PORTRAIT

SOME ARTISTS SEEM SUBTLY OFF-KEY. Lorenzo Lotto was one, Dosso Dossi another, and I see Michiel Sweerts as a third. It is hard to put one's finger on why they seem out of harmony with their world and why their art intrigues us in a way that the work of more conventional painters does not. Sweerts was visibly out of harmony, a Flemish painter who tried his luck in Rome and then finally joined a missionary enterprise to the Far East, dying en route before his fortieth birthday. This haunting picture is sometimes thought to be a self-portrait. We see a young man of almost feminine beauty, splendid in his puffed sleeves, as he faces us with a brooding countenance. The impression is that he is making up accounts: light catches the glitter of coins on the table, and there is the ample form of the inkwell with its quills. Behind this, we see the blue velvet of a purse, and ledger piled upon ledger. Pinned to a table at the front is a sheet of paper on which is written *Ratio Quique Reddenda* – "some account must be given", a highly ambivalent phrase. It could refer to money matters – the young man may be trying to balance his books – or it could refer to the bafflement of life.

PORTRAIT OF A GIRL
c.1655, oil on canvas, 17 x 15 in (44 x 37 cm), Leicestershire Museum and Art Gallery, Leicester, UK

For a long time, this painting was attributed to Vermeer, and we can understand the reasons for this high compliment. The young woman is clearly not posing for the artist and one feels that Sweerts's interest is in the body language rather than the specific personality. She turns her head, interested, alert, perhaps taken aback – a slight tension is thus created. Her face is relatively deadpan, yet it conveys some indefinable emotion that leaves us grappling for meaning. This lack of definition, which contrasts so poignantly with the visual clarity of the painting, might well be Sweerts's intention.

IS THIS YOUNG MAN *trying to come to terms with the human condition – our lack of control, our desire for happiness, the precariousness in which even the most contented live? Or, given that Sweerts had a profound sense of religion, perhaps the phrase refers to the account to be demanded on the Day of Judgment – the account of how we have lived, the weighing up of our failings and our virtues.*

IT SEEMS TO ME AN *essential part of Sweerts's genius that there should be this ambiguity. We long to know why this handsome youth sits there, lost in reverie. The artist goes even further, perhaps – if this is, indeed, a self-portrait – in making it clear that we can never know his secrets, and that we can never know the secrets of any other. This is a portrait, not of one man's otherness, but of otherness itself.*

SELF-PORTRAIT
1656, oil on canvas, 45 x 36 in (114 x 92 cm), Hermitage, St Petersburg

TANGUY, YVES 1900–55 b. France, active France and US
IMAGINARY NUMBERS

TANGUY WAS AN UNTAUGHT PAINTER whose imagination was seized by the Surrealist vision. It seemed to express to him the illogicality of existence and showed the world as an infinitely more complex and strange place than was generally acknowledged. Tanguy's background was in seafaring, and there is often a suggestion of marine creatures in his paintings. That may well be the sea in the background and a strange golden-black sky above it, but what makes the picture truly memorable is the great surging crowd of rocklike forms. There is a sinister power here, not so much a suggestion as a statement that reality is not what we think it is. Between the empty marshlands of existence crowd these verticals, not alive but physically present and visible; they stretch as far as the eye can see and almost hound us into retreat. We feel that these rocklike formations on either side extend to infinity, and Tanguy seems to suggest that at some time we soft, emotional human beings must come to terms with them.

*IMAGINARY NUMBERS
1954, oil on canvas, 39 x 31 in
(99 x 80 cm), Museo Thyssen-
Bornemisza, Madrid*

TÀPIES, ANTONI 1923– b. Spain
WHITE AND ORANGE

TÀPIES BELONGED TO A GENERATION of artists who scorned everything that seemed to them conventional. Even painting with oil on canvas was for Tàpies an avoidance of the real challenge of the external world. *White and Orange* is painted on a background of glue, plaster of Paris, and sand. In the mind of Tàpies, this represented rough reality. Into the thick material surface, he gouged a strange shape, reminiscent of either the ancient Egyptian figure of the soul or, on a less elevated level, a hand mirror. The shape is meant to be ambiguous, to represent a material image that we are free to interpret as we wish. The orange is applied roughly and inaccurately – crumbling here, splattering there – and then the whole image is cancelled out with a great strong cross, as if to say that anything created can be denied, that nothing is adequate to the artist's inchoate longing to produce what is true. Tàpies's name in Catalan Spanish actually means "walls". Perhaps this gave him an added incentive to produce not so much a piece of fine art but more a rough wall to challenge preconceptions.

*WHITE AND ORANGE, 1967,
mixed media on plywood, 24 x 20 in
(61 x 50 cm), Private Collection*

TENIERS, DAVID THE YOUNGER 1610–90 b. Belgium

AN OLD PEASANT CARESSES A KITCHEN MAID IN A STABLE

THERE IS A CERTAIN IRONY IN THE FACT that Teniers the Younger was a court painter to an archduke, given his pleasure in depicting peasant life and his enthusiastic emphasis on the vulgarity and unpleasant aspects of that life. Here, he paints an old man taking advantage of a young woman who works for him. The actual story is distasteful, and what makes the work important is the brilliance with which it is painted. Every article is seen in its full materiality: the old man and the girl are splendidly realized – his skinny and spindly leg makes a right angle to the rotundity of the pan she is holding, and the whiteness of her blouse is echoed suggestively in her white apron. It is this ability to conjure up a scene totally convincing in its three-dimensionality that raises Teniers's art above the anecdotal.

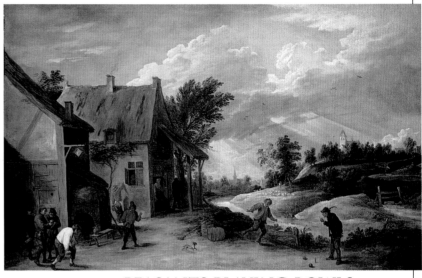

PEASANTS PLAYING BOWLS OUTSIDE A VILLAGE INN
c.1660, oil on canvas, 47 x 75 in (120 x 191 cm), National Gallery, London

Although many of Teniers's most impressive paintings show an interior with peasants up to no good, he occasionally diversified by showing an exterior with perfectly innocent occupations. Here, his peasants are playing bowls outside a village inn, although a serving maid is, of course, bringing out drinks. All attention is concentrated on the white-shirted bowler, and one can see the interest taken in the game. It is a delightful picture of a summer evening in the country, when those who labored throughout the day were able to relax.

AN OLD PEASANT CARESSES A KITCHEN MAID IN A STABLE
c.1650, oil on wood, 17 x 25½ in (43 x 65 cm), National Gallery, London

THE PICTURE IS DIVIDED *diagonally into two halves: all the foreground activity is bathed in a golden light, which floods in from an unseen window at the upper left and peters out at the abandoned slipper to the lower right. In the dark recesses that make up the other half of the canvas, we can see the irate figure of the old peasant's wife. She has clearly tracked him down and now, to her horror, finds her worst suspicions realized.*

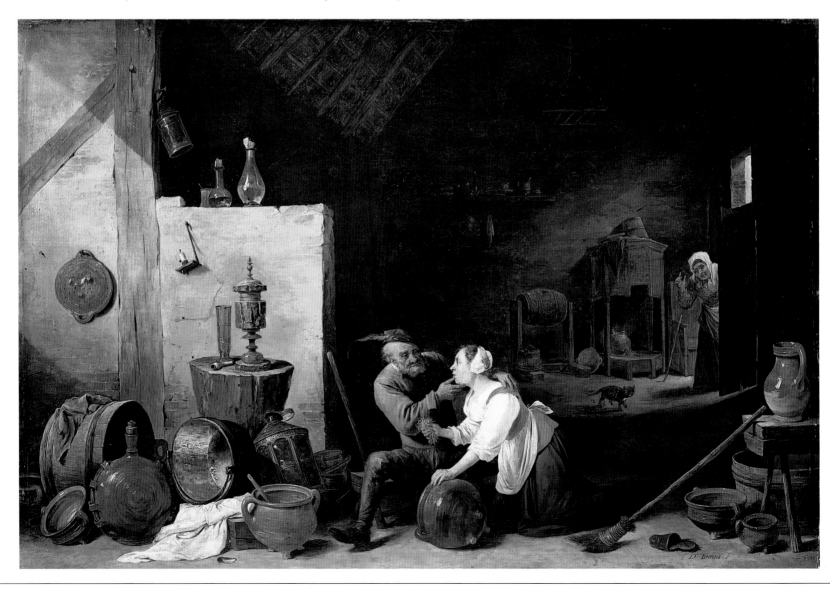

TERBORCH, GERARD THE YOUNGER 1617–81 b. Netherlands

A LADY AT HER TOILET

THE TITLE *A LADY AT HER TOILET* suggests a simple scene and yet it is not. Terborch confounds us with a sense of understated mystery. The movement of the lady – her look into the distance, pondering, perhaps questioning – makes us feel that we are looking on at some dramatic episode, the beginning and end of which we will never know. The page boy, so splendidly and extravagantly dressed, looks towards her with an air of faint surprise. His body is tensed as if he too wonders what the lady's next movement will be. Often with Terborch there seems to be an implied moral, and we are encouraged to wonder whether the lady is making some secret decision, and whether the removal of the ring has a special significance. We may further speculate about the small dog – is he there merely to indicate the lady's natural habitat, or, as a pet, does he symbolize the virtue of fidelity? Perhaps the lady is choosing between a plain fidelity and the riches indicated by the fancifully dressed page boy. In the mirror, the lady's face is drained of color – is this because vanity destroys one's integrity? Terborch leaves us wondering.

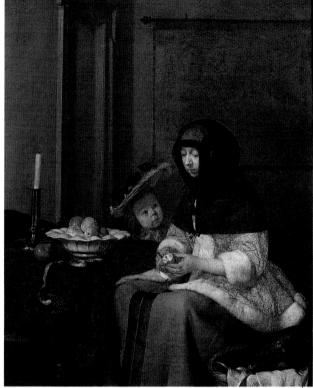

WOMAN PEELING AN APPLE
c.1661, oil on canvas, 14 x 12 in (36 x 31 cm),
Kunsthistorisches Museum, Vienna

It has been suggested that there is a moral lesson here, that the child is watching with greed and that the mother is peeling the apple not for the child to eat but to train the child to control its desires. It seems an unnecessarily harsh lesson, and the little face is turned up more with innocent astonishment than with greed.
The mother's black hood suggests mourning, and there are also black bows on the child's hat. Could it be that this apple peeling is a displacement activity? Is she peeling the apple to distract herself from her grief, and is the child waiting with a certain desolation for the return of the mother's attention?

THE SPLENDOR OF THE *lady's attire – that glorious sweep of oyster-colored silk, with its contrasting vivid azure blue of bodice and sleeve – is as nothing to the elaboration of the page boy. From curly head to ribboned heel, he is excessively overdressed. Might this suggest that the lady's relative simplicity is a deliberate choice of one who lives in the midst of almost vulgar opulence?*

THE LADY HAS STARTED TO *disrobe, and has already removed the lace collar that sartorially protected the lower neck. The maid is beginning to loosen bows, and the page boy seems to be waiting to receive the ring that she is moving from her finger. Behind are the dark and splendid hangings of her bed, while her toilet table is covered with an oriental carpet and a silver-framed mirror in which her ashen face is reflected.*

A LADY AT HER TOILET
*c.1660, oil on canvas, 30 x 24 in
(76 x 60 cm), Detroit Institute of Arts*

TERBRUGGHEN, HENDRICK 1588–1629 b Netherlands

ST SEBASTIAN TENDED BY IRENE AND HER MAID

TERBRUGGHEN IS SUCH A MASTER of form, light, and color that it comes as a shock to realize that he was barely forty when he died. Rubens visited Holland just before Terbrugghen's death, and reports suggest that Terbrugghen was the only painter Rubens admired. The main protagonist of this painting is St Sebastian, the Roman officer condemned to death by his regiment because, as a Christian, he refused to worship the Emperor. In the early Renaissance, this theme was the supreme excuse for painting a great male nude. In the 17th century, Terbrugghen needs no excuse. It is not the nakedness of Sebastian that interests him but his physical presence. We cannot distance ourselves from the immediacy of this youthful body, pressed up against the foreground, and shot through with arrows. The realism makes us wince as Terbrugghen gives us an enormous sense of fleshly reality – of the body as truth.

THE ANNUNCIATION
1629, oil on canvas, 85 x 70 in (217 x 177 cm),
Stedelijk Museum van Diest, Belgium

Among the many paintings of this event, this one stands out. Terbrugghen's use of color is dazzling. His angel is cloaked in orange silks with a red, white, and black bow, contrasting with Mary, whose pale blue shawl offsets the exquisite silver folds of her white garment. The background is equally daring, suffused in an extraordinary hot orange glow. Terbrugghen sees this as the victory of the Holy Spirit, because the Virgin's pale face is wholly closed to anything but God. Intriguingly, the angel's face is turned away and is in shadow. The angel leans forward to hector Mary, holding out the lily, and pressing her to her vocation.

ST SEBASTIAN'S TOES clench tight under the impact of pain, and the muscles in his arms bulge and cramp in response to the agony. The bowed head of this wounded man is counterbalanced by the tender but intent face of St Irene. With unswerving concentration, she carefully pulls out the arrows. Above St Irene (as the line of heads ascend), we see the maid, equally intent on her task. Her warm brown hands wrestle to untie Sebastian's arms, which are drained of blood and limp with approaching death.

TERBRUGGHEN HAD learned from Caravaggio how to use light dramatically. One of Irene's hands is in shadow, supporting Sebastian's breast, while the other is floodlit. With the delicacy of a surgeon, Irene sets herself the task of easing out that death-dealing arrow. The three figures are bracketed by scarlet and gold, in the mantle on which Sebastian sits and in the streaked and golden sky. The eagle-like outline of a thin tree reminds us of the symbol of the Roman Emperor that was rejected by St Sebastian.

ST SEBASTIAN TENDED BY IRENE AND HER MAID
1625, oil on canvas, 58 x 47 in (147 x 119 cm),
Allen Memorial Art Museum, Oberlin, Ohio

THIEBAUD, WAYNE 1920- b. US
DISPLAY CAKES

IF WE HAVE TO HANG A LABEL ON THIEBAUD, it would be that of Pop artist. However, he is distinctive in that how he paints is, to him, as important as what he paints. For many years, the subject of his paintings concentrated almost exclusively on cakes and confectionery. He became, as it were, the champion of the overlooked eclair, feeling that such objects, because of their sheer banality, were wrongly ignored by artists. Yet, objectively speaking, cakes – with their icing and sub-structure – *are* interesting to the eye, and, if we are to be honest, have a strong sensual appeal. Thiebaud chose to depict this confectionery with such thickly applied and luscious paint that the painted cake – dense and dripping from the canvas – becomes very close to the real thing. The cakes are lifted up on plinths, as if they were the very epitome of consumable objects; and yet, they are removed from us, partly by the sterile white setting, and partly by the tantalizing realization that these cakes are confections of the artist and not of the pastry maker.

DISPLAY CAKES
1963, oil on canvas, 28 x 38 in (71 x 97 cm),
San Francisco Museum of Modern Art

STEEP STREET
1980, oil on canvas,
60 x 36 in (153 x 92 cm), Private Collection

Thiebaud is very far from being a naive painter. He is capable of working in both abstract and realistic modes and is well aware of the problems of the realist painter. He talks of a perpetual dialogue in the artist's mind between what is seen and what is known: the perceptual and the conceptual. *Steep Street* calls upon our memories and our concepts of steepness. Thiebaud manipulates perspective to give us the overwhelming impression not so much of looking but of experiencing – moving past the houses, shops, and tarred roads, as the city gives way to the countryside.

THE CAKE *to the left oozes voluptuously and compellingly. The other two are more restrained. The dazzling white cake in the center is almost a minimal sculpture – only the uneven base suggests its edibility. The cake with the cherry, again, extends and increases the anticipation of sensual pleasure.*

AS WE LOOK *at* Display Cakes, *we come to realize that their elevation is insecure – that they have no visible, or even suggested, means of support. They share the empty canvas with their shadows alone, as though they have sprung into being and float like angels before our eyes and mouths.*

TIEPOLO, GIOVANNI 1692–1770 b. Italy
THE OLYMPUS

MUCH OF TIEPOLO'S BEST WORK was painted on ceilings, and one needs a fairly flexible neck to appreciate the glories of his soaring imagination. *The Olympus* is a rough sketch for what was to be – appropriately enough – a ceiling painting. In Greek mythology, the home of the gods was Mount Olympus, the highest mountain in Greece, where, it was believed, the gods lived in sunlit freedom and joy. Tiepolo's was a bright genius, and, although he could paint sorrow, he seems to have felt no natural affinity for it. All his instincts led him to the free, and the pure, and the joyous; Mount Olympus and the Olympians was a perfect theme for such a nature. Tiepolo's imagination delighted in portraying the intricacies of a complex world. He filled ceilings with luminescent skies, peopled with characters unburdened by gravity; such scenes come alive with incident, color, and the wonder of life.

ABRAHAM AND THE THREE ANGELS
c.1767–70, oil on canvas, 78 x 59 in
(197 x 151 cm), Museo del Prado, Madrid

Tiepolo was sincerely religious and his religious paintings have a sense of spiritual confidence that is very appealing. The Bible tells us of how Abraham offered a meal to three angels he encountered. The three angels symbolized the Trinity; one stood in for God, and Tiepolo has depicted this head angel superbly. That golden figure of great beauty, looking down majestically at his overwhelmed host, is a memorable image. The humble meal displayed in the lower right corner is also a memorable image, as is the nearer angel's lower leg propped on a cloud, so subtly distinguished from the stone below it. There is a dark and lowering sky, but the angels carry their light within them.

MERCURY SPIRALS *down, his caduceus and the twin wings of his scarlet cap gloriously visible. Sitting on the cloud, serenely at ease and attended by nymphs, is Zeus, while down below is Venus. She is carried in a golden chariot that is drawn by birds (though one notices Cupid hard at work, propping up the clouds beneath her).*

ATHENE, GODDESS *of wisdom and of war, dressed in her armor and with shield held aloft, signals upwards, while at the very bottom, in suitably dark silhouette, Pluto climbs out of the underworld, watched with great interest by a brilliant parrot.*

THE OLYMPUS
c.1661–64, oil on canvas,
34 x 24 in (86 x 62 cm)
Museo del Prado, Madrid

TINTORETTO (JACOPO ROBUSTI)

1518–94
b. Italy

ST GEORGE AND THE DRAGON

TINTORETTO IS PROBABLY THE MOST ELECTRIFYING artist in Venetian history. His sense of drama can be overwhelming. He seems to see the world from an angle unlike that of any other artist. Here, he treats the story of St George and the dragon with extraordinary immediacy. Usually, it is the conflict between good and evil, man and beast, life and death, that fills the foreground, with an admiring little princess watching her hero in action. Here, the foreground is the realm of the woman, and, far from watching, she takes advantage of the dragon's preoccupation with St George to run away, terrified. She runs right at us, in fact, and so precipitous is the mood that it is hard to know whether she is still in headlong flight or whether she has fallen to her knees. The splendors of her blue and silver gown ripple in front of her, and the rose-pink swathes of her impractical cloak billow behind as she runs. Between her and St George lies the explicit horror of a corpse; Tintoretto has clearly taken on board that those who fight the dreaded dragon are often unsuccessful. Outside those concentric circles of divine redemption, the sky broils with dark and threatening storm clouds. The castellated city walls look eerily insubstantial and St George fights against a background of a threatening sea. The whole theme pulsates with drama. All is in motion, nothing is decided. We cannot watch from the sidelines, as it were, for Tintoretto draws us in and involves us.

ST GEORGE AND THE DRAGON
c.1570, oil on canvas, 62 x 39 in
(158 x 100 cm), National Gallery, London

ONLY OUR PRIOR KNOWLEDGE of this story enables us to understand that the battle – bracketed by the triumphant figure in the sky (making it clear that this is not a secular story but a divine parable) and the earthly woman, terrified and in flight – will have a glorious ending. The very trees seem to quiver and sway with the energy of the picture, which forces us to experience the power of the dragon in our very nerves.

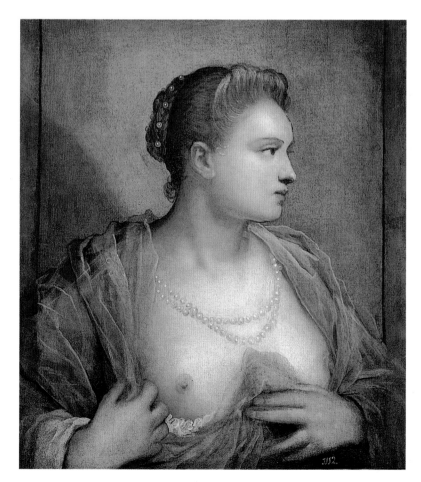

THE WOMAN WHO DISCOVERS THE BOSOM

c.1570, oil on canvas, 24 x 22 in
(61 x 55 cm), Museo del Prado, Madrid

Only Tintoretto would paint a nude of such extraordinary beauty and yet show, as the most significant fact about her, a moral tension. It is called *The Woman Who Discovers the Bosom*, but it is certainly not, in any sense, for pornographic exposure. She looks across, not at us, but at some invisible companion, and seems to be deliberately revealing her breast with some specific agenda. It is an accusing face, for all its loveliness. We feel plunged into the center of some story that we will never know. Tintoretto invites us to share the emotion, but not to understand its meaning.

TISCHBEIN, JOHANN HEINRICH WILHELM

1751–1829
b. Germany

GOETHE IN THE ROMAN CAMPAGNA

JOHANN HEINRICH WILHELM TISCHBEIN was a contemporary of Goethe. The two were friends and Tischbein was a lifelong admirer of the great poet. *Goethe in the Roman Campagna* is Tischbein's unqualified masterpiece. It was painted just before the French Revolution, and one cannot view this work without thinking of the turmoil that was soon to be wrought upon the established world of European culture. The painting shows the poet brooding in the Italian countryside. Goethe, like Dante, is one of those world figures, the extent of whose genius inspires awe. This painting was intended to show Goethe at a crucial turning point in his personal development. Up until this point, Goethe had felt as much drawn to the world of art as to that of poetry. One of the purposes of his visit to Italy was to discover for himself whether his artistic skill was sufficient to express his deep insights into life. Goethe was forced to acknowledge that, as an artist, he was no more than a gifted amateur, and from this moment on he was to devote himself to literature.

GOETHE IN THE ROMAN CAMPAGNA
1787, oil on canvas, 64½ x 81 in (164 x 206 cm),
Städelsches Kunstinstitut, Frankfurt am Main, Germany

LANDSCAPE WITH DUCK
1799, oil on wood, 22 x 29 in (55 x 74 cm), Museo Nazionale di San Martino, Italy

If Tischbein rises to the challenge of depicting Goethe, he rises equally to the challenge of depicting a duck, no less conscious of its importance. A glorious background of water, hills, and sky highlights the dignity with which this creature stalks forward. Tischbein has observed all that is peculiar to this animal, yet it is the personality of the duck that we remember; the lofty bend of the neck, the swell of the breast as, like Goethe, it confronts its future.

GOETHE SITS *amidst the ruins of the classical world, which proved to be the basis for his future poetry. He rests at ease, his gaze fixed unswervingly on his vision of the future. This is Goethe who has decided on his course. That noble head is overcast with a certain melancholy and he seems to be imbibing impressions, summoning up the energy to start on his future course.*

THE EXPOSED *leg might hint at his readiness to walk into that future. We notice that the skies are overcast, that the great art is overgrown with ivy, and that for this man of genius at this crucial moment in European history no easy task lies ahead. All this Tischbein conveys with the delicate sensitivity of a true admirer.*

TISSOT, JAMES 1836–1902 b. France, active France and England
LONDON VISITORS

TISSOT WAS A FRENCHMAN, but most of his masterworks were painted in Victorian London. Perhaps, as a foreigner, he was more conscious of the romance of this great city and, as a Frenchman, more appreciative of the elegance of its society ladies. *London Visitors* was painted, appropriately enough, on the steps of the National Gallery. The two boys are pupils of an adjacent public school, wearing their archaic uniform and earning an honest penny by guiding visitors around the collection and other sights of London. The boy at the back is still busy as the visitor peers with interest at the delights of the capital. But these two are background figures; central to Tissot's interest – behind the scraggy boy, barely into his adolescence, who is obviously on the lookout for a client – is the self-possessed couple, whose elegance rebuffs any indication of provinciality.

PORTRAIT OF MME L.L.
1864, oil on canvas, 39 x 49 in (99 x 124 cm), Musée d'Orsay, Paris

Tissot strikes me as a discreet painter, who always remains rather detached from his themes. His *Portrait of Mme L.L.* is unusual in that the extraordinary scarlet of the bolero and the ribbon in her hair dominate the canvas. (The bolero was at the height of fashion because the Empress of France was Spanish.) Although Tissot pays due homage to the young woman's dress sense, he is intent on showing us the environment that has molded her character. Here is all the fuss of Victorian decoration – the beaded curtain, flowered wallpaper, brocaded chair – amidst which she sits with surprising nonchalance. This world has not imprisoned this free spirit, who looks out at us with an air almost of cynicism. She may be young, but she is knowing.

THE LADY IS NOT ONLY *dressed in the latest fashion, but she looks down at us with an air of forbidding hauteur. If her husband needs to consult the map, she indicates with her pointing umbrella that she is well aware of London ways and only needs his attention to give him adequate directions.*

THE HUSBAND, WE FEEL, *slightly lets his companion down. His check suit, bushy beard, and billy-cock hat, do not quite live up to the standards that she sets in both costume and manner. The woman at the rear peers, open-eyed, determined that nothing will surprise her; very subtly, Tissot suggests that she is thereby the loser. Tissot is a master of light, and the tactile surface of the steps is almost palpable. He is also a master of relationships, intriguing us while he amuses.*

LONDON VISITORS, c.1874,
*oil on canvas, 63 x 45 in (160 x 114 cm),
Toledo Museum of Art, Ohio*

AROUND MARSYAS *are the symbolic figures that make Titian's meaning clear. We see the peasant – the laborer with his knife – and the friendly satyr, who brings the bucket in a pathetic attempt to help. On the far left is the young artist, who is just embarking on his musical career, still unaware of what the final cost will be if he, like Marsyas, is to challenge the greatest.*

THE THREE WITNESSES *represent the three ages of man and perhaps the three ages of an artist. The old king – Midas in the story – looks very like the old Titian. He broods; he understands what Marsyas has attempted. Perhaps he is wondering how he has come to the end of his life and kept his skin – has he saved himself and sacrificed his creativity? Titian had it all – a superb sense of design, a unique awareness of color, and an extraordinary insight into the human psyche. He was also a worldly man, with a golden touch when it came to making money.*

THE CHILD *who is present at the macabre event understands nothing and is unable to face the horror. He seeks only to hold back the large, eager dog, and as he does so, turns to address us, the viewers, as witnessess to the scene. The small dog, which represents the superficial mind that cannot understand the true majesty of the story, laps the blood in vulgar enjoyment.*

THE FLAYING
OF MARSYAS
*1570/75, oil on canvas,
83 x 81 (212 x 207 cm),
Château Archiépiscopal,
Kroměříž, Czech Republic*

TITIAN (TIZIANO VECELLI) c.1487–1576 b. Italy

THE FLAYING OF MARSYAS

I SOMETIMES THINK THAT TITIAN in his late years is the greatest painter in the world. I always think that *The Flaying of Marsyas* is the greatest picture that Titian ever painted. Not only does it have that supreme flickering light, that sense of truth just caught before it sinks back again into darkness, which makes his late work so unforgettable, but the story of Marsyas also sums up so perfectly the role of an artist, and Titian's above all. The satyr, Marsyas, had challenged the beautiful, sunlike god Apollo to a musical contest, with the proviso that the winner would mete out to the loser whatever fate he chose.

Apollo, as you might expect, won the contest and his verdict was that Marsyas should be flayed alive. In itself, this is the most hideous of stories – excessively cruel and brutal – but Titian takes the horror and sees a spiritual meaning beyond it. He shows us Marsyas tied upside-down in the tree, while Apollo, golden and beautiful, with exquisite care, cuts away the satyr's skin. Marsyas hangs in agony, and yet, if we look at his face, his lips are curled in a beatific smile. The true artist, as Marsyas was, aims at godlike status and will give his life if that is what his art demands. Marsyas knows that he has had this privilege.

> " HIS [TITIAN'S] PAINTINGS CANNOT BE VIEWED FROM NEARBY, BUT APPEAR PERFECT AT A DISTANCE…HE MAKES PICTURES APPEAR ALIVE AND PAINTED WITH GREAT ART, BUT CONCEALS THE LABOR THAT HAS GONE INTO THEM "
>
> Giorgio Vasari

PORTRAIT OF RANUCCIO FARNESE

1542, oil on canvas, 35 x 29 in (89 x 74 cm), National Gallery of Art, Washington, DC

Here, Titian is painting a young boy. The 12-year-old Ranuccio Farnese has already embarked on a military career that his aristocratic family hoped would lead to greatness. His splendid attire bears the Maltese cross, emblem of the chivalric order of the Knights of Malta. Yet it is the boy's expression that most draws our attention – a mixture of hope, fear and expectation. It shows the pressures that must be endured by a child of whom greatness is expected. His face is still chubby with innocence, but he carries himself with the dignity of his rank.

TOULOUSE-LAUTREC, HENRI DE

1864–1901
b. France

THE CLOWN CHAU-U-KAO

THE FEMALE CLOWN CHAU-U-KAO was a frequent model for Toulouse-Lautrec, and one suspects that what attracted him was her ability to make fun of her own imperfections. Toulouse-Lautrec, as the last descendant of an ancient French family, must have been bitterly conscious of his own physical deformities, and to many people he, too, was a figure of fun. Chau-U-Kao's name meant, apparently, noise and chaos, because she was laughed and hooted at – something to which Lautrec, who was impatient of the civilities of aristocratic life, felt attracted. He shows us Chau-U-Kao preparing for her act with dignity and serenity, the great swirl of her frill seems to bracket the clown so that we can truly look at her, see the pathos of that blowsy and sagging flesh, and move on to the nobility of the nose and the intense eyes. This is a degradation, but one that has been chosen by the performer and redeemed by intelligence and will power.

WOMAN LYING ON HER BACK
1896, oil on board, 12 x 16 in (31 x 40 cm), Musée d'Orsay, Paris

As an outsider to his own society, Lautrec felt most at home with those other outsiders: prostitutes. The brothel was the one area where he was accepted and made welcome. He was bitterly conscious of the tragedy of these women's lives, their need to pretend, to exploit themselves, the lack of any of the natural pleasures that make most lives tolerable. Here, he shows a prostitute in one of her rare moments of solitude. She has no customer; there are no calls on her. She collapses onto her workplace – her bed – her slim legs in their black stockings inelegantly sprawled, and luxuriates in the pleasure of being alone. Lautrec uses a quick and sketchy line to suggest the febrile and unstable nature of the woman's life.

T
462

TOULOUSE-LAUTREC is the great artist of the poster, and even in his oils one can see that outlining, that clarity, that simplicity of form – the attributes of a good poster designed to be seen from a distance. With his wonderful eye for a graphic line, Lautrec angles out Chau-U-Kao's arm, directing our attention with the foolishly dangling yellow ribbon in her topknot.

WE SEE THE CLOWN in her dressing room where the blue and yellow of the stippled walls and blurry red of her settee clash and rebound off the shock of her costume. She is buttoning herself up into an overtight purple dress, the whole of which is surrounded and surmounted by that extraordinary gaudy yellow frill.

CHAU-U-KAO BASED her act upon her superabundance of flesh, deliberately setting herself up to be laughed at. Lautrec is showing us that, despite her ludicrous appearance, here is a serious performer who chooses to use herself as an object of ridicule and accepts the financial advantages of this. The parallel here, between the clown and the artist, is poignant.

THE CLOWN CHAU-U-KAO
1895, oil on cardboard, 25 x 19 in (64 x 49 cm), Musée d'Orsay, Paris

TRECK, JAN c.1605–52 b. Netherlands

STILL LIFE WITH A PEWTER FLAGON AND TWO MING BOWLS

TRECK WAS A 17TH-CENTURY DUTCHMAN who – in the busy world of Amsterdam art – specialized in still-life paintings. This dignified and restrained still life illustrates the power of his work. Here, Trek shows an ability to accept the subject matter without any need to exaggerate, decorate, or do much more than let light shine on his arrangement. The three objects that form the center of his painting are all splendid works of master craftsmanship in themselves and would have been treasured by the wealthy household that owned them. The rounded pewter flagon swells with a lustrous sheen that Treck clearly finds engrossing. It reflects the crumpled folds of the white napkin and the glimmer of light from the distant window. A leafy vine has been wrapped around the flagon, and this reference to its possible contents is balanced by a Ming bowl, in which we can glimpse ripe raspberries. The discarded napkin tells us that the meal is over and that Treck is absorbed in recording the beauty of the remains.

STILL LIFE WITH A PEWTER FLAGON AND TWO MING BOWLS
1649, oil on canvas, 30 x 25 in (77 x 64 cm), National Gallery, London

TUKE, HENRY SCOTT 1858–1929 b. England

GIRL WITH A PITCHER

TUKE IS NOT A HOUSEHOLD NAME, but this British painter is noted for his images of the sea with naked boys bathing. *Girl with a Pitcher*, however, was painted early in his career, before he launched himself into what was to become a lifelong obsession with seascapes. It is a remarkably honest painting for the period. Tuke painted the girl, who would probably have been a fisherman's wife or daughter, in Cornwall. He makes no attempt to romanticize the girl, as he was to do later with his sunlit boys; instead, he captures her weariness and her wiry fragility. Her dark eyes peer out at us accusingly from the cramped doorway of her dungeon-like home, where only a small window is open to the light. The sophistication of Tuke's later work has none of the rough honesty that we see here; the paint is actually visible on the crude walls. For Tuke, it is not who the woman was but how she looked that stopped him in his tracks, made him stand full in her face, and sketch her poverty-stricken existence as he encountered it.

GIRL WITH A PITCHER
1884, oil on wood, 13 x 8 in (34 x 20 cm), David Messum Gallery, London

TURA, COSIMO c.1430–95 b. Italy
ALLEGORICAL FIGURE

COSIMO TURA ACHIEVES THE UNUSUAL FEAT of creating figures that are both full-bodied and full-blooded, and yet seemingly metallic. They have a hard, sharp outline, which etches them onto our imagination. Nobody knows which allegory this majestic figure embodies. Her extraordinary throne is composed of golden and jewelled sea creatures – sharp-finned, sharp-toothed, sharp-edged. Ruby eyes agleam, they arch above her and curl at the arms of her throne, digging their snouts into the marble of the seat. There are also fruits and shells, lines of curling seaweed, and a great scallop shell and circle of crystal and coral behind her head. Amid this decorative extravaganza, a female allegorical figure confronts us sideways on, all the more impressive, perhaps, for her mystery. An allegory is meant to refer point-by-point to some more prosaic truth; this figure is poetry incarnate.

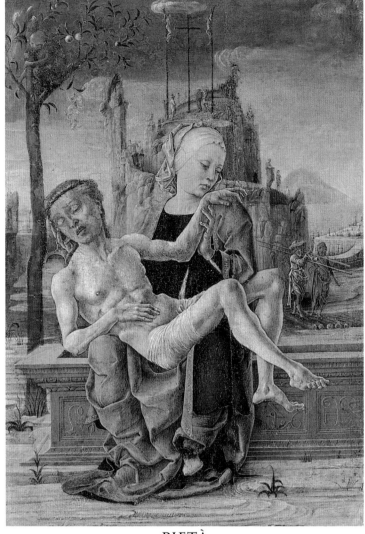

PIETÀ
1460, tempera on wood, 19 x 13 in (48 x 33 cm), Museo Correr, Venice

The pietà is a familiar image in art, but what distinguishes Tura's *Pietà* is his strange freedom with proportions. Mary, you might say, is human-sized, a beautiful adult woman whose face expresses a profound sorrow. Jesus, however, has been shrunk to mannequin size, the sharp bones of His buttocks digging into His mother's lap, and His tortured legs jutting out with terrifying sharpness. The image of the dead Jesus in His mother's lap is often meant to recall how she held the infant Christ, but here the disproportion is too uncanny, and we feel a great sense of unease; it is as though the whole Passion is basically outside of human order and reason.

WAVELIKE TENDRILS *of hair stream down the figure's body, and the laces that outline the curve of her breast and her belly are loosened – whether suggestively or not is for the viewer to interpret. She holds a long branch of cherries, but the somber richness of her apparel suggests nothing more than the majesty we can already deduce.*

THE QUEENLY WOMAN *so engrosses our attention that only after close scrutiny do we realize that she does not entirely blot out the visible world. To the left, beyond the throne, a minute man on horseback winds around a hill and, to the right, a blacksmith seems to beat with a hammer in some stone-arched smithy. The world goes on, but this strange monumental presence dominates.*

ALLEGORICAL FIGURE, *c.1455–60, oil and tempera on wood, 46 x 28 in (116 x 71 cm), National Gallery, London*

TURNER, J.M.W. 1775–1851 b. England
NORHAM CASTLE, SUNRISE

TURNER PAINTED *NORHAM CASTLE, SUNRISE* towards the end of his long, interesting, and highly successful career. By this time, he had learned he could do almost anything. He felt no constraints to hue or to story-line, no compulsion to bow to realism or even to impress the viewers. This painting was never exhibited in public, and it is possible he did it purely for his own pleasure. One can imagine what pleasure it must have given him to have created something of such luminous beauty. For all the ethereal and almost immaterial nature of his shapes, we can still make out the looming and romantic bulk of the great rock face on which the castle stands, and the cattle that browse before it, pooled in glimmering light. Turner's whole career seems to climax in this painting; he always sought to make visible the sublime, which, by definition, must elude the painter's grasp. To come as close to it as this, to float his colors onto the canvas, to suggest as much as to state, these were the aims that he steadily achieved. One can enjoy the thought of Turner, well into his seventies and with nothing to prove, creating this work out of the sheer bliss of his understanding of the world's magic.

SNOWSTORM: STEAM-BOAT OFF A HARBOUR'S MOUTH
1842, oil on canvas, 36 x 48 in (92 x 122 cm), Tate Gallery, London

Turner justified the wild and tempestuous swirl of this snowstorm at sea by asserting that he had actually experienced it tied to a mast. Subsequent investigation has suggested that perhaps this was a slight exaggeration. But in his mind he had certainly experienced the feeling of being overwhelmed by the sea – a sea that has become indistinguishable from the sky, that has lost all color and is reduced to just gray and brown elemental surges of passion.

"HE [TURNER] SEEMS TO PAINT WITH TINTED STEAM, SO EVANESCENT AND AIRY"
John Constable

TURNER FIRST *visited Norham Castle when in his youth. He returned intermittently throughout his life, and one senses that the warm colors with which he paints this morning scene are a reflection of his affection for this special haunt.*

NORHAM CASTLE, SUNRISE *c.1835–40, oil on canvas, 36 x 48 in (91 x 122 cm), Tate Gallery, London*

TWOMBLY, CY 1929– b. US, active Italy
VENGEANCE OF ACHILLES

ALL THROUGH HISTORY, ARTISTS have been drawn to Rome, firstly from across Europe and later from America. Once there, they have become enraptured by classical culture and have remained forever expatriate. Such is the case with Cy Twombly, a difficult artist to categorize. On the one hand, his art is almost graffiti-like – scribbled in a wild flurry of lines, often with minimal color, always with nervous and uncertain tension. On the other hand, he is a deeply classical artist, drawing his inspiration from the myths of Greece and Rome. *Vengeance of Achilles* is an extraordinary example of both the freedom and discipline of his art. Here, he is referring to the hero of Homer's *Iliad*. Achilles was reluctant to take part in the Trojan war but was drawn into the conflict when his best friend, Patroclus, was killed by Hector, the military leader of the Trojans. It was only then that Achilles rejoined the battle against the Trojans. One of the most memorable events in the *Iliad* is the encounter between Achilles and Hector, which ends with violent slaughter when the spear tip of Achilles is thrust again and again into the defeated Trojan. Here, we see the spear tip, smeared red with Hector's blood.

TWOMBLY HAS STRUCTURED *the work on a giant letter "A" – a powerful and solid form, like that of a pyramid. It is an "A" that stands for Achilles and an "A" for alpha, the leading letter of the Greek alphabet.*

VENGEANCE OF ACHILLES
1962, oil, crayon and pencil on canvas, 118 x 69 in (300 x 175 cm), Kunsthaus, Zurich

ANIMULA VAGULA
1979, oil, graphite, and crayon on canvas, 46 x 56 in (114 x 142 cm), Private Collection

For all Twombly's wavering eye and air of indecisiveness, he is an amazingly confident artist. Against a background of wild yellow and ocher slashes is a curious caligraphy. Speaking as one notorious for the illegibility of her handwriting, I feel in a position to say that Twombly's marks do indeed seem to be writing and their legibility to be their own business. We are excluded deliberately. He has even cut the canvas as if to emphasize that his emotion is his own affair. Although Twombly is drawn to the irrational, he leads the uncoordinated, unconditioned, and non-rational of his line into a pattern that is intensely controlled.

AT THE BOTTOM *of the canvas, Twombly has scribbled the title of the painting in a scrawl that is entirely in keeping with the theme of the work – the passionate vengeance of Achilles. From this base, the work rises with inexorable force. The deathly combat is portrayed as heroic and yet terrible – as a violence so absolute that it subsumes all in its path.*

UCCELLO (PAOLO DI DONO) c.1396–1475 b. Italy

THE HUNT IN THE FOREST

PAOLO DI DONO IS BEST KNOWN to us by his nickname, Uccello – "the bird". The story has it that he received this name because of his great love for birds, but one wonders if it might also be because he seemed to be a creature who could fly, while other artists of his time seemed only to walk. What drew him into this ecstatic artistic flight was his understanding of perspective. Perspective in itself, as a technical means of organizing a picture from a vanishing point, has little aesthetic appeal for most people, but not so for Uccello. He called perspective "my sweet mistress". We can see the almost miraculous use he made of it in a picture like *The Hunt in the Forest*. The great verticals of the trees establish an immovable pattern, while a crowd of men, with their dogs and horses, rush forward from all directions towards that central vanishing point. It must have been this glorious appearance of control that drew Uccello to perspective. Here was a way of taking the randomness of everyday experience and reducing it to a single point to which all else could be related. The psychological relief must have been immense.

THE HUNT IN THE FOREST
c.1465–70, oil on canvas, 29 x 70 in (74 x 177 cm), Ashmolean Museum, Oxford, UK

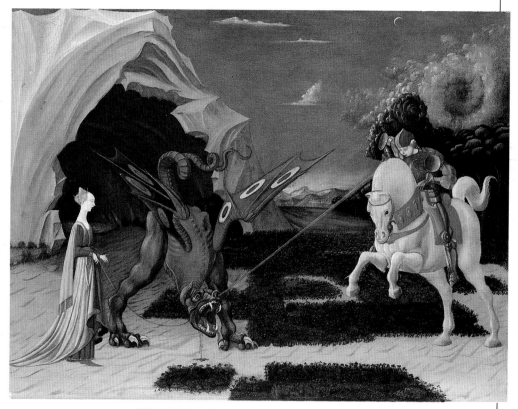

ST GEORGE AND THE DRAGON
c.1460, oil on canvas, 22 x 29 in (57 x 74 cm), National Gallery, London

Uccello's passion for perspective is less obvious here, but not so his passion for control. The story of St George and the dragon is a legend of the subjection of the irrational to the organized discipline of the hero. St George directs a long lance unerringly into the dragon's head, paralleling the batwing of the dragon and the edge of the cave. The storms gathering behind him reinforce the direction of his lance as if all nature is drawn into overcoming evil. The princess, who has full confidence in her hero, already has her girdle around the dragon's neck.

THE VANISHING POINT *in Uccello's imagination is where the great stag abides, and the hunters are drawn towards it as if by a magnet. Although it is a picture of apparent chaos, it is exquisitely balanced in its sanity. Here, we see the world organized into a purpose, all disparate activity integrated and made rational.*

IT IS AN EXTRAORDINARILY *organized rush of color and shape. The diagonals of the lances draw the eye this way and that while the hounds and the horses leap onward until they are finally lost in that perpetually receding mirage of invisibility.*

UCCELLO INTERESTS HIMSELF *in the actors, too. We can almost hear the hunters willing on the dogs with various degrees of enthusiasm, and we can see other stags leap in surprise as the hunt bypasses them and surges forward into the distance.*

UTRILLO, MAURICE 1883–1955 b. France

MARIZY SAINTE-GENEVIEVE

IMAGINE THIS AS A SCENERIO: a drunken illegitimate, raised in bohemian Paris, in and out of mental asylums, keeping his sanity by copying pictures from postcards. Who would credit that this postcard copier, rarely sober, barely sane, should be that major artist Utrillo? The miracle of Utrillo's work remains inexplicable. From a void of beauty and romance, he has created this world of glimmering purity. He has understood the geometry of the small street, and without infringing in the slightest on its bare actuality, he has created from it a world of genuine beauty. The sky may be dense with the smoke of Parisian industry, but Utrillo sees it as delicate and rare as mother-of-pearl. There were usually no people in the streets of the postcards that he copied, but there seems to be an existential reason for this. Utrillo's loneliness becomes visible in these desolate roads in which, if we peer steadily, we can discern a pedestrian or two, remote and indistinct.

MARIZY SAINTE-GENEVIEVE,
c.1910, oil on canvas, 24 x 32 in (60 x 81 cm),
National Gallery of Art, Washington, DC

SAINT-DENIS CANAL
1906–8, oil on cardboard, 21 x 30 in (54 x 75 cm), Bridgestone Museum of Art, Tokyo

This was an unusually venturesome painting for Utrillo. Here, it has not been sufficient to dwell with his usual sensitivity on the whites of house and wall. Here, he must plunge, almost literally we feel, into the turbulent waters of the grey-green canal. We must accept that his sky is punctuated by one factory chimney after another. It is a warmer picture than usual in that the sun shines on street and building, but the water is grim and gray and, although our eyes run along the path, they meet no companion and the boat seems abandoned.

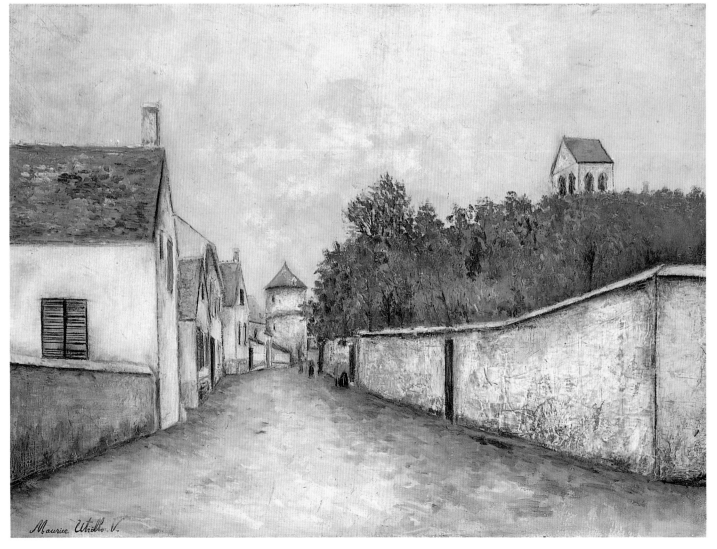

IT IS HIS WHITES, *perhaps, that make a Utrillo painting so poetic. They have a marvelous depth to them. He plays off these whites against the subtle reds of the wall, the red browns of a roof, and those feathery greens of the enclosed garden from which a small tower peeps up to the right.*

FEW THINGS *delight the eye more than that a stretch of church wall, its scribbled whites, its sense of the potential of the ordinary – a theme magnificently taken up in this work and extended by the muddy street, with the few dark and indistinct figures at its far end.*

VALADON, SUZANNE 1865–1938 b. France
THE CAST-OFF DOLL

SUZANNE VALADON SEEMED FATED to be a footnote in the history of art. She was the mother of the French painter Maurice Utrillo and steered him towards artistic success. She began as a model posing for artists such as Renoir and Toulouse-Lautrec, and it was not until her forties that she became an artist herself. *The Cast-Off Doll* is proof enough of her previously untapped potential and its belated, though real, fulfilment. This is a disturbingly ambiguous painting. Here is a girl – still with a childish hairstyle – in the presence of a doll that has been recently discarded. But, paradoxically, this child has full, sensual breasts and one is led to question whether it is her mother or the madam of a brothel who solicitously wipes her down with a towel. The doll has been dropped, and what seems to have taken its place is a narcissistic attention to appearance.

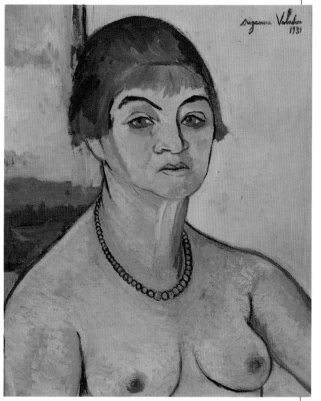

SELF-PORTRAIT
WITH BARE BREASTS
1931, oil on canvas, 18 x 15 in (46 x 38 cm),
Pierre Gianadda Foundation, Martigny, Switzerland

Valadon – shown here in her sixties – is no longer the voluptuous nude that Renoir delighted in painting. Now she paints herself with hair cropped short, naked breasts, and gazing with cool self-possession towards the viewer – it is the look of a woman who is profoundly assured of her attraction. This is, nevertheless, a highly sensual self-portrait. Her body remains seductive, with none of the withering of the flesh that age brings. She pushes her sexuality at us as if, despite her achievements as an artist, it is as a beautiful model that she wishes to be remembered. The scenery behind the figure is hard to read. Perhaps "hard to read" is an accurate assessment for all of Valadon's work.

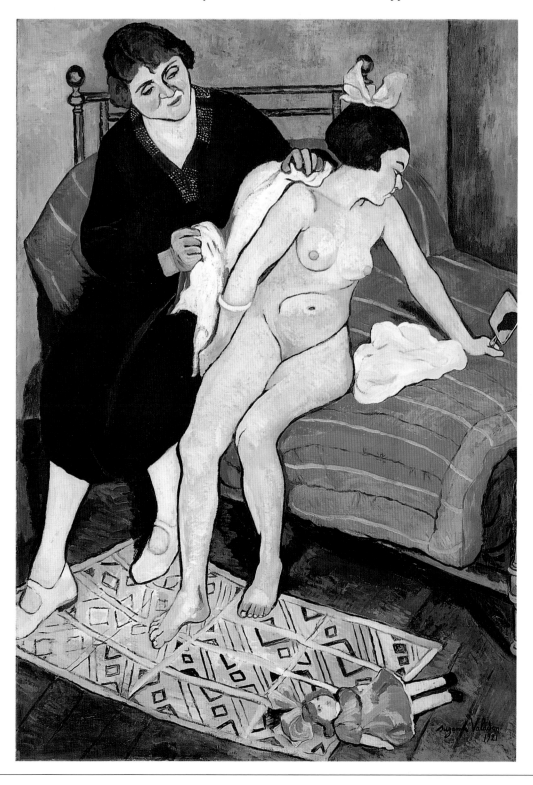

THE GIRL/WOMAN *stares fixedly into the small hand-mirror and we notice that the bed is a double bed. Despite voluptuous breasts, the girl has no pubic hair and we remain unsure as to whether this is young girl being helped through adolescence or a virgin set up to be deflowered. Valadon gives us no clues. Woman and girl are shut into a small room in which nakedness seems inappropriate. It begs the question, why is the girl naked and the woman clothed?*

WHAT IS THE NARRATIVE HERE? *The doll, we notice, has the same hairstyle – tied with a big pink bow – as the girl, and her legs are as firmly pressed together. But the doll lies there as a victim, outstretched, exposed, and discarded, and we cannot but wonder as to the fate of the young woman, engrossed in self-admiration and ignorant of the machinations of the adult world.*

THE CAST-OFF DOLL, *1921, oil on canvas, 53 x 37 in (135 x 95 cm), The National Museum of Women in the Arts, Washington, DC*

VALDÉS LEAL, JUAN DE 1622–90 b. Spain
ALLEGORY OF DEATH

SPANISH ART HAS ALWAYS been profoundly aware that all life ends in death. It has even been accused of a proclivity for suffering, and the paintings of martyrs and their torturers that adorn many a Spanish church provide some evidence for such a claim. Valdés Leal was commissioned to paint images of death, judgment, hell, and heaven for a church in Seville. The paintings are unforgettable, and they were set before a wealthy congregation to make them aware that life is a precious gift to be used responsibly. The Latin inscription within the picture, *In Ictu Oculi*, means "in the twinkling of an eye," and here it refers to the suddenness of death – life's candle being abruptly snuffed out in full course while all around lie the trappings of vanity. The whole world is under the dominion of death, and all the achievements of human endeavor might in the end be left behind in a vainglorious heap. Here, we see the trappings of a glorious life: books, swords, jewels, even a fine processional cross and the pope's tiara – suggesting ecclesiastical glory, too, will come to nothing. Reigning in eerie power looms the skeleton, balancing one bony foot upon the globe.

FINIS GLORIAE MUNDI
1670–72, oil on canvas, 87 x 85 in (220 x 216 cm),
Hospital de la Santa Caridad, Seville

Finis Gloriae Mundi ("this is the end of all worldly glory") is even more horrifying than the *Allegory of Death*. It depicts two corpses in the final stages of decay: one a maggot-ridden bishop, the other a knight. Above the two corpses are scales. On one side are heaped the deadly sins, symbolized by animals (the pig of gluttony, the goat of lust). The word *Nimas* ("nothing more") is inscribed on this side, implying that nothing more is needed for damnation. The other pile shows symbols of contrition (the sacred heart, the scourge) and the paraphernalia of a devout life; *Nimenos* ("nothing less") is inscribed on this side, meaning that nothing less will lead to salvation.

V
470

THE TECHNICAL TERM *for such a work is a* vanitas *picture, referring to a line from the Old Testament, "vanity of vanities, and all is vanity". Yet, it has been painted with such loving attention to detail that the artist almost contradicts his own message. These things may be snuffed out abruptly, without our control, but how beautiful they are, how desirable.*

SUCH LURID IMAGES *as these, with their "either/or" premise, were painted more to terrify than to persuade. This canvas could be described as deeply unpleasant, a repugnant image in its narrow and perverted view of human life, but its power is unmistakable, and the aim of the artist was not to provide delectation, but to awe and admonish.*

ALLEGORY OF DEATH, *1670–72, oil on canvas, 87 x 85 in (220 x 216 cm), Hospital de la Santa Caridad, Seville*

VALENCIENNES, PIERRE-HENRI DE 1750–1819 b. France
THE TWO POPLARS

SOME ARTISTS SEEM TO GET FORGOTTEN, and Valenciennes is one of those artists. Yet, this little landscape is of extraordinary quality. *Farm Buildings of the Villa Farnese: The Two Poplars* suggests grandeur, and perhaps opulence, yet the artist has chosen to sketch the farm buildings – where two stately pine trees straddle a road that leads from the campagna into the outhouses and stables. We feel an immediate identification with the young artist who stood there – Frenchman though he was – experiencing the shock of an Italian midday, when all sleep and only the far wall blazes golden in the sunlight. Valenciennes is completely absorbed in the experience of the moment; the silence is almost audible. The artist rightly stands at a remove. This is not his world, and he is no part of it. But at this remove, with marvelling objectivity, he encompasses the architecture, block upon block, of the buildings, where doors and window gape blankly, and where all is crushed down, as from above, by the solid blue of that Italian summer sky.

FARM BUILDINGS OF THE VILLA FARNESE: THE TWO POPLARS, *late 18th century, oil on paper, 10 x 15 in (26 x 39 cm), Musée du Louvre, Paris*

VALENCIENNES HAS *rendered the rough border of grass and bush almost impressionistically, scumbling the paint here and there to convey the density of this foreign vegetation. The delicate pallor of wild flowers are just visible among the rush of greenery.*

VIEW OF THE CONVENT OF THE ARA COELI
late 18th century, oil on paper, 8 x 22 in (20 x 55 cm), Musée du Louvre, Paris

This painting is also known as *The Umbrella Pine*. The double title suggests that Valenciennes was unable to decide which was the dominant feature of the view – the pine spreading out to provide natural shade or the great convent building that offered refuge for the spirit. A warm ocher light shines from the building with the great diagonal of shade, and the rough exuberance of the tree on the left is balanced by the exquisite austerity of the umbrella pine.

"HE IS THE PAINTER OF PAINTERS"
Edouard Manet

THE TRUE CENTER *of this picture is the glass itself, in its radiant translucence, its utter purity, its susceptibility to reflection, and its significance as something both simple and unutterably precious. The young boy and the man seem to be standing in prayer, humbled by the presence and understanding of this common and life-giving resource: water.*

V
472

JUST AS THE GREAT *wrinkled ewer belongs with the ageing waterseller, so is the boy paralleled by the smaller jug, varied and slightly awkward in its dimpled surface, which shows that it has not been perfectly formed. The darker brown of the boy's jug is not sealed, but stopped by a smaller vessel of lighter hues, open, gleaming in the sunlight.*

THE WATERSELLER OF SEVILLE
c.1619–20, oil on canvas, 42 x 32 in (106 x 82 cm), Wellington Museum, London

VELÁZQUEZ, DIEGO 1599–1660 b. Spain
THE WATERSELLER OF SEVILLE

IF ONE WERE TO CONSIDER A MASTERPIECE in the context of an artist's life, nothing can equal *The Waterseller of Seville*, which Velázquez painted before he was 21. With its virtuoso range of effects, it clearly was intended to impress, and it was this great painting that helped to secure for the young Velázquez a position at the royal court. Most artists would have labored a long working life to have achieved anything like the seemingly effortless perfection of this image. Solid in their physicality, profoundly compassionate in their depiction, the two main protagonists – the old man in the dignity of his poverty and the young man in the dignity of his youth – stand motionless, both clasping a precious glass of water. But perhaps the real heroes of this majestic work are the utensils themselves: the great swirling jug that looms in the foreground, beaded erratically with water drops and sealed with the gleam of an iron ring. It is caressed with such magisterial possessiveness by the seller's gnarled fingers that it becomes imbued with an aura of intangible significance that surpasses its material presence.

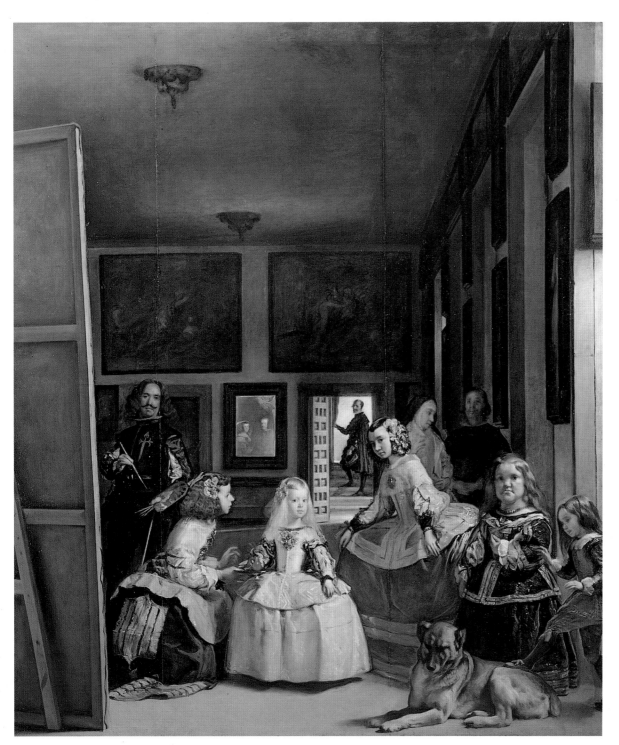

"ONE WANTS TO DO THIS THING OF JUST WALKING ALONG THE EDGE OF THE PRECIPICE, AND IN VELÁZQUEZ IT'S A VERY, VERY EXTRAORDINARY THING THAT HE HAS BEEN ABLE TO KEEP IT SO NEAR TO WHAT WE CALL ILLUSTRATION AND AT THE SAME TIME SO DEEPLY UNLOCK THE GREATEST AND DEEPEST THINGS THAT MAN CAN FEEL"
Francis Bacon

LAS MENINAS
c.1656, oil on canvas, 125 x 109 in (318 x 276 cm), Museo del Prado, Madrid

It seems almost impudent to subordinate the great work of Velázquez's maturity to an early work, but nothing can reduce the impact of *Las Meninas*, which many critics consider the greatest painting in the world. The wonder of its actuality, its ability to transcend time and involve us in the world Velázquez has created, its mystery and immediacy – these elude verbal explanation. Perhaps, above all others, this is a painting that must be seen and experienced to be understood.

VELDE, ADRIAEN VAN DE
1636–72
b. Netherlands

RIVER LANDSCAPE WITH HORSES AND COWS

THE VAN DE VELDE FAMILY, although less illustrious than the Ruysdael family, was even more prolific and greatly enriched the body of 17th-century Dutch landscape painting. One of the greatest was certainly Adriaen van de Velde. There is an indefinable poetry in a work like *River Landscape with Horses and Cows*. It has a luminous peace as the river catches the evening sun and reflects the animals grazing quietly on the banks. The wide stretch of river, bordered by feathery trees and miscellaneous buildings, seems abandoned by any presence except that of an imposing animal. The only human presence is so hidden in the shadows that, at first, we barely see him. This lack of any narrative interest is the essence of the painting's beauty; even the water does not move, and we can see the perfect reflection of small trees and buildings and admire the white horse, repeated in reflection for our delectation.

RIVER LANDSCAPE
WITH HORSES
AND COWS
*c.1660, oil on canvas,
16 x 26 in (41 x 66 cm),
Staatliche Museum, Berlin*

VAN DE VELDE'S HORSES, *in their truthfulness and nobility, recall that great horse-painter Stubbs. Here, the artist takes liberties with his paint, gently flicking a tree into existence against the skyline, and sweeping with great strokes of lightly tinted paint across the immensity of this expanse of sky.*

THE FARM
1666, oil on canvas, 25 x 31 in (63 x 78 cm), Staatliche Museum, Berlin

Although the farm is variegated in its color and admits extremes of darkness and light, it still preserves that inner stillness and sense of spiritual presence that distinguishes Adriaen van der Velde at his greatest. He sets us far back into the meadow, so that we look through the narrowing tunnel of the scattered trees, across the small farm, and up to the fence where the milkmaid sits. On the right, ducks paddle in the pond and a horse comes quietly to drink.

VELDE, WILLEM VAN DE THE YOUNGER

1633–1707 b. Netherlands

DUTCH VESSELS AT LOW TIDE

WILLEM THE YOUNGER was brother to Adriaen, both being sons of Willem van de Velde the Elder. The brothers shared a natural instinct for silence, but they seem to have divided the world between them: Adriaen got land; Willem got the sea. It is not the ships in themselves that interest the average viewer, so much as the pattern into which Willem the Younger has organized them: they fill his canvas with noble verticals and diagonals, forming a crescent around which small, naked figures cavort. The men seem rather to be paddling than bathing (perhaps, like most sailors of the past, they could not swim). There is a very pleasant contrast between, on the one hand, masculine vitality – represented by the activity of the sailors on board the ship, all busy with their occupations, and the fully-clad individual who walks across the front of the picture, and, indeed, the armored strength of those large vessels – and, on the other hand, the slim, fragile, vulnerable bodies of the bathers.

A DUTCH VESSEL IN A STRONG BREEZE
c.1670, oil on canvas, 9 x 13 in (23 x 33 cm), National Gallery, London

The sea can never be trusted, as can the land, to remain passive. Here, Willem undertakes that great artistic challenge – to show a ship grappling with the wind, and yet not overcome. The wild sea finds a rhyme in the sky, in which layers of threatening cloud bear down upon the ship, as if to bend it backwards into the waters. The outcome is left unresolved.

GREAT SHIP *and small men are confined into the bottom quarter of the picture. Only the sails, with their aspiration towards the heavens, soar up into that huge sky, where blue and white co-exist in perfect harmony.*

THERE WERE MANY *specific technicalities to be learned by a sea painter, and Willem was renowned for the exactitude with which he understood the varieties of vessel. There are four types of sea-going craft in this picture: three ships and, away in the distance, a small fishing boat.*

DUTCH VESSELS CLOSE IN SHORE AT LOW TIDE, AND MEN BATHING
1661, oil on canvas, 14 x 17 in (36 x 43 cm), National Gallery, London

VERMEER, JAN 1632–75 b. Netherlands
ALLEGORY of PAINTING

WHATEVER THE OSTENSIBLE SUBJECT of a Vermeer painting, its true subject always seems to be light. He is enraptured by the endless excitement of light playing silently over different surfaces. Here, light floods in, playing on the beams of the ceiling, glinting on the curlicues of the strange brass chandelier, exploring the folds and the creases of the great parchment map, and then flooding down onto the walls and the two figures, over the black and white tiles of the floor, and ending with the great sweeps and swirls of light and shadow on the curtain. So intensely does Vermeer absorb us in the light, that we tend to forget the secondary meaning, that here is an allegory of painting. The artist is painting Clio, the Muse of History. The artist's model is laden with the Muse's attributes: the book representing the art of history (thought to be by Herodotus), the trumpet of fame, and the laurels of victory. The map behind her symbolizes that history will broadcast fame throughout the world. It is not the Muse herself, but the artist's painting of it that intrigues Vermeer. Typically, it is not the artist as a person, but the artist as a function that interests him.

GIRL WITH A PEARL EARRING
c.1660, oil on canvas, 18 x 16 in (46.5 x 40 cm), The Mauritshuis, The Hague

This is perhaps the least complex, at one level, of all Vermeer's paintings. There is no background, no setting, the young woman simply turns to us and allows a mysterious light to irradiate her, and yet here is poetic beauty at its most indescribable. It seems impossible to explain why that shimmer on the pearl, why that brightness in the eye, and that gleam of moisture on the lower lip should seem to us so supremely beautiful.

WE ONLY SEE *the back of the artist, that wonderful mass of black with the black-and-white stripes, and the intensity of the shoulders. He has started at the top of the canvas, with Clio's laurel wreath, which is perhaps enough to explain Vermeer's secondary meaning: to paint at all, to live in the light and try to transcribe its glories, is to have won the laurels.*

THE CURTAIN *is a give-away to the constructed nature of the scene. So completely does Vermeer convince us that we are watching with him, that we can forget that this has all been set up for a deliberate artistic purpose, and that the curtain has been drawn aside, symbolically, for us to have a glimpse of the mystery of artistic creativity.*

ALLEGORY OF PAINTING (THE ARTIST'S STUDIO)
c.1665, oil on canvas, 47 x 39 in (120 x 100 cm), Kunsthistorisches Museum, Vienna

VERNET, CLAUDE 1714–89 b. France

A RIVER WITH FISHERMEN

VERNET WAS ONE OF THE MANY young artists who, in their late teens, went to Rome and found it very difficult ever to leave. He stayed there 19 years until recalled to France by the King. He painted *A River with Fishermen* while he was still enjoying what he felt was the enchanted life of Italy. It is an imaginary landscape and perhaps all the more glorious for that. On both sides of the river cluster fishermen, but although they are emphasized in the title, the evening light concentrates on the slender girl in scarlet and her excitable hound silhouetted against the pallor of the water. What rescues this image from being just one more beautiful river scene is that extraordinary tree jutting out illogically in the space between the cliffs, forcing our attention to itself and reminding us in its absurd diagonal that life is not rational.

A RIVER WITH FISHERMEN
1751, oil on canvas, 23 x 29 in
(59 x 74 cm), National Gallery, London

STORM ON THE COAST
1754, oil on canvas, 38 x 51 in (97 x 129 cm), Haworth Art Gallery, Accrington, UK

Vernet painted this imaginary port with an imaginary storm during the ten years that he spent painting the actual ports of France for Louis XV. The scene sizzles with drama: lightning zigzags through the sky; a ship crashes onto the rocks while its passengers drown, struggle, and scramble ashore. Bystanders at the port watch in dismay.

ON THE LEFT,
*the cliff still holds the
warm rose of the setting
sun, as do the upper
branches of the tree and
the young woman. On
the right, the cliffs are
sinking into the drab
anonymity of twilight.*

VERNET MAY *not
have experienced this
actual scene, but he
has certainly experienced
the atmosphere: the
sense of tranquillity,
of sunset, of the day
ending. It is with that
strange intensity of
emotion recollected
that he transfuses his
picture and makes it
linger in the memory.*

VERONESE, PAOLO c.1528–88 b. Italy
ALLEGORY OF LOVE I

VERONESE IS THE GREAT VOLUPTUARY – in the noblest sense of the word. He is, above all, the painter of amatory encounters in which man and woman play out infinite moves of mate and checkmate. He painted a great series called *Allegory of Love* – love in the precise sense of sexual involvement. The first work in the series, traditionally called *Unfaithfulness*, is the most intriguing. We see the woman from behind – a great statuesque blonde, with gleaming marble-white skin, holding out her arms to two different men. This great see-saw gesture bestraddles the picture, linking the two contestants for her favors. Both lovers seem enthralled, while two cupids watch the goings on of this human Venus with an unchildlike solemnity. Secretly, the woman is either passing a note to the younger man or receiving it from him. The point of the action is the duplicity, the desire to hide from one lover her intimacies with the other. Veronese is not just providing a witty illustration of female inconstancy – the arms that give themselves with equal abandon in two directions – he is also lamenting human inconstancy and the pain it can give, as foreshadowed in the face of the bearded lover.

ALLEGORY OF LOVE II
c.1570s, oil on canvas, 73 x 74 in (187 x 189 cm), National Gallery, London

The second part of the allegory is traditionally called *Scorn*. Here, the villain is the male, holding up his arm in mock dismay as the little cupid beats him with a bow as a punishment for his lack of reverence for womanhood. With looks of displeasure and disdain, the two women (one with an ermine symbolizing chastity) are withdrawing from the scene, leaving the man to his chastisement. He colludes in this, and Veronese is suggesting that it is all play-acting: this is not love, this is courtship.

THE OLDER LOVER *has an almost worshipping look on his face, and he holds her hand tenderly (older is, of course, a relative term – those are very vigorous legs that we see). He is backed by a strong tree trunk, which is tantalizingly crossed by another. The lover on the left, however, whose curls are tickled by an errant bough, has a certain flippancy in his approach.*

ALLEGORY OF LOVE I
c.1570s, oil on canvas, 75 x 75 in (190 x 190 cm), National Gallery, London

VERROCCHIO, ANDREA DEL c.1435–88 b. Italy
THE BAPTISM OF CHRIST

Verrocchio was primarily a sculptor, and there is a massive angularity about the shapes here that suggests this. He was also the most popular teacher in Florence, with many commissions constantly in progress, which makes it difficult to tell how much of a work the master did himself and to what extent he delegated to his pupils. The two central figures in this picture certainly are by Verrocchio. They dominate the rocky setting: John the Baptist, austere and dedicated, stepping forward to pour the waters of baptism; and the magnificently muscled young Christ with His head bowed humbly, while two angels wait beside the river to throw a cloak around Him. Verrocchio knows how bodies work, that large men have large feet, and that gestures need to be emphatic if they are to be noticed in an altarpiece. He also had a magnificent sense of color; the pale orange of John's robe contrasts with the dark olive green of his jerkin and with the extraordinary pink loincloth with which Christ is girded, with its entrancing pattern of black stripes. Above hovers the Holy Spirit, and to the right a worldly bird flies off into the dark trees, reminding us that this is earth, not heaven.

TOBIAS AND THE ANGEL
1470–80, tempera on wood, 33 x 26 in (84 x 66 cm), National Gallery, London

This is a story in the Old Testament in which Tobias sets out to recover the debt of his blind father and the angel Raphael comes to guide him. It is a biblical fairy story full of adventures, and the two heroes are shown accompanied at every step by Tobias' faithful dog. What is particularly attractive here is the relationship between boy and angel, the delicacy with which Tobias puts his arm through the angel's, laying a tentative thumb on his hand. The wings were invisible to Tobias, but clearly this wide-eyed youth is aware – as is the dog – that something mysterious is afoot.

AS A SCULPTOR, *Verrocchio must have delighted in his chance to depict a convincing landscape – the crystal water flows away into the distance, where the rocks and the hills give both a sense of place (the desert of Palestine) and a sense of destiny. The world ahead is challenging for both the baptist and the baptized.*

IT IS GENERALLY *accepted that the stocky and sturdy angel on the right was painted by Verrocchio. The angel on the left, however, with his golden curls and air of elegance, is an early work by his pupil Leonardo, and it says much for the strength of Verrocchio's imagination that his work can encompass this alien and almost epicene image without discomfort.*

THE BAPTISM OF CHRIST
c.1478–80, oil and tempera on wood, 70 x 59 in (177 x 151 cm), Galleria degli Uffizi, Florence

VIGÉE-LEBRUN, ÉLISABETH 1755–1842 b. France

PORTRAIT OF COUNTESS GOLOVIN

AS A PROMINENT SOCIETY FIGURE and court favorite, Vigée-Lebrun was forced to flee Paris after the Revolution of 1789–99 and spent six very successful years in Russia, where she became intimate with Countess Golovin. This is one of the most engaging portraits ever painted. The Countess sweeps up her luxurious shawl, drawing our attention, quite unconsciously, to the piquant vivacity of that sparkling face and the unconventional freedom with which her dark curls tumble over her back. Vigée-Lebrun understood and loved Countess Golovin; she would, no doubt, have grieved at the way gossip had surrounded this unusual woman, forced into exile from the most status-conscious of royal courts (for different reasons, Vigée-Lebrun herself suffered the same fate of banishment). We warm with affection to this intelligent, charming, and elusive character, who surveys us with wide-eyed frankness, but whose gesture is one of concealment.

SELF-PORTRAIT
1790, oil on canvas, 39 x 32 in (100 x 81 cm),
Galleria degli Uffizi, Florence

Vigée-Lebrun is of that rare band of women artists who succeeded both financially and socially. Her proudest boast – at least until the French Revolution, when she quickly removed her studio to a more favorable environment – was that she was a friend of the French Queen, and we similarly discern that the work in which she is engaged, so smilingly, is in fact a portrait of Marie Antoinette. Vigée-Lebrun shows herself as beautiful, but she is also as careful to show herself as skilful. She has an impressive array of brushes, and she gracefully outlines her painting hand, which is almost fully duplicated by its shadow.

THE COUNTESS WRAPS *her large and soft scarlet shawl tightly around her body in an unconventional gesture that both conceals and accentuates her sensuality. Vigée-Lebrun demonstrates her brilliancy through her ability to show us a friend, while not drawing us into the intimacy of that friendship. In a moment the countess will sweep her hand down, but Vigée-Lebrun has captured forever the sparkling charm of this unconventional pose.*

PORTRAIT OF COUNTESS
GOLOVIN, *c.1800,*
oil on canvas, 33 x 26 in
(84 x 67 cm), Barber Institute
of Fine Arts, Birmingham, UK

VIVARINI, BARTOLOMEO c.1432–c.1499 b. Italy
ST LOUIS OF TOULOUSE

THE VIVARINI WAS A FAMOUS FAMILY of Venetian painters, and Bartolomeo was the family genius. It was a rather askew genius, confounding the conventional expectation with a sly humor. St Louis of Toulouse was an historical figure, although his story acquired almost legendary significance. He had given up a throne to become a Franciscan friar and was immediately forced by the papacy into accepting the very responsibility he feared and the trappings of wealth he rejected – he was made bishop. Here, we see that under his episcopal grandeur Louis is wearing a version of the Franciscan habit. It has a suspicious gleam, as if it was not rough cloth but silk, but it is the artist's way of drawing our attention to the saint's true desire. St Louis's face dominates the picture: that strange sideways glance, that curious air of indifference. It is a haunting face – at once sensual and austere. He may be wearing the appropriate ecclesiastical garments, but he remains his own man.

ST LOUIS OF TOULOUSE
c.1465, tempera on wood, 27 x 14 in
(68 x 36 cm), Galleria degli Uffizi, Florence

VIRGIN AND CHILD WITH SAINTS PAUL AND JEROME
c.1460s, tempera on wood,
37 x 25 in (95 x 64 cm), National Gallery, London

What distinguishes Vivarini's version of the Virgin and Child is the cuddlesome charm of the baby, the remote, girlish beauty of the mother, and the strangely threatening aspect of the two saints who press in on either side. St Paul on the left holds his attribute of the sword almost aggressively, and St Jerome, with his bible, crowds in with his frowning, elderly face. Mary and the Child seem resolved to ignore the two saints behind them.

THE THREE KNOTS *on St Louis's girdle represent the three vows that the Franciscan makes: poverty, chastity, and obedience. However, he is clad with extraordinary richness. His bishop's miter gleams with jewels, his gloriously embroidered cope is held together by a diamond clasp, and over his gloved fingers are pushed jewelled rings.*

VLAMINCK, MAURICE DE 1876–1958 b. France
THE RIVER

It was the critic Louis Vauxcelles who first applied the word "fauves" (wild beasts) to the early followers of Matisse, because of the expressive force with which they used color. They themselves, however, were perfectly well-mannered young men – except, perhaps, for Vlaminck. Here was an artist who loved the thought of himself as a wild beast, who loudly proclaimed his ignorance of any instruction, and who shunned the great museums. Despite these self-inflicted constraints, Vlaminck was, nevertheless, a genuine and powerful artist. *The River*, fierce and primitive, grips our attention with those colors in which he took such painterly pleasure. They are brilliant and bright, aggressive in their certainty, and, although there is nothing in the picture that should arouse anxiety, we still feel those clouds in the streaked blue of the sky might soon give way to a storm. There is always a glowering darkness in Vlaminck's work, a sense of violence barely held in check. The artist's skill is to restrain this world, to parade it, and yet to keep it from disintegrating into the fierce fragments of exploding passion. Vlaminck holds the reins with a ringmaster's power.

THE RIVER, *c.1910, oil on canvas, 24 x 29 in (60 x 73 cm), National Gallery of Art, Washington, DC*

STILL LIFE
c.1910, oil on canvas, 21` x 26 in (54 x 65 cm), Musée d'Orsay, Paris

A still life, almost by definition, seems too innocuous a subject for Vlaminck, and yet he triumphs over the apparent limitations of the genre. His table, his fruits, his cloth, his vase, his askew picture frame, and even the wall itself, all seem to be trembling with an innate vitality. They blaze with activity, and we almost feel that the picture frame has been forced down aggressively towards the table in an attempt to gain control of the picture's composition.

"Only the colors on my canvas, orchestrated to the limit of their power and resonance, could render the color emotions of that landscape"
Maurice Vlaminck

The River vibrates with vitality. Houses, trees, sky, and water are held from explosion by the artist's will, imposing on these elements an intellectual structure. Vlaminck paints in great strong swipes of color, and he is intuitively aware of space and solidity. This is an entirely credible landscape, yet it conveys an immensely personal charge of emotions.

Vos, Cornelis de c.1584–1651 b. Netherlands

MAGDALENA AND JAN-BAPTIST DE VOS

FEW ARTISTS HAVE BEEN SUCCESSFUL at painting young children – think of all those podgy depictions of the infant Christ. Cornelis de Vos is one of the glowing exceptions. He is helped here, perhaps, in that Magdalena and Jan-Baptist are his own children (his four-year-old daughter and three-year-old son), but his ability with the subject matter goes beyond family ties. He has a sympathy with the excitement and unpredictability of a child's world, in which every event comes as new – nothing is taken for granted. He paints them in their Feast-day best, and, although the heart aches for young children so overdressed and confined in the weight of costumes that are precise miniatures of adult wear, they are delightful in their spontaneity. Both are wearing party hats and the artist seems to have caught them almost surreptitiously enjoying party fruit. They look up and around, not startled, but very conscious of his presence.

ALLEGORY OF EARTH
17th century, oil on canvas, 55 x 48 (140 x 122 cm), Johnny van Haeften Gallery, London

Vos made his name as a portrait painter, but he was also quite capable of producing an allegorical work. This enchanting little creature, with her big bright eyes, her thrusting bosom, and her feet insouciantly poised to swing into activity, is a delightful symbol of the vitality of earth. It is the expression on the girl's face that charms us – that vivid, interested, alert look. It is a picture that makes us feel entirely happy about being earthbound.

CORNELIS DE VOS *has caught the body language of the child, with Jan-Baptist's little feet stuck out before him in his fine new shoes, and his elder sister bossily taking charge of the fruit that is for both of them. It is not just the superb rendering of what he saw – the setting, the bodies, the clothes – that makes this so memorable, but the artist's affection. His love for his children exudes from the painting.*

THE ARTIST HAS SEATED *his children out of doors. The sun is setting and the freshness of the children is contrasted with the lurid sky and the darkening world that will soon hide the rivers and towers. The children's pink and rounded cheeks, bright eyes, and the curls twisting exuberantly under their bizarre hats have all been painted with an affectionate realism.*

MAGDALENA AND JAN-BAPTIST DE VOS *c.1622, oil on canvas, 31 x 36 in (78 x 92 cm), Staatliche Museum, Berlin*

VOUET, SIMON 1590–1649 b. France
WEALTH

BAROQUE ARTISTS LIKE VOUET felt very much at home with the allegory. It enabled them to create new worlds full of grandiose and imaginary personages, while still maintaining the seriousness of a moral message. *Wealth* is a particularly delightful example of allegory. For once, the accumulation of riches is not regarded as an occasion for breast-beating, as it so often was during Medieval times. As a French courtier, Vouet regards conspicuous consumption as a thing good in itself, and his figure of Wealth is an ample and richly colored matron. But the child in her arms suggests another form of wealth: loving and being loved. To have a family and be able to support it in ease is one of the sweetest attributes of having money, and the clasping hands indicate that what matters most to this woman is her small child.

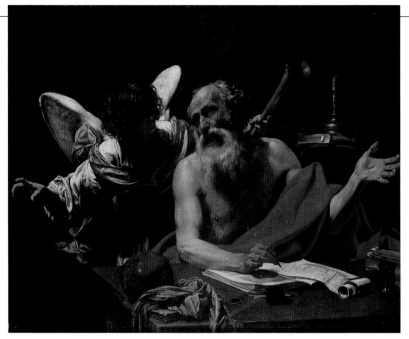

ST JEROME AND THE ANGEL
c.1625, oil on canvas, 57 x 71 in (145 x 180 cm),
National Gallery of Art, Washington, DC

Sometimes it would seem that St Jerome is the most frequently painted of all saints. Here, light falls full on this intellectual saint as he struggles with his translation of the Bible, but the most beautiful figure is the angel, face darkened, wings illuminated, and holding in one hand the golden trumpet of fame. St Jerome looks straight at the angel and is clearly aware of the presence of inspiration. However, his face is darkened as if to indicate that understanding that inspiration, and rendering it articulate, is a difficult task.

WEALTH'S GARMENTS, *flowing wide and luxuriantly around her, suggest something of that luxurious freedom that comes with having money, and she wears the laurel wreath of triumph – again an aspect of richness. At her side a little putto lifts necklaces and bracelets for her delight, and we see that his chubby knee rests upon some golden objet d'art.*

WEALTH ALLOWS ONE *to indulge in a love of art, as is seen by the great urn that rises up with such power beside the allegorical figure. It enables one to indulge one's love of literature, as we can see in the book that lies open before her. The grandeur of architecture is also accessible to the wealthy – notice the strong but austere pillars that form the background.*

WEALTH
c.1630–35, oil on canvas,
67 x 49 in (170 x 124 cm),
Musée du Louvre, Paris

VUILLARD, ÉDOUARD 1868–1940 b. France

PORTRAIT OF THÉODORE DURET

VUILLARD IS THE GREAT PAINTER OF INTERIORS and since the interiors of his youth were Victorian, he was supremely at home with the idea of clutter. He had lived in a household of women, with his mother and sister, who were busy dressmakers, and an awareness of the fabrics flung over all the surfaces and the constantly changing patterns stayed with him all his adult life. Here, he paints Théodore Duret, an art critic who had understood and championed the Impressionists. Duret sits almost imprisoned in the chaos of his study. On all sides we see evidence of his enthusiasms. The room encloses him, but it does so in a radiance of color, shape, and pattern. It is a supremely decorative picture – decoration not overwhelming the solid bulk of the sitter but complementing him, suggesting the richness of his inner life and the multiplicity, even in old age, of his interests.

MOTHER AND CHILD
c.1899, oil on cardboard, 19 x 22 in (49 x 57 cm), Glasgow Museum and Art Gallery

The charming clutter of this small room is typical of Vuillard. It is almost an abstract pattern in which we have to search out the human beings from among the glorious diversity of shapes and colors and intricate forms – where the figures themselves are subsumed into that pattern. There is the young mother and the round, rosy head of her baby, and, behind on the bed, two small dogs. Vuillard's genius is to convey the intimacy of this little scene and yet maintain as the focus of his interest its decorative quality.

REFLECTED IN THE MIRROR *over the mantelpiece is Whistler's portrait of Duret in his youth – a young opera-goer with a top hat in his hand and a woman's cloak draped over his arm. Vuillard is making an affectionate contrast between that vibrant young man, active in society, with this old scholar, sitting wearily at his empty desk with no companion but his cat.*

THE CAT LOOKS UP *at the artist as if aware of his presence, whereas Duret sinks into himself – lost in reveries of the past. Here is an old scholar, at least that is how Vuillard wishes us to see Duret. In actuality, he was more of an art critic and a dealer, but Vuillard certainly wishes to convey the idea of Duret the scholar, with his books and catalogs stacked high.*

PORTRAIT OF
THÉODORE DURET, *1912, oil on cardboard, 37 x 29½ in (95 x 75 cm), National Gallery of Art, Washington, DC*

WALLIS, ALFRED 1855–1942 b. England

"THIS IS SAIN FISHERY THAT USED TO BE"

ALFRED WALLIS WAS A RETIRED FISHERMAN in his seventies when the artists Ben Nicholson and Christopher Wood, out on a trip to St Ives, discovered his paintings on pieces of cardboard cut from boxes. Poor and barely literate, Wallis is the example *par excellence* of the untaught, primitive painter. He was a man who had rarely seen a painting and yet who instinctively sought to make sense of his world by creating images. He remained primitive – despite the interest taken in his work by the famous visitors – and continued using jagged pieces of card as his canvas, skilfully adjusting his image to the shapes of the surround. This painting is greatly irregular in format, yet the rough edges are entirely appropriate for the subject: the memory of a sight that Wallis had often seen in his youth, when dangling seine nets were set with weights and floats to catch pilchards.

"THIS IS SAIN FISHERY THAT USED TO BE", *date not known, oil and pencil on card, 16 x 23 in (41 x 58 cm), Private Collection*

WRECK OF THE ALBA
c.1939, oil on wood, 14 x 27 in (38 x 68 cm), Tate Gallery, St Ives

Any man who lives as a fisherman has lived with drama, but by and large few lives could have been more without incident than that of Alfred Wallis. However, one incident – the wreck of the *Alba* – made a deep impression on him. This is a genuine attempt to produce a serious narrative. Great waves split the ship in two, while, belatedly, a rescuer chugs towards it. From his God's-eye viewpoint, Wallis looks over a world of wild water and the remote securities of land. Paradoxically, the very innocence of his approach – his freedom from taught techniques – makes this cry of distress even louder.

WALLIS NEARLY ALWAYS PAINTED *from memory, with a nostalgia for the old times and an eagerness to recall the colors truthfully – he said he had no time for paintings that were ruined by putting colors where they do not belong.*

FOR ALL ITS APPARENT NAIVETY *and spontaneity, this painting is a deeply considered work. In it, Wallis seeks to express a visual truth, which he does with a grace and earnestness that gives the work an exceptional power.*

THE USE OF SEINE NETS *had virtually died out when Wallis painted this picture, but he remembers the activity with conviction. Standing bravely erect in the middle of the scene is one small fisherman pulling at his nets.*

WARHOL, ANDY 1928–87 b. US
MARILYN DIPTYCH

ANDY WARHOL UNDERSTOOD THAT ART can only be made out of concerns that personally affect the artist. He was interested in what might be described as contemporary vulgarities: he loved glamour and fame and he read the gossip columns; he reacted with prurient enthusiasm to disaster. All of these interests met in the figure of Marilyn Monroe. Here was a subject made for Warhol, and he treated her with profundity. He understood that to be famous means to be nothing – to have been stripped of one's private individuality and become the property of the world. Marilyn's images survive, but attacked, vandalized, hardly recognizable. Warhol is meditating on life and death. It seems to me that he makes an unmistakable claim to artistic significance.

GREEN DISASTER TEN TIMES

1963, silkscreen ink on synthetic polymer paint on canvas, 105 x 79 in (267 x 201 cm), Museum für Moderne Kunst, Frankfurt, Germany

By reducing the horror of a car crash to a mere green and black, and repeating it ten times, Warhol leaches the scene of its personal tragedy. It has become a news item. The violent death, with its screams, blood, and pain, has been distanced from the voyeur, who sees without involvement. Warhol plays out this hardening of the heart on a vast scale, both as an indictment and as an act of denial.

MARILYN DIPTYCH
1962, acrylic on canvas, 162 x 114 in (411 x 290 cm), Tate Gallery, London

USING THE IMPERSONAL *medium of silk screens, Warhol shows us a hundred images of Marilyn, daubed roughly and crudely with color, emphasizing that only the image itself matters. Gradually, this image is deprived even of the false glamour of color and is reduced to the black and white of death.*

WATERHOUSE, JOHN WILLIAM
1849–1917
b. Italy, active England

HYLAS AND THE NYMPHS

WATERHOUSE WAS A QUIET AND UNASSUMING man, who apparently lived a life of blameless rectitude. Yet his special gift seems to have been an ability to portray the *femme fatale*. To this end, he brought two great qualities: a Pre-Raphaelite sense of realism, enabling him to create settings of convincing truthfulness; and a classical ideal of beauty, which makes his ladies highly seductive examples of their sinister kind. Hylas is a figure from Greek mythology who journeyed with Hercules to find the Golden Fleece. When they stopped on an island, Hylas went to find water, and was lured to his death by water nymphs. Here we see Hylas with his jug, bewildered by the attentions of these seven unclad maidens. Their imploring eyes and delicate features give no hint of their murderous intent, and the quick of the story reveals a very dark view of life and human relationships: beautiful and apparently innocent girls will be the destruction of equally innocent young men.

CIRCE OFFERING THE CUP TO ULYSSES
1891, oil on canvas, 58 x 36 in (146.4 x 90.2 cm), Oldham Art Gallery, UK

Here is Circe, another *femme fatale* – the empress of the genre, in fact. Through her seductions, men were turned into beasts (an unsubtle metaphor for the power of wild sex). In the mirror, we see the lurking figure of Ulysses, the only one of his crew wily enough to resist the enchantress. Circe's very throne depicts lions tamed, while a tragic and bloated hog slouches at her side, no vestige remaining of its original humanity.

HYLAS AND THE NYMPHS
1896, oil on canvas, 38 x 63 in (97 x 160 cm), Manchester City Art Gallery, UK

THE DARK MESSAGE OF Hylas and the Nymphs *is charmingly non-explicit. Hylas, with his sunburned skin and bright clothes, suggests the possibility of normal life, while the nymphs are pale-skinned creatures of another world; Waterhouse makes us aware of the contrast with the gentlest of touches.*

WATTEAU, JEAN-ANTOINE 1684–1721 b. France
PIERROT: GILLES

WATTEAU DIED YOUNG. NEVER HEALTHY, HE WAS A FRAIL, difficult consumptive. Yet it is impossible to imagine that his art, had he lived and had he been stronger, would have changed. There is a particular Watteau quality – wistful, bitter-sweet, aware of life's beauty and fragility – that is utterly distinctive to his art. His work can sometimes seem too melancholic to be profound, but at his greatest Watteau presents us with unforgettable images. *Gilles* is one of these. Much of Watteau's art was based on the commedia dell'arte, the half-improvized, half-soap-opera dramas that enlivened the theaters of the 17th century. Here, Watteau is turning his back on the story – that very quality that made the commedia dell'arte so enchanting to its admirers – and is concentrating rather on this individual person. Gilles is dressed in the ludicrous costume that the commedia required, but he is isolated from the plot, he has no role to play. Watteau shows us the real Gilles – without the artifice of drama – who stands bravely to endure our glance. The rigidity of his posture shows us that the ordeal is costing him, and perhaps what costs most for the actor is allowing the audience to see his real face.

THE FAUX-PAS
1717, oil on canvas, 20 x 16 in (50 x 41 cm), Musée du Louvre, Paris

When Watteau was not painting stories of the commedia dell'arte, he painted what the French called *fêtes galantes*. It was his speciality – lovers at an outdoor party. Here, there are just two lovers who have withdrawn to a quiet place, but clearly with different intentions in mind. The young man regards this as an opportunity, and reaches forward, one eager hand clasping her body to his. The young woman, on the other hand, is clearly in a mood for conversation. Equally clearly, they know each other well, for the hand that pushes him back does not do so with enormous force, and the delicate young woman, with that slender neck, is not frightened of her lover.

GILLES'S FACE IS YOUNG, and he is trying hard to appear impassive, to keep his hands still and his head upright. We know he is longing for the moment when he can step off his dais and retreat into the comforting protection of a plot and an actor's business. Here, Gilles is Pierrot, and behind him are other actors in the drama – the doctor on the donkey, and perhaps Harlequin with the funny hat.

WHAT ALSO MAKES this picture so very memorable is its extraordinary beauty – the light glimmering on the silks, the rapture with which Watteau has seen shadows playing with creases and folds, how he has dwelt upon the contrast between the warm, sunburnt, human hands and face and the cool suavity of material.

PIERROT: GILLES, *1721, oil on canvas, 73 x 59 in (185 x 150 cm), Musée du Louvre, Paris*

WATTS, GEORGE FREDERIC 1817–1904 b. England

HOPE

GEORGE FREDERIC WATTS WAS A PAINTER who viewed himself and the world with an immense moral seriousness that for us today seems rather off-putting. No-one likes to be preached at, and the desire to preach is never very far from the surface of his paintings. In fact, Watts said that he painted so as to affect the mind seriously by the nobility of line and color. If we are honest, Watts does affect the mind, and if we approach this work without prejudice, we can see its beauty. *Hope* depicts a figure exiled from the world; he sits forlornly, barefoot, and clad in a ragged garment. This is the blindfolded figure of Hope, and the point of the allegory is that if we can see, then we have no need to hope. Hope not only holds a lyre but is chained to it. Yet the strings are broken and, although Hope forlornly lifts a hand to play, only the most fragmented of music will be possible. One hand grips the lyre with almost unbearable tension, while the other uselessly plays upon it. Watts uses the palest of colors and the gentlest of lines. At one level, he paints a defeated figure, yet Hope sits there patiently, waiting for something to change his present circumstance.

CHOOSING
*1864, oil on canvas, 19 x 14 in
(47 x 36 cm), Private Collection*

Although Watts only valued his specifically moral paintings, he was, in fact, a great portrait painter. *Choosing* has an added poignancy in that it is of his young wife, the famous Ellen Terry. Watts was a reclusive artist of nearly fifty when he fell in love with this enchantingly beautiful young actress. The marriage lasted little more than a year, but here he is still enraptured, as perhaps he always was, by her beauty. She inhales the scent of a camellia while in the other hand she holds a rosebud. For someone so beautiful, Watts implies, life can only be a choice between two perfumes.

IT IS THIS QUALITY OF *waiting, of refusing to accept defeat, that a man like Watts understood so profoundly – he himself had many years without success. As we look at the picture we can see that, despite the apparent tragedy, light shines upon this broken figure, who will wait eternally, hoping.*

THIS PICTURE IS AN *instance where the moral message has been conveyed so subtly and with such personal sensitivity that it convinces us. In this gray world, hope is still luminous, beautiful, and inspiring.*

HOPE, *1886, oil on canvas,
56 x 44 in (142 x 112 cm),
Tate Gallery, London*

W
490

WEST, BENJAMIN 1738–1820 b. US, active England

VENUS LAMENTING THE DEATH OF ADONIS

WEST WAS BORN IN THE US, studied in Italy, and lived in London, where he eventually became president of the Royal Academy. He was an artist of classical decorum, whose powerful imagination was balanced by an innate sense of restraint – qualities that made him immensely popular in his own day, but less so in our own. The story of Venus and Adonis is found often in the Renaissance, usually as a theme for passionate sensuality. Venus – the god for whom every man felt desire – for once found herself under the spell of a love for Adonis. With divine foreknowledge, she saw that he would meet his death while hunting, but the young man rejected her warnings and rejected her embraces, only to end up gored by a savage boar. West has no time for the sensual – his Venus is a gracious lady of impeccable lineage and his Adonis is a slender youth whose only fault had been impetuosity.

THE DEATH OF GENERAL WOLFE
1770, oil on canvas, 59½ x 84 in (151 x 213 cm), National Gallery of Canada, Ottawa

This was West's most famous picture. In a stroke of avant-garde brilliance, he managed to turn the contemporary tragedy of the death of Wolfe into a historical event. It is, of course, completely fanciful in its details. The hero dies as heroes do on a stage, and the officers who surround him with such dignified grief were, in fact, elsewhere at the time. They are said to have paid a hundred pounds each to be included in this picture and thus immortalized.

VENUS MOURNS, BUT WITH *grace and dignity. Present also is Cupid, the little god of love himself, who understands this tragedy. To the right are the Serpentine necks of the swans, which draw the chariot of the grieving Venus. To the left and right we can see the brave blossoms of the anemone, the plant that grows from the blood of Adonis.*

VENUS LAMENTING THE DEATH OF ADONIS
1768–1819, oil on canvas, 64 x 69½ in (163 x 177 cm), Museum of Art, Carnegie Institute, Pittsburgh

WEYDEN, ROGIER VAN DER c.1400–64 b. Netherlands
DESCENT FROM THE CROSS

VAN DER WEYDEN'S *DESCENT FROM THE CROSS* is one of the supreme masterpieces of world painting. His format is simple: he has lined up ten figures, two or three deep, against a wall, and in this compression he has concentrated the essence of human death and human grief. In the center, a young man on a ladder lowers Jesus into the arms of Joseph of Arimathaea on the left and Nicodemus on the right. The stretch of the dead body of Jesus is paralleled by the extended stretch of Mary's robe as she sprawls unconscious, with all the implicit contrast between fainting and dying. Her bloodless face will flash into life again; His, humanly speaking, will not. Much of the drama is expressed by the hands. The hand of Jesus, limp in death, hangs down and yet does not touch the hand of His swooning mother. The dead feet of Jesus are opposed on the right by the open palm of the anonymous mourner and the twisted agony of the hands of the Magdalene, writhing in pain. The extraordinary shape of the work, which rises abruptly to accommodate the Cross and which forces its ten actors into a box-like proximity, heightens the tension. However, apart from Mary Magdalene, the protagonists do not display their grief with extravagant gestures; the tragedy of the death of Christ and its consequent pain is made all too visible in van der Weyden's restraint.

ST JOHN SUPPORTS THE VIRGIN, *with Mary, the wife of Clopas, holding her as she collapses, her lower hand curved in an attitude of acceptance between a skull and the strong young foot of John. The work is bracketed with grief: from the mourning woman on the left, to Mary Magdalene on the right, closing the frame in a parabola of pain.*

DESCENT FROM THE CROSS *c.1435, oil on wood, 87 x 103 in (220 x 262 cm), Museo del Prado, Madrid*

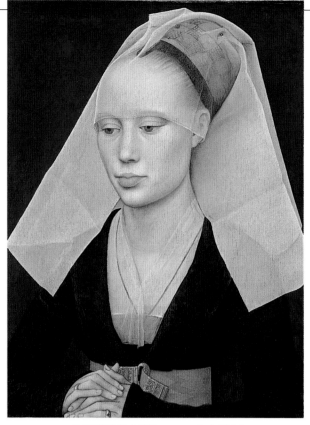

PORTRAIT OF A LADY
c.1455, oil on wood, 14½ x 11 in (37 x 27 cm), National Gallery of Art, Washington, DC

This austere beauty is possibly more appreciated in our day than in the 15th century, yet one feels that van der Weyden thrilled to every nuance of this mysterious woman. The fashion of the day – hair plucked from the forehead to reveal an intellectual brow – seems strangely apposite. One feels that if the subject raised her eyes, the look would be piercing and confrontational.

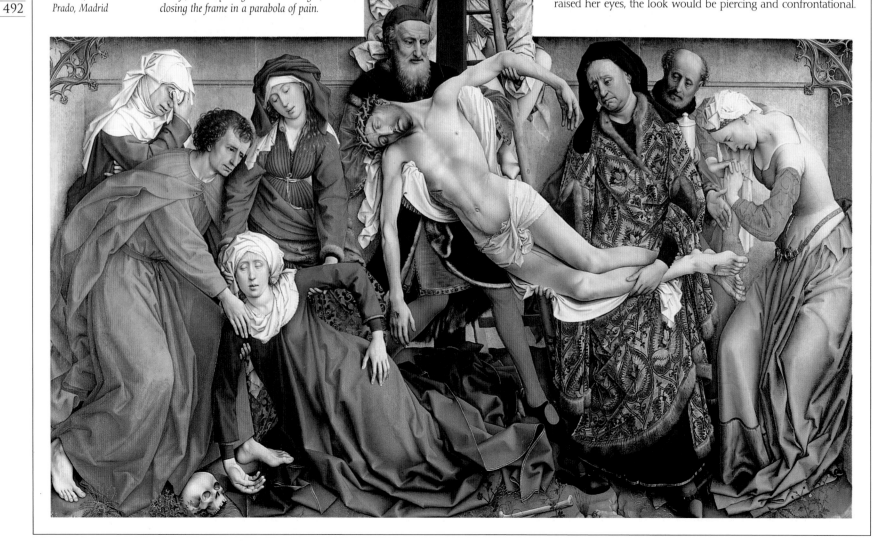

WHISTLER, JAMES 1834–1903 b. US

HARMONY IN GREY AND GREEN: MISS CICELY ALEXANDER

HAVING YOUR PORTRAIT painted by Whistler was not easy. He was a perfectionist and demanded hours upon hours of patient sitting or, in this case, standing. We can understand why young Cicely has a rather disgruntled expression, but it was worth the wait; this is a superb illustration of the fragility and sweetness of youth. Cicely is as fresh and delicate as the daisies springing up at her side, and like them she must accept the ravages of time. The same fragility of beauty is symbolized by Whistler's favorite motif of the butterfly (they hover above Cicely's head, and his famous "butterfly" signature can be seen on the back wall). The brightest color in the picture is her face, with those rosy, pouting, and unhappy lips. All else seems to float upon the canvas: whites, grays, blacks, so subtle, so nuanced that they seem to dissolve and reform themselves before our very eyes. Perhaps "infinity" – infinitely beautiful, infinitely graceful, infinitely vulnerable – is the word that best sums up this picture.

HARMONY IN GREY AND
GREEN: MISS CICELY ALEXANDER
*1872–74, oil on canvas, 75 x 39 in
(190 x 98 cm), Tate Gallery, London*

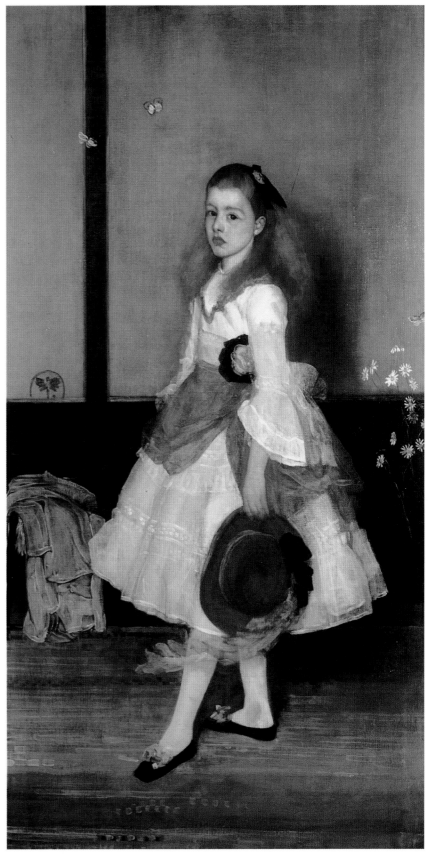

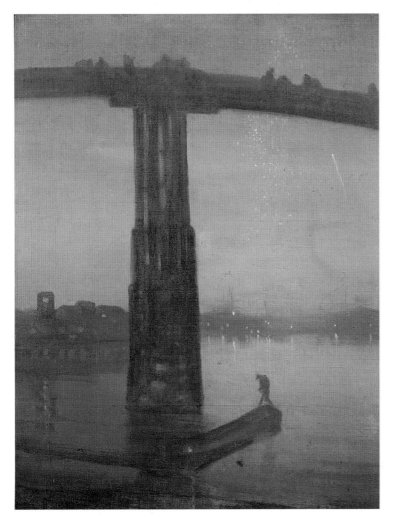

NOCTURNE: BLUE AND GOLD
*1872–77, oil on canvas, 27 x 20 in (68 x 51 cm),
Tate Gallery, London*

Whistler felt an affinity with the music of Frédéric Chopin and was convinced that the magical effects of Chopin's *Nocturnes* could be paralleled in paint. Here, around the form of old Battersea Bridge, is an efflorescence of golden fireworks and the scattered golden lights of misty London. We are meant to be affected, not by the details of the work, but by its whole harmony, to be moved as we are by music.

" I USED TO GET VERY
TIRED AND CROSS,
AND OFTEN FINISHED
THE DAY IN TEARS "
Mrs Cicely Rice,
née Alexander

WILSON, RICHARD 1714–82 b. Wales
SNOWDON FROM LLYN NANTLLE

IT WAS DURING THE 18TH CENTURY that the image of the mountain was transformed from fearsome to sublime, and here, perhaps, Richard Wilson is responding to this idea of sublimity. This is an actual view looking across lake Llyn Nantlle towards Snowdon, but Wilson has idealized and simplified it. His intention is not topographical – to recreate for us the actual outlines of lake and the towering mountain – but to awe us with a sense of the desolate grandeur of this setting. The mountain partakes of the nature of the sky. Both are unearthly colored, pale, and luminous with shifting shadow and cloud.

CAENARVON CASTLE
c.1760, oil on canvas, 24 x 48 in (61 x 123 cm), National Museum of Wales, Cardiff

As a Welshman, Wilson may have had an ambivalent attitude towards a castle like Caenarvon, built by the English in the days when they invaded the Welsh interior. Despite the bitterness of history, Wilson sees it as a splendid shape set in his native Welsh landscape. It is a picture about the importance and unimportance of the castle and the three dancers pay it not the least attention.

SNOWDON FROM LLYN NANTLLE, *c.1766, oil on canvas, 41 x 50 in (104 x 127 cm), Castle Museum and Art Gallery, Nottingham, UK*

WILSON HAS MADE LIGHT *the vehicle for almost staging our approach to this great spectacle. The lake reflects and emphasizes the great curve of the rocks that both bar our way forward and frame most magnificently the distant mountain.*

WITTE, EMANUEL DE 1617–92 b. Netherlands

ADRIANA VAN HEUSDEN AND HER DAUGHTER

DE WITTE SEEMS TO HAVE BEEN AN UNHAPPY and unstable character, who perhaps kept his balance through his interest in the outside world and his desire to paint it. Certainly, 17th-century Amsterdam must have been a world teeming with painterly interest, yet few artists ventured into the fish market. De Witte paints his landlady Adriana van Heusden with her daughter. The portly Adriana is engaged in intent conversation with a young fishmonger. Despite the fact that she is well-to-do (as is suggested by her costly jacket), the landlady is clearly refusing to be fobbed off with an inferior piece of fish. The fish themselves spread in glorious profusion over the stall and De Witte's eye obviously delighted in the silvery scales, in the pink flesh of salmon, and the darkened gleam of the many varieties of fish. As usual, the skate steals the limelight, arching in death agony – a circumstance that neither Adriana van Heusden nor the fishmonger can afford to linger upon with compassion.

ADRIANA VAN HEUSDEN AND HER
DAUGHTER AT THE NEW FISHMARKET
IN AMSTERDAM, c.1662, oil on canvas, 22 x 25 in
(57 x 64 cm), National Gallery, London

INTERIOR OF A CHURCH 1668
1668, oil on canvas, 39 x 44 in (99 x 112 cm), Boymans-van Beuningen Museum, Rotterdam

De Witte's preferred theme was the interior of a church. These churches carry the unmistakable mark of authenticity and it comes as a surprise to discover that this one is wholly invented. The artist has put together elements from various Dutch churches, combining them into what perhaps is his secret ideal - a church with massive pillars and round arches, with the cool light streaming into an uncrowded interior.

IT IS A SCENE of busy hussle, customers pass by at the rear and ships are anchoring in the harbor. The fresh breeze of the seaside at early morning seems to blow almost palpably through he picture. Adriana's little daughter is well aware that she is there to have her portrait painted and peeps out at De Witte with charming vanity.

DE WITTE has orchestrated his painting with cunning. The stall leans forward from right to left – a great thick diagonal in which the angle created by the struts holding up the canopy is repeated and reinforced by the posture of the young fishmonger. The line of the stall is met by the solid lump of the large lady who is haggling for her family's supper.

WITZ, KONRAD c.1400–44/46 b. Germany, a. Switzerland

THE QUEEN OF SHEBA BEFORE SOLOMON

WE KNOW VERY LITTLE ABOUT KONRAD WITZ, only his century, the fifteenth, and his workplace, the city of Basel in Switzerland. Nevertheless, he was an extremely interesting artist with an individual view of the world. This is, of course, a famous story: God asked Solomon to choose whatever he desired and Solomon chose wisdom. As the wisest man in the world he was greatly sought after, or so the Bible assures us, and the most famous seeker of his wisdom was the Queen of Sheba. This is a famous story that captivated the medieval imagination. There are few great queens in the Bible, and no other of such power and wealth. She lavished her gifts upon Solomon and said of his wisdom: "The half was not told me".

THE QUEEN OF SHEBA
BEFORE SOLOMON, *before 1437,
tempera on wood, 33 x 31 in (85 x 79 cm),
Staatliche Museum, Berlin*

THE MIRACULOUS DRAUGHT OF FISHES

1444, tempera on wood, 52 x 61 in (132 x 154 cm), Musée d'Art et d'Histoire, Geneva, Switzerland

This is a painting of historical importance, in which an artist attempted for the first time to show a place in its topographical accuracy. With superb insouciance, Witz has set this biblical scene on the shores of Lake Geneva. As a test of faith, Christ summoned Peter to walk with Him upon the water. Peter began successfully, but lost faith and sank. It is this instant that Witz, a natural dramatist, catches.

WITZ IMAGINES *the scene with an almost daring idiosyncrasy. The great Solomon seems absurdly young, a rather hunched, unimpressive figure. More remarkable is the splendor of his extraordinary bejeweled hat and green damask gown, which cascades with unparalleled fullness to the base of the picture and beyond. Solomon does not sit on the throne but on a long bench covered with scarlet silk.*

THE QUEEN *of Sheba is wearing a turban indicative of her exotic origins and a wimple, the mark of a modest woman. She, whom legend sees as glorious, is dressed with great simplicity and he, whom legends describe as authoritarian and wise, is arrayed with almost ludicrous pomposity.*

WOOD, GRANT 1892–1942 b. US
SPRING TURNING

GRANT WOOD BELIEVED PASSIONATELY that American artists must find their inspiration in America and free themselves from dependence on the European old masters. He was convinced that every artist should turn to his own region and celebrate it. *Spring Turning* is an extraordinary work. Wood has, of course, massively oversimplified and streamlined this vision of ploughing in the gently rounded hills of the Midwest. The great central squares, which the farmer and his horses will circumambulate, nibbling away at the greenery until all is brown ploughed land, make glorious abstract patterns. We see three fields in the process of being ploughed, and another one up on the far left shoulder in which the ploughing is finished, leaving it a mild brown hue. The intensity with which Wood stylizes the work, imposing an intellectual pattern on the scene, makes this landscape both realistic and abstract.

SPRING TURNING, *1936, oil on masonite, 18 x 40 in (46 x 102 cm), Reynolda House and Museum of American Art, North Carolina*

AMERICAN GOTHIC
1930, oil on beaverboard, 29 x 24½ in (74 x 62 cm), The Art Institute of Chicago

This painting is often misunderstood, I think, as almost a caricature of the virtues of the American Midwest. Although it is intended as a tribute, it nevertheless displays an ability to portray the relative unattractiveness of man and daughter. There is a strange subtext also, in the way the father elbows in front of his daughter and holds his pitchfork like a weapon, challenging us with a nonconformist gaze; she takes her rigid position and averts her eyes, possibly with resentment.

EVEN THE LITTLE HEDGEROW *on the right runs in an order of rigid regimentation. The very clouds have been disciplined and float like airships across the bright sky. The discipline of the artist echoes the discipline of the farmers. The small figures, laboring with their horses, are taming nature, turning what would be the wilderness into a fruitful and organized prairie.*

BY LOOKING DOWN ON THE SCENE *as though from a position of great height Wood gives the impression of regarding it almost with the omniscience of a divine eye. It is not an unthreatened world, and we notice very dark patches of shadow in three areas of the picture. But somehow the farmer himself is a figure of light, a positive element despite difficulty and threat.*

THE PAINTING IS A CELEBRATION *of the American desire to cultivate the wilderness and Wood is suggesting that the wilderness will only remain cultivated at a cost. But he does this with the lightest of touches, so that any moral teaching is swallowed imperceptibly. Spring Turning refers both to the turning of soil and the turning of spring into summer. It is a title of vigorous hope.*

WOUWERMAN, PHILIPS 1619–68 b. Netherlands

PATH THROUGH THE DUNES

THIS REMARKABLE PAINTING gives us an impression of a world in which humanity is not of great significance. Not only is Philips Wouwerman more interested in the sky and its drama than in any of the earthly activities, but the earth itself is shown to have an almost bizarre quality that scorns the rational order of the thinking man. The great, sandy surge on the right, with its scattered blobs of vegetation, is crowned by the extraordinary shape of a leafless tree, which stretches itself in all directions with an inventive eccentricity that clearly fascinated the artist. The tree that borders the house on the left obeys, as it were, the rules of "treedom" by neatly shooting its branches into the sky and layering them with leaves; but the trees on the wild dunes have a life of their own and the rough hedge with which man has attempted to control this environment seems a pathetic failure. The man and his inquisitive dog appear to function mostly as a pointer beyond the dunes into the wildness of the water. Behind them is another travesty of a fence, and then the wilderness that is paralleled – and perhaps even surpassed – by the drama of the sky.

HORSES BEING WATERED
17th century, oil on oak, 13 x 16 in (32 x 40 cm), Hermitage, St Petersburg

For some forever undiscoverable psychological reason, Wouwerman was attracted by the image of a man on horseback seen from behind. Here, we see that figure leading a splendid dappled horse to water. In this scene of contented tranquillity, the river flows golden and silent to the sea; little ships suggest an alternative mode of travel, yet the two great horses seen against the glory of that sky reveal what is dearest to the artist's heart: it is not horse as vehicle, but horse as inspiration and noble companion.

WOUWERMAN *has set his scene in a relatively civilized area of the countryside, where man has not completely abandoned his dominion. In the sky, great ominous storm clouds are brewing, and one hopes that the traveler will find shelter before nature exerts its full and overwhelming strength.*

PATH THROUGH THE DUNES, *17th century, oil on oak, 14 x 17 in (35 x 43 cm), Staatliche Museum, Berlin*

WRIGHT, JOSEPH 1734–97 b. England

AN EXPERIMENT ON A BIRD IN THE AIR PUMP

IT IS NOT THE EXPERIMENT that engrosses Wright of Derby so much as the reactions of the onlookers to the plight of the white cockatoo, which is being progressively deprived of oxygen in the air pump. The strange experiment exhibits a wanton cruelty, recognized only by the innocent. The father apparently exhorts his daughter to a greater hardness of spirit. This small circular group has come out of the darkness and stepped into the light, the very particular light that throughout the 18th century was the symbol of scientific advancement. Yet, science itself is double-edged.

We in the present day understand bitterly how its inventions can be used for ill as well as for good, and Wright is studying humanity's capacity to look truthfully on the spectacular.

AN EXPERIMENT ON
A BIRD IN THE AIR PUMP
*1768, oil on canvas, 72 x 96 in
(183 x 244 cm), National Gallery, London*

MR AND MRS THOMAS COLTMAN

*c.1770–72, oil on canvas, 50 x 40 in
(127 x 102 cm), National Gallery, London*

Marriage, of course, is a mystery, even to the married – perhaps most of all to the married. To me, this painting has always seemed a beautiful expression of the friendship that should be the essence of this relationship. It is Wright's depiction of such easy affection that makes this picture so appealing. Thomas gestures, while Mary looks down at him with tender gravity.

IT HAS BEEN *suggested that the father, far from urging his daughter to hardness of heart, is sympathetically urging her to wait, reassuring her that the experiment is not intended to culminate in the death of the bird, but in its revival as the oxygen is pumped back again into the cylinder.*

THE LOVERS USE *the social gathering for their own purposes, the males show fascination in the apparatus, and the children shudder with horror at the spectacle. At one level, this may well be a picture about male power. It is the men who have the power to make the bird suffer, while the two young children have no option but to be present.*

WTEWAEL, JOACHIM 1566–1638 b. Netherlands

PERSEUS RESCUING ANDROMEDA

MOST MANNERIST ART CARRIES AN EROTIC CHARGE, and there are few more erotic figures in art than this slender Andromeda. Wtewael attacks the scene with enormous gusto. There are almost two separate centers here. On the right is Perseus on his flying horse, newly emerged into the picture and still not wholly present; he is surging down to attack the splendidly colorful and inventive figure of the dragon. The other and more dazzling center is, of course, Andromeda. At first we may notice the glory of the shells that have a certain affinity with the pearly flesh of the heroine, but then we notice the remains of former victims and the empty helmet of an earlier would-be rescuer.

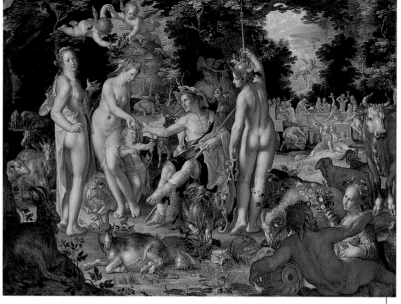

THE JUDGMENT OF PARIS
1615, oil on wood, 24 x 31 in (60 x 79 cm), National Gallery, London

This is a daring picture, in that Wtewael has set the famous story of *The Judgment of Paris* – in which the young man is asked to give the golden apple to the goddess he considers the most beautiful – within the background of another story, the Wedding of Peleus and Thetis. Isolated amidst the festivities are the central figures of Juno, Venus, and Minerva, with Paris adjudicating in the center. Wtewael has a mannerist delight in clutter, and a complete conviction of his ability to overcome it.

W

500

WTEWAEL'S IMAGINATION has run riot as he elaborates every area of the scaly dragon – he curls it, twists it, and decorates it. Finally, he sets it riding on the surface of the waters, looking up with an innocent astonishment at the figure about to launch – what to the dragon would seem to be – an unprovoked attack. That this is far from the case is clear when we examine the grisly remains scattered at Andromeda's feet.

BEAUTY IN THE tradition of the Old Masters was so often luscious and melodramatic. Here, it is clear, cool, and elegant. Andromeda's gestures have such grace and poise that it is hard to associate them with a state of mental anguish. Then we notice her left hand, and see how it finds a grisly echo on the rock floor below in the skeletal hand of one of her predecessors.

PERSEUS RESCUING ANDROMEDA, *1611, oil on canvas, 71 x 59 in (180 x 150 cm), Musée du Louvre, Paris*

WYETH, ANDREW 1917– b. US
YOUNG BULL

ANDREW WYETH HAS OCCASIONED a good deal of controversy.
Many people feel a deep affection for his work, while
others regard it as mere illustration. It is difficult not to feel
that time will do justice to this artist, whose work seems to
me to have a genuine element of greatness. His technique
is extraordinary, combining meticulousness and intensity
with a melancholy sense of the passing of time and of
human fallibility. It is this spiritual undertone that raises
the realism of this work to a higher level. There is an
almost surrealistic element in the young bull. Every strand
of the wire in the gate, every stone in the wall, every
pebble on the path, and almost every hair on the bull
has been looked at, pondered, and captured in color. We
marvel at its strange silence. The young bull stands almost
frighteningly still, yet perceptibly it is a creature different in
nature from the stone wall and the bare hill, or the white
house that is shut away from us, with its closed windows
and locked gate. The sense of exclusion is very poignant.
It is a strange and haunting painting, which leaves
us uncertain as to our reaction and keeps us looking.

YOUNG BULL
*1960, dry brush painting, 20 x 41 in
(51 x 105 cm), Private Collection*

THE DRIFTER
1964, dry brush painting, 24 x 29 in (60 x 74 cm), Private Collection

When Wyeth paints a fellow human, the subject very rarely meets our gaze.
Here, we encounter a mystery that is all the more evocative for the artist's ability
to portray external details so well. Wyeth has struggled to understand this man –
this drifter – but has been defeated, and humbly offers us the grubby textures
of a coat and jersey, and light shining on the noble dome of the man's skull. We
are involved in Wyeth's passion, and share his sense of creative frustration.

WYETH'S ABILITY TO FOCUS *as with
a magnifying glass gives these pictures an
extraordinary force. Why has he painted an
image in which nothing is happening? There is no
narrative and no activity except that of the eye, which
can play endlessly over every detail of this scene.*

THE YOUNG BULL, *displayed in his
solitude, emphasizes a greater solitude.
Behind the rickety gate is an empty
world, with one bare tree and a desolate
house. Even the sky is utterly cloudless.*

THE LONG SHADOWS *tell us that it is either
early morning or late evening. Wyeth values these
pools of shade for their sense of mystery, yet his
picture seems essentially timeless. No brilliant
colors, no activity, no decoration; this is the
bleak world of the farm, both austere and noble.*

WYJNANTS, JAN active 1643-84 b. Netherlands

PEASANTS DRIVING CATTLE AND SHEEP BY A SANDHILL

AMONG 17TH-CENTURY DUTCH LANDSCAPE ARTISTS, Wyjnants is memorable for two individual qualities. The first is his glorious ability to find a theme amid the dreary uninterest of the sand dune; his second is an appealing inability to paint the human form (the figures in every picture by Wyjnants have been graciously contributed by some other artist). Fortunately, they are of no importance whatsoever, and merely serve to offset the strange beauty of this Dutch landscape. Wyjnants celebrates the shapes and textures of these unremarkable formations – the glorious primrose yellow, for example, marked and speckled by rock – and he does so with a purity that clearly entrances him.

A LANDSCAPE WITH A WOMAN DRIVING SHEEP THROUGH A RUINED ARCHWAY
1667, oil on canvas, 14 x 17 in (36 x 44 cm), National Gallery, London

Once again, the human activity is relatively unimportant, because the essence of this picture is the ruined archway. The building to which this archway once led has completely disappeared, and it is the permanence of natural vigor, such as the trees springing with great vitality, that, in their own humble fashion, demolish pretensions of human ambition.

PEASANTS DRIVING CATTLE AND SHEEP BY A SANDHILL
c.1665–70, oil on wood, 11 x 15 in (29 x 38 cm), National Gallery, London

LIKE A GOOD DUTCHMAN, *Wyjnants pays tribute to the sky, but that strange melange of pale blue and dense white only serves as background to the gleaming aesthetic interest of the sand, piling up against the rock. To Wyjnants, the sand itself seems sufficient for a lifetime of artistic occupation.*

YÁÑEZ, FERNANDO active 1506–26 b. Spain
ST CATHERINE

St Catherine has always appealed to artists. She was said to be of royal birth, hence the crown on the balustrade behind her. But she was also a great scholar, hence the book on the other side, with the palm of martyrdom stretched across it. The wheel of torture exploded when she was tied to it, and she was finally beheaded (she holds the sword in her hand). But none of these details explains the strange charm of this picture – the winsomeness with which St Catherine digs the sword into the broken fragment of her wheel, looking down with a benign sweetness on the weapons that in real life cost her so dear. Some young aristocrat whose name was Catherine must have posed for the artist, dressed in her most exquisite robes. Everything here is intended to allure and to charm – just look at the sweet oval of her face, with the streaming locks of light brown hair – and there is no attempt by the artist to involve us in the horror of her martyrdom. Perhaps this is his point, that a saint, being a creature of heaven, is essentially uninvolved in the sordid brutality of an execution. Gentle and smiling, St Catherine remains essentially aloof.

St Catherine,
c.1520–26, oil on panel,
83 x 44 in (212 x 112 cm),
Museo del Prado, Madrid

YEATS, JACK BUTLER 1871–1957 b. Ireland
FOR THE ROAD

All through his life, Yeats painted horses. He felt a great affection for their beauty and their faithfulness to their owner, but it was, above all, their speed that entranced him. He identified with the spirit of the horse, leaping and running without constriction. Here, he imagines a master, perhaps himself, standing at the entrance to a small copse, summoning his great white horse. In an explosion of energy, the horse races undeviatingly towards its call. The small spindly human being, as Yeats might well have seen himself, is privileged to be united to the great animal dynamo. Here is a visual image of what inspiration means, when the artist, unable to achieve a vision of his own strength, calls upon the winged horse, the Pegasus of the imagination, to bear him forwards.

For the Road, 1951,
oil on canvas, 24 x 36 in (61 x 92 cm),
National Gallery of Ireland, Dublin

ZOFFANY, JOHN 1733–1810 b. Germany, active England

THE TRIBUNA OF THE UFFIZI

MANY 18TH-CENTURY GENTLEMEN went on a Grand Tour, and all of them appear to have congregated here in the Tribuna of the Uffizi Gallery in Florence. At least 22 known connoisseurs, most of them aristocratic, are recognizable here. Zoffany has painted a huge group portrait, carefully aligning the gentlemen with the works of art they most admired or felt it most incumbent on themselves to admire. Zoffany himself is here, too (on the left), peeping out from behind Raphael's *Cowper Madonna*. He has crammed into one room all the treasures of the Uffizi. It is an overcrowded picture, yet it throbs with vitality. The eager interest of the connoisseurs, and the sense we have of glory heaped upon glory, rising up above humanity, gives us a sense of how much art matters, how vital it is to seek it out, and how much more art there is in the world than any mortal could ever comprehend or categorize.

CHARLES TOWNLEY'S LIBRARY AT 7, PARK STREET, WESTMINSTER
1781–83, oil on canvas, 50 x 39 in (127 x 99 cm), Townley Hall Art Gallery, Burnley, UK

The Tribuna of the Uffizi made a great impression on Charles Townley, who had his own small but choice collection of art, and so much so that he commissioned Zoffany to paint a mini *Tribuna*. Townley himself sits with his dog at his feet, a sober scholar compared to the excited gentleman in the Uffizi. Although the art collection is smaller and many of the figures are plaster casts, there is the unspoken understanding that in this rarefied atmosphere, a lover of beauty is more likely to gain enlightenment than in a public gallery.

ZOFFANY IMPRESSES on the viewer the importance of art to the well-read. These gentlemen are not merely looking; they are studying the composition. They present themselves as serious students of aesthetics; admiring the glorious sprawl of Titian's naked Venus is no occasion for vulgar, voyeuristic interest (although the occasional lascivious smile on the lips of some of the students betrays a more personal reaction).

IT MAY BE significant that the central picture that dominates the gallery is Raphael's St John. The young saint is naked and about to set off into the wilderness. By presenting St John as a simple figure in contrast to the gold-buttoned, bewigged gentlemen (who crowd noisily around the painting expecting to crack its secret), Zoffany highlights the contrast between the truth that is art and the pretense of real-life behavior.

THE TRIBUNA OF THE UFFIZI, 1772–77, oil on canvas, 47 x 60 in (120 x 152 cm), Collection of Her Majesty, The Queen

ZURBARÁN, FRANCISCO DE 1598–1664 b. Spain
ST FRANCIS KNEELING

FEW SAINTS HAVE ATTRACTED MORE AFFECTIONATE attention than St Francis of Assisi. The reasons for this are mainly superficial: animal lovers are attracted by his intimacy with creatures such as wolves and bears, and the light-hearted enjoy his reputation for humor (which should not be as rare among the saints as it is). For Zurbarán, however, Francis was a figure of enormous power and dignity. Here is no light-hearted little brother preaching to the birds but a great pillar of the Church, who fills the canvas and clasps to his breast a skull. Zurbarán shows us merely a glimpse of his face – it is not the personality of Francis that interests him, but his spirit, as a great incarnate cry of longing for redemption. Yet Zurbarán also shows us a very material figure, a body that truly kneels, hands that truly clasp themselves in petition, and a shadowed head that looks up with anguished trust to the heavens.

SAINT MARGARET
1630–34, oil on canvas, 64 x 41 in (163 x 105 cm),
National Gallery, London

As well as painting saints with profound seriousness, Zurbarán had a profession painting elegant ladies pretending to be saints. This young woman is acting out the story of her patron saint, Margaret of Antioch. St Margaret was the protectress of women in childbirth and was said to have been swallowed by a dragon, out of which she hammered her way with a crucifix. Lurking beside the elegant little saint, with her fashionable hat and delightful shopping bag, is the vanquished dragon, now clearly under her control. It is impossible not to warm to this appealing figure, so unaware of the dichotomy between her elegance and stylishness and the true drama of doing battle with a dragon.

RECOGNITION THAT ONE *must die is common to mature humanity, but preparation for that death is the provenance of those who see death as a pathway to a more profound form of life and whose desire is never to waste their earthly time. Here, St Francis is taut with concentrated longing to pass into that life.*

A RICH GOLDEN LIGHT *glimmers on the saint's habit, but the crude rope of his girdle, the tattered sleeve, and the coarse woollen patches of his Capuchin habit, indicate his vow of poverty and the complete absence of all material possessions.*

ST FRANCIS KNEELING
1635–39, oil on canvas, 60 x 39 in
(152 x 99 cm), National Gallery, London

DIRECTORY OF MUSEUMS AND GALLERIES

The entries in this directory are major museums and galleries with five or more paintings included in this book.

AUSTRIA

KUNSTHISTORISCHES MUSEUM
Burgring 5, 1010 Vienna, Tel (43 1) 52177

Bruegel: *Hunters in the Snow*; Cranach: *Judith with the Head of Holofernes*; Fouquet: *Portrait of the Ferrara Court Jester Gonella*; Giordano: *The Fall of the Rebel Angels Goes: The Fall of Man*; Hoogstraten: *A Man Looking Through a Window*; Joos van Cleve: *Queen Eleanor of France*; Neer: *Fishing by Moonlight*; Parmigianino: *The Conversion of Paul*; *Self-Portrait in a Convex Mirror*; Rubens: *The Little Fur*; Sittow: *Katherine of Aragon*; Spranger: *Venus and Adonis*; *Glaucus and Scylla*; Steen: *Topsy-turvy World*; Terborch: *Woman Peeling an Apple*; Vermeer: *Allegory of Painting*

FRANCE

MUSÉE D'ORSAY
1 rue de Bellechasse, 75007 Paris, Tel (33 1) 40494814

Bazille: *The Pink Dress*; Bonheur: *Ploughing in the Nivernais*; Caillebotte: *Self-Portrait*; Cézanne: *Still Life with Apples and Oranges*; Daumier: *The Laundress*; Degas: *The Tub*; Gauguin: *The Meal*; van Gogh: *Self-Portrait*; Jongkind: *Ruins of the Castle at Rosemont*; Manet: *Olympia*; *The Fifer*; Marquet: *Andre Rouveyre*; Millet: *The Gleaners*; Moreau: *Hesiod and the Muse*; *Orpheus*; Puvis de Chavanne: *Young Girls by the Edge of the Sea*; Redon: *The Shell*; Sisley: *Floods at Port Marly*; Tissot: *Portrait of Mme L.L.*; Toulouse-Lautrec: *The Clown Chau-U-kao*; *Woman Lying on her Back*; Vlaminck: *Still Life*

MUSÉE DU LOUVRE
Palais du Louvre, 75001 Paris, Tel (33 1) 40205050/151

Baldovinetti: *The Virgin and Child*; Barocci: *The Circumcision*; Benoist: *Portrait of a Negress*; Boucher: *Diana Bathing*; *The Breakfast*; Carracci: *Fishing*; Champaigne: *Ex Voto*; Chardin: *The Silver Goblet*; Chassériau: *The Two Sisters*; Père Lacordaire; Clouet, Jean: *Francis I*; Corot: *The Colosseum Seen from the Farnese Gardens*; *Woman with a Pearl*; Cousin: *Eva Prima Pandora*; Daubigny: *Sunset on the Oise*; David, Gerard: *God the Father Blessing*; David, Jacques-Louis: *Madame Recamier*; Delacroix: *The Barque of Dante*; *Orphan Girl at the Cemetery*; Domenichino: *St Cecilia with an Angel Holding Music*; Dyck: *Charles I, King of England, Hunting*; Fetti: *Melancholy*; Fontainbleau: *Gabrielle d'Estrées and One of her Sisters*; Diana the Huntress; Gentileschi, Orazio: *Rest on the Flight into Egypt*; Géricault: *The Raft of the Medusa*; Ghirlandaio: *Portrait of an Old Man and a Boy*; Gros: *Napoleon on the Battlefield at Eylan, February 9, 1807*; Ingres: *The Valpinçon Bather*; Joos van Gent: *Portrait of Aristotle*; *Portrait of Solon*; Jordaens: *The Four Evangelists*; La Tour, Maurice-Quentin: *Madame de Pompadour*; Lebrun: *The Chancellor Séguier*; Leonardo: *Virgin of the Rocks*; Lotto: *Christ and the Adulteress*; Massys: *The Moneylender and his Wife*; Mélendez: *Self-Portrait*; Mignard: *Portrait of the Artist*; Murillo: *The Young Beggar*; Niccolò: *The Abduction of Persephone*; Piazzetta: *Assumption of the Virgin*; Pittoni: *The Continence of Scipio*; Poussin: *The Shepherds of Arcadia*; Provost: *A Christian Allegory*; Prud'hon: *Justice and Divine Vengeance Pursuing Crime*; *The Empress Josephine*; Quarton: *The Pietà*; Raphael: *Portrait of Baldassare Castiglione*; Ribera: *The Beggar Known as the Club-foot*; Ricci: *Allegory of France: The Triumph of Wisdom over Ignorance*; Rigaud: *Madame Rigaud, the Mother of the Artist*; Robert: *Imaginary View of the Grande Galerie in Ruins*; Rosa: *The Spirit of Samuel Called up before Saul by the Witch of Endor*; Rousseau: *Group of Oaks at Apremont in the Forest of Fountainbleau*; Solari: *Madonna with the Green Cushion*; *Head of St John the Baptist*; Stomer: *Issac Blessing Jacob*; *Pilate Washing his Hands*; Vouet: *Wealth*; Watteau: *Pierrot: Gilles*; *The Faux-pas*; Wtewael: *Perseus Rescuing Andromeda*

GERMANY

ALTE PINAKOTHEK
Barerstrasse 27, 8000 Munich 40, Tel (49 89) 23805216

Altdorfer: *Alexander's Victory (The Battle of Issus)*; St George; Brouwer: *The Bitter Draught*; Elsheimer: *Flight into Egypt*; Feininger: *Market Church at Evening*; Kessel: *America*; Konrad von Soest: *St Paul*; Liss: *The Death of Cleopatra*; Pacher: *Church Fathers' Altar: St Augustine and St Gregory*; *Church Fathers' Altar: St Ambrose*

STAATLICHE MUSEUM,
Preußischer Kulturbesitz, Generaldirektion, Stauffenbergstraße 10785 Berlin, Tel (030) 2666

Baldung Grien: *Pyramus and Thisbe*; Böcklin: *The Isle of the Dead*; *Self-Portrait with Death as a Fiddler*; Botticelli: *Virgin and Child with Eight Angels*; Christus: *A Young Lady*; Corinth: *Samson Blinded*; Courbet: *The Wave*; Daddi: *The Temptation of Thomas Aquinas*; Domenico: *The Martyrdom of St Lucy*; Elsheimer: *Nymph Fleeing Satyrs*; Fouquet: *Estienne Chevalier with St Stephen*; Friedrich: *Monk by the Sea*; Geertgen tot Sint Jans: *St John the Baptist in the Wilderness*; Gentile da Fabriano: *Virgin and Child Enthroned with SS Nicholas of Bari and Catherine of Alexandria and a Donor*; Gossaert: *Neptune and Amphitrite*; *A Nobleman*; Grosz: *Pillars of Society*; Hals: *Mad Babs*; Hooch: *Woman Lacing her Bodice beside a Cradle*; Léger: *The Two Sisters*; Lippi: *The Adoration with the Infant Baptist and St Bernard*; Lorenzetti: *Blessed Humilitas Heals a Sick Nun*; Marmion: *Scenes from the*

ITALY

Life of St Bertin; Maso di Banco: *The Descent of Mary's Girdle to the Apostle Thomas*; Mengs: *Self-Portrait*; Pechstein: *Seated Nude*; Ruisdael: *Oaks by a Lake with Waterlilies*; Ruysdael: *Dutch Landscape with Highwaymen*; *Sailboats on the Wijkermeer*; Signorelli: *St Agostino Altarpiece*; Sittow: *Madonna and Child*; Snyders: *Hungry Cat with Still Life*; Velde: *River Landscape with Horses and Cows*; *The Farm*; Witz: *The Queen of Sheba before Solomon*; Wouwerman: *Path Through the Dunes*

GALLERIA DEGLI UFFIZI
Piazzale degli Uffizi, 50122 Florence, Tel (39 55) 218341

Albertinelli: *The Visitation*; Allori: *Judith with the Head of Holofernes*; John the Baptist in the Desert; Andrea del Sarto: *Madonna of the Harpies*; Bartolommeo: *The Vision of St Bernard*; Berckheyde: *The Market Place and the Grote Kerk at Haarlem*; Botticelli: *The Birth of Venus*; Canaletto: *A View of the Ducal Palace in Venice*; Caravaggio: *The Incredulity of St Thomas*; *Bacchus*; Carriera: *Self-Portrait with a Portrait of her Sister*; Cimabue: *Madonna and Child Enthroned with Eight Angels and Four Prophets*; Clouet, François: *Francis I on Horseback*; Credi: *The Annunciation*; Venus; Crespi: *The Flea*; Froment: *The Raising of Lazarus*; Gentile da Fabriano: *Adoration of the Magi*; Gentileschi, Artemisia: *Judith Slaying Holofernes*; Giotto: *Enthroned Madonna with Saints and Angels*; Giulio Romano: *Madonna and Child*; van der Goes: *The Portinari Altarpiece*; Kessel: *Fish on the Seashore*; Lorenzetti: *The Refectory*; Michelangelo: *The Doni Tondo*; Pollaiuolo: *Hercules and the Hydra*; Pontormo: *Portrait of Maria Salviati*; Raphael: *Madonna of the Chair*; Seghers: *Mountainous Landscape*; Simone Martini: *The Annunciation*; Snyders: *Wild Boar Hunt*; Verrocchio: *The Baptism of Christ*; Vigée-Lebrun: *Self-Portrait*; Vivarini: *St Louis of Toulouse*

PALAZZO PITTI
Piazza Pitti 1, 50100 Florence, Tel (39 55) 210323/6673

Bril: *The Stag Hunt*; *Portrait of Claude of Lorraine, Duke of Guise*; Gentileschi, Artemisia: *Judith and her Maidservant*; Lippi: *Madonna and Child with Stories of the Life of St Anne*; Perugino: *Mary Magdalene*

NETHERLANDS

THE MAURITSHUIS MUSEUM
Korte Vijverberg 8, 2513 AB, The Hague, Tel (31 70) 3469244

Bosschaert: *Vase with Flowers*; Everdingen: *Trompe-l'oeil with a Bust of Venus*; Diogenes Looking for an Honest Man; Fabritius: *The Goldfinch*; Gelder: *Simeon's Song of Praise*

MUSEUM BOYMANS-VAN BEUNINGEN
Museumpark, 18–20, 3015 CB Rotterdam, (31 10) 4419400

Avercamp: *Frozen River*; Bosch: *The Hawker Magritte: Reproduction Prohibited*; Saenredam: *St Mary's Square and Saint Mary's Church at Utrecht*; Witte: *Interior of a Church 1668*

RUSSIA

Hermitage Museum
Dvortsovaya nab 34, St. Petersburg, Tel (7 812) 3113465

Berckheyde: *The Canal and City Hall in Amsterdam*; Brueghel: *Forest's Edge (Flight into Egypt)*; Caracci: *The Holy Women at Christ's Sepulchre*; Crespi: *Self-Portrait*; Dossi: *Sybil*; Fetti: *An Actor*; Fragonard: *The Stolen Kiss*; Geertgen tot Sint Jans: *St Bavo*; Greuze: *The Spoiled Child*; Hoogstraten: *Tobias's Farewell to his Parents*; Kneller: *Grinling Gibbons*; Lastman: *Abraham on the Way to the Canaan*; Lebrun: *Daedalus and Icarus*; Lucas van Leyden: *Christ Healing the Blind Man of Jericho*; Metsu: *The Doctor's Visit*; Mieris: *A Young Woman in the Morning*; Monnoyer: *Flowers and Fruit*; Morales: *Mater Dolorosa*; Potter: *Watchdog*; Proccaccini: *The Mystical Marriage of St Catherine*; Robert: *Landscape with Ruins*; Solimena: *Rebecca at the Well*; Strozzi: *The Healing of Tobit*; Sweert: *Self-Portrait*; Wouwerman: *Horses Being Watered*

SPAIN

MUSEO DEL PRADO
Paseo del Prado, 28014 Madrid, Tel (34 1) 4202836

Angelico: *The Annunciation*; Baldung Grien: *The Three Ages of Man and Death*; Barocci: *The Birth*; Bassano: *The Animals Entering Noah's Ark*; Bermejo: *St Domingo de Silos Enthroned as Abbot*; Berruguete: *Death of St Peter the Martyr*; St Dominic Presiding over an Auto da Fé; Bosch: *The Garden of Earthly Delights*; Bril: *Hebe with the Eagle of Jupiter*; Brueghel: *The Earthly Paradise*; Campin: *St Barbara*; David, Gerard: *A Rest During the Flight to Egypt*; Dughet: *A Landscape with Mary Magdalene Worshipping the Cross*; Dürer: *Self-Portrait*; Goya: *The Family of Charles IV*; *The Colossus*; Gris: *Portrait of Josette*; Guercino: *The Liberation of St Peter by an Angel*; Jordaens: *The Artist and his Family in a Garden*; Juan de Flandes: *The Resurrection of Lazarus*; Mantegna: *Death of the Virgin*; Mélendez: *Still Life with Salmon, a Lemon and Three Vessels*; Mengs: *Maria Luisa of Parma*; Metsu: *A Dead Cock Mor: Queen Mary of England: Second Wife of Philip II*; Morales: *Madonna and Child*; Murillo: *The Virgin of the Rosary*; Ostade: *Rustic Concert*; Patinir: *Landscape with St Jerome*; Landscape with Charon's Bark; Reni: *Atalanta and Hippomenes*; Ribalta: *St Francis Comforted by an Angel Musician*; Ribera: *Archimedes*; Rigaud: *Louis IV*; Tiepolo: *The Olympus*; Abraham and the Three Angels; Tintoretto: *Woman Who Discovers the Bosom*; Velázquez: *Las Meninas*; van der Weyden: *Descent from the Cross*; Yánez: *St Catherine*

MUSEO THYSSEN-BORNEMISZA
Paseo del Prado 8, 28014 Madrid, Tel (34 1) 4203944

Balla: *Patriotic Demonstration*; Boyd: *Nude Turning into a Dragonfly*; Carpaccio: *Young Night in a Landscape*; Chagall: *The Rooster*; Gorky: *Hugging/Good Hope Road II*; Heemskerck: *Portrait of a Lady with a Spindle and Distaff*; O'Keeffe: *White Iris No. 7*; Popova: *Pictorial Architectonic*; Rauschenberg: *110 Express*; Schiele: *Houses on the River (The Old Town)*; Shahn: *Riot on Carol Street*; Staël: *Mediterranean Landscape*; Still: *"Untitled"*

SWITZERLAND

KUNSTMUSEUM BASEL
St Alban-Graben 16, 4010 Basel, Tel (41 61) 2710828

Braque: *Café-bar*; Dix: *The Artist's Parents*; Hodler: *Lake of Geneva from Chexbres*; Klee: *Ancient Sound*; Kokoschka: *Bride of the Wind*; Mondrian: *Composition, 1929*

UNITED KINGDOM

NATIONAL GALLERY
Trafalgar Square, London WC2N 5DN, Tel (44 71) 8393521

Andrea del Sarto: *Portrait of a Young Man*; Antonello da Messina: *Portrait of a Man*; Avercamp: *A Winter Scene with Skaters near a Castle*; Baldovinetti: *Portrait of a Lady in Yellow*; Bassano: *The Good Samaritan*; Batoni: *Time Orders Old Age to Destroy Beauty*; Beccafumi: *An Unidentified Scene*; Marcia; Bellini: *The Doge Leonardo Loredan*; Bermejo: *St Michael Triumphant over the Devil*; Bonheur: *The Horse Fair*; Bordone: *Portrait of a Young Woman*; Bosschaert: *Flowers in a Glass Vase*; Both: *A Rocky Italian Landscape*; *Muleteers and a Herdsman with an Ox and Goats by a Pool*; Boudin: *The Beach at Tourgéville-les-Sablons*; Bouts: *Portrait of a Man*; Bronzino: *An Allegory with Venus and Cupid*; Campin: *A Woman*; Canaletto: *The Stonemason's Yard*; Cappelle: *A Small Dutch Vessel Before a Light Breeze*; *A Dutch Yacht Firing a Salute as a Barge Pulls Away*; Cavallino: *Christ Driving the Traders from the Temple*; Champaigne: *Triple Portrait of Cardinal Richelieu*; Chardin: *The Young Schoolmistress*; Cima de Conegliano: *David and Jonathan*; *Virgin and Child*; Claude Lorrain: *Landscape with Hagar and the Angel*; Constable: *Weymouth Bay (Bowleaze Cove)*; Correggio: *Venus with Mercury and Cupid (The School of Love)*; Costa: *A Concert*; *Portrait of Battista Fiera*; Cranach: *Cupid Complaining to Venus*; Crivelli: *Madonna of the Swallow*; *St Michael*; Cuyp: *A Herdsman with Five Cows by a River*; *A Distant View of Dordrecht with a Milkmaid and Four Cows*; Daddi: *The Marriage of the Virgin*; Dou: *A Poulterer's Shop*; Duccio du Buoninsegna: *Jesus Opens the Eyes of a Blind Man*; Dughet: *Landscape with Herdsman*; Dujardin: *Portrait of a Young Man*; *Woman and a Boy at a Ford*; Eyck: *A Man in a Red Turban*; Fabritius: *View of Delft with a Musical Instrument Seller's Stall*; Friedrich: *Winter Landscape*; Gainsborough: *The Painter's Daughters Chasing a Butterfly*; Giordano: *Perseus Turning Phineas and his Followers to Stone*; Giovanni di Paolo: *St John the Baptist Retiring into the Wilderness*; *The Feast of Herod*; Giulio Romano: *Mary Magdalene Borne by Angels*; Goyen: *A Windmill by a River*; *An Estuary with Fishing Boats and Two Frigates*; Guardi: *View of the Venetian Lagoon with the Tower of Malghera*; *An Architectural Caprice*; Guercino: *The Dead Christ Mourned by Two Angels*; Hals: *Young Man with a Skull (Vanitas)*; Hobbema: *The Avenue at Middelharnis*; *A Stream by a Wood*; Hogarth: *The Graham Children*; *The Shrimp Girl*; Holbein: *Lady with a Squirrel and a Starling*; Christina of Denmark; Hondecoeter: *A Cock, Hens, and Chicks*; *Birds, Butterflies and a Frog among Plants and Fungi*; Honthorst: *Christ Before the High Priest*; Huysum: *Hollyhocks and Other Flowers in a Vase*; Ingres: *Madame Moitessier*; Jones: *A Wall in Naples*; Kalf: *Still Life with the Drinking-horn of the St Sebastian Archers' Guild*; Koninck: *Extensive Landscape with a Town in the Middle Distance*; La Hyre: *Allegorical Figure of Grammar*; Lancret: *The Four Times of the Day: Morning*; *The Four Times of the Day: Midday*; Largillière: *Portrait of a Man*; Lastman: *Juno Discovering Jupiter with Io*; Lawrence: *Sir John Julius Angerstein*; Leyton: *Cimabue's Madonna Carried in Procession Through the Streets of Venice*; Le Nain: *A Woman and Five Children*; Liss: *Judith in the Tent of Holofernes*; Lochner: *SS Matthew, Catherine of Alexandria, and John the Evangelist*; Longhi: *Nobleman Kissing a Lady's Hand*; Lotto: *Lady with a Drawing of Lucretia*; Lucas van Leyden: *A Man Aged 38*; Maes: *Interior with a Sleeping Maid and her Mistress ("The Idle Servant")*; Margarito d'Arezzo: *St Margaret and the Dragon*; Marmion: *The Soul of St Bertin Carried up to God*; Master of the Wilton Diptych: *The Wilton Diptych*; *The White Heart*; Matteo di Giovanni: *Assumption of the Virgin*; *Christ Crowned*; Memling: *The Virgin and Child*; *A Man, St George and a Donor*; Mieris: *Cimera van der Cock*; Mignard: *The Marquise de Seignely and her Two Children*; Monet: *The Petit Bras of the Seine at Argenteuil*; Moretto da Brescia: *Portrait of a Young Man*; *Portrait of a Man at Prayer*; Moroni: *Portrait of a Gentleman*; *Portrait of a Tailor*; Niccolò dell' Abate: *The Death of Eurydice*; Ochtervelt: *A Young Lady Trimming her Fingernails*; *A Woman Playing a Virginal*; Ostade: *A Peasant Courting an Elderly Woman*; Palma Vecchio: *A Blonde Woman*; *Portrait of a Poet*; Palma Giovane: *Mars and Venus*; Panini: *Roman Ruins with Figures*; Perugino: *Archangel Raphael with Tobias*; Pesellino: *The Triumph of David*; Piero di Cosimo: *A Satyr Mourning over a Nymph*; Pissanello: *The Virgin and Child with St George and St Anthony Abbott*; *The Vision of St Eustace*; Pissarro: *View from Louvecienns*; Pollaiuolo: *Apollo and Daphne*; Rembrandt: *Saskia as Flora*; Reni: *St Mary Magdalene*; Reynolds: *Colonel Banastre Tarleton*; Ribalta: *The Vision of Father Simon*; *Esther Before Ahasuerus*; Rosa: *Self-Portrait*; Rousseau, Henri: *Tiger in a Tropical*

Storm; Rousseau, Théodore: *Sunset in the Auvergne*; Ruisdael: *An Extensive Landscape with Ruins*; Ruysch: *Flowers in a Vase*; Saenredam: *Interior of the Grote Kerk, Haarlem*; Saraceni: *Moses Defending the Daughters of Jethro*; Sassoferrato: *The Virgin in Prayer*; *The Virgin and Child Embracing*; Savoldo: *St Mary Magdalene Approaching the Sepulchre*; Sebastiano del Piombo: *The Raising of Lazarus*; *The Daughter of Herodias*; Signorelli: *The Circumcision*; Sodoma: *St Jerome in Penitence*; Solimena: *An Allegory of Louis XIV*; Steen: *Skittle Players Outside an Inn*; Steenwyck: *Still Life: An Allegory of the Vanities of Human Life*; Strozzi: *A Personification of Fame*; Teniers: *An Old Peasant Caresses a Kitchen Maid in a Stable*; *Peasants Playing Bowls Outside a Village Inn*; Tintoretto: *St George and the Dragon*; Treck: *Still Life with a Pewter Flagon and Two Ming Bowls*; Tura: *Allegorical Figure*; Uccello: *St George and the Dragon*; Valenciennes: *Dutch Vessel in a Strong Breeze*; *Dutch Vessels Close in Shore at Low Tide, and Men Bathing*; Vernet: *A River with Fishermen*; Veronese: *Allegory of Love I*; *Allegory of Love II*; Verrocchio: *Tobias and the Angel*; Vivarini: *Virgin and Child with SS Paul and Jerome*; Witte: *Adriana van Heusden and her Daughter at the New Fishmarket in Amsterdam*; Wright: *An Experiment on a Bird in the Air Pump*; *Mr and Mrs Thomas Coltman*; Wtewael: *The Judgment of Paris*; Wijnants: *Peasants Driving Cattle and Sheep by a Sandhill*; Zubarán: *St Francis Kneeling*; *St Margaret*

TATE GALLERY
Millbank, London SW1P 4RG, Tel (44 71) 8878000

Alma-Tadema: *A Favourite Custom*; Blake: *Ghost of a Burne-Jones: King Cophetua and the Beggar Maid*; *The Golden Stairs*; Chirico: *The Uncertainty of the Poet*; Crome: *Household Heath*; De Kooning: *The Visit*; Delaunay: *Simultaneous Open Windows*; Derain: *Portrait of Matisse*; Dubuffet: *Spinning Round*; Dyce: *Pegwell Bay, Kent: Recollection of October 5, 1858*; Ernst: *Forest and Dove*; Celebes; Eworth: *Portrait of a Lady*; Francis: *Around the Blues*; Giacometti: *Jean Genet*; Girtin: *The White House at Chelsea*; Goncharova: *The Laundry*; Grosz: *Suicide*; Guston: *Black Sea*; Hammershøi: *Interior: Sunlight on the Floor*; Hockney: *A Bigger Splash*; Hodgkin: *Rain*; Hunt: *The Awakening Conscience*; John: *The Smiling Woman*; Johns: *0 through 9*; Kneller: *Portrait of John Banckes*; Kokoschka: *Polperro II*; Larionov: *Soldier on a Horse*; Lely: *Two Ladies of the Lake Family*; Matisse: *The Snail*; Newman: *Adam*; Moment; Nicholson, Ben: *August 1937*; Nolan: *Camel and Figure*; Richter: *St John*; Riley: *Fall*; Severini: *Train de Banlieue Arrivant à Paris*; Sickert: *La Hollandaise*; Spencer: *The Centurion's Servant*; Steer: *Girls Running*; Walberswick Pier*; Stella: *Six-Mile Bottom*; Still: *1953*; Turner: *Norham Castle, Sunrise, Snowstorm: Steam-boat of a Harbour's Mouth*; Wallis: *Wreck of the Alba*; Warhol: *Marilyn Diptych*; Watts: *Hope (Replica)*; Whistler: *Harmony in Grey and Green: Miss Cicely Alexander*; *Nocturne: Blue and Gold*

UNITED STATES OF AMERICA

ART INSTITUTE OF CHICAGO
Michigan Avenue at Adams Street, Chicago IL 60603, Tel (1 312) 4435600

Bacon: *Head Surrounded by Sides of Beef*; Bazille: *Self-Portrait*; Boudin: *Approaching Storm*; Caillebotte: *Rue de Paris, Wet Weather*; Carriera: *Young Lady with a Parrot*; Fantin-Latour: *Portrait of Edouard Manet*; Seurat: *Sunday Afternoon on the Island of La Grande Jatte*; Wood: *American Gothic*

NATIONAL GALLERY OF ART
6th Street at Constitution Avenue NW, Washington DC 20565, Tel (1 202) 7374215

Bordone: *The Baptism of Christ*; Cassatt: *Girl Arranging her Hair*; Castagno: *The Youthful David*; Clouet, François: *A Lady in her Bath*; Cole: *The Notch of the White Mountains*; Copley: *Watson and the Shark*; Cosa: *St Lucy*; *The Crucifixion*; Domenico: *St John in the Desert*; Duccio: *Nativity*; Eakins: *The Biglin Brothers Racing*; Eyck: *Annunciation*; Fragonard: *A Young Girl Reading*; Gaddi: *Coronation of the Virgin*; Gentileschi, Orazio: *The Lute Player*; Gozzoli: *The Dance of Salome*; Greco: *Laocoön*; Gris: *Fantômas*; Hicks: *The Cornell Farm*; Hooch: *Two Soldiers and a Woman Drinking in a Courtyard*; Innes: *The Lackawanna Valley*; Juan de Flandes: *The Temptation of Christ*; Kalf: *Still Life*; Largillière: *Elizabeth Throckmorton*; Le Nain: *Landscape with Peasants*; Margarito d'Arezzo: *Madonna and Child Enthroned*; Marquet: *Le Pont-Neuf*; Master of the St Lucy Legend: *Mary, Queen of Heaven*; Mor: *Portrait of a Gentleman*; Morisot: *The Harbor at Lorient*; Panini: *Interior of St Peters, Rome*; Raeburn: *Miss Eleanor Urquhart*; Rousseau: *Boy on the Rocks*; Sassetta: *The Meeting of St Anthony and St Paul*; Sodoma: *St George and the Dragon*; Stuart: *The Skater*; *Mrs Richard Yates*; Utrillo: *Marizy-Sainte-Genevière*; Vlaminck: *The River*; Vouet: *St Jerome and the Angel*; Vuillard: *Portrait of Théodore Duret*; van der Weyden: *Portrait of a Lady*

SAN FRANCISCO MUSEUM OF MODERN ART
151 Third Street (between Mission and Howard Streets) San Francisco, CA 94103, Tel 415/357 4000

Albers: *Study for Homage to a Square*; Francis: *Red and Pink*; Jawlensky: *Red Light*; Mangold: *Red X Within X*; Pechstein: *Nelly*; Rivera: *The Flower Carrier*; Ryman: *Surface Veil*; Sheeler: *Aerial Gyrations*; Stella: *Khurasan Gate (Variation) I*; Thiebaud: *Display Cakes*

507

Picture Credits

KEY:

AIC = The Art Institute of Chicago
AKG = AKG London
ART = Artothek, Piessenberg
BAL = Bridgeman Art Library, London/New York
BPK = Bildarchiv Preußischer Kulturbesitz Gemäldegalerie
CAR = Carnegie Museum of Art, Pittsburgh
GIR = Photographie Giraudon, Paris
HER = State Hermitage, St Petersburg
IKO = Ikona, Italy
MNP = Museo Nacional del Prado, Madrid
NGL = National Gallery, London
NGS = National Galleries of Scotland
NGW = National Gallery of Art, Washington
RMN = Réunion des Musées Nationaux Agence Photographique, Paris
SCA = Scala, Florence
SFM = San Francisco Museum of Modern Art
TAT = © Tate Gallery, London 1999

P1: GIR: Pitti Palazzo, Florence.
P2: BAL: Courtauld Institute Galleries, University of London.
P4 – cll: TAT: Bequeathed by the artist 1856; cl: AKG: Czartoryski Museum, Cracow/Photograph: Erich Lessing; c: Musée d'Orsay, Paris; cr: The Museum of Modern Art, New York: Photograph © 1999. Acquired through the Lillie P. Bliss Bequest. © Succession Picasso/DACS, 1998; crr: Musée d'Orsay, Paris.
P5 – trb: National Gallery of Australia, Canberra: © ARS, NY and DACS, London 1998; bra: The Phillips Collection, Washington, D.C.; cra: MNP; tr: BAL: Museo de Arte, Ponce, Puerto Rica; crb: NGL
P6 – tr: SFM: Gift of Mrs Anni Albers and The Josef Albers Foundation/Photograph: Ben Blackwell/© DACS 1998; bl: BAL: Galleria Degli Uffizi, Florence.
P7 – tr: IKO: Galleria degli Uffizi, Florence/Photograph: Raffaello Bencini Fotografo Firenze; bl: AKG: Galleria degli Uffizi, Florence.
P8 – tr: TAT: Presented by the Trustees of the Chantrey Bequest 1909; b: BAL: City of Bristol Museum and Art Gallery, Avon.
P9 – tr: ART: Alte Pinakothek, Munich/Photograph: Joachim Blauel; bl: AKG: Alte Pinakothek, Munich.
P10 – tr: SCA: Oratorio di San Giorgio, Padua; bl: SCA: Oratorio di San Giorgio, Padua.
P11 – tr: NGL; bl: BAL: Galleria degli Uffizi, Florence.
P12 – tr: BAL: Museo di San Marco dell'Angelico, Florence; b: MNP.
P13 – tr: NGL; b: GIR: Galleria Regionale della Sicilia, Palermo.
P14 – tr: CAR: Museum Purchase: Gist of Mrs Thomas S. Knight, Jr, in memory of her mother, Mrs George L. Craig, Jr, 90.10/Photograph: Peter Hardoldt, 1994; bl: © Collection of the New-York Historical Society.
P15 – tl: NGS: Scottish National Gallery of Modern Art, Edinburgh/© 1999 Marlborough; b: Marlborough Fine Art (London) Ltd.: Private Collection/© 1999 Marlborough.
P16 – tr: NGL; b: Museum Boijimans Van Beuningen, Rotterdam.
P17 – tr: AKG: Private Collection/© Estate of Francis Bacon/ARS, NY & DACS, London 1999; bl: AIC: Harriott A. Fox Fund, 1956.1201, Photograph © 1999/© Estate of Francis Bacon/ARS, NY & DACS, London 1999.
P18 – tr: NGL; bl: BAL: Musée d'Orsay, Paris/Photograph: Erich Lessing.
P19 – tr: MNP; bl: BPK: Staatliche Museum, Berlin/Photograph: Jörg P Anders.
P20 – tr: BAL: Civica Galleria d'Arte Moderna, Milan, Italy/© DACS 1999; b: © Museo Thyssen-Bornemisza, Madrid/© DACS 1999.
P21 – tr: BAL: Pierre Matisse Gallery, New York City/© DACS 1998; bl: BAL: Private Collection, Paris/© DACS 1999.
P22 – tr: MNP; bl: AKG: Musée du Louvre, Paris/Photograph: Erich Lessing.
P23 – tr: BAL: Museo di San Marco dell'Angelico, Florence; bl: BAL: Galleria Degli Uffizi, Florence.
P24 – tr: Georg Baselitz/Derneburg: Private Collection/Photo © Jochen Littkemann, Berlin; bl: Georg Baselitz/Derneburg: Private Collection/Photo © Friedrich Rosenstiel, Cologne.
P25 – tr: MNP; bl: NGL
P26 – tr: NGL; bl: BAL: Holkham Hall, Norfolk.
P27 – tr: AIC: Restricted Gift of Mr and Mrs Frank H. Woods in memory of Mrs Edward Harris Brewer, 1962.336, Photograph © 1998; bl: AKG: Musée d'Orsay, Paris/Photograph: Erich Lessing.
P28 – tr: Christie's Images Ltd 1999; bl: Albright-Knox Art Gallery, New York.
P29 – tr: NGL; b: NGL
P30 – tr: AKG: Busch-Reisinger Museum, Cambridge, Massachusetts/© DACS 1999; bl: Staatsgalerie, Stuttgart/© DACS 1999.
P31 – tr: NGL; bl: Copyright The Frick Collection, New York.
P32 – tr: Manchester City Art Galleries; b: © Manchester City Art Galleries.
P33 – tr: GIR: Château Versailles/Photograph: Lauros; bl: BAL: Musée du Louvre, Paris/Photograph: Giraudon.
P34 – tr: Artephot: The Hermitage, St Petersburg /Photograph: André Held; b: BAL: Gallerie degli Uffizi, Florence.
P35 – tr: MNP; bl: NGL
P36 – tr: MNP; bl: MNP.
P37 – bl: BAL: Galleria dell'Accademia, Florence; br: SCA: Museum of the Collegiate Church, Empoli.
P38 – tr: The Brooklyn Museum of Art, New York: Dick S. Ramsay Fund, A. Augustus Healy Fund B, Frank L. Babbott Fund, A. Augustus Healy Fund, Ella C. Woodward Memorial Funds, Gift of Daniel M. Kelly, Gift of Charles Simon, Charles Smith Memorial Fund, Caroline Pratt Fund, Frederick Loeser Fund, Augustus Graham School of Design Fund, Bequest of Mrs William T. Brewster, Gift of Mrs W. Woodward Phelps, Gift of Seymour Barnard, Charles Stuart Smith Fund, Bequest of Laura L. Barnes, Gift of J.A.H. Bell, John B. Woodward Memorial Fund, Bequest of Mark Finley. 76.79; b: Courtesy of Berry-Hill Galleries, New York.
P39 – tr: The Brooklyn Museum of Art, New York: Dick S. Ramsay Fund; bl: The Metropolitan Museum of Art, New York: Morris K. Jesup Fund, 1933 (33.61)/Photograph © 1988.
P40 – tr: TAT: Bequeathed by W. Graham Robertson 1949; bl: The Whitworth Art Gallery, The University of Manchester.
P41 – tr: AKG: Walters Art Gallery, Baltimore; bl: AKG: Centraal Museum, Utrecht.
P42 – tr: BAL: Niedersachsische Landesmuseum, Hanover; b: Edimedia, Paris: Riccardo Jucker Collection, Milan.
P43 – tr: AKG: Nationalgalerie, Staatliche Museum, Berlin; bl: AKG: Nationalgalerie, Staatliche Museum, Berlin.
P44 – tr: ART: Musée d'Orsay, Paris; b: NGL
P45 – tr: Maidstone Museum & Art Gallery: (10.1944(38) Elgood Bequest; b: Nottingham City Museums: Castle Museum and Art Gallery.
P46 – tr: Musée National D'Art Moderne, Paris: Cci – Centre Georges Pompidou/© DACS 1999; b: CAR: Acquired through the generosity of the Sarah Mellon Scaife family, 70.50/Photograph: Peter Harholdt, 1994/© DACS 1999.
P47 – tr: NGL; bl: NGW: Widener Collection, © 1998 Board of Trustees.
P48 – bl: ART: Boymans-van Beuningen Museum, Rotterdam; r: MNP.
P49 – tr: NGL; bl: AKG: Den Haag, Mauritshuis/Photograph: Erich Lessing.
P50 – tr: NGL; bl: NGL
P51 – tr: BPK: Staatliche Museum, Berlin/Photograph: Jörg P. Anders; b: SCA: Galleria degli Uffizi, Florence.

P52 – tr: AKG: Musée du Louvre, Paris/Photograph: Erich Lessing; bl: Musée du Louvre, Paris.
P53 – tr: NGL; b: AIC: Mr and Mrs Lewis Larned Coburn Memorial Collection, 1938.1276, Photograph © 1999.
P54 – tr: Birmingham Museums and Art Gallery; bl: The J. Paul Getty Museum, Los Angeles: Gift of J. Paul Getty.
P55 – tr: NGL; bl: BAL: St Peter's, Louvain.
P56 – tr: © Museo Thyssen-Bornemisza, Madrid; bl: Savill Galleries, Australia: Private Collection, Sydney. *Arthur Boyd's work reproduced with the permission of Bundanon Trust.
P57 – tr: GIR: Kunstmuseum, Bale/© DACS 1999; bl: AKG: Kunstmuseum, Bern/Hermann and Margrit Rupf Foundation/© DACS 1999.
P58 – tr: BAL: Palazzo Pitti, Florence; bl: BAL: Museo del Prado, Madrid.
P59 – tr: AKG: Musée des Beaux-Arts, Dijon/Photograph: Erich Lessing; bl: AKG: Musée des Beaux-Arts, Dijon.
P60 – tr: NGL; bl: Artothek: Städelsches Kunstinstitut, Frankfurt.
P61 – tl: ART: Städelsches Kunstinstitut, Frankfurt; tr: ART: Alte Pinakothek, Munich; bl: Birmingham Museum and Art Gallery; br: Birmingham Museum and Art Gallery.
P62 – tr: MNP; b: HER.
P63 – tr: E.T. Archive: Capodimonte Gallery, Museo Nazionale, Naples; b: Kunsthistorisches Museum, Vienna.
P64 – tl: TAT: Presented by subscribers 1900; br: TAT: Bequeathed by Lord Battersea 1924.
P65 – tr: RMN: Musée d'Orsay, Paris/Photograph: C. Jean; b: AKG: Art Institute of Chicago/Photograph: Erich Lessing.
P66 – tr: IKO: Basilica di San Petronio, Bologna; bl: IKO: Capella Dell Rosario, Chiesa di San Domenico, Bologna.
P67 – tl: MNP; bl: NGL
P68 – tr: IKO: Galleria degli Uffizi, Florence; b: NGL.
P69 – tr: NGL; bl: NGL
P70 – tr: GIR: Galeria Degli Uffizi, Florence; b: SCA: Galleria degli Uffizi, Florence.
P71 – tr: BAL: Galleria Dell'Accademia, Venice; bl: AKG: Lugano, Thyssen-Bornemisza Collection/Photograph: Erich Lessing.
P72 – tr: IKO: Collection Vercesi, Rome/Luca Carrà, Milan/© DACS 1999; bl: IKO: Civica Galleria d'Arte Moderna, Milan/Luca Carrà, Milan/© DACS 1999.
P73 – tr: AKG: Musée du Louvre, Paris; bl: BAL: Hermitage, St Petersburg.
P74 – tr: AIC: Helen Regenstein Collection, 1985.40, Photograph © 1998; bl: SCA: Galleria degli Uffizi, Florence.
P75 – tr: Los Angeles County Museum of Art: Mrs Fred Hathaway Bixby Bequest; bl: NGW: Chester Dale Collection/© 1998 Board of Trustees.
P76 – tr: BAL: Santissima Annunziata, Florence; bl: NGW: Widener Collection/© 1998 Board of Trustees/Photograph: Richard Carafelli.
P77 – tr: SCA: Santa Cecilia in Trastevere, Rome; br: NGL.
P78 – AKG: Museum of Art, Philadelphia.
P79 – Musée d'Orsay, Paris.
P80 – tr: AKG: Kunstsammlung Nordrhein-Westfalen, Düsseldorf/Photograph: Erich Lessing/© DACS 1999; bl: SCA: Thyssen-Bornemisza Museum, Madrid/© DACS 1999.
P81 – NGL; b: BAL: Musée du Louvre, Paris/Photograph: Peter Willi.
P82 – tr: Edimedia, Paris: Musée du Louvre, Paris; bl: NGL
P83 – tr: Artephot: Musée du Louvre, Paris/Photograph: André Held; bl: SCA: Musée du Louvre, Paris.
P84 – tr: TAT: © DACS 1999; bl: Artephot: Private Collection/Photograph: Nimatallah/© DACS 1999.
P85 – tr: Birmingham Museums and Art Gallery; bl: ART: Gemäldegalerie, Berlin/Photograph: Hans Hinz.
P86 – tr: Courtesy of Berry-Hill Galleries, New York; b: The Detroit Institute of Arts: Founders Society

Purchase, Robert H Tannahill Foundation Fund, Gibbs-Williams Fund, Dexter M Ferry, Jr, Fund, Merrill Fund, Beatrice W Rogers Fund, and Richard A Manoogian Fund, Photograph © 1985.
P87 – tr: NGL; bl: NGL
P88 – tr: GIR: Galeria Degli Uffizi, Florence/Photograph: Alinari; bl: SCA: Fondazione Contini Bonacossi, Florence.
P89 – tr: BAL: Ashmolean Museum, Oxford; bl: NGL
P90 – tl: Galleria degli Uffizi, Florence, Italy; tr: NGW: Samuel H. Kress Collection, © 1998 Board of Trustees; bl: BAL: Musée du Louvre, Paris, France; br: BAL: Palazzo Pitti, Florence, Italy.
P91 – tr: NGW: Andrew W. Mellon Fund, © 1998 Board of Trustees; b: Photograph courtesy of Terra Museum of American Art, Chicago: Terra Foundation for the Arts, Daniel J. Terra Collection 1993.2.
P92 – tr: Courtesy of The Trustees of the V&A; bl: HER.
P93 – tr: BAL: Victoria & Albert Museum, London; bl: BAL: Private Collection.
P94 – tr: NGW: Ferdinand Lammot Belin Fund, © 1998 Board of Trustees; b: The Royal Collection © Her Majesty Queen Elizabeth II: Photograph: A.C. Cooper Ltd, March 1993.
P95 – tr: ART: Kunstmuseum, Bern/Photograph: Joachim Blauel; bl: AKG: Alte Nationalgalerie, Berlin.
P96 – tr: GIR: Musée du Louvre, Paris; bl: BAL: Musée du Louvre, Paris.
P97 – tr: Musées des Beaux Arts de Strasbourg; bl: AKG: Art Institute of Chicago/Photograph: Erich Lessing.
P98 – tr: NGW: Samuel H. Kress Collection, © 1998 Board of Trustees; bl: NGW: Samuel H. Kress Collection, © 1998 Board of Trustees.
P99 – tr: NGL; bl: NGL
P100 – tr: National Gallery of Victoria, Melbourne; bl: BAL: Towneley Hall Art Gallery & Museum, Burnley.
P101 – tr: San Diego Museum of Art, USA/Gift of Anne R. and Amy Putnam; bl: AKG: Museo Provincial, Granada.
P102 – tr: BAL: Norfolk Museums Service (Norwich Castle Museum); bl: BAL: By Courtesy of the Board of Trustees of the Victoria and Albert Museum, London.
P103 – tr: BPK: Staatliche Museum, Berlin; b: BAL: Musée Fabre, Montpellier.
P104 – tr: BAL: Musée du Louvre, Paris/Photograph: Lauros-Giraudon; bl: © Manchester City Art Galleries; br: BAL: Victoria & Albert Museum, London.
P105 – tr: Oldham Art Gallery Museum Local Studies Library and Archive Service; b: Ashmolean Museum, Oxford.
P106 – tr: BAL: Kunsthistorisches Museum, Vienna; bl: NGL
P107 – tr: BAL: Galleria degli Uffizi, Florence; bl: AKG: Galleria degli Uffizi, Florence/Photograph: Erich Lessing.
P108 – tr: HER; bl: IKO: Galleria degli Uffizi, Florence/Photograph: Raffaello Bencini Fotografo, Firenze.
P109 – bl: NGL; r: NGL.
P110 – tr: TAT: Purchased 1863; b: BAL: Norfolk Museums Service (Norwich Castle Museum).
P111 – tr: NGL; bl: NGL.
P112 – tr: BPK: Gemäldegalerie, Berlin/Photograph: Jörg P Anders; bl: NGL
P113 – tr: Edimedia, Paris: Philadelphia Museum of Art/© Salvador Dali/Foundation Gala-Salvador Dali/DACS, London 1999; bl: AKG: Museo Nacional Centro de Arte Reina Sofia, Madrid/© Salvador Dali/Foundation Gala-Salvador Dali/DACS, London 1999.
P114 – tr: BAL: Musée du Louvre, Paris; b: The Taft Museum, Cincinnati, Ohio: Bequest of Charles Phelps and Anna Sinton Taft.
P115 – tr: Glasgow Museums, The Burrell Collection: Snark International; bl: AKG: Musée d'Orsay, Paris/Photograph: Erich Lessing.
P116 – tr: AKG: Musée du Louvre, Paris/Photograph: Erich Lessing; bl: MNP.

P117 – tr: BAL: Musée du Louvre, Paris/Photograph: Giraudon; bl: BAL: Musées Royaux des Beaux-Arts de Belgique, Brussels/Photograph: Giraudon.
P118 – tr: CAR: Gift of the H.J. Heinz Company, 79.42/Photography by Peter Harholdt, 1994/© Stuart Davis/VAGA, NY and DACS, London 1999; bl: Edimedia, Paris: Cincinnati Art Museum/© Stuart Davis/VAGA, NY and DACS, London 1999.
P119 – tr: The Phillips Collection, Washington, D.C.; b: Musée d'Orsay, Paris.
P120 – tr: TAT: Purchased 1969/© Willem de Kooning/ARS, NY and DACS, London 1998; bl: Stedlijk Museum, Amsterdam: © Willem de Kooning/ARS, NY and DACS, London 1998.
P121 – tr: Musée du Louvre, Paris; bl: Musée du Louvre, Paris, France/Photograph: Giraudon.
P122 – tr: The Solomon R. Guggenheim Foundation, New York: Photograph: David Heald/© L & M Services B.V. Amsterdam 990404; TAT: Purchased 1967/© L & M Services B.V. Amsterdam 990404.
P123 – tr: BAL: Christie's Images, London/© Fondation P Delvaux - St Idesbald, Belgium/DACS 1999; b: BAL: Southampton City Art Gallery/© Fondation P Delvaux - St Idesbald, Belgium/DACS 1999.
P124 – tr: Whitney Museum of American Art, New York: Purchase, with funds from Gertrude Vanderbilt Whitney; bl: The Metropolitan Museum of Art, New York: Alfred Stieglitz Collection, 1949 (49.59.1)/Photograph © 1996.
P125 – tr: TAT: Purchased 1958/© DACS 1999; bl: The Phillips Collection, Washington, D.C.: © DACS 1999.
P126 – tl: Yale Center for British Art, Connecticut: Paul Mellon Collection; tr: Spink Leger: Private Collection; bl: Fitzwilliam Museum, Cambridge; br: Oldham Art Gallery Museum Local Studies Library and Archive Service.
P127 – tr: Phyllis Diebenkorn: Private Collection; bl: Phyllis Diebenkorn: Private Collection/Photograph: Jon Abbott.
P128 – tr: ART: Kunstmuseum Basel/Photograph: Hanz Hinz/© DACS 1999; bl: BAL: Musée National D'Art Moderne, Paris/© DACS 1999.
P129 – tr: BAL: Musée d'Orsay, Paris, France/Photograph: by Peter Willi; bl: SCA: Vatican Museums, Rome.
P130 – tr: BPK: Staatliche Museum, Berlin – Preußischer Kulturbesitz, Gemäldegalerie/Photograph Jörg P Anders; bl: NGW: Samuel H. Kress Collection, © 1998 Board of Trustees.
P131 – tr: Artephot: Hermitage, St Petersburg/Photograph: A Held; bl: SCA: Galleria Borghese, Rome.
P132 – tr: BAL: Johnny van Haeften Gallery, London; bl: NGL.
P133 – tr: AKG: Collection of Linda and Harry Macklowe, New York/© DACS 1999; b: TAT: Presented by Mrs Cynthia Fraser in memory of her husband, W. Lionel Fraser 1965/© DACS 1999.
P134 – tr: NGL; bl: NGW: Andrew W. Mellon Collection, © 1998 Board of Trustees.
P135 – tr: BAL: Philadelphia Museum of Art, Pennsylvania/© Succession Duchamp/DACS 1999; bl: Philadelphia Museum of Art, Pennsylvania: Bequest of Katherine S. Drier/© Succession Duchamp/DACS 1999.
P136 – tr: BAL: Galerie Daniel Malingue, Paris/© DACS 1999; bl: BAL: Galerie Daniel Malingue, Paris/© DACS 1999.
P137 – tr: NGL; b: MNP.
P138 – tr: NGL; bl: NGL.
P139 – tr: BAL: Graphische Sammlung Albertina, Vienna; bl: MNP.
P140 – tl: Courtesy of the Board of Trinity College, Dublin: Ms 57, fol 191v; br: TAT: Purchased 1894.
P141 – tr: BAL: Blenheim Palace, Oxfordshire; bl: BAL: Musée du Louvre, Paris/Photograph: Lauros-Giraudon.
P142 – tr: BAL: Jefferson College, Philadelphia; b: NGW: Gift of Mr

and Mrs Cornelius Vanderbilt Whitney/© 1998 Board of Trustees/Photograph: Richard Carafelli.
P143 – tr: BPK: Staatliche Museum, Berlin/Photograph: Jörg P Anders; b: ART: Alte Pinakothek, Munich.
P144 – tr: SCA: Musées Royaux des Beaux Arts, Brussels/© DACS 1998; b: BAL: Musées Royal des Beaux Arts de Belgique, Brussels/© DACS 1998.
P145 – tr: TAT: Purchased 1975/© DACS 1999; bl: TAT: Presented by the Friends of the Tate Gallery 1962/© DACS 1999.
P146 – tr: Photograph © Mauritshuis, The Hague: Inventory no. 39; bl: Photograph © Mauritshuis, The Hague: Photograph: Daniël van de Ven/Inventory No. 1088.
P147 – tr: TAT: Purchased with assistance from the Friends of the Tate Gallery 1984; bl: BAL: Courtauld Gallery, London.
P148 – l: NGW: Andrew W. Mellon Collection, © 1998 Board of Trustees; br: NGL
P149 – tr: GIR: Mauritshuis Museum, The Hague/Photograph: Bridgeman; b: NGL
P150 – tr: AIC: Stickney Fund, 1905.207, Photograph © 1998; bl: AIC: Ada Turnbull Hertle Fund, 1951.226, Photograph © 1998.
P151 – tr: The Detroit Institute of Arts: Gift of Robert H. Tannahill, Photograph © 1998/© DACS 1999; bl: ART: Alte Pinakothek, Munich/© DACS 1999.
P152 – tr: BAL: Hermitage, St Petersburg, Russia; bl: BAL: Musée du Louvre, Paris/Photograph: Peter Willi.
P153 – tr: Musée du Louvre, Paris; bl: BAL: Musée du Louvre, Paris, France.
P154 – tr: BAL: Kunsthistorisches Museum, Vienna, Austria; bl: BPK: Staatliche Museum, Berlin/Photograph: Jörg P Anders.
P155 – tr: BAL: Hermitage, St Petersburg, Russia; bl: NGW: Gift of Mrs. Mellon Bruce in memory of her father, Andrew W. Mellon, © 1998 Board of Trustees.
P156 – tr: TAT: Purchased 1964/© DACS 1999; bl: SFM: Partial Gift of Mrs Wellington S Henderson/© DACS 1999.
P157 – tr: From the Collection Becky and Pete Smith: Reproduction courtesy of Helen Frankenthaler; b: NGW: Collection of the Artist, on loan to the NGW/Reproduction courtesy of Helen Frankenthaler.
P158 – tr: BAL: Private Collection; b: BAL: Private Collection.
P159 – tr: NGL; b: Edimedia, Paris: Nationalgalerie, Berlin.
P160 – tr: BAL: Saint Saveur Cathédral, Aix-en-Provence/Photograph: Giraudon; bl: SCA: Galleria degli Uffizi, Florence.
P161 – tr: tl: NGW: Samuel H. Kress Collection, © 1998 Board of Trustees; br: SCA: Baroncelli Chapel, Santa Croce, Florence.
P162 – tr: NGL; bl: Super Stock: The Huntington Library, Art Collections and Botanical Gardens, San Marino, California.
P163 – tr: BAL: Musée d'Orsay, Paris; b: BAL: Courtauld Gallery, London.
P164 – tr: HER; bl: ART: Gemäldegalerie, Berlin.
P165 – tr: ART: Städelsches Kunstinstitut, Frankfurt; bl: Photograph © Mauritshuis, The Hague.
P166 – tr: BAL: Galleria degli Uffizi, Florence; bl: BPK: Staatliche Museum, Berlin/Photograph: Jörg P Anders.
P167 – tr: SCA: Galleria Palatina, Florence; bl: BAL: Galleria degli Uffizi, Florence.
P168 – tr: AKG: Musée du Louvre, Paris/Photograph: Erich Lessing; bl: NGW: Ailsa Mellon Bruce Fund, © 1998 Board of Trustees/Photo: Lyle Peterzell.
P169 – tr: BAL: Musée des Beaux Arts, Lyon; b: SCA: Musée du Louvre, Paris.
P170 – tr: BAL: Musée du Louvre, Paris; b: GIR: Eglise Santa Maria Novella, Florence/Photograph: Alanari.
P171 – tr: BAL: Galerie Maeght, Paris/© DACS 1999; bl: TAT: Accepted by H.M. Government in lieu of tax and allocated to the Tate

510

Gallery 1987/© DACS 1999.
P172 – tr: AKG: Kunsthistorisches Museum, Vienna/Photograph: Erich Lessing; b: NGL
P173 – tr: AKG: Gallerie dell' Accademia, Venice; bl: BAL: Galleria dell'Accademia, Venice.
P174 – BAL: Scrovegni (Arena) Chapel, Padua/Photograph: Giraudon;
P175 – tr: BAL: Galleria degli Uffizi, Florence.
P176 – tr: NGL; b: NGL.
P177 – tr: Fitzwilliam Museum, Cambridge; b: TAT: Bequeathed by Mrs Ada Montefiore 1933.
P178 – tr: BAL: Galleria degli Uffizi, Florence, Italy; b: NGL
P179 – tr: BAL: Galleria degli Uffizi, Florence; bl: BAL: Kunsthistorisches Museum, Vienna, Austria.
P180 – tr: Musée d'Orsay, Paris; bl: BAL: Courtauld Institute Galleries, University of London.
P181 – tr: GIR: Musée Nacional d'Arte Antiga, Lisbon; bl: GIR: Musée Nacional d'Arte Antiga, Lisbon.
P182 – tr: IKO: Private Collection/Photograph: Luca Carrà, Milan/© DACS 1999; bl: TAT: Presented by Eugène Mollo and the artist 1953/© DACS 1999.
P183 – tr: Whitney Museum of American Art, New York/Gift of Julien Levy for Maro and Natasha Gorky in memory of their father/© DACS 1999; bl: © Museo Thyssen-Bornemisza, Madrid/© DACS 1999.
P184 – tr: AKG: Staatliche Museum, Berlin/Photograph: Erich Lessing; bl: Edimedia, Paris: Museum Dahlem Gemäldegalerie, Berlin.
P185 – tr: © Adolph and Esther Gottlieb Foundation, New York: © Estate of Adolph Gottlieb/VAGA, NY & DACS, London 1999; bl: Krannert Art Museum and Kinkead Pavilion, University of Illinois: Festival of Arts Purchase Fund/© Estate of Adolph Gottlieb/© VAGA, NY. & DACS, London 1999.
P186 – MNP.
P187 – MNP.
P188 – tr: NGL; bl: NGL
P189 – tr: NGW: Samuel H. Kress Collection, © 1998 Board of Trustees/Photograph: Richard Carafelli; b: BAL: Palazzo Medici-Riccardi, Florence.
P190 – tr: NGW: Samuel H. Kress Collection, © 1998 Board of Trustees/Photograph: Richard Carafelli; bl: SCA: Church of Santa Tomé, Toledo.
P191 – tr: NGS; bl: SCA: State Hermitage, St Petersburg.
P192 – tr: MNP./© ADAGP, Paris and Dacs, London, 1999; bl: NGW: Chester Dale Fund, © 1998 Board of Trustees/© ADAGP, Paris and Dacs, London, 1999.
P193 – tr: BAL: Musée du Louvre, Paris/Photograph: Giraudon; bl: BAL: City of Bristol Museum and Art Gallery, Avon.
P194 – tr: AKG: Staatliche Museum Preußischer Kulturbesitz, Gemäldegalerie, Berlin/© DACS 1999; bl: TAT: Purchased with assistance from the National Art Collections Fund 1976/© DACS 1999.
P195 – tr: GIR: Musée D'Unterlinden, Colmar; br: GIR: Musée d'Unterlinden, Colmar.
P196 – tr: NGL; b: NGL.
P197 – MNP.; bl: NGL
P198 – tr: The Phillips Collection, Washington, D.C.; b: TAT: Purchased 1982.
P199 – tr: ART: Berlin Gemäldegalerie/Photograph: Joachim Blauel; br: NGL.
P200 – tr: TAT: Purchased 1930; bl: Statens Museum for Kunst, Copenhagen: Photograph: Hans Petersen.
P201 – tr: SCA: Collection Thyssen, Lugano/© DACS 1999; bl: Buchheim-Museums, Feldafing/© DACS 1999.
P202 – tl: Gemäldegalerie Alte Meister, Dresden; tr: BAL: Hermitage, St Petersburg: Photograph © Mauritshuis, The Hague: Inventory No. 1099; br: Photograph © Mauritshuis, The Hague: Inventory No. 613.
P203 – tr: AKG: Staatliche Museum, Kassel; bl: © Museo Thyssen-Bornemisza, Madrid.
P204 – tr: NGW: Gift of Edgar William

and Bernice Chrysler Garbisch, © 1998 Board of Trustees; bl: CAR: Bequest of Charles J. Rosenbloom, 74.7.13/Photograph: Peter Harholdt 1994.
P205 – tr: Courtesy of the Trustees of the V&A; b: TAT: Lent by the National Portrait Gallery, London 1965.
P206 – tr: NGL; bl: NGL
P207 – tr: CAR: Museum purchase: Gift of Richard M. Scaife, 82.67/© David Hockney; bl: TAT: Purchased 1981/© David Hockney.
P208 – tr: Courtesy Anthony d'Offay Gallery, London: Sue and David Workman Collection, Stamford; bl: TAT: Purchased 1990/Courtesy Anthony d'Offay Gallery, London.
P209 – tr: ART: Kunstmuseum, Basel; bl: Kunstmuseum Winterthur: Haags Gemeentemuseum.
P210 – tr: NGL; bl: NGL.
P211 – tr: NGL; bl: NGL.
P212 – tr: The Brooklyn Museum of Art, New York: Sustaining Membership Fund; A. Augustus Healy Fund, 23.98; b: The Butler Institute of American Art, Ohio.
P213 – tr: NGL; bl: NGL
P214 – tr: BAL: Collection of the Earl of Pembroke, Wilton; bl: NGL.
P215 – tr: BPK: Staatliche Museum, Berlin/Photograph: Jörg P Anders; bl: NGW: Andrew W. Mellon Collection, © 1998 Board of Trustees.
P216 – tr: HER; bl: BAL: Kunsthistorisches Museum, Vienna.
P217 – tr: Whitney Museum of American Art, New York: Purchase, with funds from the Whitney Museum of American Art/Photograph: Robert E. Mates, N.J.; b: Whitney Museum of American Art, New York: Purchase, with funds from Gertrude Vanderbilt Whitney/Photograph: Geoffrey Clements.
P218 – tr: BAL: Laing Art Gallery, Newcastle-upon-Tyne, Tyne & Wear; bl: TAT: Presented by Sir Colin and Lady Anderson through the Friends of the Tate Gallery 1976.
P219 – tr: By Courtesy of Peterborough Museum and Art Gallery; bl: NGL.
P220 – tr: BAL: Musée du Louvre, Paris; bl: NGL
P221 – tr: The Brooklyn Museum of Art, New York: Gift of Mrs W.W. Phelps in Memory of her mother and father, Ella M. and John C. Southwick; b: NGW: Gift of Mrs Huttleston Rogers, © 1998 Board of Trustees.
P222 – tr: SFM: Gift of Charlotte Mack/Photograph: Don Myer/© ADAGP, Paris and DACS, London 1998; bl: TAT: Presented by the Contemporary Art/© Estate of Augustus John 1999 All rights reserved DACS.
P225 – tr: © Manchester City Art Galleries: © The Estate of Gwen John 1998 All rights reserved DACS; b: Yale Center for British Art: Paul Mellon Collection/© The Estate of Gwen John 1998 All rights reserved DACS.
P224 – tr: TAT: Presented by the Friends of the Tate Gallery 1961/© Jasper Johns/VAGA, NY & DACS 1999; b: Leo Castelli, New York/© Jasper Johns/VAGA, NY & DACS 1999.
P225 – tr: NGL; br: AKG: Musée d'Orsay, Paris/Photograph: Erich Lessing.
P226 – tr: BAL: Kunsthistorisches Museum, Vienna, Austria; bl: BAL: Walker Art Gallery, Liverpool, Merseyside.
P227 – tr: BAL: Musée du Louvre, Paris/Photograph: Giraudon; bl: BAL: Musée du Louvre, Paris.
P228 – tr: BAL: Musée du Louvre, Paris; bl: MNP.
P229 – tr: NGW: Ailsa Mellon Bruce Fund, © 1998 Board of Trustees; bl: MNP.
P230 – tr: Art Collection, Harry Ransom Humanities Research Centre, The University of Texas at Austin: Instituto Nacional de Bellas Artes Y Literatura, Mexico/Banco de Mexico; bl: AKG: Museo de Arte Moderno, Mexico City/Instituto Nacional de Bellas Artes Y Literatura, Mexico/Banco de Mexico.

P231 – tr: NGW: Chester Dale Collection, © 1998 Board of Trustees/Photograph: Richard Carafelli; bl: NGL
P232 – tr: © The Solomon R. Guggenheim Foundation, New York: Gift, Solomon R. Guggenheim, 1941/Photograph: David Heald/© VAGA, NY & DACS, London 1999; bl: AKG: State Museum of Russia, St Petersburg/© ADAGP, Paris & DACS, London 1999.
P233 – tr: Marlborough Gallery, Inc.: © Alex Katz, courtesy, Marlborough Gallery; bl: Marlborough Gallery, Inc.: © Alex Katz, courtesy, Marlborough Gallery/The Saatchi Collection, London.
P234 – tr: The National Trust: Yorkshire Photographic Library/Photograph: John Hammond/Reproduced by Kind Permission of the Winn Family and The National Trust (Nostell Priory); b: AKG: Gemäldegalerie, Alte Meister, Dresden.
P235 – tr: BAL: Trinity College Library, Dublin; bl: BAL: Trinity College Library, Dublin.
P236 – tr: Courtesy Anthony d'Offay Gallery, London; b: Courtesy Anthony d'Offay Gallery, London.
P237 – tr: SCA: Galleria degli Uffizi, Florence; b: ART: Alte Pinakothek, Munich.
P238 – tr: Entwhistle Gallery, London; bl: CAR: Richard M. Scaife Fund and A.W. Mellon Acquisition Endowment Fund, 83.53.
P239 – tr: Allen Memorial Art Museum, Oberlin College, Ohio: Charles F. Olney Fund, 50.29/Copyright by Dr Wolfgang & Ingeborg Henze-Ketterer, Wichtrach/Bern; bl: AKG: Brucke Museum, Berlin/Copyright by Dr Wolfgang & Ingeborg Henze-Ketterer, Wichtrach/Bern.
P240 – tr: GIR: Kunstmuseum Balel/© DACS 1998; bl: Paul Klee Stiftung: Kunstmuseum Bern/© DACS 1998.
P241 – tr: BAL: Österreichische Galerie, Vienna, Austria; bl: BAL: Österreichische Galerie, Vienna, Austria.
P242 – tr: CAR: Gift of Friends of the Museum, 59.21/Photograph: Richard Stoner, 1990; bl: Whitney Museum of American Art, New York: Purchase, with funds from the Friends of the Whitney Museum of American Art.
P243 – tr: HER; bl: TAT: Purchased with assistance from the Friends of the Tate Gallery 1987.
P244 – tr: Statens Museum for Kunst, Copenhagen: Photograph: Hans Petersen; b: Statens Museum for Kunst, Copenhagen: Photograph: Hans Petersen.
P245 – tr: TAT: Presented by Dr Edvard Benes, President of Czechoslovakia 1941/© DACS 1999; bl: AKG: Kunstmuseum, Basel/© DACS 1999.
P246 – tl: NGL; tr: The J. Paul Getty Museum, Los Angeles; br: Artephot: Parish Church of Bad Wildungen/Photograph: M Babey; br: ART: Alte Pinakothek, Munich.
P247 – tr: BAL: Scottish National Gallery of Modern Art, Edinburgh; bl: BAL: Private Collection.
P248 – tr: The Metropolitan Museum of Art, New York: Gift of Mr. and Mrs. Eugene Victor Thaw, 1983 (1983.202)/Photograph © 1983/© DACS 1999; b: Photograph courtesy of the Robert Miller Gallery, New York: © DACS 1999.
P249 – tl: BAL: Phototèque des Musées de la Ville de Paris/© ADAGP, Paris and DACS, London 1999; br: NGL
P250 – tl: NGL; tr: NGL; bc: BAL: United Distilleries Ltd, London; b: BAL: Forbes Magazine Collection, New York.
P251 – tr: NGL; bl: NGW: Ailsa Mellon Bruce Fund, © 1998 Board of Trustees.
P252 – tr: AKG: Private Collection, Lugano/© DACS 1999; bl: TAT: Presented by Mme Alexandra Larionov, the artist's widow 1965/© DACS 1999.
P253 – tr: Robert Harding Picture Library; b: Robert Harding Picture Library: © Explorer.
P254 – tr: HER; b: NGL
P255 – tr: BAL: Musée Departmental des Vosges, France/Photograph: Peter

Willi; bl: AKG: Musées des Beaux-Arts et d'Architecture, Rennes/Photograph: Erich Lessing.
P256 – tr: RMN: Musée du Louvre, Paris; GIR: Musée du Louvre, Paris.
P257 – tr: NGL; bl: The Metropolitan Museum of Art, New York: Bequest of Edward S Harkness, 1940 (50.135.5)/Photograph © 1980.
P258 – HER; b: GIR: Musée du Louvre, Paris/Photograph: Lauros.
P259 – tr: BPK: Staatliche Museum, Berlin/Photograph Jörg P Anders January 1997/© DACS 1999; bl: GIR: Musée National D'Art Moderne, Paris/© DACS 1999.
P260 – AKG: Von der Heydt-Museum, Wuppertal; bl: BAL: Hamburger Kunsthalle, Hamburg, Germany.
P261 – tr: BAL: Museo de Arte, Ponce, Puerto Rica; b. NGL
P262 – tr: TAT: Purchased with assistance from the National Art Collections Fund 1955; bl: BAL: Collection of the Earl of Bathurst.
P263 – tr: NGL; b: NGW: Samuel H. Kress Collection, © 1998 Board of Trustees/Photograph: Richard Carafelli
P264 – BAL: Musée du Louvre, Paris/Photograph: Giraudon; b: ART: Alte Pinakothek, Munich.
P265 – AKG: Czartoryski Museum, Cracow/Photograph: Erich Lessing.
P266 – tr: SCA: Mauritshuis Museum, The Hague; bl: NGL
P267 – tr: Museum für Moderne Kunst, Frankfurt: Photograph: Axel Schneider, Frankfurt/© Estate of Roy Lichtenstein/DACS 1999; bl: AKG: Ludwig Museum, Cologne/© Estate of Roy Lichtenstein/DACS 1999.
P268 – tr: Stiftung Preußische Schlösser und Gärten, Berlin; bl: BAL: Collection of the Earl of Pembroke, Wilton House, Wiltshire.
P269 – tr: BAL: Musée Condé, Chantilly, Ms. 65/1284 f.2v; bl: BAL: Musée Condé, Chantilly, MS. 65/1284 f.14v.
P270 – tr: British Library, London: Cott.Nero.O.IV. Folio:27(WF); bl: British Library, London: Cott.Nero.0.IV. Folio:26v.
P271 – tl: © Musée d'art et d'Histoire, Ville de Genève: Cabinet des Dessins; bl: BAL: Gemäldegalerie, Dresden.
P272 – tr: BAL: Master & Fellows of Christ Church, Oxford; bl: BAL: Church of the Badia, Florence.
P273 – tr: BAL: Palazzo Pitti, Florence; bl: BPK: Staatliche Museum, Berlin.
P274 – tr: NGL; bl: ART: Alte Pinakothek, Munich.
P275 – tr: ART: Cologne Cathedral/Photograph: Joachim Blauel; bl: NGL.
P276 – tr: NGL; bl: NGL
P277 – tr: SCA: Palazzo Pubblico, Siena; b: SCA: Palazzo Pubblico, Siena.
P278 – tr: BAL: Galleria degli Uffizi, Florence; bl: BPK: Staatliche Museum, Berlin/Photograph: Jörg P Anders.
P279 – IKO: Vatican Museums, Rome/Photograph: L Giordano; bl: BAL: Galleria dell' Accademia, Florence.
P280 – tr: AKG: Musée du Louvre, Paris/Photograph: Erich Lessing; bl: NGL
P281 – tr: Whitney Museum of American Art, New York: Purchase, with funds from the Friends of the Whitney Museum of American Art/Photograph: Geoffrey Clements/Reproduced by kind permission of Garfinkle & Associates, Washington, D.C.; b: Private Collection/Reproduced by kind permission of Garfinkle & Associates, Washington, D.C.
P282 – l: BAL: Hermitage, St Petersburg, Russia; br: NGL.
P298 – tl: British Library, London, Add 42130 f.202v; bl: British Library, London, Add 42130 f.170v.
P284 – tr: ART: Städtisches Kunstmuseum, Bonn; bl: Staatsgalerie, Stuttgart, Inv., Nr 28260.
P285 – tr: BAL: Harold Samuel Collection, Corporation of London; bl: NGL
P286 – tr: MNP; b: BAL: Hermitage, St Petersburg.
P287 – tr: GIR: Musée Boymans van Beuningen, Rotterdam/Photograph: Phototeque René Magritte/© DACS 1999; b: BAL: Private Collection/© DACS 1999.

P288 – tr: Edimedia, Paris: Stedelijkmuseum, Amsterdam; bl: State Russian Museum, St Petersburg.
P289 – tr: Musée d'Orsay, Paris; b: Musée d'Orsay, Paris.
P290 – SFM: T.B. Walker Foundation Fund Purchase; b: Photograph courtesy of PaceWildenstein, New York: Photograph: Eeva-inkeri.
P291 – tl: BAL: Pinacoteca di Brera, Milan; bl: MNP.
P292 – tr: ART: Staatsgalerie Moderner Kunst, Munich/Photograph: Joachim Blauel; bl: ART: Städtische Galerie im Lenbachhaus, Munich/Photograph: Joachim Blauel.
P293 – tr: Brice Marden: © DACS 1999; bl: Museum Ludwig, Köln: Rheinisches Bildarchiv, Cologne/© DACS 1999.
P294 – tr: NGL; bl: NGL
P295 – tr: NGL; bl: BPK: Staatliche Museum, Berlin/Photograph: Jörg P Anders.
P296 – tr: BAL: Musée National D'Art Moderne, Paris, France/Photograph: Peter Willi/© DACS 1999; bl: NGW: Chester Dale Collection, © 1998 Board of Trustees/© DACS 1999.
P297 – tr: Des Moines Art Center, Iowa: Purchased with funds from the Coffin Fine Arts Trust and partial gift of Arnold and Mildred Glimcher; Nathan Emory Coffin Collection of the Des Moines Art Center, 1992.12; bl: Norton Simon Museum, Pasadena, CA: Gift of Nicholas Wilder in Memory of Jordan Hunter (1949-68), 1969.
P298 – l: AKG: Chiesa del Carmine, Brancacci Chapel, Florence/Photograph: Erich Lessing; br: BAL: Museo e Gallerie Nazionali di Capodimonti, Naples.
P299 – tr: BPK: Staatliche Museum, Berlin/Photograph: Jörg P Anders; b: SCA: Santa Croce, Florence.
P300 – tr: The John G. Johnson Collection, Philadelphia Museum of Art, Pennsylvania; bl: SCA: Galleria degli Uffizi, Florence.
P301 – tl: IKO: Collection of the Prince of Liechtenstein, Vaduzl; bl: AKG: Musée du Louvre, Paris.
P302 – t: SCA: Museo Civico, Pistoia; br: National Gallery in Prague.
P303 – tr: GIR: National Museum, Helsinki; bl: Museum der bildenden Künste Leipzig.
P304 – tr: BAL: Bibliothèque Nationale de France, Paris/Photograph: Giraudon; bl: Bibliothèque Nationale de France, Paris.
P305 – tr: Musée Royaux des Beaux-Arts de Belgique, Brussels: Koninklijke Musea voor Schone Kunsten van Belgie, Brussels/Photograph: Cussac; bl: NGW: Samuel H. Kress Collection, © 1998 Board of Trustees.
P306 – tr: St Louis Art Museum, Missouri, USA: Photograph: BAL: Walker Art Gallery, Merseyside/Board of Trustees: National Museums & Galleries on Merseyside.
P307 – tr: NGL; bl: NGL
P308 – tr: National Gallery in Prague; bl: National Gallery in Prague.
P309 – tr: TAT: Purchased with assistance from the Friends of the Tate Gallery 1962/© Succession H Matisse/DACS 1998; b: The Baltimore Museum of Art: The Cone Collection, formed by Dr Claribel Cone and Miss Etta Cone of Baltimore, Maryland, BMA 1950.258/© Succession H Matisse/DACS 1998.
P310 – tr: NGL; bl: NGL
P311 – tr: AKG: Musée du Louvre, Paris; b: MNP.
P312 – tr: GIR: Sanctuaire della Santa Casa, Lorette/Photograph: Leaner; bl: GIR: Basilica of the Santa Casa, Lorette/Photograph: Alinari.
P313 – tr: AKG: Stuttgart, Staatsgalerie; bl: NGL
P314 – tr: BPK: Staatliche Museum, Berlin; bl: MNP.
P315 – tr: MNP; bl: BAL: Hermitage, St Petersburg
P316/7 – bl: BAL: Galleria degli Uffizi, Florence; t: BAL: Vatican Museums and Galleries, Vatican City.
P318 – tr: NGL; bl: BAL: Hermitage, St Petersburg.
P319 – tr: AKG: Musée du Louvre, Paris/Photograph: Erich Lessing; bl: NGL
P320 – tr: BAL: Manchester City Art

Gallery; bl: BAL: Birmingham Museums and Art Gallery.
P521 – tr: BAL: Museum of Fine Arts, Boston, Massachusetts; bl: AKG: Musée d'Orsay, Paris/Photograph: Erich Lessing.
P322 – tr: Private Collection, Zurich: © DACS 1998; bl: BAL: Private Collection/© DACS 1999.
P323 – tr: Artephot: Folkwang Museum, Esses; b: AKG: Kunsthalle, Bremen.
P324 – tr: NGW: Chester Dale Collection, © 1998 Board of Trustees; bl: SCA: Galleria Civica d'art Moderna, Milan.
P325 – tr: Collection Kröller-Müller Museum, Otterlo, The Netherlands: © Mondrian/Holtzman Trust, c/o Beeldrecht, Amsterdam, Holland 1998/DACS 1999; br: ART: Kunstmuseum, Basel/Photograph: Hans Hinz/© Mondrian/Holtzman Trust, c/o Beeldrecht, Amsterdam, Holland 1998/DACS 1999.
P326 – tr: AKG: Musée Marmottan, Paris/© ADAGP, Paris & Dacs, London, 1999; b: NGL/© ADAGP, Paris and Dacs, London, 1999.
P527 – tl: NGL; br: BAL: Rafael Valls Gallery, London.
P528 – tr: NGW: Andrew W. Mellon Collection, © 1998 Board of Trustees/Photograph: Richard Carafelli; bl: MNP.
P529 – MNP; bl: HER.
P530 – tr: Fondazione Maghani - Rocca: © DACS 1999; bl: Elke Walford Fotowerkstatt, Hamburg: Hamburger Kunsthalle/© DACS 1998.
P531 – tl: RMN: Musée d'Orsay, Paris/Photograph: D Arnaudet; tr: GIR: Musée d'Orsay, Paris; bl: NGL; br: NGL
P532 – tr: NGW: Chester Dale Collection, © 1998 Board of Trustees; b: NGW: Ailsa Mellon Bruce Collection, © 1998 Board of Trustees/Photography: Richard Carafelli
P533 – tr: NGL; bl: NGL
P534 – tr: The Dedalus Foundation: © Estate of Robert Motherwell/VAGA, NY and DACS, London 1998; b: The Dedalus Foundation: © Estate of Robert Motherwell/VAGA, NY and DACS, London 1998.
P535 – tr: SCA: National Gallery, Oslo/© The Munch Museum/The Munch-Ellingsen Group/DACS 1999; bl: SCA: National Gallery, Oslo/© The Munch Museum/The Munch-Ellingsen Group/DACS 1999.
P536 – tr: MNP; bl: SCA: Musée du Louvre, Paris.
P537 – tr: The Reece Galleries, Inc.; bl: BAL: Kunsthistorisches Museum, Vienna.
P538 – tr: TAT: Presented by Mrs Annalee Newman, the artist's widow, in honour of the Directorship of Sir Alan Bowness 1988/© ARS, NY and DACS, London 1999; bl: TAT: Purchased 1968/© ARS, NY and DACS, London 1999.
P539 – tr: NGL; bl: BAL: Musée du Louvre, Paris.
P540 – tr: Hirshhorn Museum and Sculpture Garden: Smithsonian Institution, Gift of the Joseph H. Hirshhorn Foundation, 1966/Photograph: Lee Stalsworth/© DACS 1999; b: TAT: Purchased 1955/© DACS 1999.
P541 – tr: TAT: Presented by the Contemporary Art Society 1917/Reproduced by permission of Elizabeth Banks; bl: Copyright Winifred Nicholson Trustees.
P542 – tr: TAT: Presented by Lord McAlpine of West Green 1983; b: National Gallery of Australia, Canberra: Gift of Sunday Reed, 1977/Estate of Sir Sidney Nolan.
P543 – tr: The Detroit Institute of Arts: Bequest of Robert H. Tannahill, Photograph © 1998/© Nolde-Stiftung Seebüll; bl: Museum am Ostwall, Dortmund: © Nolde-Stiftung Seebüll/Photograph: Jürgen Spiler.
P544 – tr: NGL; bl: NGL.
P545 – tr: © Museo Thyssen-Bornemisza, Madrid/© DACS 1999; b: The Phillips Collection, Washington, D.C./© DACS 1999.
P546 – tr: The Royal Collection © Her Majesty Queen Elizabeth II: Photograph: EZM December 1995; b: BAL: Burghley House Collection,

Lincolnshire.
P347 - tr: NGL; bl: MNP.
P348 - tr: Hessische Landes-und Hochschul-Bibliothek, Darmstadt; bl: BAL: Musée Conde, Chantilly.
P349 - tr: BAL: Wallace Collection, London; bl: BAL: Private Collection.
P350 - tr: ART: Alte Pinakothek, Munich; bl: ART: Alte Pinakothek, Munich.
P351 - tr: NGL; bl: NGL
P352 - tl: IKO: The Oratory of the Crociferi, Venice; tr: NGL; bl: NGW: Samuel H. Kress Collection, © 1998 Board of Trustees/Photograph: Richard Carafelli; br: NGL.
P353 - tr: AKG: Kunsthistorisches Museum, Vienna; br: AKG: Kunsthistorisches Museum, Vienna.
P354 - tr: MNP; bl: MNP.
P355 - tr: AKG: Nationalgalerie, Staatliche Museum, Berlin/ Photograph: Erich Lessing/© DACS 1999; b: SFM: Purchase/Photograph: Don Myer/© DACS 1999.
P356 - tl: NGL; br: BAL: Palatine Gallery, Pitti Palace, Florence.
P357 - tr: NGL; b: NGL
P358 - tr: SCA: Musée du Louvre, Paris; b: GIR: Pinacoteca di Brera, Milan/Photograph: Cameraphoto Arte.
P359 - tr: SCA: Ganz Collection, New York/© Succession Picasso/DACS 1999; bl: The Museum of Modern Art, New York: Photograph © 1998. Acquired through the Lillie P. Bliss Bequest. © Succession Picasso/DACS, 1998.
P360 - tr: SCA: Pinacoteca Comunale, Museo Civico, Sansepulcro; bl: SCA: Pinacoteca Comunale, Museo Civico, Sansepulcro.
P361 - c: Ashmolean Museum, Oxford; b: NGL.
P362 - tr: NGL; bl: NGL.
P363 - tr: NGL; bl: The Brooklyn Museum of Art, New York: Purchased with funds given by Dikran G. Kelekian.
P364 - tr: BAL: City of York Art Gallery, York; b: BAL: Musée du Louvre, Paris/Photograph: Giraudon.
P365 - tr: GIR: Galleria del Uffizi, Florence/Photograph: Alinari; bl: NGL
P366 - tr: Musée National D'Art Moderne, Paris: Cci – Centre Georges Pompidou/Photograph: Jacques Faujour/© ARS, NY and DACS, London 1998; b: National Gallery of Australia, Canberra: © ARS, NY and DACS, London 1998.
P367 - tr: BAL: Santa Felicità, Cappella Bardori, Florence; br: SCA: Galleria degli Uffizi, Florence.
P368 - tr: © Museo Thyssen-Bornemisza, Madrid; bl: Ludwig Museum, Cologne: Rheinisches Bildarchiv.
P369 - tr: BAL: Hermitage, St Petersburg; b: BAL: The Mauritshuis, The Hague.
P370 - BAL: Walker Art Gallery, National Museums & Galleries on Merseyside, Liverpool.
P371 - BAL: Musée du Louvre, Paris/Photograph: Giraudon.
P372 - tr: BAL: Hermitage, St Petersburg; bl: BAL: Musée du Louvre, Paris.
P373 - tr: BAL: Musée du Louvre, Paris/Photograph: Giraudon; bl: AKG: Musée du Louvre, Paris/Photograph: Erich Lessing.
P374 - tr: BAL: Musée d'Orsay, Paris/Photograph: Lauros – Giraudon; bl: BAL: Musée d'Orsay, Paris.
P375 - tr: Rijksmuseum Foundation, Amsterdam; bl: NGS.
P376 - tr: BAL: Musée du Louvre, Paris/Photograph: Giraudon; bl: Artephot: Musée de l'Hospice, Villeneuve-Les-Avignons/ Photograph: K Takese.
P377 - tr: BAL: British Library, London, Roy 2 B VII f.78; bl: BAL: British Library, London, Roy 2 B VII f.151r.
P378 - tr: NGW: Andrew W. Mellon Collection, © 1998 Board of Trustees; bl: BAL: National Gallery of Scotland, Edinburgh.
P379 - tr: MacLeod Estate, Dunvegan: In the Collection of John MacLeod, Dunvegan Castle; bl: BAL: National Gallery of Scotland, Edinburgh.
P380 - SCA: Musée du Louvre, Paris.
P381 - GIR: Pitti Palazzo, Florence.
P382 - tr: Leo Castelli, New York/©

Robert Rauschenberg/VAGA, NY & DACS 1999; b: © Museo Thyssen-Bornemisza, Madrid/© Robert Rauschenberg/VAGA, NY & DACS 1999.
P583 - tc: GIR: Musée d'Orsay, Paris; tr: © Phototèque des Musées de la Ville de Paris: Petit Palais, Paris/ Photograph: Patrick Pierrain; bl: The Brooklyn Museum of Art, New York: Gift of the Artist/© DACS 1999; br: Photograph courtesy of PaceWildenstein, New York/© DACS 1999.
P584 - tr: NGL; bl: Devonshire Collection, Chatsworth: By permission of the Duke of Devonshire and the Chatsworth Settlement Trustees.
P585 - tr: NGL; bl: MNP.
P586 - tr: National Museums & Galleries of Wales; b: BAL: Fitzwilliam Museum, University of Cambridge.
P587 - tr: NGL; bl: National Portrait Gallery, London.
P588 - tr: NGL; bl: MNP.
P589 - tr: MNP; bl: AKG: Musée du Louvre, Paris/Photograph: Erich Lessing.
P590 - tr: NGL; bl: RMN: Musée du Louvre, Paris/Photograph: Jean Bellot.
P591 - tr: © Gerhard Richter: Private Collection; bl: TAT: Presented by the Patrons of New Art through the Friends of the Tate Gallery 1988/© Gerhard Richter.
P592 - tr: SCA: Musée du Louvre, Paris; bl: MNP.
P593 - tr: Courtesy of Abbot Hall Art Gallery, Kendal, Cumbria: Reproduction by kind permission of Bridget Riley; bl: TAT: Purchased 1963/Reproduction by kind permission of Bridget Riley.
P594 - tr: SFM: Albert M. Bender Collection/Photograph: Ben Blackwell; bl: The Detroit Institute of Arts: Palacio Nacional Stairway, Mexico City/Photograph: Dirk Bakker, © 1998.
P595 - tr: HER; bl: BAL: Musée du Louvre, Paris.
P596 - tr: The English Heritage Photo Library: The Iveagh Bequest, Kenwood House, London; bl: National Trust Photographic Library: Upton House, Warwickshire (Bearsted Collection)/Photograph: Angelo Hornak.
P597 - tr: NGL; bl: BAL: Musée du Louvre, Paris.
P598 - tr: AKG: National Museum, Stockholm; bl: BAL: Victoria & Albert Museum, London.
P599 - tr: Courtesy Sperone Westwater, New York: Collection Harry W. and Mary Margaret Anderson; b: Collection Mr and Mrs Frank Rothman.
P400 - tr: The Phillips Collection, Washington, D.C.: © Kate Rothko Prizel & Christopher Rothko/DACS 1999; bl: Photograph courtesy of PaceWildenstein, New York: © Kate Rothko Prizel & Christopher Rothko/DACS 1999.
P401 - tr: Bridgestone Museum of Art, Ishibashi Foundation, Tokyo: © DACS 1999; bl: CAR: Patrons Art Fund, 40.1/© DACS 1999.
P402 - tr: NGW: Chester Dale Collection, © 1998 Board of Trustees; bl: NGL
P403 - tr: BAL: Musée du Louvre, Paris; bl: NGL
P404 - The J. Paul Getty Museum, Los Angeles.
P405 - Kunsthistorisches Museum, Vienna.
P406 - tr: AKG: Tretjackov Gallery, Moscow; bl: BAL: Tretyakov Gallery, Moscow.
P407 - tr: BPK: Staatliche Museum, Berlin; bl: NGL.
P408 - tr: Elke Walford Fotowerkstatt, Hamburg: Hamburger Kunsthalle, Hamburg; bl: Elke Walford Fotowerkstatt, Hamburg: Hamburger Kunsthalle, Hamburg.
P409 - tr: NGL; b: Glasgow Museums, The Burrell Collection.
P410 - tr: BPK: Staatliche Museum, Berlin/Photograph: Jörg P Anders; b: BPK: Staatliche Museum, Berlin/Photograph: Jörg P Anders.
P411 - tr: Stedlijk Museum, Amsterdam: Photograph courtesy of PaceWildenstein, New York; bl: SFM: Extended loan of the artist and

promised gift of Mimi and Peter Haas/San Francisco Museum of Modern Art/Ben Blackwell/ Photograph courtesy of PaceWildenstein, New York.
P412 - tr: Museum Boymans-van Beuningen, Rotterdam; b: NGL
P413 - tr: BAL: By Courtesy of the Board of Trustees of the V&A; b: BAL: Castle Museum and Art Gallery, Nottingham.
P414 - tr: © Musée des Beaux-Arts, Dijon; bl: NGL
P415 - tr: Courtesy, Museum of Fine Arts, Boston: Gift of Miss Julia Overing Boit; bl: Courtesy, Museum of Fine Arts, Boston: Gift of Mary Louisa Boit, Julia Overing Boit, Jane Hubbard Boit, and Florence D. Boit, in memory of their father, Edward Darley Boit.
P416 - tr: Artephot: Musée Condé, Chantilly/Photograph: K Takase; bl: NGW: Samuel H. Kress Collection, © 1998 Board of Trustees/Photograph: Richard Carafelli.
P417 - tr: NGL; bl: NGL
P418 - tr: Utrecht Central Museum; b: AKG: National Gallery, Prague.
P419 - tr: NGL; b: SCA: Borghese Gallery, Rome.
P420 - tr: ART: Museo-Thyssen Bornemisza, Madrid; b: AKG: Osterreichische Galerie at Belvedere, Vienna/Photograph: Erich Lessing.
P421 - tr: ART: Brücke Museum, Berlin/Photograph: Joachim Blauel/ DACS 1998; bl: BAL: Church of Saint Martin, Colmar.
P422 - tr: BAL: Jan Van Haeften Gallery, London; bl: Rijksmuseum Foundation, Amsterdam.
P423 - tr: NGL; bl: NGL
P424 - tr: SCA: Galleria degli Ufflizi, Florence/Photograph: Raffaello Bencini Fotografo Firenze; bl: BAL: Collection of the Earl of Pembroke, Wilton House, Salisbury.
P425 - tr: BAL: Herron Art Institute, Indianapolis; b: AIC: Helen Birch Bartlett Memorial Collection, 1926.224.
P426 - tr: TAT: Purchased with assistance from a member of the National Art Collections Fund 1968/© DACS 1999; bl: © Museo Thyssen-Bornemisza, Switzerland/ Ben Shahn/VAGA, NY & DACS, London 1999.
P427 - Courtesy of Berry-Hill Galleries, New York; bl: SFM: Mrs Manfred Bransten Special Fund Purchase/Photograph: Ben Blackwell.
P428 - tr: Art Gallery of South Australia, Adelaide: Gift of William Bowmore OBE through the Art Gallery of South Australia Foundation 1990/© Estate of Walter Sickert 1998 All rights reserved DACS; bl: TAT: Purchased 1983/© Estate of Walter Sickert 1998 All rights reserved DACS.
P429 - tr: BAL: Bridgestone Museum of Art, Tokyo/Photograph: Peter Willi/© DACS 1999; bl: National Gallery of Victoria, Melbourne/© DACS 1999.
P430 - tr: BPK: Staatliche Museum, Berlin/Photograph: Jörg P Anders; bl: NGL
P431 - tr: SCA: Museo dell'Opera Metropolitana; bl: SCA: Galleria degli Uffizi, Florence.
P432 - tr: BAL: Musée d'Orsay, Paris/Photograph: Erich Lessing; b: Bridgestone Museum of Art, Ishibashi Foundation, Tokyo.
P433 - tr: BPK: Staatliche Museum, Berlin/Photograph: Jörg P Anders; bl: BAL: Kunsthistorisches Museum, Vienna.
P434 - tr: BPK: Staatliche Museum, Berlin; b: IKO: Galleria degli Uffizi, Florence/Photograph: Raffaello Bencini Fotografo Firenze.
P435 - tr: NGL; bl: NGW: Samuel H Kress Collection, © 1998 Board of Trustees.
P436 - tr: AKG: Musée du Louvre, Paris/Photograph: Erich Lessing; bl: AKG: Musée du Louvre, Paris/Photograph: Erich Lessing.
P437 - tr: HER; b: NGL
P438 - tr: The Phillips Collection, Washington, D.C.: Acquired 1941/© ADAGP, Paris and DACS, London 1998; bl: Sotheby's, Inc., New York: 1998/© ADAGP, Paris and DACS, London 1998.
P439 - tr: GIR: Hospital de la Santa

P439 - TAT: Presented by the Trustees of the Chantrey Bequest 1960/© Estate of Stanley Spencer 1998 All rights reserved DACS; bl: BAL: Fitzwilliam Museum, University of Cambridge/© Estate of Stanley Spencer 1999 All rights reserved DACS.
P440 - tr: AKG: Kunsthistorisches Museum, Vienna; bl: AKG: From the Collection of Rudolf II/ Kunsthistorisches Museum, Vienna/Photograph: Erich Lessing.
P441 - tr: The Phillips Collection, Washington, D.C. © DACS 1999; b: GIR: Collection Thyssen-Bornemisza, Madrid/© DACS 1999.
P442 - tr: BAL: Kunsthistorisches Museum, Vienna; bl: NGL
P443 - tr: NGL; br: TAT: Presented by Lady Augustus Daniel 1951.
P444 - tr: TAT: Purchased 1972/© DACS 1999; b: SFM: Gift of Mr and Mrs Frederick R. Weisman/© DACS 1999.
P445 - tr: © Museo Thyssen-Bornemisza, Madrid; bl: TAT: Purchased 1971.
P446 - tr: AKG: Musée du Louvre, Paris/Photograph: Erich Lessing; b: BAL: The Barber Institute of Fine Arts, University of Birmingham.
P447 - tr: NGL; b: BAL: Hermitage, St Petersburg, Russia.
P448 - tr: NGW: Andrew W. Mellon Collection, © 1998 Board of Trustees; bl: NGW: Andrew W. Mellon Collection, © 1998 Board of Trustees.
P449 - tr: BAL: Manchester City Art Galleries; b: BAL: Private Collection
P450 - tr: Leicester City Museums; bl: BAL: Hermitage, St Petersburg.
P451 - tr: © Museo Thyssen-Bornemisza, Madrid/© ARS, NY and DACS, London 1998; bl: Fundació Antoni Tàpies/Gasull Fotografía/© DACS 1998.
P452 - tr: NGL; b: NGL
P453 - tr: BAL: Kunsthistorisches Museum, Vienna; bl: The Detroit Institute of Arts: Founders Society Purchase, Eleanor Clay Ford Fund, General Membership Fund, Endowment Income Fund and Special Activities Fund, Photograph © 1998.
P454 - tr: AKG: Stedelijk Museum van Diest; bl: Allen Memorial Art Museum, Oberlin College, Ohio: R.T. Miller, Jr. Fund, 1953.
P455 - tr: Courtesy of Campbell Thiebaud Gallery, San Francisco: Private Collection; bl: SFM: Mrs Manfred Bransten Special Fund Purchase/Photograph: Ben Blackwell.
P456 - tr: MNP; bl: MNP.
P457 - tr: NGL; bl: MNP.
P458 - tr: IKO: Museo Nazionale di San Martino; bl: AKG: Städelsches Kunstinstitut, Frankfurt.
P459 - tr: BAL: Musée d'Orsay, Paris; bl: The Toledo Museum of Art, Ohio.
P460 - AKG: Château Archiépiscol, Kromeriz/Photograph: Erich Lessing
P461 - NGW: Samuel H. Kress Collection, © 1998 Board of Trustees/Photograph: Lee Ewing.
P462 - tr: Musée d'Orsay, Paris; bl: AKG: Musée d'Orsay, Paris/ Photograph: Erich Lessing.
P463 - tr: NGL; bl: By Kind Permission of David Messum Fine Art Limited, 8 Cork Street, London W1.
P464 - tr: BAL: Museo Correr, Venice; bl: NGL
P465 - tr: TAT: Bequeathed by the artist 1856; b: TAT: Bequeathed by the artist 1856.
P466 - tr: Kunsthaus Zurich: © 1999 by Kunsthaus Zurich. All rights reserved; bl: BAL: Private Collection.
P467 - tr: NGL; b: Ashmolean Museum, Oxford.
P468 - tr: Bridgestone Museum of Art, Ishibashi Foundation, Tokyo/© Association Maurice Utrillo/© ADAGP, Paris and DACS, London 1999; bl: NGW: Chester Dale Collection, Photograph © 1998 Board of Trustees, National Gallery of Art Washington/© Association Maurice Utrillo/© ADAGP, Paris and DACS, London 1999.
P469 - tr: P Bernardeau: Pierre Gianadda Foundation, Martigny/© DACS 1999; bl: The National Museum of Women in the Arts, Washington/© DACS 1999.
P470 - tr: GIR: Hospital de la Santa

Caridad, Seville; bl: GIR: Hospital de la Santa Caridad, Seville.
P471 - t: BAL: Musée du Louvre, Paris/Photograph: Peter Willi; b: AKG: Musée du Louvre, Paris/Photograph: Erich Lessing.
P472 - GIR: Wellington Museum, London/Photograph: Joseph Martin.
P473 - MNP.
P474 - tr: BPK: Staatliche Museum, Berlin/Photograph: Jörg P Anders; b: BPK: Staatliche Museum, Berlin/Photograph: Jörg P Anders.
P475 - tr: NGL; bl: NGL
P476 - tr: AKG: The Mauritshuis, The Hague; bl: Kunsthistorisches Museum, Vienna.
P477 - tr: Haworth Art Gallery, Accrington: Hyndburn Borough Council; b: NGL
P478 - tr: NGL; bl: NGL
P479 - tr: NGL; b: AKG: Galleria degli Uffizi, Florence/Photograph: Erich Lessing.
P480 - tr: BAL: Galleria degli Uffizi, Florence; bl: BAL: The Barber Institute of Fine Arts, University of Birmingham.
P481 - tr: SCA: Galleria degli Uffizi, Florence; bl: NGL
P482 - tr: AKG: Musée d'Orsay, Paris/Photograph: Erich Lessing/© DACS 1999; bl: NGW: Chester Dale Collection, © 1998 Board of Trustees/© DACS 1999.
P483 - tr: BAL: Johnny van Haeften Gallery, London; bl: BPK: Staatliche Museum, Berlin – Preußischer Kulturbesitz Gemäldegalerie/Photograph: Jörg P Anders.
P484 - tr: NGW: Samuel H. Kress Collection, © 1998 Board of Trustees; bl: AKG: Musée du Louvre, Paris/Photograph: Erich Lessing
P485 - tr: Glasgow Museums, The Burrell Collection: Art Gallery and Museum, Kelvingrove/© ADAGP, Paris and DACS, London 1999; bl: NGW: Chester Dale Collection, © 1998 Board of Trustees/© ADAGP, Paris and DACS, London 1999.
P486 - tr: TAT: Presented by the Tate Friends St Ives 1994/© ARS, NY and DACS, London 1999; b: BAL: Barbara Hepworth Museum and Sculpture Garden, St Ives/© ARS, Paris and DACS, London 1999.
P487 - tr: Museum für Moderne Kunst, Frankfurt: Photograph: Ströher/© The Andy Warhol Foundation for the Visual Arts Inc/ARS, NY & DACS, London 1999; b: TAT: Purchased 1980/© The Andy Warhol Foundation for the Visual Arts Inc/ARS, NY & DACS, London 1999/TM Estate of Marilyn Monroe by CMG Worldwide Inc, Indpls, IN, 46256 USA www.MarilynMonroe.com
P488 - tr: BAL: Oldham Art Gallery, Lancashire; b: BAL: Manchester City Art Galleries.
P489 - tr: Artephot: Musée du Louvre, Paris/Photograph: André Held; bl: AKG: Musée du Louvre, Paris/ Photograph: Erich Lessing.
P490 - tr: National Portrait Gallery, London; bl: TAT: Presented by George Frederic Watts 1897.
P491 - tr: National Gallery of Canada,

Ottowa: Transfer from the Canadian War Memorials, 1921 (Gift of the 2nd Duke of Westminster, Eaton Hall, Cheshire, 1918); b: CAR: Museum purchase, 11.2/Photograph: Peter Hardoldt, 1994.
P492 - tr: NGW: Andrew W. Mellon Collection, © 1998 Board of Trustees/ Photograph: Bob Grove; b: MNP.
P493 - tr: TAT: Bequeathed by W.C. Alexander 1932; bl: TAT: Presented by the National Art Collections Fund 1905.
P494 - tr: National Museums & Galleries of Wales; b: BAL: Castle Museum and Art Gallery, Nottingham.
P495 - tr: Museum Boymans-van Beuningen, Rotterdam; bl: NGL
P496 - tr: © Musée d'art et d'Histoire, Ville de Genève: Photograph: Bettina Jacot-Descombes; bl: ART: Gemäldegalerie, Berlin.
P497 - tr: Photograph courtesy of AIC: Friends of American Art Collection, All rights reserved, 1930.954/© Estate of Grant Wood/VAGA, NY & DACS, London 1999; b: Reynolda House, Museum of American Art, Winston-Salem, North Carolina: Photograph: Jackson Smith.
P498 - tr: BPK: Staatliche Museum, Berlin/Photograph: Jörg P Anders; b: HER.
P499 - tl: NGL; bl: NGL
P500 - tr: NGL; b: BAL: Musée du Louvre, Paris/Photograph: Giraudon.
P501 - tr: Wyeth Collection, Pennsylvania; b: Wyeth Collection, Pennsylvania.
P502 - tr: NGL; b: NGL
P503 - tr: MNP; br: Reproduction courtesy of the National Gallery of Ireland, Dublin: By kind permission of Anne Yeats.
P504 - tr: BAL: Townley Hall Art Gallery and Museum, Burnley; b: The Royal Collection © Her Majesty Queen Elizabeth II.
P505 - tr: NGL; bl: NGL

Jacket:
Front - tcl: AIC: Helen Birch Bartlett Memorial Collection, 1926.224, Photograph © 1999, The Art Institute of Chicago, All Rights Reserved; tc: TAT: Purchased 1981/© David Hockney; tcr: SuperStock Ltd: The Huntington Library, Art Collections and Botanical Gardens, San Marino, California; bl: BAL: Österreichische Galerie, Vienna, Austria; cra: SCA: Galleria degli Uffizi, Florence; clb: Robert Harding Picture Library: © Explorer; cbl: SCA: Ganz Collection, New York/© Succession Picasso/ DACS 1999; cbr: NGW: Chester Dale Fund, © 1998 Board of Trustees/© ADAGP, Paris and Dacs, London, 1999; crb: NGL; br: BAL: Courtauld Gallery, London.
Spine - t: The Whitworth Art Gallery, The University of Manchester.
Back - cbl: ART: Städtische Galerie im Lenbachhaus, Munich/Photograph: Joachim Blauel; cb: AKG: Musée d'Orsay, Paris/Photograph: Erich Lessing; cbr: NGL.

ACKNOWLEDGMENTS

Sister Wendy Beckett would like to thank: Sylvia and Anthony Hopkins for their support and hospitality; Melbourne Bury is an ideal setting for creative work; Sean Moore, for commissioning this enormous project; Damien and Claire at Studio Cactus; and all of the design, editorial and picture research team at DK for their creative hard work.

Dorling Kindersley would like to thank: Flavia Taylor, Julia Harris-Voss, Katherine Mesquita, Mariana Sonnenberg, Rita Selvaggio, Simon Holland, Steve Knowlden, Tracy Hambleton Miles and Zirrinia Austin. Text for the US edition was edited and design-checked in-house by Dorling Kindersley, London.

Studio Cactus would like to thank Michael Ellis, Amanda Hess, Daniel O'Sullivan, Charlotte Byrd, Elizabeth Byrd, Gwen Edmunds, Bella Pringle, Helen Bracey, Sharon Moore, Hilary Bird, Fiona Wild, and Laura Harper.